TIME AND SCIENCE IN THE *LIBER FLORIDUS* OF LAMBERT OF SAINT-OMER

RÉPERTOIRE ICONOGRAPHIQUE DE LA LITTÉRATURE DU MOYEN ÂGE

LES ÉTUDES DU RILMA

13

Collection dirigée par Christian Heck
Ancien Membre senior de l'Institut Universitaire de France
Professeur émérite à l'Université de Lille 3

Le RILMA est un programme d'histoire de l'art fondé sur une recherche collective, internationale et interdisciplinaire. Le noyau en est constitué par la collection des volumes du Corpus, dans laquelle sont présentés, reproduits dans leur intégralité, et commentés, les cycles d'illustrations des œuvres de la littérature du Moyen Âge, tous domaines confondus. Dans une perspective plus large, les Études du RILMA confrontent les enluminures à tous les autres champs de la création artistique, et examinent leur place dans l'histoire culturelle du Moyen Âge. La création du RILMA a bénéficié d'un projet de recherche retenu par l'Institut Universitaire de France, dans le cadre de la chaire d'iconographie médiévale.

Time and Science in the *Liber floridus* of Lambert of Saint-Omer

Edited by
Patrizia Carmassi

BREPOLS

Cover: Gent, Universiteitsbibliotheek, Hs. 92, folios 226'v–226''r

D/2021/0095/288

ISBN 978-2-503-59692-1

Printed in the EU on acid-free paper

Table of Contents

Times and their Declination

Préface

Temps et science dans le Liber floridus de Lambert de Saint-Omer

Patrizia Carmassi

Ce volume constitue les Actes du colloque qui s'est tenu le 27 et 28 Mars 2019 à Orléans – LE STUDIUM[1]. Qu'il ait été hébergé dans les murs de l'ancien palais des évêques d'Orléans, bâtiment qui fut construit au xviie siècle, et plus précisément de 1635 à 1665, est une heureuse coïncidence. C'est en effet dans ces mêmes années que se déroulaient la vie et la carrière du philologue et collectionneur Marquard Gude (1636–1689). Dans les années 60 du xviie siècle, il a fait un grand tour de France, en passant par Orléans, à la recherche de manuscrits anciens. Peut-être avait-il déjà dans ses coffres, après un séjour à Reims de deux mois en 1660, l'un des plus anciens et précieux manuscrits du *Liber floridus*, après la version autographe de Lambert, à savoir le ms. Cod. Guelf. 1 Gud. lat. de la Herzog August Bibliothek de Wolfenbüttel[2].

Marquard Gude était un savant qui s'interrogeait sur l'identité et sur le milieu intellectuel de Lambert. En écrivant ce qu'il avait découvert sur l'auteur dans le prologue de ce qui était devenu son manuscrit, il exprime sa déception de ne pas en avoir trouvé plus sur le chanoine : *Sed eius nullam alibi mentionem reperio*[3] ! Plus récemment, Jean-Charles Bédague a posé la question de savoir si Lambert de Saint-Omer avait rédigé certaines des chartes de son église et il lui a attribué une influence dans la préparation à Saint-Omer du privilège de Grégoire VII du 25 mars 1076. Les conclusions sont pourtant très prudentes : il termine en disant «que les activités d'écriture de ce chanoine – entendues au sens large – ne se sont pas limitées au seul *Liber floridus*, mais ont pu s'étendre à d'autres productions, dont certaines étaient plus directement liées aux droits et à la vie religieuse de son église»[4].

D'autre part, malgré ces incertitudes sur la biographie de l'auteur, on dispose d'un document exceptionnel pour comprendre l'activité intellectuelle de Lambert et les différentes étapes de composition et remaniement de son œuvre : c'est le manuscrit autographe, conservé à Gand, Bibliothèque de l'Université, HS 92. Selon la reconstruction de Albert Derolez le travail de Lambert s'est déroulé en différents stades de 1106 à 1121[5].

Mais revenons au présent volume : pourquoi centrer notre propos sur le temps ? L'idée de la conférence est née à cause du manuscrit de Wolfenbüttel, mais aussi à l'occasion du travail qui j'avais fait antérieurement au sein du groupe de recherche *ZeitenWelten* concernant les diverses dimensions du temps et la construction culturelle de l'idée de temps au haut Moyen Âge[6].

Les questions liées au concepts de temps (et de science) jouent en effet un rôle clef dans l'œuvre médiévale de Lambert : on pense au calendrier liturgique, placé relativement au début de l'œuvre[7] et enrichi des éléments du *computus*[8], au mouvement des planètes et des signes du zodiaque, à la distinction des années, des mois et des jours, au déroulement de l'histoire locale et universelle depuis la Création avec ses divisions en *aetates*, aux généalogies[9], mais aussi aux questions théologiques concernant le Jugement dernier et la fin des temps[10]. Dans ce cas, il s'agit aussi des relations qui subsistent entre différentes conditions existentielles et temporelles (voire intemporelles)[11]. Il est aussi question de l'interprétation que Lambert donne aux événements historiques et au présent, en tenant compte de la tradition biblique, exégétique et théologique dont il disposait. Sa vision des événements imminents est influencée par la littérature exégétique qu'il connaît et utilise[12].

Le sujet du temps nous permet portant d'explorer autant les traditions textuelles spécifiques et les sources utilisées par Lambert[13], que leurs traductions en images et en diagrammes[14]. Les contributions permettent de nous rattacher aux courants de recherche les

plus récents sur la fonction des diagrammes[15], sur la définition de ce que sont les recueils, les miscellanées scientifiques ou une « encyclopédie »[16], mais aussi sur l'eschatologie, le futur ou le pronostic au Moyen Age[17].

La représentation du temps et des phénomènes qui lui sont liés dans l'espace de la page d'un manuscrit est toujours un défi et offre beaucoup de possibilités plus ou moins ancrées dans la tradition : soit on peut utiliser la liste pour représenter l'ordre chronologique des personnes dans leurs offices, des événements passés, des jours ou des années futures, soit on emploie une organisation schématique des formes qui exprime les rapports entre plusieurs niveaux temporels, soit on cherche une reproduction fidèle des données astronomiques, ou alors on représente l'imaginaire de l'invisible et de l'« à-venir », pour n'évoquer ici que quelques possibilités[18]. On doit considérer aussi les plus larges traditions iconographiques inspirées par les sources bibliques, liturgiques ou exégétiques (par exemple concernant l'Apocalypse, Marie, Salomon, etc.), et leur adaptation spécifique dans le *Liber floridus*, soit leur interaction avec les images corrélées, avec toutes les possibles connotations liées au concept du temps.

À une époque de changements profonds et d'innovations, le XIIe siècle, avec la circulation de nouvelles théories scientifiques qui concernent la cosmologie et l'ordre de l'univers, l'activité de Lambert devient singulière et très importante pour analyser les phénomènes de transformation, de contamination, de créativité, voire de contradiction entre les doctrines. Lambert, toutefois, compose son œuvre avant les grandes transformations scientifiques et philosophiques, dues à la réception des auteurs arabes en traduction latine dans l'Occident. Certains développements originels de sa pensée peuvent toutefois être observés, si on examine en détail textes et images[19].

Pascale Bourgain a souligné qu'il y avait au Moyen Âge des œuvres, même remarquables, qui n'étaient pas conçues pour une reproduction, « because they were simply too sophisticated to recreate, the creator having anticipated only a single copy. Such was the case with Lambert of Saint-Omer's *Liber floridus* and Herrade of Landsberg's *Hortus deliciarum*, image-books of a personal nature »[20]. Or, les copies manuscrites du *Liber floridus* nous obligent à considérer ce que ces transcriptions nous révèlent sur l'œuvre et sa signification, et aussi sur les enjeux liés à la transmission du savoir[21]. Quels sont dans les différents exemplaires du *Liber floridus*, ou même pour Lambert au moment de réaliser son ouvrage, les stratégies de choix, de réorganisation, d'omission ou d'adaptation, de disposition des contenus en images, ou des images sur la page, prenant en considération aussi la succession de feuillets et les pratiques de lecture, notamment la matérialité du codex[22] ?

Des disciplines fondamentales et distinctes sont donc nécessaires pour aborder toutes ces questions posées par *Liber floridus*. Elles vont de la philologie, la codicologie à l'histoire de l'art et des sciences médiévales. Tous ces angles d'approche sont représentés dans ce volume.

Exactement neuf cents ans sont passés depuis le jour où Lambert termina d'organiser la riche table de son recueil, si on revient à la métaphore qu'il a employée dans le prologue. Les contributions de ce volume ont montré que l'on n'a pas terminé de découvrir tous les éléments qui composent son banquet, ni d'explorer avec de nouvelles questions le contexte scientifique, littéraire, théologique et historique de ses choix[23]. En tout cas, l'idée du temps comme entité structurelle dans une perspective autant scientifique que théologique, aussi que le sens de l'urgence face aux réalités naturelles et surnaturelles auxquelles il se confrontait, constituaient pour Lambert, dans son *Liber floridus*, un moteur incontestable d'approfondissement intellectuel et de synthèse littéraire.

Wolfenbüttel, 25.03.2021

NOTES

1. Je remercie LE STUDIUM, Loire Valley Institute for Advanced Studies, qui a soutenu cette conférence dans le cadre de mon séjour de recherche (Marie Skłodowska-Curie Research Fellowship), en partenariat scientifique avec le laboratoire POLEN de l'université d'Orléans. Ma reconnaissance va aussi au Prof. Jean-Patrice Boudet (Orléans), host-scientist de mon projet à Orléans, qui a contribué à la réalisation de cet event. Mes vifs remerciements vont aussi à l'IRHT, Orléans, pour l'accès aux livres et microfilms de l'Institut, à la Herzog August Bibliothek, Wolfenbüttel, à l'Universiteitsbibliotheek Gent et à la Mediathèque, Orléans, pour avoir mis à disposition les reproductions de leurs manuscrits.

2. Cf. C. HEITZMANN et P. CARMASSI, *Der Liber floridus in Wolfenbüttel : eine Prachthandschrift über Himmel und Erde*, Darmstadt, 2014, ici p. 12–19 ; *Retter der Antike. Marquard Gude (1635–1689) auf der Suche nach den Klassikern*, éd. P. CARMASSI, Wiesbaden, 2016 (Wolfenbütteler Forschungen, 147).

3. Wolfenbüttel, Herzog August Bibliothek, Cod. Guelf. 1 Gud. lat., folio Ir : Cf. reproduction online http://diglib.hab.de/mss/1-gud-lat/start.htm ?image = 00005.

4. J.-C. BEDAGUE, «Lambert de Saint-Omer, rédacteur de chartes ? Nouveaux regards sur l'auteur du Liber floridus», *Bulletin de la Société nationale des antiquaires de France* 2018 (Séance du 30 mai 2012), p. 108–123, ici p. 121. Voir aussi récemment W. BLOCKMANS, «À la recherche de l'ordre divin. Le *Liber floridus* de Lambert de Saint-Omer en contexte (1121)», *Revue du Nord* 100 (2018), p. 11–31, sur le contexte historique, ecclésiastique et institutionnel de l'œuvre.

5. See A. DEROLEZ, *The making and meaning of the Liber Floridus. A study of the original manuscript, Ghent, University Library, MS 92*, London, 2015. Voir pour la reproduction digitale du manuscrit : https://lib.ugent.be/viewer/archive.ugent.be :018970A2-B1E8–11DF-A2E0-A70579F64438# ?c = &m = &s = &cv = &xywh = -667%2C–2466%2C13333%2C14211.

6. *Zeiten Welten. Zur Verschränkung von Weltdeutung und Zeitwahrnehmung, 750–1350*, éd. M. CZOCK et A. RATHMANN-LUTZ, Köln, 2016, en particulier l'introduction p. 9–37 pour les réflexions théoriques et l'état de la recherche. Pour les différents concepts du temps dans la philosophie médiévale voir l'article de Hans Otto Seitschek dans ce volume.

7. Sur le calendrier et la dimension liturgique du temps voire l'article de Laura Albiero.

8. Cf. A. DEROLEZ, *Die komputistischen Tafeln des Liber floridus*, Trier, 2003.

9. Cf. l'article de Christian Heitzmann sur les aspects de la narration historique dans le *Liber floridus*.

10. Voir les articles de Hanna Vorholt, Marco Rizzi, Raffaele Savigni et Philippe Faure.

11. Pour des questions supplémentaires reliées à la cosmologie dans le *Liber floridus*, comme celle de la demeure de Dieu, voir l'article de Barbara Obrist dans ce voulme. Pour des considerations sur la science dans le Haut Moyen Âge d'un point de vue historiographique et méthodologique cf. A. PARAVICINI BAGLIANI, «Quale scienza nell'alto medioevo ?», in *La conoscenza scientifica nell'alto medioevo*. Settimana di studio della Fondazione Centro italiano di studi sull'alto Medioevo, Spoleto 2020, 1 (Settimane di studio della Fondazione Centro Italiano di Studi sull'Alto Medioevo 67), p. 1–18.

12. Cf. les articles de Raffaele Savigni et Philippe Faure.

13. Cf. les articles de Albert Derolez, Isabelle Draelants, Barbara Obrist, Marco Rizzi.

14. Voir les articles de Hanna Vorholt, Anja Rathmann-Lutz, Philippe Faure, Isabelle Draelants, Barbara Obrist.

15. Cf. A. SOMFAI, «The *Liber Floridus* in the Encyclopaedic Tradition. Philosophical and Scientific Diagrams in Context», in *Liber Floridus 1121. The world in a book*, éd. K. DE COENE, M. DE REU et P. DE MAEYER, Warnsveld, 2011, p. 75–89 ; K. MÜLLER, «Admirabilis forma numeri. Diagramm und Ornament in mittelalterlichen Abschriften von Boethius' De arithmetica», in *Ornament. Motiv – Modus – Bild*, éd. V. BEYER et C. SPIES, München, 2012, p. 181–210 ; J.-C. SCHMITT, «Qu'est-ce qu'un diagramme ? A propos du *Liber Floridus* de Lambert de Saint-Omer (ca. 1120)», in *Diagramm und Text. Diagrammatische Strukturen und die Dynamisierung von Wissen und Erfahrung*, éd. E. C. LUTZ, V. JERJEN et C. PUTZO, Wiesbaden, 2014, p. 79–94 ; *Diagramme im Gebrauch*, éd. H. HAUG, Ch. LECHTERMANN et A. RATHMANN-LUTZ, Berlin, 2017 (Das Mittelalter, 22, 2), partic. p. 259–272 ; B. OBRIST, «"Imaginatio" and Visual Representation in Twelfth-Century Cosmology and Astronomy : Ibn al-Haytham, Stephen of Pisa (and Antioch), (Ps.) Masha'allah, and (Ps.) Thabit ibn Qurra», in *Image, Imagination, and Cognition. Medieval and Early Modern Theory and Practice*, éd. C. LÜTHY, C. SWAN, P. BAKKER et C. ZITTEL, Leiden, 2018 (Intersections, 55), p. 32–60 ; *The Visualization of Knowledge in Medieval and Early Modern Europe*, éd. M. KUPFER, A. S. COHEN et J. H. CHAJES, Turnhout, 2020 (Studies in the Visual Cultures of the Middle Ages, 16) ; J. F. HAMBURGER, *Diagramming devotion. Berthold of Nuremberg's Transformation of Hrabanus Maurus's Poems in Praise of the Cross*, Chicago, 2020 ; A. WORM, *Geschichte und Weltordnung. Graphische Modelle von Zeit und Raum in Universalchroniken vor 1500*, Berlin, 2021 (Jahresgabe des Deutschen Vereins für Kunstwissenschaft , 2016), spéc. p. 11–19 et 25 sur le *Liber floridus*.

16. Cf. *Encyclopédire. Formes de l'ambition encyclopédique dans l'Antiquité et au Moyen Âge*, éd. A. ZUCKER, Turnhout, 2013 (Collection d'études médiévales, 14). Voir aussi les articles de Patrizia Carmassi et Isabelle Draelants dans ce volume.

17. Cf. B. KÜHNEL, *The End of Time in the Order of Things. Science and Eschatology in Early Medieval Art*, Regensburg 2003 ; *Krise und Zukunft in Mittelalter und (Früher) Neuzeit. Studien zu einem transkulturellen Phänomen. Festschrift für Gerhard Wolf zum 60. Geburtstag*, éd. N. HUFNAGEL, S. KNAEBLE, S. WAGNER et V. WITTMANN, Stuttgart 2017 ; *Mittelalterliche Zukunftsgestaltung im Angesicht des Weltendes*, éd. F. SCHMIEDER, Köln 2015 (Archiv für Kulturgeschichte. Beihefte zum Archiv für Kulturgeschichte 77) ; J. M. DE TORO, «Historia y escatología en el Liber floridus de Lamberto de Saint-Omer», *Teología y Vida* 60 (2019), p. 149–174 ; D. GANZ, « Gefäße der Endzeit. Inszenierungen der apokalyptischen Bücher in der mittelalterlichen Bildkunst », in *Geschichte vom Ende her denken. Endzeitentwürfe und ihre Historisierung im Mittelalter*, éd. S. EHRICH et A. WORM, Regensburg 2019 (Forum Mittelalter. Studien 15), p. 377–418, spéc. p. 391–401. Voir aussi les articles de Hanna Vorholt et Charles Burnett dans ce volume.

18. Voir les articles de Patrizia Carmassi et Anja Rathmann-Lutz dans ce volume.

19. Cf. *The diffusion of the Islamic sciences in the western world*, éd. A. PARAVICINI BAGLIANI, Firenze, 2020 (Micrologus, 28. Conférences transculturelles de l'Union académique internationale, 3). Voir aussi les contributions de Charles Burnett, Barbara Obrist, Marco Rizzi dans ce volume.

20. P. BOURGAIN, «The circulation of texts in manuscript culture», in *The Medieval Manuscript Book : Cultural Approaches*, ed. M. JOHNSTON and M. VAN DUSSEN, Cambridge, 2015 (Cambridge studies in medieval literature, 94), p. 140–159, ici p. 141.

21. Cf. H. VORHOLT, *Shaping Knowledge. The Transmission of the Liber Floridus*, London, 2017 (Warburg Institute studies and texts, 6). Dans ce volume cf. l'article de Philippe Faure qui se concentre principalement sur le manuscrit de Wolfenbüttel.

22. Voir les articles de Hanna Vorholt et Anja Rathmann-Lutz.

23. Entre les plus remarquables enjeux concernant la tradition manuscrite cf. A. DEROLEZ, « *Codex Aldenburgensis*, Cotton Fragments Vol. 1, and the Origins of the *Liber Floridus*», in *Manuscripta* 49 (2005), p. 139–163. Récemment voir aussi le colloque sur le *Liber floridus*, organisé à la Bibliothèque universitaire de Gent par le *Centre for Medieval Literature* avec le *Henri Pirenne Institute for Medieval Studies* (24–25 Octobre 2019) : https://cml.sdu.dk/event/cml-workshop-liber-floridus.

PATRIZIA CARMASSI

Manuscripts

Before the *Liber floridus*: Texts and Compilations about Time in the Early Middle Ages

With Examples from the Library of Fleury

Patrizia Carmassi

Introduction

In the prologue of the *Liber floridus*, Lambert of Saint-Omer expresses with different metaphors the difficulties of his time and the real nuisance (cf. the words *fastidiosus, incommoditas*) caused by too many books having been written on the subject of God's creation since the Church Fathers. Reading all of them seems to go beyond human capabilities, and Lambert likens this to the impossibility of testing the best dishes at the table of a powerful man without being overwhelmed by the task. If a selection of the exquisite and rare has not taken place in advance, the risk is to enjoy nothing (Fig. 1).[1] This is reminiscent to some degree of the words of Gottfried Wilhelm Leibniz five centuries later, and of his paradoxical vision of the development of science: '… cette horrible masse de livres, qui va toujours augmentant … Car enfin le disordre se rendra presque insurmontable, la multitude des auteurs qui deviendra infinie en peu de temps, les exposera tous ensemble au danger d'un oubli general',[2] and further: 'Plus une science est perfectionnée, et moins a-t-elle besoin de volumes'.[3] In any case, Lambert's prologue prizes the usefulness of his work of reduction through selection, with the goal of investigating (the nature = *perscrutari*) and transferring the selected information. He describes it as the result of *excipere, contexere* and *coadunare* in one book: the *Liber floridus*.

Compilation, excerpt and *florilegia* are well-known phenomena of transmission of knowledge, which were used long before Lambert. Their mechanisms and techniques have been examined in many respects by scholars, who have defined different methods

Fig. 1. Wolfenbüttel, Herzog August Bibliothek, Cod. Guelf. 1 Gud. lat., folio 1, Lambert of Saint-Omer, *Liber floridus*, third quarter of the 12th c.: Prologue

and criteria of analysis for changes and rearrangements.[4] In particular, it is important to determine whether knowledge has been

transformed in the process, and how, following which strategies, the transformation has occurred. Is it only a reduction of elements, or is it the matter of simplification? If a reorganization of the contents has taken place, what is the influence of the new context of reception on revision, exclusion and/or inclusion? What does it mean if new elements are inserted, e.g. images and diagrams? What happens if older sources are reinterpreted or combined with further sections of different cultural origin, and when has a tradition definitely been broken, generating something new? Could we speak of compilations in times of crisis and rupture in the same terms as for the transition of media at the end of the Middle Ages? It is important to consider in this respect that 'print and other new media are', in Lisa Gitelman's words, 'less points of epistemic rupture, than they are socially embedded sites for the ongoing negotiation of meaning'.[5] Finally, what role do the material aspects of the medieval book play in the processes of collecting and organizing of knowledge?[6] All these topics are important with regard to the transmission of scientific knowledge in the Middle Ages and in dealing with the heritage of the Past.[7]

It is often the case that a general evaluation and the judgment about the compiler is the ultimate outcome of the textual analysis of his work. Thus, Albert Derolez speaks of Lambert as an 'author of great originality', who transformed the Isidorian tradition of *Etymologiae* by adding pictures and by 'stressing the symbolical and moral sense of the world and of history'.[8]

Examples and their context from the early Middle Ages

Going back to the early Middle Ages, the importance of the analysis of each single compilation as a whole in its original context is stressed e.g. by Simon Keynes in his investigation of the three bifolia copied in the ninth century in southern England (London, BL, Cotton MS Vespasian B VI, folio 104–109). They form a *libellus*, including amongst other texts a metrical calendar of York, a chronological note, a chronology of the world, a list of popes and of Anglo-Saxon bishops together with royal genealogies.[9] He concluded that

'the compiler was not a mindless drone, bringing together whatever lay around him'.[10] He recognized a logic behind the compilation as a whole, which 'seems … to have been to reduce the world to order', whereas 'establishing the larger chronological context' was a substantial goal for his project.[11]

The monastery of Fleury, which flourished in the ninth and tenth centuries, but which also has witnesses attesting to an active scriptorium already during the seventh/eighth century, can serve as an example. We will consider here some challenges and research paths offered by the extant corpus of manuscripts produced there.

The intellectual contribution of Abbo of Fleury (*c.* 950–1004) during the tenth century in the fields of the Quadrivium, namely *computus* and astronomy, have been thoroughly studied in recent years.[12] For istance, his treatise *De ratione spere* has been seen as 'The first Latin text of the Middle Ages entirely devoted to planetary astronomy'.[13] Some of the manuscripts of this period are well-known computistical/astronomic miscellanies, like The Codex Berlin, Staatsbibliothek Preußischer Kulturbesitz, MS Phill. 1833 from the tenth century, written in Fleury. It collects among other authors (Macrobius, Isidore, Bede, etc.) many of Abbo's texts, tables and diagrams.[14] The compilation London, BL, Harley MS 2506, with texts by Hyginus, Abbo of Fleury, Aratus of Soli, *Phaenomena* (translation of Cicero), Macrobius, Martianus Capella, Plinius (Pliny the Elder), etc., is believed to have been written at Fleury as well, even if illuminated by an English artist, around the last decade of the tenth century (990–1000).[15] Apparently, a Carolingian exemplar was used as a model for this manuscript, with contemporary material added to an older core.[16] In other cases, a Carolingian codicological unit could be combined with new sections or receive later glosses and additions. The first example of typology is to be seen in the codex Bern, Burgerbibliothek, Cod. 250, which reflects in its first part (folio 1v–12), written in Seligenstadt in 836, the meeting between Einhard and Lupus of Ferrières, and the texts that he had received: The Calculus of Victorius of Aquitania and a model majuscule alphabet. The following part (folio 12–28), copied in Fleury around 1000, contains texts connected

with the scientific work of Abbo on *compu-tus* for the calculation of the date of Easter. Cod. 306 of the same library, a separate quaternion, belonged to the tenth-century part of Cod. 250 as well. It has indications about the history of Fleury (*Annales minores*) alongside tables with the 19-year cycle of the calculation of the *Dies Paschae*.[17] For the second typology we can quote the manuscript Paris, BNF, latin 5543, which contains texts from Dionysius Exiguus to Isidore, *De temporibus*, Beda Venerabilis, *De temporum ratione*, *De natura rerum*, and the anonymous work *De signis coeli* with miniatures. Additions concerns e.g. the calendar (cf. on 11 July the note about the reception of Benedicts relics: *Apud Floriacum monasterium susceptio corporis beatissimi Benedicti abbatis*), chronological notes about kings, tables of Abbo's *computus*, Verses.[18] Two different original parts seem to have been put together: *De signis coeli* begins incomplete as a new quire and the first signs of zodiac are missing (folio 158). It is not always easy to discern exactly the different stages of additions in the first part.[19] In any case, we can not consider the two main parts of the book as a production of the middle of the tenth century, as was recently proposed.[20] The traditional dating is 847,[21] which is reasonable, especially from a palaeographical point of view, since the script goes back to the ninth century in the major core of the book's parts.

The library of Fleury in the ninth century: survey and questions of method

Besides the aspect of the implications of the reckoning of time for the liturgical calendar, the investigation of time and its units was fundamentally connected with what we today call cosmology and the course of the planets. This was determined not only by the classical heritage, but also by the narrative of the creation in the book of Genesis: the creation 'was measured in days in Genesis and the Creator established the very stars and planets to declinate the seasons, the days, and the years (Gen 1,14)'.[22] About 50 years after the *Liber floridus* we find these contents displayed in one miniature of the Stammheim Missal.[23] During the early Middle Ages this scientific attitude is evident e.g. in the dedicatory letter

of Isidore of Seville to the Visigothic king Sisebut, when he writes (around 613) his *De natura rerum*:[24]

Ego autem satisfacere studio animoque tuo decursis priorum monumentis non demoror, expediens aliqua ex parte rationem dierum ac mensuum, anni quoque metas et temporum vicissitudinem, naturam etiam elementorum, solis denique ac lunae cursus et quorundam causas astrorum, tempestatum scilicet signa atque ventorum, necnon et terrae positionem alternosque maris aestus.[25]

Isidore refers to the writings of Christian authors but also of the old men (*veteres viri*) as his sources. The original works of Isidore, which also include the *Etymologiae*, and later the scientific contribution of Bede (†735) on nature and time (*De temporibus*, *De natura rerum*, c. 703, *De temporum ratione*, c. 725) were widespread in the early Middle Ages, even if their contents could be excerpted and rearranged as well.[26]

At this point, fundamental questions arise, in the attempt to understand how the cultural and scientific discourse about these subjects developed in Fleury. What was available in the monastery among the literature about time in the centuries before the tenth century? In what form and how was it read? A systematic overview on this specific matter is missing; could that be the reason why Immo Warntjes in 2017 still mentions the study of *computus* in early medieval Fleury as a *desideratum* for research?[27] We have already encountered one of the difficulties connected with the corpus of manuscripts, the dating, which sometimes differs in the opinion of scholars (even from ninth to eleventh century). A second issue concerns the origin and circulation of manuscripts. If some evidence (notes of possessions, mentions in later catalogues, additions) indicates the presence of a codex in the monastery of Fleury at some point, it is not always possible to establish (I) when the manuscript arrived there and (II) where exactly it was written (indications of origin sometimes remain approximate, such as France, East-France, West-France, the Loire region).[28] Ties have to be considered with Auxerre,[29] Limoges, Brittany (later England) and other centers. Even at the cathedral in Orléans there was a local scriptorium. However, there are groups of manuscripts with similar characteristics of

writing and decoration, which can be linked, and further special analysis, e.g. of color and ink, will help to clarify some open questions about the origin of the manuscripts.[30]

Turning to a preliminary survey of works about time for the period up to the tenth/eleventh century we find different manuscripts; already in the seventh/eighth century, a first excerpt of Bede *De temporum ratione* is preserved in a grammatical compilation written at Fleury, today Bern, Burgerbibliothek, Cod. 207, Fleury eighth c., (Folio 2: 'separate leaf containing an Easter Cycle AD 779–797 and a part of DTR I' of Bede).[31] A copy of Isidor, *De natura rerum*, with diagrams, was made in Fleury in the seventh/eighth century (Paris, BNF, latin 6400G).[32] In the ninth century, there were available in the monastery a compilation of Bede's texts about time (Orléans, Médiathèque MS 31, written in the region)[33] and a copy of Isidore, *Etymologiae* (now preserved in Bern, Burgerbibliothek, Cod. 36).[34]

A provisional list could also contain the following manuscripts:[35]

- Bern, Burgerbibliothek, MS B 56, 9th c. ex. (Pars I) and 10th c. in. (Pars II), Fleury, Auxerre or Lorsch, Martianus Capella, *De nuptiis Mercurii et philologiae*.[36]
- Bern, Burgerbibliothek, MS 347, 9th c., 2nd half, Loire area, astronomical and grammatical texts with diagrams (Macrobius, Pliny).[37]
- Città del Vaticano, BAV, Reg. lat. 598, 9th/10th c., Fleury (?), fragment of Martianus Capella, *De nuptiis Mercurii et philologiae* (folio 58–60v).[38]
- Città del Vaticano, BAV, Reg. lat. 1260, 9th c., second half, Fleury or Auxerre (?), Bede, *De natura rerum* (folio 1–16); Isidore, *De natura rerum*; Hyginus, *De astronomia* (folio 44v–83v), followed by a *computus*, cosmography and a medical treatise.[39]
- Città del Vaticano, BAV, Reg. lat. 1587, 9th c. med., Fleury (?), Macrobius, *Commentarius in somnium Scipionis*.[40]
- Leiden, Bibliotheek der Rijksuniversiteit, Voss. Lat. folio 70, folio 51–66, 10th–11th c., Fleury, Macrobius, *Commentarius in somnium Scipionis*.[41]
- Leiden, Bibliotheek der Rijksuniversiteit, Voss. Lat. 12 β, folio 15–26, c. 850, Auxerre or Fleury, folio 24v–26v Macrobius, *Commentarius in somnium Scipionis*.[42]

- Paris, BNF, latin 5543, 9th c. med., Fleury, folio 25–76, 85–90v, Bede, *De temporum ratione*, *De temporibus*.[43]
- Paris, BNF, latin 6365, 10th–11th c., Fleury: Cicero, *Somnium Scipionis*.[44]
- Paris, BNF, latin 7299, 11th c. in., Fleury, folio 28r–61v: Macrobius, *Commentarius in somnium Scipionis*.[45]
- Paris, BNF, latin 7400B, 9th c., third quarter, Auxerre or Fleury?, prov. Fleury, folio 12–27, 27–31v, Beda, *De natura rerum*; Bede, *De temporibus*.[46]
- Paris, BNF, latin 7887, 9th c. ex., Western France, Fleury (?), folio 1–50v; 51–60, Aratus, *Phaenomena*; Bede, *De natura rerum*.[47]
- Paris, BNF, latin 8663, 10th–11th c., Loire valley, Hyginus, Macrobius, *Commentarius in somnun Scipionis*, *Tractatus de abaco*, etc.[48]
- Paris, BNF, latin 16677, folio 1–72, 9th c., Fleury (?), Macrobius, *Commentarius in somnium Scipionis*.[49]
- Paris, BNF, NAL 1611, 10th c., second half, Feury, Cicero, *Somnium Scipionis*.[50]
- Paris, BNF, NAL 1615, 9th c., (Auxerre or Fleury?); Beda, *De temporum ratione* (folio 19–126v), *De natura rerum* (128v–135), *De temporibus* (135–140v), Calendar (Auxerre), computistic material, extracts of Martianus Capella, *De nuptiis*.[51]
- Paris, BNF, NAL 1616, Brittany, later Fleury?, 9th c. med., Moon tables, computistic material.[52]
- Paris, BNF, NAL 1630, Fleury, 10th–11th c., folio 14v–16v, Macrobius, *Commentarius in somnium Scipionis*.[53]
- Paris, BNF, NAL 1632, Tours or Auxerre, later Fleury, 9th c., folio 1–9, Beda, *De natura rerum*, folio 10–67v, Beda, *De temporum ratione*.[54]

In additon to complete works or extracts, some annotations in the margins of codices that contained exegetical commentaries on the book of Genesis are worth noting in this context. They are often not considered, but in this case they are relevant because of the description of the creation. The manuscript Orléans, Médiathèque, MS 34, contains Bede, *Libri quattuor in principium Genesis* (Fig. 2). It goes back to the second quarter of the ninth century and was written in Fleury.[55] At p. 11 of the manuscript, where Bede deals with Genesis 1,14, and in particular the part *luminaria*

Fig. 2. Orléans, Médiathèque, MS 34, p. 1, Beda Vene-rabilis, *Libri quattuor in principium Genesis*, 9th c., second quarter: opening page

Fig. 3. Orléans, Médiathèque, MS 34, p. 13, Beda Vene-rabilis, *Libri quattuor in principium Genesis*, 9th c., second quarter: Text with later marginal annotations

in signa et tempora et dies et annos, we find in the margins a sign, made with a drypoint. Bede speaks in this passage about the origin of time (*transitus temporum*), connecting it with the planets (and not with the creation of light as per Genesis 1,3).[56] The hand of the annota-tor is very active in the part concerning the creation (until p. 25 of the manuscript), men-tioning concepts, authors, biblical books and subjects that the reader had found in the text, e.g. (p. 13): *Quando vulgo inter kanem et lupum vocant … In quae signa sint stellae … Quando ceperint vices temporum discerni … embolismus* (Fig. 3).[57] Very striking is the fact that the same person (a monk) who read Bede in MS 34 also annotated in the margins another, much older codex of the library of the monastery, now preserved only in a few folios as a frag-ment (Orléans, Médiathèque, MS 192). This manuscript from the sixth century transmitted the text of the Church father Ambrose on the same matter: the commentary on the six days of the creation, the *Hexameron*.[58] Thus, we can

reconstruct, at least in part, practices of reading and specific interests within the monastery, in this case the creation and the divisions of time.

Following the master? Manuscript production in Fleury after Abbo

The monk Aimoinus lived in Fleury in the period of transition between the abbot Abbo († 1004) and the new abbot Gauzlinus († 1030). He died probably around 1010.[59] In the prefatory letter to Abbo at the beginning of his *Gesta Francorum* he also used the topos of the compilation from previous sources: the facts which were earlier dispersed in different books are now being collected in only one work, he says. Moreover, accordingly to the description of his qualities in the *Vita Gauz-lini*, as we will see, he emphasizes that one of his main concerns is the quality of the lite-rary outcome, the revision of the corrupted language and the restoration of the correct *latinitas*:

Res gestas Francorum sive regum quae et per diversos sparsae libros et inculto erant sermone descriptae in unius redigerem corpus opusculi ac ad emendationem latinitatis revocarem formam.[60]

In fact, this period is described by the later monk of Fleury Andreas, who wrote of the life of Gauzlinus as a time of great eruditeness:

Tot ea tempestate speciali arcium prerogativa floruere, ut nil aliut crederes Floriacense solum quam liberalium torrentem disciplinarum dominicęque scolę gymnasium.[61]

Aimoinus is said there to have excelled among the other monks for his rhetoric skills and his writings. In addition to other works, he wrote a sermon in honor of Saint Benedict, in prose and verses that consisted of collecting and interweaving the statements of the earlier Fathers about the great virtue of the saint:

Texuit et quendam in patris Benedicti laude sermonem, metrorum intercalatione pulchrę micantem, quo precedentium colligens asserciones patrum, hunc adtestantium patriarcharum equiperandum virtuti, signorum pretiosissimum efficit margaretum.[62]

The sermon is preserved in the first section of one manuscript for liturgical use, today in Orléans, Archives départementales du Loiret, MS H 20, which contains other hagiographical texts about Benedict, beginning with Gregory the Great's *Dialogi* (book II). Primary focus is given to the translation of the relics of the saint, which were kept in Fleury since the seventh century and represented one of the main spiritual (and material) resources of the monastery. The codex, with its precious decoration and the formalized setting of liturgical readings, represented an 'investment' for, and at the same time a symbol of, the prosperous existence and the religious identity of the community under the glorious aegis of the patron saint. This program and the codicological/palaeographical features of the book indicate a production in the first quarter of the eleventh century, probably under the abbot Gauzlinus (= after 1004), who is described in the same *Vita* as having enriched architecture, chant and the cultural life in the monastery in general. The origin of the manuscript in Fleury is confirmed not only by the specific local content, but also by the historical circumstances of preservation, the codex having

Fig. 4. Orléans, Médiathèque, MS 145, p. 7–8, Hrabanus Maurus, *Liber in honorem sanctae crucis*, Fleury, 11th c. in.: The crucified Christ (*De imagine Christi in modum crucis*)

Fig. 5. Orléans, Médiathèque, MS 145, p. 40–41, Hrabanus Maurus, *Liber in honorem sanctae crucis*, Fleury, 11th c. in.: 'On the number 40 and its mystery' (*De numero quadragenario et mysterio eius*), with visible traces of gold in the frame

been kept together within the arch of the relics until early modern times.[63]

Why is this codex important? It can be related to another manuscript, now in Orléans, Médiathèque, MS 145, which brings us back to the subject of compilation and time.[64] In the first codicological unit (p. 1–84), MS 145 contains a very accurately written and illuminated copy of Hrabanus Maurus, *Liber in honorem sanctae crucis* (Fig. 4). Only the very last section of book two is missing, probably only a single leaf, now lost. The second part of the codex is slightly later and contains sermons. The original binding of the volume is also lost.[65]

The work of Hrabanus was well known in Fleury at the time of Gauzlinus, as it is documented in his *Vita*, where it is said that he embellished the poem of Hrabanus with gold and silber: *Poema Rabani, exaratum in laude sanctę crucis auro argentoque eleganter adornavit*.[66]

This sentence has already been related to the codex MS 145, which had been dated by the most scholars to the tenth century. The description points to the materials that were used for the decoration of the manuscript on behalf of the abbot. In fact, with a closer look,

we can observe that in MS 145 gold was definitely used e.g. for the filling of the rectangular frames of the *carmina figurata* (Fig. 5).[67] Today, the green color of the (oxydated) base dominates the page, but the use of gold is visible as well. In order to determine whether gold was used in some letters in the *carmina figurata*, e.g. on p. 1 and 7, further analysis of the pigments will be necessary. I could not find traces of silver, but this could have been used for an expensive book cover. Some holes due to oxydation of metal can be found in the middle of the external margin of p. 1–9, probably because of a metal clasp from a former binding. Considering these codicological facts and the remark in the *Vita Gauzlini*, we can affirm that the Hrabanus manuscript was commissioned by Gauzlinus and therefore its dating must be shifted to the beginning of the eleventh century (1004–1030), at the time of Gauzlin's office as abbot in Fleury.[68]

Furthermore, the analysis of the scribes' hands allows the observation that at least one same scribe worked on the two mentioned codices Orléans, Archives départementales du Loiret, MS H 20 and Médiathèque, MS 145, which were consequently both produced in

the same scriptorium. Very similar features are to be found in the script and they point to a common training in one scriptorium at the same time (see the shape of the letters, angular a, shape of g, ligatures &, st, ct, rt with 'high' r. e.g. *virtus*, p. 47 in the manuscript H 20, and *mortalium* p. 41 of MS 145 (see fig. 5 above), majuscule *N* in minuscule words, nexus *NT* at the end of a word, etc.). In sum, all the elements we have observed and the latest discovered codicological/palaeographical features point to a certain production of precious and relevant manuscripts at Fleury in the first quarter of the eleventh century. In support of this assumption, we find in another document, the *Life of Robert the Pious*, written around 1041 by Helgaud of Fleury, contemporary of Abbo and Gauzlinus, that Gauzlinus is described as having made significant donations to the monastery, enriching the *ornamenta ecclesiae*.[69] In the same source, he is portrayed as an Abbo's disciple, highly learned in the Holy Scripture and excellent in theological and philosophical science (*pollens scientia spirituali simul et humana*):

Fulsit in monasterio Floriacensi, loco celebri, splendidus mundo Gauzlinus abba merito, sanctis Deo conjunctus operibus, pollens sciencia spirituali simul et humana. Inerant ejus cordi Abonis magistris [!] prolati sancte Scripturę flores boni, de quibus honestissime imbutus ita eructuabat omnibus ut possent delectari in cęlestibus.[70]

The question is: given this cultural context in Fleury at the beginning of the eleventh century, could we possibly explain the decision to copy such an expensive and elaborate work from the ninth century such as Hrabanus' *Liber in honorem sanctae crucis*? With this purpose in mind, we can consider first of all the work itself. The *Liber* had been written in Fulda in 810 by a Benedictine monk, who had represented himself piously genuflecting under the cross of Christ; in this sense he could be imitated in his path of faith and wisdom throughout the book by any well-educated monk in Fleury. Moreover, Hrabanus' work must be considered in two other respects: first, it expressed under the sign of the cross a sort of compendium of traditional theological matters, exegetical sources and the knowledge available at its time.[71] Moreover, the means Hrabanus had chosen in order to convey these contents was extremely complex, demanding great skills not only in the knowledge of theology but also in Latin poetry, numerology, techniques of symbolic and graphic visualization. The ability to read difficult compositions combining text, single words and letters in Latin and Greek, symbolic images, geometrical and diagrammatical elements was requested from the reader. However, together with the instructions for reading the page (*legendus est, notandum est*), which are given in the prosa texts which accompany each *carmen figuratum*, the whole book could also be used as a pedagogical instrument in order to improve the studying of such visual skills.[72] In the explanation of how the *versus intexti* in the opposite page (verso) are to be read, spacial categories of orientation are used: See e.g. *In supremo circulo hic est versus ... In infimo vero hic ... Dextro namque hic ... Et in sinistro hic;*[73] *In latitudine ... in longitudine;*[74] *subtus dextrum cornu crucis ... supra dextrum cornu crucis;*[75] *in medio crucis ... in base crucis ... qui transversam partem crucis faciunt.*[76] There are also references to the direction of reading, e.g. *per transversum* (p. 33),[77] *In cruce quoque hic versus est in longitudine a summo deorsum vadens* (p. 22),[78] *ab infimo angulo primum sursum ascendendo* (p. 18),[79] to the geometrical figures and their characteristics (*geometricae figurae potestas*),[80] and also an awareness of the produced textual and pictorial artefact on the page (p. 12): *Novem ergo litterae maiores quae in hac pagina speciem crucis faciunt;*[81] *Quattuor ergo cruces in hac pagina, per quattuor loca pictae atque conscriptae sunt, hoc modo longitudo enim crucis*[82]

Concerning the subject of time, some of the *carmina figurata* and their explanations in prose are explicitly dedicated to the order of nature and the place of time in the history of salvation: the four elements and seasons, the twelve signs of the zodiac and their circles, the partitions of the time, the ages of the world, the life of Christ within the frame of universal chronology and the eschatological dimension of time with reference to the apocalypse. At p. 5 a detailed table of contents (*capitula*), transmitted also in the oldest codices, offers an orientation through the subjects of each *carmen*. The author is mentioned in the third person as the *opifex*. Already in the titles the symbolic meaning of numbers is connected with the praise of the cross and associated

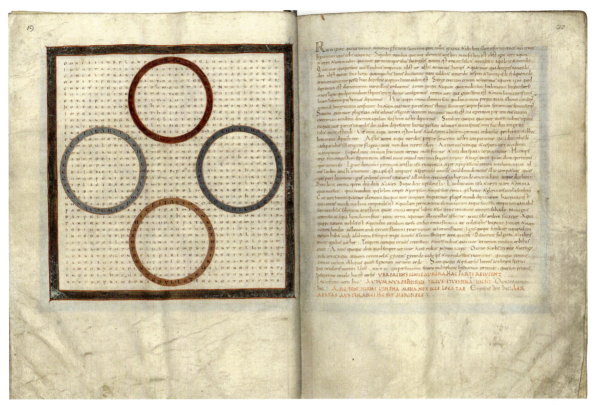

Fig. 6. Orléans, Médiathèque, MS 145, p. 19–20, Hrabanus Maurus, *Liber in honorem sanctae crucis*, Fleury, 11th c. in.: 'On the forur elements…' (*De quattuor elementis et quattuor vicissitudinibus temporum …*)

with natural phenomena and their numeric aspects. Cosmological and computistical aspects are included in some of the poems in verses (on the left) and in the parallel texts, which were copied on the corresponding page on the right of the open book. A few examples follow.

Capitulum VII (= B7/C7) (Fig. 6): *De quattuor elementis et quattuor vicissitudinibus temporum …* In the prose explication, the four circles (*rotae*) build the figure of the cross, but they also represent the four elements, the four directions and parts of the world (*plagae orbis*), the four seasons and the temporal partitions of one day (*quadrantes diei*), so that Hrabanus speaks of *vicissitudines temporum*. All together, this mix of time and elements of the world, and especially the idea of movement, mobility and mutability, which is intrinsic in the cyclical recurring and in the succession of time (the whole world-machinery), is therefore, in the words of Hrabanus, visually well expressed by the geometrical figure of the *rota* – 'times go on in circles':

Cum vero in rotis quattuor elementa sive quattuor tempora seu quattuor plagas mundi dipinxerim, haec ratio

est, quia omnis mundi machina temporalis est, et quadam permixtione elementorum atque successu temporum variabilis sive mutabilis, Salomone attestante, qui ait: Omnia tempus habent, et suis spatiis transeunt universa sub caelo.

… Tempora namque circulis transeunt, et vicissitudines quattuor ternorum mensium orbibus eunt. Annus quoque ab eo quod semper vertatur, et in se redeat nomen accipit.[83]

Capitulum VIII (= B8/C8): *De mensibus duodecim et duodecim signis atque duodecim ventis … et de ceteris mysteriis duodenarii numeri.* This poem, dedicated to the number 12, mentions a. o. months, winds and the signs of the zodiac (Fig. 7). The disposition of the figure, with departing lines from each branch of the cross, is intended to to indicate groups of three coherent units within a bigger group of twelve elements, e.g. winds. In the case of the months, the groups of three build the four times (*quattuor tempora*) in the year, following the cosmological science about time by Greeks and Aegyptians. Interesting here is the description of the lines, revealing the consciousness about their function

Fig. 7. Orléans, Médiathèque, MS 145, Fleury, 11th c. in., p. 21–22, Hrabanus Maurus, *Liber in honorem sanctae crucis*, B8/C8: 'On the twelve months …' (*De mensis duodecim …*)

in the visual perception of concepts (which is also typical for other diagrams): the lines go in different directions and allow distinctions, but they also connect concepts, relating them to a main line and a unique logical source.

Habet ergo haec species sanctae crucis in cornibus suis ternas lineas, ut demonstret, quod sicut ipsa dextra laevaque, in directo tramite suo vicinas et coadhaerentes lineas habet, ita ventorum quattuor cardinalium principalitas, in dextra et in sinistra ventos alios positione sua consociat, sic et quattuor tempora ….[84]

Cap. VIIII (= B9/C9): *De diebus anni in quattuor hexagonis et monade comprehensis et de bissextili incremento.*[85] In this case the poem begins with the invitation that sun and moon should worship Jesus as God; at the end of the next page in the explanation of the *carmen figuratum* and of the last (left with respect to the cross = right) hexagon, the relationship is the reverse: Christ is described as holding the stars of the universe – *Cuncta tenet Christus.*[86] In the text in prose, a long part is dedicated to the division of the solar year into 365 days,

these into hours, considering the measuring of the leap year increment, six hours accumulated each year. The challenge for Hrabanus was to represent these technical computistical aspects in coherent images, building a cross that was based on the the value of number six (hence the Hexagon) (Fig. 8). Moreover, these figures had to be conceived and drawn in order to contain not only perfect *versus intexti* but also a selected number of words, here 90 + 1, which can be multiplied by four and, adding the one letter which is in the middle of the cross, give 365, the number of the days of one year. The explication in prose is particularly interesting, because it deals with the matters of *calculus* and *computus*, including the leap year increment. Augustine is indicated as the source, but a substantial passage (which contains Augustine's quotation) has been actually taken from Bede, *De temporum ratione*, ch. 39.[87] The geometrical structure, as Michel Perrin pointed out, is inspired by Boethius' *De arithmetica.*[88] Moreover, the figure becomes for Hrabanus an essential part of the demonstration because each corner of the hexagon can be also seen as representing an

PATRIZIA CARMASSI

Fig. 8. Orléans, Médiathèque, MS 145, Fleury, 11th c. in., p. 23–24, Hrabanus Maurus, *Liber in honorem sanctae crucis*, B9/C9: 'On the days of the year in four hexagons …' (*De diebus anni in quattuor hexagonis …*)

hour: multiplying the six hours of one hexagon by four years, the number of the hexagons which build the cross, the result are the 24 hours, the *bissextilis dies*.

Notandum tamen quod in hac figura quadrantis demonstratio aliter non sit, nisi sub intellectu et examinatione sex angulorum, ut horae singulae singulis deputentur angulis. Si enim quattuor hexagonos in angulis suis perspexeris… … Si enim in quattuor annis quadrantilis portio ad unius diei pervenerit summam, rite in quattuor hexagonis quater sex horarum crux ostendit et normam.[89]

The visual examination is an active part of the intellectual process of logic demonstration.[90]

In each carmen, the scope is also always to provide synthetic statements about the subject of the poem in the *versus intextus*, which is here the number 365 of the days of the year. They build what can be called the universal time of the annual circle:

Terque centenos deciesque senos
Et semel quinos habet universum
Tempus annalis cruce circuitus
Ecce dies hic.[91]

The detailed analysis of *carmina figurata* which are dedicated to the subject of time could be continued with other chapters, such as e.g. Cap. XIII (B13/C13): *De diebus conceptionis Christi in utero virginis in quattuor crucibus demonstratis*,[92] or Cap. XIV (B14/C14): *De annis ab exordio mundi usque in annum passionis Christi in notis Graecarum litterarum.*[93] (Fig. 9)

The general christological focus of the *Liber in honorem sanctae crucis* and the universal dimension of the history of salvation is clear from one of the first miniatures (*De imagine Christi*) where Jesus is represented as a man, crucified and glorious at the same time.[94] The cosmic dimension of the cross and of Christ's redemption in this world and in the celestial realm, with all the implications for the time of the church on earth and after the end of time, are expressed e.g. in the words of the prologue: [*crux*] *quae columna est caelestis aedificii, in qua videlicet constructa est domus Christi.*[95] On the cross which surrounds the head of Christ (Carmen B1) three letters are written, Alpha, Omega and M, which are explained in the text in prose as follows: all the times, the very beginning, the middle and the end are

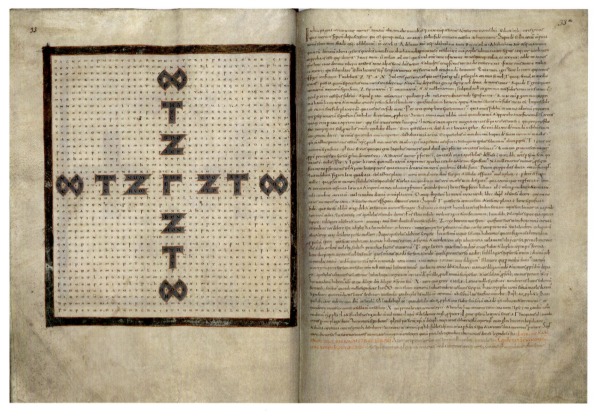

Fig. 9. Orléans, Médiathèque, MS 145, Fleury, 11th c. in., p. 33–33bis, Hrabanus Maurus, *Liber in honorem sanctae crucis*, B14/C14: 'On the years from the beginning of the world until the year of the Passion of Christ …' (*De annis ab exordio mundi usque in annum passionis Christi …*)

embraced by him – *tres litterae, hoc est A, M et Ω, quod significat initium et medium et finem ab ipso omnia conprehendi.*[96] About the reading and reception of the *Liber in honorem sanctae crucis* in Fleury we could also mention the manuscript Città del Vaticano, BAV, Reg. lat. 592, with Andreas Floriacensis' *De gestis patris Benedicti.* This contains on folio 3, which had remained empty, one apparently not completed *Carmen figuratum* in form of a cross.[97]

After having examined these aspects of the work of Hrabanus, we can come back to the question of the possible *Sitz im Leben* of the Fleury manuscript with regard to the cultural life in the monastery under abbot Gauzlinus. He was a disciple of Abbo, and was considered to have continued his heritage, as we have seen in the sources. Abbo's works were available in copies made in and for the monastery, and we can suppose that the monks studied them at the beginning of the eleventh century. As is evident even from a selection of examples, it is striking that there are profound affinities between the topics that we have encountered in Hrabanus, and in particular the methods used for their demonstration visually,

and the scientific subjects that were elaborated by Abbo together with the visual tools used for their layout, even if Abbo used different sources and developed new results.

Beyond works on *computus* and astronomy, Abbo wrote two logical treatises on categorical and hypothetical propositions and a commentary on the *Calculus* of Victorius of Aquitaine (fifth century), which was a series of tables of multiplication. The already mentioned miscellany produced in Fleury in the tenth century, Berlin, Ms. Phill. 1833, contains among other texts this last treatise (from folio 7v). The editor of the text has described Abbo's aim as follows: 'to demonstrate the relationship between unity and plurality and thereby show the special nature of unity, as the source of number and even existence itself. Everything else is composite and divisible, … and Abbo explores composites in nature and those made by "will"'. The former gave him an opportunity to discuss cosmological phenomena familiar to him for his studies in astronomy and *computus*, such as the phases of the moon and the divisions of the day.[98] Tables and diagrams were used in this

work, taken from the tradition of Calcidius or Boethius, e.g. the one from the commentary on Timaeus about the generation of the soul (*psycogonia*), which is described as very suitable figure, *apta figura*, in order to understand the flow descending from a singular source, God or the intellect, represented by the top of the image (*cacumen, summitas*).[99] Moreover, in the treatise *De categoricis syllogismis*, Abbo introduces the work in his dedication poem to the scholar B(ernardus), with an explicit consideration for the figures that are used for the drawing of diagrams in the field of logic. In order to visualize opposite, 'fighting' concepts, true and false, e.g., the image of the cross with its branches turns out to be very useful. The intellect observes and take on the 'winning' ones (thereby continuing the metaphor of fight). The concomitant inscriptions also help the reader to recognize the opposites, *Pugnantes nosces inscriptos nomina circum*, but it is mainly the figure of the cross which distinguishes the antitheses from each other. At the end Abbo mentions also the quadrangle and its kind of 'reliability' (cf. the adjective *fidelis*), because it provides the possibility to separate each item, but also to establish a form of scripture. About this example we can consider also the display of the tables of *computus* which were essential to Abbo's work, where the basic units are indeed little squares.

…

Tunc obliqua crucis torquentur brachia signis
Quae satis a falsis vera tuentur ibi

…

Quisque cruces complexus ea modus arte quaternus,
Qua statuunt pugnas militibus varias.
Hos circumspectat ceu maximus induperator
Mens et victores ad sua serta rapit.
Pugnantes nosces inscriptos nomina circum;
Nam crux alterutras efficit antithetas.
Quarum vera quidem signetur grammate rubro
Et ferrugineo falsa colore suo.

…

Omnibus exemplis quadrangulus ipse fidelis
Quo quasi scripta putes, singula quaeque refer.[100]

This poem is transmitted in the manscript Paris, BNF, NAL 1611, folio 6–6v. The script is related to Fleury and there are diagrams in the form of a x-cross in the colors red and brown at folio 6v.[101] On the following pages, a red x connect the elements between different columns.[102] It also must be considered that this manuscript originally built one unit together with the codex Orléans, Médiathèque, MS 267, and both parts were detached by Guglielmo Libri in the ninteenth century.[103] The volume contained Boethius, *In Porphyrii Isagogen commentariorum*, other treatises on logic and dialectic, and two *Opuscola* of Cicero. Additions were made e.g. of one bifolium at the beginning (p. 2–5), containing logical schemes and divisions which employ lines and squares. Other diagrams are drawn within the main texts (e.g. p. 25: *substantia*), or added in the margins (e.g. at p. 6, 7, 19, 34, 64: *quaedam similitudo inter orationem et numerum*), 79,[104] 82–84. Beside the lines, different geometrical figures were used.[105] In a further manuscript from Fleury from the tenth–eleventh century, Orléans, Médiathèque, MS 269, we find on p. 175–311 Boethius' *Commentarius in Aristotelis Categorias*.[106] There, diagrams are used for logical concepts, at the beginning of the work (p. 172–174) and in the margins. Furthermore, there are geometrical figures such as a square with a x-cross in the middle in order to indicate the relationship between *substantia universalis* and *accidens particularis* (p. 193).[107] It can be compared with Orléans, Médiathèque, MS 277.[108]

Finally, in the already mentioned manuscript Berlin, Staatsbibliothek Preußischer Kulturbesitz, Ms Phill. 1388, there is a table at folio 31v, with the rubric *Cursus lunae per duodecim signa*. From the point of view of the layout, it is worth noticing that the table has been organized in the form of a cross. The explanation written on the corners of the page refers to the form of the cross and its branches. In this case, the branches allow the creation of separate compartments with similar contents:

Hanc paginam supra exposuimus quae in crucis modum
figuratur habetque dextro brachio XII signa grece et latine
scripta quorum tria idest cancer scorpius et pisces occupant
tria spatia reliqua vero non nisi gemina …
Sinistro brachio….[109]

All these examples reveal the awareness of the function of diagrammatic forms for the visual organization of contents and their relationships in manuscripts of the tenth century in Fleury. An increased use of these intellectual

tools, and the reflections surrounding them, can be attributed to the studies on logic, *computus*, calculation or grammar, which had been flourishing in Fleury in these years through the school of Abbo, together with the transmission of texts such as Macrobius, Boethius and Calcidius. The production of new scientific works on *computus* or astronomy required additional and intensive use of tables, abstract images of planetary courses, diagrams of rational demonstrations, among other things.[110]

Some conclusions

The *Liber in honorem sanctae crucis* offered an opportunity to exercise the intellect by reading but also to reflect and measure the skills and achievements of the learned community in Fleury: if Gauzlinus was said to have been an excellent scholar, *sollers ingenio, litterarum divinarum quamque saecularium prepollens studio*,[111] the entire monastery was described at that time as a stream of fluent disciplines and a gymnasium for the school of the Lord. The work of Hrabanus, therefore, was not only modern in its technical aspects connected with the arts of the Quadrivium and the artful instruments that could be used for transmitting knowledge, but it also communicated in its classical beauty the wisdom of the Holy Scripture and the *litterae divinae*.

Was Hrabanus writing an encyclopaedic work with the *Liber in honorem sanctae crucis*? Yes and no. Surely not in the sense of the genre of compilation that took on after Isidore, such as Hrabanus' *De rerum naturis,* which he wrote later for the bishop of Halberstadt.[112] Nevertheless, the book in the praise of the Cross was an original creation and a rich synthesis in many areas of knowledge and could very well inspire the 'laboratory' of Fleury in its efforts to re-define itself after Abbo.

NOTES

1. Cf. Ghent, University Library, MS 92, folio 3v (https://lib.ugent.be/catalog/rug01%3A000763774/items/900000106992); Wolfenbüttel, HAB, Cod Guelf. 1 Gud. lat., folio 1ra (http://diglib.hab.de/mss/1-gud-lat/start. htm?image = 00007). For surviving representations and images of banquets from the Middle Ages cf. also D.-J. BENRUBI, 'La Cène et les autres festins: brèves remarques sur l'iconographie des repas sacrés et profanes', in *Thèmes religieux et thèmes profanes dans l'image médiévale: transferts, emprunts, oppositions.* Actes du colloque du RILMA, Institut Universitaire de France (Paris, INHA, 23–24 mai 2011), ed. C. HECK, Turnhout, 2013, p. 89–107. For the the autograph manuscript and the metaphors used in the prologue see also H. VORHOLT, *Shaping Knowledge. The Transmission of the Liber Floridus*, London, 2017 (Warburg Institute studies and texts, 6), p. 10–12 and the contribution of Charles Burnett in this volume. I use following abbreviations: BAV = Biblioteca Apostolica Vaticana; BL = British Library; BNF = Bibliothèque nationale de France; HAB = Herzog August Bibliothek.

2. (Préceptes 1992, p. 96). Quoted by U. ERNST, *Facetten mittelalterlicher Schriftkultur. Fiktion und Illustration, Wissen und Wahrnehmung*, Heidelberg, 2006 (Beihefte zum Euphorion, 51), p. 201–202, with regard to the concept of encyclopedia.

3. Cf. C. FAUVERGUE, 'Séméiotique et "anatomie" chez Leibniz et Diderot', *Dix-Huitième Siècle* 37, 2005, p. 483–496, here p. 488 with note 33 [online: https://www.persee.fr/doc/dhs_0070-6760_2005_num_37_1_2688]: 'Il en résulte une abréviation des connaissances et des sciences similaire à celle que l'on rencontre dans les mathématiques; d'où le '"paradoxe" selon lequel "les sciences s'abrègent en s'augmentant", paradoxe qui rend compte de l'encyclopédisme de Leibniz et de Diderot', referring to 'Leibniz, Discours, GP VII, 180'.

4. See *Florilegien, Kompilationen, Kollektionen: literarische Formen des Mittelalters*, ed. K. ELM, Wiesbaden, 2000 (Wolfenbütteler Mittelalter-Studien, 15); *Encyclopédire, Formes de l'ambition encyclopédique dans l'Antiquité et au Moyen Âge*, ed. A. ZUCKER, Turnhout, 2013 (Collection d'études médiévales, 14); S. DUSIL, G. SCHWEDLER and R. SCHWITTER, 'Transformationen des Wissens zwischen Spätantike und Frühmittelalter. Zur Einführung', in *Exzerpieren – Kompilieren – Tradieren: Transformationen des Wissens zwischen Spätantike und Frühmittelalter*, ed. S. DUSIL, G. SCHWEDLER and R. SCHWITTER, Berlin, 2017 (Millennium-Studien, 64), p. 1–22; With regard to the *Liber floridus* cf. A. DEROLEZ, *The Making and Meaning of the Liber Floridus. A Study of the Original Manuscript, Ghent, University Library, MS 92*, London, 2015; VORHOLT, op. cit. (our note 1).

5. J. T. KNIGHT, 'Organizing manuscript and print: from compilatio to compilation', in *The Medieval Manuscript Book: Cultural Approaches*, ed. M. JOHNSTON and M. VAN DUSSEN, Cambridge, 2015 (Cambridge studies in medieval literature, 94), p. 77–95, here p. 79.

6. Cf. for the importance of this topic in recent years: *Objekte als Quellen der historischen Kulturwissenschaften. Stand und Perspektiven der Forschung*, ed A. C. CREMER and M. MULSOW, Köln, 2017; *Codex und Material*, ed. P. CARMASSI and G. TOUSSAINT, Wiesbaden, 2018 (Wolfenbütteler Mittelalter-Studien, 34); *Medieval Documents as Artefacts. Interdisciplinary Perspectives on Codicology, Palaeography and Diplomatics*, ed. E. C. DIJKHOF in collaboration with A. BERTELOOT, Hilversum, 2020 (Schrift en schriftdragers in de Nederlanden in de middeleeuwen, 6).

7. For new research on different aspects of this topic see recently: *La conoscenza scientifica nell'alto medioevo*. Settimana di studio della Fondazione Centro italiano di studi sull'alto Medioevo, Spoleto 2020, 1–2 (Settimane di studio della Fondazione Centro Italiano di Studi sull'Alto Medioevo 67–68). For our subject see especially B. OBRIST, 'La cosmologie du Haut Moyen Age, le statut de la connaissance philosophique et la question d'un univers christianisé', 1, p. 53–112; F. WALLIS, 'Bede's eye: Number and experience as a grammar of science in the Early Middle Ages', 2, p. 659–693.

8. DEROLEZ, op. cit. (our note 4), p. 183.

9. http://www.bl.uk/manuscripts/Viewer.aspx?ref = cotton_ms_vespasian_b_vi!1_f. 104r. See on this manuscript S. KEYNES, 'Between Bede and the Chronicle: London, BL, Cotton Vespasian B. vi, fols 104–109', in *Latin Learning and English Lore: Studies in Anglo-Saxon Literature for Michael Lapidge*, ed. K. O'BRIEN O'KEEFFE and A. ORCHARD, Toronto, 2005 (Toronto Old English series, 14), 1, p. 47–67. The first part of the manuscript is of French origin and contains Beda, *De temporum ratione*, Digitized: http://www.bl.uk/manuscripts/Viewer.aspx?ref = cotton_ms_vespasian_b_vi_f. 001r.

10. KEYNES, op. cit. (our note 9), p. 59.

11. KEYNES, op. cit. (our note 9), p. 60.

12. See P. VERBIST, *Duelling with the Past. Medieval Authors and the Problem of the Christian Era (c. 990–1135)*, Turnhout, 2009 (Studies in the early Middle Ages, 21), p. 35–84 (Abbo of Fleury D. 1004); B. OBRIST, 'Abbon de Fleury: cosmologie, comput, philosophie', in *Abbon, un abbé de l'an mil*, ed. A. DUFOUR et G. LABORY, Turnhout, 2008 (Bibliothèque d'histoire culturelle du Moyen Âge, 6), p. 177–203; *Abbon de Fleury. Philosophie, science et comput autour de l'an MIL*. Actes des journées organisées par le Centre d'Histoire des Science et des Philosophies Arabes et Médievales CNRS/EPHE/Université Paris, ed. B. OBRIST, Paris-Villejuif, 2006² (Oriens, occidens, 6); N. GERMANN, *De temporum ratione. Quadrivium und Gotteserkenntnis am Beispiel Abbos von Fleury und Hermanns von Reichenau*, Leiden 2006 (Studien und Texte zur Geistesgeschichte des Mittelalters, 89); Abbo Floriacensis, *Miscellanea de computo, de astronomia et de cosmographia secundum codicem Berolinensem Phill. 1833*, ed. A. LOHR; introductionem historicam addidit B. OBRIST, Turnhout, 2019 (CCCM, 300).

13. D. JUSTE, 'Neither Observation nor Astronomical Tables: An Alternative Way of Computing the Planetary Longitudes in the Early Western Middle Ages', in *Studies in the History of the Exact Sciences in Honour of David Pingree*, ed. Ch. BURNETT, J. P. HOGENDIJK, K. PLOFKER and M. YANO, Leiden, 2004, p. 181–222, here p. 196.

14. See Abbo Floriacensis, *Miscellanea de computo*, op. cit. (our note 12), for one part of the manuscript. Digitized under http://resolver.staatsbibliothek-berlin.de/SBB0001A74A00000000.

15. M. MOSTERT, 'The Tradition of Classical Texts in the Manuscripts of Fleury', in *Medieval Manuscripts of the Latin Classics. Production and Use*, ed. C. A. CHAVENNES-MAZEL and M. M. SMITH, Los Altos Hills, 1996, p. 19–40, here p. 33. See also digitized copy and description in https://www.bl.uk/catalogues/illuminatedmanuscripts/record.asp?MSID = 18480; http://www.bl.uk/manuscripts/FullDisplay.aspx?ref = Harley_MS_2506 and https://ptolemaeus.badw.de/ms/289 (D. Juste). The manuscript London,

BL, Harley MS 647, however, *c.* 830, with astronomical texts (Hyginus, Cicero, Plinius), cf. MOSTERT, p. 33, has recently been attributed to the diocese of Reims. It was later in England. Cf. http://www.bl.uk/manuscripts/FullDisplay. aspx?ref = Harley_MS_647.

16. See OBRIST, 'Abbon de Fleury: cosmologie, comput, philosophie', op. cit. (our note 12), p. 190–191.

17. Folio 1r addition of an *abacus*-table. Cf. the standard description online on https://www.e-codices.unifr. ch/de/description/bbb/0207/Mittenhuber, referring to: 'O. HOMBURGER, *Die illustrierten Handschriften der Burgerbibliothek Bern*, Bd. II (Bern, um 1960) [unpubliziertes Typoskript]. Redigiert und ergänzt von Michael I. Allen und Florian Mittenhuber, Oktober 2014'.

18. Folio 140 is an addition in a script of the 10th century. See MOSTERT, op. cit. (our note 15), p. 35; M. MOSTERT, *The Library of Fleury. A Provisional List of Manuscripts*, Hilversum, 1989 (Middeleeuwse studies en bronnen, 3), p. 207–208.

19. JUSTE, op. cit. (our note 13).

20. D. BLUME, M. HAFFNER and W. METZGER, *Sternbilder des Mittelalters. Der gemalte Himmel zwischen Wissenschaft und Phantasie*, 1: 800–1200: Text und Katalog der Handschriften, Berlin, 2012, here p. 422–429.

21. Cf. B. BISCHOFF, *Katalog der festländischen Handschriften des neunten Jahrhunderts (mit Ausnahme der wisigotischen). Teil III. Padua – Zwickau*, Wiesbaden, 2014 (Veröffentlichungen der Kommission für die Herausgabe der Mittelalterlichen Bibliothekskataloge Deutschlands und der Schweiz), no. 4367, p. 109.

22. Cf. J. J. CONTRENI, 'Counting, Calendars, and Cosmology: Numeracy in the Early Middle Ages', in *Word, Image, Number: Communication in the Middle Ages*, ed. J. J. CONTRENI, Tavarnuzze (Firenze), 2002, (Micrologus' library, 8), p. 43–83, here p. 59.

23. Los Angeles, The J. Paul Getty Museum, MS 64, folio 10v, with illuminated episodes from the book Genesis, such as Genesis 1,14 *Fiant luminaria in firmamento caeli ut dividant diem ac noctem et sint in signa et tempora et dies et annos*. Cf. E. C. TEVIOTDALE, *The Stammheim Missal*, Los Angeles, 2001 (Getty Museum studies on art). On this iconography see also A. POZHIDAEVA, 'À propos de la variété des sources iconographiques des Jours de la Création au XIIe siècle en Europe occidentale; tentative de reconstitution d'un modèle perdu', in *Les modèles dans l'Art du Moyen Âge (XIIe–XVe siècles)*, ed. D. BORLEE and L. TERRIER ALIFERIS, Turnhout, 2018 (Les Études du RILMA, 10), p. 99–108.

24. On this passage of Isidore see F. GUIDETTI, 'A Sky without Myths? Imagery in Early Medieval Astronomy', in *Mittelalterliche Mythenrezeption. Paradigmen und Paradigmenwechsel*, ed. U. REHM, Wien, 2018 (Sensus, 10), p. 57–79, here p. 63–67.

25. Isidore de Séville, *Traité de la nature*. Introduction, texte critique, traduction et notes par J. FONTAINE, Paris, 2002 (Collection des Études Augustiniennes. Série Moyen Age et Temps Modernes, 39), *Praefatio*, 1, p. 167.

26. Cf. J. CONTRENI, 'Bede's scientific works in the Carolingian age', in Id., *Learning and Culture in Carolingian Europe. Letters, Numbers, Exegesis, and Manuscripts*, Farnham, Surrey, 2011 (Variorum collected studies series, 974), IV, p. 247–259; Id, 'John Scottus and Bede', in ibid., V, p. 91–140. On the *Etymologiae* see C. CARDELLE DE HARTMANN, 'Wissensorganisation und Wissensvermittlung im ersten Teil von Isidors Etymologiae (Bücher I–X)', in *Exzerpieren – Kompilieren – Tradieren, op. cit.* (our note 4), p. 85–103.

27. Cf. I. WARNTJES, 'Introduction: State of research on late Antique and Early medieval computes', in *Late Antique Calendrical Thought and its Reception in the Early Middle Ages*, ed. I. WANTJES and D. Ò CRÓINÍN, Turnhout, 2017 (Studia Traditionis Theologiae, 16), p. 1–42, here p. 26.

28. Cf. as reference for the early medieval library of Fleury following works: M. MOSTERT, *The Library of Fleury. A Provisional List of Manuscripts*, Hilversum, 1989 (Middeleeuwse studies en bronnen, 3); MOSTERT, op. cit. (our note 15); B. BISCHOFF, *Katalog der festländischen Handschriften des neunten Jahrhunderts (mit Ausnahme der wisigotischen). 1–3*, Wiesbaden, 1998–2014 (Veröffentlichungen der Kommission für die Herausgabe der Mittelalterlichen Bibliothekskataloge Deutschlands und der Schweiz); D. GANZ, 'Manuscript copied at Fleury in the tenth century', in *Wissen und Bildung in einer Zeit bedrohter Ordnung: Der Zerfall des Karolingerreiches um 900. Knowledge and Culture in Times of Threat: the Fall of the Carolingian Empire (ca. 900)*, ed. W. PEZÉ, Stuttgart, 2020 (Monographien zur Geschichte des Mittelalters, 69), p. 235–247; M. MOSTERT, 'Libraries as an Expression of Monastic Identities: The Case of Fleury (Saint-Benoît-sur-Loire)', in *Bücher und Identitäten. Literarische Reproduktionskulturen der Vormoderne. Überstorfer Colloquium 2016*, ed. N. EICHENBERGER, E. C. LUTZ und C. PUTZO, Wiesbaden, 2020, p. 13–32. Digitized manuscripts from Fleury, now in Orléans, Médiathèque, are to be found under https://mediatheques.orleans-metropole. fr/patrimoine/collections-patrimoniales-numerisees.

29. For the similarity of the script in the Carolingian period between Auxerre and Fleury see MOSTERT, *The Library*, op. cit. (our note 28), p. 23.

30. Cf. already in this direction J. VEZIN and P. ROGER, 'Étude des matériaux de la couleur dans les manuscrits médiévaux: emploi inédit de bleu égyptien dans trois manuscrits des VIIIe et Xe siècles', *Comptes rendus des séances de l'Académie des Inscriptions et Belles-Lettres* 151, 2007, p. 67–87; P. ROGER, *Étude technique sur lés décors de manuscrits carolingiens*, in *Les manuscrits carolingiens. Actes du colloque de Paris, Bibliothèque Nationale de France, le 4 mai 2007*, ed. J.-P. CAILLET et M.-P. LAFFITTE, Turnhout, 2009 (Bibliologia, 27), p. 203–216; C. DENOËL, P. ROGER PUYO, A. M. BRUNET and N. POULAIN SILOE, 'Illuminating the Carolingian era: new discoveries as a result of scientifc analyses', *Heritage Science* 6, 28, 2018. Open access: https://doi. org/10.1186/s40494–018–0194–0191.

31. Codex digitized on https://e-codices.unifr.ch/de/ list/one/bbb/0207. One part of the original manuscript (24 folio) is now Paris, BNF, latin 7520. See MOSTERT, *The Library*, op. cit. (our note 28), p. 217. Quote from 'The manuscripts', in *Bedae opera de temporibus*, ed. C. W. JONES, Cambridge, Mass., 1943 (The Mediaeval Academy of America, Publication no. 41), p. 149.

32. Digitized on https://gallica.bnf.fr/. See also bibliography in https://archivesetmanuscrits.bnf.fr/ark:/12148/ cc65484r, with link to the digitized copy.

33. Cf. the list of manuscripts in Bede, *On the Nature of Things and on Times*, translated by C. B. KENDALL and F. WALLIS, Liverpool, 2010 (Translated texts for historians, 56), here p. 50; E. PELLEGRIN and J.-P. BOUHOT, *Catalogue des manuscrits mediévaux de la Bibliothèque Municipale d'Orléans*, Paris, 2010 (Documents, études et répertoires, 78), here p. 31–34. On Bede, *computus* and vizualisation of time see also recently F. WALLIS, 'Visualizing Knowledge in Medieval Calendar Science: A Twelfth-Century Family of "Graphic Glosses" on Bede's *De temporum ratione*', in *The Visualization of Knowledge in Medieval and Early Modern Europe*, ed. M. KUPFER, A. S. COHEN and J. H. CHAJES, Turnhout, 2020, p. 291–326; M. MACCARRON, *Bede and Time: Computus, Theology and History in the Early Medieval World*, London, 2020.

34. O. HOMBURGER, *Die illustrierten Handschriften der Burgerbibliothek Bern. Die vorkarolingischen und karolingischen Handschriften*, Bern, 1962, p. 95–97; MOSTERT, *The Library*, op. cit. (our note 28), p. 49–50.

35. Cf. as the basis for the early medieval cosmography the authors mentioned by B. OBRIST, *La cosmologie médiévale, textes et images. 1. Les fondements antiques*, Firenze 2004

(Micrologus' library 11); B. S. EASTWOOD, *Ordering the Heavens. Roman Astronomy and Cosmology in the Carolingian Renaissance*, Leiden, 2007 (History of science and medicine library, 4. History of science and medicine library, 8. Medieval and early modern science, 8); OBRIST, op. cit. (our note 7). It is striking, that many of the works used by Abbo of Fleury, see OBRIST, 'Abbon de Fleury' op. cit., (our note 12), were actually preserved in manuscripts of the abbey. Many other liturgical, theological, or classical texts which were read and available in the library of the monastery, could directly or indirectly refer to different topics connected with the subject of time. These can not be exhaustively considered here. For a parallel analysis of the different sources about time avalable in the medieval monastery of Weißenburg cf. P. CARMASSI, 'Concezioni e percezioni del tempo nel monastero benedettino di Weißenburg nell'Alto Medioevo', in *De re monastica VI. Il tempo delle comunità monastiche nell'altomedioevo. Atti del convegno internazionale, Roma – Subiaco, 9–11 giugno 2017*, ed. L. PANI ERMINI, Spoleto, 2020, p. 163–186.

36. Cf. MOSTERT, op. cit. (our note 15), p. 29.

37. MOSTERT, op. cit. (our note 15), p. 31; MOSTERT, *The Library*, op. cit. (our note 28), p. 73, where a possible provenance from Fleury is also proposed; Macrobe, *Commentaire au songe de Scipion*. Tome I. Livre I, ed. M. ARMISEN-MARCHETTI, Paris 2003, p. LXXIX; BISCHOFF, op. cit. (our note 28), Teil I., no. 579, p. 123: 'Nähe zu Ferrières, IX. Jh., 3. Viertel'. Digitized and described, also referring to the detached parts, in https://www.e-codices.unifr.ch/en/list/one/bbb/0347.

38. With Fragment of Orléans, Médiathèque, Ms 261. MOSTERT, op. cit. (our note 15), p. 38; BISCHOFF, op. cit. (our note 28), Teil II., no. 3730, p. 348: 'IX./X. Jh oder X. Jh. 1. Hälfte'. Digitized on https://digi.vatlib.it/view/MSS_Reg.lat.598.

39. MOSTERT, op. cit. (our note 15), p. 39; Hygin, *L'Astronomie*, ed. A. LE BŒUFFLE, Paris, 2002², *Introduction*, p. XLVIII; BISCHOFF, op. cit. (our note 21), no. 6769, p. 438: 'Fleury (?), Auxerre (?) IX Jh., 2. Hälfte'; no. 6770, p. 438: 'Auxerre (?), IX. Jh., ca. 3. Viertel'. Digitized on https://digi.vatlib.it/view/MSS_Reg.lat.1260. Cf. also the fragment in Bern, Burgerbibliothek, MS 45, folio 59-v, with only dedication and text to 1,6,2, cf. ibid., p. XLIX; MOSTERT, op. cit. (our note 15), p. 29; KENDALL and WALLIS (our note 33), no. 125, p. 54–55, no. 101, p. 64. Digitized on https://e-codices.unifr.ch/de/list/one/bbb/0045.

40. MOSTERT, op. cit. (our note 15), p. 39; BISCHOFF, op. cit. (our note 21), no. 6789, p. 440; with Paris, BNF, latin 16677: 'Westfrankreich (?), mittleres Frankreich (?) IX. Jh., ca. Mitte'. Digitized on https://digi.vatlib.it/view/MSS_Reg.lat.1587.

41. MOSTERT, op. cit. (our note 15), p. 32, and p. 31 for the list of other detached parts of the original manuscript, among them Orléans, Médiathèque, MS 277, see MOSTERT, *The Library*, op. cit. (our note 28), p. 163–164; BISCHOFF, op. cit. (our note 28), Teil II., no. 2196, p. 52.

42. MOSTERT, op. cit. (our note 15), p. 31–33; ARMISEN-MARCHETTI, op. cit. (our note 37), p. LXXIX; BISCHOFF, op. cit. (our note 28), Teil II., no. 2185, p. 49. Parts of the original manuscript are now in Leiden, Bibliotheek der Rijksuniversiteit, Voss. Lat. folio 122 and London, BL, Royal MS 15 B.

43. JONES, op. cit. (our note 31), no. 66, p. 155, no. 31, p. 166; MOSTERT, *The Library*, op. cit. (our note 18), p. 207–208. See also above our note 21.

44. Cf. R. CALDINI MONTANARI, *Tradizione medievale ed edizione critica del Somnium Scipionis*, Tavarnuzze (Firenze), 2002 (Millennio medievale, 33), p. 31; MOSTERT, op. cit. (our note 15), p. 35.

45. MOSTERT, op. cit. (our note 15), p. 35. See also Paris, BNF, latin 16678: ibid., p. 37.

46. MOSTERT, *The Library*, op. cit. (our note 28), p. 216; KENDALL and WALLIS (our note 33), no. 86, p. 51, no. 65, p. 61. Digitized on https://gallica.bnf.fr/ark:/12148/btv1b9078321x; BISCHOFF, op. cit. (our note 21), no. 4439, p. 123: '(Mehr westliches) Frankreich'. See also bibliography in https://archivesetmanuscrits.bnf.fr/ark:/12148/cc66617h.

47. MOSTERT, *The Library*, op. cit. (our note 28), p. 220; KENDALL and WALLIS (our note 33), no. 88, p. 51; BISCHOFF, op. cit. (our note 21), no. 4507, p. 135: 'Westfrankreich möglich (?)'. Digitized on https://gallica.bnf.fr/ark:/12148/btv1b10721144c; see https://archivesetmanuscrits.bnf.fr/ark:/12148/cc67141z for bibliography.

48. Cf. MOSTERT, *The Library*, op. cit. (our note 28), p. 225; Hygin, op. cit. (our note 39), *Introduction*, p. LI. Hyginus's text is at folio 1–19v of the manuscript, with only one illustration. Cf. also CALDINI MONTANARI, op. cit. (our note 44), p. 26–27; D. JUSTE, *Les manuscrits astrologiques latins conservés à la Bibliothèque Nationale de France à Paris*, Paris, 2015 (Catalogus codicum astrologorum Latinorum, 2. Documents, études et répertoires, 84), p. 185–186. Digitized on https://gallica.bnf.fr/ark:/12148/btv1b8432469w; bibliography also in http://archivesetmanuscrits.bnf.fr/ark:/12148/cc67965q.

49. MOSTERT, op. cit. (our note 15), p. 37; CALDINI MONTANARI, op. cit. (our note 44), p. 32. ARMISEN-MARCHETTI, op. cit. (our note 37), p. LXXVIII. Digitized on https://gallica.bnf.fr/ark:/12148/btv1b90671593; for bibliograpy see https://archivesetmanuscrits.bnf.fr/ark:/12148/cc77098m. The original second part of the miscellany is now Città del Vaticano, BAV, Reg. lat. 1587, see MOSTERT, op. cit. (our note 15), p. 39; BISCHOFF, op. cit. (our note 21), no. 6789, p. 440.

50. It was part of Orléans, Médiathèque, MS 267: MOSTERT, *The Library*, op. cit. (our note 28), p. 242–243; CALDINI MONTANARI, op. cit. (our note 44), p. 29–30. Digitized on https://gallica.bnf.fr/ark:/12148/btv1b10037292c, bibliography in http://archivesetmanuscrits.bnf.fr/ark:/12148/cc69936m. See also PELLEGRIN, op. cit. (our note 33), p. 344–347.

51. KENDALL and WALLIS (our note 33), no. 95, p. 52, no. 72, p. 61; MOSTERT, op. cit. (our note 15), p. 38; BISCHOFF, op. cit. (our note 21), no. 5102, p. 242: 'Auxerre'; https://archivesetmanuscrits.bnf.fr/ark:/12148/cc69940c with link to the digitized manuscript.

52. Digitized on Gallica: https://gallica.bnf.fr/ark:/12148/btv1b100331398. Cf. bibliography in http://archivesetmanuscrits.bnf.fr/ark:/12148/cc13524w; MOSTERT, *The Library*, op. cit. (our note 28), p. 243; BISCHOFF, op. cit. (our note 21), no. 5103, p. 242: cf. JUSTE, op. cit. (our note 48), p. 267–268.

53. MOSTERT, op. cit. (our note 15), p. 38. For the parts of the original codex see MOSTERT, *The Library*, op. cit. (our note 18), p. 245–246. Cf. also bibliography in https://archivesetmanuscrits.bnf.fr/ark:/12148/cc699578, with link to the digitized manuscript: https://gallica.bnf.fr/ark:/12148/btv1b10546494c/f. 37.item.

54. MOSTERT, *The Library*, op. cit. (our note 28), p. 247; KENDALL and WALLIS (our note 33), no. 96, p. 52; BISCHOFF, op. cit. (our note 21), no. 5109, p. 244: 'Frankreich, IX Jh., ca 2. Viertel'. Digitized on Gallica: https://gallica.bnf.fr/ark:/12148/btv1b52506589 n. Cf. also bibliography in https://archivesetmanuscrits.bnf.fr/ark:/12148/cc69959r.

55. See PELLEGRIN, op. cit. (our note 33), p. 35–36. Critical edition of the text: Beda venerabilis, *Opera. Pars II. Opera exegetica 1. Libri quatuor in principium Genesis usque ad nativitatem Isaac et eiectionem Ismahelis adnotationum*, ed. Ch. W. JONES, Turnhout, 1967 (CCSL, 118A).

56. See on Bede's interpretation of Genesis 1–2, C. O'BRIEN, 'Bede on creation', *Revue bénédictine* 123 (2013), p. 255–273.

57. Among the mentioned sources there are biblical books, *Ieronimus, poeta, Basilius, Petrus*, an also comments such as *exemplum utile*.

58. *Fragmentum quartum*, folio 7–14v, Italy (?), end of the 6th century. See notes on the margins of folio 12, corresponding to Ambrosius Mediolanensis, *Exameron*, ed. C. SCHENKL, Wien, 1896 (CSEL 32,1), I, 10, 36, p. 38: *Et factum est vespere ... Quaerunt aliqui cum prius vesperum postea mane scriptura memoraverit ...* Description of the recueil factice in PELLEGRIN, op. cit. (our note 33), p. 238–245, here p. 239.

59. Cf. CALMA I (Firenze, 2003), p. 90–91.

60. The work is transmitted in the manuscript Paris, BNF, latin 12711, cf. bibliography in https://archivesetmanuscrits. bnf.fr/ark:/12148/cc738976, digitized on Gallica: https:// gallica.bnf.fr/ark:/12148/btv1b105434376/f. 17.item. Quote here from folio 5.

61. André de Fleury, *Vie de Gauzlin, Abbé de Fleury*. Andreas, *Vita Gauzlini, Abbatis Floriacensis Monasterii*, Texte édité, traduit et annoté par R.-H. BAUTIER et G. LABORY, Paris, 1969 (Sources d'histoire médiévale, 2), I, 1, here p. 32.

62. Ibid., I, 2a, p. 32–34. Other works of Aimoinus beside the sermon and the history of the Franks (*Gesta Francorum*) were: one history of the abbots of Fleury (*Gesta abbatum*, now lost), one *Passio* about Abbo's martyrdom († 1004) and one continuation of the *Miracula sancti Benedicti*.

63. Cf. PELLEGRIN, op. cit. (our note 33), p. 567–569.

64. Dimensions: 42 × 32 cm. Description in PELLEGRIN, *op cit.* (our note 33), p. 152–156; MOSTERT, *The Library*, op. cit. (our note 28), p. 133, both with dating of this part of the manuscript (p. 1–84) to the 10th century.

65. Cf. also M. PERRIN, *Bède le Vénérable: une source invisible de l'"In honorem Sanctae Crucis" de Raban Maur (810)*, in *Bède le vénérable entre tradition et postérité*. Colloque organisé à Villeneuve d'Ascq et Amiens par le CRHEN-O (Université de Lille 3) et Textes, Images et Spiritualité (Université de Picardie – Jules Verne) du 3 au 6 juillet 2002, éd. S. LEBECQ, Villeneuve d'Ascq, 2005 (Collection Histoire de l'Europe du Nord-Ouest, 34), p. 231–245, here p. 232. Open access: https://books.openedition.org/irhis/346. The text of Hrabanus will be quoted following the edition: Rabanus Maurus, *In honorem sanctae crucis*, ed. M. PERRIN, Turnhout, 1997 (CCCM, 100).

66. André de Fleury, *Vie de Gauzlin*, op. cit. (our note 61), I, 44g, p. 82; PELLEGRIN, op. cit. (our note 33), p. 153.

67. See e.g. p. 40. The use of gold was not indicated in the catalogue of 2010: PELLEGRIN, *op. cit.* (our note 33), p. 152–156.

68. This date is also proposed in C. DENOËL and E. VERHAGEN, *Make it new. Conversations avec l'art médiéval: carte blanche à Jan Dibbets*, ed. M.-C. DUFAYET, Paris, 2018, p. 108, without further description of the manuscript.

69. Helgaud de Fleury, *Vie de Robert le Pieux*, ed. R.-H. BAUTIER and G. LABORY, Paris, 1965 (Sources d'histoire médiévale, 1), § 15, p. 88.

70. Ibid., § 25, p. 120.

71. Cf. the *Index fontium*, in the edition Rabanus Maurus, *In honorem*, op. cit. (our note 65), p. 325–327; M. PERRIN, *L'iconographie de la "Gloire à la sainte croix" de Raban Maur*, Turnhout, 2009 (Répertoire iconographique de la littérature du Moyen Age. Le corpus du RILMA, 1); PERRIN, *Bède le Vénérable, une source invisible*, op. cit. (our note 65); M. PERRIN, 'Les lectures de Raban Maur pour l'*In honorem sanctae crucis*: ébauche d'un bilan', in *Raban Maur et son temps*, ed. P. DEPREUX, S. LEBECQ, M. PERRIN and O. SZERWINIACK, Turnhout, 2010 (Collection Haut Moyen Âge, 9), p. 219–245.

72. For Hrabanus see also D. F. BRIGHT, 'Carolingian hypertext: visual and textual structures in Hrabanus Maurus, *In honorem Sanctae Crucis*, in *Classics Renewed. Reception and Innovation in the Latin Poetry of Late Antiquity*', ed. S. MCGILL and J. M. PUCCI, Heidelberg, 2016 (Bibliothek

der klassischen Altertumswissenschaften. 2. Reihe. Neue Folge, 152), p. 355–383; J. F. HAMBURGER, *Diagramming devotion. Berthold of Nuremberg's Transformation of Hrabanus Maurus's Poems in Praise of the Cross*, Chicago, 2020.

73. Cf. C 7: Rabanus Maurus, *In honorem*, op. cit. (our note 65), p. 73 (in the manuscript p. 20).

74. Cf. C 13, ibid., p. 111 (in the manuscript p. 32). The expressions *in longitudine / in latitudine* are used 12 times in the work.

75. C 5, ibid. p. 61 (in the manuscript p. 16). *Subtus / supra* are used at least 4 times in combination in the work.

76. Cf. C 14, ibid., p. 115: *quoque semel in medio crucis est posita*; C 11, ibid., p. 99: *Ultimus etiam qui in ultimo tetragono, id est, in base crucis descriptus est, ita sonat: NAM DEVTERNOMIVM RENOVANTIS GAVDIA DICIT*; C 9, ibid., p. 85: *Illi autem duo hexagoni, qui transversam partem crucis faciunt, metro elegiaco conpositi sunt*.

77. C 4, ibid., p. 55: *In cruce quoque hic uersus est in longitudine a summo deorsum uadens: EN ARX ALMA CRVCIS, EN FABRICA SANCTA SALVTIS*.

78. Cf. C 4, ibid., p. 55: *In cruce quoque hic uersus est in longitudine a summo deorsum uadens ... Iste quidem in latitudine ... supra dextrum cornu ... Supra cornu sinistrum ... in Cherubim dexteriore ... In sinisteriore*.

79. C 6, ibid., p. 67: *Dexterae autem partis trigonus continet hunc uersum, ab infimo angulo primum sursum ascendendo, sicque circumeundo ceteros usque ad initium suum*. See also C 8, ibid. p. 79: *Sunt autem in ipsa cruce duo uersus hexametri, quorum prior in longitudine a summo deorsum uadens, hic est: IN CRVCE NVNC MENSES, VENTI, DVODENA QVE SIGNA*.

80. C 18, ibid., p. 149: *Est autem quadragenarius ipse in quattuor triangulis hic conprehensus, secundum geometricae figurae potestatem, continens uersum quadraginta litterarum in hunc modum: CRVX SACRA, TV AETERNI ES REGIS VICTORIA CHRISTI*.

81. C 3, ibid., p. 48–49: *Omnia subiecit sub pedibus eius, et ipsum dedit caput supra omnia Ecclesiae, quae est corpus ipsius Nouem ergo litterae maiores, quae in hac pagina speciem crucis faciunt, hoc sonant CRVX SALVS; habent que singulae singulos ordines angelorum, quod facile cuilibet patebit qui litteras nouit et nomina nouem ordinum non ignorat*.

82. C 13, ibid., p. 111, p. 32 in the manuscript.

83. C 7, ibid., p. 72–73; See also PERRIN, *L'iconographie*, op. cit. (our note 71), p. 70–71, 136–137.

84. Rabanus Maurus, *In honorem sanctae crucis*, op. cit. (our note 65), p. 78. PERRIN, *L'iconographie*, op. cit. (our note 71), p. 72, 138–139.

85. Rabanus Maurus, *In honorem sanctae crucis*, op. cit. (our note 65), p. 80–85. PERRIN, *L'iconographie*, op. cit. (our note 71), p. 72–74, 140–141.

86. Rabanus Maurus, *In honorem sanctae crucis*, op. cit. (our note 65), p. 85: *Cuncta tenet Christus baratrum, orbem atque ethera celsa, nam regit astra poli hic claustraque cuncta diei*.

87. C 9, ibid., p. 83–85; PERRIN, 'Les lectures', op. cit. (our note 71), p. 221, 231; PERRIN, *L'iconographie*, op. cit. (our note 71), p. 72–74.

88. *De arithmetica* II, 17: Cf. PERRIN, *L'iconographie*, op. cit. (our note 71), p. 74 and note 70.

89. C 9: Rabanus Maurus, *In honorem sanctae crucis*, op. cit. (our note 65), p. 83.

90. For diagrams and their multiple functions see also C. ERNST, 'Cultural techniques of explication. Medieval diagrams and their role in the overall history of information visualization', in *Ordinare il mondo. Diagrammi e simboli nelle pergamene di Vercelli*, ed. T. LEONARDI and M. RAININI, Milano 2018 (Ricerche – storia. Dies nova 3), p. 23–40; J. F. HAMBURGER, 'Mindmapping: The Diagram as Paradigm in Medieval Art – and Beyond', in KUPFER et al., op. cit. (our note 33), p. 61–86, A. S. COHEN, 'Diagramming the Diagrammatic: Twelfth-Century Europe', in ibid.,

p. 383–404, and the contribution of Anja Rathmann-Lutz in this volume.

91. B 1: Rabanus Maurus, *In honorem sanctae crucis*, op. cit. (our note 65), p. 26–27.

92. Ibid., p. 106–111. PERRIN, *L'iconographie*, op. cit. (our note 71), p. 77–78, 148–149.

93. Rabanus Maurus, *In honorem sanctae crucis*, op. cit. (our note 65), p. 112–119. PERRIN, *L'iconographie*, op. cit. (our note 70), p. 78–80, 150–151.

94. B 1, Rabanus Maurus, *In honorem sanctae crucis*, op. cit. (our note 65), p. 26. PERRIN, *L'iconographie*, op. cit. (our note 71), p. 60–63, 125–126.

95. A 7, *Prologus*, Rabanus Maurus, *In honorem sanctae crucis*, op. cit. (our note 65), p. 17.

96. Ibid., p. 33. For the image of Christus and poem cf. ibid., p. 26–28 and fig. 4 above.

97. Digitized on https://digi.vatlib.it/view/MSS_Reg. lat.592.

98. Abbo of Fleury and Ramsay, *Commentary on the Calculus of Victorius of Aquitaine*, ed. A. M. PEDEN, Oxford, 2003 (Auctores Britannici medii aevi, 15), p. XXIX.

99. Ibid., p. 73–74, here p. 73: *Unde Plato in Thimeo pro generatione animae aptam figuram repperit in qua singularitas cacumini superinposita summitatem atque arcem obtinere consideratur.* Cf. also I. CAIAZZO, *Abbon de Fleury et l'héritage platonicien*, in *Abbon de Fleury*, op. cit. (our note 12), p. 11–41, here p. 17. Open access: http://halshs.archives-ouvertes.fr/halshs-00131945.

100. Abbo Floriacensis, *Opera inedita. 1: Syllogismorum categoricorum et hypotheticorum enodatio*, ed. A. VAN DE VYVER, Brugge, 1966, p. 30–31, here vv. 17–18, 21–28, 31–32. For the treatise *De Syllogismis hypotheticis* see the new edition Abbo von Fleury, *De syllogismis hypoteticis*, ed. F. SCHUPP, Leiden, 1997 (Studien und Texte zur Geistesgeschichte des Mittelalters, 56), with some critical remarks on the earlier edition, p. XXIII–XXIV; F. SCHUPP, 'Abbon de Fleury et la logique: quelques questions historiques et systématiques', in *Abbon de Fleury*, op. cit. (our note 12), p. 43–59.

101. See edition VAN DE VYVER, op. cit. (our note 100), with reproduction of the schematic order, p. 34. Manuscript digitized on Gallica: https://gallica.bnf.fr/ark:/12148/btv1b10037292c.

102. At folio 11 begins a new part. For a description see also CALDINI MONTANARI, op. cit. (our note 44), p. 29–30.

103. Cf. MOSTERT, *The Library*, op. cit. (our note 28), p. 242–243, 160; PELLEGRIN, op. cit. (our note 33), p. 344–347; Anicius Manlius Severinus Boethius, *De divisione liber*, ed. J. MAGEE, Leiden, 1998 (Philosophia antiqua, 77), p. LXVI.

104. Page is 79 is another added folium.

105. Cf. e.g. p. 95 on the upper margin.

106. Description of the manuscript in PELLEGRIN, op. cit. (our note 33), p. 349–350.

107. See also p. 251 about angles and p. 262 about the triangle.

108. Description of the manuscript in PELLEGRIN, op. cit. (our note 33), p. 363–365. See e.g. there p. 10 (*contrariae / subcontrariae*), p. 21, p. 25 (*contradictio*), p. 34, p. 48, (*contrariae vel incongruae*).

109. See reproduction in https://digital.staatsbibliothek-berlin.de/werkansicht?PPN = PPN83017379X&PHYSID = PHYS_0068&DMDID = DMDLOG_0019. Transcription in Abbo Floriacensis, *Miscellanea de computo*, op. cit. (our note 12), p. 28–29.

110. Cf. also for an example Abbo Floriacensis, *De differentia circuli et sphere*, in the manuscript London, BL, Harley MS 2506, with a diagramm on folio 31v. See for a description above our note 15. For the monastery of Micy, connected with Fleury, see C. DENOËL, 'Imaging time, Computation and Astronomy. A *Computus* Collection from Micy-Saint-Mesmin (Vatican, BAV, MS Reg. lat. 1263 and Early Eleventh-Century Illumination in the Loire Region', in *After the Carolingians. Re-defining manuscript illumination in the 10th and 11th centuries*, ed. B. KITZINGER and J. O'DRISCOLL, Berlin, 2019 (Sense, matter, and medium, 2), p. 118–160.

111. *Vita Gauzlini*, op. cit. (our note 61), p. 32.

112. See B. RIBEMONT, *Les origines des encyclopédies médiévales: d'Isidore de Séville aux Carolingiens*, Paris, 2001 (Nouvelle bibliothèque du Moyen Âge, 61), esp. Chapter III: *Le mouvement encyclopédique carolingien*; P. CARMASSI, 'The program of a book: the Fulda – Halberstadt connection in the first half of the 9th century', *Wolfenbütteler Beiträge* 15, 2009, p. 103–127.

The Autograph Manuscript and the Sources of the *Liber floridus*

Albert Derolez

The *Liber floridus*

Without the survival of the autograph manuscript of the *Liber floridus* (hereafter *LF*), it would have been most difficult (if not impossible) to understand the work of Lambert of Saint-Omer and the aims he had in mind while composing his encyclopaedic compilation, the earliest illustrated encyclopedia of the Latin West. An in-depth codicological and textual investigation of this extremely complicated manuscript (Ghent, University Library MS 92) has made possible a close examination of the one-man undertaking, to which Lambert gave all his thoughts and efforts during the latter part of his life.[1] In other words, we are now almost able to look over his shoulder during all the time he was at work. Most of the supposed weaknesses and incoherences that in the course of time have been imputed to the author have proved to be either unfounded, or explainable by material circumstances. Adding continually new materials and inserting these into the codex after it was already written, decorated and illustrated, while at the same time preserving the formal and beautiful character of the manuscript, was indeed an insurmountable challenge for a single author, scribe and illuminator and, in spite of immense efforts to the contrary, doomed to result in interruptions incomprehensible at first sight and oddities in the logical sequence of texts and images.

Nevertheless, the combined study of the parchment and the leaves, the quire structure with its countless irregularities, the varying number of lines on the page, the handwriting, the decoration and the colours used for it, the text, the passages written upon erasure, and the references from one part of the codex to another, have made possible a sketch of the growth of the manuscript, and thus of the work. Thirteen phases have been distinguished in the creation of the *LF*.[2] These

have tentatively been dated between 1111 and 1121. The overall soundness of this chronology cannot be denied, in spite of its theoretical character and uncertainties about the actual number of phases that should be distinguished. To be sure, it is possible (and in some cases it is clear) that a text or an illustration was sometimes made in one phase and inserted into the codex during a later phase; it is difficult to attain certainty in that respect. It is necessary, in any case, to keep in mind that during the whole process of its making the *LF* had the shape of a pile of quires, bifolios and leaves which could be erased, rewritten, augmented, removed, transposed, dismounted at will. The manuscript even remained unbound for a certain time after the author's death, for only on that hypothesis can the removal of some leaves or entire quires, such as the one carrying the Apocalypse illustration, be explained.

The sources[3]

When dealing here with the sources of the *LF*, I shall not consider the sources for the overall conception of the encyclopaedic compilation, nor the sources for the images, maps and diagrams. The *LF* consists for the greatest part of texts, covering from a few lines up to tens of pages. As expected in an encyclopaedic compilation, very few of these are original. Almost all are renderings, generally more or less abbreviated, of existing texts, even if Lambert has quite often changed the order or the wording or the tendency of these sources. It more than once appears that in doing so, our author has consciously created new versions, which appear in the *LF*-copies and occasionally also in other manuscripts. He often gives the name of his sources, e.g. in the decorative headings of his chapters (Isidore of Seville,[4] Bede,[5] Orosius,[6] etc.). These indications are a great help, but they sometimes prove to be

wrong. Almost all the sources for the texts of the *LF* have now been identified, and although further research may result in discovering new details, the list of sources for the texts in the *LF* will probably remain unchanged, and it will be the basis for the considerations in the present article.

In the survey of the contents and the sources printed at the end of this contribution, all sections of the *LF* – again, these range from a few lines to full-length chapters – are marked using the numbering introduced by Léopold Delisle (1906)[7] and used by myself in *The Making and Meaning of the Liber Floridus* (2015). In my opinion the original manuscript as it left Lambert's hands contained 325 such sections (Delisle items 1–301 and 304–327). This division into sections is not perfect, but it is much more adequate than the chapters introduced by Lambert himself, numbered I–CXC. These do not cover the entire content, are more than once confusing due to continual adding and moving of texts, and strangely enough seem to betray that at times Lambert no longer had, in the end, a good understanding of what he had written before.

The question of how Lambert became acquainted with his sources is naturally of prime importance. Closely related to it is another question: at what time during the process of composing the *LF* did the author have access to the individual sources, and did he use them? I shall try to answer both questions in the following.

The basis for this research is the already mentioned survey of all the 'Delisle' sections of the text of the *LF*, recording for each of them the title and where possible the source(s) that appear to have been used. In the survey, printed at the end of the present article as Appendix I, the sections are recorded in the order in which I believe they were written or incorporated into the book, expressed in terms of the thirteen phases that I have distinguished in the composition of the *LF*. These phases are marked by Roman numerals from I to XIII, but Phase VII is to be supposed a phase of consolidation, during which no new materials were added, and so is omitted here. Some of these phases have tentatively been dated as follows: I: 1111–1115; III: 1111–1118; V: 1115; IX: 1115–1116; X: 1118–1120; XII: 1117–1120; XIII: 1119–spring 1121.

A preliminary remark: it is likely that some sources, such as extensive works of the Church Fathers or texts of Canon Law, were not used by Lambert in their original form, but as collections of excerpts, sentences, etc.

Sources available in the chapter library of Saint-Omer[8]

It is obvious that Lambert would have searched for his sources first among the manuscripts belonging to the chapter of Our Lady in Saint-Omer, of which he was a member, and perhaps the librarian. This library is badly documented: there is no medieval catalogue and the surviving manuscripts of the eleventh and early twelfth centuries that can be ascribed to it with some certainty are rare. Nevertheless, a few manuscripts appear to have been used by Lambert, because he has left his marks or annotations in them. There is a large manuscript in the Royal Library in Brussels, containing no less than nine historical texts, seven of which have been excerpted in the *LF*: the *Breviarium ab Urbe condita* of Eutropius, the *Chronicon* of Marcellinus Comes, the *Notitia Galliarum*, the *Historia Francorum* of Gregory of Tours, the *Annales regni Francorum*, the *Annales Bertiniani* and the *Annales Vedastini*.[9] This manuscript is a copy from a codex in the abbey of Saint-Bertin, and there are reasons to suppose that it was Lambert who had the transcription made. From Table I, it appears that all these sources, apart from the *Notitia Galliarum*, were used already in the first phase of Lambert's activity, and some of them continued to be excerpted in subsequent phases. Lambert refers to this manuscript as *Gesta Francorum*.

A second manuscript featuring a series of sources certainly used by Lambert contains the *Historiae adversus paganos* of Orosius, the *Cosmographia* of Ps.-Aethicus, part of *De origine actibusque Getarum* of Iordanes and the *Historia ecclesiastica tripartita*.[10] The latter text is certainly copied from a Saint-Bertin codex. Of great importance is also a codex containing the *Historia* of the so-called Hegesippus and part I of the *Historiae* of the Carolingian writer Freculphus of Lisieux, both, but especially the latter, long and extensively used by Lambert.[11]

Beside these manuscripts offering our author, in one volume, two or more texts ready

I	II	III	IV	V	VI	VIII	IX	X	XI	XII	XIII
Actus Silvestri papae											
-	-	-	-	-	-	-	-	X	-	-	-
Ps.-Aethicus, Cosmographia											
-	-	III	-	-	-	-	-	X	-	-	-
Annales Bertiniani											
I	II	-	-	-	VI	-	-	-	-	-	-
Annales regni Francorum											
I	-	-	-	-	-	-	-	-	-	-	-
Annales Vedastini											
I	-	-	-	-	-	-	-	-	-	-	XIII
Burchardus Wormatiensis, *Decretum*											
-	II	-	-	-	-	-	-	X	-	-	-
Eutropius, *Breviarium a.U.c.*											
I	-	-	-	-	-	-	-	-	-	-	-
Freculphus Lexoviensis, *Historiae*											
I	-	III	-	-	-	-	IX	-	-	XII	-
Gregorius Turonensis, *Historia Francorum*											
I	II	III	-	-	-	-	-	-	XI	-	-
Hegesippus, *Historia*											
-	-	III	-	-	-	-	IX	-	-	-	-
Helpericus Autissiodorensis, *De computo*											
-	-	(III)	-	-	-	-	-	-	-	-	-
Historia ecclesiastica tripartita											
I	-	-	-	-	-	-	-	-	-	-	-
Investiturae documenta											
I	-	-	-	-	-	-	-	-	-	-	-
Iordanes, *De origine actibusque Getarum*											
-	-	(III)	-	-	-	-	-	-	-	-	-
Isidorus Hispalensis, *Etymologiae*											
I	II	III	IV	-	-	VIII	-	X	-	-	-
Ps.-Isidorus Mercator, *Decretales*											
-	II	-	-	-	-	-	-	X	-	-	-
Liber Pontificalis											
-	-	-	-	-	VI	-	-	X	-	-	-
Marcellinus Comes, *Chronicon*											
I	-	-	-	-	-	-	-	-	-	-	-
Notitia Galliarum											
-	-	III	-	-	-	-	-	-	-	-	XIII
Orosius, *Historiae adversus. paganos*											
I	-	III	-	-	-	-	-	X	-	-	-
Vita S. Audomari											
-	-	-	-	-	-	-	-	-	-	XII	-

to be used, there were codices at his disposal containing a single text which he excerpted: one with the *Liber Pontificalis*,[12] one with the treatise *De computo* by Helperic of Auxerre,[13] one with the Pseudo-Isidorian Decretals[14] and one with another book of canon law, the *Decretum* of Burchard of Worms;[15] in the latter, documents were added about the Investiture Struggle, which also were copied into the *LF*. A hagiographical manuscript in four volumes contained the Acts of Pope Silvester,[16] another codex the *Vita S. Audomari*, the Genealogy of Christ according to Luke and Matthew, and a further document about the Investiture Struggle.[17] Finally, it is almost impossible that there would not have been a

TABLE II: SOURCES AVAILABLE IN THE ABBEY LIBRARY OF SAINT-BERTIN

I	II	III	IV	V	VI	VIII	IX	X	XI	XII	XIII
Amalarius, *De divinis officiis*											
-	-	-	-	-	-	-	-	X	-	-	-
Augustinus, *De civitate Dei*											
I	-	-	IV	-	-	-	-	-	-	-	-
Beda, *De temporum ratione*											
-	-	(III)	IV	-	-	VIII	-	X	-	-	-
Chalcidius, *Commentum in Timaeum Platonis*											
-	-	-	-	-	-	VIII	-	-	-	-	-
Dares Phrygius, *De excidio Troiae*											
-	-	-	-	-	-	-	-	-	-	XII	-
Eucherius Lugdunensis, *Instructiones*											
I	-	-	-	-	-	-	-	-	-	-	-
Gregorius Magnus, *Dialogi*											
-	-	-	-	-	-	-	-	X	-	-	-
-, *Homiliae*											
-	II	-	-	-	-	-	-	-	-	-	-
-, *Moralia in Iob*											
I	-	-	-	-	-	-	-	-	-	-	-
Ps.-Haimo Halberstadtensis, *Homiliae*											
-	-	-	-	-	-	-	-	X	-	-	-
Hieronymus, *Epistolae*											
I	-	-	-	-	-	VIII	-	-	-	-	-
Historia Apollonii regis Tyri											
-	-	-	-	-	-	-	-	-	XI	-	-
Hrabanus Maurus, *De rerum naturis*											
-	-	-	-	-	-	-	-	-	XI	-	-
Iosephus, *Antiquitates Iudaicae*											
I	-	-	-	-	-	-	-	-	-	-	-
-, *De bello Iudaico*											
I	-	-	-	-	-	-	-	-	-	-	-
Iulianus Toletanus, *Prognosticum futuri saeculi*											
-	II	-	-	-	-	VIII	-	-	-	-	XIII
Iulii Valerii epitome											
-	-	-	-	-	VI	-	-	-	-	-	-
Macrobius, *Commentum in Somnium Scipionis*											
-	(II)	(III)	-	-	-	VIII	-	-	-	-	-
Martianus Capella, *De nuptiis Philologiae et Mercurii*											
-	-	(III)	(IV)	-	-	-	-	-	-	-	XIII
Nennius, *Historia Brittonum*											
I	-	-	-	-	-	-	-	-	-	-	-
Ovidius, *Metamorphoseon*											
-	-	-	-	-	-	-	-	X	-	-	-
Visio Caroli III											
-	-	-	-	-	-	-	-	-	-	-	XIII

copy of Isidore of Seville's *Etymologiae* in the chapter library, given the intensive use that Lambert makes of this source during approximately the entire period he worked on the *LF*; whether this was the manuscript now belonging to the Royal Library in Brussels is not sure.[18] In any event, the large majority of the sources mentioned here were used by Lambert in phase I or in other early phases in the genesis of the *LF*.

Of course the chapter library was in the possession of Bible manuscripts, probably also

of Augustine's *De civitate Dei* and the *Moralia in Iob* of Gregory the Great.

Sources available in the abbey library of Saint-Bertin[19]

The question of whether Lambert had access to the rich library of the abbey of Saint-Bertin, situated in his immediate neighbourhood, has been debated.[20] For some chapters he indeed appears not to have used manuscripts available in Saint-Bertin, but other, now untraced codices offering the same materials. It is also noticeable that some sources present in the abbey library seem to have been accessible to Lambert for a short time only, and that our author could rely on the abbey neither for scribal support nor for supply of parchment.

Many arguments, on the contrary, are in favour of the existence of more or less close contacts between our canon and the monks of Saint-Bertin and their library. It is indeed almost impossible to imagine that the strong historical bias visible in the *LF* would be independent of the activity of the outstanding historiographical centre that was Saint-Bertin. And a few manuscripts have turned up whose content can only be explained by admitting a form of collaboration between Lambert and one or more monks of Saint-Bertin. They will be discussed in a moment.

The twelfth-century library catalogue of Saint-Bertin, titled *Brevis annotatio librorum sancti Bertini*, is in the present discussion a precious document. It is a pity that the original is lost and that the text is only known from an edition of the late eighteenth century.[21] However, extensive ongoing research by Dominique Stutzmann has already drawn important conclusions on this rare example of an early alphabetical catalogue:[22] it is now dated to the first third of the twelfth century (with a few later additions at the end), and the total of 305 *volumes* counted by Gustav Becker in his edition (1885) has now been replaced by 179 *entries*. This document mentions a series of works that were sources for the *LF*; but we have no certainty at all that the Saint-Bertin manuscripts containing them were actually used by Lambert, although in many cases this is plausible.

Most authors and works copied or excerpted in the *LF* are easily retrievable in the Becker edition of the twelfth-century catalogue (in the following the Becker numbers are placed between parentheses): this is the case for Amalarius, *De divinis officiis* (41), Augustinus, *De civitate Dei* (10), Beda, *De temporum ratione* (48), Chalcidius, *Commentum in Timaeum Platonis* (68), Dares Phrygius, *De excidio Troiae historia* (93: *Fabula et excidium Troiae*), Eucherius of Lyon, *Instructiones ad Salonium* (84: the catalogue entry is erroneous, probably due to the omission of a section of text between *Eucherii L.* and *epitoma Roberti regis*, the latter being a work by the eleventh-century writer Helgaud of Fleury-sur-Loire: *Epitoma vitae Roberti regis*), the *Dialogi*, Homilies and *Moralia in Iob* of pope Gregory the Great (94, 95, 97), the Homilies falsely ascribed to Haimo of Halberstadt (123: *Hanno super epistolas et evangelia*), the Letters of St Jerome (117), the encyclopedia of Hrabanus Maurus (248: *Rabani libri ethimologiarum*), the works (or a work) of Flavius Josephus (127: *Iosephi historia*), the *Prognosticon futuri saeculi* of Julian of Toledo (128: *Iuliani pronostica*), the commentary of Macrobius on Cicero's *Somnium Scipionis* (180), Martianus Capella, *De nuptiis Philologiae et Mercurii* (182: *Marciani liber*), Nennius, *Historia Brittonum* (109: *Gesta Anglorum*) and the Metamorphoses of Ovid (195–197: *Ovidii libri III*). Except for Gregory the Great the Church Fathers play a minor role in the *LF*, and as has been said it is quite possible that Lambert found the excerpts he transcribed not in the original works of Augustine or Jerome, but in a florilegium; other excerpts may have been found in homiliaries, etc.

The texts of the History of Apollonius King of Tyre and Julius Valerius' *Epitome* of the Life of Alexander the Great are not mentioned in the catalogue, but were once part of a Saint-Bertin manuscript, of which only one section survives, containing the *Gesta Francorum Hierusalem expugnantium*, and that will be discussed in the next section of this article. But the History of Apollonius in the *LF* was not copied by Lambert himself: the quires on which it is written are in a handwriting very different from the hands of Lambert and his occasional collaborators, and have been inserted by Lambert himself: do they perhaps originate in Saint-Bertin?[23] Lambert's Vision of Charles the Bald, finally, is obviously an adaptation by himself of the Vision of Charles III the Fat,

found in a famous illuminated manuscript of the ninth–tenth century in the abbey library of Saint-Bertin.[24]

Almost all the works listed above were used by our encyclopaedist during only one phase in the making of the *LF*, which seems to confirm the idea that Lambert had only limited access to the resources of the Saint-Bertin library and could only consult or borrow one or other of its manuscripts for a short period. Apart from Bede's *De temporum ratione*, there is only one noticeable exception: Julian of Toledo, whose *Prognosticon futuri saeculi* was used during the second, eighth and last phases. Julian's is a peculiar case insofar as Saint-Bertin possessed a full copy of this work as well as a collection of excerpts, which has survived.[25] Perhaps Lambert was allowed to use the latter on a long-term loan, and had recourse to the full manuscript for a few short texts not present in the collection of excerpts.

As for the *Etymologiae* of Isidore of Seville, Lambert certainly did *not* find this basic source in the surviving Saint-Bertin copy (recorded among the additions to the twelfth-century catalogue, 301–302), as this codex is posterior to the *LF*.[26]

Contemporaneous authors

For most authors of the late eleventh and early twelfth century whose works appear in the *LF*, no manuscripts are known from which Lambert could have made his transcriptions or excerpts. We do not know how he became acquainted with the poems of or ascribed to Hildebert of Le Mans (d. 1133) and Marbod of Rennes (d. 1123) that he quotes. He probably excerpted the short theological or canon law texts ascribed to Anselm of Laon (d. 1117) and Guillaume de Champeaux (d. 1121) or their school from a collection of sentences. Both groups of excerpts were written in the eighth, ninth or tenth phases of the making of the *LF*. It is not without interest that a manuscript that has close links with the *LF* and will be discussed at the end of this article contains the epitaph of Anselm of Laon.

Lambert knew other authors and their works no doubt through personal contacts. This is probably the case with Odo of Cambrai (d. 1113), successively bishop of Tournai and Cambrai, who ended his life in the abbey of Anchin, and Anselm of Canterbury (d. 1109). The latter visited the abbey of Saint-Bertin in 1097 and on the invitation of the canons also paid a visit to the collegiate church of Our Lady. It is almost impossible that Lambert would not have met the famous theologian on that occasion, and one can imagine that he afterwards obtained from him the material for the *Flores Anselmi cur Deus homo*, an autonomous abridgement reflecting the whole of Anselm's work. There are reasons to believe that the *Flores* are an adaptation by Lambert himself – in any case, this extensive text is also found in two other early manuscripts related to the *LF*.[27] Its lyrical tone contrasts with the normally impersonal style of Lambert and the idea that this version was realised in collaboration with another author, perhaps a monk of Saint-Bertin, is not far-fetched. And since Gilbert Crispin, abbot of Westminster (d. 1117) was the first pupil of Anselm, it is not unlikely either that it was through the latter that Lambert became acquainted with Crispin's *Disputatio Iudaei et Christiani*.

The case of Petrus Pictor (d. after 1110) is even more compelling: a colleague of Lambert in the chapter of Saint-Omer and an author like him, they knew each other and presumably were friends. As the autograph of the *LF* is the earliest manuscript containing (most of) the poems of Petrus Pictor, one must conclude that Peter handed them over to Lambert, perhaps at the time he was forced to leave the country, or that Lambert found them in the chapter library after Peter's departure.[28]

Foucher de Chartres (d. 1127), finally, Lambert's source for the history of the First Crusade, is interesting because he lived in the Holy Land at the time Lambert composed the *LF*. Lambert ascribed the *Gesta Francorum Hierusalem expugnantium*, an extremely long chapter in the *LF*, to Foucher, but the *Gesta* differs from the latter's work, because it includes data not mentioned by Foucher, and is also based on *aliorum narratus*, as is explicitly stated in the prologue to the text. So in the first decades of the twelfth century, Foucher's notes on the history of the Crusade were available in Saint-Omer, together with 'the account of others', presumably eyewitnesses. It is not difficult to guess who brought both to Flanders: Bohemond of Antioch, hero of the Crusade,

I	II	III	IV	V	VI	VIII	IX	X	XI	XII	XIII
Anselmus Cantuariensis (+ 1109)											
-	-	-	-	V	-	-	-	-	-	-	-
Anselmus Laudunensis (+ 1117)											
-	-	-	-	-	-	VIII	IX	X	-	-	-
Fulcherus Carnotensis (+ 1127)											
I	-	-	-	-	-	-	-	-	-	-	-
Gilbertus Crispinus (+ 1117)											
-	-	-	-	-	-	-	-	X	-	-	-
Guillelmus de Campellis (+ 1121)											
-	-	-	-	-	-	-	IX	-	-	-	-
Hildebertus Cenomannensis (+ 1133)											
-	-	-	-	-	-	-	-	X	-	-	-
Marbodus Redonensis (+ 1123)											
-	-	-	IV	-	-	-	-	-	-	-	-
Odo Cameracensis (+ 1113)											
-	-	-	-	-	-	-	-	X	-	-	XIII
Petrus Pictor (+ post 1110)											
I	-	-	-	-	-	-	-	X	-	-	-

travelled to Flanders and delivered a speech in Saint-Omer at the end of March 1106. Lambert repeatedly refers to Bohemond and his visit and there can be no doubt that he actually heard him preaching, as Jay Rubenstein observed already in 2012.[29] Another manuscript survives containing the same version of the *Gesta*: it belonged to Saint-Bertin abbey, is strictly contemporaneous with the *LF* and, what is more, was written by several hands in a succession of campaigns, obviously in keeping with the availability of the information.[30] Lambert's hand is not among them, but the headings of the chapters in the second part of the text are those introduced by him in the *LF* text of the *Gesta*. Only one conclusion is possible: the *Gesta Francorum Hierusalem expugnantium* is the result of the collaboration between Lambert, canon of Saint-Omer, and monks of Saint-Bertin.[31]

In Table III we see that the works of all contemporary authors were used by Lambert in the later or last phases of the composition of the *LF*, except, for reasons we now understand, Foucher of Chartres and Petrus Pictor.

Other sources

For a whole series of older texts in the *LF* we cannot point to a – surviving or lost – manuscript that might have been used as a source by Lambert. Among the historical texts, the *Anglo-Saxon Chronicle* or parts of it were perhaps included in the *Gesta Anglorum* manuscript in Saint-Bertin mentioned above. It was excerpted in the first phase of Lambert's compiling activity. The same is true for Bede's *Historia eclesiastica gentis Anglorum*, the Chronicle of Eusebius-Hieronymus, and the spurious correspondences between Alexander the Great and Aristotle (about the wonders of the East) and Alexander and Dindimus, king of the Brahmins (which is of a moral nature). Adso of Montiérender appears also in the first phase as the source for a chapter on the coming of the Antichrist, which Lambert attributes to Methodius of Olympus, in a version of which he most probably is the author himself.[32] It has its counterpart in the Antichrist prophecy, which is actually a work of the so-called Pseudo-Methodius, and which was inserted in phase VIII. The *Chronica* of Isidore of Seville was used in phase III, the *Historia ecclesiastica* of Eusebius-Rufinus in phase IX, and two sources of Frankish history, the *Liber historiae Francorum* and the *Historia Francorum Senonensis* appear to have been consulted in the very latest phase of Lambert's activity. Astronomical and other scientific texts were found in Aratus manuscripts, in Bede's *De natura rerum* and in various treatises falsely attributed to the same author. From a *Physiologus*

TABLE IV: OTHER SOURCES

I	II	III	IV	V	VI	VIII	IX	X	XI	XII	XIII
Adso Dervensis, *De ortu et tempore Antichristi*											
I	-	-	-		-	-	-	-	-	-	-
Ps.-Alexander, *Collatio cum Dindimo*											
I	-	-	-		-	-	-	-	-	-	-
- *Epistola ad Aristotelem*											
I	-	-	-		-	-	-	-	-	-	-
Anglo-Saxon Chronicle											
I	-	-	-		-	-	-	-	-	-	-
Aratea											
-	II	-	-		-	-	-	X	-	-	XIII
Beda, *Historia ecclesiastica gentis Anglorum*											
I	-	-	-		-	-	-	-	-	-	-
-, *De natura rerum*											
-	II	(III)	-		-	(VIII)	-	-	-	-	-
Ps.-Beda, *Tractatus varii*											
I	II	III	-		-	VIII	-	X	-	-	-
Eusebius-Hieronymus, *Chronicon*											
I	-	-	-		-	-	-	-	-	-	-
Eusebius-Rufinus, *Historia ecclesiastica*											
-	-	-	-		-	-	IX	-	-	-	-
Gennadius, *Liber sive diffinitio ecclesiasticorum dogmatum*											
-	(II)	-	-		-	(VIII)	-	-	-	-	-
Historia Francorum Senonensis											
-	-	-	-		-	-	-	-	-	-	XIII
Isidorus Hispalensis, *Chronica*											
-	-	III	-		-	-	-	-	-	-	-
-, *De fide catholica contra Iudaeos*											
-	-	-	-		-	-	IX	-	-	-	-
Liber historiae Francorum											
-	-	-	-		-	-	-	-	-	-	XIII
Ps.-Methodius, *Revelationes*											
-	-	-	-		-	VIII	-	-	-	-	-
Physiologus											
-	-	-	-		-	-	-	X	-	-	-

manuscript Lambert excerpted additions to his Bestiary.

Cotton Fragments 1

The 30 charred leaves in the British Library known as Cotton Fragments 1 are all that remains from a small enigmatic manuscript with extremely close links to the *LF*.[33] It is not only strictly contemporaneous with Lambert's autograph, but originates like the latter in Saint-Omer, though in all probability it was not produced in the chapter of Our Lady but in the abbey of Saint-Bertin. As far as can be ascertained, almost all the texts that this badly damaged manuscript contains are also found in the *LF* – mostly, however, in a more or less deviant form. It was not illustrated, apart from the circular map of Jerusalem also occurring in the *LF*, and it certainly was informal in appearance: it had no decoration and was in no way comparable to the much larger, carefully written and illuminated work of Lambert. We do not know how much of the manuscript has been lost, but whatever the original number of leaves, it is absolutely sure that we are in the presence of a kind of mini- or proto-*Liber floridus*, which is neither a source for Lambert's work, nor copied from it. It is also absolutely impossible that the *LF* and the

TABLE V: SOURCES OF THE COTTON FRAGMENTS

I	II	III	IV	V	VI	VIII	IX	X	XI	XII	XIII
Beda, *De natura rerum*											
-	II	-	-	-	-	-	-	-	-	-	-
Ps.-Beda, *Tractatus varii*											
-	-	-	IV?	-	-	-	-	-	-	-	-
Eucherius Lugdunensis, *Instructiones*											
I	-	-	-	-	-	-	-	-	-	-	-
Freculphus Lexoviensis, *Historiae*											
-	-	III	-	-	-	-	-	-	-	-	-
Fulcherus Carnotensis											
I	-	-	-	-	-	-	-	-	-	-	-
Investiturae documenta											
I	-	-	-	-	-	-	-	-	-	-	-
Isidorus Hispalensis, *Etymologiae*											
I	II	-	IV	-	-	-	-	-	-	-	-

Cotton Fragments would have been created independently from each other. Instead, the Cotton Fragments should probably be considered in the same way as the Saint-Bertin manuscript of the *Gesta Francorum Hierusalem expugnantium* discussed above: as the result of a form of collaboration between Lambert and the abbey of Saint-Bertin. As we see in Table V, the sources used for the compilation of the Fragments are the same as some of those that have been used for the writing of the *LF*, but these are only sources used by Lambert *in the first four phases* of his work on the *LF*. In the same way, the subjects dealt with in the Cotton Fragments manuscript are generally subjects treated in the first four phases in the making of the *LF*. Basic sources of the *LF* such as Isidore of Seville's *Etymologiae* and Freculph of Lisieux' *Historiae* are prominent in the Fragments. It seems as if in the first decades of the twelfth century there was a common encyclopaedic project in the minds of members of the abbey of Saint-Bertin and of Lambert of Saint-Omer. In spite of all the uncertainty, and recognizing that many manuscripts have been lost, the conclusion that there were talks and discussions between the two parties is inevitable, even if the full character and importance of the Cotton Fragments and their relationship with the *LF* remain hidden from us.[34]

Annex I: Content of the *Liber floridus* and its Sources during its Development

★ = picture, map, diagram
° = page-filler
() texts accompanying pictures, maps, diagrams, tables, other texts

PHASE I (*c.* 1111–1115)		
49.	Provinces of the World	Isidorus Hisp., *Etymologiae*
51.	Peoples of the World	Isidorus Hisp., *Etymologiae*
52.	Cities of the World	Isidorus Hisp., *Etymologiae*
54.	Previous and Present Names of Asian Cities	Eucherius Lugdunensis, *Instructiones*
55.	Islands	Isidorus Hisp., *Etymologiae*
56.	The Rivers of Paradise	Eucherius Lugdunensis, *Instructiones*
59.	Rivers, Sources and Lakes	Isidorus Hisp., *Etymologiae*
60.	Human Monsters	{ Isidorus Hisp., *Etymologiae* / Augustinus, *De civitate Dei*
61.	Names of Christ	–
62.	Biblical Names and Terms	Eucherius Lugdunensis, *Instructiones*
63.	Names concerning Christianity	{ Eucherius Lugdunensis, *Instructiones* / Isidorus Hisp., *Etymologiae*
64.	Names of Pagan Deities	{ Eucherius Lugdunensis, *Instructiones* / Isidorus Hisp., *Etymologiae*
65.	Names of Weights	Eucherius Lugdunensis, *Instructiones*
66.	Names of Measures	Eucherius Lugdunensis, *Instructiones*
71.	Bestiary: Mammals	Isidorus Hisp., *Etymologiae*
72.	Bestiary: Birds★	Isidorus Hisp., *Etymologiae*
73.	Bestiary: Reptiles★	Isidorus Hisp., *Etymologiae*
74.–77.	Bestiary: Fishes★	Isidorus Hisp., *Etymologiae*
78.	Marvels of Britain	Nennius, *Hist. Brittonum*
82.	Lapidary	Isidorus Hisp., *Etymologiae*
86.	History of Britain	{ Nennius, *Hist. Brittonum* / *Anglo-Saxon Chronicle*
87.	List of the 28 Cities of Britain	Nennius, *Hist. Brittonum*
91.	History of Normandy	original
92.	Gothic Kings and Dukes of Normandy	–
93.	Palm Tree★	–
94.	Kings and Patriarchs of Jerusalem	–
177.	History of Flanders. Counts of Flanders	–
179.	Documents on the Investiture Struggle	–
180.	On the Coming of Antichrist	Adso Dervensis, *De ortu et obitu A.*
182.	History of the First Crusade	Fulcherus Carnotensis
183.	Holy Sepulchre★. Plan of Jerusalem★	–
184.	Additional Note about the Crusade	Fulcherus Carnotensis
198.	Letter of Alexander to Aristotle	–
199.	Alexander, Correspondence with Dindimus	–
206.–212.	Poems	Petrus Pictor
215.	Short History of the World	Orosius, *Hist. adv. paganos*
222.	History of the Roman Emperors	{ Orosius, *Hist. adv. paganos* / Marcellinus Comes, *Chron.* / *Ann. Bertiniani* / *Ann. regni Francorum* / *Hist. eccles. tripartita*

225.	Noah's Ark★	-
226.	Note on Noah and his Offspring	Freculphus Lexoviensis, *Hist.*
227.	Disasters, Wonders, etc.	Marcellinus Comes, *Chron.*
228.	Signs announcing the Destruction of Jerusalem	Iosephus, *De bello Iudaico*
229.	Wonders, Signs, a False Prophet	{ Gregorius Turonensis, *Hist. Francorum* *Ann. regni Francorum*
230.	Signs in the Sun and the Moon	*Ann. regni Francorum*
231.	Miraculous Events	*Ann. regni Francorum*
232.	An Earthquake and a Miraculous Fast	*Ann. regni Francorum*
233.	Grain Raining from the Sky	*Ann. regni Francorum*
234.	Famine, Violent Wind, incursion of Wolves	*Ann. Bertiniani*
235.	People Killed by Lightning	*Ann. Bertiniani*
236.	A Thunderstorm	*Ann. Bertiniani*
237.	An Earthquake and a Miraculous Tree	*Ann. Bertiniani*
238.	A Wolf Entering a Church	*Ann. Bertiniani*
239.	Signs in the Moon and the Sun	*Ann. Bertiniani*
240.	A Miracle in Thérouanne	*Ann. Bertiniani*
241.	Incursions of the Vikings	{ *Ann. Bertiniani* *Ann. Vedastini*
242.	Gothic Kings and Dukes of Normandy	-
243.	Vision of a British Priest	*Ann. Bertiniani*
244.	A Flood, Appearances in the Sky, etc.	{ *Ann. Bertiniani* *Ann. Vedastini*
245–246.	Divisions of the Frankish Empire	*Ann. Bertiniani*
286.	Map of Europe★	-
96.	Virtues and Vices	Gregorius Magnus, *Moralia in Iob*
98.	Vision of Drothelmus	Beda, *Hist. eccl. gentis Anglorum*
106.	Truce of Soissons, etc.	-
107–108.	Greek Alphabet. Names of Numbers	-
109.	*Caracteres*	? Ps.–Beda
110.	Classification and Mystic Sense of Numbers	{ Ps.–Beda Augustinus, *De musica*
111.	The Four Seasons	?
112.	Subdivisions of the Year. The Leap Day	? Ps.–Beda
185.	Computistical Tables	? Ps.–Beda
186.	Directions for the Sun-Dial. Calculations	? Ps.–Beda
188–189.	Pre-Christian World History, etc	{ Eutropius, *Breviarium* Freculphus Lexoviensis, *Hist.*
190.	Trees Symbolising the Beatitudes★	*Biblia*
191.	Trees, Plants and Herbs	-
192.	Moses and his Contemporaries	{ Iosephus, *Antiquitates Iud* Orosius, *Hist. adv. pag.* Eusebius-Hieronymus, *Chron.*
193.	About Christ and John the Baptist	{ Iosephus, *Antiquitates Iud.* Eusebius-Hieronymus, *Chron.*
194.	Herod and his Family	Beda, *Homilia*
195.	The Nine Choirs of Angels	Gregorius Magnus, *Homilia*
PHASE II		
121.	Constellations★	{ *Aratea* Ps.–Beda
122.	Course of the Sun	-

124.	Map of the World★	- (Gennadius, *Liber ecclesiast. dogm.*) (Macrobius, *Comm. in Somn. Scip.*)
123.	Sun, Earth and Moon★	- (Macrobius, *Comm. in Somn. Scip.*)
125.	Phases of the Moon★	- (Macrobius, *Comm. in Somn. Scip.*)
126.	Northern Sky★	- (*Aratea*)
127.	Ptolemaic Planetary System★	Isidorus Hisp., *De natura rerum?* (Macrobius, *Comm. in Somn. Scip.*) (Beda, *De natura rerum*)
128.	Constellations	*Aratea*
129.	Risings and Settings of the Constellations	*Aratea*
130.	The Starry Sky Presided by Christ★	-
131.	Thunder and Lightning	Beda, *De natura rerum*
132.	Note on the Sun and the Year	Beda, *De natura rerum*
133.	Meteorology	Beda, *De natura rerum*
134.	Weather Forecast	Beda, *De natura rerum*
135.	Floods	Isidorus Hisp., *Etymologiae*
136.	Power of Satan	Burchardus Wormat., *Decretum*
137.	Penance of Solomon	Theological sentences
138.	Murder of the Innocents. Rachel. James the Elder	Biblical commentary Gregorius Tur., *Hist. Francorum*
139.	Christ in Limbo, Joseph of Arimathea, etc.	Ps.-Augustinus Gregorius Tur., *Hist. Francorum*
140.	Sleep of St. John the Evangelist	Gregorius Tur., *Hist. Francorum*
141.	The Twelve Apostles	-
142.	Names of the Days	-
143.	The Ten Plagues of Egypt	-
144.	The Elect and the Reprobate	Gregorius Magnus, *Homiliae*
145.	Decalogue	*Biblia*
146.	Canonical Books of the Bible	Ps.-Isidorus Mercator, *Decretales*
147.	Authorised Prefaces of the Eucharist	Burchardus Wormat., *Decretum*
148.	List of Liturgical Readings	Burchardus Wormat., *Decretum*
149.	Calculation of the Time from Adam to Christ	-
152.	List of Apocryphal Books	Burchardus Wormat., *Decretum*
153.	List of Magi and Heretics	Burchardus Wormat., *Decretum*
154.	The Two Paradises	Iulianus Toletanus, *Prognosticon*
155.	The Two Hells	Iulianus Toletanus, *Prognosticon*
156.	The Elect and the Reprobate	Iulianus Toletanus, *Prognosticon*
157.	The Resurrection of Monstrous Men	Iulianus Toletanus, *Prognosticon*
158.	Prophecy and Music in the Bible	Cassiodorus, *Expositio Psalmorum*
159	The Forgiving of Sins	Cassiodorus, *Expositio Psalmorum*
160.	The Paschal Cycle	Isidorus Hisp., *Etymologiae*
163.	Diet: Food and Drinks. Medical Recipes	-
164.	The Lord's Prayer in Latin and Greek	-
165.	The Nicene Creed in Latin and Greek	-
167.	Job and his Ancestors	Gregorius Tur., *Hist. Francorum*
168.	Transportation of Relics to Saint-Omer°	*Ann. Bertiniani*
PHASE III (*c.* 1111–1118)		
15.	Gospel Harmony	-
18.	Jewish History	Freculphus Lexoviensis, *Hist.*
23.	World History up to Christ	Freculphus Lexoviensis, *Hist.* Hegesippus, *Historia*

24.	Jewish History	{ Hegesippus, *Historia* { Freculphus Lexoviensis, *Hist.*
38.	Calendar	–
39.	Short Pre-Christian World History	Isidorus Hisp., *Chron. maiora*
40.	Calcul. of the Time between Adam and Christ	–
41.	Chronological, etc. Definitions	Isidorus Hisp., *Etymologiae*
42.	Pre-Christian World History	{ Freculphus Lexoviensis, *Hist.* { Isidorus Hisp., *Chron. minora*
44.	Lists of Emperors and Popes	–
43.	Annals	{ – { (Helpericus Autiss., *De computo*) { (Iordanes, *De orig. actibusque Getarum*)
33.	Diagram of the Winds★	(Beda, *De natura rerum*)
34.	Map of the World★	(Macrobius, *Comm. in Somn. Scip.*)
19.	Map of the Peoples of the World★	{ Ps.-Aethicus, *Cosmographia* { Orosius, *Hist. adv. paganos*
20.	Diagram of the Six Ages of the World★	–
21.	Labyrinth and Minotaur★	–
22.	Diagram of the Six Ages of the World★	Ps.-Beda?
35.	Diagram of the Sunrises and Sunsets★	{ (Helpericus Autiss., *De computo*) { (Beda, *De temp. ratione*) { Isidorus Hisp., *Etymologiae*
36.	Diagram of Lunar Phases, etc.★	{ (Helpericus Autiss., *De computo*) { (Isidorus Hisp., *Etymologiae*)
37.	Sphere of Apuleius★	Ps.-Pythagoras
31.	Annunciation★	–
32.	Apocalypse★	–
173.	Map of the World★	{ (Martianus Capella, *De nuptiis*) { (Macrobius, *Comm. in Somn. Scip.*)
46.	Geographical Names	*Notitia Galliarum*
48.	Five Famous Cities	Gregorius Tur., *Hist. Francorum* etc.
316.	Saint-Omer and St. Audomarus★	–
PHASE IV		
70.	Bestiary: Lion★	(Isidorus Hisp., *Etymologiae*)
67.	Names of the Sibyls	{ Isidorus Hisp., *Etymologiae* { (Martianus Capella, *De nuptiis*)
68.	Sibylline Prophecies about Christ	Augustinus, *De civitate Dei*
75.	Devil and Behemoth★	*Biblia*
76.	Antichrist and Leviathan★	*Biblia*
79.	The Heavenly Jerusalem★ Building of the Temple	– *Biblia*
80.	Virtues of the Apocalyptic Stones	–
81.	Verses on the Apocalyptic Stones	Marbodus Redonensis?
88.	Meanings of *Hebdomas*	Beda, *De temporum ratione*
117.	Chronological Definitions	Isidorus Hisp., *Etymologiae*
97.	On the Descent of the Jewish People	–
99.	Virtues of the Dove	–
113.	Various Types of Years	Beda?
114.	Table of Roman Numbers	–
PHASE V		
196.	*Cur Deus homo* (*Flores*)	Anselmus Cantuariensis

PHASE VI (*c.* 1115)		
197.	History of Alexander Alexander on Horseback★	Iulius Valerius, *Epitome* (Iulius Valerius, *Epitome*)
216.	History of the Popes	{ *Liber Pontificalis* { *Ann. Bertiniani* etc.
PHASE VIII		
247.	Antichrist Prophecy	Ps.-Methodius, *Revelationes*
248.	15 Signs Announcing the Last Judgment	{ Ps.-Beda { Iulianus Toletanus, *Prognosticon*
249.	On the Last Judgment and Resurrection	Iulianus Toletanus, *Prognosticon*, etc.
250.	Platonic Philosophy★	{ Chalcidius, *Comm. in Timaeum* { Ps.-Beda { (Macrobius, *Comm. in Somn. Scip.*)
251.	Scipio's Dream	Cicero/Macrobius, *Somn. Scip.*
253.	Map of the World and Phases of the Moon★	{ (Macrobius, *Comm. in Somn. Scip.*) { (Beda, *De natura rerum*)
254.	Astronomical Diagrams★	(Macrobius, *Comm. in Somn. Scip.*)
257.	Apparent Course of the Planets★	{ Beda, *De temporum ratione* { (Cicero/Macrobius, *Somn. Scip.*)
258.	Map of the Earth and the Sky★	{ Macrobius, *Comm. in Somn. Scip.* { (Beda, *De natura rerum*)
259.	Map of the Earth amidst the Planets★	{ Macrobius, *Comm. in Somn. Scip.* { (Beda, *De natura rerum*)
260.	Diagram of Cosmic Relations★	{ Isidorus Hisp., *De natura rerum* { (Beda, *De natura rerum*) { (Gennadius, *Liber ecclesiast. dogmatum*)
264.	Lily★	–
267–268.	Trees of Virtues and Vices★	(*Biblia*)
269.	Nebuchadnezzar's Dream★	(*Biblia*)
261.	Canon and Roman Law Texts	{ Anselmus Laudunensis { Isidorus Hisp., *Etymologiae*
262.	Precious Stones	Isidorus Hisp., *Etymologiae*
263.	Sentences about the Last Judgment	{ Hieronymus, *Epistolae* { Iulianus Toletanus, *Prognosticon*
265.	Bishops of Thérouanne (List)	–
266.	Marvels of the World. A Marvellous Stone	Ps.-Beda
PHASE IX (*c.* 1115–1116)		
271.	On Simony	Guillelmus de Campellis
272.	On the Eucharist	–
273.	On the Giving of Alms	Anselmus Laudunensis
274.	On the Origin of Herod	–
275.	Later Jewish History	{ Freculphus Lexoviensis { Hegesippus
276.	List of High Priests and Bishops	–
277.	Frankish History (first state)	–
289 bis	Lists of Rulers (deleted)	–
290–291	Anti-Jewish Controversy	Isidorus Hisp., *De fide catholica*
292.	Christ, Church and Synagogue★	–
292–294.	Genealogies of Christ	{ *Biblia* { Eusebius-Rufinus, *Hist. eccles.*
295–296	Letters of Abgar and Christ	Eusebius-Rufinus, *Hist. eccles.*
297.	Medical Recipes	–

299.	Dice Prognosis	-
300.	Numbers	-
301.	Chronological Computations	-
PHASE X (*c.* 1118–1120)		
8.	Dispute with a Jew	Odo Cameracensis, *Disputatio c. Iudaeo*
9.	Dispute with a Jew	Gilbertus Crispinus, *Disputatio Iudaei*
12.	St. Audomarus★	-
13.	Saint-Omer and Lambert of Saint-Omer★	-
28.	King Solomon★	- (*Biblia*)
29.	Diagram of the Subdivisions of the Year★	Ps.-Beda
56.	Paradise★	-
57.	Rivers	Ps.-Aethicus, *Cosmographia*
58.	The Three Continents	Orosius, *Hist. adv. pag.*
71.	Bestiary: addition	*Physiologus*
85.	List of English Rulers	-
83.	Note on the Coming of the Holy Ghost	Amalarius Mettensis, *Liber off.*
84.	Birth and Life of Christ	{Ps.-Haimo Halberst., *Homiliae*
95.	Excerpts and Miracles	Gregorius Magnus, *Dialogi*
100.-105.	Poems	⎧ Petrus Pictor ⎨ °Hildebertus Cenomannensis? ⎩ °Ovidius, *Metamorphoseon*
115–116.	Excerpts	*Biblia*
128.	Constellations	*Aratea*
178.	Poem on the Counts of Flanders	-
169.	Grades of Consanguinity	Isidorus Hisp., *Etymologiae*
170.	On Consanguinity	Isidorus Hisp., *Etymologiae*
171.	Impediments to Marriage	⎰ Burchardus Worm., *Decretum* ⎱ Anselmus Laudunensis
172.	Legitimate Marriage and Abduction	Burchardus Worm., *Decretum*
174.	Counties, Cities and Abbeys of Flanders	-
175.	Relics Venerated in Flanders	-
176.	Counts of Flanders, Rivers of Flanders	-
181.15	Signs Announcing the Last Judgment	Ps.-Beda
185.	Computistical Tables	⎰ Ps.-Beda ⎱ Beda, *De temporum ratione*
219.	Donation of Constantine	Ps.-Isidorus Mercator, *Decretales*
220.	Decrees of Constantine	*Actus Silvestri papae*
221.	History of Julius Caesar	Orosius, *Hist. adv. pag.*
217.	Foundations and Donations of Constantine	*Liber Pontificalis*
218.	Chronological Note	-
1–2, 201–204.	Various texts. Lambert's Pedigree	-
PHASE XI		
304.	Names of God	Hrabanus Maurus, *De rerum naturis*
305.	Jewish Heresies	Hrabanus Maurus, *De rerum naturis*
306.	Old and New Testament	Hrabanus Maurus, *De rerum naturis*
307.	Countries and Islands	Hrabanus Maurus, *De rerum naturis*
308.	Mountains and Places	Hrabanus Maurus, *De rerum naturis*
309.	Cities ad Towns	Hrabanus Maurus, *De rerum naturis*
310.	Pagan Philosophy	Hrabanus Maurus, *De rerum naturis*
311.	Christian Philosophy	Hrabanus Maurus, *De rerum naturis*
313.	A Miracle happened in Antioch	Gregorius Tur., *Hist. Francorum*

314.	Short History of the World	{ Gregorius Tur., *Hist. Francorum* { Hrabanus Maurus, *De rerum naturis*
315.	Romance of Apollonius of Tyre	–
PHASE XII (*c.* 1117–1120)		
316.	Saint-Omer and St. Audomarus★	–
317.	Life and Miracles of St. Audomarus	*Vita S. Audomari*
318.	Chronology of Audomarus' Episcopacy	–
319–320.	Abbots and Provosts of Sithiu	–
321.	Catalogue of Popes	–
322.	Chalice and Paten of St. Audomarus	–
323	Notes on the Churches of Saint-Omer, etc.	–
324	List of Carolingian Rulers	–
325	History of the Trojan War	Dares Phrygius, *De excidio*
326–327.	Roman History up to Pompey's Death	Freculphus Lexoviensis, *Hist.*
PHASE XIII (*c.* 1119–spring 1121)		
10.	*Dialogus Malchi et Iesu*	–
11.	On Eternal Salvation°	Iulianus Toletanus, *Prognosticon*
16.	On the Gospel Canons	Odo Cameracensis, *De canonibus ev.*
17.	The Three Mary's. Christ's Appearances	–
26.	The Six Days of Creation	compilation after the *L.F.* itself
27.	Various Notes related to King Solomon	–
53.	On Peoples and Monsters, etc.	{ Martianus Capella, *De nuptiis* { compilation after the *L.F.* itself
166.	Mountains not Covered by the Flood	{ – { Martianus Capella, *De nuptiis*
161.	The Fast of the Ember Days	–
162.	The Twelve Vigils to be Observed	–
129.	Risings and Settings of the Constellations	*Aratea*
223.	Vision of Charles the Bald	*Visio Caroli III*
224.	Death of Charles the Bald	*Ann. Vedastini*
255–256.	Ptolemaic System★. Computations, etc.	partly compilation after the *L.F.* itself
277.	Frankish History (second state)	{ *Liber historiae Francorum* { *Notitia Galliarum*
278.	Frankish History	{ – { *Historia Francorum Senonensis*
279–288.	Lists of Bishops and Rulers	–
5.	Lists of Rulers	–
3–4.	Various Notes	excerpts from the *L.F.* itself

Annex II: Contents and Sources of Ms. Cotton Fragments 1

In the four columns the following data are given: number of the section, after DEROLEZ, 'Le *Liber Floridus* et l'énigme du manuscrit Cotton Fragments vol. 1' (see n. 33); subject; corresponding section in the *LF*; phase during which that section was made; source (where possible)

1.	Calendar?	38	III	
2.	The Ten Plagues of Egypt	143	II	
3.	Pre-Christian World History	42	III	Freculphus Lexoviensis, *Hist.*
4.	Annals	43	III	
5+7.	Latin and Greek Names of Chris	61	I	
6.	On the Sibyls	(67)	IV	Isidorus Hisp., *Etymologiae*
8.	The Lord's Prayer in Latin and Greek	164	II	
	The Nicene Creed in Latin and Greek	165	II	
9.	Various Types of Years	(113)	IV	Beda?
10.	Definitions	(63)	I	Isidorus Hisp., *Etymologiae*
11.	Prophecy about King Cyrus	69		
12.	Thunder and Lightning	131	II	Beda, *De natura rerum*
13.	Inventors of Laws	–		
14.	On Music	(158)	II	Isidorus Hisp., *Etymologiae*
15.	Names of Pagan Deities	64	I	Eucherius Lugdunensis, *Instructiones* Isidorus Hisp., *Etymologiae*
16.	List of Popes	(44)	III	
17.	Early History of Rome	–		
18.	On Emperor Augustus	(188)	I	
19.	Chronicle of the Emperors	–		
20.	Description of Jerusalem	–		
21–22.	History of the First Crusade	182	I	Fulcherus Carnotensis
23.	On the Investiture Struggle	179	I	
24.	Bestiary	71–77	I	Isidorus Hisp., *Etymologiae*
25.	Computations	(301)	IX	
26.	Bestiary: the Horse	71	I	Isidorus Hisp., *Etymologiae*
27.	On the Canicule	–		Isidorus Hisp., *Etymologiae*
28.	Epitaph of Anselm of Laon (d. 1117)	–		
29.	Lapidary	(82)	I	Isidorus Hisp., *Etymologiae*
30.	Volcanoes			
31.	Distances between the Planets	(257)	VIII	
32.	Astronomical Text	258	VIII	Beda, Macrobius
33.	On Human Monsters	60	I	Isidorus Hisp., *Etymologiae* Augustinus, *De civitate Dei*
34.	On Leviathan	(76)	IV	
35	Early History of Rome	42	III	
36.	Frankish Kings and Emperors	–		
37.	Genealogy of the Counts of Flanders	(177)	I	
38.	Computations	40	III	
39.	Genealogy of the Counts of Flanders	177	I	

NOTES

1. A. DEROLEZ, *The Making and Meaning of the Liber Floridus. A Study of the Original Manuscript, Ghent, University Library MS 92*, London, Turnhout, 2015; quoted in the following as DEROLEZ, *The Making*.

2. DEROLEZ, *The Making*, p. 173–182. More details about this chronology and its foundations in A. DEROLEZ, *Lambertus qui librum fecit. Een codicologische studie van de Liber Floridus-autograaf (Gent, Universiteitsbibliotheek, hs. 92). With a Summary in English: The Genesis of the Liber Floridus of Lambert of Saint-Omer*, Brussels, 1978 (Verhandelingen van de Koninklijke Academie voor Wetenschappen, Letteren en Schone Kunsten van België, Klasse der Letteren, 40.89, p. 361–379 and 393–435.

3. See DEROLEZ, *The Making*, p. 39–43.

4. Folio 57.

5. Folio 68v.

6. Folio 166v.

7. L. DELISLE, 'Notice sur les manuscrits du "Liber floridus" de Lambert, chanoine de Saint-Omer', *Notices et extraits des manuscrits de la Bibliothèque nationale et autres bibliothèques*, 38, 1906, p. 577–791.

8. DEROLEZ, *The Making*, p. 195–197.

9. Brussels, Royal Library, MS 6439–6451 (3108).

10. Saint-Omer, Bibliothèque d'agglomération, MS 717.

11. Saint-Omer, Bibliothèque d'agglomération, MS 718.

12. Saint-Omer, Bibliothèque d'agglomération, MS 188.

13. Paris, BNF, MS Nouv. acq. lat. 1249.

14. Saint-Omer, Bibliothèque d'agglomération, MS 189.

15. Saint-Omer, Bibliothèque d'agglomération, MS 194.

16. Saint-Omer, Bibliothèque d'agglomération, MS 715.

17. Saint-Omer, Bibliothèque d'agglomération, MS 698.

18. Brussels, Royal Library, MS 9843–9844 (1324).

19. DEROLEZ, *The Making*, p. 197–199.

20. See DEROLEZ, *The Making*, p. 41–42.

21. The text edited in 1788 by Berthod is now currently cited after the edition by G. BECKER, *Catalogi bibliothecarum antiqui*, Bonn, 1885, p. 181–184.

22. See Institut de recherche et d'histoire des textes (IRHT-CNRS), 'Edition de l'inventaire: Brevis annotatio librorum sancti Bertini', dans Stutzmann Dominique (dir.), Saint-Bertin: centre culturel du VIIᵉ au XVIIIᵉ siècle, 2016 (permalink: https://saint-bertin.irht.cnrs.fr/site/php/inventaires.php?inventaire =../../sources/inventaires/BMMF_1733.xml).

23. DEROLEZ, *The Making*, p. 165–166 (no. 115) and fig. 112.

24. Saint-Omer, Bibliothèque d'agglomération, MS 764; see DEROLEZ, *The Making*, p. 41, n. 106.

25. Boulogne, Bibliothèque municipale, MS 63; see DEROLEZ, *The Making*, p. 41–42 and n. 107; J. N. Hillgarth, 'Julian of Toledo in the *Liber Floridus*', *Journal of the Warburg and Courtauld Institutes*, 26, 1963, p. 192–196.

26. Saint-Omer, Bibliothèque d'agglomération, MS 642.

27. DEROLEZ, *The Making*, p. 127–128 (no. 196) and n. 436.

28. L. VAN ACKER (ed.), *Petrus Pictor. Carmina*. Corpus Christianorum. Continuatio Mediaevalis, 25 (Turnhout, 1972), p. LXXXVI–LXXXVII and CXXVIII–CXXXVII.

29. J. RUBENSTEIN, 'Lambert of Saint-Omer and the Apocalyptic First Crusade', in N. PAUL, S. YEAGER (eds), *Remembering the Crusades. Myth, Iamge and Identity*, Baltimore, 2012, p. 69–95.

30. Saint-Omer, Bibliothèque d'agglomération, MS 776, folios 36–64.

31. A. DEROLEZ, 'The Abbey of Saint-Bertin, the *Liber Floridus*, and the Origin of the *Gesta Francorum Hierusalem expugnantium*', *Manuscripta*, 57, 2013, p. 1–28; see also H. VORHOLT, *Shaping Knowledge. The Transmission of the Liber Floridus*, London, 2017 (Warburg Institute Studies and Texts), p. 28–29.

32. DEROLEZ, *The Making*, p. 113–114 (no. 180).

33. A. DEROLEZ, 'Le *Liber Floridus* et l'énigme du manuscrit Cotton Fragments vol. 1', *Mittellateinisches Jahrbuch*, 17, 1982, p. 120–129; ID., 'Codex Aldenburgensis, Cotton Fragments vol. 1, and the Origins of the *Liber Floridus*', *Manuscripta*, 49, 2005, p. 139–163; VORHOLT, *Shaping Knowledge* (as in n. 31), p. 27–28.

34. I thank Benjamin Victor most sincerely for reading the text and correcting its linguistic flaws.

Visual Studies for the End of Time

Hanna Vorholt

The most dramatic visual component of Lambert of Saint-Omer's *Liber floridus* was an extensive cycle of miniatures picturing the Apocalypse. It must be due to the early attention that it garnered, rather than accident, that the quire containing these miniatures went missing at an early stage from Lambert's autograph (Ghent, Universiteitsbibliotheek, MS 92).[1] Before this happened, however, at least two *Liber floridus* copies were created that transmit the cycle, and they were copied in turn. The earliest of these to survive are Wolfenbüttel, Herzog August Bibliothek, Cod. Guelf. 1 Gud. lat., and Paris, Bibliothèque nationale de France, MS lat. 8865. For a long time, the approach prevalent in scholarship has been to regard the copies as substitutes for lost sections in Lambert's autograph, and to situate the cycle as transmitted in them among assumed groups of illuminated Apocalypses, using shared motifs as evidence for affiliations.[2] While it has proven difficult to pinpoint a specific exemplar that Lambert may have used for his cycle, such studies have identified a considerable number of Apocalypse manuscripts and artworks in other media that may, in turn, have been based on his own.[3] More recently, and in line with wider changes in approaches to the study of Apocalypse manuscripts, attention has shifted away from researching affiliations to interpreting the Apocalypse miniatures in their own right, using either *Wolfenbüttel* or *Paris 8865* as a primary focus, and to examining their relation to the wider contents of those manuscripts.[4]

When it comes to assessing the cycle lost from Lambert's own manuscript, however, using the *Liber floridus* manuscripts as evidence poses considerable challenges. These can be exemplified by considering the diagram of the constellations of the northern sky that survives on folio 94r of the autograph (Fig. 1). Lambert inscribed this diagram with

the names of the planets, thereby establishing a connection with the diagram of the planetary spheres that occupies the verso of the same leaf and has exactly the same dimensions; in effect, he blended the two images into one, as if we were looking through the parchment to the other side. During his working process, Lambert also altered the positions of several constellations, aligning them with written indications that he had added to the preceding constellation cycle (folios 89r–91v).[5] The diagram of the northern sky, then, is the result of ongoing compilation from different visual and textual sources, and is closely allied with other parts of Lambert's compilation, as well as with the materiality of the manuscript

Fig. 1. Ghent, Universiteitsbibliotheek, MS 92, folio 94r, *Liber floridus* (Lambert's autograph), *c.* 1111–1121: constellations of the northern sky

itself. This can also explain why it is difficult to identify specific exemplars for his images, even more so when one looks at the images in the guise of later copies. In these, evidence of changes made by Lambert in the course of the working process is obliterated, and their makers have themselves modified and reorganized texts and images, supplanting the specific alliance between content and material space in Lambert's manuscript. In *Wolfenbüttel*, for example, the diagram of the northern sky is combined with the planetary diagram on one page (folio 61r, Fig. 2) and followed rather than preceded by the constellation cycle (folios 62r–63v). In the case of leaves lost from Lambert's autograph the situation is therefore not straightforward, as we need to understand from the later manuscripts not only what happened in Lambert's autograph, but also how his final version was then transformed in the course of its transmission history.[6]

This article assesses specifically what we can learn from the *Liber floridus* copies about the strategies that Lambert employed to integrate the Apocalypse cycle firmly into his growing encyclopedic compilation. A particular focus will be on examining the role of the images he positioned immediately before and after the cycle; four of these were also part of the lost quire and count among the least discussed images of the *Liber floridus*. The analysis builds on Albert Derolez's fundamental research on the autograph[7] and aims to contribute to wider debates on how images were combined and designed to interact with one another in the space of medieval manuscripts. It argues that, for Lambert, such visual and material dynamics were critical instruments for knowledge generation, and that they could also serve an urgent hermeneutical purpose: to prepare for the arrival of Antichrist.

Counting the losses

Six of the extant *Liber floridus* manuscripts transmit miniatures from Lambert's Apocalypse cycle.[8] *Paris 8865*, which dates from the third quarter of the thirteenth century and is probably based on a *Liber floridus* manuscript (now lost) produced in the second half of the twelfth century,[9] is the only manuscript to transmit the cycle in full, from St John on Patmos to the Heavenly Jerusalem and the River

Fig. 2. Wolfenbüttel, Herzog August Bibliothek, Cod. Guelf. 1 Gud. lat., folio 61r, *Liber floridus*, second half of 12th century: constellations of the northern sky and planetary spheres

of Life (Apocalypse 1–22), on folios 34v–42v. *Wolfenbüttel*, which is a direct copy of Lambert's autograph and was made in the second half of the twelfth century,[10] includes the scenes up to the worship of the Beast (Apocalypse 1–13), on folios 9v–15v. The other four *Liber floridus* manuscripts that transmit the cycle depend on *Wolfenbüttel*, and three of them include the scenes up to the seventh vial (Apocalypse 16),[11] suggesting that, if *Wolfenbüttel* did once contain the full Apocalypse cycle, the leaves containing the last scenes were lost in two stages from that manuscript. Further evidence regarding Lambert's cycle is provided by the *Liber floridus* autograph: Lambert replaced one bifolium from his Apocalypse cycle and inserted the discarded version, with modifications, in another section of his manuscript (now folios 88 and 91). He also recorded the cycle as *Apocalypsis depictus* in the table of contents – a table that he added while he was still working on the manuscript and then continued to modify.[12] This sheds

further light on the position of the cycle and on changes made by Lambert in the incremental course of production.

It is clear from these later *Liber floridus* manuscripts and the evidence in Lambert's autograph that the lost quire was positioned between folios 23 and 24, and that it contained more than the Apocalypse miniatures themselves (see Table 1). Albert Derolez established that, in all probability, eleven leaves are lost between folios 23 and 24, configured as a singleton (folio ★1), followed by a quinion (folios ★2–★11); this quire included an image of Solomon with accompanying texts, an *annus-mundus* diagram, an excerpt from Bede, a text for the feast of the Assumption, an image of Mary, the eighteen-page long Apocalypse cycle and an image of the Lion of Judah.[13]

The evidence also suggests that, as far as the number and sequence of these texts and images are concerned, *Wolfenbüttel* reflects the contents of Lambert's lost quire up to the scene of the worship of the Beast. The close adherence is in line with the overall approach of this manuscript's makers: while they increasingly took more liberties with the contents of their exemplar and ended up omitting, adding, and rearranging a significant number of texts and images, they had started out by closely copying the exemplar's material in the given order and followed this for some time, including in the early section that interests us here (Figs 3–4).[14] However, some minor changes were made in *Wolfenbüttel* to the contents that immediately precede this section: the text *De sapientia Salomonis* was moved to fill a gap on folio 5r (becoming chapter III), and two texts were given new chapter numbers (IX–X), with subsequent chapter numbers being adjusted accordingly. We may also note that the margin of folio 9v includes the beginning of an Apocalypse commentary that takes the form of a quotation from Apocalypse 1, 9–11, followed by four glosses on phrases from this passage that were likely copied from a glossed Bible manuscript – the complex layout of such a manuscript would account for the fact that the glosses are not presented in the order of the biblical text.[15] As Lambert's concept was principally that of a series of images with only short texts embedded into them (as his title *Apocalypsis depictus* makes clear), I assume that this commentary is an addition made by the

Wolfenbüttel scribe. In any case, it appears to have been quickly abandoned, with the scribe perhaps realizing that the margins would not afford enough space to accommodate a full commentary throughout.

If the changes to the number and sequence of texts and images were few and far between in this early phase of the copying process, it is important to note that *Wolfenbüttel*, with its much larger dimensions and regularized layout,[16] was always designed to look different. While this did not affect the disposition of the scenes in the Apocalypse cycle itself – as far as these scenes survive in *Wolfenbüttel*, they have been shown to take up the same number of recto and verso pages as they would have done in Lambert's autograph[17] – it did have an impact on the disposition of the contents on many other pages, especially those containing a circular diagram or map. In Lambert's autograph, such an image usually extends the full width of the page, whereas in *Wolfenbüttel*, two successive full-page diagrams or maps are frequently combined on a single page (cf. Figs 1–2). This must also have been the case with the image of Solomon – in all likelihood enclosed by an inscribed circular frame as in *Wolfenbüttel* – and the *annus-mundus* diagram, which would have taken up folio ★1r–v instead of appearing together on a single page. We will assess the significance of this arrangement in due course.

In *Paris 8865*, the images and texts of the lost quire, from the image of Solomon to that of the Lion of Judah, appear in a separate part of the manuscript, without the *annus-mundus* diagram (Fig. 5).[18] The first part of the manuscript (folios 1–31) includes texts that were not derived from Lambert's autograph; the second (folios 32–43) contains the texts and images of the lost quire; and the third (folios 44–262) provides a large proportion of the remaining texts and images from the *Liber floridus* in a substantially rearranged order, followed by texts that derive from other sources. In the second part, twice the number of Apocalypse scenes were accommodated on each page relative to *Wolfenbüttel* and Lambert's autograph, in such a way that one of their openings corresponds to one page in the *Paris 8865* cycle (Fig. 6).[19] However, all the miniatures are painted with gold and on just one side of the parchment to prevent show-through – the

Fig. 3. Wolfenbüttel, Herzog August Bibliothek, Cod. Guelf. 1 Gud. lat., folios 8v–9r, *Liber floridus*, second half of 12th century: Solomon and *annus-mundus* diagram facing Gabriel and Mary with the Christ Child

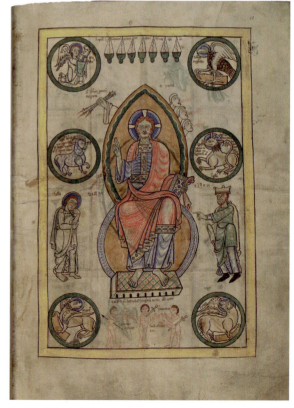

Fig. 4. Wolfenbüttel, Herzog August Bibliothek, Cod. Guelf. 1 Gud. lat., folios 9v–10r, *Liber floridus*, second half of 12th century: beginning of Apocalypse cycle

HANNA VORHOLT

Fig. 5. Paris, Bibliothèque nationale de France, MS lat. 8865, folios 32v–33r, *Liber floridus*, *c.* 1250–1270: Solomon facing Gabriel and Mary with the Christ Child

Fig. 6. Paris, Bibliothèque nationale de France, MS lat. 8865, folios 34v–35r, *Liber floridus*, *c.* 1250–1270: beginning of Apocalypse cycle

only images in the manuscript to receive such lavish treatment. The theme of the Apocalypse is further highlighted by the first part of the manuscript, most of which (folios 3v–31r) is taken up by a Commentary on the Apocalypse, labelled in the newly devised table of contents *Exposicio Apocalypsis*.[20] In effect, by combining a commentary with a miniature cycle, the first two parts of *Paris 8865* can be seen to bring together key features of contemporaneous illuminated luxury Apocalypse manuscripts. The arrangement in *Paris 8865* also shows that, while the broader context of the Apocalypse cycle is now entirely different, the images and texts that immediately preceded and followed the Apocalypse in Lambert's manuscript were still considered in the thirteenth century to form a unit with the cycle, except for the *annus-mundus* diagram. In the following, we will assess what role they had in Lambert's autograph, beginning with the image of Solomon and using *Wolfenbüttel* as a point of departure.

Solomon, Augustus and Christ

In the upper half of folio 8v of *Wolfenbüttel*, King Solomon is seated frontally on a cushioned throne, holding up a lily sceptre and a sword (Fig. 3). The image is framed by a double circle and accompanied by three texts. The longer text outside the circular frame brings together information from 3 Kings 10–11 about Solomon's throne and his riches, detailing his golden drinking vessels, the number of his chariots, horsemen, wives, and concubines, and the weight of gold he received every year; this is followed by an explanation of the unit of weight measurement and a calculation of his annual and daily income.[21] The text next to Solomon situates him in time and in space by mapping his reign within the Fourth Age of the World amongst that of other contemporary rulers.[22] This ties in with the third text, which is inscribed within the circular frame, insofar as the two Old Testament passages on which it is based state that Solomon 'exceeded all the kings of the earth' (3 Kings 10, 23–24; 2 Chronicles 9, 22–23). The specific wording of the eulogy, however, 'Solomon, king of peace, whose face the whole earth desires, is magnified',[23] is not directly derived from those Old Testament

passages, but instead cites the antiphon *Rex pacificus magnificatus est*, which was ubiquitous in the office for Christmas.[24] In this way, words that were originally connected with Solomon, and which refer liturgically to the incarnation of Christ, are here related back to Solomon, staging him as a prefiguration of Christ.

This idea is enhanced through visual analogies. Lambert frequently employed such analogies throughout his manuscript: some are between images that appear in the immediate vicinity of one another, while others rely on the beholder's memory to realize the connection. In all cases, they work through visual and textual similarities as well as subtle differences. Comparisons between such images encourage careful reflection, as the tension between similarity and difference not only serves to expand upon the images' interpretive potential, but also reveals contrasting messages and harbours warnings. The image of Solomon, too, is related to a number of other images across the manuscript through such analogies. Among these, the images of Augustus and Mary are particularly pertinent to the theme of the incarnation of Christ.

The image of Augustus, Roman emperor at the time of Christ's birth, is found at a distance from the lost image of Solomon, on folio 138v of Lambert's autograph (Fig. 7). It is part of the *Genealogia mundi* – an account of the Ages of the World composed by Lambert himself.[25] Augustus is placed in an inscribed circular frame[26] and seated frontally on a throne with his feet resting on a footstool, holding up a sword in his right hand – closely mirroring the way in which Solomon was presented, according to the copies. The seats were apparently configured differently in each case, but are still related, as the seat of Augustus in Lambert's autograph has lions' heads and feet, configured in the shape of an orb.[27] Lion thrones are typical for medieval representations of rulers, but in view of the similarities between Augustus and Solomon, the beholder would have been encouraged to see in these lions a more specific reference to the biblical throne of Solomon, especially as this is described in the text that Lambert included next to the image of Solomon as having 'two hands on either side holding the seat: and two lions stood, one at each hand' (3 Kings 10,

19).[28] Visual and textual cross-references work in tandem here.

The text that is inscribed in the circular frame of the image of Augustus is a quotation from the Gospel of Luke: 'there went out a decree from Caesar Augustus, that the whole world [*universus orbis*] should be enrolled' (Luke 2, 1) – a decree that led to Christ being born in Bethlehem, fulfilling the prophecy in Micah 5, 2.[29] Augustus holds up an orb in his left hand, with the then-known habitable areas marked out in the form of a T-O map signifying this *universus orbis* – words that in turn echo in both phrasing and position the *universa terra* in the inscription that surrounds Solomon, the *rex pacificus*. This leads to the more fundamental theme proclaimed by the T-O map, which is the *pax Augusta*, as the *Genealogia mundi* explains: 'with all peoples from East to West, from North to South and across the entire circle of the Ocean unified in one peace [by Augustus], Christ, the son of God, was born in Judea'.[30] Another reference to this theme is made by the inscription below the image, 'he closed the doors of Janus on the sixth of January': the closure of the Temple of Janus was the visible symbol of peace throughout the Roman Empire.[31] Thus while Solomon, the pacific king and builder of the Temple, is staged as a prefiguration of Christ, Augustus is presented here as the emperor who created universal peace, paving the way for the coming of Christ and the age of the Church – a point that is underlined by the image's prominent position at the start of the Sixth Age of the World in the *Genealogia mundi*.[32]

Before we discuss the second analogy, between Solomon and Mary, it is relevant to introduce another visual strategy employed by Lambert, that of the composite image. While visual analogies encourage the beholder to link two or more separate images in their minds, composite images are ready-made combinations of distinct iconographies within a single visual entity, achieved by connecting them in modular fashion or by blending them in collage-like superimpositions. Like visual analogies, such composite images are indicative of the important role associations play in the *Liber floridus* as a whole.[33] One of the most famous composite images in the *Liber floridus* is Lambert's combination of an ecumenical and hemispherical map, now lost

Fig. 7. Ghent, Universiteitsbibliotheek, MS 92, folio 138v, *Liber floridus* (Lambert's autograph), *c.* 1111–1121: Augustus

from the autograph, but transmitted in later *Liber floridus* manuscripts, including on folios 69v–70r of *Wolfenbüttel*. Another, no less intriguing example is the composite image of Mary transmitted on folio 9r of *Wolfenbüttel* (Fig. 3).

This image of Mary combines an Annunciation scene with a depiction of Mary as *sedes sapientiae*, bringing together announcement and fulfilment.[34] The Annunciation is represented by the archangel Gabriel pronouncing the words *Ave Maria Gratia plena*. These are not exactly the words of Luke 1, 28, but, as in many other Annunciation scenes, the incipit of the Hail Mary, which provides a devotional cue for the beholder to imitate the angel in his salutation.[35] The *sedes sapientiae* takes the form of a double enthronement, with the crowned Virgin Mary seated on a cushioned, three-tiered throne with footstool, and the Christ Child seated frontally on her lap, raising his right hand in a gesture of benediction, and holding a book in his left. Mary is thus presented as both the mother of Christ and as the throne of Divine Wisdom incarnate.[36]

Two texts add further perspectives to this juncture of iconographies. Both of them are placed above the image of Mary on folio 9r of *Wolfenbüttel*. One, marked in red, is a gloss on *Hodie Maria virgo caelos ascendit* – ubiquitous as an antiphon (or more rarely a responsory) text for the feast of the Assumption throughout the Middle Ages. It celebrates her as the 'fount of mercy, mother of life, gate of eternal light' and as a 'glorious empress' ascended to heaven, where she sits to reign in eternity with her son, 'the heavenly court and host rejoicing with her'.[37] In light of this text, the combination of Gabriel and the crowned figure of Mary can be seen to give visual expression to this idea of rejoicing, approaching the iconography of the *Regina angelorum*, while at the same time retaining the distinct blending between an Annunciation scene and the *sedes sapientiae*.[38]

The other text, excerpted from Bede's *De natura rerum*, is concerned with the invisible spiritual realm of the 'heaven of the upper orbit', described as the 'dwelling place of the angelic powers' who, 'in order to visit us, take ethereal bodies for themselves so that they can be like men'.[39] The text then continues to set out the 'lower heaven' (the firmament), the waters between the upper and lower heavens, and finally lists the seven planets, which 'hang between heaven and earth', with the sun in the middle. As such, it outlines in concrete terms the layout of the cosmos, providing a spatial framework for both the Annunciation and Assumption, in parallel to the diagram on the facing page (Fig. 3).

This diagram, concerned with the area encompassed by the 'lower heaven' and entitled *Menses xii cum signis et elementis mundi*, consists of rings arranged in concentric circles.[40] The central ring (*mundus*) is connected to four rings (*annus*), which designate the seasons and their qualities and are framed by the associated four elements (using *ventus* instead of *terra*). Twice twelve rings surround the central configuration: the smaller circle contains the signs of the Zodiac and the interlinked larger one the months in Latin and Hebrew, with the number of days contained in each, and the letter of the day with which the month begins in the Calendar.[41] The seasons and months are arranged not in parallel but in contrasting fashion, yet the diagram clearly conveys the cyclical nature of the year and its division into days, weeks, months, and seasons, as well as the material composition of the created world, made up of the four elements. It also speaks vividly to the fact that all these different parts are interconnected with one another.

The proximity to the Annunciation scene lends the *annus-mundus* diagram a further inflection. It is likely that the feast of the Annunciation (25 March) served as the beginning of a new year at Saint-Omer,[42] and that Lambert associated here the cyclical year with its annual starting point. And in the Calendar, Lambert associates 25 March not only with the Annunciation but also with a number of other key events in salvific history, including the creation of the world itself.[43] From this, the diagram can emerge as a more substantive signifier for the sum of created time and space. The association of the diagram with the image of Mary as the *sedes sapientiae* and with the text for the feast of the Assumption may provide yet more direct points of encounter: while the *Hodie Maria* text is ubiquitous as an Assumption antiphon (or responsory), a thirteenth-century breviary-antiphoner for the collegiate church of Our Lady in Saint-Omer – which may well reflect the twelfth-century practice Lambert would have known – has it as a responsory verse for Terce,[44] where it stands directly adjacent to excerpts from Wisdom 7, 29 and 7, 26 that serve as the chapter for Prime. The qualities that the scriptural text attributes to *sapientia* are here turned into those of the Virgin by means of their liturgical context, and the shared pronoun *haec*: 'She is more beautiful than the sun, and beyond every order of the stars, she is found, when compared with light, to take precedence. For she is the brightness of eternal light, and the unspotted mirror of God's majesty'.[45] Fittingly for a feast celebrating Mary's Assumption and her status as the Queen of Heaven, then, the liturgy of the Assumption used celestial bodies as a metaphor to demonstrate Mary's exalted status, and *Wolfenbüttel* (as well as Lambert's own manuscript, as we will see) offered opportunities for seeing them in conjunction on the same opening.

Bringing together central elements of Marian devotion in this composite image and its associated texts must have been especially important to Lambert, given that his own

collegiate church was dedicated to the Virgin, and it is conceivable that he also encoded in the composition references to a prominent local sculpture of Mary, displayed on a column in the nearby market square at the time.[46] If the cityscape that surmounts Mary in *Paris 8865* corresponded to the way in which the image was framed in Lambert's autograph, this might have enhanced the conflation between Mary's heavenly realm and Lambert's own environment, insofar as he employs such towers elsewhere to designate the collegiate church and Saint-Omer as well as the Heavenly City.[47]

Composite images and visual analogies are not alternative strategies, but go hand in hand with one another. This also applies to the image of Mary and its relationship to the image of Solomon. We have seen that Solomon, by way of the surrounding antiphon *Rex pacificus magnificatus est*, is staged as a prefiguration of Christ. This typological relationship between Solomon and Christ, as well as the idea of Mary as the throne of God, were long-standing exegetical tropes. Perhaps mediated through Rabanus Maurus' comparison between the throne of Solomon and *Ecclesia*,[48] theologians later articulated more concrete comparisons between the throne of Solomon and Mary. One of the first to do so is Lambert's contemporary Guibert of Nogent, who states that 'The wisdom of God the Father which, according to the Apostle [James 3, 17], is first of all pacific, is Solomon himself, and wisdom made a throne of ivory for herself, and she made a seat for herself in the Virgin, as nothing was ever more chaste'.[49] Whether or not one can, from the small pool of textual sources that are usually considered in regard to this topos, deduce that 'for the Romanesque period Mary clearly figured the Throne of Solomon' may be open to debate.[50] But Lambert suggested this point in visual terms and used the material space of his manuscript to make it explicit. The visual point is suggested by the similarities in *Wolfenbüttel* between the enthroned figures of Solomon and Mary with Christ.[51] The material point becomes clear if we consider the disposition of the images on the pages of Lambert's autograph.[52]

In the autograph, the image of Solomon would have stood on folio ★1r, the diagram of the months on folio ★1v, and the image of Mary on folio ★2r. This would have been followed by the Apocalypse scenes, arranged across the same number of recto and verso pages as in *Wolfenbüttel*, as we have seen.[53] Accordingly, folios ★2v–★3r corresponded to *Wolfenbüttel* folios 9v–10r (Fig. 4): folio ★2v covered the scenes from St John on Patmos writing to the seven churches in Asia, to the door opened in heaven revealing 'the things which must be done hereafter' (Apocalypse 1–4, 1); folio ★3r contained the vision of the throne of God, which was another composite image, bringing together different sections of the Apocalypse text (Apocalypse 4–5; 6, 9–11); and folios ★3v–4r presented the 24 Elders around the throne of God and the Lamb, extending the vision from the previous page (Apocalypse 4–5). Upon turning those leaves, then, this arrangement would have revealed three superimposed images of enthroned figures on folios ★1r, ★2r, ★3r – two of those preceding the Apocalypse cycle and one forming part of it.

Superimpositions of images on subsequent recto- or verso-pages can be found in other contemporary manuscripts, including in prefatory cycles of Psalters, which were designed for extensive use in private devotion, often over the course of an entire lifetime. An example is the St Albans Psalter (Figs 8–9), where, upon turning the leaves, the Entombment of Christ on the left-hand side of the opening is visually replaced by an image that presents the three Maries at Christ's tomb, replicating the architectural framing structure and dramatically staging the central message that this very tomb is now empty and that Christ has risen. Lambert, on his part, used the superimpositions to layer and correlate different stages of salvific history. In the process of turning the pages of his autograph, the enthroned Solomon (folio ★1r) was unveiled as a prefiguration of Christ in the image of the *sedes sapientiae* (folio ★2r), which in turn gave way, in a literal 'revelation', to the apocalyptic vision of the throne of God, who appears in the form of Christ, framed by the Lamb of God and the Lion of Judah, themselves symbols of Christ (folio ★3r). As on the previous leaf, Christ is holding a book in his left hand and blessing with his right hand, strengthening the effect of this superimposition. In this way, Mary could be beheld in a double sense

Fig. 8. Hildesheim, Dombibliothek, MS St God. 1, property of the Basilica of St Godehard, Hildesheim, page 48, *St Albans Psalter, c.* 1120–1140: Entombment of Christ

Fig. 9. Hildesheim, Dombibliothek, MS St God. 1, property of the Basilica of St Godehard, Hildesheim, page 50, *St Albans Psalter, c.* 1120–1140: three Marys at the tomb of Christ

as the 'unspotted mirror of God's majesty' – in her mirroring of both the Child's posture on her lap and the *Maiestas domini* that came to stand in their place on the following leaf.[54] Going further, the Enthroned was then revealed to be one with the Lamb who is worthy to open the book (folio ★4r). In effect, these superimpositions can be seen as an expansion upon the strategy of blending images with one another in single composite images, now using the performative element of leaf-turning to implement the connection.

Given this emphasis on the materiality of the manuscript, it is remarkable that, in the top right-hand corner of folio 9v of *Wolfenbüttel*, the door which was opened in heaven (Apocalypse 4, 1) is configured like an open codex. While we cannot be sure that Lambert shaped the door so explicitly as a codex as the *Wolfenbüttel* illuminator did (it is presented as an open gate on folio 34v of *Paris 8865*), its position close to the margin of the manuscript (indeed, the gate tower in *Paris 8865* reaches into that margin), and near the central fold, inevitably associates the act of seeing the Divine with the materiality of the book itself, as David and Ulrike Ganz have pointed out.[55] While the association between book and vision is central to the Apocalypse itself, Lambert goes further here in staging his own encyclopedic *libellus* beyond the section covered by the Apocalypse cycle as an instrument in this process:[56] in the course of turning the pages, his manuscript becomes a means of exegesis and ontological progression, moving through the figure of Solomon, towards the view of Christ and Mary, to envisioning God. In this, he not only opens up the way for a typological connex between Old Testament, New Testament and the end of time, but also to beholding God, who reigns in eternity, transcending and encompassing all time.[57]

Processes of making and viewing

As so often, Lambert's complex solution was not the result of a predetermined strategy, but of gradual changes made in the course of his extensive work process. One such change was the replacement of a bifolium from the Apocalypse cycle itself early on in the process.[58] A comparison between the discarded version (now folios 88/91) and the new one is complicated

Fig. 10. Ghent, Universiteitsbibliotheek, MS 92, folio 88r, *Liber floridus* (Lambert's autograph), *c.* 1111–1121: modified version of the vision of the throne of God

by the fact that we can see the former only in the guise of the modifications that Lambert made when he inserted the bifolium into the new context, and the latter only as transmitted through the copies. Yet it is clear that one major alteration concerns the vision of the throne of God. In the first version, the figure of God appeared in a comparatively small mandorla in the upper part of the page (Fig. 10), whereas in the second version, it took up a majority of the page and was more centrally positioned (Fig. 4). The change later enabled the superimposition of the three enthroned figures to come into effect, with the vision of the throne of God as the climax in that sequence. This effect was fully realized only when Lambert developed his interest in Solomon and inserted the singleton containing his image and the diagram (folio ★1).[59] Possibly Lambert also altered the image on folio ★2r in conjunction with one of these changes, turning it from an Annunciation scene into a composite image with Mary as *sedes sapientiae*, though as the original leaf is lost and with it any physical traces of alterations, this cannot be verified.

Lambert further enhanced the connection between Mary and Solomon when he inserted another leaf ahead of folio ★1, which survives as folio 23 of the autograph.[60] Following an account of the six days of creation on folio 23r, Lambert continued on folio 23v with a chronology from Adam to Solomon and the building of the Temple, followed by an account of the destruction of the Temple, the Babylonian exile, the return from exile, and the rebuilding of the Temple, as well as of the walls of Jerusalem. Adding up the total number of years in which the Temple was built or rebuilt, he then takes those 46 years and compares them to Mary's pregnancy, with the embryo fully formed and beginning to live on the 46th day. In this way, he creates a numerical analogy for an exegetical trope similar to that of Mary as the throne of Solomon, now with the Temple built by Solomon and rebuilt by subsequent kings prefiguring the body of Christ.[61] The header explicitly draws attention to the process of comparison between the Temple and Christ's body.[62]

A further visual analogy and superimposition in the Apocalypse cycle itself appears to have enriched this network of ideas. Judging by folio 14v of *Wolfenbüttel*, the image of the Woman 'clothed with the sun, and the moon under her feet, and on her head a crown of twelve stars' from Apocalypse 12, 1–5, interpreted in contemporary exegesis as both Mary and *Ecclesia*, was configured in a manner similar to the *sedes sapientiae* (Fig. 11, cf. Fig. 3).[63] The sun took the shape of a large sphere made up of rows of red flames set behind her upper body, similar to the blending that would have occurred between Mary and the *annus-mundus* diagram when the book was closed, and strengthening the associations established by the texts from Bede and the Assumption liturgy. *Wolfenbüttel* also suggests that Lambert arranged the scenes in the Apocalypse cycle in such a way that, upon turning the leaves, the Woman clothed with the Sun came to stand in the place of the temple that John is asked to measure (Apocalypse 11, 1–2): this temple is positioned in the lower half of folio 13v of *Wolfenbüttel* and takes the form of a centrally domed structure labelled not *Templum dei*, as in the biblical text, but *Templum domini* – the name used by Christian writers after the First Crusade for the Dome of the Rock,

Fig. 11. Wolfenbüttel, Herzog August Bibliothek, Cod. Guelf. 1 Gud. lat., folio 14v, *Liber floridus*, second half of 12th century: section from Apocalypse cycle including the Woman clothed with the Sun

associating it with the Temples of the Old and New Testaments, which were believed to have occupied the same place.[64]

Returning to folio 23v, after Lambert compared the building of Solomon's Temple and Mary's pregnancy, Christ's birth then leads on to the Ages of Man from infancy to decrepitude and death, which Lambert then correlates with the Ages of the World, metals and hours of the day, before finally positioning the building of the Temple within this scheme, and giving a brief account of the lineage of Solomon. In this way, he establishes not only a link to the image of Solomon on the facing page, but at the same time also provides cues for further paths that can be pursued across the encyclopedic compilation more widely, such as cutting across to the *Genealogia Mundi* with its account of the Ages of the World and the image of Augustus. Both the visual strategies that he employed and such series of notes may be seen as indicative of the ways in which Lambert conceived the manuscript: not to be read in a linear way from beginning to end, but instead as a network of thematic associations that can be pursued, uncovered, and interpreted during slow and repeated use, involving mental and bodily engagement.

The Lion of Judah and the Heavenly Jerusalem

Let us now move to the end of the Apocalypse cycle and ask whether Lambert interlinked it with what followed as he did with the beginning and what preceded it. While the final images of the lost section are only transmitted in *Paris 8865*, Albert Derolez demonstrated that the last of the lost leaves (folio ★11) almost certainly contained on the recto-side the image of the Heavenly Jerusalem and the River of Life (Apocalypse 21–22), which appear in the lower two registers of folio 42v of *Paris 8865*, and on the verso-side the image of the Lion of Judah from folio 43r (Fig. 12); this would have been followed by the series of diagrams that are preserved in Lambert's autograph on folios 24r–26r (Figs 13–14, see Table 1).[65]

The Lion of Judah is the messianic title given to Christ in Apocalypse 5, 5. According to *Paris 8865*, Lambert depicted the Lion with a cruciform nimbus and holding a cross-staff, which can visualize the prophecy in Genesis 49, 9–10 and its fulfilment in Christ: 'Juda is a lion's whelp … The sceptre shall not be taken away from Juda, nor a ruler from his thigh, till he come that is to be sent, and he shall be the expectation of nations'.[66] The image was closely linked to the full-page image and description of the lion at the start of the Bestiary section on folios 56v–57r, as well as to folio ★3r with the vision of the throne of God (Fig. 4). Here we focus on the relation of the image to the latter scene, where the Lion of Judah and its equivalent, the Lamb of God, were positioned on either side of the throne in small roundels, above the Elder who is instructing John not to weep because 'the lion of the tribe of Juda … hath prevailed to open the book, and to loose the seven seals thereof' (Apocalypse 5, 5). In effect, Lambert may be seen to have extracted and zoomed into this particular component of the apocalyptic vision in the image on folio ★11v.

Fig. 12. Paris, Bibliothèque nationale de France, MS lat. 8865, folios 42v–43r, *Liber floridus, c.* 1250–1270: end of Apocalypse cycle and Lion of Judah

In the vision of the throne of God on folio ★3r, the lion was accompanied by two inscriptions. One is an almost verbatim quotation from Apocalypse 5, 5; the other, although it relates to the same verse, is again more closely connected to the liturgy – in this case to two verses from a sequence trope. Relevant here is that, according to *Paris 8865*, this latter inscription was also and more prominently quoted on folio ★11v (Table 2).[67] The sequence in question (*Fulgens praeclara*)[68] as well as its trope *Rex in aeternum* occupy a special place in the church calendar, as they form part of the liturgy for Easter Sunday, when both the Alleluia and the sequence following it would have been heard for the first time again after Lent. The trope *Rex in aeternum* appears to be first documented in tenth- and eleventh-century sources from northern France and England, and had attained some currency in this part of Europe by the twelfth.[69] In the liturgy, following the verses cited in the image, the verses

of the trope continue: '[you rise in glory,] reaching for the heavenly kingdoms, rewarding the just in eternity. Thus Christ, pious king, redeeming our sins, make us rise together with you to blessed glory'.[70] Placed on the reverse of the image of the Heavenly Jerusalem, the image of the Lion of Judah therefore can not only be seen to proclaim Christ's victory over death but also implies a prayer by the community of the faithful – including Lambert – for their resurrection.

According to *Paris 8865*, Lambert presented the Heavenly Jerusalem on folio ★11r as a circular structure with concentric rows and inscribed it 'Peace-bringing Jerusalem, these are your foundations' (Fig. 12).[71] The innermost ring includes in twelve compartments the twelve precious stones that adorn the foundations of the wall of the city (Apocalypse 21, 19), followed by the twelve Apostles within the twelve gates (conflating Apocalypse 21, 12 and 14), and then above the gates the twelve

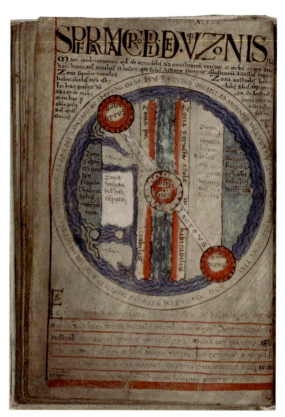

Fig. 13. Ghent, Universiteitsbibliotheek, MS 92, folio 24r, *Liber floridus* (Lambert's autograph), *c.* 1111–1121: winds

Fig. 14. Ghent, Universiteitsbibliotheek, MS 92), folio 24v, *Liber floridus* (Lambert's autograph), *c.* 1111–1121: Macrobian world map

angels, situated between twelve towers.[72] Relevant to the question of how this relates to other images in his encyclopedic compilation is that Lambert was especially interested in how the current world would be transformed at the end of time. He states twice that, at the end of time, the outer form or manifestation (*figura, imago*) of the world will perish, but not its substance (*elementa, substantia*),[73] and Kathrin Müller has convincingly argued that Lambert used some of his diagram pages as a way to derive information from the present about the future world, and to visualise that lasting substance.[74] This can explain not only the diagrammatic layout of the Heavenly Jerusalem itself, but also its similarities to the *annus-mundus* diagram before the cycle, with its arrangement in concentric rings and emphasis on the number twelve (Fig. 3).[75] It also shows that it must have been a meaningful decision on Lambert's part to position the angels on the outside of the image of the Heavenly Jerusalem in a way that is analoguous to their lasting dwelling place in the upper heaven above the firmament, when seen in conjunction with the *annus-mundus* diagram and the excerpt from Bede's *De natura rerum*. Taken together, the material and spatial structure of the created cosmos, as presented in the *annus-mundus* diagram, could be seen to prefigure the 'new heaven and the new earth' (Apocalypse 21, 1) that would arise after the end of time, just as Solomon was seen to prefigure Christ. The two sets of prefigurations – between the present and the future world, and between Solomon and Christ – were also clearly interwoven. Not only did Lambert label the Heavenly Jerusalem as *Jerusalem pacifera*, relating it back to Solomon as *rex pacificus*, he also added details about the building of the Temple in the earthly Jerusalem from 2 Chronicles 2 to a second image of the Heavenly Jerusalem that survives in Lambert's autograph, on folio 65r.[76] This is in line with ideas expressed, for example, by Isidore of Seville, who wrote 'Solomon foretells the figure of Christ, who built the house of the Lord in the Heavenly Jerusalem, not of wood and stones, but of all the saints'.[77]

The image of the Lion of Judah was followed by the series of diagrams and maps

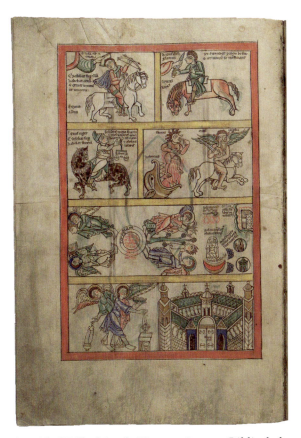

Fig. 15. Wolfenbüttel, Herzog August Bibliothek, Cod. Guelf. 1 Gud. lat., folio 11v, *Liber floridus*, second half of 12th century: section from Apocalypse cycle including the angels holding the four winds

that survives in Lambert's autograph on folios 24r–26r.[78] The first leaf, containing a diagram of the winds and a Macrobian world map (Figs 13–14) was moved by Lambert into this position at a late stage – in fact during the same phase in which he also inserted the image of Solomon ahead of the cycle.[79] The key to understanding Lambert's motivation for doing so is again the material dimension of his manuscript, as he thereby created another superimposition of two images on successive recto-pages, with the image of the Heavenly Jerusalem (Fig. 12) being visually replaced by the wind diagram (Fig. 13) as the leaves of the manuscript were turned. Like the *annus-mundus* diagram, the circular wind diagram shares with the Heavenly Jerusalem a visual and textual emphasis on the number twelve.[80] It also offers further thematic links to the cycle as a whole: the text below the wind diagram, which was written upon erasure, probably only once the leaf had been moved into its current position, is concerned with thunder, lightning and

earthquakes – topics that feature prominently in the Apocalypse as signs of the approaching end. In particular, the theme of the winds and their depiction in the form of wind-masks appear in the image for Apocalypse 7, 1, where John says 'After these things, I saw four angels standing on the four corners of the earth, holding the four winds of the earth, that they should not blow upon the earth, nor upon the sea, nor on any tree' (Fig. 15).[81] In the biblical text, this is followed by John seeing 'another angel ascending from the rising of the sun [*ab ortu solis*], having the sign of the living God; and he cried with a loud voice to the four angels, to whom it was given to hurt the earth and the sea, saying: Hurt not the earth, nor the sea, nor the trees, till we sign the servants of our God in their foreheads' (Apocalypse 7, 2–3).[82] This latter scene was not visualised in Lambert's Apocalypse cycle, but the Macrobian map that follows the diagram of the winds on folio 24v (Fig. 14) is overlaid with the path of the sun, beginning with sunrise (labelled *solis ortus*) above the earth and the sea, notionally conveying this chain of themes through the medium of diagrams.

What is in the difference?

The visual strategies that have emerged in the discussion so far show that Lambert's manuscript was an instrument not just for conveying but also for generating knowledge. In particular, we have seen how the associations created through visual analogies, composite images, and superimpositions could be used to enhance the interpretive potential of the images and even open up ways for envisioning the hereafter and God himself. But we also need to consider the extent to which they provide scope for reflection upon the differences.

I will use the apparently straightforward analogies between Augustus, Solomon and Christ as examples. In the case of Augustus, Lambert expands on folio 139r upon the signs that link the Emperor and Christ. On 6 January – the day which, as Orosius says in his *History against the Pagans* (on which Lambert largely draws in this section), came to be known to everyone as the 'feast of Epiphany, that is the appearance or manifestation of the Lord's sacrament'[83] – the Emperor entered the city in a triple triumph, was called Augustus for the first time, and closed

the Temple of Janus to mark the conclusion of the Civil War. Lambert (following Orosius) is careful to point out that this shows that Augustus' rule was ordained by God and indicated the coming of Christ on Earth. He reports on two further signs in support of this. The first is the sudden appearance of 'a circle of light like a rainbow [which] surrounded the sun in a clear, serene sky as if to mark him [= Augustus] as the one, the mightiest man in this world, and alone the most glorious on the earth, in whose days would come he [= Christ] who alone made and rules over the sun itself and the whole world'.[84] The second sign, a fountain of oil in Trastevere in Rome, leads more straightforwardly to the question: 'What could be more obvious than that this sign declared that the birth of Christ would occur when Caesar ruled the whole world?'.[85] Such passages as these not only highlight the importance of the Emperor, but also provide guidance as to the correct interpretation of signs that refer to Christ himself, and the differences between him and Augustus. A similar point is conveyed on folio 191v, in the *Deeds of the Roman Emperors*, where Augustus is said to have deferred to Christ as the true ruler of the earth: 'At this time, the emperor [Augustus], with whom the sum of all things was in harmony, did not allow himself to be called a good lord, indeed he dared not, because the true Lord of all mankind had been born amongst the humans'.[86]

The tension between similarity and difference becomes even clearer in the comparison between Solomon and Christ. For one, there is the question of their genealogical relationship. On folio 253r, Lambert emphasizes that, according to Luke, the genealogy of Christ proceeds from David's son Nathan, whereas according to Matthew it goes through his son Solomon.[87] He also reproduces both genealogies on folio 253r–v and provides further considerations resolving the divergences on folio 254r–v. On the pages that bear the superimposed images of Solomon and Mary with Christ, however, he does not make much of this: there is only a brief reference to David's fatherhood in the summary account of Solomon's lineage on folio 23v,[88] and we might see an indirect reference to it in the Annunciation, insofar as in the biblical account the angelic salutation is followed by the prophecy to Mary that 'the Lord God shall give unto him

the throne of David his father' (Luke 1, 32; cf. 3 Kings 5, 5), and that his reign will have no end – a phrase that is in turn echoed by the conclusion of the text for the feast of the Assumption.[89] Much more pronounced, however, is Lambert's explicit reference in the text immediately next to the king, that 'this Solomon is the son of Bathsheba, who was the wife of Uriah'.[90] This not only de-emphasizes the genealogical link by omitting the patrilinear ancestry, but also highlights the controversy around David's adulterous union with Bathsheba, in contrast to the conception of Christ.

Yet more controversial from the point of view of Solomon's reception in the medieval period was his idolatry in later life.[91] Lambert stops short of addressing this explicitly here, but it is implied in his reference to Solomon's many wives and concubines. While this is at first glance just one factor in Lambert's calculations concerning Solomon's extraordinary wealth, it must have been clear to readers that, in the biblical text, these women are held responsible for turning Solomon's heart and leading him to worship other gods,[92] especially as Lambert treats this issue in more detail in the *Penitentia Salomonis* on folio 96r–v.[93] Taken together, then, Lambert not only stages here a relationship between type and antitype, but also invites careful reflection about the ways in which Solomon did and did not resemble Christ in his own person. In this, he might be seen to convey a message similar to that of Augustine of Hippo in *The City of God*, who cautioned that, while 'at the outset of his reign he [Solomon] was marvellously worthy of praise … he in his own person merely foreshadowed the future coming of Christ the Lord, but did not show us Christ himself'.[94]

Such reflections, of course, were especially important when it came to visual analogies that signified inversions. Many such inversions are part and parcel of the Apocalypse text itself, such as that between the Woman clothed with the Sun, who is devoured by the seven-headed dragon (Apocalypse 12, 1–4), and the Whore of Babylon riding on the seven-headed beast (Apocalypse 17, 1–6); and Lambert also employed them outside the cycle, as in the case of the Trees of the Virtues and Vices (folios 231v–232r).

The ultimate inversion, however, was the Antichrist, and it is here that keen eyes, trained

by critical comparisons, were most urgently needed.[95] The recent First Crusade had been closely tied up with apocalyptic expectations, and the *Liber floridus* as a whole speaks to Lambert's concern with the end of time.[96] While he seems to have wrestled with the question of where precisely to situate his present in relation to the end of time, it is plausible that he expected the arrival of the Antichrist.[97] In fact, any insecurity that Lambert may have felt on that score would only have heightened the need to be ready if and when it did occur. Lambert includes a number of texts and images relating to the Antichrist in the *Liber floridus*, including his own version of the popular *De ortu et tempore Antichristi* by Adso of Montier-en-Der (folios 108v–110r). This begins with the words 'The Antichrist, in everything the contrary of Christ',[98] and includes examples that at the same time parallel and invert Christ, such as his birth and parentage (with a vision of how the devil will enter the womb of his mother, whereas the Holy Spirit had entered the Virgin),[99] and the miracles that he will perform. While there will be some who remain faithful to Christ, the Antichrist's strategies of deception are said to seduce many during his three-and-a-half year reign – especially, as Lambert stresses in one of many antisemitic passages of his compilation, the Jews.[100] Lambert visually articulates the Antichrist's pretence and true nature in the Bestiary section through a pair of images that take up the front and back of the same leaf and show the Devil riding Behemoth (folio 62r) and the Antichrist riding Leviathan (folio 62v, Fig. 16). The Antichrist is here shown as a beautiful ruler, posing in much the same way as Solomon, Augustus and Christ ('as though he were God').[101] It is only by reading the texts and by critical visual analysis and comparison between the four figures – which evince shared motifs such as the two horns or the curled shoes and teeth – that the Antichrist is revealed to be one and the same as the Devil, Leviathan and Behemoth.

If visual analysis is considered an ever-more important tool today for critically interrogating and orienting ourselves within image-based communication technologies, Lambert may have felt a yet more urgent need to provide guidance for the ultimate test of faith and resistance: the arrival of the Antichrist. At such a crucial time, the *Liber floridus* would

Fig. 16. Ghent, Universiteitsbibliotheek, MS 92, folio 62v, *Liber floridus* (Lambert's autograph), *c.* 1111–1121: Antichrist on Leviathan

have provided an especially powerful training ground in which to conduct comparative visual analyses and flex the muscles of the mind so as not to fall victim to deception, and to remain faithful to Christ 'who alone made and reigns over the sun itself and the entire world'. More fundamentally, the *Liber floridus* constituted a multi-faceted instrument with which to generate wider knowledge about this world and the next, and for envisioning God. We have seen that the visual strategies deployed by Lambert engage users not only mentally but also physically with his manuscript, and place them in the centre of the learning process, as each component could be the starting point for investigation and lead in multiple directions across the manuscript, while at the same time circling back upon certain key issues. Who were those intended users? The continued production process, which may have extended until his death, suggests that Lambert came to consider the manuscript not primarily as a tool for others, but as an instrument by which to work out and evidence existential questions for himself.

Table 1: The content and context of the lost quire IIIbis in Lambert's manuscript. ★ = lost leaf; ? = position of item unclear; [] = inclusion of item doubtful.

CONTENT	TABLE OF CONTENTS IN LAMBERT'S AUTOGRAPH	LAMBERT'S AUTOGRAPH	TABLE OF CONTENTS IN *WOLFENBÜTTEL*	*WOLFEN-BÜTTEL*	TABLE OF CONTENTS IN *PARIS 8865*	*PARIS 8865*
World history from Creation to Christ	*VII. Fretulfus de regnorum principibus*	21r–v	*VII. Fretulfus de regnorum principibus*	6r–7r	–	–
Account of Jewish judges, high priests, and kings	*VIII. Egesyppus de Iudeorum iudicibus*	21v–22v	*VIII. Egesippus de iudeorum iudicibus*	7r–v	–	–
Text on the Wisdom of Solomon; paraphrase of 2 Chronicles 2, 1–2	*VIIII. De sapientia Salomonis*	22v	*III. De sapientia Salomonis*	5r	–	–
Text on the six days of Creation	–	23r	*IX. Quid in principio deus sex diebus fecit*	7v–8	–	–
Notes on a range of topics, including Solomon	–	23v	*X. De etate mundi ab adam*	8r	–	–
Image of Solomon with accompanying texts	*X. De Salomone et eius gloria*	★1r	*XI. De Salomone et eius gloria*	8v	*Rex Salomon depictus et annunciacio dominica depicta*	32v
Annus-mundus diagram	*XI. Spera mensium XII et elementorum*	★1v	*XII. Spera mensium XII et elementorum*	8v	–	–
Bede on the heavens	*XII. De circulo superioris celi*	?★2r	*XIII. De circulo superioris celi*	8v	–	33r
Text concerning the feast of the Assumption	–	★2r	–	9r	–	33r
Image of Gabriel and Mary with the Christ Child	–	★2r	–	9r	*Rex Salomon depictus et annunciacio dominica depicta*	33r
Cycle of Apocalypse miniatures	*XIII. Apocalypsis depictus*	★2v–★11r	*XIIII. Apocalipsis depictus*	9v–15v, ★1r–v, [★2r–★3r]	*Figure et ymagines depicte super Apocalypsim*	34v–35r, 36v–37r, 38v–39r, 40v–41r, 42v
Lion of Judah	–	★11v	–	[★3v]	–	43r

Diagram of the Winds	XIIII. Sperae duę ventorum et zonarum	24r	XV. Spere due ventorum et zonarum	16r	–	–
Macrobian Zone Map	XIIII. Sperae duę ventorum et zonarum	24v	XV. Spere due ventorum et zonarum	16v	–	–
Diagram of the course of Sun	XV. Sperae duę solis et lune	25r	XVI. Spere duę solis et lunę	16v	–	–
Diagram of the lunar phases, winds, year	XV. Sperae duę solis et lune	25v	XVI. Spere duę solis et lunę	17r	–	–

Table 2: The texts associated with the images of the Lion of Judah.

APOCALYPSE 5, 5	FOLIO ★3R (AFTER *WOLFENBÜTTEL*, FOLIO 10R, WITH VARIANTS IN *PARIS 8865*, FOLIO 34V)	FOLIO ★11V (AFTER *PARIS 8865*, FOL. 43R)	EXCERPT FROM SEQUENCE TROPE (SEE N. 70 FOR FULL TEXT)
ne fleveris	*NE FLEVERIS* [in mirror script across page in *Wolfenbüttel*; not in *Paris 8865*]		
ecce vicit leo de tribu Iuda radix David	*Ortus de tribu Iuda leo potens surrexisti in gloria* [in *Paris 8865*, in reads *cum*].	*O \de/ stirpe davitica ortus de tribu Iuda leo potens surrexisti cum gloria*	*Ortus de tribu Iuda leo potens surrexisti in gloria*
aperire librum et septem signacula eius	*aperire librum et solvere vii signacula eius*		

NOTES

This article was devised as part of the DFG network 'ZeitenWelten. Zur Verschränkung von Weltdeutung und Zeitwahrnehmung im frühen und hohen Mittelalter', Cz 206/1–1, led by Miriam Czock and Anja Rathmann-Lutz. I am grateful for the support that this network has provided and I would also like to thank Tim Ayers, Patrizia Carmassi, Thomas Schmidt, Joseph Spooner, Elizabeth Tyler, and Wim Verbaal for helpful discussions and comments on the text.

Editorial note: after the first mention, Ghent, Universiteitsbibliotheek, MS 92 is referred to as Lambert's autograph or as *Ghent*; Wolfenbüttel, Herzog August Bibliothek, Cod. Guelf. 1 Gud. lat. is referred to as *Wolfenbüttel*; and Paris, Bibliothèque nationale de France, MS lat. 8865 is referred to as *Paris 8865*. Due to the codicological nature of the argument, this article uses 'r' indications in folio references to distinguish recto-pages from leaves. Quotations from Lambert's autograph follow Albert Derolez's edition (see note 1). Latin quotations from the Bible are taken from *Biblia sacra iuxta Vulgatam versionem*, ed. R. WEBER et al., Stuttgart, 2007; English quotations from the Bible follow *The Holy Bible: Douay-Rheims Version*, ed. R. CHALLONER, Baltimore, 1899.

1. The thirteenth-century quire marks do not include this section in their count, demonstrating that it must have already been missing at that stage. For the quire marks, see Lambert of Saint-Omer, *Liber Floridus. Codex autographus Bibliothecae Universitatis Gandavensis, auspiciis eiusdem Universitatis in commemorationem diei natalis editus*, ed. A. DEROLEZ, intro. E. I. STRUBBE and A. DEROLEZ, Ghent, 1968, p. x, xxi. Lambert's manuscript may have remained unbound for some time after he ceased to work on it in 1121, which would have facilitated the removal of individual portions.

2. For this approach, see especially P. K. KLEIN, 'Les cycles de l'Apocalypse du haut Moyen Age (IX–XIIIᵉ s.)', in *L'Apocalypse de Jean. Traditions exégétiques et iconographiques, IIIᵉ–XIIIᵉ siècles*, Geneva, 1979, p. 135–186; P. K. KLEIN, 'Introduction: The Apocalypse in Medieval Art', in *The Apocalypse in the Middle Ages*, ed. R. K. EMMERSON and B. MCGINN, Ithaca and London, 1992, p. 159–199.

3. Publications addressing the afterlife of Lambert's cycle include P. KURMANN, 'Le portail apocalyptique de la cathédrale de Reims. A propos de son iconographie', in *L'Apocalypse de Jean*, op. cit. (our note 2), p. 245–317; P. K. KLEIN, *Apocalypse MS Douce 180. Vollständige Faksimile-Ausgabe im Originalformat der Handschrift Ms Douce 180 aus dem Besitz der Bodleian Library – Oxford. Kommentar*, Graz, 1983, p. 77–79; U. REHM, 'Eine Bildfolge des 14. Jahrhunderts zur Apokalypse des Johannes: Das Bild als Medium des kulturellen Gedächtnisses', *Anzeiger des Germanischen Nationalmuseums*, s. n. (1996), p. 7–34; L. RIVIÈRE CIAVALDINI, *Imaginaires de l'Apocalypse. Pouvoir et spiritualité dans l'art gothique européen*, Paris, 2007, esp. p. 190–198, 243–246.

4. The most important of these are E. WOODWARD, 'The Illustrated Apocalypse Cycle in the *Liber Floridus* of Lambert of Saint-Omer', MA diss., Florida State University, 2010; D. GANZ and U. GANZ, *Visionen der Endzeit. Die Apokalypse in der mittelalterlichen Buchkunst*, Darmstadt, 2016, p. 63–67; and R. K. EMMERSON, *Apocalypse Illuminated. The Visual Exegesis of Revelation in Medieval Illustrated Manuscripts*, University Park, 2018, p. 88–92. See also H. SWARZENSKI, 'Comments on the Figural Illustrations', in *Liber Floridus Colloquium. Papers Read at the International Meeting Held in the University Library Ghent on 3–5 September 1967*, ed. A. DEROLEZ, Ghent, 1973, p. 21–30, here p. 27–30; and G. SCHILLER, *Die Apokalypse des Johannes*, 2 vols, Gütersloh, 1990 (Ikonographie der christlichen Kunst, 5), esp. vol. 1, p. 152–155.

5. The main source for the cycle is the early-ninth-century catalogue of stars known as the *De ordine ac positione stellarum in signis*; the indications are derived from the so-called *Excerptum de astrologia Arati*. For a full discussion, see H. VORHOLT, 'The Local, Regional, and Universal in Knowledge Compilations: Observations on the *Codex Aldenburgensis*' (forthcoming).

6. See H. VORHOLT, *Shaping Knowledge. The Transmission of the Liber Floridus*, London, 2017 (Warburg Institute Studies and Texts, 6).

7. A. DEROLEZ, *The Making and Meaning of the Liber Floridus. A Study of the Original Manuscript Ghent, University Library MS 92*, London, 2015. Also relevant to the discussion of the relationship among the images in the lost quire is V. G. TUTTLE, *An Analysis of the Structure of the 'Liber Floridus'*, PhD diss., Ohio State University, 1979, even though her principal argument, that the *Liber floridus* is made up of twelve sections in imitation of the structure of Beatus of Liébana's *Commentary on the Apocalypse*, can no longer be upheld.

8. For the manuscripts, see VORHOLT, op. cit. (our note 6); Appendix III provides an overview of the transmission of Lambert's images in those manuscripts. See also WOODWARD, op. cit. (our note 4); her Appendix C provides a scene-by-scene overview of the Apocalypse cycle in five of the six *Liber floridus* manuscripts that transmit the Apocalypse miniatures.

9. For *Paris 8865*, see *Catalogue général des manuscrits latins. nos. 8823 à 8921*, ed. M.-P. LAFFITTE and J. SCLAFER, Paris, 1997, p. 57–68; for its place in the transmission of the *Liber floridus*, see VORHOLT, op. cit. (our note 6), p. 40–41, 100–103.

10. For *Wolfenbüttel*, see C. HEITZMANN and P. CARMASSI, *Der Liber Floridus in Wolfenbüttel. Eine Prachthandschrift über Himmel und Erde*, Darmstadt, 2014; and VORHOLT, op. cit. (our note 6), esp. p. 43–96.

11. The four manuscripts are The Hague, Koninklijke Bibliotheek, MS 72 A 23 (together with its copy The Hague, Koninklijke Bibliotheek, MS 128 C 4), Chantilly, Musée Condé, MS 724 (1569), and Genoa, Biblioteca Durazzo-Giustiniani, MS A IX 9; all except for the manuscript in Genoa include the scenes up to the seventh vial.

12. For the bifolium, see A. DEROLEZ, *Lambertus qui librum fecit. Een codicologische Studie van de Liber Floridus-Autograaf*, Brussels, 1978, p. 169–171; and DEROLEZ, op. cit. (our note 7), p. 63, 102. For the table of contents, see ibid., p. 37–39, 49–50, and passim.

13. DEROLEZ, op. cit. (our note 7), p. 61–64.

14. See VORHOLT, op. cit. (our note 6), esp. p. 43–96.

15. The text is edited in DEROLEZ, *Lambertus*, op. cit. (our note 12), p. 67–68. The glosses are [1] *In dominica die. Solet rerum … nocte suscepit*; [2] *Communis admonitio … et cetera*; [3] *Ego Iohannes. Quasi scio … ipsius regni*; [4] *Sive simul … conferre potuit*. They appear as four separate glosses, for example, in Saint-Omer, Bibliothèque municipale, MS 170, folios 116r–116v.

16. *Wolfenbüttel* measures 435 × 295 mm, Lambert's autograph 310 × 210 mm. For the regularized layout, see VORHOLT, op. cit. (our note 6), p. 56–68.

17. DEROLEZ, op. cit. (our note 7), p. 62–63; DEROLEZ, *Lambertus*, op. cit. (our note 12), p. 66–67.

18. The order of the images and texts that precede the cycle in *Paris 8865* is almost the same as that in *Wolfenbüttel*, except that the texts that appear within and next to the image of Solomon in *Wolfenbüttel* are positioned above and below the image in *Paris 8865*; the excerpt from Bede and the text for the feast of the Assumption that appear above the image of Mary in *Wolfenbüttel* are positioned within and below the image of Mary in *Paris 8865*.

19. See our note 17.

20. It is doubtful that this text is by Lambert himself, or that it was included in his autograph, as is sometimes suggested. The commentary is listed in F. STEGMÜLLER, *Repertorium Biblicum Medii aevi*, 11 vols, Madrid, 1950–1980, vol. II, p. 115, no. 1364, but a full edition and analysis are outstanding. See G. LOBRICHON, 'La Femme d'Apocalypse 12 dans l'exégèse du haut Moyen Âge latin (760–1200)', in *Marie. Le culte de la vierge dans la société médiévale*, ed. D. IOGNA-PRAT, É. PALAZZO and D. RUSSO, Paris, 1996, p. 407–439, with a partial edition on p. 425–428; G. LOBRICHON, *La Bible au Moyen Âge*, Paris, 2003, esp. p. 119, 124–126; S. LEWIS, 'Encounters with Monsters at the End of Time: Some Early Medieval Visualizations of Apocalyptic Eschatology', in *Different Visions. A Journal of New Perspectives on Medieval Art*, 2, June 2010, p. 55.

21. *Wolfenbüttel*, folio 8v: *Fecit Salomon thronum de ebore grandem, vestitum auro fulvo, et due manus hinc atque inde tenentes sedile, et duo leones stabant iuxta manus singulas, et .xii. leunculi stantes super sex gradus sed et omnia vasa erant aurea* [cf. 3 Kings 10, 18–21]. *Facti sunt ei mille quadringinti currus, et xii milia equitum* [3 Kings 10, 26]. *Fuerunt ei uxores quasi regine septingente et concubine trecente* [cf. 3 Kings 11, 3]. *Erat pondus auri quod offerebatur Salomoni per annos singulos sexcentorum sexaginta sex talentorum, excepto eo quod offerebant viri qui super vectigalia erant, et negotiatores, et omnes reges arabie, ducesque terre* [cf. 3 Kings 10, 14–15]. *Talentum unum lxxxᵃ libras continent. Hec fuere per annum que offerebantur Salomoni libre auri quinquaginta tria milia et ducente lxxx. Quod fuit pondus auri per singulos dies talenti unius et dimidii et quarta pars talenti. Hoc fuit in die centum et quadraginta auri libre.*

22. Ibid.: *Iste Salomon filius bethsabee que fuit uxor urie rex erat in iudea etate mundi .iiiiᵃ. quando Silvius filius aschanii regnabat in italia, et eupales in assyria, et codrus in Grecia.*

23. Ibid.: + *Salomon Rex pacificus magnificatus est cuius vultum desiderat universa terra.*

24. For the antiphon *Rex pacificus magnificatus est*, see *Corpus Antiphonalium Officii*, ed. R.-J. HESBERT with R. PRÉVOST, 6 vols, Rome, 1963–1979, vol. III, no. 4657; http://cantusindex.org/id/004657 [accessed 15.7.2019].

25. For the image of Augustus and the *Genealogia mundi*, see A.-D. VON DEN BRINCKEN, '"…ut describeretur universus orbis". Zur Universalkartographie des Mittelalters', in *Methoden in Wissenschaft und Kunst des Mittelalters*, ed. A. ZIMMERMANN, Berlin and New York, 1970, p. 249–278, here p. 249–251; J.-G. ARENTZEN, *Imago mundi cartographica. Studien zur Bildlichkeit mittelalterlicher Welt- und Ökumenekarten unter besonderer Berücksichtigung des Zusammenwirkens von Text und Bild*, Munich, 1984, p. 259–260; S. CONKLIN AKBARI, *Idols in the East. European Representations of Islam and the Orient, 1100–1450*, Ithaca, 2009, p. 79–80; M. STERCKEN, 'Repräsentieren mit Karten als mediales Modell', *Das Mittelalter*, 15, 2010, p. 96–114, here p. 107–109; J. RUBENSTEIN, 'Lambert of Saint-Omer and the Apocalyptic First Crusade', in *Remembering the Crusades. Myth, Image, and Identity*, ed. N. PAUL and S. YEAGER, Baltimore, 2012, p. 69–95, here p. 79–81; DEROLEZ, op. cit. (our note 7), p. 122–124; J. RUBENSTEIN, *Nebuchadnezzar's Dream. The Crusades, Apocalyptic Prophecy, and the End of History*, Oxford, 2019, p. 28–29.

26. The circular frame is enclosed within a further, square, frame. The miniature on folio 32v of *Paris 8865* (Fig. 5)

suggests that this may also have been the case with the image of Solomon in Lambert's autograph.

27. Cf. Jena, Thüringische Universitäts- und Landesbibliothek, MS Bose q. 6, folios 38v, 67v, 78v, where Augustus, Charlemagne, and Otto the Great are presented in near-identical manner to one another on a lion throne, accompanied by differing framing figures and inscriptions. For this analogy, see H.-W. GOETZ, *Geschichtsschreibung und Geschichtsbewußtsein im hohen Mittelalter*, Berlin, 2/2008, p. 211–213.

28. See our note 21. Solomon himself is rarely depicted on a lion throne; see I. RAGUSA, 'Terror Demonum and Terror Inimicorum: The Two Lions of the Throne of Solomon and the Open Door of Paradise', *Zeitschrift für Kunstgeschichte*, 40, 1977, p. 93–114, here p. 102–103. It is relevant to this network of cross-references that, judging by the miniature on folio 8v of *Wolfenbüttel*, Solomon's throne is also similar to that of St Peter on folio 168r of Lambert's autograph. For the links between the design of imperial and papal thrones and the biblical throne of Solomon, see esp. F. WORMALD, 'The Throne of Solomon and St Edward's Chair', in *De Artibus Opuscula XL. Essays in Honor of Erwin Panofsky*, ed. M. MEISS, New York, 1961, p. 532–539; M. STROLL, *Symbols as Power. The Papacy following the Investiture Contest*, Leiden, 1991, p. 11–15; A. IAFRATE, *The Wandering Throne of Solomon. Objects and Tales of Kingship in the Medieval Mediterranean*, Leiden, 2016, esp. p. 216–234.

29. *Ghent*, folio 138v: + *Exiit edictum a Cesare Augusto, ut describeretur universus orbis.*

30. *Ghent*, folio 139r: *Anno itaque ab Urbe condita DCCLII Cesar Augustus* [sic] *ab Oriente in Occidentem, a Septentrione in Meridiem ac per totum Oceani circulum cunctis gentibus una pace compositis, Christus Dei filius in Iudea nascitur.* An almost identical phrase appears on folio 191v, where the point is made more explicitly: *Quo anno Christus natus est, cuius adventu, pax ista famulata est.* This is quoted almost verbatim from Orosius, *Historiae adversus paganos* VI. 22. The section of the *Genealogia mundi* that comes to stand above the image includes a reference to how Augustus' predecessor Julius Caesar had the world measured by Nicodoxus, Polyclitus, and Theodocus. Lambert may therefore here also be associating the decree of Augustus with the measurement of the world, as argued in C. NICOLET and P. G. DALCHÉ, 'Les "quatre sages" de Jules César et la "mesure du monde" selon Julius Honorius: réalité antique et tradition médiévale', *Journal des savants*, 4, 1986, p. 157–218, here p. 203–204; and D. SCULLY, 'Augustus, Rome, Britain and Ireland on the Hereford *mappa mundi*: Imperium and Salvation', *Peregrinations. Journal of Medieval Art and Architecture*, 4, 2013, p. 107–133, here p. 117–118.

31. *Ghent*, folio 138v: *Octavianus Augustus VIII IDus. Ianuarii clausit portas Iani.*

32. This is an idea that was promoted particularly by Orosius, who is quoted by Lambert (cf. our note 30). See I. OPELT, 'Augustustheologie und Augustustypologie', *Jahrbuch für Antike und Christentum*, 4, 1961, p. 44–57; H.-W. GOETZ, *Die Geschichtstheologie des Orosius*, Darmstadt, 1980, esp. p. 80–88 and 161; H.-W. GOETZ, *Das Geschichtsbild Ottos von Freising. Ein Beitrag zur historischen Vorstellungswelt und zur Geschichte des 12. Jahrhunderts*, Cologne, 1984, p. 143–148; J. STROTHMANN, 'Christus, Augustus und der mittelalterliche römische Kaiser in der staufischen Herrschaftstheologie: Von der Parallele Christus-Augustus bei Otto von Freising zu dem Kaiser als *augustus* und *alter christus* bei Petrus von Eboli', *Archiv für Kulturgeschichte*, 84, 2002, p. 41–66; SCULLY, op. cit. (our note 30), p. 118–119; RUBENSTEIN, 'Lambert of Saint-Omer', op. cit. (our note 25), p. 79–81.

33. For the role of associations in the *Liber floridus* and how they are visually expressed, see, for example, J.-C. SCHMITT, 'Qu'est-ce qu'un diagramme? A propos du *Liber Floridus* de Lambert de Saint-Omer (ca. 1120)',

in *Diagramm und Text. Diagrammatische Strukturen und die Dynamisierung von Wissen und Erfahrung. Überstorfer Colloquium 2012*, ed. E. C. LUTZ, V. JERJEN and C. PUTZO, Wiesbaden, 2014, p. 79–94; VORHOLT, op. cit. (our note 6), p. 15–20.

34. Like the image of Solomon, this image has been hardly discussed in the scholarship. See, however, TUTTLE, op. cit. (our note 7), p. 60–62 and 73–74; SWARZENSKI, op. cit. (our note 4), p. 28–29; R. MUIR WRIGHT, 'The Virgin in the Sun and in the Tree', in *Women and Sovereignty*, ed. L. O. FRADENBURG, Edinburgh, 1992, p. 36–59.

35. See H. WENZEL, 'Die Verkündigung an Maria. Zur Visualisierung des Wortes in der Szene oder: Schriftgeschichte im Bild', in *Maria in der Welt. Marienverehrung im Kontext der Sozialgeschichte 10.-18. Jahrhundert*, ed. C. OPITZ, H. RÖCKELEIN, G. SIGNORI and G. P. MARCHAL, Zurich, 1993, p. 23–52, esp. p. 34; A. VAN DIJK, 'The Angelic Salutation in Early Byzantine and Medieval Annunciation Imagery', *The Art Bulletin*, 81.3, 1999, p. 420–436, esp. p. 422.

36. For the throne of Wisdom, see esp. I. H. FORSYTH, *The Throne of Wisdom. Wood Sculptures of the Madonna in Romanesque France*, Princeton, 1972; also T. HEILBRONNER, 'The wooden "Chasuble Madonnas" from Ger, Ix, Taragasona and Talló', *Locus Amœnus*, 9, 2007–2008, p. 31–50.

37. *Wolfenbüttel*, folio 9r: *Fons misericordie, mater vite, porta perpetue lucis, HODIE MARIA VIRGO ergastulo mundi relicto imperatrix gloriosa CELOS ASCENDIT. GAUDETE exultantes die ista, et eius assumptionem celebrate, QUE CUM Deo Ihesu CHRISTO regnum possidens miro scemate preparatum a Patre, regnatura sedet in arce celi, curia et militia congaudente superna, et vivit feliciterque REGNAT IN ETERNUM.* The words in capitals (my emphasis) make up the entirety of the relevant text from the liturgy: *Hodie Maria virgo caelos ascendit gaudete quia cum Christo regnat in aeternum* (*Corpus Antiphonalium Officii*, no. 3105 (A) and 6815 (R); see http://cantusindex.org/id/003105 and http://cantusindex.org/id/006851 [accessed 15.7.2019]).

38. In images of the *Regina angelorum*, the enthroned Virgin and Child tend to be symmetrically flanked by angels (often the archangels Michael and Gabriel), who often stretch out their arms towards her, as in Paris, Bibliothèque nationale de France, MS NAL 710. See F. RADEMACHER, *Die Regina Angelorum in der Kunst des frühen Mittelalters*, Düsseldorf, 1972, esp. p. 65–98.

39. Bede, *De natura rerum*, 7–8, cf. also 12–13, ed. C. W. JONES, CCSL 123A; Lambert's text is edited in DEROLEZ, *Lambertus*, op. cit. (our note 12), p. 64. For the English translation and a commentary, see C. B. KENDALL and F. WALLIS, *Bede. On the Nature of Things* and *On Times*, Liverpool, 2010.

40. This motif is reminiscent of the chains that Solomon is said to have fastened to the capitals on top of the pillars in front of the Temple (2 Chronicles 3, 16: *nec non et quasi catenulas in oraculo et superposuit eas capitibus columnarum*; 3 Kings 7, 17: *et quasi in modum retis et catenarum sibi invicem miro opere contextarum*).

41. For this diagram, see DEROLEZ, op. cit. (our note 7), p. 64–65.

42. See H. GROTEFEND, *Zeitrechnung des deutschen Mittelalters und der Neuzeit*, vol. 1, Hannover, 1891, p. 9; A. GIRY, *Manuel de Diplomatique*, Paris, 1894, p. 114; and P. C. MAYO, 'Concordia discordantium: A Twelfth-Century Illustration of Time and Eternity', in *Album Amicorum Kenneth C. Lindsay. Essays on Art and Literature*, ed. S. A. STEIN and G. D. MCKEE, Binghamton, 1990, p. 29–56, here p. 44–45.

43. *Ghent*, folio 27v, indicates for 25 March: *Mundus factus. Adam plasmatus. Christus adnuntiatus et passus. Immolatio Isaac et transitus filiorum Israhel per mare Rubrum et victoria Michahelis archangeli contra draconem.*

44. The full office is found in Saint-Omer, Bibliothèque Municipale, MS 205, folios 120r–123v; the responsory verse for Terce is on folio 122v. I am grateful to Anne Laurent for helping me access images of this manuscript.

45. Saint-Omer, Bibliothèque Municipale, MS 205, folio 122r: *Hec est speciosior sole, et super omnem stellarum dispositionem luci comparata invenitur prior. Candor enim lucis eterne est, et speculum sine macula dei maiestatis.* See E. PANOFSKY, *Early Netherlandish Painting. Its Origins and Character*, Cambridge (Mass.), 1953, vol. I, p. 148; and TUTTLE, op. cit. (our note 7), p. 84–85 note 17. The same liturgy contains several further references to the celestial bodies. For example, the Benedictus antiphon for Prime reads *Que est ista que ascendit sicut aurora consurgens pulchra ut luna electa ut sol terribilis ut castrorum acies ordinata* (folio 122r); the antiphon for Terce reads *Maria virgo assumpta est ad ethereum thalamum in quo rex regum stellato sedet solio* (folio 122r).

46. Unfortunately, the dimension and design of this statue are unknown. See G. COOLEN, 'Notre-Dame des Miracles: Vierge en Majesté', *Bulletin de la Société des Antiquaires de la Morinie*, 16, 1942, p. 414–428, here p. 423; and M. ALBARIC, 'La Dévotion à Notre-Dame-des-Miracles de Saint-Omer', in *La cathédrale de Saint-Omer. 800 ans de mémoire vive*, ed. N. DELANNE-LOGIÉ and Y.-M. HILAIRE, Paris, 2000, p. 271–279, here p. 271–273. We might also note that, in *Wolfenbüttel*, the border at the neckline of Mary's garment is reminiscent of gemstones such as those attached to sculptures of Mary as *sedes sapientiae*.

47. These images are on folios 13r, 65r and 259v of Lambert's autograph (he also employs towers in other images, widening this network of references). For the blending between Saint-Omer and Jerusalem in Lambert's mind, see J. RUBENSTEIN, 'Heavenly and Earthly Jerusalem: The View from Twelfth-Century Flanders', in *Visual Constructs of Jerusalem*, ed. B. KÜHNEL, G. NOGA-BANAI and H. VORHOLT, Turnhout, 2014, p. 265–276.

48. Rabanus Maurus, *Commentaria in Libros IV Regum*, PL 109, cols 9–280, here col. 195–198.

49. Guibert of Nogent, *Liber de laude Sanctae Mariae*, PL 146, cols 537–578, here col. 542: *Sapientia Dei Patris primum, juxta apostolum, pacifica, ipsa est Salomon, quae thronum de ebore sibi facit, dum sedem in Virgine, qua nil unquam fuit castius, sibi ponit.* For Guibert of Nogent, see J. RUBENSTEIN, *Guibert of Nogent. Portrait of a Medieval Mind*, New York and London, 2002. A slightly later text that discusses Mary as the throne of Solomon (long attributed to Peter Damian but now to Nicholas of Clairvaux) compares one of the two lions that guard the armrests to Gabriel, conjuring up a similar picture to that established by Lambert: *duo leones sunt Gabriel archangelus et Joannes evangelista, quorum alter dexterae Virginis, alter sinistrae custos deputatus est. Gabriel enim mentem, Joannes carnem pervigili sollicitudine servaverunt. Qui bene leones dicuntur, propter rugitum altisonae vocis; duo enim verba nuntiaverunt orbi terrae qualia nec dicta sunt nec dicentur, et in quorum comparatione omnia muta debeant apparere. 'Ave, Maria, gratia plena, Dominus tecum [Luke 1]', ait archangelus. Audisne in hoc verbo incarnationem Dei, redemptionem hominum, renovationem mundi?* (quoted from PL 144, cols 736–740, here col. 739). In the thirteenth century, this is reiterated in the *De laudibus Beatae Mariae* long attributed to Albertus Magnus, now to Richard of Saint-Laurent.

50. FORSYTH, op. cit. (our note 36), p. 26. For Mary as the throne of Solomon more widely, and for the textual sources, see esp. F. PIPER, 'Maria als Thron Salomos und ihre Tugenden bei der Verkündigung', *Jahrbücher für Kunstwissenschaft*, 5, 1872, p. 97–137; WORMALD, op. cit. (our note 28); A. D. MCKENZIE, *The Virgin Mary as the Throne of Solomon in Medieval Art*, PhD diss., New York University, 1965; and IAFRATE, op. cit. (our note 28), p. 236–248.

51. Another, more tenuous link is that Mary's throne has twelve arcade-like openings at the front in *Wolfenbüttel*; this

might be a numerical reference to the twelve little lions that, according to the biblical description (3 Kings 10, 20), stood on the steps leading up to the throne.

52. Important studies of how the materiality of the codex (esp. the disposition of images in the space of the manuscript, and the processes of opening, unfolding, closing and turning leaves) can create meaning include J. H. MARROW, 'Art and Experience in Dutch Manuscript Illumination around 1400: Transcending the Boundaries', *The Journal of the Walters Art Gallery*, 54, 1996, p. 101–117; B. REUDENBACH, 'Die Londoner Psalterkarte und ihre Rückseite', *Frühmittelalterliche Studien*, 32, 1998, p. 164–181; W. C. SCHNEIDER, 'Geschlossene Bücher – offene Bücher: Das Öffnen von Sinnräumen im Schließen der Codices', *Historische Zeitschrift*, 271.3, 2000, p. 561–592; W. C. SCHNEIDER, 'Die "Aufführung" von Bildern beim Wenden der Blätter in mittelalterlichen Codices: Zur performativen Dimension von Werken der Buchmalerei', *Zeitschrift für Ästhetik und Allgemeine Kunstwissenschaft*, 47.1, 2002, p. 7–35; *Codex und Raum*, ed. S. MÜLLER, L. E. SAURMA-JELTSCH and P. STROHSCHNEIDER, Wiesbaden, 2009; J. HAMBURGER, 'Openings', in *Imagination, Books & Community in Medieval Europe*, ed. G. KRATZMANN, South Yarra, 2009, p. 50–133; L. E. SAURMA-JELTSCH, 'Der Codex als Bühne: Zum Szenenwandel beim Blättern in der Handschrift', *Wiener Jahrbuch für Kunstgeschichte*, 58, 2009, p. 77–93; B. REUDENBACH, 'Salvation History, Typology, and the End of Time in the *Biblia Pauperum*', in *Between Jerusalem and Europe. Essays in Honour of Bianca Kühnel*, ed. R. BARTAL and H. VORHOLT, Leiden, 2015, p. 217–232. More widely for the ways in which the visual shapes theological discourse, see also *The Mind's Eye. Art and Theological Argument in the Middle Ages*, ed. J. F. HAMBURGER and A.-M. BOUCHÉ, Princeton, 2006.

53. See our note 17.

54. This series of superimpositions may have further encouraged seeing Solomon as prefiguring the judge at the end of time. For the connection between Solomon and the Last Judgement, see esp. MCKENZIE, op. cit. (our note 50); RAGUSA, op. cit. (our note 28). Lambert does not explicitly refer to the topic of judgement in the texts that directly accompany the image of Solomon, but has the Queen of Sheba saying in a nearby text: *Sit Dominus Deus tuus benedictus, cui placuisti et posuit te super thronum Israhel et constituit te regem ut faceres iudicium et iusticiam* (Ghent, folio 13v).

55. GANZ and GANZ, op. cit. (our note 4), p. 64; see also WOODWARD, op. cit. (our note 4), p. 33–34. For the connex between these ideas, see HAMBURGER, op. cit. (our note 52), p. 51–60; B. REUDENBACH, 'Der Codex als Verkörperung Christi: Mediengeschichtliche, theologische und ikonographische Aspekte einer Leitidee früher Evangelienbücher', in *Erscheinungsformen und Handhabungen Heiliger Schriften*, ed. J. F. QUACK and D. C. LUFT, Göttingen, 2014, p. 229–244, here p. 236.

56. The term *libellus* ('little book') is used by Lambert in the prologue, Ghent, folio 3v: *ego Lambertus filius Onulfi, canonicus Sancti Audomari, libellum istum de diversorum auctorum floribus … Quem, quoniam sic ratio postulat, Floridum intitulavi, quia et variorum librorum ornatibus floret rerumque mirandarum narratione prepollet.*

57. For the end of time and the transcending of time in typological concepts, see esp. C. KIENING, 'Einleitung', in *Figura. Dynamiken der Zeiten und Zeichen im Mittelalter*, ed. C. KIENING and K. MERTENS FLEURY, Würzburg, 2013, p. 7–20, here p. 13; H. SCHLIE, 'Der Klosterneuburger Ambo des Nikolas von Verdun: Das Kunstwerk als *figura* zwischen Inkarnation und Wiederkunft des Logos', ibid., p. 205–247. See also U. KLEINE, 'Zukunft zwischen Diesseits und Jenseits: Zeitlichkeit und ihre Visualisierung in der karolingischen Visionsliteratur', in *Zeiten Welten. Zur Verschränkung von Weltdeutung und Zeitwahrnehmung,*

750–1350, ed. M. CZOCK and A. RATHMANN-LUTZ, Cologne, Weimar and Vienna, 2016, p. 135–168, here p. 142.

58. While the first half of the bifolium appears to have been entirely or mostly completed, all that remains from the Apocalypse cycle on the second half of the bifolium (now folio 91) are frames that divide the pages into two registers, suggesting that the scenes themselves had not been executed when the bifolium was discarded, and that the latter happened while Lambert was at work on the cycle itself. The frames came to accommodate figures of the constellation cycle. Albert Derolez concluded that both the Apocalypse cycle and the constellation cycle were executed in the early phases of the work (phases 3 and 2 respectively, which are not considered to be consecutive but concurrent); this would suggest that the bifolium was not only discarded but also repurposed at this early date. See DEROLEZ, op. cit. (our note 7), p. 63, 102–103, 176; DEROLEZ, *Lambertus*, op. cit. (our note 12), p. 169–171, 374–375, 405, 411. It is unclear precisely which Apocalypse scenes were intended for folio 91 when the leaf was discarded: according to the proposed quire structure, the discarded bifolium 88/91 was replaced by ★3/★10, but according to the proposed allocation of scenes, folio ★10r accommodated a full-page image (of the Whore of Babylon) rather than scenes in two registers. Therefore, either a change was made to the size of this scene when the bifolium was replaced, or the composition of the lost quire was irregular, or the distribution of the final scenes was slightly different from that which has been proposed. Whatever the case, it is almost certain that folio ★10v would have contained the Last Judgement scene and that, if folios ★3/★10 constituted one bifolium, this scene would have been designed in conjunction with the vision of the throne of God on folio ★3r by Lambert.

59. Albert Derolez concluded that this insertion belongs to phase 10. See DEROLEZ, op. cit. (our note 7), p. 59–60, 64, 179; DEROLEZ, *Lambertus*, op. cit. (our note 12), p. 63, 69, 421. It is not clear exactly where the excerpt from Bede would have been positioned in Lambert's autograph. The most logical place would have been the space above and below the diagram on folio ★1v (as in the case of the text on the upper heavens next to the diagram on folios 92v–93r of Lambert's autograph). However, the fact that the entry for this excerpt by Bede is unaltered in the table of contents shows that it must have been there before folio ★1 was inserted. A possible scenario is that it was initially joined with the image of Mary on folio ★2, then copied across onto folio ★1v and replaced by the text for the feast of the Assumption. Cf. DEROLEZ, op. cit. (our note 7), p. 63–65; DEROLEZ, *Lambertus*, op. cit. (our note 12), p. 64–69.

60. Albert Derolez concluded that this insertion belongs to phase 13. See Derolez, op. cit. (our note 7), p. 61, 181; DEROLEZ, *Lambertus*, op. cit. (our note 12), p. 57–58, 61, 430–431.

61. Ghent, folio 23v: *Quadraginta et sex annorum sub prefatis regibus templi edificatio corpus Dominicum in utero Virginis formatum pulcre signaverat.*

62. Ghent, folio 23v: *De etate mundi ab Adam usque ad Salomonem et de Templo comparato Christi corpori et de natura hominum.* For this topic more widely, see J. A. HARRIS, 'The Body as Temple in the High Middle Ages', in *Sacrifice in Religious Experience*, ed. A. I. BAUMGARTEN, Leiden, 2002, p. 233–256.

63. For the *mulier amicta sole* and her relationship with Mary, see P. K. KLEIN, 'Les apocalypses romanes et la tradition exégétique', *Les Cahiers de Saint-Michel de Cuxa*, 12, 1981, p. 123–140; MUIR WRIGHT, op. cit. (our note 34); J. MONIGHAN-SCHÄFER, *Offenbarung 12 im Spiegel der Zeit. Eine Untersuchung theologischer und künstlerischer Entwicklungen anhand der apokalyptischen Frau*, PhD diss., Marburg, 2005; *Maria, l'apocalisse e il medioevo*, ed. C. M. PIASTRA and F. SANTI, Florence, 2006; WOODWARD, op. cit. (our note 4), p. 38.

64. The term *Templum domini* is also used on folio 14v of *Wolfenbüttel* for the temple that opened up in heaven to reveal the ark of the covenant (Apocalypse 11, 19) and features in other places in the *Liber floridus*, notably within the long description of the city of Jerusalem that forms part of the *Gesta Francorum Iherusalem expugnantium*, where the link with Solomon's Temple is made explicit: *Templum Domini est celeberrimum, miro opere fabricatum, quod licet primum opus non sit Salomonis egregium, sed nec aliud quod sub Giro rege persarum ab Hesdra et Neemia secunda reedificatione totius mundi fabricam in opere excessit, tamen quatuor habet introitus, sicut et primum habuit templum … Fuit et in hoc loco, tempore Salomonis, propitiatorium aureum et archa testamenti, in qua erant tabule Moysis et virga Aaron et manna, et cetera quae dicebantur Sancta Sanctorum* (the relevant section is missing from Lambert's autograph and is quoted here from folio 133v of *Paris 8865*). More generally, on the appropriation of the Dome of the Rock at this time: D. PRINGLE, *The Churches of the Crusader Kingdom of Jerusalem: A Corpus*, III, Cambridge, 2007, p. 397–417; B. Z. KEDAR and D. PRINGLE, '1099–1187: The Lord's Temple (*Templum Domini*) and Solomon's Palace (*Palatium Salomonis*)', in *Where Heaven and Earth Meet. Jerusalem's Sacred Esplanade*, ed. O. GRABAR and B. Z. KEDAR, Austin, 2009, p. 133–149.

65. DEROLEZ, op. cit. (our note 7), p. 62–63; DEROLEZ, *Lambertus*, op. cit. (our note 12), p. 66–67. See also our note 58.

66. Genesis 49, 9–10: *catulus leonis Iuda … non auferetur sceptrum de Iuda et dux de femoribus eius donec veniat qui mittendus est et ipse erit expectatio gentium*. For this image, see DEROLEZ, op. cit. (our note 7), p. 63; WOODWARD, op. cit. (our note 4), p. 38–39.

67. Lambert also includes a similar invocation on folio ★3v: *Ecce vicit radix david Leo de tribu Juda et regnabit in eternum ipsi honor et gloria ex omni tribu et lingua in secula* (quoted from folio 10v of *Wolfenbüttel*; in *Paris 8865* on folio 35r, *honor et gloria* reads *gloria et honor*). Cf. Apocalypse 5, 5 and 5, 9.

68. For the sequence *Fulgens praeclara*, see http://cantusindex.org/id/ah53035 [accessed 10.12.2020].

69. An early example for its Continental transmission is an eleventh-century gradual from Saint-Vaast in Arras (Cambrai, Médiathèque municipale, MS 75 (76), folios 22v–23r); see *Catalogue des manuscrits notés*, 4/I. *Collections du Nord – Pas-de-Calais et de Picardie*, ed. C. MEYER with B. HAGGH-HUGLO and S. NISHIMAGI, Turnhout, 2014, p. 202–208.

70. *Rex in aeternum / suscipe benignus / preconia nostra. // Victor ubique / morte superata / atque triumphata, // Ortus de tribu Iuda / leo potens, / surrexisti in gloria, // Regna petens supera, / iustis reddens premia / in saecula. // Ergo, pie rex Christe, / nobis dans peccamina, / Fac tecum resurgere / ad beatam gloriam*. In *Tropen des Missale im Mittelalter. II. Tropen zum Proprium Missae*, ed. C. BLUME, Leipzig, 1906 (Analecta Hymnica, 49), p. 271 (no. 516), with a list of sources.

71. *Paris 8865*, folio 42v: *Jerusalem pacifera hec tua sunt fundamenta*.

72. For Jerusalem in the *Liber floridus*, see esp. RUBENSTEIN, op. cit. (our note 47). For the image on folio 42v of *Paris 8865*, see also H. ŠEDINOVÁ, 'The Precious Stones of Heavenly Jerusalem in the Medieval Book Illustration and Their Comparison with the Wall Incrustation in St Wenceslas Chapel', *Artibus et Historiae*, 21.41, 2000, p. 31–47; G. SCHILLER, op. cit. (our note 4), vol. 2, p. 174–175; WOODWARD, op. cit. (our note 4), p. 20–22.

73. *Ghent*, folios 92v and 228v: *Elementa mundi, id est çelum et terram, non credamus abolenda per ignem sed in melius commutanda, [et] figuram mundi, id est imaginem, non substantiam transituram*. Lambert probably drew on the pseudo-Augustinian *Liber sive diffinitio ecclesiasticorum dogmatum* by Gennadius of Marseilles, ch. XXXVII (PL 42, col. 1219).

74. K. MÜLLER, 'Mutmaßungen über *figura* und *substantia* der Welt: Die Diagramme im *Liber Floridus* des Lambert von Saint-Omer', in *Figura*, op. cit. (our note 57), p. 173–204. See also MAYO, op. cit. (our note 42), esp. p. 45; TUTTLE, op. cit. (our note 7), p. 162–169; HEITZMANN and CARMASSI, op. cit. (our note 10), p. 23–26. For the transition from this world to the next, see also H.-W. GOETZ, 'Endzeiterwartung und Endzeitvorstellung im Rahmen des Geschichtsbildes des frühen 12. Jahrhunderts', in *The Use and Abuse of Eschatology in the Middle Ages*, ed. W. VERBEKE, D. VERHELST and A. WELKENHUYSEN, Leuven, 1988, p. 306–332, esp. p. 323–326. For correspondences between diagrammatical structures and visualisations of the hereafter, see also B. REUDENBACH, 'Heilsräume: Die künstlerische Vergegenwärtigung des Jenseits im Mittelalter', in *Raum und Raumvorstellungen im Mittelalter*, ed. J. A. AERTSEN and A. SPEER, Berlin, 1998, p. 628–640. See also the article by A. RATHMANN-LUTZ in this volume.

75. For the similarities between this image of the Heavenly Jerusalem and the diagrams included by Lambert, see also WOODWARD, op. cit. (our note 4), p. 39–44.

76. For this image of the Heavenly Jerusalem see esp. TUTTLE, op. cit. (our note 7), p. 116–119; C. FUMARCO, 'La Gerusalemme Celeste ed il tema crociato nei manoscritti del *Liber Floridus* dal XII al XV secolo', in *Il cammino di Gerusalemme. Atti del II Convegno Internazionale di Studio (Bari-Brindisi-Trani, 18–22 maggio 1999)*, ed. M. S. CALÒ MARIANI, Bari, 2002, p. 633–646; DEROLEZ, op. cit. (our note 7), p. 89–90; HEITZMANN and CARMASSI, op. cit. (our note 10), p. 41–42.

77. Isidore of Seville, *Allegoriae quaedam S. Scripturae*, PL 83, cols 97–130, here col. 113: *Salomon Christi praenuntiat figuram qui aedificavit domum Deo in coelesti Jerusalem, non de lignis et lapidibus, sed de sanctis omnibus*. Cf. A. R. MEYER, *Medieval Allegory and the Building of the New Jerusalem*, Woodbridge, 2003, esp. p. 64, 169–170. We might also note that, underneath the image of the Heavenly Jerusalem on folio 42v of *Paris 8865*, the throne from which the river of life proceeds (Apocalypse 22, 1) is depicted with lions' feet.

78. For this set of diagrams, see DEROLEZ, op. cit. (our note 7), p. 65–67. For the wind diagram on folio 24r, see also B. OBRIST, 'Wind Diagrams and Medieval Cosmology', *Speculum*, 72, 1997, p. 33–84, esp. p. 54–57, 75–76.

79. Albert Derolez concluded that this insertion belongs to phase 10 (see our note 59). See DEROLEZ, op. cit. (our note 7), p. 59–60, 65–66, 179; DEROLEZ, *Lambertus*, op. cit. (our note 12), p. 73–75, 77, 421.

80. The effect achieved by the superimposition of the Heavenly Jerusalem and the wind diagram was already noted by MÜLLER, op. cit. (our note 74), p. 184–186.

81. Apocalypse 7, 1: *post haec vidi quattuor angelos stantes super quattuor angulos terrae tenentes quattuor ventos terrae ne flaret ventus super terram neque super mare neque in ullam arborem*. For this image, see SCHILLER, op. cit. (our note 4), vol. 2, p. 52–58; P. K. KLEIN, 'Der Apokalypse-Zyklus der Roda-Bibel und seine Stellung in der ikonographischen Tradition', *Archivo Español de Arqueología*, 45–47, 1972/74, p. 267–311, here p. 285–290. For the connection between the Apocalypse cycle and the wind diagram, see also GANZ and GANZ, op. cit. (our note 4), p. 67.

82. Apocalypse 7, 2–3: *et vidi alterum angelum ascendentem ab ortu solis habentem signum Dei vivi et clamavit voce magna quattuor angelis quibus datum est nocere terrae et mari dicens nolite nocere terrae neque mari neque arboribus quoadusque signemus servos Dei nostri in frontibus eorum*.

83. Orosius, *Historiae adversus paganos*, VI. 20, ed. H.-P. ARNAUD-LINDET, Paris, 1990–1991: *Porro autem hunc esse eundem diem, hoc est VIII idus Ianuarias quo nos Epiphania [sic], hoc est apparitionem siue manifestationem Dominici sacramenti, obseruamus, nemo credentium siue etiam fidei contradicentium*

nescit. The translation follows *Orosius. Seven Books of History against the Pagans*, tr. A. FEAR, Liverpool, 2010, p. 309.

84. *Ghent*, folio 139r: *In diebus Augusti una dierum, hora III^a, repente liquido ac puro sereno circulus ad speciem celestis arcus orbem solis ambiit, quasi eum unum ac potentissimum in hoc mundo solumque clarissimum in orbe monstraret, cuius tempore venturus esset qui ipsum solem solus mundumque totum et fecisset et regeret* (cf. also folio 13v). Lambert quoted here almost verbatim from Orosius VI.20. For this topic more widely, see GOETZ, *Die Geschichtstheologie*, op. cit. (our note 32), p. 82–85, 161.

85. *Ghent*, folio 139r: *Quo signo quid evidentius quam in diebus Cesaris toto orbe regnantis futura Christi nativitas declarata es?* The source for this is once again Orosius IV.20; the English translation follows *Orosius. Seven Books*, op. cit. (our note 83), p. 310.

86. *Ghent*, folio 191v: *Eo tempore Cesar, ad quem rerum omnium summa consenserat, dominum se bonum appellari non passus est, immo non ausus, quo verus Dominus totius generis humani inter homines natus est.*

87. *Ghent*, folio 253r: *David autem genuit Nathan, a quo secundum Lucam generatio processit, et Salomonem, a quo secundum Matheum eadem genealogia descendit.* For the differences between the two genealogies, see A. L. A. HOGETERP, 'King Solomon in the New Testament and Jewish Tradition', in *The Figure of Solomon in Jewish, Christian and Islamic Tradition: King, Sage and Architect*, ed. J. VERHEYDEN, Leiden and Boston, 2013, p. 143–163, here p. 161.

88. *Ghent*, folio 23v: *Absalon et Salomon filii David de una uxore erant. Absalon autem in ramo suspensus, Salomon obiit parvulus, ob cuius memoriam Salomonem vocavit quem ex ea que fuit Urie genuit*; virtually the same passage appears again in a section that survives imperfectly on folio 34v in Lambert's autograph but which is transmitted on folio 21r of *Wolfenbüttel*.

89. See our note 37.

90. See our note 22.

91. For the medieval reception of Solomon, see M. BOSE, 'From Exegesis to Appropriation: the Medieval Solomon', *Medium Aevum*, 65.2, 1996, p. 187–210. Cf. also J.-P. BOUDET, 'Le modèle du roi sage aux XIII^e et XIV^e siècles: Salomon, Alphonse X et Charles V', *Revue Historique*, 310, 2008, p. 545–566; and P. SÄRKIÖ, 'Solomon in History and Tradition', in *The Figure*, op. cit. (our note 87), p. 45–56, esp. p. 50–52.

92. 3 Kings 11, 3–4: *FUERUNT EI UXORES QUASI REGINAE SEPTINGENTAE ET CONCUBINAE TRECENTAE et averterunt mulieres cor eius cumque iam esset senex depravatum est per mulieres cor eius ut sequeretur deos alienos nec erat cor eius perfectum cum Domino Deo suo sicut cor David pateris eius*. The passage cited by Lambert is given in capitals; see our note 21.

93. For this text, see L. DITOMMASO, 'The *Penitence of Solomon* (De Penitentia Salomonis)', in *The Embroidered Bible. Studies in Biblical Apocrypha and Pseudepigrapha in Honour of Michael E. Stone*, ed. L. DITOMMASO, M. HENZE and W. ADLER, Leiden and Boston, 2018, p. 371–452.

94. Augustinus Hipponensis, *De civitate Dei*, 17.8: *Facta est quidem nonnulla imago rei futurae etiam in Salomone, in eo quod templum aedificavit et pacem habuit secundum nomen suum – Salomon quippe pacificus est Latine – et in exordio regni sui mirabiliter laudabilis fuit; sed eadem sua persona per umbram futuri praenuntiabat etiam ipse Christum Dominum, non exhibebat.* Latin text and English translation cited from Augustine, *City of God*, V (*Books 16–18.35*), trans. E. M. SANFORD and W. M. GREEN, Cambridge (Mass.), 1965, p. 282–283.

95. Nathaniel Campbell pursues similar questions with regard to Herrad of Landsberg: N. CAMPBELL, '"Lest He Should Come Unforeseen": The Antichrist Cycle in the Hortus Deliciarum', *Gesta*, 54, 2015, p. 85–118.

96. For Lambert's concern regarding the end of time, see D. VERHELST, 'Les textes eschatologiques dans le *Liber Floridus*', in *The Use*, op. cit. (our note 74), p. 299–305; R. MUIR WRIGHT, *Art and Antichrist in Medieval Europe*, Manchester and New York, 1995, p. 60–77; LEWIS, op. cit. (our note 20), esp. p. 34–65. The degree to which the First Crusade was tied up with apocalyptic thinking has been fully demonstrated in RUBENSTEIN, *Nebuchadnezzar's Dream*, op. cit. (our note 25); see also RUBENSTEIN, 'Lambert of Saint-Omer', op. cit. (our note 25); P. MAYO, 'The Crusaders under the Palm: Allegorical Plants and Cosmic Kingship in the "Liber Floridus"', *Dumbarton Oaks Papers*, 27, 1973, p. 29–67.

97. See, for example, DEROLEZ, op. cit. (our note 7), p. 187: 'The victorious end of the Crusade has shaped the conditions for the opening of this last, apocalyptic age of world history, when the Devil's *alter ego*, the Antichrist, will make his appearance'. Jay Rubenstein considers the historical and prophetic ideas pertaining to the end of time and considers how Lambert may have reconciled them: 'Perhaps the Seventh Age had not yet begun … But it is also possible … that Lambert now believed himself to be living in the Seventh Age'; RUBENSTEIN, 'Lambert of Saint-Omer', op. cit. (our note 25), p. 85–87. Cf. E. SEARS, *The Ages of Man. Medieval Interpretations of the Life Cycle*, Princeton, 1986, p. 68; LEWIS, op. cit. (our note 20), esp. p. 62.

98. *Ghent*, folio 108v: *Antichristus in omnibus Christo contrarius*. For this text (which is entitled *Epistola Methodii de Antichristo* in Lambert's manuscript) and an edition, see *Adso Dervensis, De ortu et tempore Antichristi, necnon et tractatus qui ab eo dependunt*, ed. D. VERHELST, CCCM 45, p. 139–152. See also the article by M. RIZZI in this volume.

99. *Ghent*, folio 108v (damaged, lacunae emended from *Wolfenbüttel*, folios 74v–75, in square brackets): *Nascetur autem ex patris et matris copulatione, non, ut quidam dicunt, de sola virgine. Sed tamen totus in peccato concipietur, in peccato generabitur et in peccato nascetur. In ipso vero conceptionis sue initio diabolus simul in ventrem matris sue introibit et ex virtute diaboli confovebitur et virtus diaboli semper erit cum illo. Sicut in matrem Domini Nostri Ihesu Christi Spiritus Sanctus venit et eam sua virtute obumbravit et divinitate replevit, ut de Spiritu Sancto conciperet, et quod nasceretur divi[n]um esset et sanctum, ita quoque diabolus in matrem Antichristi descendet et [totam] eam replebit, totam circumdabit, totam interius exteriusque posside[bit], ut diabolo cooperante per hominem concipiat et quod natum fuer[it tot]um sit iniquum, totum malum totumque perditum.*

100. See J. TOLLEBEEK, 'Arbor mala: Het antijudaisme van Lambertus van Sint-Omaars', *Studia Rosenthaliana*, 20, 1986, p. 1–33.

101. *Ghent*, folio 62v: *Ingredietur in Iherusalem et sedebit in templo Dei quasi sit Deus*. For this set of ideas and the two images in particular, see R. K. EMMERSON, *Antichrist in the Middle Ages. A Study of Medieval Apocalypticism, Art, and Literature*, Seattle, 1981; LEWIS, op. cit. (our note 20); RUBENSTEIN, *Nebuchadnezzar's Dream*, op. cit. (our note 26), p. 35–48; MUIR WRIGHT, op. cit. (our note 96), p. 60–77; G. SCHÜSSLER, *Studien zur Ikonographie des Antichrist*, PhD diss., Heidelberg, 1975, p. 87–99; J. POESCH, 'The Beasts from Job in the *Liber Floridus* Manuscripts', *Journal of the Warburg and Courtauld Institutes*, 33, 1970, p. 41–51; H. BREDEKAMP, *Der Behemoth. Metamorphosen des Anti-Leviathan*, Berlin, 2016, p. 20–27. These publications also include some brief comments on the similarity between the figure of Antichrist and that of Augustus or Christ (e.g. POESCH, 'The Beasts', p. 42). Cf. also WOODWARD, op. cit. (our note 4), p. 47–49.

The Wolfenbüttel Manuscript and the Place and Function of History in the *Liber floridus*

Christian Heitzmann

The complex process of composing Lambert's autograph manuscript of the *Liber floridus* has been meticulously reconstructed by Albert Derolez.[1] According to his research, the motivation for Lambert's long-time project was rooted not so much in the rather conventional reasons given by the author in the preface of the *Liber floridus*, namely that human knowledge being distributed throughout too many, combined with a certain weakness of mind of the contemporaries, created the need to collect or preserve essential knowledge in one volume in order to explain in short the great deeds of God in history and nature.[2] Rather, the motivation arose from more or less political events in contemporary history:

> Lambert obviously conceived the idea of writing his encyclopedia under the influence of two events of his time: the Conquest of England (1066) and the victorious end of the First Crusade (1099). He started working in the troubled atmosphere of the Investiture Struggle and in the wake of the growth of the county of Flanders as a political power. All this explains the unusually strong historical and eschatological components in his book, which are superimposed upon a traditional body of encyclopedic matter.[3]

Indeed, Lambert's encyclopedia differs significantly from the earlier ones, for instance from the ones by Isidore and Raban, in so far as historiographic texts constitute a very considerable part of the *Liber floridus*, no less important than theology, cosmology, geography or the knowledge of animals, plants and precious stones. On the one side, these more or less traditional or conventional components (and the terrific apocalypse cycle, missing in the autograph, but transmitted by the Wolfenbüttel codex and its copies) contain the famous illustrations by Lambert and have imprinted on the mind of any person who

has ever taken a closer look at the *Liber floridus* manuscripts. On the other side, the historiographic texts were rarely illustrated and, in contrast to the other parts, might seem to be less visible and prominent to its readers. Still, as noted above, historiography is an essential part of Lambert's work. According to Albert Derolez, the *Liber floridus* may be called a 'historic encyclopedia'.[4]

In a first step, I would like to consider what kinds of historiographic texts Lambert included and how they were partly re-organised in the Wolfenbüttel copy. It will be necessary to understand the composition and contextualisation of the historiographic parts in a second step. Finally, I aim to conclude what function they might have had in the context of Lambert's work and the version presented in the Wolfenbüttel manuscript.

The Wolfenbüttel manuscript

I will now concentrate on the texts transmitted in the Wolfenbüttel copy, which is, regrettably, incomplete. Indeed, the last third of the codex has been lost since an unknown time after the new binding was made for Marquard Gude in the second half of the seventeenth century. Therefore, only 104 folia containing 126 of originally 171 chapters remain. The content of the lost part can not only be traced by the index given at the beginning of our codex, but also by the reliable copies of it preserved in other libraries (Leiden, University Library, Voss. Lat. folio 31, thirteenth century; Genova, Biblioteca Durazzo, A IX 9, fifteenth century; Den Haag, Royal Library, 72.A.23, dated 1460; Chantilly, Musée Condé, 724, *c.* 1470).[5] The main achievement of the Wolfenbüttel editor or scribe – it is difficult to decide what he should be called – is regulation: not only of the layout, but also of some contents. The editor decided to produce a

codex slightly taller than the Ghent autograph and characterized by the regular two-column layout typical of manuscripts of this format, thus replacing the single-column layout of Lambert's autograph.

It is still not known who the editor or scribe of the Wolfenbüttel copy was and where this edition was acquired. As some detailed material about the city of Saint-Omer and the bishopric of Thérouanne and even the impressive image of *Gloriosus pontifex Audomarus* has been omitted, the Wolfenbüttel copy is supposed to have its origin – or better: was intended to be used – outside the neighbourhood of Saint-Omer; however, not too far away, perhaps in an abbey within the counties of Hainaut or Artois.[6] A later addition, the *Ordo ad inungendum et coronandum regem*, mentioning the Sainte Ampoulle of Saint Remi, an entry probably written in the first half of the fourteenth century, may suggest that the manuscript might have been kept in Reims, where the coronation of the kings of France had to take place. Unfortunately, we do not know where and when Marquard Gude acquired the manuscript for his precious collection that became part of the ducal library in Wolfenbüttel in 1710, when Gottfried Wilhelm Leibniz persuaded duke Anton Ulrich of Braunschweig-Lüneburg to buy the entirety of Gude's manuscripts.[7]

Lambert's idiosyncratic art of compilation is characterized by Albert Derolez as follows:

> The logic in the *LF* is indeed one of *associative* nature: mental associations evoked by one chapter become the subject of the next. In that way chains of chapters are created, among which the most conspicuous is perhaps the series of texts containing the History of Flanders, the Investiture struggle, an Antichrist prophecy, the First Crusade, the expedition of Alexander the Great, and moralising poetry successively. The global and synthetic view of the world, on the other hand, so typical of the Romanesque mind, favoured a simultaneous consideration of Creation and history in their multiple senses, literal and symbolical. The world as a whole, in its static and dynamic aspects, is in fact the subject of Lambert's work.[8]

Let us now take a closer look at the historiographic sections in the *Liber floridus* in order to understand how Lambert arranged these chapters within his encyclopedia. There are mainly three different types of historiographic texts in the *Liber floridus*: world history, local history (of Britain, Normandy and Flanders) and contemporary history, the latter often closely connected with the history of the Investiture Controversy and the First Crusade.

World history in the *Liber floridus*

World history, beginning with the Creation and building up a continuum from the earliest times of mankind up to the present day, is a common feature of late antique and early medieval historiography. Chronology, of course, is the basis of a reliable historiography. Lambert gives detailed computistic information and the number of years for the six eras of the world.[9] Biblical Jewish history is the subject of chapter 2 of the *Liber floridus*. Lambert compiled information about the history of the Jewish people, following the Carolingian historian Freculphus of Lisieux (chapter 2). Interrupted by diagrams illustrating the six eras of the world, he continues in chapter 7, also according to Freculphus, with world history from the Creation to the birth of Christ. The following chapter 8 gives an account of the judges and kings of the Jews and is taken from Hegesippus (second c.). Then, Lambert goes back to the six days of Creation. The composition of these chapters is obviously lacking chronological rigour. This section is an example of the associative method of composing texts and facts that is so typical of Lambert's encyclopedia. The most significant statement within this context may be found – slightly hidden – in a diagram illustrating the six eras of the world (Fig. 1: folio 6): the sixth era, beginning with Octavianus Augustus as customary, ends with a contemporary person –surprisingly not with the Roman emperor, but Duke Godfrey of Bouillon, the Christian conqueror of Jerusalem in 1099. This is the first, almost inconspicuous, hint to the importance of the Crusade for Lambert's conception of history within his encyclopedia.

The next historical section, the calendar of saints (folios 17v–18v, chapter 17), is enriched with a small number of notes on contemporary events, for instance on 2 April as the death of King Baldwin of Jerusalem in 1118 and on 19 October marking the convocation of the council of Reims in 1119.

Fig. 1. Wolfenbüttel, Herzog August Bibliothek, Cod. Guelf. 1 Gud. lat., folio 6, Lambert of Saint-Omer, *Liber floridus, c.* 1150/75: *Sex aetates mundi*

The continuous history of the sixth era, beginning in the time of the emperor Augustus and the birth of Christ, is given in the traditional list of years of the emperors and popes (folios 22v–29), refined by some – but not too many – notes about remarkable events, for instance the Scandinavian raids devastating Flanders in the ninth century. It is not until after the middle of the eleventh century, or precisely since the apparition of a comet in 1065 allegedly announcing the Norman conquest of England, that there emerge numerous entries on contemporary local and imperial history and history of the crusades. This context also provides the opportunity for Lambert's most personal entry: the note on the death of his father Onulf in 1077.

Local historiography in the *Liber floridus*

Local historiography as integrated by Lambert concentrates on Flanders, Normandy and the British Isles. The history of Britain (chapters 58–59, folios 46–50r) is drawn mainly

from Bede, the most prominent writer on this subject for the time until the early eighth century. For the time after Bede, Lambert had to follow – among others – the less known Welsh author Nennius (early ninth century) whose name he avoided to mention.[10] British history appears mainly as a chain of rulers or events, concluding with the Norman Conquest of 1066. More elaborate information about Britain and its special and miraculous places is given in another, earlier section dedicated to the wonders in nature, where Lambert inserted a chapter about *Miranda Britanniae*, mainly extracted from Nennius (chapter 53, folio 42v–43v).

In comparison to the Ghent autograph, the scribe of the Wolfenbüttel codex unified the narrative about British and Norman history on folios 46–50. The *Historia Anglorum regum* and its continuation are uninterruptedly followed by the *Genealogia ducum Normannorum.* He omitted or transferred a list of British towns and the two smaller chapters *De annorum ebdomadibus* and *Dicta septem sapientium* in order to achieve a better coherence of the historiographical narrative.[11]

To that effect, the history of Britain is closely connected with the history of Normandy and the Norman Dukes, culminating in the person of William the Conqueror. This chapter, the *Genealogia comitum Normannorum,* seems to be one of the rare texts in the *Liber floridus* composed by Lambert himself (Fig. 2, folio 50). He is eager to demonstrate that William was the legitimate heir to King Edward the Confessor, stating '*regnumque obtinuit iure hereditario*' (folio 50). In a sober manner he talks about the conflicts between William's sons and the tragedies that occurred in his family: his son William Rufus hunting in the woods and accidently being killed by an arrow; his grandson William travelling from Normandy to England by ship and being killed during a shipwreck in a sea storm. But then, the marriage of William's granddaughter Matilda to the emperor Henry V demonstrates the arrival of the Norman dynasty at the highest level of European aristocracy.

The close connections between both sides of the Channel ruled by one family intensified the political and economical contacts from Flanders to England. As Hanna Vorholt has shown, the scribe of the Wolfenbüttel

Fig. 2. Wolfenbüttel, Herzog August Bibliothek, Cod. Guelf. 1 Gud. lat., folio 50, Lambert of Saint-Omer, *Liber floridus*, c. 1150/75: *Genealogia comitum Normannorum*

manuscript rearranged the sections about Britain and the Normans and omitted additional information given in Lambert's autograph. His changes were obviously aimed at contstructing a homogeneous historiographic section.

The same procedure seems to have occured in a section today lost in the Wolfenbüttel codex, but still reconstructable using the index of chapters and later copies of our manuscript. This concerns the history of the Frankish and French kings whose lineage starts with the Trojans (chapters 127–130). The Wolfenbüttel scribe collects and unites material from different sections of the Ghent autograph in order to unify and simplify the story he is telling.[12]

Contemporary history in the *Liber floridus*

Flemish history is a central point of reference in the *Liber floridus* (chapters 111–113, folios 70v–74v). Furthermore, the history of

Flanders is closely connected with the narrative about the Investiture Contest and the First Crusade. This subject was so important to Lambert that he decided to tell it in his own words and not by simply reproducing it from other sources.[13] A short chapter about the cities, rivers, abbeys and saints of Flanders is the first part of this section. Then the *Genealogia comitum Flandrie* offers an overview of the period since the ninth century, beginning with the legendary count Lindricus in the time of Charlemagne. Lambert provides a condensed history through the centuries. The oppression of the clergy by Count Robert (1070/71–1093) is an important item of his narrative. Lambert inserts the text of a reprehensive letter by Pope Urban II. Only shortly before his death in 1093 did the count repent for his evil deeds. The editor of the Wolfenbüttel copy made an addition to Lambert's text: he added information about the assassination of Count Charles the Good in 1127. This is further evidence of the assumption that the Wolfenbüttel version has its roots at least in the vicinity of Flanders.

The events happening in Flanders are interwoven with information about the Investiture Contest, especially concerning the conflict between Henry V and the popes.[14] Lambert had access to copies of official documents like letters of cardinals regarding the negotiations in Rome in 1111. He included the text of the humiliating conditions of a treaty Pope Paschalis II had to accept while being held prisoner by the emperor. Other documents include the revocation of the treaty, the excommunication of the emperor during the council of Vienne in 1112 and the public condemnation of the emperor in Northern France and Western Germany.

Lambert had already been dead when the Investiture Contest was settled with the treaty of Worms in 1122, which set the rules for electing bishops in the Empire in the future. The nearly apocalyptic shock resulting from this conflict between empire and church was still vividly felt decades later in the world history written by Otto of Freising.[15]

The oppression of the church by persons like Count Robert or the emperors seem to have encouraged Lambert to believe in the approaching arrival of the Antichrist and the end of the world. This assumption was made

CHRISTIAN HEITZMANN

by Albert Derolez and is supported by the fact that Lambert inserted a chapter compiled from Adso's *De ortu et tempore Antichristi*.[16]

Among pagan rulers and heroes only Alexander the Great merited to be mentioned in the *Liber floridus* in a more detailed way. The Wolfenbüttel chapter 122 concerning Alexander the Great (folios 88r–93v) follows the autograph exemplar in Ghent but also offers some significant changes, as Hanna Vorholt has shown.[17] The editor of the Wolfenbüttel manuscript did not only compare Lambert's text with at least one other copy in order to correct Lambert where necessary: he also added a small portion to the text of the *Collatio Alexandri et Dindimi* because Lambert had stopped in the middle of a sentence and thus interrupted the argument. However, the editor did so only insofar as the free space remaining at the end of the column would allow, thus omitting the arguments of the Brahmin wise man in favour of the ascetic lifestyle culminating a few sentences later in the text. This points to the predominant aim being to reach at a professional layout rather than extending or improving the text found in Lambert's autograph. The interest in Alexander certainly corresponds to the expedition to the East during the First Crusade and the apocalyptic element connected with Alexander, as he was thought to have imprisoned Gog and Magog, the furious people who would precede the arrival of the Antichrist (Apc 20,8). (Fig. 3, folio 88)

This survey of the historiographical sections in the Wolfenbüttel *Liber floridus* may result in the following conclusions:

1. Lambert tried to include world history in its chronological entirety, but he did not provide a coherent nor sequential account of the consecutive eras.
2. For contemporary times, he concentrated on local history: Britain, Normandy and

Fig. 3. Wolfenbüttel, Herzog August Bibliothek, Cod. Guelf. 1 Gud. lat., folio 88, Lambert of Saint-Omer, *Liber floridus, c.* 1150/75: Alexander the Great on his horse *Bucephalus*

the legitimacy of the Norman Conquest, the local history of Flanders and the role of Flemish noblemen for contemporary history.
3. Local history is thus connected with the most upsetting events in contemporary history: both the Investiture Contest and the First Crusade are indications of the approaching end of times.
4. Lambert's associative method of compiling historical information reflects his personal expectations for the future to come.

NOTES

1. A. DEROLEZ, *The Making and Meaning of the Liber Floridus*, London, 2015; A. DEROLEZ, *The Autograph Manuscript of the Liber Floridus. A Key to the Encyclopedia of Lambert of Saint-Omer*, Turnhout, 1998 (Corpus Christianorum. Autographa Medii Aevi, 4).

2. On the prologue see also the contribution of Ch. BURNETT in this volume.

3. DEROLEZ, op. cit. (note 1), p. 183.

4. A. DEROLEZ, *Die komputistischen Tafeln des Liber Floridus*, Trier, 2003, p. 8: 'Man hat den Liber floridus eine historische Enzyklopädie genannt. Und dies zu Recht: Obwohl Texte und Bilder über Bibel, Gottesdienst, Erd- und Himmelkunde, Tiere, Pflanzen, Steine usw. ungemein zahlreich vertreten sind, ist auch der Umfang an historischem Interesse, das Lambert aufbringt, ganz erstaunlich. Dieses Interesse an der Geschichte tritt an zahllosen Stellen zutage: Es finden sich Ausführungen zu Weltgeschichte, Geschichte der Kaiser und Päpste, Geschichte Flanderns, Englands, der Normannen, Geschichte des Kreuzzugs, Geschichte Alexanders des Großen usw.'

5. Cf. G. I. LIEFTINCK, 'Observations codicologiques sur le groupe W des manuscrits du Liber Florïdus', *Liber Floridus Colloquium. Papers Read at the International Meeting held in the University Library Ghent on 3–5 September 1967*, ed. A. DEROLEZ, Ghent, 1973, p. 31–36.

6. LIEFTINCK, op. cit. (note 5), p. 31: 'l'examen du codex de Wolfenbüttel nous a convaincu qu'il provient d'une abbaye du Nord de la France ou de la Belgique méridionale. Son écriture et le style de ses rares initiales décorées indiquent cette origine d'une façon assez claire.'

7. See chapter 4 in Ch. HEITZMANN and P. CARMASSI, *Der* Liber floridus *in Wolfenbüttel. Eine Prachthandschrift zwischen Himmel und Erde*, Darmstadt, 2014, p. 12–19.

8. DEROLEZ, op. cit. (note 1), p. 184.

9. See DEROLEZ, op. cit. (note 4).

10. Cf. D. N. DUMVILLE, 'The Liber Floridus of Lambert of Saint-Omer and the Historia Brittonum', *Bulletin of the Board of Celtic Studies*, 26, 1975, p. 103–122, repr. in D. N. DUMVILLE, *Histories and Pseudo-Histories of the Insular Middle Ages*, Aldershot, 1990, no. XII.

11. H. VORHOLT, *Shaping knowledge. The transmission of the Liber floridus*, London, 2017 (Warburg Institute Studies and Texts, 6), p. 50–51.

12. VORHOLT, op. cit. (note 11), p. 54.

13. R. C. VAN CANEGEM, 'The Sources of Flemish History in the Liber Floridus', *Liber Floridus Colloquium. Papers Read at the International Meeting held in the University Library Ghen on 3–5 September 1967*, ed. A. DEROLEZ, Ghent, 1973, p. 71–85; VORHOLT, op. cit. (note 11), p. 48–50.

14. HEITZMANN, CARMASSI, op. cit. (note 7), p. 55–57.

15. See J. EHLERS, *Otto von Freising. Ein Intellektueller im Mittelalter. Eine Biographie*, München, 2013, p. 184–190.

16. D. GANZ, 'Gefäße der Endzeit. Inszenierungen der apokalyptischen Bücher in der mittelalterlichen Bildkunst', *Geschiche vom Ende her denken. Endzeitentwürfe und ihre Historisierung im Mittelalter*, ed. S. EHRLICH and A. WORM, Regensburg, 2019, p. 377–418, esp. p. 391–401. On this topic see also the article of M. RIZZI in this volume.

17. VORHOLT, op. cit. (note 11), p. 79–82.

Texts, Images, Diagrams

I. Texts and Exegesis

Is the End at Hand? Pseudo-Methodius, the Jews and the *Liber floridus*[*]

Marco Rizzi

Within the developments, the metamorphoses, the real inversions that the rhetoric of the Antichrist has undergone from the time of his birth under the pen of Irenaeus of Lyon onwards,[1] the *Liber floridus* plays a secondary, but interesting role in the Medieval Age, not only because the *Liber* canonized the texts recollected in it, but also because it contains an otherwise unknown Antichristological text, as we will see. This paper attempts to place the chapters of the *Liber floridus* dedicated to the Antichrist within the context of this literature, showing where they are shaped by it, where instead they take their own direction and start new declinations of the topic (Fig. 1). In this way, it could be possible to identify the features of time as perceived and represented in these chapters of the *Liber floridus*, through the filter, changing and variable, of an eschatological figure that underwent a significant revival during that period. The decades around the redaction of the *Liber*, indeed, made possible the last and most definitive move of the Antichrist, through the pages of Geroh of Reichesberg, Hildegard of Bingen and Joachim of Fiore: from Jerusalem to Rome, from the ruins of the Temple of Solomon to the throne of Peter.[2] In fact, starting from its first appearance on the scene under the pen of Irenaeus of Lyon, through to subsequent centuries and the writings of hundreds of theologians, biblical exegetes and (questionable) prophets, the Antichrist had become a key protagonist in the representation of the drama of the final days. In medieval Latin Christianity, it was a shared conviction that the end of times would be announced by an escalation of terrifying signs culminating in the sudden arrival of the worst protagonist of the world history, the Antichrist, who would summarize in himself all the powers and deceits of evil. For this reason, knowing who, where and especially when was to appear, was a matter

Fig. 1, Wolfenbüttel, Herzog August Bibliothek, Cod. Guelf. 1 Gud. lat., folio 42, Lambert of Saint-Omer, *Liber floridus*, 12th c., third quarter: The Antichrist sitting on the Leviathan.

worthy of the best intellectual efforts, which the author of the *Liber floridus* could not avoid, either.

There are two chapters dedicated to the Antichrist in the *Liber floridus*, 119 and 156;[3] this is already a significant feature but even more important is the fact that both these sections are concluded by the same text, falsely attributed to Jerome, which lists the fifteen signs that will precede the end of the world. This text, therefore, had a particular value in the eyes of the compiler of the *Liber floridus*, who evidently considered it closely linked to his anti-Christological vision. The first chapter

contains what Lambert calls *Epistola Methodii de Anticristo*, while the second contains a shortened version of one of the apocalyptic 'best-sellers' of the Middle Ages, the so-called *Liber* or *Revelationes* of the same Methodius.[4] In reality, as is already well known, the first text is a reworking of the treatise *De ortu et tempore Antichristi* written by Adso of Monter-en-der for Queen Gerberga, dating from the tenth century.[5] This, in turn, was derived from the same text on the basis of which the *Revelationes* reported in the other chapter of the *Liber floridus* were shaped. It is therefore worth spending a few words on Methodius, or rather on the Apocalypse apocryphally attributed to him.[6] Originally, it was a text of political and religious propaganda, written in Syriac language in the last decade of the seventh century in a monastery in northern Mesopotamia. It aimed to counteract the conversions from Christianity to Islam after the conquest of the Middle East by the Saracens, referred to as the 'sons of Ishmael' as part of the effort to include them in the biblical lineage of Abraham and his servant Agar. The subtext that guides the Anti-christological section of this writing is represented by the second letter to the Thessalonians, in particular by its second chapter where it announces the appearance of the Wicked and Son of Perdition, which will determine the *discessio* or apostasy of false believers. In general terms, the pseudo-Methodius' apocalypse is marked by the millenarian scheme, according to which the history of the world is divided into six ages; the last period will see the advent of the 'sons of Ishmael', who will progressively conquer the Christian world, until a Roman and Christian king will defeat them and bring peace to the whole world; peace and prosperity will last until he deposes his crown in Jerusalem, raising it on a cross on Golgotha from where God will bring them both to heaven. In these circumstances the Son of Perdition will appear, who will settle in the rebuilt Temple of Solomon to be worshipped as God, before 'the Lord shall consume him with the spirit of his mouth'.[7] Following the second letter to the Thessalonians, the ruler of the final times is not only the one who will defeat the 'sons of Ishmael' and restore the Roman-Christian empire, but also 'the one who now holds back' the Antichrist, the mysterious *katechon* of the Pauline epistle.[8] The Antichrist, in fact, will reveal himself only when the sovereign of the final times, after deposing the crown, would cease from that function.

The pseudo-Methodius text, thus, appears as an act of propaganda in favour of a Byzantine king, implicitly referring to the historical precedents of Heraclius and Constantius II, and the mythical model of a Christianized Alexander the Great. It is therefore not surprising that it was translated or rather paraphrased into Greek between the end of the seventh and the beginning of the eighth century in a monastery located in the territories occupied by the Arabs, perhaps in the Sinai Peninsula. Alongside the full version, there are also three other redactions that summarize it in broad terms, in a total of seventy surviving manuscripts. All these translations/redactions underwent a process of adaptation to the changing needs that the copyist/reviser had to face according to circumstances, as in the case of further translations into various eastern languages (Aramaic, Arabic, Ethiopian and Turkish) and Slavic (Russian, ecclesiastical Slavic).[9] The history of the Latin translations deserves a closer examination. The pseudo-Methodius apocalypse was first translated by a certain *Petrus Monachus*, sometime after the Greek translation, on which the Latin version is based. As Potestà rightly observes,[10] the translator's intent remains tied to eschatological and ethical considerations, rather than to the political-military concerns that were at the basis of the original Syriac. The Arab expansion is the consequence of the moral degradation of the church, on which the translator focuses. For the monk Peter, what matters is the call to conversion in view of the approaching time of the end. On the contrary, the fear unleashed by the Arabic expansion in Aquitaine and Rhone Valley characterizes a second translation/revision of the text, which can be more precisely placed in 732.[11] The anonymous author of this second translation updates the list of invading peoples, bringing closer to the Turks and Arabs also the populations from northern Europe that had not affected the East and for this reason are not mentioned in the original Syriac text and in the Greek translations: Gauls, Germans, Swabians, Bretons and Bavars. Also the regions conquered or devastated by the sons of

MARCO RIZZI

Ishmael are updated: Gaul, Aquitaine and Italy. The most important innovation introduced by this translation consists in the clear identification of the enemy of the final times with the Antichrist; in fact, in the original Syriac text and in the Greek translations the word Antichrist never appears, and even the monk Peter had been careful not to modify the text in this regard. Instead, the second translator systematically introduces the glossa *qui est / qui dicitur Antichristus* in the places where the original has Son of Perdition, and uses the term other two times *sua sponte*.[12] Antichrist and the Islamic conquests appear here for the first time closely linked in the Latin world.

The second Latin version had a great success: we have about one hundred and fifty manuscripts (with even conspicuous variations), while the number of those of the monk Peter is about fifty. Two other translations count about ten manuscripts each. Overall, in its various versions, the text of the pseudo-Methodius is second only to the canonical Apocalypse within the apocalyptic-escatological literature of the Latin West.[13] A significant cause for this enormous circulation was the attribution to the bishop and martyr Methodius, mentioned by Jerome in his *De viris illustribus*.[14] Not by chance, Adso of Monter-en-Der drew from the second translation of the pseudo-Methodius' apocalypse, namely the entire final section concerning the events of the last emperor, when between 949 and 954 he wrote his successful treatise on the Antichrist, dedicated to the Frankish Queen Gerberga.[15] Lambert did not hesitate to place both chapters dedicated to the Antichrist under the name and authority of Methodius, correctly in the second case, but committing an injustice to Adso in the first – whether consciously or not, however, is difficult to determine with absolute certainty. The answer is in fact linked to the problem of the provenance of the so-called *Methodii Epistula*, that is whether Lambert inserted it in the *Liber floridus* having found it in some other manuscript at his disposal, possibly without the attribution to the monk of Monter-en-Der, or whether he wrote it himself, manipulating the original text of Adso and attributing it to the more famous bishop and martyr. The editor of Adso's writing, Daniel Verhelst, inclines to this second interpretation, observing also that all the codices that report the

Epistle are direct copies of the *Liber floridus* or have some indirect relationship with it,[16] except one.[17] In my opinion, the question to be asked, rather, is whether Lambert was able to make an adaptation of Adso's text moulding it on the new theological-political values coming from the changes that were taking place in the eschatological imaginary of the Latin West.

As is well known, the text copied in the *Liber floridus* updates Adso's epistle, and consequently the pseudo-methodian substratum itself, in numerous aspects: for example, references to the Persians, typical of the Syriac historical and cultural context where the text had originated, disappear; many passages of Adso are paraphrased and summarized, numerous digressions eliminated, in order to simplify the narration and make it more accessible to the Latin public to whom it was addressed. Above all, scholars[18] have immediately individuated two most significant innovations in the version inserted by Lambert in the *Liber floridus*. Firstly, the drastic reversal of the action of the last sovereign; Adso had already transferred the final scene of the story from Golgotha to the Mount of Olives, where the king would simply place his crown, without raising it on the cross, which thus disappears from the scene; to the crown the king adds the sceptre, that is to say the typical sign of the royal power in the Franks' milieu.[19] In the letter reported in the *Liber floridus*, sceptre and crown remain, but instead of being placed on the Mount of Olives by the sovereign, they are delivered to him by God Himself who thus entrusts the *imperium christianorum* to the king.[20] The second innovation is represented by the insertion, on the narrative proposed by the pseudo-Methodius and substantially followed by Adso, of an anti-Jewish development. According to the letter reported by the *Liber floridus*, at the climax of the Antichrist's power, after having killed the two prophets Enoch and Elijah, he will pretend to be killed and will reappear after three days, dressed in royal vestments; in this way, he will deceive the Jews and send preachers all over the world to announce his resurrection, saying that it is the first authentic resurrection and negating that of Christ.[21] This will be precisely the reason why the Antichrist will be killed by the *Spiritus oris Domini*[22] on the Mount of Olives, the

place where Jesus ascended to heaven from; at this point, the Jews, *stulti tunc denuo*, will keep the body for another three days, waiting for another resurrection, which obviously will never come. At this point, the Jews will be converted, baptized and the prophecy of Paul in the letter to the Romans will be fulfilled:[23] *Si fuerit numerus filiorum Israel sicut arena maris reliquiae tamen salvae fient.*[24]

Gian Luca Potestà[25] has clearly identified the origin of such changes within the story of the last Emperor according to the *Liber floridus*. The giving of the crown by God to the last Emperor appears in a writing of Benzo, bishop of Alba, who sided with Henry IV against Gregory VII in the climate of the so-called investiture controversy and died before the year 1090. In chapter 15 of the first of the seven books dedicated to the emperor, a somewhat confused miscellany, Benzo reports what he says is a prophecy of the Sybil of Cumae; in it, the last ruler will arrive in Jerusalem, after having regained the territories dominated by the Arabs in southern Italy and having taken possession of Byzantium, where the mythical founder of the city, Bizas, *videbit eum coronatum* in his homeland. In the holy city, after paying homage to the Holy Sepulchre and to the other sanctuaries of the Lord, the sovereign of the final times will be crowned *ad laudem et gloriam viventis in secula seculorum*.[26] Sure, the sibylline prophecy reported by Benzo ends here, without developing what will happen after those events nor even mentioning the appearance of the Antichrist. Nevertheless, its eschatological dimension is evident, for two reasons: first, for the attribution to a Sibyl as in the case of another, previous eschatological prophecy linked to the theme of the last emperor, namely the Tiburtine Sibyl dating from around the year one thousand;[27] second, for the explicit declaration that, due to this coronation, the biblical prophecy of Isaiah 11.10 will be fulfilled: *Tunc implebitur quod scriptum est: et erit sepulchrum eius gloriosum*.[28] Again, the prophecy appears also in the Tiburtine Sybil, consisting of a combination of Gospel verses with a passage from Isaiah: in Benzo's vision, the emperor of the final times, shaped on the figure of Henry, would sweep away not only the 'sons of Ismael', but also the remains of the Byzantine empire, and would reconstitute for the last and definitive time the universal Latin Christian empire no longer in Rome or Constantinople, but in Jerusalem, directly crowned by God and not by the pope.

Benzo's seven books do not seem to have had great success. However, it is not hazardous to think that similar ideas could have circulated within the prophetic literature of that time, whether they were attributed to the Cumaean Sibyl, or in other forms, since they are present also in an Arabic apocalypse pertaining to the genre of the pseudo-Daniel's apocryphal apocalypses. Moreover, similar ideas could be applied to any royal figure, not necessarily to Henry IV or to his epigones who were opponents of the pope; afterwards, even Godfrey, the leader of the first crusade, could have taken on the features of this king crowned directly by God in Jerusalem after his military triumph – I will return to this point shortly. If, as Potestà believes, the text reported in the *Liber floridus* has been influenced by ideas of this kind, I believe we can also consistently explain its second original feature, that is, what we can call, to simplify, its significant reinforcement of the anti-Judaism already present in the Anti-christological tradition.[29] It takes concrete form in the story of the false resurrection and the true death of the Antichrist, who, in this way, will mislead the Jews twice. In fact, if the coronation of the last emperor has already taken place in Jerusalem, on the Mount of Olives, by God Himself, the time of history, understood as political and military history, has now come to an end, because such a kingdom directly established by God cannot be overthrown by any man, not even by the Antichrist. In fact, the author of the letter inserted in the *Liber floridus* explicitly represents the Antichrist as the Messiah yearned for by the Jews; he carefully rewrites and arranges the passages in which Adso had used *Cristus* or *Deus* to indicate the false perception of the nature of the Antichrist by the Jews or the *electi* quoted by Paul in second Thessalonians; the letter of the *Liber floridus*, instead, uses the term Messiah in both cases, referring indubitably to the Jews.[30] In other words, if Adso had emphasized the antithesis between Christ and the Antichrist, showing how the latter endeavoured to falsify, imitating the former, the true Saviour and God, and assuming, so to speak, the point of view of

the Antichrist, the *Liber floridus* takes the point of view of the Jews who see in the Son of Perdition the long-awaited Messiah. However, since they are only a marginal presence and could not aspire to a universal empire, the Antichrist must stage his false resurrection in order to wear the emblems of royalty: *regalibus indutus ornamentis, auro gemmisque resplendens, gloriosus coronatus.*[31] But his royalty is as false as his resurrection, because by now the true sovereign, the last emperor, has been crowned by God. Obviously, in this way the narration may seem inconsistent, since the persecution of the Antichrist will involve the entire world for three and a half years, as announced by all biblical prophecies and the whole exegetical tradition; but maintaining logical coherence was a problem that did not concern the authors of ancient and medieval prophetic texts, who cared only about conveying the main contents of their political-religious and eschatological message. A further change made to the text confirms that the coming of the Antichrist assumes religious and eschatological features, rather than political: God's punishment falls on him not for the killing of Enoch and Elijah or the persecution of Christians, as in the pseudo-Methodius and Adso, but precisely because the preachers of the Antichrist go around the world to announce his false resurrection and deny the authentic one of Christ.[32]

It is necessary, at this point, to investigate the reasons that led the author of the anti-Christological text included in the *Liber floridus* to reshape in this way the traditional narrative of the final conversion of the Jews. Moreover, is it possible to identify the sources, or at least the context, that offered him the specific cues to describe it according to these singular modalities, such as the false resurrection and the true decomposition of the Antichrist? If, in accordance with the prophetic text, the Arab enemy, the 'sons of Ishmael', are going to be defeated by the last emperor, what has to happen in the period between the era of the world regained to the true religion and the end of time? For the author, the answer is easy: the conversion of the Jews, who are still waiting for their false Messiah; one may wonder whether it is a simple polemical *topos* or if the author actually had news of real messianic expectations in the Jewish milieu

at that time; in the fourteenth century, for instance, such Jewish expectations inspired Arnaldo di Villanova's calculations about the date of the coming of the Antichrist.[33] In any case, the author of the text reported in the *Liber floridus* takes two ideas from the works of Haimo di Auxerre[34] in order to update the Anti-christological and the anti-Jewish traditions and arranges them to this purpose. In his commentary on the thirteenth chapter of the Apocalypse, where it speaks of the 'beast that was wounded and healed',[35] Haimo makes an explicit reference to the simulated death of the Antichrist by which he will deceive men (generally speaking and not only the Jews): *Ipse simulabit se occisum, et post mortem resurrexisse. Unde subjungitur: Et plaga mortis ejus curata est. Tanta quippe temeritas erit in illo damnato homine, ut ad deludendendos animos parvulorum, imitatione veri capitis Christi, occisum se dicat et resurrexisse post mortem.*[36] The author of the *Epistola Methodii* qualifies Haimo's note in a specific anti-Jewish sense and adds the scene of the royal vestments to create a counterpoint to the crowing of the last King, as seen above. The killed ram used to fake Antichrist's death also comes from Haimo, as already noted by Verhelst;[37] in this case, the source is Haimo's commentary on the second letter to the Thessalonians, where he remembers how Simon the Magician had made a similar gesture thanks to his magical arts. The *Glossa ordinaria* confirms that there was a great interest, at the latest in the beginning of the twelfth century, in defining the magical actions of the Antichrist mentioned in the thirteenth chapter of the Apocalypse; the *Glossa* combines Haimo's presentation of the Antichrist's false death with his failed ascension to heaven, shaped again by the model of Simon the Magician in the apocryphal acts of Peter.[38] In the second half of the century, Hildegard of Bingen would follow the same path in her *Liber divinorum operum.*[39]

Even though the text, as we have seen, could come from a milieu of pro-imperial propaganda, the euphoric climate ignited by the success of the first crusade and the establishment of the Kingdom of Jerusalem and the other Christian kingdoms in the Middle East could have made people believe that the prophecy was accomplished – Lambert along with them.[40] It is hard, maybe impossible, to

reconstruct the relevance of such ideas on the actual political and military champions of those day. At any rate, they had an impact on the contemporary intellectual life and literary production, as the insertion of this text into the *Liber floridus* shows. I hesitate to consider Lambert as its author, notwithstanding the relevant codicological arguments adduced by Verhelst and shared by Derolez.[41] Of course, once deprived of any pro-imperial feature, the text fits very well into Lambert's ideological scheme and represents the pivot around which the chronological exposition of his times rotates, preceded by the harsh criticism against Henry the Fifth and followed by the continuation of the history of the First Crusade.[42] Lambert, however, copies after the *Epistula* another text that seems to postpone the fatal date, the *Quindecim signa ante Dei iudicium*, falsely ascribed to Jerome, as in this case, or Bede in other manuscripts.[43] The origins of this boring list of fifteen huge disgraces (earthquakes, famines, floods, horrible prodigies and so on) that will precede the Doomsday are to be traced back to the Christian Greek and Byzantine apocalyptic literature, starting from the pseudo-Hippolytus' *De consummatione mundi* of the fourth century to the so-called *Greek Apocalypse of Daniel* of the ninth.[44] In these texts, they are part of the scenario in which the story of the Antichrist takes place. The Latin summary, however, displaces them and makes them a sort of alternative chronology to that of the Antichrist. There is no doubt that the successful outcome of the First Crusade and the reconquest of Jerusalem had marked, in Lambert's eyes, the beginning of the last days of world history, as the pseudo-Methodius' prophecies had foretold; probably, he also thought that Jerusalem and the Mount of Olives would be the setting for the future conversion of the Jews, just as they had already been the setting for the establishment of what really seemed the last and final Christian empire, even though Godfrey and his successor were never formally crowned as emperors. Moreover, Lambert does not take care to tune the two narrative of the last days precisely to the last Emperor's actions. In fact, chapter 156 of the *Liber floridus* summarizes and shortens the text of the second Latin translation of the pseudo-Methodius' apocalypse, without modifying the scene on the Golgotha: in this case, the last emperor will consign his reign to God and then a cross will appear in the sky, according to the original version of the narration as for the acts and places (the Golgotha instead of the Mount of Olives).[45] Something, indeed, was not so clear, and Lambert would have probably harmonized the two tales of the Antichrist if he were the author of the *Epistula Methodii*, or at least he had rewritten or reshaped the end section of Adso's text, especially since these lines of chapter 156 are written by his own hand in the Ghent manuscript.[46] Moreover, a marginal note explicitly reminds the reader about the previous chapter 119 devoted to the Antichrist, where the passages on Antichrist's birth and death can be read. Instead, Lambert chooses to repeat the text of the *quindecim signa*, so stressing again the incertitude about the coming of the last day.[47]

It is worth noting how Lambert manipulates the text of the pseudo-Methodius in chapter 156. I leave aside the questions relating to the palimpsest state of some of these pages and the presence of a second hand in their writing in the manuscript of Ghent.[48] As said above, the original narrative is summarized or paraphrased in numerous passages, although this operation does not seem to correspond to particular ideological aims, but only to the need to facilitate the understanding of readers or even to adjust to the limited space available.[49] Instead, Lambert reduces to a few lines the large end section of the pseudo-Methodius' *visio*, also significantly inverting the succession of events as presented there: in the pseudo-Methodius, the preaching of Enoch and Elijah converts firstly the *Gentes*; only afterwards do the Jews also convert to the true faith in Christ, the Antichrist having now been unmasked by the two prophets. At this point the pseudo-Methodius quotes the one hundred and forty-four thousand people of the seventh chapter of John's Revelation, pointing them out as those who would have been killed by the Antichrist for having converted to Christ: *ex omni tribu Israhil erunt interfecti pro Christo CXLIIII milia.*[50] Thus, the last persecution finally takes place, but it is suddenly interrupted by the return of Christ, who kills the Antichrist and immediately *erit consummacio seculi et erit iudicium.*[51] Instead Lambert writes that the two prophets will be put to death immediately after their appearance by the Antichrist

who, in turn, would be killed *post hec modicum temporis* by the breath of the mouth of the Lord. Only then (*tunc*), will the Jews convert to God.[52] For Lambert, the number of one hundred and forty-four thousand does not indicate the Jewish martyrs, but the number of the Jews who will be saved after the death of the Antichrist; for this reason Lambert, after having signalled to the reader the end of the text of the pseudo-Methodius, reports the verses of the seventh chapter of the canonical Apocalypse, in which the tribes of origin of the one hundred and forty-four thousand are listed. At this point, Lambert inserts a phrase for shifting to the text of the *quindecim signa*: *Antichristo autem interfecto consummatio seculi et iudicium Dei appropinquabit.*[53]

It comes naturally to think that in this case Lambert wants to coordinate the chronology of the final events proposed here with that of the previous chapter 119, which he has dedicated – or even created – to the Antichrist, where the Jews were converted only after his killing and missing resurrection. However, the question remains open as to why he does not do the same for the events and places concerning the last emperor, since this is the most important modification from the theological-political point of view that he would have introduced in Adso's text, if Lambert were the author of the *Epistola*. Perhaps Lambert was more interested in the anti-Jewish aspects of that text than in those related to the last sovereign. In other words, Lambert shares in the view that saw the conquest of Jerusalem as a sign of the beginning of the last times, but he focuses above all on the religious consequences of that event, that is, the role that the Jews should play in the scenario of the end of time. Indeed, Lambert shares, on the one hand, the anti-Jewish attitude of the *Epistola*, so as to deny the possibility that the Jews could convert before the Antichrist's death and modify in this direction the final *Revelationes* of the pseudo-Methodius; on the other hand, he considers it appropriate to specify in a more stringent and effective way the *caveat* present in all the anti-Christological prophecies about the unknowability of the day and time of judgment.[54] To do this, Lambert associates the two texts attributed to Methodius with the *quindecim signa*, which further widens the space between the appearance of

the Anti-Christ, the conversion of the Jews and the day of judgment.

An elusive tradition could confirm my interpretation; it is difficult to reconstruct, but shows the infinite ways of transmission of the antichristological ideas recorded in the *Liber floridus*. Two centuries later, in fact, we find the same textual combination of the *quindecim signa* with the episode of the narrative of the Antichrist that mainly shapes the *Epistola* in an anti-Jewish sense. It appears in a homily by Roger of Platea, who in 1336 was Provincial of the Franciscan friars in Sicily, then studied at the University of Cambridge, was elected bishop by Pope Innocent VI and held important positions at the Aragonese court of Frederick IV, before dying in 1383.[55] Roger had a good literary and theological culture, even though the tones of his preaching are often popular especially in his tirades against the Jews. In a sermon for the first Sunday of Advent, which traditionally was the occasion for preaching on the Antichrist and the end of the world, he quotes literally the *quindecim signa*; then he offers a very brief account of the Antichrist's deeds, which ends with the Jews, convinced that he was the Messiah, waiting in vain for his resurrection on the third day after his death: after going to the tomb, they find only a terrible stench that reveals the deception of the Antichrist and compels them to conversion.[56]

If my reconstruction is sound, therefore, Lambert is convinced that the last days of world history have already begun, perhaps influenced by the enthusiasm ignited by the conquest of Jerusalem a few decades before; however, he appears more interested in the anti-Jewish implications of the fulfilment of the pseudo-Methodius' prophecies than in their political dimension. While admiring the feat accomplished by the first crusaders and their Frankish captain, Lambert maintains a prudent attitude about the actual proximity of the final times and the Antichrist's appearance. Other signs must confirm that the kingdom of Jerusalem accords precisely with the last Christian empire prophesied by Methodius in both texts he had copied in the *Liber floridus*, which he probably had not harmonised for this reason. The following years would confirm Lambert's caution. Around the middle of the same twelfth century, when the Frankish dominion

in the Holy Land was already experiencing profound difficulties, another erudite monk, Gerhoch of Reichersberg,[57] set in motion the overall rethinking of the places and events of the Antichrist. Faced with the crisis of the Roman church, split in its loyalty to Alexander III or Victor IV, Gerhoch deconstructed the traditional narration inspired by Adso and pseudo-Methodius; instead, he proposed a vision that made the Antichrist the internal enemy of the church: heresy and the church, no longer the emperor and the *regnum*, are at the centre of his concerns. Soon, Hildegard of Bingen and Joachim of Fiore would take the decisive steps in transferring the scene of the final events from Jerusalem to Rome.[58] Perhaps, notwithstanding the prophecies and the conquest of Jerusalem, even Lambert had sensed that the end was not at hand, and the Jews remained a problem for the Christians.

NOTES

* I owe Gian Luca Potestà most of the information used to write this paper, derived partly from the joint work done for preparing the three volumes anthology *L'Anticristo*, ed. G. L. POTESTÀ – M. RIZZI, Roma – Milano, 2006–2019, and especially from his fine and important essay on the last Messiah: G. L. POTESTÀ, *L'ultimo messia. Profezia e sovranità nel Medioevo*, Bologna, 2014 (French translation: *Le Dernier messie. Prophétie et souveraineté au Moyen Âge,* Les Belles Lettres, Paris, 2018).

1. On the rhetoric of the Antichrist and its origin, see *L'Anticristo*, vol. 1: *Il nemico dei tempi finali. Testi dal II al IV secolo*, ed. G. L. POTESTÀ – M. RIZZI, Roma – Milano, 2006, p. XI–XXXVI; and in a more discorsive way, M. RIZZI, *Anticristo. L'inizio della fine del mondo*, Il mulino, Bologna, 2015, p. 17–66.

2. On this move, see *L'Anticristo*, vol. 2: *Il Figlio della perdizione. Testi dal IV al XII secolo*, ed. G. L. POTESTÀ – M. RIZZI, Roma – Milano, 2006, p. XXX–XXXIV; RIZZI, op. cit. (see note 1), p. 86–116.

3. I quote from Albert Derolez's seminal and still fundamental edition: *Lamberti S. Audomari canonici Liber floridus. Codex autographus Bibliothecae Universitatis Gandavensis, auspiciis eiusdem Universitatis in commemorationem diei natalis*, ed. A. Derolez, Ghent, 1968. Chapter 119 is on folio 108v–110; chapter 156 on folio 217–220.

4. On the Pseudo-Metodius's apocalypse see in short *L'Anticristo*, vol. 2 cit. (see note 2), p. XXVI–XXX; and more widely G. L. POTESTÀ, *L'ultimo messia. Profezia e sovranità nel Medioevo*, Bologna, 2014, p. 39–49 who summarizes also previous studies.

5. On Adso' work, see *L'Anticristo*, vol. 2 cit. (see note 2), p. 341–359 and related notes.

6. I follow POTESTÀ, op. cit. (see note 4), p. 39–49.

7. 2 Thessalonians 2:8.

8. 2 Thessalonians 2:7.

9. See POTESTÀ, op. cit. (see note 4), p. 61 and related notes.

10. See POTESTÀ, op. cit. (see note 4), p. 62–64.

11. For text and introductory information, see O. PRINZ, 'Eine frühe abendländische Aktualisierung der lateinischen Übersetzung des Pseudo-Methodios', *Deutsches Archiv für Erforschung des Mittelalters*, 41, 1985, p. 1–23.

12. See M. RIZZI, 'L'ombra dell'anticristo nel cristianesimo orientale tra tarda antichità e prima età bizantina', in *Antichrist. Konstruktionen von Feinbildern*, ed. W. BRANDES – F. SCHMIEDER, Berlin, 2010, p. 12 note 82; and RIZZI, op. cit. (see note 1), p. 67–78.

13. See POTESTÀ, op. cit. (see note 4), p. 61.

14. Hieronymus, *De viris illustribus* 83.

15. See this passage in *L'Anticristo*, vol. 2 (see note 2), p. 352–358.

16. See Adso Dervensis, *De ortu et tempore Antichristi, necnon et tractatus qui ab eo dependunt*, ed. D. VERHELST, Turnhout, 1976 (CCCM 45), p. 141–142.

17. As noted by A. DEROLEZ, *The making and meaning of the Liber Floridus. A study of the original manuscript, Ghent, University Library, MS 92*, London, 2015, p. 114; in any case, Derolez shares Verhelst's view.

18. See Verhelst in ed. cit. (see note 16), p. 140; and Derolez, op. cit. (see note 17), p. 114.

19. See *L'Anticristo*, vol. 2 (see note 2), p. 602 note 43.

20. *Lamberti S. Audomari canonici Liber floridus*, ed. cit. (see note 3), folio 109v of the autograph manuscript.

21. Ibidem.

22. 2 Thessalonians 2:8.

23. *Lamberti S. Audomari canonici Liber floridus*, ed. cit. (see note 3), folio 110.

24. Romans 9:27.

25. See POTESTÀ, op. cit. (see note 4), p. 100–101.

26. See the text in Benzo von Alba, *Sieben Bücher an Kaiser Heinrich IV*, ed. H. SEYFFERT, Hannover, 1996, p. 144.

27. On the Tiburtine Sybil see *L'Anticristo*, vol. 2 (see note 2), p. 360–364.

28. Benzo von Alba, op. cit., p. 144; again, the prophecy appears also in the Tiburtine Sybil: see *L'Anticristo*, vol. 2 (see note 2), p. 378.

29. On the anti-Jewish attitude operating in the Anticristological literature, see briefly *L'Anticristo*, vol. 1 (see note 1), p. XXXI–XXXIV.

30. Compare *Lamberti S. Audomari canonici Liber floridus*, ed. cit. (see note 3), folio 109: *Quando autem tanta et talia signa viderint, dubitabunt utrum sit Messias, quem prophete in fine mundi predixere venturum*, with Adso's corresponding passage in *L'Anticristo*, vol. 2 (see note 2), p. 350: *Quando autem tanta et talia signa viderint etiam illi, qui perfecti et electi Dei sunt, dubitabunt, utrum sit ipse Christus, quem in fine mundi secundum scripturas venturus est, annon.* And folio 109v: *Tunc confluent ad eum omnes Iudei estimantes Messiam suscipere*, with p. 354: *Tunc confluent ad eum omnes Iudei, estimantes Deum suscipere, sed suscipient diabolum.*

31. *Lamberti S. Audomari canonici Liber floridus*, ed. cit. (see note 3), folio 109v.

32. *Ibidem*, 109v–110.

33. On this regard, see *L'Anticristo*, vol. 3: *La scienza della fine. Testi dal XIII al XV secolo*, ed. G. L. POTESTÀ – M. RIZZI, Roma – Milano, 2019, p. 166–167.

34. On Haimo, see *L'Anticristo*, vol. 2 (see note 2), p. 280–281, also for his own identity in relation to Haymo of Halberstadt, under whose name the former's writings have been handed down to us.

35. *Rev.* 13.12.

36. Haymo Halberstatensis, *Expositio in Apocalypsin* IV 13 (PL 117 col. 1094D).

37. In ed. cit. (see note 16), p. 151 *in apparatu*.

38. See *Biblia latina cum glossa ordinaria*, ed. A. Rusch, 4 voll., Strassburg 1480/81, repr. Turnhout 1992, vol. 4, p. 565.

39. Hildegard Bingenis, *Liber divinorum operum, pars tertia, visio quinta* 35–36 (see the text in *L'Anticristo*, vol. 2 [see note 2], p. 478–480).

40. See DEROLEZ, op. cit. (see note 17), p. 114.

41. See Verhelst in ed. cit. (see note 16), p. 141–142; and DEROLEZ, op. cit. (see note 17), p. 113–114.

42. *Lamberti S. Audomari canonici Liber floridus*, ed. cit. (see note 3), folio 110v.

43. For a brief introduction to this text see *L'Anticristo*, vol. 3 (see note 33), p. 456–457 note 1.

44. See Pseudo-Hippolytus, *De consummatione mundi* 27; *Danielis apocalypsis graeca* 12 (see both passages in *L'Anticristo*, vol. 2 [see note 2], p. 128 and 232, respectively).

45. *Lamberti S. Audomari canonici Liber floridus*, ed. cit. (see note 3), folio 219v.

46. As noted by DEROLEZ, op. cit. (see note 17), p. 150.

47. *Lamberti S. Audomari canonici Liber floridus*, ed. cit. (see note 3), folio 220.

48. See DEROLEZ, op. cit. (see note 17), p. 150.

49. Ibidem.

50. PRINZ, op. cit. (see note 11), p. 16.

51. Ibidem.

52. *Lamberti S. Audomari canonici Liber floridus*, ed. cit. (see note 3), folio 219v.

53. Ibidem.

54. Starting from the very author of first wide Antichristological treatise: Hippolytus, *In Danielem* IV 21.1–23.1: see the text in *L'Anticristo*, vol. 1 (see note 1), p. 208–210.

55. For a short introduction to the author and his work see *L'Anticristo*, vol. 3 (see note 33), p. 148–149.

56. *Ibidem*, p. 152–153.

57. On Gerhoch see *L'Anticristo*, vol. 2 (see note 4), p. 385–388.

58. See note 2 above.

Temps et apocalypse dans le *Liber floridus* et dans le cadre de la tradition exégétique médiévale

Raffaele Savigni

Entre la fin du xıᵉ et le début du xııᵉ siècle, le nord de la France et la Flandre étaient un important atelier culturel et exégétique. Comme l'a souligné Guy Lobrichon, « autour de 1100 […] se produit une mutation dans la perception du texte apocalyptique et celle-ci révèle un bouleversement profond dans la perception de l'histoire universelle et de ses accomplissements, tout au moins dans l'espace occidental […] et notamment dans les trois royaumes de Germanie, Bourgogne et France »[1]. Pendant la querelle sur les investitures les polémistes des deux courants ont souvent utilisé des images de l'Apocalypse, et plus généralement des Écritures (l'Antéchrist, Béhémot, Leviathan, Nabuchodonosor roi de Babylone transformé en bête sauvage)[2] pour dénigrer leurs adversaires. Par exemple Benzo d'Albe juge que Grégoire VII (appelé *Folleprandus*) est l'Antéchrist et le maître de toutes les erreurs, en tant que instrument du diable[3]. Les auteurs « grégoriens » identifient l'empereur à l'Antéchrist ou à des personnages négatifs comme Nabuchodonosor, qui selon Bruno de Segni préfigure le diable[4].

Le début du xııᵉ siècle est marqué aussi par d'importants changements et des affrontements politico-ecclésiastiques (la première croisade, à laquelle le comte de Flandre et d'autres *milites* de la région ont participé ; la capture de Pascal II et la violente révolte de Laon en 1112) et culturels (l'activité de Guibert de Nogent, Pierre Abelard et Anselme de Laon et les premières traces du processus complexe de rédaction de la Glose ordinaire)[5], dont des traces peuvent être trouvées dans le *Liber floridus*.

Le *Liber floridus* rassemble et réélabore une longue tradition exégétique et encyclopédique[6]. Les œuvres d'Augustin, Orose, Isidore de Séville, Fréculf de Lisieux ont donné à Lambert de Saint-Omer des modèles d'interprétation du temps et de l'histoire fondés sur le schéma augustinien des six âges du monde (dont la naissance du Christ a inauguré le sixième)[7], sur la théorie des quatre empires de la vision du roi Nabuchodonosor (Daniel 2, 31–45)[8] et sur le parallélisme providentiel entre la fondation de l'Empire romain avec Octavien Auguste et la naissance du Christ[9].

Introduisant le schéma des six âges, Lambert de Saint-Omer rappelle la conception isidorienne du temps et la polysémie du mot *aetas*, qui peut indiquer un millénaire, une époque de l'histoire humaine ou de la vie d'un homme, la vie entière de l'homme jusqu'à la mort ou l'éternité :

Sex etates pro sex milibus dicuntur finem faciens in anno Domini DCCXII. Aetas quod de multis saeculis instruitur dicta est : totum tempus vitae praesentis ab initio usque ad finem. Isidorus dicit : Aetas perpetua est, cuius neque initium neque extremum nescitur[10].

Lambert déclare que le premier jour Dieu créa les nouveaux ordres angéliques et rappelle un passage des homélies de Grégoire le Grand, qui avait souligné le parallélisme entre les neuf ordres angéliques et les hommes élus[11].

Il refuse l'interprétation millénariste (six millénaires ont déjà passé, précisément à partir de l'année 742 après le Christ) et souligne l'impossibilité de prévoir la date exacte à une fois pour la fin du monde[12] et pour la mort individuelle (de l'homme microcosme, dont la vie est également divisée en six âges (Fig. 1) : sept pour Lambert, qui après l'enfance, la puérilité, l'adolescence et la *iuventus*, l'âge mûr, et avant l'*aetas decrepita* fait une distinction entre la *gravitas*, jusqu'à soixante-dix ans, et la vieillesse, à quatre-vingts ans)[13]. La légende qui introduit la section, *Mundi aetates usque ad Godefridum regem* (Fig. 2), indique clairement que le point d'arrivée de la narration est identifié au couronnement de Godefroy de Bouillon à Jérusalem[14], même si le processus historique

Fig. 1. Wolfenbüttel, Herzog August Bibliothek, Cod. Guelf. 1 Gud. lat., folio 31, Lambert de Saint-Omer, *Liber floridus*, XIIe siècle, troisième quart : Les âges du monde et de l'homme

Fig. 2. Wolfenbüttel, Herzog August Bibliothek, Cod. Guelf. 1 Gud. lat., folio 6, Lambert de Saint-Omer, *Liber floridus*, XIIe siècle, troisième quart : Les six âges du monde

reste ouvert (comme est mis en évidence dans le calendrier-martyrologe, qui laisse une place à l'avenir jusqu'à la fin du XIIIe siècle, lorsque le deuxième millénaire sera achevé à partir de la fondation de Rome)[15]. Le sixième âge, qui ne coïncide pas avec le sixième millénaire de l'histoire humaine, est destiné à se terminer avec la persécution de l'Antéchrist : *huius aetatis vespera ceteris obscurior in Antichristi est persecutione ventura*[16].

Les modèles de l'historiographie universelle. L'histoire du salut, l'Église et l'Empire

Les recherches sur les chroniques universelles et l'historiographie ecclésiastique ont mis en évidence un parallélisme entre l'histoire du salut et l'histoire politique des empires et la recherche d'un critère pour encadrer l'histoire universelle, destinée à se dérouler entre la naissance du Christ et la seconde venue. Dans son *De civitate Dei*

Augustin avait souligné l'opposition fondamentale entre les deux cités de Dieu et de l'homme, fondées respectivement sur l'amour de Dieu et sur l'amour de soi de l'homme, mais il n'avait pas identifié la cité de Dieu avec l'Église, car dans l'histoire terrestre les deux villes étaient mélangées[17]. Après un prologue dans le ciel, avec la défaite des anges rebelles, les deux villes de l'histoire humaine sont nées avec Caïn et Abel[18]. Les six jours de la création préfiguraient les six âges du monde, qui selon les millénaristes, sur la base de l'exégèse du psaume 89 (Vulgate : « Dans les yeux de Dieu, un jour est comme un millier d'années et mille ans comme un seul jour »), devaient durer mille ans chacun. Mais Augustin, emprunté par Isidore, Bède et les exégètes carolingiens, a combattu les conceptions millénaristes, déclarant qu'on ne pouvait pas connaître la durée de chaque âge et même pas le temps de la fin du monde[19].

Son disciple Orose a écrit une histoire *adversus paganos* pour répondre aux accusations

des païens contre les chrétiens, accusés d'avoir provoqué la colère des dieux et donc le sac de Rome de 410. En passant la tâche qui lui a été confiée par Augustin, il a élaboré une théologie politique basée sur l'idée de la mission providentielle de l'Empire romain, soulignée par la synchronie entre le triomphe d'Auguste et la naissance du Christ, qui avait voulu naître citoyen romain[20] : donc une *Augustustheologie* que nous retrouvons dans le *Liber floridus* de Lambert à travers l'image du premier empereur, Octavien Auguste, tenant dans ses mains l'épée et le globe des trois continents (Fig. 3)[21], tandis que pour l'exégète carolingien Christian de Stavelot Auguste était condamné à l'Enfer[22]. Pour Orose la naissance du Christ avait inauguré l'époque chrétienne (*christiana tempora*), considérée comme une période heureuse après l'époque sombre du paganisme[23].

Orose voit dans la statue du rêve de Nabuchodonosor (Daniel 2) la préfiguration des quatre empires universels : ceux de Babylone, de Perse, de Carthage, de Rome. Mais la liste de Jérôme, suivie par la plupart des exégètes et des historiens et aussi par Lambert, est différente : Carthage est remplacée par l'empire macédonien[24].

Ces royaumes étaient destinés à être vaincus par l'Empire du Christ (représenté par la pierre qui a frappé la statue), qui toutefois n'a pas annulé le rôle de l'Empire romain, destiné à retenir la venue de l'Antéchrist : cela a desserré la tension apocalyptique. Orose avait souligné le rôle de l'Empire chrétien, considéré capable de rassembler les Romains et les barbares : il s'agit d'une vision plus optimiste et "politique" que celle d'Augustin, qui avait rapproché les empires à un brigantage[25], même s'il faut distinguer les différents réinterprétations des idées d'Augustin, qui avaient déjà connu une évolution pendant sa vie. Mais le livre de Daniel (4, 19) présente même une image négative du roi babylonien, puni par Dieu pour sa fierté et réduit à un état bestial[26]. Nous retrouvons cette image (que Orose n'a pas développé et que Benzo a utilisé contre le pape Grégoire VII))[27] dans le *Liber floridus* (Fig. 4).

Fig. 3. Ghent, Universiteitsbibliotheek, MS 92, folio 138v, Lambert de Saint-Omer, *Liber floridus*, 1120/21 : Octavien Auguste

Fig. 4. Ghent, Universiteitsbibliotheek, MS 92, folio 232v, Lambert de Saint-Omer, *Liber floridus*, 1120/21 : Le rêve de Nabuchodonosor

Dans les chroniques universelles carolingiennes de Fréculf de Lisieux et d'Adon de Vienne on entrevoit la centralité de l'incarnation du Christ, qui devient le critère (comme dans *l'Histoire ecclésiastique* de Bède) pour organiser la chronologie, fondée sur les événements de l'histoire biblique des patriarches et du peuple juif (le déluge, l'élection d'Abraham, la construction, la destruction et la reconstruction du temple de Jérusalem) plutôt que de l'histoire politique[28]. Fréculf a souligné la centralité de la dimension du culte, de la fondation du temple juif à la fermeture des temples païens et à la transformation du Panthéon en église chrétienne dédiée à la Vierge et à tous les saints par décret de l'empereur Phocas : sa chronique se termine par cet événement que l'historiographie protestante considérera comme une manifestation de la bête (l'Église romaine) et un signe précurseur de l'Antéchrist[29]. Toutefois E. Mégier pense que le nouvel élément, chez Fréculf et Adon, peut être identifié avec une histoire politique fondée sur la succession des empires, et que le modèle des six âges reste lié à une conception circulaire, peu dynamique, de l'histoire humaine. À son avis, seulement chez Hugues de Fleury, auteur d'une *Histoire ecclésiastique* rédigée en 1110–1111, ce schéma devient un facteur marquant du mouvement de l'histoire[30]. À mon avis on peut entrevoir une nouvauté dans ce sens déjà avec Fréculf.

Lambert rappelle l'opposition augustinienne entre la Jérusalem céleste (Fig. 5), dont le temple de Salomon est l'image[31], et la ville terrestre fondée par Caïn ou Nembroth[32], mais il entrevoit aussi le nouveau rôle assumé par la Jérusalem terrestre dans l'imaginaire de l'époque des croisades[33] et propose un parallélisme entre les six âges du monde et les principaux royaumes[34] et entre les deux listes des papes et des empereurs[35]. Il emprunte à Orose et à Fréculf l'insistance sur le rôle providentiel d'Auguste, mais aussi la tradition selon laquelle l'empereur Philippe l'Arabe fut le premier empereur chrétien, qui célébra en tant que tel le millénaire de Rome[36].

Lambert souligne la centralité du temple (figure du corps du Christ et de l'Église) dans l'histoire du peuple de Dieu (Israël, et ensuite l'Église) et le parallélisme entre le temple de Salomon, construit en quarante-six ans, et le

Fig. 5. Wolfenbüttel, Herzog August Bibliothek, Cod. Guelf. 1 Gud. lat., folio 43v, Lambert de Saint-Omer, *Liber floridus*, XIIᵉ siècle, troisième quart : La Jérusalem céleste

corps humain, qui selon les conceptions de son âge se forme en quarante-six jours[37]. En outre il voit, dans la précarité de l'histoire humaine, évoquée par l'image du labyrinthe (Fig. 7)[38], un parallélisme entre les six âges du monde (énumérés selon un ordre descendant en correspondance avec les différents métaux, de l'or au fer, jusqu'à la boue), les âges de la vie humaine et les heures du jour selon la parabole des ouvriers de la vigne (Matthieu 20,2)[39].

Représentant le rêve de Nabuchodonosor (Fig. 4), Lambert juxtapose la succession des âges à celle des empires (représentés par de métaux de valeur décroissante) pour souligner la précarité du pouvoir terrestre. Entremêlant plusieurs passages du livre de Daniel, il ne dépeint pas la pierre qui frappe la statue, mais un roi (le Christ) qui coupe un arbre (qui évoque la puissance brisée du roi babylonien assimilé à un bœuf qui mange du foin, Daniel 4, 22). La citation des vers de l'Apocalypse

Fig. 6. Wolfenbüttel, Herzog August Bibliothek, Cod. Guelf. 1 Gud. lat., folio 8v, Lambert de Saint-Omer, *Liber floridus*, XIIe siècle, troisième quart : Le roi Salomon sur le trône

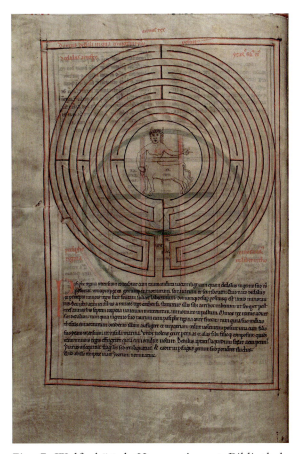

Fig. 7. Wolfenbüttel, Herzog August Bibliothek, Cod. Guelf. 1 Gud. lat., folio 19v, Lambert de Saint-Omer, *Liber floridus*, XIIe siècle, troisième quart : Le labyrinthe

«Babylone la grande, avec laquelle les rois de la terre avaient forniqué, est tombée» (Apocalypse, 14,8 ; 17,2) et la juxtaposition entre le sixième âge «de la boue» et la fin du monde («finis mundi aetas VI luti») a une signification eschatologique[40].

Les commentaires latins de l'Apocalypse

Dans l'histoire des interprétations latines de l'Apocalypse (un livre longtemps considéré avec méfiance par l'Église d'Orient) nous pouvons entrevoir quelques étapes fondamentales : l'antiquité tardive, et surtout le sixième siècle (avec les œuvres de Cassiodore, Césaire, Primase), le VIII–IX siècle (de Bède et Ambroise Autpert aux Carolingiens)[41], et après un siècle et demi de silence exégétique, l'époque inaugurée par la réforme ecclésiastique du XIe siècle, qui culmine dans l'activité d'Anselme de Laon et dans la rédaction de la Glose ordinaire et du *Liber floridus*.

L'histoire de l'exégèse de l'Apocalypse et des conceptions apocalyptiques a été analysée surtout par Kamlah, Christe, Landes, Lobrichon[42], tandis que Roger Gryson a publié l'édition critique de plusieurs commentaires du haut Moyen Âge (en particulier Bède, Beatus et quelques auteurs mineurs, comme Théodulphe et, autour de l'an Mil, l'Anonyme de Cambridge)[43]. Guy Lobrichon a fourni, dans plusieurs essais, un aperçu de l'évolution de l'exégèse de l'Apocalypse des Pères de l'Église à Joachim de Flore et un premier recensement des commentaires et gloses sur l'Apocalypse rédigées entre 1080 et 1180. Il a souligné les innovations du XIe au XIIe siècle, en particulier la relance du système de Beda (les sept *periochae*, antécédents du schéma des sept visions d'Anselme de Laon et de Bérengaud, qui a introduit une nouvelle perception historique)[44] et la réinterpretation des visions selon deux schémas, respectivement des sept âges du monde et des sept états de l'Église (*status ecclesiae*)[45]. Les commentateurs

du XIIᵉ siècle «se confrontent à trois grandes traditions (patristique, insulaire, carolingienne) mais ils «s'en affranchissent»[46]. L'Apocalypse fournit donc le critère d'interprétation de l'histoire universelle.

Les commentaires latins de l'Apocalypse de l'antiquité tardive et du haut Moyen Âge (en particulier ceux de Primase, d'Ambroise Autpert, d'Haymon d'Auxerre) proposaient, contre le millénarisme, une lecture ecclésiologique des visions du dernier livre de la Bible : les anges de l'Apocalypse évoquaient en général les prédicateurs des églises, et le temple de Salomon aussi préfigurait l'Église. Dans la femme vêtue de soleil de l'Apocalypse 12, les exégètes ont vu préfigurée l'Église, mais parfois aussi la Vierge Marie[47]. Même la représentation de la Vierge *Fons misericordie* (Fig. 8) et de la Vierge et l'Enfant avec le dragon (Fig. 9) dans le *Liber floridus* peut évoquer cette interprétation mariologique[48]. Ces commentaires favorisaient l'exégèse allégorique (principalement en direction ecclésiologique, à différents niveaux : l'Eglise toute entière, les prédicateurs, les fidèles) par rapport à l'interprétation historique et littérale : en particulier pour Autpert et Haymon *in hac autem revelatione nihil historicum est accipiendum*[49]. Reprenant la distinction (déjà décrite par Augustin) entre trois types de vision (corporelle, spirituelle et intellectuelle), Autpert et Haymon considèrent la vision de l'apôtre Jean comme intellectuelle[50]. Le dernier livre de la Bible décrit pour eux une dynamique intemporelle de l'Église, à travers l'utilisation systématique des critères herméneutiques (notamment la récapitulation) fournis par Tyconius[51] : ils soulignent donc les différences entre *l'ordo narrationis* et *l'ordo visionis*, c'est à dire la succession des visions, qui ne suit pas un ordre chronologique[52].

Le travail d'Autpert a connu une fortune plus limitée que l'oeuvre d'Haymon, largement utilisée également au XIIᵉ siècle ; son commentaire (que j'ai déjà analysé ailleurs) est transmis par de nombreux manuscrits. Les mille ans de l'Apocalypse 20 préfigurent pour

Fig. 8. Wolfenbüttel, Herzog August Bibliothek, Cod. Guelf. 1 Gud. lat., folio 9, Lambert de Saint-Omer, *Liber floridus*, XIIᵉ siècle, troisième quart : La Vierge intronisée et l'Annonciation

Fig. 9. Wolfenbüttel, Herzog August Bibliothek, Cod. Guelf. 1 Gud. lat., folio 14v, Lambert de Saint-Omer, *Liber floridus*, XIIᵉ siècle, troisième quart : La Femme de l'Apocalypse 12 et le dragon

presque tous les exégètes tout le temps de la naissance (ou de la passion) du Christ jusqu'à la venue de l'Antéchrist[53], malgré les tensions apocalyptiques évoquées par Rodolphe le Glabre et d'autres auteurs. Il suffit de rappeler rapidement ici les discussions animées sur la propagation de l'attente de l'année mille[54].

Avec Bruno de Segni (qui utilise toutefois surtout Haymon), Bérengaud et surtout avec les gloses attribuées à Anselme de Laon ou publiées sous son nom, le sens littéral réapparaît, comme l'a souligné Elisabeth Mégier[55]. Commentant les sceaux et les chevaux de l'Apocalypse 6 Bruno souligne le développement historique de l'Église et entrevoit différents moments de sa prédication. Mais pour Bruno l'interprétation d'un livre qui *tot habet sacramenta quot verba* (Jérôme, ép. 53,9) doit être encore surtout spirituelle[56].

Un maître anonyme a copié, vers 1120–1140, peut-être à Laon, une glose associée à un commentaire (Laon, BM 89) : cette génération a mis à point la *Glossa ordinaria*[57]. Le commentaire inédit d'Anselme (Leipzig Univ. ms. 172, folio 84v) identifie *iuxta litteram* Gog et Magog d'Apocalypse 20 avec deux peuples qui vivent dans le nord et vont obéir d'abord à l'Antéchrist, tout en proposant également l'interprétation allégorique traditionnelle (encore suivie par Berengaud)[58] qui les avait identifiés avec les hérétiques occultes et les persécuteurs manifestes :

hoc faciet (sc. Sathanas) per Gog et Magog, id est per duos populos qui secundum litteram in septentrione habitant et primi cedent Antichristo vel secundum allegoriam Gog, id est tectum significat latentes inimicos ut sunt haeretici et ypochrite, et Magog, id est detectum in quibus notantur tyranni et aperti persecutores ecclesie[59].

Dans le commentaire transmis per le manuscrit BNF, lat. 8865 (qui contient aussi le *Liber floridus*) Gog et Magog représentent deux peuples du Nord dans un sens spirituel, pas spatial : l'interprétation traditionnelle n'est donc pas oubliée[60].

Ce commentaire incite à plusieurs reprises les fidèles à la patience (avec des formules variables)[61], et il rejette le millénarisme, mais prévoit une possibilité de purification pour les péchés mineurs par le feu (*per ignem purgatorium* : la naissance du Purgatoire est proche)[62] et identifie les anges de l'Apocalypse 7,1 avec

les rois des quatre royaumes principaux (Chaldéens, Assyriens, Grecs, Romains), et ceux de l'Apocalypse 7,11 et 8,1 avec les *praelati*, c'est-à-dire avec les évêques, et en général avec les prédicateurs[63].

Lobrichon juge «très proches d'Anselme» Menegaudus et l'auteur d'un commentaire lié au *Liber floridus* (Paris, BNF ms. 8865), tandis que le commentaire publié sous le nom d'Anselme, qui souligne l'eschatologie individuelle et le lien hiérarchique entre prélats et sujets[64], aurait été rédigé par un maître anonyme (peut-être Raoul, le frère d'Anselme?)[65]. Menegaudus (Leipzig ms. 173) voit préfigurés dans les quatre anges de l'Apocalypse 7,1–3 les quatre royaumes de la vision de Nabuchodonosor (Assyriens, Persans, Macédoniens, Romains), soumis au royaume du Christ (la pierre de la vision de Daniel 2,45)[66]. À l'époque d'Otton de Freising, la pierre détachée de la montagne de la vision de Daniel était parfois assimilée à l'Église romaine victorieuse sur l'Empire : le chroniqueur rapporte cette interprétation en termes problématiques[67]. Pour Menegaudus, le millénaire d'Apocalypse 20 est le temps où les prélats peuvent librement exercer le pouvoir de lier et de dissoudre, c'est-à-dire gouverner et juger leurs églises :

Et in ipsis M annis ligato diabolo vidi sedens id est ecclesias et doctores sederunt super es et illud prelatis sedentibus datum est iudicium ut libere iudicarent de ecclesiis suis ligando ex iusticia[68].

Dans Gog et Magog il entrevoit en général tous les méchants, mais en particulier les peuples enfermés dans les montagnes par Alexandre le Grand, qui apparaissent également dans le mappemonde de Lambert (Fig. 10) :

Hic sunt populi pugnaces et sevissimi olim soliti evincere vicinas regiones. Contra quos pugnavit Alexander et illos devictos in faucibus montium clausis versus aquilonem murum validissimum obstruens illo, quos solvet Antichristus et in fortitudine eorum subiugavit sibi regna mundi. Vel Gog qui dicitur tectum et Magog de tecto omnes iniquos accipimus[69].

La rédaction du commentaire de Bérengaud (identifié par Visser avec le carolingien Bérengaud de Ferrières)[70] a été placée par Lobrichon «dans une aire comprise entre le Sud de

Fig. 10. Wolfenbüttel, Herzog August Bibliothek, Cod. Guelf. 1 Gud. lat., folio 69v, Lambert de Saint-Omer, *Liber floridus*, XIIe siècle, troisième quart : Carte du monde, les tribus fermées par Alexandre le Grand

l'Angleterre et la moyenne vallée du Rhin »[71] : Berengaud, peut-être un moine du royaume anglais ou de Flandre impériale, serait lié à un groupe impérial ou anglo-normand[72]. Son commentaire est caractérisé par un ton très personnel, et présente quelques éléments communs à d'autres textes de XIe–XIIe siècle, comme l'intérêt pour le sens littéral et la division du texte en visions. Berengaud interprète aussi l'ouverture des sept sceaux et des quatre chevaux de l'Apocalypse 6 en référence aux étapes de l'histoire du salut (contrairement à la plupart des exégètes) : les deux premiers chevaux (blanc et rouge) représentent les justes avant et après le déluge, le troisième (noir) les docteurs de la loi, le quatrième (pâle), pas l'Antéchrist (comme dans d'autres exégètes), mais, *in bonam partem*, les prophètes[73]. La plupart des exégètes (par exemple l'auteur du commentaire transmis par le ms. *Reg. lat.* 21) voit représentés dans le cheval blanc l'humanité du Christ guidé par sa divinité ; dans les

chevaux rouge, noir et pâle, les hérétiques et persécuteurs dirigés par le diable[74].

En outre Berengaud montre un nouvel intérêt pour la vie après la mort des âmes : la première résurrection (Apocalypse 20,6) évoque la vie des fidèles chrétiens avant le jugement dernier : *(vita) quae a passione Christi usque ad finem mundi extenditur, in qua sancti sine corporibus cum Domino vita aeterna perfruantur*[75]. Dans le commentaire anonyme de Düsseldorf B 19 (cité par Lobrichon) les mille ans (Apocalypse 20,2–7) préfigurent toute la vie des saints, *totam vitam praesentem sanctorum*, tandis que la *prima resurrectio* est identifiée avec la résurrection du péché par la pénitence[76] : à côté de la dimension de l'histoire du monde et de l'Église il y a donc la dimension du salut personnel, avant et après la mort. Les deux dimensions coexistent dans le *Liber floridus*.

Mais dans les commentaires du XIIe siècle, listés par Lobrichon, on entrevoit aussi la tendance à identifier les dix cornes de la bête de l'Apocalypse 13,1 et 17,12 et les couronnes avec les peuples et les royaumes barbares, comme « Persae, Saraceni, Wandali, Gothi, Longobardi, Burgundiones Franci, Hunni, Alani, Suevi »[77]. Pour Berengaud aussi les dix cornes de la bête *significant quippe ea regna, per quae Romanum imperium destructum est*[78]. L'auteur des gloses du ms. *Reg. lat.* 21 préfère l'interprétation traditionnelle (allégorique) de Gog et Magog et s'éloigne de la perspective d'une identification avec les Goths et les Massagets ou avec les peuples conquis par Alexandre le Grand et confinés dans deux îles :

Gog tectum tecto odio nitente sanctam aecclesiam signat. Magog detectum et qui aperta sedicione impugnantes aecclesiam signat vel a parte totum. Dicunt quidam Getas et Massagetas esse duas gentes in septentrionali plaga. Alii dicunt Alexandrum Magnum has duas gentes superasse et exilio iam dedisse in duobus insulis orientalis maris sed hoc nil valet ad universalitatem[79].

Dans le commentaire publié par Maddalena Ferri, rédigé probablement à Pise au début du 12ème siècle, il n'y a pas de tels développements, même s'il présente quelques convergences avec ceux de Bérengaud, Bruno de Segni, Anselme[80].

Les commentaires de l'Apocalypse sont souvent associés, dans les manuscrits des XIe et XIIe siècles (par exemple le *Reg. lat.* 21), à

ceux du Cantique des Cantiques, peut-être en raison des besoins de l'école[81]. Dans les manuscrits du *Liber floridus*, il y a une représentation du lis (qui évoque l'Eglise parmi les fils de Babylone), accompagnée de la légende *Sicut lilium inter spinas sic amica mea inter filias* (Cantique 2.2) (Fig. 11). Sur les côtés du lis il y a une double liste : des sept dons du Saint-Esprit et de douze arbres sous le titre *Sanctus Spiritus* ; des sept arts libéraux et de douze plantes odorantes, sous le mot *phylosophia* ; à côté l'autre, où figure une liste des évêques de Thérouanne (*Morinorum episcopi*), jusqu'à Jean, élu en 1096. Le lis évoque l'Eglise, l'épouse du Cantique, qui garde les dons du Saint-Esprit et peut harmoniser la culture profane avec eux[82].

Eschatologie et croisade

Lambert a intégré et corrigé ces modèles avec quelques textes prophétiques (en particulier les textes sibyillins, transmis par Augustin, *De civitate Dei* XVIII 23 ; le Pseudo-Méthode et la lettre d'Adson de Montier-en-Der)[83], qui fondaient une interprétation apocalyptique de la lutte entre la papauté et l'empire (jusqu'à l'affrontement entre Henri V et Pascal II) et de la première croisade[84]. Lambert entrevoit une marque eschatologique dans la figure ambiguë d'Alexandre le Grand (Fig. 12)[85], qui apparaît avant tout comme la puissance qui restreint les peuples barbares de Gog et Magog, et dans la division de l'empire carolingien[86] : il attribue à Charles le Chauve une vision et un voyage dans l'au-delà (Fig. 13), à travers lequel il exprime un jugement très critique envers les rois carolingiens et l'élite de l'Empire[87]. Lambert évoque aussi les faux prophètes et les merveilles mentionnées dans l'*Histoire des Francs* de Grégoire de Tours et les annales carolingiens[88] et rappelle la paix de Dieu en Flandre[89]. Il reconnaît un rôle fondamental à l'Église de Rome (Fig. 14) et au

Fig. 11. Wolfenbüttel, Herzog August Bibliothek, Cod. Guelf. 1 Gud. lat., folio 31v, Lambert de Saint-Omer, *Liber floridus*, XIIe siècle, troisième quart : Le lis parmi les épines

Fig. 12. Wolfenbüttel, Herzog August Bibliothek, Cod. Guelf. 1 Gud. lat., folio 88, Lambert de Saint-Omer, *Liber floridus*, XIIe siècle, troisième quart : Alexandre le Grand

Fig. 13. Ghent, Universiteitsbibliotheek, MS 92, folio 207r, Lambert de Saint-Omer, *Liber floridus*, 1120/21 : Charles le Chauve

Fig. 14. Wolfenbüttel, Herzog August Bibliothek, Cod. Guelf. 1 Gud. lat., folio 99v, Lambert de Saint-Omer, *Liber floridus*, XIIe siècle, troisième quart : Rome et saint Pierre

royaume croisé de Jérusalem, qui, préparé par l'essor des comtes de Flandre[90], annonce la fin des temps[91].

Autour de 1100 l'Apocalypse devient « le manuel de l'histoire chrétienne pour les contemporains des premières Croisades »[92], bien que les commentateurs ne disent rien sur les associations évidentes entre la conquête de Jérusalem et le sentiment d'une proximité de la Parousie, dont reste le témoignage dans la chronique de Raimond d'Aguilers[93]. Lambert considère la première croisade comme un tournant historique et souligne le rôle joué par les comtes, desquels il donne la généalogie, et les aristocrates de Flandre. Il représente le palmier, dont les feuilles représentent les vertus opposées aux vices, en l'accompagnant d'une légende rappelant le passage de l'Ecclésiastique, 24,17–23 (Fig. 15). L'arbre est planté sur le mont Sion et sur le pays de Juda. L'image est suivie d'une référence au concile de Clermont et à la croisade et d'une liste des premiers rois et patriarches de Jérusalem :

> Sous le pontificat du pape Urbain, le conseil de l'expédition à Jérusalem était célébré à Clermont, avec trois cent dix pères. Après le concile de 1097, l'expédition chrétienne fut faite et la troisième année, en 1099, Jérusalem fut conquise[94].

Le dernier roi mentionné est Baudouin III (1143–1162) et le dernier patriarche Foucher (1146–1157). Cette entrée a donc dû être complétée par une main différente après 1146.

Lambert souligne l'opposition entre l'Église et la Synagogue, malgré la perspective de la conversion finale des Juifs. Dans une image, deux arbres opposés apparaissent : le bon arbre est l'Église, tandis que la Synagogue (le mauvais arbre) est sur le point d'être engloutie par la bête de l'abîme (Fig. 16)[95]. En outre Lambert intègre le récit orosien de la destruction de Jérusalem à l'époque de Tit et de Vespasien avec une tradition selon laquelle les hommes juifs auraient été castrés, de sorte que les femmes juives se seraient mariées à des

Vandales ou à des Huns, et le peuple juif serait tombé dans la barbarie :

> « En voyant les hommes juifs castrés, les femmes qui se trouvaient en Judée prenaient comme maris Vandales et Huns, qui avaient envahi les royaumes de l'est. Par conséquent, à partir de ce moment-là, on pense que les Juifs ne descendent pas de la lignée d'Abraham mais de la lignée des Vandales[96]. »

Quelques conclusions

Au-delà de la reprise des motifs traditionnels tirés des Pères (en particulier le schéma des six âges du monde et la théorie des quatre empires) et des textes encyclopédiques (comme les *Ethymologiae* d'Isidore de Séville) et historiographiques, Lambert met en lumière une nouvelle attention portée au mouvement de l'histoire, en particulier à la lutte entre la papauté et l'empire et à la croisade (qui ouvre une nouvelle époque), mais également au

rôle joué par les Normands et les comtes de Flandre[97]. L'action violente de l'empereur Henri V contre le pape Paschal II et le *pravilegium* de l'année 1111[98] marquent une rupture et un déplacement évident du rôle providentiel de l'empire (maintenant désacralisé, aussi par la référence à la figure du roi Nabuchodonosor, devenu fou et comme une bête à cause de sa fierté) vers l'Église de la réforme "grégorienne" et les royaumes croisés. Lambert souligne fortement l'opposition entre la Synagogue des Juifs et le nouveau peuple élu, l'Église.

Le temps de l'histoire est donc un temps linéaire, différent du temps circulaire des saisons et de la liturgie et projeté vers la seconde venue du Christ, dont la première croisade semble être une préfiguration.

Cette perspective centrée sur l'Eglise et sur la société chrétienne est cependant soudée avec une attention nouvelle portée au salut individuel des chrétiens[99].

Fig. 15. Wolfenbüttel, Herzog August Bibliothek, Cod. Guelf. 1 Gud. lat., folio 32, Lambert de Saint-Omer, *Liber floridus*, XIIᵉ siècle, troisième quart : Le palmier

Fig. 16. Ghent, Universiteitsbibliotheek, MS 92, folio 253r, Lambert de Saint-Omer, *Liber floridus*, 1120/21 : L'Église et la Synagogue

NOTES

Abréviations utilisées : Ghent = Ghent, University Library, ms. 92 ; Wolfenbüttel = Cod. Guelf.1 Gud.lat.; BAV = Biblioteca apostolica Vaticana ; BNF = Bibliothèque Nationale de France.

1. G. LOBRICHON, « Les commentaires sur l'Apocalypse du prétendu "siècle obscur" jusque vers 1100 », dans *Tot sacramenta quot verba : zur Kommentierung der Apokalypse des Johannes von den Anfängen bis ins 12. Jahrhundert*, éd. K. HUBER, R. KLOTZ et Ch. WINTERER, Münster, 2014, p. 195–218, en particulier p. 196.

2. Sur les racines bibliques-patristiques de la représentation de Behemot et du Léviathan voir S. LEWIS, « Encounters with Monsters at the End of Time : Some Early Medieval Visualizations of Apocalyptic Eschatology », *Different Visions : A Journal o News perspectives on Medieval Art*, 2, 2010, p. 1–76.

3. Benzo von Alba, *Ad Heinricum IV imperatorem libri septem*, VI 6, éd. H. SEYFFERT, dans MGH, *Scriptores rerum Germanicarum in usum scholarum*, LXV, Hannover, 1996, p. 560 : *Priusquam fieret mundus, Folleprandus visus est / et in fine seculorum primus antichristus est ; / omnium herrorum caput a Behemoth factus est*. Voir S. SAGULO, *Ideologia imperiale e analisi politica in Benzone, vescovo d'Alba*, Bologna, 2003, p. 141–149.

4. Bruno de Segni (de Asti), *Expositio in Apocalypsim*, II 14, PL CLXV, 683A. Voir aussi Rupert von Deutz, *De victoria verbi Dei*, VI 27, éd. R. HAACKE, dans MGH, *Quellen zur Geistesgeschichte des Mittelaters*, V, Weimar, 1970, p. 210–211 : *Nabuchodonosor sicut in culpa, ita et in poena similis factus est captivatori generis humani diabolo* ; VII 25–26, où le diable est assimilé aux monstres bibliques Behemot (Job 40.10) et Léviathan, représentés dans le *Liber Floridus* (Ghent, chap. XLIX, folio 62rv ; *Diabolus sedens super Beemoth, Antichristus sedens super Leviathan* ; Wolfenbüttel, folios 41v–42).

5. Voir L. SMITH, *The Glossa ordinaria : the making of a medieval Bible commentary*, Leiden-Boston, 2009, p. 12, 26, qui souligne, suivant G. LOBRICHON (« Une nouveauté : les gloses de la Bible », dans *Le Moyen Âge et la Bible*, éd. P. RICHÉ, G. LOBRICHON, Paris, 1984, p. 111), la complexité de la tradition textuelle de l'Apocalypse ; *Anselmi Laudunensis Glosae super Iohannem*, éd. A. ANDRÉE, CCCM CCLXVII, Turnhout, 2014, p. XXIII–XV pour le contexte historique.

6. Par exemple, pour la description du dragon (Ghent, folio 60v) Lambert utilise Isidore de Séville, *Ethymologiae*, XII 4, 4–5. Sur la structure et les sources de l'oeuvre de Lambert et sur les rapports entre les manuscrits voir CH. HEITZMANN-P. CARMASSI, *Der Liber Floridus in Wolfenbüttel : Eine Prachthandschrift über Himmel und Erde*, Darmstadt, 2014 ; A. DEROLEZ, *The making and meaning of the Liber Floridus : a study of the original manuscript, Ghent, Univeristy Library MS 92*, Turnhout, 2015 (avec bibliographie).

7. Ghent, folios 19v, 32v, 46. Voir Bède, *Chronica maiora*, 268, dans *Chronica minora*, éd. Th. MOMMSEN (MGH, *Auctores antiquissimi*, XIII), Berolini, 1898, p. 281–282.

8. R. SAVIGNI, « Storia universale e storia ecclesiastica nel 'Chronicon' di Freculfo di Lisieux », *Studi medievali*, III s., 28, 1987, n. 1, p. 155–192. Voir aussi J. RUBENSTEIN, *Nebuchadnezzar's Dream. The Crusades, Apocalyptic Prophecy, and the End of History*, Oxford, 2019.

9. Fréculf de Lisieux, *Historiae*, II, 1, 2, éd. M. I. ALLEN, CCCM CLXIXA, Turnhout, 2002, p. 441–442.

10. Ghent, VI, folio 20v ; voir aussi XX, folio 33 : *Aetas aliquando pro VII annis dicitur sicut dicuntur sex aetates unius hominis. Aliquando aetas quinquaginta anni, aliquando tempus vitae hominis a nativitate sua usque ad mortem, aliquando pro*

sex milibus sex aetates dicuntur. Prima aetas ab Adam usque [ad] diluvium. Secunda a diluvio usque ad Abraham. Tertia ab Abraham usque ad David. Quarta a David usque ad transmigrationem Babylonis. Quinta a transmigratione Babylonis usque ad Christum. Sexta a Christo usque ad iuditium. Unde Ysidorus dicit : sexta aetas que nunc agitur usque quo mundus finiatur cuius tempus soli Deo est cognitum. Aetas ergo dicitur etiam totum tempus vitae praesentis ab initio usque ad finem, qui rappelle Isidore, *Ethymologiae* V 38, 1–5 ; V 39, 42.

11. Ghent, folio 220, qui rappelle Grégoire le Grand, *Homiliae in evangelia*, II 34, 11 (éd. R. ETAIX, CCSL, CXLI, Turnhout, 1999, p. 309).

12. Ghent, folio 33r : *cuius tempus soli Deo est cognitum* (emprunté à Isidore, *Etymologiae*, V 39,42) ; 220r. Sur la perspective antimillénariste de la tradition exégétique du haut Moyen Âge sur l'Apocalypse voir R. SAVIGNI, « Il tema del millennio in alcuni commentari altomedievali latini », *Annali di storia dell'esegesi* 15/1, 1998, p. 231–273.

13. E. SEARS, *The ages of man : medieval interpretations of the life cycle*, Princeton, 1986, p. 67–69 ; I. COCHELIN, « Introduction. Pre-Thirteenth-Century Definitions of the Life Cycle », dans *Medieval Life Cycles : Continuity and Change*, éd. I. COCHELIN et K. SMYTH, Turnhout, 2013, p. 1–54, en particulier p. 30–31.

14. Ghent, VI, folio 20v.

15. Ghent, folio 20v ; XXII, folio 46.

16. Ghent, IV, folio 19v, qui rappelle Bède, *De temporum ratione* 10 (éd. H. W. JONES, CCSL CXXIIIB, Turnhout, 1977, p. 311–312).

17. *De civitate Dei*, I 35, éd. B. DOMBART-A. KALB, CCSL XLVII, Turnhout, 1955, p. 34 ; XIV 28, p. 451 ; XIX 26, p. 696–697.

18. *De civitate Dei*, XV 1, 17 et 20–21, p. 453, 479, 484–487. Voir Ghent, folios 1v, 49v.

19. *De civitate Dei*, XX 7, éd. cit. (notre note 17), p. 708–712. Voir les essais sur *Il millenarismo cristiano e i suoi fondamenti scritturistici*, rassemblés dans *Annali di storia dell'esegesi* 15/1, 1998.

20. Orose, *Historiae adversus paganos* VI 22, 5–9 (*Le storie contro i pagani*, éd. A. LIPPOLD, Milan, 1976, II, p. 234–236). Voir E. CORSINI, *Introduzione alle Storie di Orosio*, Torino, 1968, p. 168–174.

21. Ghent, folio 138v (image d'Octavien avec l'épée à la main et la légende *Exiit edictum a Cesare Augusto ut describeretur universus orbis, VIII idus ianuarii clausit portas Iani*). Voir même Ghent, folio 2v : *Octaviano Augusto regnante anno nono fuit prima indictio* ; folio 13v : *Christo vero nato in diebus Augusti […] Quo signo quid evidentius quam in diebus Cesaris toto orbe regnantis Ihesu Christi nativitas declarata ?*, qui rappelle Orose, *Historiae*, op. cit. (notre note 20), VI 18, 34, p. 212 ; 20, 6–7, p. 220–222 ; folio 36, folio 138v–139, qui rappelle Orose, *Historiae* VI 20,1 et 5–6, p. 218–220 ; VII 4,5–6, p. 250–252.

22. Christianus Stabulensis, *Expositio super Librum generationis (Expositio in evangelium Matthaei)*, 16, éd. R. B. C. HUYGENS, CCCM, CCXXIV, Turnhout, 2008, p. 324 : *Quid profuit illis imperatoribus qui istum mundum habuerunt per viginti annos, ut Octavianus per LVI annos, cum iam per DCCC annos iaceat in inferno ?* ».

23. Orose, *Historiae adversus paganos*, op. cit. (notre note 20), III 8,3, p. 188 ; VII, 43,16–19, p. 402.

24. *Ibid.*, II 1, 5–6, p. 96 ; Jérôme, *Commentarii in Danielem*, II 7 ; Bède, *Explanatio Apocalypseos*, I 9, 7, 1, éd. R. GRYSON, CCSL CXXIA, Turnhout, 2001, p. 307.

25. Augustin, *De civitate Dei* IV 4, *éd. cit.* (notre note 17), p. 101.

26. Daniel 4, 19–22 : « (l'arbre du songe) c'est toi, ô roi ! [...] Cette vision, ô roi, en voici l'interprétation, la décision du Très-Haut qui atteint mon seigneur le roi. Tu seras chassé d'entre les hommes, tu auras ta demeure avec les animaux sauvages, on te nourrira d'herbe, comme les bœufs, tu seras trempé de la rosée du ciel, et sept temps passeront sur toi, jusqu'au moment où tu reconnaîtras que le Très-Haut est maître du royaume des hommes et le donne à qui il veut ».

27. Ghent, CLXII, folio 232v. Voir Benzo von Alba, *op. cit.* (notre note 3), VI, p. 528, 560.

28. Fréculf de Lisieux, *op. cit.* (notre note 9), en particulier I 2, 30, p. 154 ; 3, 19, p. 205–206 ; 4, 28, p. 269 ; 5, 11, p. 313 ; Ado Viennensis, *Chronicon*, dans PL CXXI, 23–138. Voir Savigni, « Storia universale », *op. cit.* (notre note 8), p. 172–175.

29. Fréculf de Lisieux, *op. cit.*, (notre note 9), II 5, 26, p. 722. Voir R. Savigni, « La *Historia ecclesiastica* e il commento di Newton all'Apocalisse », dans *La* Historia ecclesiastica *di Isaac Newton*, éd. G. Vespignani, Bologna, 2017, p. 25–69, en particulier 47–51.

30. E. Mégier, « Le temps des âges du monde, de saint Augustin à Hugues de Fleury (en passant par Isidore de Séville, Bède le Venerable, Adon de Vienne et Fréculphe de Lisieux) », dans *Le Sens du temps. The Sense of Time*, Actes du viie congrès international de latin médiéval (Lyon, 10–14 septembre 2014), éd. P. Bourgain et J. Y. Tilliette, Genève, 2017, p. 581–600, en particulier 600 : « Chez Hugues de Fleury l'histoire biblique devient ainsi capable de remplacer l'histoire des empires dans son rôle de faire avancer le temps vers la venue du Christ et la propagation de l'Église ». Voir aussi les essais réimprimés dans E. Mégier, *Christliche Weltgeschichte im 12. Jahrhundert : Themen, Variationen und Kontraste. Untersuchungen zu Hugo von Fleury, Odericus Vitalis und Otto von Freising*, Frankfurt am Main, 2010 ; Ead., *Scripture and History in the Middle Ages = Schriftsinn und Geschichte im Mittelalter : studies in Latin biblical exegesis (ca. 350-ca. 1150) : Untersuchungen zur Bibelauslegung im Mittelalter*, Berlin, 2018.

31. Wolfenbüttel, folio 43v ; et 44r pour pour le récit de la construction du temple de Salomon, le roi pacifique (préfiguration du Christ) représenté sur le sur le trône et exalté pour sa sagesse (folio 8v ; fig. 6).

32. Ghent, folio 1v : *Caim filius Adam primus civitatem primam quam Effrem vocavit condidit*, 217r ; folio 2 : *Babylonia Persidis post diluvium anno septingentesimo a Nenbroth gigante in campo Sennaar fundata* ; 217, qui utilise, avec de nombreuses variantes, le texte de Pseudo Methodius.

33. Wolfenbüttel, folio 32. Voir C. Fumarco, « La Gerusalemme celeste ed il tema crociato nei manoscritti del *Liber Floridus* dal XII al XV secolo », dans *Il cammino di Gerusalemme*, éd. S. Calò Mariani, Bari, 2002, p. 633–646.

34. Ghent, IV, folio 19v : *Ordo regnorum principaliter regnantium. Prima etas mundi ante diluvium fuit. II post diluvium fuit his laborantibus. III Assyriorum regibus precipue regnantibus. IIII Medorum regibus post regnantibus. V Persarum regibus post hos regnantibus. VI Romanorum regibus regnantibus.*

35. Ghent, XXIII–XXIV, folio 46v–47r : *Sexta aetas Romanorum imperatores et apostolicos habet.*

36. Fréculf de Lisieux, *Historiae*, pars II, 3, 5, *op. cit.* (notre note 9), p. 564 : *Hic natalis annus a Christiano imperatore celebratus est*, qui rappelle Orose, *Historiae adversus paganos, op. cit.* (notre note 20), VII 20, 1–3, p. 298–300. Voir aussi Ado Viennensis, *Chronicon, op. cit.* (notre note 28), col. 87A.

37. Ghent, folio 23v : *Quadraginta et sex annorum sub prefatis regibus templi aedificatio corpus dominicum in utero virginis formatum pulcre signaverat. Quadraginta sex anni dies XLta sex significant quibus infans in utero mulieris formatur hoc modo.* Voir Raban Maur, *Commentaria in libros Machabaeorum*, I 4, PL CIX, col. 1163AB.

38. Ghent, folio 20.

39. Ghent, folio 23v : *Aetates mundi et hominis. Aetas prima aurea hora prima et infantia ab Adam usque ad Noe. Aetas secunda argentea hora tercia a Noe usque ad Abraham. Aetas tercia aerea hora sexta et adolescentia ab Abraham usque ad David. Aetas quarta enea hora nona et iuventus a David usque ad transmigrationem Babylonis. Aetas quinta ferrea hora decima et senectus a transmigratione Babylonis usque ad Christum. Aetas sexta lutea hora XI et decrepita a Christo usque ad Dei iuditium. Item. In aetate ergo quarta mundi hora nona in iuventute fervida et gloriosa templi fabrica sub Salomone totum nobilitatur in orbe, sed accepit vesperam quando a Chaldaeis regnum illud inclitum templumque sanctissimum est dissipatum et genus David in Babyloniam translatum* ; Wolfenbüttel, folio 8.

40. Ghent, CLXII, folio 232v.

41. R. Gryson, « Les commentaires patristiques latins de l'Apocalypse », *Revue théologique de Louvain*, 28, 1997, p. 305–337, 484–502.

42. W. Kamlah, *Apokalypse und Geschichtstheologie : die mittelalterliche Auslegung der Apokaypse vor Joachim von Fiore*, Berlin, 1935 ; Y. Christe, « Beatus et la tradition latine des commentaires sur l'Apocalypse », dans *Actas del Simposio para el estudio de los Códices del "Comentario al Apocalypsis" de Beato de Liébana*, I, Madrid, 1978, p. 53–67, qui a souligné (p. 64) la « Enteschatologiesierung à dominante ecclésiale, de l'interprétation bas-romaine et médiévale » ; J. Fried, « Endzeiterwartung um die Jahrtausendwende », *Deutsches Archiv zur Erforschung des Mittelalters* 45 (1989), p. 381–473 ; G. Lobrichon, « Conserver, réformer, transformer le monde ? Les manipulations de l'Apocalypse au Moyen Âge central », dans *The role of the book in medieval culture : proceedings of the Oxford international Symposium (26 September–1 October 1982)*, éd. P. Ganz, II, Turnhout, 1986, p. 75–94 ; R. Landes, « 'Lest the Millennium Be Fulfilled : Apocalyptic Expectations and the Pattern of Western Chronography 100–800 », dans *The Use and Abuse of eschatology in the Middle Ages*, éd. W. Verbreke, D. Verhelst, A. Welkenhuysen, Leuven, 1988, p. 137–211.

43. Tyconii Afri *Expositio Apocalypseos : accedunt eiusdem Expositionis a quodam retractatae Fragmenta Taurinensia*, CCSL CVIIA, Turnhout, 2011 ; *Variorum auctorum Commentaria minora in Apocalypsin*, CCSL CVII, Turnhout, 2003 ; *Bedae presbyteri Expositio Apocalypseos*, CCSL CXXIA, Turnhout, 2001 ; *Beati Liebanensis Tractatus de Apocalipsin*, éd. R. Gryson, CCSL CVIIBC, Turnhout, 2012 ; *Incerti auctoris Glossa in Apocalypsin, e codice Bibliothecae universitatis Cantabrigiensis Dd. 10. 16*, CCSL CVIIIG, Turnhout, 2013.

44. Bède, *Explanatio Apocalypseos, op. cit.* (notre note 24), praefatio, p. 221–223. Voir Ps. Anselme, *Enarrationes in Apocalypsin*, PL CLXII, 1499–1586 ; Y. Christe, « Le *visiones* dell'Apocalisse all'undicesimo e al tredicesimo secolo : immagini, testi e contesti », *Schede medievali*, 19 (juillet-novembre 1990), p. 278–296 minimise les innovations des auteurs du XI–XII siècles (p. 283 : « Se c'è innovazione, essa è più apparente che reale »).

45. G. Lobrichon, *L'ordre de ce temps et les désordres de la fin. Apocalypse et société, du IXe à la fin du XIe siècle*, dans *The Use and Abuse of Eschatology, op. cit.* (notre note 42), p. 221–241 (réimprimé dans Lobrichon, *La Bible au Moyen Âge*, Paris, 2003, p. 129–144).

46. Lobrichon, « L'Apocalypse en débat : entre seculières et moines au XIIe siècle (v. 1080-v. 1180) », dans *L'Apocalisse nel Medioevo*, Actes du Colloque de Gargnano sul Garda (18–20 mai 2009), éd. R. E. Guglielmetti, Firenze, 2011, p. 404–426 : p. 407.

47. Berengaud, *Expositio super septem visiones libri Apocalypsis*, IV 12, PL XVII, 875A–876D : *Haec mulier Ecclesiam designat [...] Possumus per mulierem in hoc loco et beatam Mariam intelligere, eo quod ipsa mater sit Ecclesiae ; quia eum peperit, qui caput est Ecclesiae : et filia sit Ecclesiae, quia maximum membrum est Ecclesiae* ; BAV, *Reg. lat.* 21, folio 12 : *aecclesia quae fruitur sole iustitiae vel Maria* », 12v : *vel Mariam vel aecclesiam* » ; G. Lobrichon, « La Femme d'Apocalypse 12 dans l'exégèse

du haut Moyen-Age latin (760–1200) », dans *Marie. Le culte de la Vierge dans la société médiévale*, éd. D. IOGNA-PRAT, D. RUSSO, E. PALAZZO, Paris, 1996, p. 407–439 ; ID., « Les maîtres francs et l'histoire de la Femme (Apocalypse 12). Tentations et résistances mariologiques (VIII^e–XII^e siècles) », dans *Maria, l'Apocalisse e il Medioevo*, Actes du III^e Colloque mariologique, éd. C. M. PIASTRA-F. SANTI, Firenze, 2006, p. 43–55.

48. Wolfenbüttel, folio 9r (la Vierge intronisée et l'Annonciation), 14v (la femme avec l'enfant et le dragon : *Milier amicta sole habens coronam stellarum XII que peperit filium, masculum*).

49. R. SAVIGNI, *Il commentario di Aimone all'Apocalisse*, in *L'Apocalisse nel Medioevo, op. cit.* (notre note 46), p. 207–266 : p. 228. Voir aussi BAV, Vat. Lat. 1334, folio 71 : *nichil autem istorice, allegorice totum*.

50. SAVIGNI, *Il commentario di Aimone, op. cit.* (notre note 49), p. 208–209. Cette distinction est rappelée dans le commentaire attribué à Anselme de Laon, *Enarrationes in Apocalypsin*, PL CLXII, 1499 CD : *Sed quia constat hanc revelationem visione factam esse, videndum est quo genere visionis. Visio autem alia corporalis, alia spiritualis, alia intellectualis. Visio corporalis, qua videmus coelum et terram et caetera corpora. Visio spiritualis est, quando in eo quod videtur aliud praetenditur. Sicut fuit de Moyse qui vidit rubum non ardentem ardere, quod aliud significabat. Intellectualis vero quando Spiritu sancto intimante, aliquis concipit aliquid mysticum, sicut sanctus Joannes in hoc libro fecit*.

51. Voir J. M. VERCRUYSSE, « Bède lecteur de Tyconius dans l'*Expositio Apocalypseos* », dans *Bède le Vénérable entre tradition et postérité*, éd. S. LEBECQ, M. PERRIN, O. SZERWINIACK, Villeneuve d'Asq, 2005, p. 19–30.

52. Haymon d'Auxerre, *Expositio in Apocalypsin*, II 4, PL CXVII, col. 1009A : *prophetia non servat ordinem historiae : quod si faceret, iam non prophetia, sed historia esset*.

53. SAVIGNI, *op. cit.* (notre note 12), p. 251, 257 (sur Autpert et Haymon) ; Leipzig Univ. ms. 172 (Anselme), folio 84v : *tempus Deo cognitum a passione Christi usque ad Antichristum* ; BAV, *Reg. lat.*, ms. 21 (Menegaudus), folio 20v : *mille annos dixit pariter id est reliquias sexti dieiin quo natus est Dominus et passus vel mille annos vocat ab incarnatione Domini usque ad iudicium*. Pour Bruno de Segni (de Asti), *Expositio in Apocalypsim*, préf., PL CLXV, 713D–714C les mille ans préfigurent *omnes ante iudicium, et post iudicium annos*, c'est-à-dire l'éternité.

54. FRIED, *op. cit.* (notre note 42) ; *The apocalyptic year 1000 : religious expectation and social change, 950–1050*, éd. R. LANDES, A. GOW, D. C. VAN METER, Oxford-New York, 2003, en particulier D. VERHELST, « Adso of Montier-en-Der and the Fear of the Year 1000 », p. 81–92.

55. E. MÉGIER, « Il senso letterale dell'Apocalisse : negazione e affermazione, in alcuni commentari latini del Medioevo monastico, da Beda il Venerabile a Ruperto di Deutz », dans *L'Apocalisse nel Medioevo, op. cit.*, (notre note 46), p. 133–179, en particulier p. 149–151.

56. Bruno de Segni (de Asti), *Expositio in Apocalypsim*, préf., PL CLXV, 605A ; I 1, 611CD : *Convertere ergo et tu, quicunque hanc prophetiam intelligere cupis, ut nihil carnaliter sapiens, totus ad spiritualem intellectum rapiaris*.

57. LOBRICHON, *op. cit.* (notre note 1), p. 208.

58. Berengaud, *op. cit.* (notre note 47), V 20, 932AB : *Gog namque interpretatur tectum, Magog de tecto. Per Gog igitur, qui interpretatur tectum, ii designantur, qui malitiam suam in corde tegentes, justi ab hominibus videbuntur, cum futuri sint mente reprobi : Magog vero, qui interpretatur de tecto, eos designat, qui de tecto cordis sui in apertas miserias prorumpentes, omnibus se impios esse demonstrabunt*.

59. Leipzig Univ. ms. 172, folio 84v. Sur cettes traditions voir R. MANSELLI, « I popoli immaginari : Gog e Magog », dans *Popoli e Paesi nella cultura altomedievale*, Actes de la XXIX Semaine d'études, Spolète, 1983, p. 487–517.

60. BNF, *lat.* 8865, folio 25v : *duos populos septentrionales non localiter sed mente in prelium contra fideles, vel Gog qui interpretatur tectum accipiamus omnes occultos persecutores ecclesie et Magog qui interpretatur detectum manifestos persecutores*.

61. Voir par exemple folio 12v : *Ut cum illis esse possimus libenter patimini pro Domino tribulationes*. Comme l'a déjà souligné LOBRICHON, « L'Apocalypse en débat », *op. cit.* (notre note 45), p. 415, l'anonyme auteur « ponctue d'appels à la conversion » et à l'imitation du Christ les unités textuelles de son commentaire.

62. BNF, *lat.* 8865, folio 16v : *regnabit non ad tempus sicut dixerant quidam heretici qui putaverunt sanctos per mille annos esse in gloria et malis* [sic] *in penis et postea redituros in seculum* » ; 25, 29 : *si alique sunt sordes in illis minoribus per purgatorium ignem purgabuntur*. Sur la purification à travers le feu du purgatoire voir aussi Berengaud, *op. cit.* (notre note 46), 889 B et 950D.

63. Voir folio 12.

64. *Enarrationes in Apocalypsin*, dans PL CLXII, col. 1499–1586, en particulier 1573BD.

65. LOBRICHON, *op. cit.* (notre note 1), p. 208 ; ID., *op. cit.* (notre note 46), cit., p. 409–412.

66. Leipzig 173, folios 28v–29 (sue Apocalypse 7,3–4 ; Daniel 2,31–45) : *Hec quadriformis statua IIIIor reges significat [...] Videbatur etiam lapis abscisus de monte sine manibus conterere pedes ferreos et contractis pedibus caput et omnia conterebantur quia Romano imperio contrito et fidei Christi subiugato cetera regna contrita sunt et fidei supposita*.

67. Otto de Freising, *Chronica sive historia de duabus civitatibus*, VII, prol., éd. A. HOFMEISTER, dans MGH, *Scriptores rerum Germanicarum in usum scholarum*, XLV, Hannoverae et Lipsiae, 1912, p. 309 : *regno decrescente ecclesia [...] in presenti quoque in magnum montem crescens in magna auctoritate stare cepit*.

68. Leipzig 173, folio 73v.

69. Leipzig 173, folio 74r. Voir la carte du monde dans Wolfenbüttel, folio 69v (fig. 10) : *Hic inclusit Alexander regna XXXII*.

70. D. VISSER, *Apocalypse as utopian expectation (800–1500) : the apocalypse commentary of Berengaudus of Ferrières and the relationship between exegesis, liturgy and iconography*, Leiden, 1996.

71. LOBRICHON, *op. cit.* (notre note 46), p. 406, 410.

72. LOBRICHON, *op. cit.* (notre note 1), p. 206.

73. Berengaud, *op. cit.* (notre note 47), III 6, PL XVII, 813–838.

74. BAV, *Reg. lat.*, 21, folios 6v–7r, 20. Sur ce commentaire voir LOBRICHON, *op. cit.* (notre note 42), p. 85 : « la glose la plus ancienne de l'Apocalypse, en provenance du Nord de la France à la fin du XI^e siècle (BAV, *Reg. lat.* 21), reproduit des citations de Bède le Vénérable et de Haymon d'Auxerre ».

75. Berengaud, *op. cit.* (notre note 47), V 20, col. 931B.

76. LOBRICHON, *op. cit.* (notre note 1), p. 216–217.

77. BAV, *Vat. lat.* 134, folio 98.

78. Berengaud, *op. cit.* (notre note 47), V 17, col. 914C.

79. BAV, *Reg. lat.* 21, folio 21r.

80. M. FERRI, *Il commento all'Apocalisse dei mss. Cremona, Biblioteca statale 79 e Parigi, Bibliothèque national de France, lat. 16300*, E-Codicibus, Firenze, 2012, p. I–V (online : http://ecodicibus.sismelfirenze.it/index.php/expositio-in-apocalypsim-rbma-9061 ;dc).

81. F. DOLBEAU, « L'association du Cantique des Cantiques et de l'Apocalypse, en Occident, dans les inventaires et manuscrits médiévaux », dans *L'Apocalisse nel Medioevo, op. cit.* (notre note 46), p. 361–402, en particulier p. 396–398.

82. Ghent, folio 230v. Voir P. C. MAYO, « The Crusaders under the Palm : Allegorical Plants and Cosmic Kingship in the "Liber Floridus" », *Dumbarton Oaks Papers* 27, 1973, p. 29–67, en particulier p. 48.

83. D. VERHELST, « Les textes eschatologiques dans le Liber floridus », dans *The Use and Abuse of Eschatology, op. cit.* (notre note 42), p. 299–305 ; S. IVANOV, « A Text on Antichrist in St. Petersburg, National Library of Russia Lat. Q. V. IV.3 and the "Liber Floridus" », *Medieval studies* 75, 2013, p. 93–108, en particulier p. 102 : « the text of *Epistola Ps.-Methodii* has a longer and more complicated history than it was thought,

and the version included into LF does not represent its earliest recension ».

84. J. Rubinstein, « Lambert of Saint-Omer and the Apocalyptic First Crusade », in *Remembering the Crusades : myth, image, and identity*, éd. N. Paul et S. Yeager, Baltimore, 2012, p. 69–95, en particulier p. 75 : « Godefrey's elevation was an epochal moment in human history : a new empire and a new era », 83 : « he tries to harmonize the model of the four kingdoms with that of the Six Ages of history ». Sur les sources de la croisade voir J. Flori, *Chroniqueurs et propagandistes. Introduction critique aux sources de la première croisade*, Genève, 2010, p. 147 note 17 : en 1106 « Bohémond est attesté dans la région » de Saint-Omer.

85. Wolfenbüttel, folio 88 (Alexandre avec l'épée et le cheval) : *Alexander rex vultu et forma pulcherrimus subcrispa et flavescente cesarie et coma leonina*, qui rappelle Iulii Valerii *Epitome*, I 13, éd. J. Zacher, Halle, 1867, p. 16 ; Ghent, folio 18rv. Le *Liber Floridus* (Wolfenbüttel, folios 86v–93v) rappelle même trois textes de la légende d'Alexandre : la légende de sa naissance prodigieuse grâce à l'art magique de Nectanébo, la lettre d'Alexandre à Aristote et la correspondance entre Alexandre et Dindyme, roi des Brahmanes.

86. Ghent, CLV, folio 216v : *Ludovico Augusto regnante Karoli Magni filio regnum Francorum divisum est a Romanorum imperio ita. [...] Anno Domini DCCCLXXI [sic] haec divisio regnorum facta est indictione IIIIta.*

87. Ghent, LXXII, folios 207r–208r.

88. Ghent, CXLII, folios 210v–212, qui rappelle Grégoire de Tours, *Historiae Francorum*, IV 9, p. 140 ; X 25, éd. B. Krusch-W. Levison, dans MGH, *Scriptores rerum Merovingicarum*, I, Hannoverae, 1951, p. 517–519 ; *Annales regni Francorum*, éd. G. H. Pertz-F. Kurze, dans MGH, *Scriptores rerum Germanicarum in usum scholarum*, VI, p. 44, 133, 157, 163, 168, 176 ; *Annales Bertiniani*, éd. G. Waitz, dans MGH, *Scriptores rerum Germanicarum in usum scholarum*, V, Hannoverae, 1883, p. 33, 47–49, 53, 59.

89. Ghent, LXVI, folio 84v, qui rappelle la *Pax Roberti II comitis Flandriae* (27 mai 1111), dans MGH, *Constitutiones et acta publica imperatorum et regum*, I, éd. L. Weiland, Hannoverae, 1893, p. 617.

90. R. C. van Caenegem, « Sources of Flemish History in the Liber Floridus », dans *Liber Floridus Colloquium*, éd. A. Derolez, Ghent, 1973, p. 71–85.

91. Sur le « sentiment d'une proximité de la Parousie » et sur « l'échec de cet moment espéré » dans l'oeuvre de Raimond d'Aguilers voir Lobrichon, *op. cit.* (notre note 1), p. 212–213. Sur la légende du dernier empereur et ses transformations voir G. Potestà, *L'ultimo messia. Profezia e sovranità nel Medioevo*, Bologna, 2014, en particulier p. 97–103.

92. Lobrichon, *op. cit.* (notre note 1), p. 210.

93. *Ibid.*, p. 212–213.

94. Wolfenbüttel, folio 32 ; Ghent, folio 76v ; voir aussi CXX, folios 110v–128r (*Gesta Francorum Hierusalem expugnantium*). Voir A. Derolez, « The Abbey of Saint-Bertin, the *Liber Floridus*, and the Origin of the *Gesta Francorum Hierusalem Expugnantium* », *Manuscripta* 57/1, 2013, p. 1–28, en particulier 27–28 : « the historical account contained in the Gesta stops in 1106, the year Bohemond visited Saint-Omer and (there can be little doubt) met canon Lambert and monks of Saint-Bertin ».

95. Ghent, CLXII, folios 231v–232 (*arbor bona Ecclesia- arbor mala Synagoga*) ; CLXX, folio 253 : *Synagoga Christum Dei Filium abnegans prophetis incredula recedens a Deo corona deposita vexillo confracto ad infernum properans.*

96. Ghent, LXIII, folio 81 : *In cuius destructione ut genus eorum deleretur reliquos civitatis et provinciae Titus eunuchizari id est castrari praecepit. Quod infortunium cernentes quae in Iudaea erant mulieres Wamdalos et Hunos qui tunc sorte orientis regna invaserant maritos acceperunt. Quapropter tempore ab illo non de Abraham sed de Wandalorum semine descendisse creduntur* ; CXXXVII, folio 192v. Sur l'origine des Huns voir Ghent, folio 45v, qui rappelle Jordanes, *Getica*, XXIV 121 (les Huns sont nés de l'union entre les sorcières et les esprits du désert).

97. Ghent, LX, folio 76, *Genealogia comitum Normannorum* ; CXVII, folios 104–105, *Genealogia comitum Flandrie* ; et sur la lutte entre Henri V et Pascal II CXVIII, folios 105–108.

98. Ghent, CXVIII, folios 106v–108.

99. Voir la vision de Dryhthelm, transmise par Bède, *Histoire ecclésiastique* V 12, 8, éd. M. Lapidge, Paris, 2005 (Sources chrétiennes, 491), p. 82–84, et rappelée dans le *Liber floridus* (Ghent., LXIV, folios 81v–82v).

II. Images and Diagrams

Between Text and Image.
The Role of Diagrams and the Notion
of Time in the *Liber floridus*

Anja Rathmann-Lutz

This article charts some aspects of medieval ideas on linearity and cyclicity of time and the notion of history and its end, as well as characteristics of medieval diagrams in general and in the *Liber floridus* specifically.[*] Finally, it will discuss the role diagrams hold in supporting Lambert's vision of 'time and temporality' as well as of 'history' in the *Liber floridus*.

Concepts of time and temporality

Recent research has analysed the interplay of cyclic, linear and layered time in the heterogenous medieval concepts of time and has described the conceptualisation of 'time' in that period as multidimensional; it got conceptualised in unfolding, collapsing, concentrically sprawling or disruptive patterns.[1] For analytical purposes one can discern three features.

First, the dimensions of time – past, present, future – were conceived of as layers (or strata) that could merge and overlap. In historiography, liturgy, manuscript illumination, exegesis, and many other contexts, past, present and future were constantly overlaying each other, simultaneously present, harmoniously ordered and competitive at the same time. The simultaneousness of the dimensions of time served a potential transcendence of worldly time helping to understand salvation history and the non-temporal existence of God, especially when enacted in the liturgy.[2] The idea of simultaneity can also be found in considerations that stress the *synchronicity* of events in salvation history, as Fassler has shown: in his sermon *In Annunciatione Mariae* Honorius of Autun stated

It is said that on the same day and in the same hour that the first man was formed in paradise, the Son of God, who is the new man, was conceived in the womb of the Virgin. … It has also been said that the hour which Adam ate of the forbidden fruit is

the same in which Christ, suspended from the cross, drank vinegar mixed with gall; and that hour in which God expelled men from Paradise, is that in which Christ led the thief with him into Paradise.[3]

It is important to realize how closely related the ideas of layered time are at work in liturgical, exegetical, historiographical and encyclopaedic texts. By creating moments of synchronicity, those ideas in fact accentuate the theological differentiation of times and notion of caesura like the incarnation and the end of time. The twelfth-century Anglo-Norman paraliturgical play *Ordo representacionis Ade*, for example, provided the concept of an '*all time*, wherein the beginning, the middle, and the end of human history can be viewed at once'[4] as Fassler put it.[5]

Second, the relation of circularity and linearity of time was also complex and interrelated. Chronometrical methods, the bible, exegesis and ritual proved to be interdependent, and cooperated in the adaptation of linear and cyclical concepts of time into history. This can be seen for example in medieval historiography shaped by the ambition to illuminate the relation between sacred, eschatological time and history on earth.[6] The biblical revelation was the most important foundation for the understanding and conceptualisation of temporal structures: past, present and future times are typologically interlocked, and ultimately all worldly events, be they institutional or individual, are linked to a sacred timeline leading up to the last days and to the end of time. This sacred time is one model that enfolds a (nearly) linear sequence of time. Another would be the simultaneous overlapping of all dimensions, as well as the punctual coalescence of historical and eschatological time, and eternity (as indicated above).[7] Circularity and cyclicity of time come into play with an Augustinian concept of time, with the liturgy

and the liturgical as well as the 'natural' calendar.[8] The biblical past was re-enacted again and again, saints' days were celebrated year round and reiterated each year, the monthly labours as well as local and regional (later 'national') events were periodically remembered – just so that the time on earth and the road to salvation seemed to be a spiral (or a spring), not a straight line.

Third, history in time certainly did not always evolve at the same pace and with the same degree of intensity. There are ways of perceiving time as concentrated, packed, or accelerated. This aspect of temporality becomes crucial especially in the context of eschatological thinking. Here, the idea of a concentration or acceleration of time towards and just before the end becomes especially virulent as can be seen in the visuality, materiality and performativity surrounding the topic: in liturgy, but also in other ritual action, on cathedral facades and in illuminated manuscripts it is possible not only to show and explain but also to 'make feel' the interconnections of time layers, the accumulation of meaning towards the end and – on occasion – the proximity of the last days: in her study of the representations of the three enthroned figures of Solomon, Mary and Christ depicted in the *Liber floridus* Hanna Vorholt has shown the subtle use of the potential of the medium 'book' that made it possible for Lambert to combine and compress linear, cyclical and simultaneous dimensions of time within a short sequence.[9]

As so many of his predecessors and contemporaries, Lambert was rather obsessed with time – either with calculating historical time and rendering it in neat tables, enumerations, or lists, or with the relation of these worldly temporal arrangements in the microcosm to the macrocosm and eternity.[10] And like his peers he used to stage the past as present and to use those complex concepts of time to cope with present and future expectations. In the last part, this article will discuss the three aspects – the different layers of time (past, present, future, eternity, the last being 'no-time' of course), the relation of circularity and linearity of time, and the concentration or acceleration of time in periods of heightened eschatological interest – in relation to Lambert's use of diagrams. In order to better grasp this use what follows is a short overview of

the special functions of diagrams in medieval manuscripts and of the diagrams we encounter in the *Liber floridus*.

Diagrams

In the last decades there has been a lot of research discussing the ancient scientific, cosmological traditions[11] as well as the various types of medieval diagrams, underlining the notion that diagrams are situated precisely between the text and the image, and investigating how this position leads to their special function in the processes of understanding, organizing, transmitting, and creating knowledge.[12] Diagrams – that is agreed on – are not only passive, static representations or renderings of already known facts, but *agents* in those processes.[13]

Following Michael Evans, Faith Wallis defined diagrams basically as 'inscribed geometrical figures',[14] in combination with the notion of diagrams as 'arguments in visual form' that leads consequently to the idea of 'diagrammatical thinking' as an epistemological deployment.[15] And although there is no clear dividing line between a 'proper' diagram and a map, diagrams are conceived of as being more dynamic, as 'constantly subject to change'.[16]

The idea is that there is a 'diagrammatical momentum' that structures the reception and production of both texts and images, and provides the opportunity to transfer the authoritative power of diagrams to the text or image in question. A diagram conveys order by its regular and regulated composition, and claims attention by its specific visual appearance within the layout of the codex. At the same time, one has to accept a potential ambiguity and ambivalence of diagrammatic structures set between geometry, figure and ornament, and oscillating in their semiotic status between indexicality, symbolicity and iconicity: they point to something, they stand for something and they are a picture/representation of something.[17] As to *time*, diagrams store in themselves and display – in form and content – all different time layers. They offer the possibility of simultaneous perception, of going back and forth in a process (of understanding), and of multidirectional repetition.[18]

The realization of this potential is different for each text and diagram in the process of

its design and production, and it changes over time with its audience and use. Diagrams thereby are 'doubly relational': the diagram is the medium through which abstract relations become visible and at the same time relations are the subject matter of the diagram. The relational element is potent not only within the diagrams but also in their referentiality to the external, the beholder and their performance of decoding.[19] While there is always a preceding decision on which elements are to be omitted in order to arrive at a uniform and discernible image – a decision that renders invisible many elements of the theme or object referenced – the graphic rework on the folio also adds new spatial and temporal relations: the elements are connected to 'above or beneath', 'high or low', 'left or right', east (or north) is above, plus is right, the incarnation may be left from the beholders 'now', the 'after' in the right corner.[20]

To summarise, medieval diagrams are characterized by a) the manifoldness of their manifestations (often based on ancient types) and applications, b) their epistemic impulse or momentum, supported by their authority as well as their didactic and dialogic features (*haec figura demonstrat ...*),[21] c) their instrumentality,[22] and d) contemporary reflections on their role and potential in different contexts.

All these aspects are to be found in the *Liber floridus*:[23] the classical types, the analogical arguments, the hybridity of text and image in various manifestations, the didactic purpose, as well as the performative and dynamic force of the diagrams. It is therefore no coincidence that in his contribution to the volume *Diagramm und Text* (2014) Jean-Claude Schmitt developed a kind of typology of medieval diagrams by surveying the diagrams of the *Liber floridus*.[24]

It contains more than thirty diagrams scattered throughout the manuscript, but clustered on folios 19–26, 88–94 and 221–232, mostly in sections on astronomical and cosmological themes.[25] They draw on ancient models transmitted via Isidor of Sevilla, Bede, and many others, sometimes giving them a new twist.[26] Normally they consist of a circlet endowed with the respective information on the continents, the climate zones, the winds, the cycle of the sun, the moon phases, the fixed stars and the planets. They visualize

and demonstrate the relations of *microcosm* and *macrocosm* (folio 20v; W, folio 31). Sometimes figural, symbolic or ornamental elements are added to the segments and lines of the circles. But the diagrams would not be complete – and in fact would not serve their function, would not be understandable – without the accompanying texts: inscriptions consisting of single words, small phrases or text blocks deriving from Bede, Isidor and many others, as well as of numbers and numerals.[27] The folios with those diagrams in the proper sense are clearly distinct from the surrounding pages, the layout centres around the diagram, and the texts themselves are fitted to encompass it, both in terms of their layout and content.[28]

The role of diagrams and the notion of time in the *Liber floridus*

Right at the beginning of his work Lambert provides a brilliant example of how different dimensions of time are visually blended into each other.[29] In the author-picture on folio 13 facing the patron saint on folio 6v (Fig. 1), Lambert blends the time of the historical figure, Audomar, now elevated into eternity, the history of Saint-Omer, the present of his own time (writing), the liturgical time (*versus*) and the 'now' of his readers as well as the future of the book.[30] By analogising the frontal figure of the saint with other enthroned figures of the Antichrist (62v), Christ (88, W.64v), Augustus (138v), Peter (168), Godfather (232v) and to a lesser degree *Karolus calvus* (207), and the city walls of Saint-Omer with the Paradise (52), the heavenly Jerusalem (65) and Rome (168), he adds further temporal layers as well as spatial connections to that initial image. Representations of space, especially the world map (92v–93; W.69v–70) and the map of Europe (241), underline the notion of simultaneity by combining different historical strata in a design that incorporates its ancient sources and historical narratives *en miniature*.[31]

At the same time, visual analogies and parallelisation generate a 'time of the book', the time it takes to read and understand the contents of Lambert's composition. The reader/user/beholder are required to interlink these images, to go back and forth at least mentally but probably also physically by

Fig. 1. Ghent, Universiteitsbibliotheek, MS 92, folio 6v, 13, Lambert of Saint-Omer, *Liber floridus* (autograph), 1121: Saint-Omer and Lambert

flipping the pages or ruminating in the unbound leaves.[32] Thus while taking their time to understand and reflect, they contribute to the temporality of the book as a whole and create their very own time-space. It is this intellectual and physical engagement with the ideas expressed in text and image that gains momentum through the use of the diagrams and their respective traditions, their sequence in the manuscript and the meaning added by Lambert in the inscriptions. It may have been an analogous experience as reading in the hyperlink age – the decision to follow a 'link' must be renewed every time the opportunity appears and it leads to various new or known fields of information and knowledge. At the end of such a reading process always stands a new text, created by the reader. The aspect of learning and structuring but also dynamizing the thought process is boosted by the diagrams (and the other visual renderings as well).[33] Thus, with Gerald Guest the *Liber floridus* can be seen as a 'machine' of knowledge transmission and production.[34]

Towards the future the cross-fading of times is reinforced by the special 'reverse' order that Kathrin Müller delineated for the cosmological diagrams, where the pages with astronomical and cosmological content always follow chapters on apocalyptic and eschatological topics; so Lambert purported an order that required the end of the world to engage with its present form.[35] It is worth noting that after the diagrams often follow computistical or historiographical chapters carrying this engagement from the natural to the historical order of the world, again a macrocosm microcosm relation, embedded in its frame of salvific history. This engagement may have been urgent for Lambert as he was expecting the end of time imminently.

The concern with eschatological urgency can be seen in the attempt to compress time, to tightly link the past, the present of the beholder and the end of times, the latter usually conceived as a more distant future, and to add a sense of acceleration or movement or the need for action in the face of

Fig. 2. Ghent, Universiteitsbibliotheek, MS 92, folio 88, Lambert of Saint-Omer, *Liber floridus* (autograph), 1121: Christ in a Mandorla/*De quatuor elementis*

the second coming of Christ. The first can be seen on folio 88 (Fig. 2). It was initially conceived to be the beginning of the Apocalypse cycle and has been relocated under the caption *De quatuor elementis* (chapter 78) to be the preface to an astrological series of diagrams on folios 88v to 94v: planets and months, the signs of the zodiac, the course of the sun and the moon through the signs, the respective positions of sun, moon, and earth, the map *globus terre*, and finally three diagrams on the phases of the moon, the northern sky and the planetary system.[36] The central figure of Christ with the lamb in a mandorla inscribed with verses from Apc 5 points to the apocalyptic future, and the same goes for the truncated circle of *abyssus* lower on the page. The elements (*ignis, aer, terrae, aqua*) are arranged around Christ like the symbols of the four Evangelists.[37] The inscriptions in the margins invoke the biblical and exegetical past, the creation according to Bede,[38] while the altar located between the abyss and Christ provides the link to the readers present. Above the altar stands a – again truncated

– circle with inscriptions on the different modes of the year.[39] Together they close the gap between the world, fixed in its temporalities, and 'a visionary eternity'. The present of the beholder is invoked by the liturgy thought to be performed at the altar, 'just as cosmic harmony is achieved by the unification of the different elements the concord of the discordant year modes is realized in the liturgy'.[40] Once again it becomes visible how crucial the liturgy is for the temporal order and for the understanding of different dimensions of time as synchronic and simultaneous. On the verso, the highly abstract rendering of densely compressed time layers of folio 88 is transformed into the cyclical sequence of a year with its pertaining planets and zodiac, *annus* being the connecting element.[41] Apart from *Sol* in his wagon placed in a circle, all the other elements on the page are represented in rectangles. The course of time – of a year on earth and in the sky – is here and in the following pages presented as stable and secure, based on ancient cosmological knowledge. But the different temporal layers are still existent through the circle, which represents the ongoing change and eternal sameness at once.[42] This section would have been closed by another outstanding composition under the caption *Item de astrologia* which is transmitted only by the Wolfenbüttel copy of the *Liber floridus* (W, folio 64v, fig. 3).[43] Here Christ in the mandorla presides over a cosmological diagram composed around the central T-O-map, echoing the composition on folio 88 and subtending the abyss with the paradise. Again, time is both represented and suspended simultaneously.

For Lambert's conception of temporality in texts, images and diagrams alike, one can summarize with Fassler's comment on the *Ordo representacionis Ade* that it 'represents all time, both in its use of liturgical sources and in its exegesis. It challenges its audience members to position themselves within this time, to be ready for the inevitable judgment that they were created to face'.[44] The diagrams were part of that challenge the readers had to engage with. Through typology and analogy they convey a 'presence of the future'[45] without bluntly 'telling' the readers – presumably Lambert's fellow canons and pupils – how things would be and when they would eventually come, but

Fig. 3. Wolfenbüttel, Herzog August Bibliothek, Cod. Guelf. 1 Gud. lat., folio 64v, *Liber floridus*, 12ᵗʰ century (2ⁿᵈ half): Christ in a Mandorla / *Item de astrologia*

Fig. 4. Ghent, Universiteitsbibliotheek, MS 92, folio 76v, Lambert of Saint-Omer, *Liber floridus* (autograph), 1121: Palm Tree

required close and cross reading, analogizing, self-reflection and historicizing.

Embedded within this ravel of interwoven dimensions of time focussing on a known future is Lambert's 'historical time', putting forward enumerations, lists and – again – diagrams. Considerable portions of the *Liber floridus* are filled with historiography and time reckoning.[46] In these parts time manifests as linear as far as it is chronological, chronometrical, genealogical, computistical, or annalistic. Moreover, these parts are full of lists and enumerations clearly distinguished by their layout, that provide an even more linear view of time, for example the names of emperors and popes on folios 46v and 47 or the British dukes and kings on folio 68 or the *nomina regum Francorum* on folio 240.[47] In addition to Lambert's use of the concept of linear time, he transposes Augustin's idea of the six ages consequentially into a circle, thus drawing on and profiting from the idea of the circle as finite and infinite at the same time.[48] On

folio 19v and 20v (figs 6, 7), the familiar sight of round diagrams engages with the *Ordo regnorum principaliter regnantium* in Chapter IV and the *Mundi etates usque ad Godefridum regem* in Chapter VI. On folio 19v, a short world history also organised along the six ages and written below the diagram corresponds with the age-defining names of important persons or rulers in the sections of the circle above, requiring a reader who compares both elements on the page, eyes jumping up and down, looking for the equivalents.[49] On folio 20v six half-circles surround a face in a circle circumscribed *mundus*. They contain the six ages, their intersecting arcs conveying potentially infinite motion through them.[50] Each part has the names and facts pertaining to the respective age. The first compartment is located at the top of the circle, the ages then run clockwise to the sixth, where it ends with the caption *In hac anno Domini MXCIX Godefridus dux cepit Hierusalem, ind. VII* while other computations generally name only the number of years and

Fig. 5. Ghent, Universiteitsbibliotheek, MS 92, folio 230v, Lambert of Saint-Omer, *Liber floridus* (autograph), 1121: Lily

Fig. 6. Ghent, Universiteitsbibliotheek, MS 92, folio 19v, Lambert of Saint-Omer, *Liber floridus* (autograph), 1121: Diagram/*Ordo regnorum principaliter regnantium*

Fig. 7. Ghent, Universiteitsbibliotheek, MS 92, folio 20v, Lambert of Saint-Omer, *Liber floridus* (autograph), 1121: Diagram/*Mundi etates usque ad Godefridum regem*

not a date. While on 19v the end of the sixth age is kept vague with *Dagobertus et multi alii*, on 20v the imminent end of the world looms following the conquest of Jerusalem.[51] On folio 20v, the short list of the seven ages of man reinforce the idea of the microcosm-macrocosm-relation so important to Lambert under the superscription *Microcosmos, hoc est minor mvndvs, per VII ętates hominis descriptus*. These are derived from musings on the number 7 and link to the seven days of Creation while the more common theme, the six ages of man, is dealt with in chapter 27.[52] But in this way the potential movement of the wheel is indicated: the time after the capture of Jerusalem can be imagined as the seventh age.[53]

Here the second element – acceleration and the sense of the need for action – becomes visible. The notion of acceleration and compression of time is highlighted with the announcement of the coming of the Antichrist under the circle on folio 19v[54] and with a date given for the end of the sixth age on folio 20v, while on folio 76v beneath the palm tree as

well as on folio 230v next to the lily (figs 4, 5) Lambert had left space – and therefore time on earth – to complete the lists of names.[55] The space Lambert provided was to be filled with the names of the persons who would use the time left on earth to continue their rightful actions, because he may have sensed that the countdown had begun after the capture of Jerusalem.[56] Time was running out for the worldly rulers to complete their moral and military journey in order to help accomplish the last steps to the Last Judgement and the transition to eternity that must inevitably follow the end of the sixth age.[57]

So with his circle diagrams of the six ages Lambert certainly did not imagine history to be repeated, but in using the circle he is pointing again to the idea that the last day is at hand: when the sixth age ends in the last compartment of folio 20v with *Godefridus dux cepit Hierusalem*, it is the power of the round symbol that – potentially – transforms the time on earth into heavenly eternity. Moreover, even if worldly life continues to develop up until the

Fig. 8. Wolfenbüttel, Herzog August Bibliothek, Cod. Guelf. 1 Gud. lat., folio 31, *Liber floridus*, 12th century (2nd half): Diagrams/Microcosm and Macrocosm

last judgement, the time of history is thought to unfold dynamically like a rolling wheel.[58] The traditional circle-diagrams come with the authority imbued them from their ancient cosmological contexts and in addition remind the readers of the *rota fortunae*, requiring a reading orientation that moves in circles and imagines a typologically thought recurrence of events, strengthened by the graphic concatenation of the segments. That, in turn, picks up the diagrams showing the course of the year and of the planets so often pictured in the manuscript – suggesting the 'natural', cosmologically approved motion and *motivation* of history towards the last days and the judgement.[59]

Seen together, the two diagrams, which present history in a dynamic, circular way, and the enumerations, genealogies and lists so numerous throughout the manuscript, join cyclical and linear temporalities in order to 'spiral' the way up to the Apocalypse, while constantly representing the simultaneity of past and present dimensions of time, oriented towards the known, already revealed, future.

NOTES

* The article is based on research conducted in cooperation with Miriam Czock (†), Henrike Haug, and Christina Lechtermann (cf. note 1, 15). I would like to thank them as well as Patrizia Carmassi, Urte Krass, Cornelia Logemann, and Hanna Vorholt, for sharing their ideas, thoughts, and critique with me.

1. For the following cf. M. CZOCK and A. RATHMANN-LUTZ, 'ZeitenWelten – auf der Suche nach denVorstellungen von Zeit im Mittelalter. Eine Einleitung', in *ZeitenWelten. Zur Verschränkung von Weltdeutung und Zeitwahrnehmung, 750–1350*, ed. M. CZOCK and A. RATHMANN-LUTZ, Köln, 2016, p. 9–26 (bibliography, p. 27–37). Since the publication of that volume research on this topic has increased, cf. D. A. BRITTON, 'Book Review Essay. Histories and temporalities past, present, and future', *postmedieval*, 10/1, 2019, p. 111–126.

2. Liturgy attempts to transcend worldly time by blending time layers and performative acts in order to be able to invoke the salvation history as well as the eternal presence of God during Mass. CZOCK and RATHMANN-LUTZ, p. 13; cf. especially M. E. FASSLER, 'The Liturgical Framework ofTime and the Representation of History', in *Representing History, 900–1300. Art, Music, History*, ed. R. A. MAXWELL, University Park, Pa., 2010, p. 149–186. Cf. also the article of Laura ALBIERO, 'The sacred time in *Liber floridus*: calendar and liturgy', p. 237–245 (present volume).

3. *Legitur quod ea die eademque hora qua primus homo conditus est in paradyso, etiam Filius Dei in ea novus homo sit conceptus in Virginis utero.* […] *Traditur etiam quod ea hora qua Adam de vetita arbore commederit, ea Christus in arbore crucis pendens, acetum cum felle biberit; atque ea hora quae Dominus hominem de paradyso expulerit, ea Christus latronem in eum introduxerit.* Honorius Augustodunensis, Speculum ecclesiae, In Annunciatione Sanctae Mariae, PL 172, cols 901D–908B, here 902D–903; cited and translated by M. E. FASSLER, 'Representations ofTime in *Ordo representacionis Ade*', *Yale French Studies*, Special Issue: Contexts: Style andValues in Medieval Art and Literature, 1991, p. 97–113, here p. 112.

4. FASSLER, op. cit. (note 3), p. 100. Note that there is no proven link between Lambert and Honorius, A. DEROLEZ, *The Making and Meaning of the Liber Floridus. A Study of the Original Manuscript, Ghent, University Library, MS 92*, London 2015 (Studies in Medieval and Early Renaissance Art History, 76), p. 43.

5. See below part III for those layers in Lambert's work. For the play C. SYMES, 'The Play of Adam (Ordo representacionis Ade). 12th century', in *The Broadview Anthology of Medieval Drama*, ed. C. M. FITZGERALD and J. T. SEBASTIAN, Peterborough, 2012, p. 23–67 (Web edition, p. 1–45).

6. CZOCK and RATHMANN-LUTZ, op. cit. (note 1), p. 17.

7. Cf. P. CARMASSI, 'Zeit und Reform in mittelalterlichen Handschriften aus Halberstadt', in CZOCK and RATHMANN-LUTZ (ed.) op. cit. (note 1), p. 195–212.

8. Cf. K. MONDSCHEIN/D. CASEY, 'Time and Timekeeping', in *Handbook of Medieval Culture* 3, ed. A. CLASSEN, Berlin, 2015, p. 1657–1679; H.-W. GOETZ and A. RATHMANN-LUTZ, 'Zeit- und Geschichtsvorstellungen', in *MIRA. Mittelalter und Renaissance in der Romania*, ed. L. BECKER et al., Frankfurt/M., 2020 (in press).

9. Cf. H.VORHOLT, 'Visual Studies for the End of Time', in this volume.

10. Cf. ALBIERO, op. cit. (note 2).

11. Cf. the work of B. Obrist, e.g. B. OBRIST, 'Démontrer, montrer et l'évidence visuelle: Les figures cosmologiques, de la fin de l'Antiquité a Guillaume de Conches et au début du xiiie siècle', in *Diagramm und Text. Diagrammatische Strukturen und die Dynamisierung von Wissen und Erfahrung.* Überstorfer Colloquium (2012), ed. E. C. LUTZ,V. JERJEN and C. PUTZO,Wiesbaden, 2014, p. 45–78; B. OBRIST, 'Les figures des textes cosmologiques et astronomiques du xiie siècle', *Humanistica*, 7, 2013, p. 81–91; B. OBRIST, 'Wind Diagrams and Medieval Cosmology', *Speculum*, 72, 1997, p. 33–84.

12. "Sie [die Diagrammatik] führt grundsätzlich über die Wahrnehmung und abbildende Darstellung des Natürlichunmittelbar-Vorhandenen hinaus und setzt Analyse, Strukturierung, Neukombination in stärkerem Maß in Gang als andere Darstellungsformen. Die Differenzierung von Komplexem und die Reduktion von Multiplizität ist häufig ihre Aufgabe. Sie tendiert generell vom Aggregat zum System. Damit wird die Beherrschung des Mannigfaltigen und die Transparenz von schwer Durchschaubarem in gedachten Ordnungen angestrebt. Mit der Abstraktion von der vielteiligen Summe der Phänomene wird über ihre Repräsentation durch ausgewählte Zeichen das Abstrakte, das Unsichtbare selbst erreicht. C. MEIER, 'Die Quadratur des Kreises: die Diagrammatik des 12. Jahrhunderts als symbolische Denk- und Darstellungsform', in *Die Bildwelt der Diagramme Joachims von Fiore. Zur Medialität religiös-politischer Programme im Mittelalter*, ed. A. PATSCHOVSKY, Ostfildern, 2003, p. 23–53, here p. 53.

13. S. BOGEN and F.THÜRLEMANN, 'Jenseits der Opposition von Text und Bild: Überlegungen zu einer Theorie des Diagramms und des Diagrammatischen', in *Die Bildwelt der Diagramme Joachims von Fiore. Zur Medialität religiös-politischer Programme im Mittelalter*, ed. A. PATSCHOVSKY, Ostfildern, 2003, p. 1–22; K. MÜLLER, 'Mutmaßungen über *figura* und *substantia* der Welt. Die Diagramme im *Liber Floridus* des Lambert von Saint-Omer', in *Figura. Dynamiken der Zeiten und Zeichen im Mittelalter*, ed. C. KIENING and K. MERTENS FLEURY,Würzburg, 2013, p. 173–204.

14. F. WALLIS, 'What a medieval diagram shows: a case study of *Computus*', *Studies in iconography*, 36, 2015, p. 1–40, here p. 3.

15. E. C. LUTZ, 'Diagramm, Diagrammatik und diagrammatisches Denken. Zur Einleitung', LUTZ, JERJEN and PUTZO (ed.), op. cit. (note 11), p. 9–22, here p. 11.; H. HAUG, C. LECHTERMANN and A. RATHMANN-LUTZ, 'Diagramme im Gebrauch', *Das Mittelalter*, 22/2, 2017, p. 259–266. One could also call it 'thinking in analogies' like Jean-Claude Schmitt put it (J.-C. SCHMITT, 'Qu'est-ce qu'un diagramme? A propos du *Liber Floridus* de Lambert de Saint-Omer (ca. 1120)', in LUTZ, JERJEN and PUTZO [ed.], op. cit. [note 11], p. 79–94, here p. 80), but then the geometrical argument stands back and the connection to the typological thinking gets more visible.

16. 'Although we can map various aspects of reality, a map is always an explicit representation of whatever reality that is. A diagram, on the other hand, presents only one of the many possible ways of depicting knowledge in a structured manner. In other words, a diagram is constantly subject to change'. K. DE COENE, 'Continuity or innovation? No dilemma in the *Liber Floridus* of Lambert of Saint-Omer (1121)', *Caert-Thresoor*, 34/2, 2015, p. 67–78, here p. 69;

cf. also K. WHITTINGTON, *Body-Worlds: Opicinus de Canistris and the medieval cartographic imagination*, Toronto, 2014 (Text. Image. Context. Studies in Medieval Manuscript Illumination, 1 / Studies and texts, 186), p. 112–124. For the maps of the *Liber floridus* cf. among others D. LECOQ, 'La Mappemonde du "Liber Floridus" ou la vision du monde de Lambert de Saint-Omer', *Imago mundi. The international journal for the history of cartography*, 39, 1987, p. 9–49; K. DE COENE – M. DE REU – P. DE MAEYER, *Liber Floridus 1121. The World in a Book*, Tielt, 2011.

17. HAUG, LECHTERMANN and RATHMANN-LUTZ, op. cit. (note 15), p. 263–264. 'Ils portent dans leur configuration même une part de la vérité qu'ils expriment. A la limite, on pourrait dire que le diagramme se substitue au savoir caché ou trop vaste dont il est l'indice. C'est pourquoi la question essentielle que posent les diagrammes est celle de leur rapport à la vérité: si celle-ci est au-delà de la figure, on peut dire aussi que la figure la contient.' SCHMITT, op. cit. (note 15), p. 94.

18. 'Mit einem kontuitiven oder polyperspektivischen Sehen erfaßt sie die Simultaneität des an sich Sukzessiven, Kontinuierlichen. Das Angebot verschiedener Perzeptionsweisen fordert den Scharfsinn oder die meditative Versenkung des Rezipienten. All diese Operationen, die visuell gelenkte oder logische sind, setzen eine starke Bewußtheit von den Erkenntnisstrukturen voraus'. MEIER, op. cit. (note 12), p. 53. 'In the case of these computus schemata, these relationships and patterns evoke order, stability, repetition, circularity – a ratio within the formless flow of time that is perceived by the intellect but that can be represented to the senses by an image, just as the *figura solida* can represent the intangible properties of the elements.' WALLIS, op. cit. (note 14), p. 32, 4.

19. S. KRÄMER, *Figuration, Anschauung, Erkenntnis: Grundlinien einer Diagrammatologie*, Berlin, 2016 (Suhrkamp-Taschenbuch Wissenschaft, 2176), p. 71; cf. also S. KRÄMER, 'Diagrammatisch', in *Rheinsprung. Zeitschrift für Bildkritik*, 11, 2013, p. 162–174; S. KRÄMER, 'Zur Grammatik der Diagrammatik', *Zeitschrift für Literaturwissenschaft und Linguistik*, 44, 2014, p. 11–30.

20. HAUG, LECHTERMANN and RATHMANN-LUTZ, op. cit. (note 15), p. 261–263; cf. for Hildegard of Bingen MEIER, op. cit. (note 12), p. 37.

21. DE COENE, op. cit. (note 16); J. F. HAMBURGER, *Haec figura demonstrat: Diagramme in einem Pariser Exemplar von Lothars von Segni 'De missarum mysteriis' aus dem frühen 13. Jahrhundert*, Boston 2013 (Wolfgang Stammler Gastprofessur Für Germanische Philologie. Vorträge, 20). For the didactic and dialogic purpose of the *Liber floridus* cf. also note 33.

22. 'Darstellungen der Diagramme [sind] in hohem Maße abhängig einerseits vom im Instrument verkörperten "Wissen", andererseits von den ,Möglichkeiten'der Instrumente und Zeichenwerkzeuge neues Wissen zu erzeugen'. HAUG, LECHTERMANN and RATHMANN-LUTZ, op. cit. (note 15), p. 264–266, here p. 264.

23. This article is concerned with the autograph, Ghent, University Library, Ms. 92 (G), including sometimes the parts reconstructed from later manuscripts. All references are to G if not labelled otherwise. Cf. LAMBERT VON ST.-OMER, *Lamberti S. Audomari canonici Liber Floridus. Codex autographus Bibliothecae Universitatis Gandavensis*, ed. Albert DEROLEZ and Egied I. STRUBBE, Gent, 1968; DEROLEZ, op. cit. (note 4); H. VORHOLT, *Shaping knowledge. The transmission of the Liber Floridus*. London 2017 (Warburg Institute Studies and Texts, 6).

24. SCHMITT, op. cit. (note 15); cf. the review of S. KRÄMER in *Arbitrium* 34/3, 2016; see also A. SOMFAI, 'The *Liber Floridus* in the Encyclopaedic Tradition. Philosophical and Scientific Diagrams in Context', in DE COENE, DE REU, DE MAEYER, op. cit. (note 16), p. 75–88. I would not agree with Schmitt that only the

Sphere of Life and Death (folio 26) has a performative function – instead especially when we ask for the concepts of time and temporality, I would emphasize the performative aspect for most of the diagrams (and pictures) in the *Liber floridus*. As Penelope Mayo, Kathrin Müller and many others have already shown it is the active engagement with the pictures and the diagrams – both intellectual and physical – which brings forward the or rather a meaning. And even if Schmitt differentiates between static and dynamic diagrams the performative aspect needs more emphasize, as Schmitt seems to suggest himself: 'Les diagrammes statiques livrent et hiérarchisent un ensemble d'informations sans établir entre elles de mouvement explicite. Toutefois, même dans ce cas, le déchiffrement du diagramme suppose un parcours par les yeux ou avec le doigt pour en suivre les lignes et en déchiffrer les inscriptions'. SCHMITT, op. cit. (note 15), p. 86.

25. Or to be more concise folios 19–20v, 24r–26v, 88, 88v–91v, 92–94v, 221v–228v, cf. MÜLLER, op. cit. (note 13), p. 180; SOMFAI, op. cit., p. 77–81.

26. Albert Derolez called them 'original' at the Orléans conference, March 2019. Cf. DEROLEZ, op. cit. (note 4), p. 43, 62.

27. MÜLLER, op. cit. (note 13), p. 180.

28. Cf. note 16 for the distinction between maps, other images and diagrams.

29. Müller calls him consequently 'a mediator between the times'. MÜLLER, op. cit. (note 13), p. 179.

30. MÜLLER, op. cit. (note 13), p. 178. This 'now' encompasses also the contemporary history of Flanders. Cf. A. DEROLEZ, 'The Abbey of Saint-Bertin, the *Liber Floridus*, and the Origin of the *Gesta Francorum Hierusalem expugnantium*', *Manuscripta* 57/1, 2013, p. 1–28; C. HEITZMANN, 'The Wolfenbüttel manuscript and the place and function of history in the *Liber floridus*', in this volume.

31. A.-D. VON DEN BRINCKEN, 'Raum und Zeit in der Geschichtsenzylopädie des hohen Mittelalters', *Beiträge zur Geschichte von Stadt und Stift Essen*, 96, 1981, p. 18–19, for medieval maps as 'history maps', ibid., p. 7; M. STERCKEN, 'Mapping Time at the Threshold of Modernity', in *Temporality and Mediality in Late Medieval and Early Modern Culture*, ed. C. KIENING and M. STERCKEN, Turnhout, 2018, p. 147–175; LECOQ, op. cit. (note 16); cf. DEROLEZ, op. cit. (note 4), p. 76–77, 147–148 for the original place of the maps.

32. Cf. A. RATHMANN-LUTZ, '… vide infra, … vide supra. Flipping Through Times in the *Rudimentum Novitiorum* (1475)', in: KIENING –STERCKEN, Temporality and Mediality, p. 177–196.

33. Cf. the article by P. CARMASSI in the present volume. For the intellectual and political context of the *Liber floridus*, especially its relation to the Gregorian Reform, cf. also W. P. BLOCKMANS, 'À la recherche de l'ordre divin. Le *Liber floridus* de Lambert de Saint-Omer en contexte (1121)', *Revue du Nord*, 424/1, 2018, p. 11–31. He suggested a *didactic use* of the *Liber floridus* comparable to the *Hortus deliciarum* some sixty years later. 'L'unité de pensée du Liber floridus peut être comprise comme une recherche de la cohérence des systèmes circulaires du cosmos et du monde, une vision unitaire et globale destinée à offrir un réconfort intellectuel aux chrétiens' (ibid.). Cf. also F. J. GRIFFITHS, *The Garden of Delights. Reform and Renaissance for Women in the Twelfth Century*, Philadelphia, 2007 (The Middle Ages Series); K. P. KINSELLA, 'Teaching through Architecture: Honorius Augustodunensis and the Medieval Church', in *Horizontal Learning in the High Middle Ages. Peer-to-Peer Knowledge Transfer in Religious Communities*, ed. M. LONG, T. SNIJDERS and S. VANDERPUTTEN, Amsterdam, 2019, p. 141–162. DE COENE, op. cit. (note 16), p. 69. emphasises the dialogic character of the maps.

34. 'Illuminated manuscripts are machines for the production of meaning, machines activated by readers whose own subjectivities are transformed in the reading process'. G. B.

GUEST, 'Illuminated Manuscripts as Machines', *Manuscripta*, 55/2, 2011, p. 139–169, here p. 168.

35. MÜLLER, op. cit. (note 13), p. 184. I do not agree with her suggestion that – from a medieval perspective – it would have been more plausible to arrange the topics the other way round (ibid., p. 187). Why would a medieval reader have 'expected' a 'chronological' order?

36. DEROLEZ, op. cit. (note 4), p. 102–105.

37. P. CARMASSI, 'Quellen und Methode in Lamberts Enzyklopädie', in *Der Liber Floridus in Wolfenbüttel. Eine Prachthandschrift über Himmel und Erde*, ed. P. CARMASSI and C. HEITZMANN, Darmstadt, 2014, p. 5–27, here p. 23–26. For the connections between the *maiestas Domini* motif and astronomical and computistical diagrams cf. also B. KÜHNEL, *The End of Time in the Order of Things: Science and Eschatology in Early Medieval Art*, Regensburg 2003, and the critical review K. MÜLLER, 'Bianca Kühnel: The End of Time in the Order of Things. Science and Eschatology in Early Medieval Art, Regensburg 2003', *sehepunkte* 4/10, 2004, http://www.sehepunkte.historicum.net/2004/10/4192.html [15.10.2004].

38. Excerpts from Bede, *De natura rerum*, ed. C. W. JONES, Turnhout, 1975 (CCSL 123A), p. 189–234, ch. 1–2, here p. 192–193.

39. On folio 88 the year modes are abstracted to their names cannot be traced simultaneously on any physical chart: *ANNVS X modis dicitur: annus civilis, annus naturalis, annus iubileus et luscralis et byssextilis et Olympiadis et ęra et solaris et communis et embolismalis et brevis.*

40. P. C. MAYO, 'Concordia discordantium: A Twelfth-Century Illustration of Time and Eternity', in *Album amicorum Kenneth C. Lindsay: Essays on Art and Literature*, ed. S. A. STEIN, Binghamton, 1990, p. 45 (both citations).

41. 'The front of our metaphoric icon is a metaphysical distillation of time; the reverse is convulsed into pinwheel motion.' MAYO, op. cit., p. 47.

42. For this discussion in Hildegard of Bingen, Bernard Silvestris, and others see MEIER, op. cit. (note 12, p. 38–40).

43. DEROLEZ, op. cit. (note 4), p. 105.

44. FASSLER, op. cit. (note 3), p. 111.

45. MÜLLER, op. cit. (note 13), p. 189.

46. Cf. DEROLEZ, op. cit. (note 4), p. 339–341, Index III. Titles in Lambert's table of contents. The contents range from computistical material to world chronicles and annals with contemporary events, and genealogies (including Lambert's own, at the very end, folio 154). It is not always easy to draw strict lines between the genres as historiography and the *computus* on one side and the *computus* and cosmology on the other side intersect. See also note 55.

47. As can be seen on the layout for folio 36v–37 however even an annalistic schema is not that linear as one might suppose.

48. Cf. note 42. For a late 13th-century example of this visualization in St Petersburg, National Library of Russia, Ms. prov. Fr. Fv. XIV 1, see J.-C. SCHMITT, *L'histoire en lignes et en rondelles. Les figures du temps chrétien au Moyen Âge*, Wiesbaden, 2015 (Wolfgang-Stammler-Gastprofessur Für Germanische Philologie. Vorträge, 21), 19–20, and fig. 14. Only that here the last segment of folio 20v is the beginning and its runs anticlockwise. Cf. G. DUNPHY, 'Six Ages of the World', in *Encyclopedia of the Medieval Chronicle 2*, ed. Graeme DUNPHY and Cristian BRATU, Leiden, 2010, p. 1367–1370, for an introduction on the Six Ages.

49. The circumscriptions around the diagram point to the idea of the four kingdoms instead. Cf. DEROLEZ, op. cit. (note 4), p. 57. Rubenstein argues that Lambert highlights his conflation of the four kingdoms and the six ages in the visualisation of the dreams of Nebuchadnezzar on folio 232v. J. RUBENSTEIN, 'Lambert of Saint-Omer and the Apocalyptic First Crusade', in *Remembering the crusades: myth, image, and identity*, ed. N. PAUL and S. M. YEAGER, Baltimore, 2012 (Rethinking Theory), p. 69–95,

here p. 81–83; P. C. MAYO, 'The Crusaders under the Palm: Allegorical Plants and Cosmic Kingship in the "Liber Floridus"', *Dumbarton Oaks Papers*, 27, 1973, p. 55–67.

50. Cf. VORHOLT, op. cit. (note 9).

51. DEROLEZ, op. cit. (note 4), p. 57–58, as for the intersecting arcs points to their origin in Bede manuscripts. Cf. for example Baltimore, The Walters Art Museum, Cosmography, Ms. W.73, folio 8, http://www.thedigitalwalters.org/Data/WaltersManuscripts/html/W73/description.html [22.11.2019]; MAYO, op. cit. (note 49), p. 65.

52. The diagrams on macrocosm and microcosm are transmitted via the Wolfenbüttel manuscript and are similar to that on 20v. DEROLEZ, op. cit. (note 4), p. 75–76.

53. Situated in between the two historical diagrams one finds the labyrinth *Domus Dedali in qua Minotaurum posuit Mynos rex* pointing not only to circular but more complicated – bodily – movements within the circle of the world and through the pages of the *codex*. It can – in addition to its – be considered as a 'reading help', see note 32. Cf. DEROLEZ, op. cit. (note 4), p. 58–59.

54. *Huius ętatis vespera ceteris obscurior in Antichristi est persecutione ventura.* Cf. Hrabanus Maurus, De rerum naturis X, 9 *De ebdomadibus*, PL 111, col. 299; Beda, *De temporum ratione*, X, 42; DEROLEZ, op. cit. (note 4), p. 57.

55. Cf. MAYO, op. cit. (note 49), p. 38, 65. As in the *Ordo representacionis Ade* it is Nebuchadnezzar who provides the link to the Last Judgement (232v). Cf. FASSLER, op. cit. (note 3), p. 111.

The historical texts in the *Liber floridus* have two focus points, the history of Flanders, and the crusade. Cf. DEROLEZ, op. cit., p. 28. 'Whether the monks of Saint-Bertin were particularly interested in the eschatological implications of the delivery of Jerusalem by the Christian army is not known. Lambert of Saint-Omer certainly was'. For this link cf. RUBENSTEIN, op. cit. (note 49); and lately J. RUBENSTEIN, *Nebuchadnezzar's Dream. The Crusades, Apocalyptic Prophecy, and the End of History*, Oxford, 2019, p. 21–63.

Time spaces to fill – sometimes very small, sometimes already partly filled – appear on folio 3, 44, 44v–46, 46v, 47, 68, 76v, 105, 105', 188, 230v, 240, 240v, 271.

On the Antichrist see M. Rizzi, 'Is the end at hands? Pseudo-Methodius, the Jews and the *Liber floridus*', in this volume.

56. How important in fact the crusade was to Lambert can also be seen in the excerpts at the beginning of the LF where he not only copied and pasted historical data from the *Liber* into a 'survey of world history in a nutshell' (DEROLEZ, op. cit. [note 4], p. 46.) but also in the text added on folio 1 *De pomo Paradysi*. The text dates the discovery of the Paradis Apple in relation to the crusade – *Parvo tempore ante expedicionem Christianorum, quę sub rege Godefrido Hierosilimis facta est* [...] (ibid., p. 45) – thereby creating an ironic or reluctant analogy to the retrospective incarnation era. Cf. A.-D. VON DEN BRINCKEN, 'Beobachtungen zum Aufkommen der retrospektiven Inkarnationsära', *Archiv für Diplomatik*, 25, 1979, p. 1–20; cf. RUBENSTEIN, op. cit. (note 49), p. 75, on the excerpts on folio 1v.

57. For further ideas on time on earth after the end of the sixth age cf. R. E. LERNER, 'Refreshment of the Saints: The Time after Antichrist as a Station for Earthly Progress in Medieval Thought', *Traditio*, 32, 1976, p. 109–117.

58. Later in the 12th century Otto of Freising wrote in the prologue to his 'Chronicle or the History of the two Cities' that the wise should not whirl around with the world around him (*Sapientis enim est officium non more volubilis rotae rotari, sed in virtutum constantia ad quadrati corporis modum firmari*. Otto of Freising, *Chronica sive Historia de duabus civitatibus*, Leipzig 1912 (MGH Scriptores Rerum Germanicarum, 45), 6. Respectively the *predestinatio* in Hildegard's vision is symbolized by a square. Cf. MEIER, op. cit. (note 12), p. 37, 44.

59. The genealogies and linear historical narratives on the succession of rulers and kingdoms serve a similar purpose – they reinforce the idea that these lines have come to a natural and logical terminus with Godfrey. MAYO, op. cit. (note 49), p. 64. Take for example chapter CLXVIIII (234–240v) narrating world history (from Troy) to the capture of Jerusalem concluding with the genealogy of Frankish and Flemish crusaders. Cf. A. WORM, 'Arbor autem humanum genus significat: Trees of Genealogy and Sacred History in the Twelfth Century', in *The tree. Symbol, Allegory, and Mnemonic Device in Medieval Art and Thought*, ed. P. SALONIUS and A. WORM, Turnhout, 2014 (International Medieval Research, 20), p. 35–67.

L'univers du *Liber floridus* et les lieux des anges, des âmes et de la divinité

Barbara Obrist

Daté de 1120/21, le *Liber floridus* a été composé à une époque charnière de l'histoire des conceptions médiévales de l'univers. A la suite des traductions de textes arabes d'astronomie et de philosophie naturelle entreprises à partir de la fin du XIe siècle, le modèle platonico-stoïcien à huit sphères concentriques qui avait prévalu dans le monde latin depuis l'Antiquité commençait à faire l'objet de modifications. Puis, au début du XIIIe siècle, le modèle à neuf sphères s'y était définitivement substitué, en même temps que la cosmologie aristotélicienne avait fini par triompher.

Se pose donc la question du modèle cosmologique qui sous-tend les nombreuses figures visuelles des sphères célestes dans le manuscrit autographe du *Liber floridus*, ainsi que ceux de ses textes qui portent sur la structure et la constitution corporelle de l'univers. Ce modèle est-il marqué ou non par la première vague de traductions de textes astronomiques et physiques, étant entendu que ces deux disciplines étaient constitutives – à des degrés variables – des diverses représentations de l'univers, grecques et romaines, puis arabes ? Surtout, comment est conçue et représentée la limite externe de l'univers sphérique dans ce vaste florilège de figures visuelles et de textes compilés par Lambert de Saint-Omer ?

Toutefois, les facteurs susceptibles d'avoir contribué à modifier les idées sur le nombre et la constitution des sphères célestes durant la première moitié du XIIe siècle ne se réduisent pas à l'influence des documents nouvellement venus à la connaissance des latins. En effet, la spéculation théologique contemporaine y a puissamment contribué, cependant que, à l'époque précédant le XIIe siècle, les concepts cosmologiques de base étaient transmis dans une relative indépendance vis-à-vis de la théologie. Un corpus de connaissances issu de textes antiques consacrés à la cosmographie s'était diffusé principalement en association

avec des recueils de textes, de tables et de figures ayant servi d'outils de travail pour l'établissement du calendrier ecclésiastique luni-solaire, les recueils dits de comput. Très présents dans les communautés monastiques et cléricales, ces recueils comportent des exposés cosmographiques centrés sur l'univers physique, à savoir l'univers soumis aux contingences du temps et du lieu. Dans le contexte de la pratique du calcul des intervalles temporels, les perspectives scripturaires, théologiques et spirituelles demeuraient marginales, et n'intéressaient qu'à titre exceptionnel, leur présence se manifestant notamment par quelques interprétations allégoriques de telle partie de l'univers physique.

Mais au début du XIIe siècle, l'importance croissante de l'histoire du salut et de la perspective eschatologique conduisirent pour la toute première fois à des altérations de la structure même de l'univers : les lieux des âmes soit condamnées soit sauvées s'ajoutent en son centre et à sa périphérie, l'enfer et le paradis céleste[1]. La composition donnée de l'univers physique, ainsi que son extension, se modifièrent ainsi en fonction de l'idée d'un temps linéaire débutant avec la Création et trouvant son terme au Jugement dernier. Les listes chronologiques et généalogiques structurant l'histoire du salut avaient bien fait partie d'un grand nombre de recueils de comput depuis l'époque des écrits de Bède, mais elles ne faisaient que se juxtaposer aux exposés cosmographiques qui restaient dans le sillage des manuels romains et de leurs prolongements médiévaux. Quant au *Liber floridus* qui lui-même se conforme au genre littéraire des recueils de comput pour ce qui concerne ses sections cosmographiques, astronomiques et computistes, il témoigne de façon exemplaire de l'intensification des préoccupations d'ordre historique et apocalyptique : de nombreuses sections en sont consacrées à divers aspects de

l'histoire, ainsi qu'à des questions théologiques afférentes, y compris celle de l'Incarnation et de la Rédemption. Fait significatif, le *Liber floridus* comporte des extraits du *Cur Deus homo* d'Anselme de Cantorbéry.

Se pose ainsi la question de savoir si les représentations de l'univers du *Liber floridus* sont influencées ou non par les courants théologiques et spirituels contemporains. Plus particulièrement, les figures et les textes qui ont pour sujet les sphères externes, ménagent-ils une place aux âmes bienheureuses, ainsi qu'aux créatures qui leur sont associées, les anges, étant entendu que de telles extensions de l'univers posaient le problème redoutable de la constitution, corporelle ou non, des lieux supplémentaires, ainsi que de leur rapport à l'univers des astronomes et des philosophes de la nature. S'y ajoute la question concomitante du statut épistémologique des ces lieux : sont-ils des objets de perception sensible, de connaissance spirituelle ou intellectuelle, ou bien se soustraient-ils à toute compréhension ? Si quelques-uns des théologiens du XIIe siècle admettaient bien des lieux supplémentaires soit à la périphérie soit au-delà de l'univers – bien plus facilement que dans le cas du lieu infernal central –, la justification philosophique de ces lieux s'avérait difficile. En effet, les théories aristotéliciennes du lieu qui excluent la possibilité d'un lieu extra cosmique et d'un vide extra cosmique commençaient à être connues autrement que par la voie d'une doxographie plus ou moins sommaire. Et lorsque, de surcroît, les manipulations de la périphérie de l'univers ne s'arrêtaient pas aux lieux attribués aux créatures, aux âmes bienheureuses et aux anges, mais s'étendaient à la divinité, se posait avec acuité le problème du lieu ou du non-lieu de Dieu.

La présente étude se propose de passer en revue, tout d'abord, les traits distinctifs du modèle de l'univers qui avait prévalu à l'époque précédant le XIIe siècle, et encore à son début, tout en distinguant entre composantes astronomiques et composantes physiques. Puis elle relèvera les principales caractéristiques de la représentation de l'univers du *Liber floridus*, d'abord celles qui appartiennent au domaine de l'astronomie puis celles qui sont davantage redevables de la physique élémentaire, tout en cherchant à situer ces caractéristiques par rapport au modèle de l'univers qui avait

prédominé jusqu'au début du XIIe siècle. Les figures visuelles des sphères concentriques seront au centre de l'intérêt dans la mesure où les sections cosmographiques du *Liber floridus* se composent principalement de séries de figures et de leurs légendes, cependant que le rapport entre les figures et les exposés cosmographiques suivis demeure lâche. Dans un deuxième temps, l'étude cherchera à dégager celles des prises de position théologiques du compilateur qui sont susceptibles d'avoir marqué ses idées sur les parties externes de l'univers, corporelles ou incorporelles. Enfin, la représentation de l'univers du *Liber floridus* sera évaluée dans le contexte historique des premières décennies du XIIe siècle.

★ ★ ★

Les théories des mouvements stellaires et de la structure de l'univers sphérique qui sont à la base du modèle cosmologique des manuels romains puis des manuels de l'époque médiévale précédant le XIIe siècle relevaient en dernière instance de l'astronomie mathématique. Dans les exposés destinés à un public de non-spécialistes, les représentations astronomiques les plus généralement acceptées de l'univers admettaient le mouvement diurne des astres dits fixes, d'est en ouest, ainsi que ceux, en sens inverse, de chacune des sept planètes, depuis Saturne jusqu'à la Lune. Disposé autour d'un point géométrique central, l'ensemble de ces mouvements était conçu dans des termes de cercles concentriques ayant constitué, par la même occasion, la structure du monde. Il s'agit là de la matrice à la fois conceptuelle et picturale de la cosmologie romaine puis médiévale[2] qui sous-tend non seulement les représentations astronomiques de l'univers mais aussi celles qui relèvent de la philosophie de la nature.

Dans le contexte des spéculations physiques – tant platoniciennes qu'aristotéliciennes –, les cercles célestes intelligibles des astronomes représentent des sphères célestes de constitution corporelle. Quant à la composition du corps du monde dans son intégralité, la théorie la plus couramment admise, y compris dans les manuels des premiers siècles du Moyen Age, supposait quatre corps élémentaires. Disposés en strates sphériques, la terre, l'eau et l'air étaient réservés au domaine sublunaire, un feu

plus ou moins subtil, à sa partie supra lunaire. A propos des lieux de ces quatre corps élémentaires, diverses traditions philosophiques convergeaient dans les manuels, péripatéticiennes, plato- et néoplatoniciennes. Si ces lieux étaient déterminés en principe par le recours aux opposés du lourd et du léger, ou encore du dense et du subtil, la cohésion des éléments – et simultanément leurs transformations les uns dans les autres – était censée être assurée soit par des proportions géométriques, soit par des opposés de qualités tangibles telles que le chaud et le sec, le froid et l'humide. Unitaire, le modèle de l'univers physique constitué de quatre éléments, issu en dernier lieu de Platon, prévalait dans les manuels romains, tout comme il était pris à leur compte par les Pères de l'Église.

Concernant le domaine astronomique dans le sens étroit du terme, donc celui consacré notamment aux mouvements des corps célestes, les manuels des premiers siècles du Moyen Age transmettaient deux types principaux d'astronomie, d'une part l'astronomie stellaire qui remontait pour l'essentiel aux *Phénomènes* d'Aratos de Sole (vers 315–245 av. J.-C.) et, d'autre part, l'astronomie planétaire dérivée, quant à elle, principalement du Livre II de *l'Histoire naturelle* de Pline. De ce dernier type, le *De la nature des choses* de Bède (vers 703) constituait l'un des principaux canaux de transmission[3]. Une deuxième série d'extraits astronomiques de l'*Histoire naturelle* était mise en circulation dans les *Libri computi* rassemblés vers 809[4]. Si le *De la nature des choses* de Bède accordait une certaine place à l'astronomie planétaire, la toute première cosmographie médiévale, le *De la nature des choses* d'Isidore de Séville (vers 613), privilégiait la physique élémentaire. Toutefois, la question des transformations cycliques des corps élémentaires dont se compose l'univers occupant une place centrale dans ce manuel[5], la question de leurs lieux y demeure en retrait.

Les passages astronomiques et physiques extraits de divers manuels romains, ainsi que des cosmographies d'Isidore et de Bède, étaient couramment transmis, à partir de l'époque carolingienne, par les recueils de comput. A l'occasion, les descriptions de la structure de l'univers y étaient accompagnées de figures visuelles des sphères célestes concentriques. Les figures représentant les seules sept sphères

planétaires étaient redevables de la tradition picturale issue du *De la nature des choses* d'Isidore[6]. Celles, en revanche, qui comprennent l'ensemble des huit sphères reproduisaient les modèles de diverses sources picturales antiques, à commencer par le *Commentaire au Songe de Scipion* de Cicéron de Macrobe (420–430)[7], étant entendu que ni l'*Histoire naturelle* de Pline ni la cosmographie de Bède ne comportaient de figures visuelles. Quant aux strates élémentaires concentriques dont le corps de l'univers sphérique était censé se composer, ils ne faisaient pas l'objet de transpositions picturales. Les figures composées de cercles concentriques visualisaient soit les seuls cercles célestes soit y ajoutaient un cercle central dénotant la sphère terrestre. Ni la sphère de l'eau ni celle de l'air, entre la terre et le ciel, n'y étaient signifiées par ces cercles supplémentaires.

Toutefois, les connaissances cosmologiques de l'époque précédant le XIIe siècle ne se réduisaient pas à celles transmises par la doxographie souvent succincte des manuels les plus couramment consultés. En effet, traduit en latin par Calcidius au début du Ve siècle, le *Timée* de Platon – ou tout au moins la partie du dialogue qui s'étend de 17a à 53c – était remise en circulation aux alentours de 800[8]. Quant au commentaire sur le *Timée* composé par son traducteur, Calcidius, lui aussi connu depuis l'époque carolingienne, il introduisait des éléments de philosophie néoplatonicienne, en même temps qu'il transmettait au Moyen Age latin des parties substantielle d'un ouvrage élémentaire grec d'astronomie d'Adraste, perdu, et destiné à servir de guide dans la lecture de Platon. Mais l'étude de ces textes philosophiques de base et de leur astronomie demeurait confinée dans quelques cercles restreints de maîtres d'école. La seconde source majeure de la cosmologie platonicienne – ainsi que de ses élaborations stoïciennes et néoplatoniciennes –, à savoir le *Commentaire au Songe de Scipion* de Macrobe était plus largement diffusé et des extraits de ses chapitres astronomiques faisaient partie intégrante des recueils de comput, contrairement à ceux transmis par Calcidius.

Le modèle cosmologique de l'un et l'autre de ces ouvrages est le même que celui des manuels rudimentaires : leurs sections astronomiques sont dotées de figures visuelles de huit

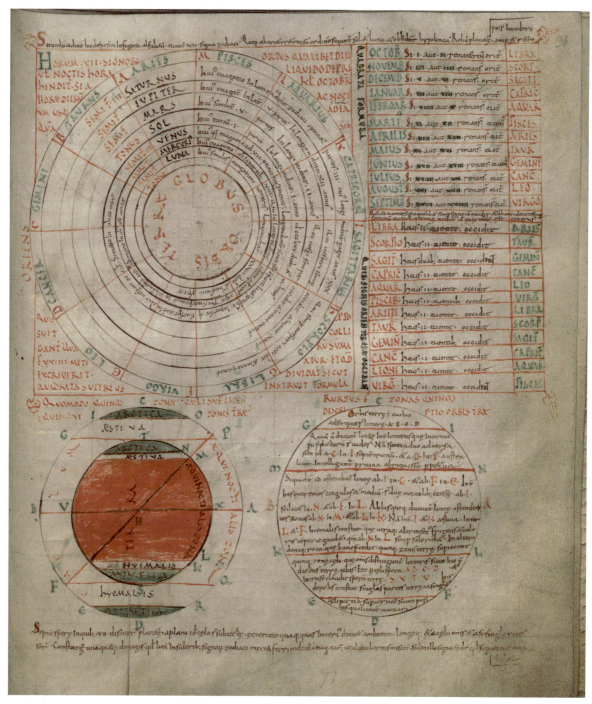

Fig. 1a. Berlin, Staatsbibliotek zu Berlin, Preussischer Kulturbesitz, Phill. 1833, folio 36, Fleury, s. XI in., Ecole d'Abbon de Fleury. Compendium computiste, cosmographique et astronomique : Figures extraites du *Commentaire au Songe de Scipion* de Macrobe : les sphères célestes concentriques et la bande du zodiaque entourant le globe terrestre ; la correspondance entre les cinq zones célestes et terrestres ; les zones terrestres

sphères célestes concentriques, celle transmise par Calcidius se composant des sept sphères planétaires et d'une ultime sphère intitulée « *aplanes* ». Les sphères y sont disposées autour d'un médaillon central doté de la légende « *terra* »[9]. Dans la figure des sphères planétaires du *Commentaire* de Macrobe, les sept sphères planétaires sont entourées par la seule bande

du zodiaque, tandis que le cercle central y est appelé « *globus terre* »[10].

Si l'astronomie transmise par Macrobe était très présente dans les recueils de comput, ses figures des sphères célestes l'étaient tout autant. A ce propos, le compendium computiste, cosmographique et astronomique issu de l'enseignement d'Abbon de Fleury, écolâtre

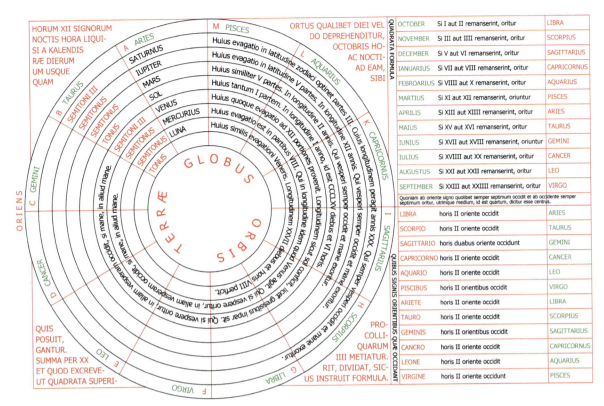

Fig. 1b. Berlin, Staatsbibliotek zu Berlin, Preussischer Kulturbesitz, Phill. 1833, folio 36, Fleury, s. XI in. A. Lohr transcr., in *Abbonis Floriacensis Miscellanea de computo, de astronomia et de cosmographia*, Turnhout, 2019, p. 48–49 : Figures extraites du *Commentaire au Songe de Scipion* de Macrobe : les sphères célestes concentriques et la bande du zodiaque entourant le globe terrestre ; la correspondance entre les cinq zones célestes et terrestres ; les zones terrestres.

célèbre en son temps, peut servir d'exemple privilégié (Fig. 1). Compilé soit par le maître lui-même soit par son entourage immédiat, le principal manuscrit de ce recueil, des alentours de l'an mil, est conservé à Berlin (SBPK, Phill. 1833). Comme l'indiquent les légendes qui accompagnent la première des figure circulaires du folio 36 de ce manuscrit, les cercles concentriques s'y ordonnent autour du «*globus orbis terrae*» selon la durée du parcours des planètes dans les douze signes du zodiaque, de la Lune jusqu'à Saturne, le tout étant entouré par la bande du zodiaque. S'y ajoute, dans la partie inférieure de la page, à gauche, la figure macrobienne des cinq «ceintures» climatiques à la fois célestes et terrestres. A droite, une deuxième figure circulaire des zones sert de cadre au texte consacré à la démonstration de la correspondance des ceintures célestes et terrestres[11]. Composé principalement de séries de figures cosmologiques et de tables computistes auxquelles des textes explicatifs ne font que se rattacher, le compendium d'Abbon de Fleury avait joui d'un succès exceptionnel, ce dont atteste le nombre élevé

de manuscrits qui en comportent des extraits – plus d'une quarantaine –[12]. Aussi l'une des nombreuses versions de ce compendium est-elle susceptible d'avoir été connue de Lambert de Saint-Omer ; mais la question attend d'être approfondie (Fig. 1a, 1b).

Le modèle cosmologique qui avait prévalu à l'époque précédant le XIIᵉ siècle était fondamentalement platonicien et il prédomina jusqu'à ce que les traductions fassent connaître avec plus de détails qu'auparavant la cosmologie d'Aristote à partir de la première moitié de ce siècle. Or dans la tradition cosmologique aristotélicienne, d'abord connue à travers les traductions de résumés cosmographiques arabes, l'ensemble des quatre corps élémentaires sont confinés dans la partie sublunaire du monde où ils forment (idéalement) trois strates sphériques autour de la sphères terrestre centrale. En revanche, la partie céleste de cet univers est supposée se constituer d'un élément à part, l'éther ni léger ni pesant, incorruptible et éternellement mû d'un mouvement circulaire. Grande figure du platonisme du XIIᵉ siècle, Guillaume

de Conches se profile comme l'un des premiers auteurs latins à avoir discuté le modèle aristotélicien de l'univers dans son *Dragmaticon philosophie* (1144–1149), dans le seul but de s'y opposer. Le graphique qui visualise ce modèle dans le manuscrit le plus ancien du *Dragmaticon* à nous être parvenu se compose à la fois des cercles concentriques des huit orbes célestes et d'un ensemble de cercles dénotant les quatre strates élémentaires sublunaires, ce qui représente une nouveauté. La légende placée sur le pourtour de la figure indique que les sphères célestes se composent de quintessence, tandis que les strates élémentaires de la partie centrale de l'univers sont désignées par les mots feu, air, eau et terre[13].

En principe, tant le modèle platonicien que le modèle aristotélicien, ainsi que leurs dérivés, ont en commun d'attribuer huit orbes à la partie céleste de l'univers. Mais, très présente dans les élaborations arabes de la physique aristotélicienne et de ses prolongements métaphysiques, l'idée d'un neuvième orbe céleste, avec sa fonction de premier moteur, commence elle aussi à être connue dans la première moitié du XIIᵉ siècle. A ce propos, le *Libellus de astrolapsus* d'Adélard de Bath (entre 1149 et 1150 offre l'un des premiers témoignages de sa réception[14]. Enfin, les traditions astronomiques grecques et arabes, ou bien gréco-arabes, nouvellement venues à la connaissance des latins du XIIᵉ siècle proposaient elles aussi soit huit, soit neuf, voire dix sphères célestes. Celle qui remonte à l'*Almageste* – ou la *Syntaxe mathématique* – suppose un ciel divisé en huit sphères, en même temps que son introduction, par Ptolémée, met en avant le modèle aristotélicien de l'univers. En revanche, la tradition issue en dernier lieu des *Hypothèses planétaires* de ce même astronome pose un neuvième orbe dépourvu d'étoiles. Dans ce cas-ci, l'hypothèse d'un orbe supplémentaire visait à dissocier le mouvement diurne des astres fixes de celui, en sens inverse, de la précession, à raison d'un degré en cent ans[15]. Tout comme la philosophie péripatéticienne, l'astronomie et la cosmologie ptoléméennes étaient d'abord connues, au XIIᵉ siècle, par l'intermédiaire d'abrégés traduits de l'arabe, la première traduction d'un abrégé de l'*Almageste*, les *Eléments* d'Alfraganus (al-Farghānī), datant de 1135.

Au terme de ce survol des modèles cosmologiques ayant prévalu jusqu'au début du XIIᵉ siècle et des modèles nouvellement venus à la connaissance des latins, on constate que, de par sa date, 1120, le *Liber floridus* a précédé de très peu la déferlante des traductions.

★ ★ ★

Quels sont, dès lors, les traits distinctifs de l'univers du *Liber floridus*, et plus particulièrement ceux de ses sphères célestes ? Les principales sections de cette compilation à être consacrées à l'univers sont au nombre de quatre. La première se compose de figures et de textes qui portent sur la météorologie, la géographie, la physique élémentaire et aussi l'astronomie (ff. 24–25v). La seconde est plus spécifiquement axée sur l'astronomie (ff. 88v–96). La troisième (ff. 220v–224v) est centrée sur la cosmologie platonicienne et néoplatonicienne (ff. 222v–224v). Suit, en quatrième lieu, une série de figures et de textes à contenu principalement astronomique, mais qui se termine néanmoins par une figure centrée sur la physique élémentaire (ff. 225–228v).

Accompagnés de textes assez brefs, les schémas visuels – ou les diagrammes – représentant l'univers structuré par ses sphères concentriques prédominent dans les trois premières sections. Pris ensemble, le nombre de ces schémas s'élève à autant que dix : ff. 92v–93 (sans titre) ; folio 93v (*De anno mundano. Macrobius a Romulo*) ; folio 94 (*De astrologia secundum Bedam*) ; folio 94v (*Circuli VIItem cursusque VIItem planetarum*) ; folio 225 (*Macrobius*) ; folio 225v (*Circuli VII planetarum VII*) ; ff. 226'v–226'r (sans titre)[16] ; folio 227v (*Ordo VII planetarum et spera celi et terre secundum Macrobium*) ; folio 228 (*Septem circuli celorum divisi. Septem planetarum et signa XII*) ; folio 228v (sans titre).

La majorité de ces schémas s'inscrit dans le droit fil de la tradition picturale et textuelle issue du *Commentaire au Songe de Scipion* de Macrobe. Mais la manière dont Lambert de Saint-Omer dispose des éléments picturaux et textuels macrobiens se distingue par une certaine liberté, voire originalité, ce dont témoigne tout particulièrement la première figure de la série, des ff. 92v–93 (Fig. 2). Cette figure fusionne en effet des schémas visuels qui, en règle générale, étaient transmis séparément dans les recueils de comput.

Fig. 2. Gand, UB, 92, folio 92v–93, Lambert de Saint-Omer, *Liber floridus*, Saint-Omer, 1120/21 :
Figure fusionnant la représentation des sphères planétaires concentriques entourées du zodiaque
avec la figure des cinq zones. A la zone équatoriale se superpose le graphique des cours planétaires
dans la bande zodiacale déroulée en rectangle, de couleur rouge.

Représentant les sept sphères, ou orbes[17] planétaires entourées de la bande du zodiaque, le schéma pictural de base s'y combine, tout d'abord, avec la figure macrobienne des cinq ceintures qui structurent tant la voûte céleste que la surface terrestre, donc des cinq zones climatiques glaciales, tempérées et torride[18]. A l'instar de la figure correspondante du recueil d'Abbon de Fleury conservé à Berlin (Fig. 1), la zone équatoriale, torride, qui s'étend sur la latitude de l'écliptique, est colorée en rouge dans le *Liber floridus*. Puis se superpose à cette zone équatoriale un schéma visuel supplémentaire, celui des oscillations en latitude de 12° de chaque planète pour la durée de douze mois, entre les limites nord et sud de la bande du zodiaque. Ainsi, la bande zodiacale qui entoure les sphères planétaires se retrouve dans la même figure, mais déroulée en rectangle. Isolé, ce même schéma des cours planétaires se trouve au folio 227 du *Liber floridus* (*Cursus VII planetarum per zodiacum*)[19]. En fait, conçu à l'époque carolingienne à partir de

l'astronomie de l'*Histoire naturelle* de Pline[20], il avait fait partie intégrante des recueils de comput, y compris celui d'Abbon de Fleury[21].

On ajoutera que les figures des zones célestes et terrestres intéressaient Lambert au point de les avoir reproduites en cinq variantes, quatre fois en combinaison avec des figures représentant les cours ou les orbes planétaires, à commencer par celle des ff. 92v–93. Dans la variante du folio 227v (*Ordo VII planetarum et spera celi et terre secundum Macrobium*), les cinq zones célestes et terrestres constituent le schéma de base, tandis que les orbes planétaires ne s'y trouvent plus. En revanche, les pictogrammes des planètes accompagnés de leurs noms sont placés sur la ligne de l'écliptique (Fig. 3). La figure du folio 228 représente à nouveau les sept sphères planétaires concentriques entourées de la bande zodiacale. Mais ici, le schéma des orbes célestes se combine avec les seules zones terrestres, les zones torride et tempérées s'étendant jusqu'à la sphère du Soleil. A nouveau, la zone torride est

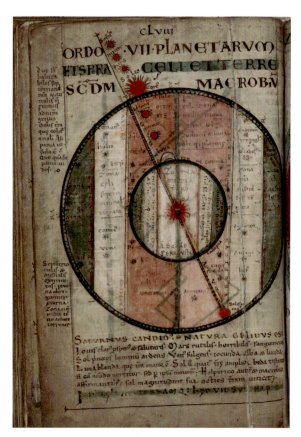

Fig. 3. Gand, UB, 92, folio 227v, Lambert de Saint-Omer, *Liber floridus*, Saint-Omer, 1120/21 : *Ordo VII planetarum et spera celi et terre secundum Macrobium*. Figure des cinq zones célestes et terrestres, avec la ligne de l'écliptique traversant la zone torride centrale, en rouge. Les pictogrammes des planètes sont disposés le long de la ligne de l'écliptique

Fig. 4. Gand, UB, 92, folio 228, Lambert de Saint-Omer, *Liber floridus*, Saint-Omer, 1120/21 : *Septem circuli celorum divisi. Septem planetarum et signa XII*. Figure fusionnant la représentation des sphères planétaires concentriques entourées du zodiaque avec la figure des cinq zones climatiques. La zone équatoriale est traversée par la ligne de l'écliptique

traversée par la ligne de l'écliptique. Mais cette figure-ci comporte davantage d'éléments géographiques que celles des ff. 92v–93 et 227v ; des légendes qui se rapportent aux cours des eaux océaniques sont disposées sur le pourtour du cercle terrestre[22] (Fig. 4). La quatrième variante de figures combinant, d'une part, les cours et sphères planétaires et, d'autre part, les zones climatiques, celle du folio 225, est à nouveau centrée sur la surface terrestre et ses mers. Ici, la liste des phases de la Lune entoure la surface de l'orbe terrestre, tandis que des bandes de couleurs diverses dénotent les sphères planétaires[23]. Enfin, réduit aux seules zones terrestres, le cinquième schéma macrobien des zones se trouve au folio 24v (*Spera Macrobii de Vque zonis*)[24].

Les figures visuelles des orbes célestes du *Liber floridus* qui viennent d'être évoquées comprennent toutes les sept orbes planétaires. Réduit aux seuls signes zodiacaux, le

huitième orbe demeure en retrait. Tant les figures que les textes s'inspirent essentiellement du *Commentaire au Songe de Scipion* de Macrobe. Cet auteur est nommé encore et encore dans le domaine de l'astronomie, mais le nom d'Helpéric, à son tour grand lecteur de Macrobe, est lui aussi très présent dans le *Liber floridus* (ff. 25 ; 25v ; 94v ; 226 ; 227v). Composé aux alentours de 900, le *De computo* de cet écolâtre jouissait en effet d'une autorité certaine. Bède figure comme troisième autorité dans le domaine de l'astronomie et plus généralement de la cosmographie. Toutefois, nombre de figures visuelles et d'extraits de textes du *Liber floridus* suggèrent l'intermédiaire des recueils de comput. Par exemple, les trois passages macrobiens qui se rapportent aux distances cosmiques (ff. 225 ; 226v ; 228) font partie intégrante des recueils de comput, à commencer par les *Libri computi* de 809[25].

Des recherches ultérieures à la fois stylistiques et doctrinales contribueront certainement à faire la part des deux types de sources de Lambert, soit tels manuscrits du *Commentaire* de Macrobe soit tels recueils de comput.

D'une manière ou d'une autre, les représentations des sphères célestes du *Liber floridus* se placent dans le droit fil de la tradition cosmologique qui avait prévalu à l'époque précédant le XIIᵉ siècle. Mais, loin de simplement reproduire telle source picturale, Lambert se montre très inventif sur le plan de la combinatoire des éléments picturaux et textuels. Il n'a cesse de combiner et de recombiner, sous diverses formes, les mêmes éléments picturaux et textuels, ces combinaisons toujours changeantes s'y substituant à toute démarche spéculative suivie. Sans doute, de par leur répétitivité, les schémas visuels du *Liber floridus* servaient-ils essentiellement de lieux de mémorisation, pour inculquer dans l'esprit du lecteur la maigre doxographie astronomique dont disposait Lambert.

Il n'en demeure pas moins que Lambert réoriente à sa manière l'astronomie d'école des recueils de comput. Ainsi, l'un des traits distinctifs de ses combinatoires picturales réside dans l'importance accordée à la surface terrestre divisée non seulement en ses cinq zones climatiques mais aussi en ses trois continents. Ceux-ci sont représentés soit au centre des sphères célestes concentriques (ff. 92v–93 [Fig. 2] ; folio 94v [Fig. 5] ; ff. 225 ; 225v ; 226'v–226'r [Fig. 10]), soit isolément (ff. 19 ; 241, la seule Europe[26]). Comme le note la dernière phrase d'un texte du folio 93, la terre offrait le cadre topographique de la diffusion sur terre des fils d'Adam[27]. En accord avec cette idée, la carte en O–T du folio 19 sert de cadre aux listes des *gentes* diffusées sur les trois continents, l'Afrique, l'Europe et l'Asie[28]. Par rapport aux représentations cosmologiques des recueils de comput, axés principalement sur le temps cyclique, Lambert opère ainsi un déplacement d'accent en faveur du temps linéaire de l'histoire, l'intérêt porté à l'histoire du salut, du début à la fin des temps, marquant nombre de ses figures composites (Fig. 5).

Le modèle cosmologique qui sous-tend les figures et les textes astronomiques du *Liber floridus* relève de façon générale du platonisme. Mais Lambert s'intéresse plus en particulier à deux thématiques philosophico-cosmologiques, celle de l'Âme du monde et celle des

Fig. 5. Gand, UB 92, folio 94v, Lambert de Saint-Omer, *Liber floridus*, Saint-Omer, 1120/21 : *Circuli VIItem cursusque VIItem planetarum*. Sphères planétaires concentriques disposées autour d'un médaillon central représentant la surface terrestre et ses trois continents, l'Asie, l'Europe et l'Afrique

êtres vivants qui remplissent l'univers. Deux extraits de texte provenant principalement du commentaire sur le *Timée* de Calcidius en témoignent. La page consacrée à l'Âme cosmique, *De mundi anima* (folio 222), est un montage qui se compose en partie d'une liste de titres tirés de ce commentaire. Appelé « *Spera Platonis de mundi anima* » et entouré d'extraits du *Commentaire* de Macrobe sur le *Songe de Scipion*, un diagramme d'harmonique lambdoïde s'y ajoute dans la partie inférieure du feuillet. La tradition manuscrite à laquelle se rattache ce diagramme attend d'être identifiée[29]. L'emprunt textuel traitant des êtres vivants qui remplissent l'univers les distribue sur cinq parties, ou régions (*Calcidius super Platonem de quinque mundi regionibus*, ff. 220v–221). Cet extrait est à son tour accompagné d'une figure qui, cette fois-ci, se présente sous forme d'un tableau circulaire divisé en cinq bandes horizontales, chacune renfermant un texte sur les êtres vivants de ces cinq régions

(*Spera Platonis de quinque regionibus celi*); en marge : *De quinque regionibus celi, id est stellarum, demonum, calodemonum, cacodemonum atque hominum spera Platonis*) (Fig. 6)[30].

La présence d'extraits du commentaire de Calcidius sur le *Timée*, dans le *Liber floridus*, offre un intérêt particulier en ce que l'étude suivie de ce commentaire n'était courante ni avant ni immédiatement après le tournant du douzième siècle, Abbon de Fleury se profilant comme l'un des rares écolâtres à en avoir tenu compte. Or si, comme telle, la présence d'extraits du commentaire de Calcidius ne livre aucun indice sur le statut de ce document, au sein de la communauté de Saint-Omer, elle montre clairement l'intérêt manifesté par Lambert pour la philosophie plato- et néoplatonicienne. Surtout, un petit texte du folio 88 révèle que Lambert avait approfondi sa lecture de l'exposé de Calcidius sur les cinq régions du monde au point d'en avoir tenu compte dans sa description du feu céleste.[31]

En somme, se rattachant aux représentations de l'univers qui prévalaient à l'époque précédant le xiie siècle, l'astronomie du *Liber floridus* demeure à l'abri des ondes de choc provoquées par les premières traductions, ce qui n'a rien de surprenant compte tenu de sa date de composition. Aux alentours de 1120, la consultation de nouveaux documents astronomiques demeurait largement limitée aux cercles des spécialistes praticiens qui, dans un premier temps, s'intéressaient principalement aux tables astronomiques élaborées en Andalousie afin d'être en mesure, entre autres, de prédire des phénomènes tels que les éclipses[32]. Quant aux nouvelles théories astronomiques, ptoléméennes ou autres, elles n'étaient pas encore connues. Ainsi, l'astronomie du *Liber floridus* représente celle qui, vers le milieu du xiie siècle, est réfutée et tournée en dérision par un astronome familier des hypothèses ptoléméennes, Etienne de Pise et d'Antioche, traducteur et commentateur du *Traité de la figure du monde* d'Ibn al-Haytham. D'après cet auteur, les pauvres latins, ignorant les mathématiques, ne savaient faire qu'une chose, s'accrocher à l'astronomie d'un Macrobe[33].

★ ★ ★

Les nombreux schémas visuels des sphères célestes concentriques que rassemble le *Liber*

Fig. 6. Gand, UB 92, folio 221v, Lambert de Saint-Omer, *Liber floridus*, Saint-Omer, 1120/21 : *De supradictis mundi regionibus spera Platonis*. Le monde sensible et ses cinq régions, la région sidérale, l'éther, l'air, la région humide et la région terrestre, avec les êtres vivants qui les peuplent : les astres, les trois sortes de démons, les hommes

floridus relèvent bien principalement de l'astronomie. Toutefois, Lambert de Saint-Omer s'était également intéressé à la physique élémentaire, donc à la question de la composition corporelle du monde tant supra- qu'infra-lunaire. Appartenant à la tradition picturale issue du *De la nature des choses* d'Isidore de Séville[34], la première des deux figures visuelles correspondantes est intitulée « annus » (folio 25v) (Fig. 7). Autour du médaillon central de cette figure circulaire sont disposés quatre arcs de cercle qui s'entrecroisent, signifiant ainsi les combinaisons des qualités élémentaires compatibles entre elles, et qui s'associent les unes aux autres au rythme des changements saisonniers. On remarquera que Lambert de Saint-Omer adjoint au noyau pictural isidorien des motifs et des légendes qui se rapportent aux vents et aux levers et couchers du Soleil. De plus, la bande extérieure

Fig. 7. Gand, UB, 92, folio 25v, Lambert de Saint-Omer, *Liber floridus*, Saint-Omer, 1120/21 : *Annus*. Les combinaisons des qualités élémentaires compatibles entre elles (l'humide et le chaud, etc.)

Fig. 8. Gand, UB 92, folio 228v, Lambert de Saint-Omer, *Liber floridus*, Saint-Omer, 1120/21 : *Homo*. Les quatre saisons et les transformations cycliques des quatre corps élémentaires ; les sphères planétaires et le firmament

aligne les pictogrammes des phases de la Lune[35].

Placée bien plus loin (folio 228v), la figure intitulée *homo* (Fig. 8) offre une variante de la figure *mundus annus homo* du *De la nature des choses* d'Isidore, où elle accompagne le chapitre *De partibus mundi*[36]. Dans le *Liber floridus*, elle se compose de quatre médaillons renfermant les noms des saisons et des quatre éléments qui sont disposés autour d'un médaillon central intitulé « *homo* ». Sur le pourtour de cette figure sont inscrits les noms des paires de qualités tangibles attribuées à chaque élément, et dont les combinaisons cycliques assurent la continuité du processus de transformation.

Toutefois, l'intérêt de Lambert ne se limite pas à la question du rythme temporel de la transformation des quatre éléments, mais s'étend à celle de leurs lieux, ce qui le conduit à procéder, en deux endroits, à des combinaisons originales de motifs picturaux et de passages textuels. Ainsi, consacré au processus continu de transformation auquel sont

soumis les quatre corps élémentaires, le schéma *homo* du folio 228v s'enrichit d'éléments graphiques et verbaux qui évoquent le cadre spatial dans lequel se déroulent ces transformations, en l'occurrence celui constitué par les orbes célestes désignés par le terme « firmament »[37]. Ce cadre est dénoté, tout d'abord, par la légende « *firmamentum* » placée dans l'axe vertical de la figure, sur le pourtour supérieur du cercle qui entoure le schéma central des éléments soumis au cycle de leurs transformations réciproques. Puis, au-dessus de la légende « *firmamentum* » se place la liste, ou plutôt la table, des noms des sept planètes suivant l'ordre de leurs orbes, de la Lune jusqu'à Saturne. Séparés les uns des autres par des lignes horizontales rouges, les noms des planètes sont entourés d'un cadre rectangulaire, cette structure graphique se situant, à l'instar de nombre de celles des recueils de comput, à mi-chemin entre la table et la représentation mimétique de l'univers sphérique et de ses divisions en sphères concentriques.

Fig. 9. Gand, UB, 92, folio 88, Lambert de Saint-Omer, *Liber floridus*, Saint-Omer, 1120/21 : Le Christ en mandorle et l'*Agnus dei*, au-dessus de l'autel de Dieu et de l'abysse. La mandorle est flanquée de quatre médaillons renfermant des textes relatifs aux quatre éléments constitutifs du monde corporel. Sur le côté gauche du Christ, un texte se rapportant à la création.

De par ces combinatoires picturales et verbales, Lambert en arrive à relier entre elles la dimension temporelle des éléments pris dans leur incessant mouvement de transformation et le cadre spatial dans lequel se déroule ce processus, cependant qu'habituellement, les deux domaines demeuraient séparés dans les textes et les images des manuels. Mais les références aux lieux des corps élémentaires ne se limitent pas à la présence de quelques mots-clé disposés de telle sorte qu'ils évoquent la partie céleste de l'univers. En effet, deux passages textuels placés entre le médaillon central et le pourtour de la figure, dans l'axe horizontal, apportent des précisions sur le lieu qu'occupe chacun des quatre éléments en fonction de sa pesanteur ou de sa légèreté tout au moins idéalement, c'est-à-dire s'ils en venaient à rejoindre leur lieu naturel de la physique aristotélicienne et à y demeurer. Ainsi, en raison de sa pesanteur, la terre occupe le lieu le plus bas,

suivent l'eau et l'air, tandis que le feu cherche à atteindre son «siège naturel» au-dessus de l'air[38].

Ces passages associés à la figure «homo» du *Liber floridus* se composent d'éléments hétéroclites. En principe, les opposés du lourd et du léger d'après lesquels est conçu la distribution spatiale des corps élémentaires sont incompatibles avec ceux des qualités tangibles du froid et du chaud, du sec et de l'humide – un problème que pose fondamentalement la cosmologie d'Aristote. Alors que d'habitude les exposés sommaires maintiennent séparées ces deux catégories d'opposés, Lambert introduit les qualités tangibles à propos de l'air humide et chaud et de la terre sèche. De surcroît, il associe à ses exposés une phrase qui se rapporte à la Création lorsqu'il évoque les eaux au-dessus du firmament, ainsi qu'une phrase sur la fin des temps et la dissolution du monde composé de quatre parties élémentaires.

La figure des éléments et des saisons du folio 228v n'est pas seule à témoigner de l'intérêt porté à la question du lieu des corps élémentaires. Au folio 88, ne se limitant pas à modifier un schéma pictural donné, Lambert altère en effet la mise en page du feuillet entier. Plus précisément, il investit d'une signification physique une partie des éléments graphiques qui avaient originellement appartenu au cycle pictural de l'Apocalypse du *Liber floridus* de Gand (Fig. 9). Les motifs picturaux et les passages textuels qui se rapportent à la fin des temps y sont placés dans l'axe du feuillet : le Christ en mandorle et l'*agnus Dei*, au-dessous, l'autel de Dieu et, tout en bas, un arc de cercle dénotant l'abysse, comme l'indique le texte qu'il contient. Les figures des innocents selon toute vraisemblance initialement placées entre l'autel et l'abysse semblent avoir été effacées[39]. Quant aux éléments graphiques investis d'une signification physique, donc interprétés «*secundum physicam*»[40], il s'agit principalement des quatre médaillons qui flanquent le Christ de part et d'autre. Ayant très vraisemblablement d'abord représenté les quatre Vivants symboles des Evangélistes[41], ils renferment maintenant des textes relatifs aux éléments et leurs qualités distinctives. Par ailleurs, dans la structure picturale donnée de ce feuillet, le champ sémantique de ces quatre médaillons ne s'écarte pas fondamentalement de l'une des significations attribuées aux quatre symboles

des Evangélistes entourant les représentations de théophanies : par leur emplacement, ils symbolisent les quatre parties, ou extrémités du monde[42].

Ainsi, au folio 88 du *Liber floridus* Lambert de Saint-Omer représente sur le plan pictural la distribution spatiale des quatre éléments constitutifs du monde. Les paires de médaillons qui flanquent la partie supérieure de la mandorle entourant le Christ sont, d'une part, celle des éléments « légers » du feu et de l'air et, d'autre part, celle des éléments « pesants » de la terre et de l'eau, qui se trouvent en dessous. Conformément à une doctrine physique péripatéticienne universellement admise – ici évoquée à propos du feu –, ces éléments cherchent à atteindre leur lieu naturel, en accord avec leur pesanteur ou légèreté. Mais comme Lambert combine des doctrines physiques assez diverses, il évoque également celle de leur densité relative. De plus, tout comme aux folios 228v et 93, la notice sur l'eau ménage une place aux eaux au-dessus du firmament de Genèse I, 2.

Ignis serenus summum locum tenet ethereus, naturalem sui sedem querens super aera, crassior quam celestis. Aer humidus et calidus terre sociatur aride, vaporaliter aquam de imis et ignem de superioribus trahens. Aqua terre levior et aere gravior firmamento imposita ad ignem syderum temperandum multi affirmant. Terra gravissima a ceteris omnibus ambitur manens immobilis et ima sede semper heret complexa medium mundi locum (« Le feu pur, éthéré, occupe le lieu le plus élevé, cherchant ainsi à atteindre son siège naturel au-dessus de l'air, plus dense que <le feu> céleste. Humide et chaud, l'air s'associe à la terre, sèche, en se qu'il attire d'en bas l'eau sous forme de vapeur, et le feu depuis <les parties> supérieures »)[43].

De ces quatre notices sur les éléments entourées d'un cercle, celle qui se rapporte au feu mérite une attention particulière du fait qu'elle témoigne de ce que Lambert avait approfondi sa lecture de l'extrait du commentaire de Calcidius sur le *Timée* (*Calcidius super Platonem de quinque mundi regionibus*), reproduit aux ff. 220v–221. Ayant de toute évidence jugé trop sommaire la doxographie courante relative à la constitution ignée du ciel, Lambert s'en inspire pour qualifier de pur et d'éthéré le feu qui occupe le lieu le plus élevé de l'univers. Toutefois, le chapitre de Calcidius qui repose sur l'*Epinomis* – un dialogue platonicien vraisemblablement composé dans l'entourage de Platon – décrit cinq lieux cosmiques : tout en haut se trouve celui du feu pur et, au-dessous, celui d'un feu moins pur appelé « éther »[44]. Or Platon et, à sa suite, les Stoïciens n'en avaient posé que quatre[45]. Aussi tout en tenant à atténuer la corporéité du feu céleste par le recours à Calcidius, Lambert sauvegarde néanmoins la doctrine des quatre lieux élémentaires en fusionnant la région du feu pur avec celle d'un feu moins pur, la région éthérée. Cette manipulation d'ordre doctrinal témoigne du problème qu'avait posé l'hypothèse d'un feu céleste corporel tant aux philosophes des diverses traditions platoniciennes[46] qu'aux théologiens chrétiens. Ces derniers étaient confrontés notamment à la nécessité d'attribuer un lieu aux êtres angéliques, eux-mêmes d'une constitution toujours ambivalente, à mi-chemin entre le spirituel et le corporel.

Ainsi, les quatre cercles de part et d'autre du Christ apocalyptique orientent dans un sens physique la lecture des éléments graphiques de ce feuillet initialement consacré à la seule fin de l'histoire, tandis que le texte sur les types d'années, au-dessous de la mandorle, met en avant la temporalité du monde. Mais l'exégèse physique de Lambert ne se limite pas au récit scripturaire de la fin des temps. Assez classique, celle du verset initial de la Genèse est elle aussi présente sur le feuillet 88. Dans les écrits patristiques, « ciel » et « terre » du verset « *In principio creavit celum et terram* » étaient en effet assez couramment interprétés dans le sens de feu et d'air, d'eau et de terre. A ce propos, Lambert s'en rapporte à la version donnée par Bède dans le chapitre hexaméral de son *De la nature des choses*. Placé entre les deux médaillons sur le côté gauche du Christ, le texte retenu par Lambert débute ainsi : *In ipso quidem principio conditionis facta sunt celum, terra, angeli, aer et aqua de nichilo* […][47].

Pour résumer, la méthode d'exposition de Lambert, dans le domaine de la physique élémentaire, ne relève certes pas d'une démarche spéculative poursuivie selon les règles de l'art dialectique. Mais, une fois de plus, ses combinaisons insolites d'éléments graphiques et verbaux ne sont pas dépourvues d'une certaine originalité. En fait, comme c'est le cas des figures qui relèvent principalement de

Fig. 10. Gand, UB, 92, folio 226'v-226", Lambert de Saint-Omer, *Liber floridus*, Saint-Omer, 1120/21 : Les sept sphères planétaires concentriques et la bande du zodiaque disposées autour de la terre avec ses trois continents. La figure intègre le schéma des cours équinoxiaux et solsticiaux du soleil, ainsi qu'une table des phases de la lune entourant le médaillon central. Les légendes placent Dieu, les Chérubim et les Séraphim dans la sphère de Saturne. Les autres ordres angéliques occupent les sphères planétaires inférieures

l'astronomie, les figures à orientation physique se démarquent des variations dont les figures visuelles des recueils de comput font occasionnellement l'objet : elles ne s'en tiennent pas au seul plan formel, donc à la seule visée d'efficacité mnémonique, mais introduisent de nouveaux niveaux de signification. Ainsi, la figure de la transformation des éléments et des sphères célestes du folio 228v fusionne physique élémentaire et astronomie de manière insolite, tandis que la structure graphique du folio 88 fait converger les perspectives scripturaires et physiques, la première mettant en évidence la composition corporelle du monde, la seconde, sa temporalité.

★ ★ ★

Tels qu'ils se présentent au folio 88, les rapports entre physique élémentaire et histoire demeurent lâches dans la mesure où les motifs picturaux et les textes qui se rapportent à la constitution corporelle de l'univers et à son historicité sont combinés de manière quasi-ludique. Mais qu'en est-il du rapport entre astronomie et histoire du salut, entre les orbes des astronomes et les ciels des théologiens ? Dans quelle mesure Lambert tient-il compte des perspectives théologiques à propos de la périphérie de l'univers ?

Parmi les figures visuelles des orbes célestes précédemment évoquées (ff. 92v–93 ; 93v ; 94 ; 94v ; 225 ; 225v ; 227 v ; 228 ; 228v), seule celle du folio 228v porte la trace d'une prise de position théologique de la part du compilateur puisqu'elle renferme une notice évoquant les eaux au–dessus du firmament. Mais aucune de ces figures n'est dotée de sphères qui se superposeraient à la sphère des fixes, à commencer par celle des eaux célestes. D'autre part, dans

le manuscrit autographe du *Liber floridus*, aucune image du Christ ne surmonte l'univers corporel.

Quelles sont, dès lors, les prises de position de Lambert sur les lieux, ou les non-lieux, des créatures spirituelles et de leur Créateur ? Plusieurs textes consacrés au rapport entre, d'une part, le monde créé et, d'autre part, les anges, les âmes et Dieu recèlent des éléments de réponse. Surtout, dans la figure des ff. 226'v–226"r, les sept orbes planétaires sont dotés de légendes évoquant Dieu, les anges et le paradis céleste, donc le lieu des âmes bienheureuses (Fig. 10). Aussi pour dégager les choix doctrinaux de Lambert sur ces thématiques, seront d'abord passés en revue trois petits textes (ff. 143v–144 ; ff. 92v–93 ; folio 23), la figure visuelle des ff. 226'v–226'–, ainsi qu'un passage du folio 94v. Dans un deuxième temps sera discuté le petit traité intitulé *Dialogus Malchi ad Hiesum presbiterum*.

Le premier de ces textes fait connaître de manière générale l'intérêt que porte Lambert de Saint-Omer à l'angéologie puisqu'il offre un extrait de l'œuvre de l'une des deux principales autorités dans le domaine, Grégoire le Grand (*Excerptum de Omelia beati pape Gregorii de angelorum ordinibus et electorum gradibus*, ff. 143v–144)[48]. Dans l'extrait de l'homélie retenu par Lambert, Grégoire cite à son tour (Ps.) Denys l'Aréopagite[49]. Cet extrait comporte la liste des neuf ordres angéliques : les Anges, les Archanges, les Vertus, les Puissances, les Principautés, les Dominations, les Thrônes, les Chérubim et les Séraphim (*angeli, archangeli, virtutes, potestates, principatus, dominationes, throni, cherubin, seraphin*).

Se composant d'une mosaïque de citations en partie paraphrasées, le deuxième texte est plus révélateur des préférences doctrinales du compilateur. Il occupe le côté droit de la figure des orbes célestes qui s'étend sur les ff. 92v–93 (Fig. 3) :

Celum superioris circuli Deum virtutesque continet angelicas, quod Deus glacialibus aquis solidavit. Celum huic proximum continet infixos stellarum cursus eternos. Celum a supremo tertium celestes continet potestates. Celum a superno quartum continet angelos et archangelos, qui ad nos nuntiando exeunt. Celum a supremo Vtum continet paradysum, in quo Paulus fuerat raptus, ubi perfectorum anime locantur, Augustino testante. Celum huic proximum dicitur firmamentum multiplici motu solidatum

propter sustentationem superiorem [...rum] aquarum ad ignem syderum temperandum. Celum inferius ethereum iacincto simile terris est proximum. Omnis terra que colitur parva insula est circumfusa mari Oceano, que in parte Septentrionali a filiis Ade colitur media ; partem autem alteram, Australem videlicet, ut ferunt, antipodes obtinent[50].

Inspiré principalement d'Augustin et de Bède, cet assemblage de textes se distingue par trois caractéristiques principales, la première se rapportant à la périphérie de l'univers. En effet, Lambert modifie en profondeur le très bref chapitre que Bède consacre à ce sujet dans le chapitre VII du *De la nature des choses*. Le moine northumbrien y intègre les seuls anges dans ce qu'il qualifie de « ciel du cercle supérieur », ce ciel étant placé au-dessus du ciel inférieur, le firmament[51]. Pour sa part, Lambert adjoint la divinité aux anges : « Le ciel du cercle supérieur consolidé par les eaux glacées contient Dieu et les vertus angéliques ».

Concernant les anges, Lambert s'écarte à la fois de Grégoire le Grand et de (Ps.) Denys l'Aréopagite dans la mesure où il met en évidence l'étagement des ciels sur lesquels il distribue les divers ordres angéliques, étant entendu que « ciel » est un terme couramment utilisé depuis l'époque des écrits patristiques pour désigner les orbes célestes. Au contraire, dans le texte néo-platonicien fondateur de l'angéologie médiévale, la *Hiérarchie céleste*, les ordres angéliques se déploient non pas en fonction de repères locaux, mais de leur aptitude à recevoir les illuminations divines, sans compter que pour son auteur, les intelligences célestes « vivent au-delà du ciel »[52].

Enfin, à propos du paradis céleste – celui du troisième ciel de saint Paul (II Cor., 12, 2) –, Lambert fait partie des premiers auteurs du XIIe siècle à avoir tenté de le localiser précisément en l'insérant dans la structure des orbes célestes, cependant qu'auparavant les exégètes ayant fait autorité, y compris Augustin, étaient restés vagues à ce sujet. Ainsi, dans l'énumération des ciels, ou orbes, du folio 93, ce lieu de félicité occupe le cinquième ciel. Il est précédé du ciel des Anges et des Archanges, du ciel des Puissances, du ciel du cours éternel des étoiles fixes et enfin, du « ciel du cercle supérieur », celui de Dieu et des anges. Au-dessous se trouve celui qui « est dit être le firmament consolidé au moyen de multiples

mouvements pour soutenir les eaux destinées à tempérer le feu des astres». Concernant l'orbe céleste qui entoure le médaillon central du schéma, l'«*orbis terrarum*», la légende le désigne comme le «ciel inférieur», éthéré, ressemblant à l'hyacinthe.

L'évocation du «ciel du cercle supérieur» dans le texte du folio 93 appelle quelques observations. Elle suggère une division en un ciel théologique et un ciel astronomique, mais sans que cette division soit énoncée clairement. Dans la tradition théologique issue du commentaire de saint Hilaire de Poitiers sur le *Psaume* 135, 8–9 et reprise à leur compte par Isidore et par Bède[53], le ciel est effectivement divisé en deux, en un «ciel du cercle supérieur» et en un «ciel inférieur», ce dernier étant délimité par l'orbe des astres fixes. Le texte très succinct du *De la nature des choses* de Bède et, à sa suite, celui de Lambert, n'établissent toutefois pas une distinction nette entre le «ciel du cercle supérieur» et le ciel étoilé, ou le firmament, l'emplacement des eaux au-dessus du firmament représentant la *crux* du problème. En effet, d'après l'exégèse patristique, les eaux au-dessus du firmament tempèrent la chaleur provoquée par le mouvement des astres et nullement, comme semble le suggérer Bède puis à sa suite, Lambert, celle d'un ciel placé au-dessus des orbes planétaires et de l'orbe des fixes, le firmament. Néanmoins, dans son *In principium Genesis*, Bède fait une distinction plus nuancée entre la partie supérieure et la partie inférieure du ciel, l'expression «ciel supérieur» se substituant à l'expression «cercle du ciel supérieur». Mais dans les deux cas il s'agit du ciel du premier jour de la Création. Distinct du monde soumis à la mutabilité et du ciel doté de ses luminaires nécessaires à la vie d'ici-bas, ce ciel supérieur est éternellement dans la quiétude et dans la gloire de la présence divine[54]. Il a d'emblée été rempli d'anges et demeure inaccessible au regard des humains[55]. Et si le ciel supérieur est rempli de créatures spirituelles invisibles, le ciel inférieur est le ciel corporel des créatures visibles et corruptibles[56]. Dans son traité hexaméral Bède assimile également le ciel supérieur au «ciel du ciel» de Ps. 113, 16[57], tout en citant un passage de saint Jérôme sur la chute de Lucifer et sa tentative de monter au ciel supérieur où se trouve le trône de Dieu[58]. Enfin, si Bède ne s'attarde pas sur la

nature du ciel du premier jour de la Création, il le qualifie indirectement de spirituel en l'assimilant aux créatures angéliques et en l'opposant au ciel corporel créé le deuxième jour[59].

Les écrits de Bède sur les créatures spirituelles du ciel du cercle supérieur, ou du ciel supérieur tout court, sont bien à la base du texte du folio 93 du *Liber floridus*. Mais l'intérêt de Lambert pour ces créatures est également perceptible dans un troisième assemblage de textes, *Quid in principio Deus sex diebus* (folio 23). Il s'y éloigne de Bède en détaillant les créatures spirituelles qui peuplent le ciel créé au premier jour : les Anges, les Archanges, les Vertus, les Puissances, les Principautés, les Dominations, les Thrônes, les Chérubim et les Séraphim. D'autre part, la création des sept ciels – ou orbes planétaires – est accomplie au deuxième jour[60]. Albert Derolez n'a certes pas tort de qualifier de «rambling composition» le texte du folio 23[61]. Il n'en demeure pas moins qu'en associant les neuf ordres angéliques au ciel du premier jour de la création, Lambert se profile comme l'un des premiers représentants de la vague de l'angéologie dionysienne que connaît le XIIe siècle, ainsi que de celle de Grégoire le Grand[62].

Aux témoignages sur les ciels et leurs occupants qui viennent d'être évoqués s'en ajoute un quatrième, la représentation visuelle des sphères concentriques des ff. 226'v–226" (Fig. 10). Dans cette figure, les sphères, ou orbes célestes se réduisent à ceux des planètes, si bien que ni le ciel supérieur ni l'orbe des étoiles fixes n'y trouvent leur place. Il s'en suit que Dieu et les anges ne se trouvent plus dans le ciel supérieur, ou le ciel du cercle supérieur, ni même dans le huitième ciel des étoiles fixes. La légende qui se rapporte au «septième ciel», l'orbe de Saturne, est sans équivoque : il contient Dieu, les Chérubim et les Séraphim : *Celum VIImum continet Deum et cherubin seraphinque. Hoc Deus glacialibus aquis tempera<vit>. Candidus Saturnus annis XXXta.* Le sixième ciel, l'orbe de Jupiter, contient les Dominations et les Trônes, ainsi que, toujours d'après le texte explicatif, le cours sempiternel des étoiles fixes. Inutile d'insister sur le fait que la révolution sempiternelle des étoiles fixes devrait se trouver au-dessus de l'orbe de Saturne, et non pas au-dessous, dans celui de Jupiter. Quant au paradis de saint Paul, il est localisé dans le troisième ciel comme il se doit, ce ciel étant aussi la sphère du Soleil[63].

Aux ff. 226'v–226" du *Liber floridus*, l'idée selon laquelle la divinité et les anges font partie des sphères planétaires se trouve promue au rang de l'évidence visuelle. L'association des anges avec des planètes était certes courante dans un certain nombre d'apocryphes vétéro-testamentaires[64], mais lorsque Lambert ajoute le nom de Dieu à ceux des Chérubins et des Séraphins, dans l'orbe de Saturne, même Dieu s'en trouve circonscrit à la fois localement et temporellement. La présence, à l'intérieur de la structure graphique donnée des orbes concentriques, en l'occurrence du huitième orbe, d'une phrase extraite une fois de plus du *De la nature des choses* de Bède, et d'après laquelle Dieu tempéra l'ardeur du ciel étoilé à l'aide des eaux glacées, ne fait que confirmer cette localisation à l'intérieur de l'univers corporeal. Plus tard, l'emplacement quelque peu extravagant du nom de la divinité, dans la figure du manuscrit de Gand, a conduit à une modification majeure du dispositif graphique. Ayant intégré la mandorle qui le sépare de toute créature, le Christ Logos trône au-dessus du monde corporel dans la copie la plus ancienne du *Liber floridus*, du xiie siècle. Les anges, en revanche, demeurent confinés dans les sphères planétaires (Fig. 11)[65].

Le texte du folio 93, ainsi que les légendes associées aux orbes planétaires dans la figure des ff. 226'v–226", montrent donc bien que Lambert de Saint-Omer avait un certain penchant pour l'idée d'un Dieu circonscrit. Un passage textuel supplémentaire vient confirmer – de manière oblique – ce parti pris. Placé au-dessous de la figure des sphères planétaires du folio 94v (Fig. 5), le passage en question identifie Dieu avec la sphère externe des étoiles fixes, cependant que la figure elle-même, ainsi que les légendes qui en font partie, se rapportent au seul ciel des astronomes :

Novem ordinibus [« orbibus »] vel globis conexa sunt omnia, quorum unus est celestis extimus, qui reliquos omnes complectitur, summus ipse Deus arcens et continens ceteros, in quo sunt infixi illi qui volvuntur stellarum cursus sempiterni. Cui subiecti sunt septem qui versantur retro contrario motu atque celum. Summus ille celi stellifer cursus, cuius conversio est concitatior, acuto et excitat movetur sono gravissimo autem lunaris infimus.

Extrait selon toute vraisemblance du *Commentaire au Songe de Scipion* de Macrobe,

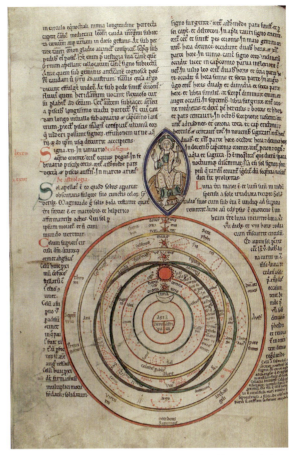

Fig. 11. Wolfenbüttel, HAB, Cod. Guelf. 1 Gud. lat., folio 64v, Lambert de Saint-Omer, *Liber floridus*, France du Nord, 2e m. du xiie s.: Le Christ-Logos en mandorle, au-dessus du monde corporel. Les anges demeurent confinés dans les sphères planétaires

l'auteur du passage cité par Lambert est Cicéron[66], le neuvième orbe n'y étant autre que la terre[67]. Mais si Macrobe a tenté de sauver la transcendance de Dieu dans son commentaire sur la description cicéronienne de la structure du monde en s'en rapportant aux hypostases plotiniennes[68], Lambert a choisi de ne retenir que l'affirmation de la divinité du monde. Certes, le chanoine de Saint-Omer n'avait pas à sa disposition la place nécessaire, au feuillet 94v, pour ajouter tel autre passage susceptible de nuancer et donc d'atténuer la portée des propos de Cicéron. Il n'en demeure pas moins que le choix du compilateur s'est porté précisément sur ce passage d'inspiration stoïcienne. A cet égard, la comparaison avec la réception médiévale du Livre II de *l'Histoire naturelle* de Pline est éclairante. Bien que ce livre ait fourni l'essentiel de l'astronomie planétaire des manuels de l'époque précédant le xiie siècle, son début hymnique qui évoque la divinité du

monde, « cet ensemble qu'on s'est plu à appeler d'un autre nom, "ciel" », n'a guère incité les compilateurs médiévaux à le retenir[69].

Cependant, en son temps Lambert de Saint-Omer n'était pas seul à s'arrêter sur la question de la divinité de la sphère extérieure et donc du monde. Figurant parmi les premiers philosophes de la nature du XIIe siècle, Adélard de Bath en faisait autant dans ses *Questions naturelles* dédiées à Richard de Douvres, évêque de Bayeux de 1107–1133. Comme dans nombre d'autres passages de cet ouvrage, Adélard prend appui sur le *De la nature des dieux* de Cicéron. Mais contrairement à Lambert, il approfondit la question. Tout en se modelant en partie sur Macrobe, Adélard affirme ainsi que la sphère extérieure, l'« *applanon* », est bien un dieu dès lors qu'« on s'enquiert d'un dieu animé, raisonnable, immortel ». Cependant, n'étant ni immuable ni infini, ce dieu n'est pas « la cause universelle des choses »[70].

A ce point de l'enquête sur la dimension théologique des représentations de l'univers du *Liber floridus*, et plus particulièrement de sa périphérie, on retiendra que la perspective de l'histoire du salut est bien présente dans quelques textes et dans la figure visuelle des ff. 226'v–226''. Toutefois, comme le montre la figure, la structure du ciel des astronomes n'en est pas pour autant affectée puisque Lambert a choisi d'insérer dans les orbes planétaires à la fois la divinité, les anges et le paradis céleste. Ces prises de position ne manquent pas de laisser perplexe notamment à propos de l'idée d'un Dieu circonscrit localement, et ce, même à supposer que le mot « *deus* » se rapporte au Dieu incarné. Quant aux créatures spirituelles, leur statut et leur emplacement avait toujours posé problème. A l'occasion, elles étaient présentées comme étant supra-mondaines. Mais aucun des textes du *Liber floridus* ne se prononce de manière univoque en faveur d'un tel lieu, qu'il s'appelle « cercle du ciel supérieur » ou bien « ciel supérieur ». Et aucune des figures visuelles des orbes célestes de la compilation de Lambert de Saint-Omer n'ajoute au ciel visible des astronomes des lieux qui seraient réservés aux anges et aux âmes bienheureuses, pas plus que le centre terrestre ne se voit doté d'un lieu infernal de rétribution.

★★★

Les combinatoires d'éléments textuels et d'éléments graphiques qui suggèrent la localisation de la divinité et des anges dans le *Liber floridus* de Gand, correspondent-elles à des prises de position excentriques, de la part de Lambert de Saint-Omer, ou bien se font-elles l'écho de courants théologiques contemporains ? Compte tenu de la brièveté de ces éléments, la réponse s'avère malaisée. Mais le *Liber floridus* comporte également un petit traité qui se compose d'une série d'exposés argumentés, entre autres sur la question du lieu de la divinité, le *Dialogus Malchi ad Hiesum presbiterum*[71]. Ce dialogue offre un intérêt d'autant plus grand que, d'après Albert Derolez, il représenterait l'un des rares textes à avoir été composés par Lambert lui-même. Si tel est le cas – et il n'y a pas de raison d'en douter –, il est également légitime de supposer que ce dialogue à tort négligé par l'historiographie de l'enseignement du XIIe siècle se soit fait l'écho de discussions d'école et que le chanoine de Saint-Omer ait donc été au fait des questions théologiques et philosophiques débattues en son temps.

Dans la série de thématiques exposées dans le *Dialogus Malchi ad Hiesum presbiterum*, celle du lieu occupe une place importante, à commencer par celle, fondamentale, du lieu de l'univers. Le disciple Malchus pose ainsi la question suivante : « Où est le corps qui n'est contenu par aucun lieu ? ». La réponse du maître, Jésus, s'inscrit dans la lignée de la philosophie aristotélicienne connue, en ce qui concerne le concept de lieu, bien avant que l'œuvre d'Aristote elle-même ait été traduite en latin, en particulier par l'étude des catégories aristotéliciennes. Dans la *Physique*, Aristote définit le lieu comme l'extrémité immobile et première du contenant[72]. Et comme la tradition physique issue du Philosophe n'admet pas de lieu au-delà de l'univers corporel – pas plus qu'elle n'admet un vide –, la réponse à la question de Malchus est que, à l'exception du corps entier de l'univers, aucun corps n'est dépourvu d'espace local (*localis spatium*)[73]. Puis, toujours à propos du lieu, le *Dialogus* aborde la question du lieu du Christ ressuscité. Malchus souhaite ainsi savoir « où se trouve le Christ selon la chair, dans le ciel éthéré (*celo ethereo*), au-dessous ou bien au-dessus du firmament » ? Le maître rappelle que, d'après saint Paul et saint Augustin, le Christ était bien monté

au-dessus des cieux, mais qu'il était également possible de savoir de manière certaine que, si le Christ avait choisi d'être dans le ciel éthéré en tant qu'homme, cette localisation n'aurait diminué ni son mérite ni sa puissance dans la mesure où il était le Seigneur de toutes choses non seulement selon sa divinité mais aussi son humanité[74]. En outre, Malchus s'interroge sur le lieu des justes après le Jugement dernier, terrestre ou céleste. Bien que donnant sa préférence au ciel, où ils verront Dieu et les anges, le maître répond de manière quelque peu elliptique, certainement en raison de la complexité du sujet[75]. Enfin, deux questions portent sur le lieu de l'enfer, ce lieu pouvant se situer dans la terre où ailleurs[76].

Le *Dialogus Malchi ad Hiesum presbiterum* est un dialogue d'école passant en revue les questions qui avaient dû être couramment débattues au tout début du XIIe siècle, y compris celle de la catégorie du lieu. Il révèle un Lambert bien plus au fait de ces questions que ne le laisseraient soupçonner ses combinatoires de motifs picturaux et de brefs passages textuels. Mais le *Dialogus* n'aborde pas le sujet du lieu des anges et des âmes en attente de résurrection. Pourtant, non seulement la question du lieu ou du non-lieu de la divinité mais aussi celle des résidences célestes des anges et des âmes avaient précédemment fait l'objet d'exposés dans le contexte scolaire, notamment dans le *Lucidarum* (env. 1100), ainsi que dans l'*Imago mundi* (1110) d'Honorius Augustodunensis[77]. Dans le *Lucidarium*, un autre dialogue théologique, l'une des premières questions que pose le disciple est celle du lieu de résidence de Dieu. La réponse du maître consiste à affirmer que Dieu «réside partout en puissance», mais qu'il «réside en substance dans le ciel intellectuel»[78]. Suit immédiatement une énumération de trois types de ciels : le ciel corporel objet de perception sensible ; le ciel spirituel qui est supposé être habité par les substances spirituelles, les anges ; le troisième ciel, un ciel intellectuel dans lequel la Sainte Trinité est contemplée face à face[79]. Comme le fait remarquer Yves Levèbre, en distinguant entre ces trois ciels Honorius s'appuie sur saint Paul, II Cor., 12, 2 ; le Psaume 113, 16, ainsi que sur les trois types de visions, corporelle, spirituelle et intellectuelle, évoqués par saint Augustin au livre XII du *Sur la Genèse au sens littéral*[80]. Quant à la cosmographie intitulée *Imago mundi*, elle accentue l'aspect spatial de la disposition des ciels spirituel et intellectuel en même temps qu'elle circonscrit les eaux mosaïques au-dessus du firmament sous la forme d'un ciel. De plus, dans l'*Imago mundi* le ciel spirituel identifié avec le ciel primordial de Genèse I, 1[81] est déjà la demeure des neuf ordres angéliques, tout comme il comporte le paradis des paradis. Enfin, Honrorius y affirme que, loin au-dessus, le roi des anges réside dans le ciel des cieux[82].

Ainsi, quelques deux décennies avant Lambert de Saint-Omer, Honorius apparaît comme l'un des premiers, sinon le premier auteur à avoir établi une séquence bien définie des divers types de ciels, corporels et incorporels, et à avoir assigné au ciel du premier jour de la création les neuf ordres angéliques. Sa cosmographie fusionne la tradition romaine d'un ciel corporel composé de huit sphères concentriques et la tradition philosophique et théologique de lieux extra-mondains, tout comme elle ménage un lieu de châtiment au centre de la terre. Honorius avait donc systématisé la restructuration du système cosmique deux décennies environ avant que le *Liber floridus* n'ait été achevé et que Lambert ait à son tour abordé la question du lieu de la divinité, des anges et des âmes bienheureuses. Mais ni le *Lucidarum* ni l'*Imago mundi* d'Honorius ne semblent avoir été connus du chanoine de Saint-Omer. Quoi qu'il en soit, les prises de position du *Dialogus Malchi ad Hiesum*, qui se place bien dans la lignée des exposés d'école sur un Dieu échappant à toute délimitation locale, et qui affirment qu'en principe, les anges et les âmes ne pouvaient se trouver dans un lieu[83], semblent irréconciliables avec la figure visuelle des ff. 226'v–226" : Dieu, les anges, ainsi que les âmes bienheureuses y sont circonscrits. Sans doute Lambert était-il au fait tant de la perspective christologique du corps de Dieu (Col. 2, 9) que des théories selon lesquelles les incorporels pouvaient être localisés intelligiblement et par leur opération. Mais que l'orbe de Saturne abrite Dieu et ses anges demeure une singularité du *Liber floridus*.

★ ★ ★

En conclusion, il est possible d'affirmer que le *Liber floridus* n'est pas encore affecté par ceux des courants astronomiques, physiques

et métaphysiques qui avaient entraîné, au XIIe siècle, des modifications dans le sens de l'augmentation à neuf du nombre de sphères célestes concentriques. Les bribes doxographiques d'astronomie et de physique péripatéticienne qu'il véhicule proviennent de manuels qui les transmettaient tout au long du Haut Moyen Age. Cette vaste compilation de figures et de textes cosmographiques s'en tient à l'univers corporel traditionnel, à huit sphères, des textes romains fondateurs et des recueils médiévaux de comput. Et c'est comme si l'extrême répétitivité des mises en page de ces sphères de l'univers corporel, dans le *Liber floridus*, avait servi à conjurer une dernière fois l'ancienne image du monde. D'autre part, les courants théologiques contemporains axés sur l'histoire du salut ont bien affecté sa représentation de l'univers, mais de manière marginale, sans pour autant aboutir à l'adjonction, au corps du monde, de sphères incorporelles. Liée à la théorie d'un espace au-delà de l'univers corporel, l'idée d'un ciel empyrée rempli d'anges, et qui se diffusera par la suite, n'y est pas encore évoquée. Toutefois, les manipulations, par Lambert de Saint-Omer, de schèmes conceptuels et picturaux donnés des sphères célestes ne sont pas exemptes d'une certaine originalité. Aux alentours de 1120, il n'était pas courant d'associer la divinité – fût-elle créatrice, juge, ou simplement triomphante – aux figures visuelles des sphères célestes disposées en cercles concentriques autour du centre terrestre. Surtout, l'emplacement des anges, les âmes bienheureuses et même de la divinité à l'intérieur des sphères planétaires de l'image des ff. 226'v–226'' du *Liber floridus* conservé à Gand ne manque pas de surprendre. Or même si ses prises de position ne se présentent guère sous la forme de théories argumentées, mais principalement de combinaisons de motifs picturaux et de lieux communs doctrinaux, elles ne sont pas dénuées d'intérêt du fait qu'elles précèdent les écrits de théologiens majeurs tels que ceux d'un Hugues de Saint Victor ou d'un Abélard. Quant au *Dialogus Malchi ad Hiesum presbiterum*, qui semble se rattacher à l'enseignement des alentours de 1100, il témoigne de ce que Lambert était au courant du problème du lieu que posaient Dieu et les créatures spirituelles.

NOTES

1. B. OBRIST, « The Physical and the Spiritual Universe. Infernus and Paradise in Medieval Cosmography and its Visual Representations (Seventh-Fourteenth Century) », *Studies in Iconography*, 36 (2015), p. 41–78 ; Ead., « L'introduction de l'enfer dans la cosmographie médiévale : d'Honorius Augustodunensis à Michel Scot », in *Orbis disciplinae. Hommages en l'honneur de Patrick Gautier Dalché*, éd. N. BOULOUX, A. DAN, G. TOLIAS (Turnhout, 2017), p. 83–101 ; Ead., « Corporeal and Spiritual Celestial Spheres and their Visual Figurations : From Adelard of Bath and Honorius to John of Sacrobosco and Michael Scot », in *The Diagram Paradigm : Cross-Cultural Approaches*. Byzantine Studies Symposium, Dumbarton Oaks, April 20–21, 2018, éd. J. F. HAMBURGER, D. ROXBURGH, L. SAFRAN (Washington, D.C.), à paraître.

2. Ead., « The Idea of a Spherical Universe and its Visualization in the Earlier Middle Ages (Seventh to Twelfth Century) », in *The Visualization of Knowledge in Medieval and Early Modern Europe*, Conference, Jerusalem, Israel Institute for Advanced Studies, June 6–9, 2016, éd. M. KUPFER, A. COHEN, J. H. CHAIES, A. WORM (Turnhout, 2020), p. 229–258.

3. Bède, *De natura rerum*, spéc. c. 12–16, éd. C. W. JONES, in *Bedae Opera*, I, *CCSL*, 123A (Turnhout, 1975), p. 203–208. Sur la réception de cette astronomie, B. S. EASTWOOD, *Ordering the Heavens. Roman Astronomy and Cosmology in the Carolingian Renaissance* (Leiden-Boston, 2007), p. 97–132.

4. *Libri computi*, V, 3–6, éd. A. BORST, in *Schriften zur Komputistik im Frankenreich von 721–818*, III, MGH, Quellen zur Geistesgeschichte des Mittelalters, 21 (Hannover, 2006), p. 1260–1273.

5. Isidore de Séville, *De natura rerum*, VII, 4, éd. et trad J. FONTAINE, *Isidore de Séville, Traité de la nature* (Bordeaux, 1960 ; rééd., Paris, 2002), p. 201–202 ; fig. 2.

6. *Ibid.*, XXIII, 4 (éd. et trad FONTAINE, p. 260–260 bis, fig. 6).

7. Macrobe, *Commentaire au Songe de Scipion*, I, 24, 4, éd. et trad. M. ARMISEN-MARCHETTI, Macrobe, *Commentaire au Songe de Scipion*, I (Paris, 2001), p. 122 ; fig. 1.

8. R. MCKITTERICK, « Knowledge of Plato's *Timaeus* in the Ninth Century. The Implications of Valenciennes, Bibliothèque Municipale MS 293 », in *From Athens to Chartres. Neoplatonism in Medieval Thought. Studies in Honour of Edouard Jeauneau*, éd. H. J. WESTRA (Leiden-New York-Köln, 1992), p. 85–134.

9. Calcidius, *Commentarius in Timaeum*, 73, éd. J. H. WASZINK, *Timaeus a Calcidio translatus commentarioque instructus*, Corpus Platonicum Medii Aevi. Plato Latinus, 4 (London-Leiden, 1962), p. 121 ; éd. et trad. B. BAKHOUCHE ; trad. L. BRISSON, Calcidius, *Commentaire au Timée de Platon* (Paris, 2011), p. 292/293.

10. Macrobe, *Commentaire*, I, 24, 4 (éd. et trad. M. ARMISEN-MARCHETTI, *op. cit.*, note 7, p. 122 ; fig. 1).

11. *Abbonis Floriacensis Miscellanea de computo, de astronomia et de cosmographia. Editio secundum codicem Berolinensem Phill. 1833. Introductionem historicam addidit Barbara OBRIST*, éd. A. LOHR, CCCM, 300 (Turnhout, 2019), p. 48–49.

12. Pour une première liste, cf. D. JUSTE, in *Abbon de Fleury. Philosophie, science et comput autour de l'an mil*, éd. B. OBRIST, Oriens-Occidens. Sciences, mathématiques et philosophie de l'Antiquité à l'Âge classique, 6 (2ᵉ éd. rév., Paris, 2006), p. 239–240.

13. Montpellier, Bibliothèque interuniversitaire., Sect. méd., MS H 145, folio 15 (Pontigny, 1170–1175) ; B. OBRIST, « Guillaume de Conches : cosmologie, physique du ciel et astronomie ; Textes et images », in *Guillaume de Conches : philosophie et science au XIIᵉ siècle*, éd. B. OBRIST, I. CAIAZZO, Micrologus Library, 42 (Florence, 2011), p. 123–196 ; 148, fig. 3.

14. B. OBRIST, « Les modèles cosmologiques à huit, neuf et dix sphères célestes concentriques au XIIᵉ siècle », in *De l'homme, de la nature et du monde : Mélanges d'histoire des sciences médiévales offerts à Danielle Jacquart par les élèves et les amis de sa conférence de l'École pratique des hautes études*, éd. N. WEILL-PAROT (Paris-Genève, 2019), p. 121–152 ; 133–135.

15. Pour la réception de cette hypothèse au XIIᵉ siècle, cf. *ibid.*, 125–131.

16. La foliation 226''v-226''r, qui sera maintenue dans ce travail, ne figure pas encore dans l'édition et le facsimile du *Liber floridus* : éd. A. DEROLEZ, *Lamberti S. Audomari canonici "Liber floridus" : Codex autographus Bibliothecae Universitatis Gandavensis* (Gand, 1968). A. DEROLEZ l'a introduite dans : *The Autograph Manuscript of the Liber floridus. A Key to the Encyclopedia of Lambert of Saint-Omer*, CCAM, 4 (Turnhout, 1998), p. 158, fig. 37.

17. A la suite de Cicéron, Macrobe utilise de manière interchangeable les termes de sphère et d'orbe : Macrobe, *Commentaire*, I, 17, 2 ; I, 14, 24 (éd. et trad. M. ARMISEN-MARCHETTI, *op. cit.*, note 7, p. 93 ; 83).

18. *Ibid.*, II, 7, 1–7 (éd. et trad. M. ARMISEN-MARCHETTI, Macrobe, *Commentaire au Songe de Scipion*, II [Paris, 2003], p. 32–34 ; 111, fig. 3). Pour la transcription des textes qui sont à l'intérieur de la figure, cf. DEROLEZ, *Codex autographus, op. cit.* (note 16), p. [69] ; pour ceux qui sont à l'extérieur (Inc. : « Augustinus. Elementa mundi id est celum et terram […] »), transcr., p. [70] ; A. DEROLEZ, *The Making and Meaning of the "Liber floridus" : A Study of the Original Manuscript, Ghent, University Library, MS 92* (Londres, 2015), p. 103, n. 124.

19. DEROLEZ, *Codex autographus, op. cit.* (note 16), p. 453 ; transcr., p. [97] ; Id., *The Making, op. cit.* (note 18), p. 152, n. 257.

20. Pour le texte de Pline, cf. *Libri computi*, V, 6, *De cursu earum* [planètes] *per zodiacum circulum*, éd. BORST, p. 1270–1273 ; pour la figure, cf. EASTWOOD, *op. cit.* (note 3), p. 119–126 ; 136–138.

21. *Abbonis Floriacensis Miscellanea*, folio 38, éd. Lohr, p. 172 ; transcr., p. 59 ; B. OBRIST, « Le recueil de comput, d'astronomie et de cosmographie de Berlin et l'enseignement d'Abbon de Fleury », in *Abbonis Floriacensis Miscellanea de computo, de astronomia et de cosmographia. Editio secundum codicem Berolinensem Phill. 1833. Introductionem historicam addidit Barbara Obrist*, p. VII–L ; XLV ; éd. R. B. THOMSON, « Two Astronomical Tractates of Abbo of Fleury », in *The Light of Nature. Essays in the History and Philosophy of Science presented to A. C. Crombie*, éd. J. D. NORTH, J. J. ROCHE (Boston, Lancaster, Dordrecht, 1985), p. 113–133 ; 124.

22. DEROLEZ, *Codex autographus, op. cit.* (note 16), transcr., p. [99] ; Id., *The Making, op. cit.* (note 18), p. 153, n. 259.

23. *Ibid.*, p. [94] ; 152, n. 253.

24. DEROLEZ, *The Making, op. cit.* (note 18), p. 66, n. 34 ; comp. Macrobe, *Commentaire*, II, 5, 8–16 ; 9, 1–7 (éd. et trad. ARMISEN-MARCHETTI, *op. cit.*, note 18, p. 24–26 ; 40–41 ; 110, 112, fig. 3).

25. *Libri computi*, VI, 4–5 (éd. BORST, p. 1310–1316).

26. DEROLEZ, *The Making, op. cit.* (note 18), p. 58, n. 19 ; p. 147–148, n. 286.

27. *Infra*, p. 141.

28. DEROLEZ, *The Making, op. cit.* (note 18), p. 58, n. 19.

29. DEROLEZ, *Codex autographus, op. cit.* (note 16), p. 443 ; transcr., p. [92] - [93] ; Id., *The Making, op. cit.* (note 18), p. 151, n. 551. Pour la tradition manuscrite, voir M. HUGLO, «Recherches sur les diagrammes de Calcidius», *Scriptorium*, 62 (2008), p. 185–230.

30. DEROLEZ, *Codex autographus, op. cit.* (note 16), transcr., p. 440–441 ; [91] - [92] ; Id., *The Making, op. cit.* (note 18), p. 151, n. 250 ; Calcidius, *Commentaire au Timée de Platon*, p. 129, éd. WASZINK, *op. cit.* (note 9), p. 171–172 ; éd. et trad. BAKHOUCHE, trad. BRISSON, *op. cit.* (note 9), p. 366/367 ; pour la citation, *infra*, n. 47. B. En outre, B. BAKHOUCHE, «Anges et démons dans le *Commentaire au Timée* de Calcidius (IV^e siècle de notre ère)», *Revue des Etudes latines*, 77 (1999), p. 260-275.

31. *Infra*, p. 139.

32. R. MERCIER, «Astronomical Tables in the Twelfth Century», in *Adelard of Bath. An English Scientist and Arabist of the early Twelfth Century*, dir. C. BURNETT, Warburg Institute Surveys and Texts, 14 (Londres, 1987), p. 87–115.

33. Etienne de Pise et d'Antioche, *Liber Mamonis*, éd. et trad. D. GRUPE, *Stephen of Pisa and Antioch : Liber Mamonis. An Introduction to Ptolemaic Cosmology and Astronomy for the Early Crusader States* (Berlin, 2019), p. 50–54.

34. Isidore de Séville, *De natura rerum*, VII, 4 (éd. et trad FONTAINE, p. 201–202 ; fig. 2).

35. DEROLEZ, *Codex autographus, op. cit.* (note 16), p. 52 ; trascr., p. [12] ; Id., *The Making, op. cit.* (note 18), p. 66–67, n. 36. L'autographe comprenait également une variante de la figure «*annus*» intitulée, quant à elle «*mundus*» et «*annus*» (folio [1]v), perdue ; cf. *The Making, op. cit.* (note 18), p. 64, n. 29 ; comp. Wolfenbüttel, Herzog August Bibliothek, Cod. Guelf. 1 Gud. lat., folio 8v (France du Nord, 2e m. du XII^e s.), reprod. in C. HEITZMANN, P. CARMASSI (éd.), *Der Liber floridus in Wolfenbüttel. Eine Prachthandschrift über Himmel und Erde* (Darmstadt, 2014). Pour le manuscrit et ses matières, voir H. VORHOLT, *Shaping Knowledge. The Transmission of the "Liber floridus"*, Warburg Institute Studies and Texts, 6 (Londres, 2017), p. 43–96.

36. Isidore de Séville, *De natura rerum*, XI, 2–3 (éd. et trad. FONTAINE, p. 214–216 ; fig. 216 bis).

37. DEROLEZ, *Codex autographus, op. cit.* (note 16), transcr., p. [100] ; Id., *The Making, op. cit.* (note 18), p. 153–154, n. 260. Dans les exposés cosmographiques, le terme vétéro-testamentaire de «*firmamentum*» se réfère le plus souvent soit à l'ensemble des orbes dont se compose le ciel visible, soit à sa seule limite extérieure. Pour les quatre significations principales du terme, voir, par exemple, Jean Scot Erigène, *De divisione nature*, III, *Patrologia latina*, 122, col. 693 D ; trad. I. P. SHELDON-WILLIAMS, rév. J. O'MEARA, *Eriugena, Periphyseon (The Division of Nature)* (Montréal, Washington, 1987), p. 323 ; Honorius Augustodunensis, *Clavis physicae*, par. [177], *De die secundo. Quid firmamentum*, éd. P. LUCENTINI, Temi e testi, 21 (Rome 1974), p. 21, 140.

38. *Liber floridus*, MS Gand, Bibl. Univ. 92, folio 228v : «Elementa natura et situ differunt. Terra gravissima imum obtinet locum. Aqua vero quanto levior terre, tanto est aere gravior. Aquas firmamento impositas multi affirmant. Ignis accensus naturalem sui sedem super aera querit. Aer autem humidus et calidus terre sociatur aride. Unde et ignem in terris et aere nubila terrenaque corpora videmus. Elementa mundi, id est celum et terram, non credamus abolenda per ignem, sed in melius commutanda et figuram mundi, id est imaginem, non substantiam transituram», DEROLEZ, *Codex autographus, op. cit.* (note 16), transcr., p. [100] - [101]. Une variante de cette exégèse se trouve au folio 92v.

39. Pour une analyse codicologique et une description détaillée, voir DEROLEZ, *The Autograph Manuscript*, 99–100 ; Id., *The Making, op. cit.* (note 18), 102, n. 119.

40. Pour l'interprétation de la Genèse selon les lois de la physique, cf. Thierry de Chartres (mort env. 1152/55), *Tractatus de sex dierum operibus*, éd. M. HÄRING, *Commentaries on Boethius by Thierry of Chartres and His School* (Toronto, 1971), p. 555.

41. Comp. Wolfenbüttel, Herzog August Bibliothek, Cod. Guelf. 1 Gud. lat., folio 10, reprod. in HEITZMANN, CARMASSI, *Der Liber floridus in Wolfenbüttel, op. cit.* (note 37).

42. L'idée de la diffusion de l'Evangile aux quatre coins du monde a été abondamment glosée : B. MAURMANN, *Die Himmelsrichtungen im Weltbild des Mittelalters. Hildegard von Bingen, Honorius Augustodunensis und andere Autoren* (Munich, 1976) ; A. ESMEIJER, *Divina quaternitas. A Preliminary Study in the Method and Application of Visual Exegesis* (Assen, 1978) ; B. KÜHNEL, *The End of Time in the Order of Things. Science and Eschatology in Early Medieval Art* (Regensburg, 2003).

43. *Liber floridus*, MS Gand, Bibl. Univ. 92, folio 88 ; DEROLEZ, *Codex autographus, op. cit.* (note 16), transcr., p. [62].

44. Calcidius, *Commentaire au Timée de Platon, op. cit.* (note 9), c. 129 : *Quinque regiones sive locos idem Plato esse dicit in mundo capaces animalium, habentes aliquam inter se differentiam positionum ob differentiam corporum quae inhabitent eosdem locos. Summum enim esse locum ait ignis sereni, huic proximum aethereum, cuius corpus esse ignem aeque, sed aliquanto crassiorem quam est altior ille caelestis, dehinc aeris, post humectae substantiae, quam Graeci hygran usian appellant, quae humecta substantia aer est crassior, ut sit aer iste quem homines spirant [...]* (éd. WASZINK, p. 171–172 ; éd et trad. BAKHOUCHE, BRISSON, p. 366/367) ; comp. *Epinomis*, 984b-c.

45. Toutefois, Platon distinguait entre deux sortes d'air, le plus pur étant appelé «éther», le moins pur, «air» ; cf. D. E. HAHM, *The Origins of Stoic Cosmology* (Columbus, 1977), esp. p. 91–92.

46. Macrobe, par exemple, évoque un éther céleste d'une grande pureté, mais s'abstient de lui assigner une nature ignée, *Commentaire*, I, 22, 5 : *Quidquid ex omni materia de qua facta sunt omnia purissimum ac liquidissimum fuit, id tenuit summitatem et aether vocatus est. Pars, cui minor puritas et inerat aliquid levis ponderis, aer extitit et in secunda delapsus est* (éd. et trad. ARMISEN-MARCHETTI, *op. cit.*, note 7, p. 131–132) ; Ailleurs, Macrobe précise que, contrairement à l'air, l'éther n'est pas soumis à la variabilité et au changement (I, 21, 33, p. 130). Pour l'arrière-plan philosophique de Macrobe, en partie stoïcien, cf. P. BOYANCÉ, *Etudes sur le Songe de Scipion. Essais d'histoire et de psychologie religieuse*, Thèse complémentaire (Limoges, 1936), p. 65–72.

47. Bède, *De natura rerum*, c. 2, éd. JONES, p. 192.

48. DEROLEZ, *The Making, op. cit.* (note 18), p. 125, n. 195.

49. L'extrait de Denys l'Aréopagite se trouve au folio 144.

50. *Liber floridus*, MS Gand, Bibl. Univ. 92, folio 93 ; DEROLEZ, *Codex autographus, op. cit.* (note 16), transcr., p. [70] ; Id., *The Making, op. cit.* (note 18), p. 103, n. 124 ; K. MÜLLER, «Mutmassungen über *figura* und *substantia* der Welt. Die Diagramme im *Liber Floridus* des Lambert von St.-Omer», in *Figura. Dynamiken der Zeiten und Zeichen im Mittelalter*, éd. C. KIENING, K. MERTENS FLEURY, Philologie der Kultur, 8 (Würzburg, 2013), p. 173–204 ; 196.

51. Bède, *De natura rerum*, c. 7, *De caelo superiore*: *Caelum superioris circuli proprio discretum termino et aequalibus undique spatiis collocatum virtutes continet angelicas. Quae ad nos exeuntes, aetherea sibi corpora summunt, ut possint hominibus etiam in edendo similari, eademque ibi reversae deponunt. Hoc deus aquis glacialibus temperavit ne inferiora succenderet elementa. Dehinc inferius caelum non uniformi sed multiplici motu solidavit, nuncupans illud firmamentum propter sustenationem superiorum aquarum* (éd. JONES, p. 197–198). Voir également les très intéressantes gloses rédigées entre 850 et 873 (JONES, P. 185) ; éd. F. LIPP : «"*Caelum*": Primum caelum est ab aqua usque ad lunam, quod est aer. Secundum a luna usque ad

firmamentum, quod est aethereum firmamentum. Tertium et quartum a firmamento usque ad infinitum, quod est superius caelum; "*discretum*": Veluti enim aeris terminus est in luna, aetheris in firmamento, firmamenti in aquis quae super illud sunt; sic superioris caeli terminus est aquae. Superiorem enim terminum ignoramus» (in *Bedae Opera*, I, éd. JONES, p. 197). Le ciel supérieur est igné (p. 198).

52. (Ps.) Denys l'Aréopagite, *La hiérarchie céleste*, 6 (200 C), trad. M. de GANDILLAC, in *Œuvres complètes du Pseudo-Denys l'Aréopagite* (Paris, 1943), p. 205.

53. B. OBRIST, «La cosmologie du Haut Moyen Age, le statut de la connaissance philosophique et la question d'un univers christianisé», in *La conoscenza scientifica nell'Alto Medioevo*, Sessantasettesima Settimana di studio, Spoleto, 25 aprile-1 maggio 2019 (Spolète, 2020), p. 53–112.

54. Bède, *In principium Genesis*, I, 2: *Ipsum est enim caelum superius quod, ab omni huius mundi volubilis statu secretum, divinae gloria presentiae manet semper quietum (nam de nostro caelo, in quo sunt posita luminaria huic seculo necessaria, in sequentibus scriptura vel quomodo vel quando sit factum declarat)*, éd. C. W. JONES, *Bedae Opera*, II, 1, CCSL, 118 A (Turnhout, 1967), p. 4, l. 37–41.

55. *Ibid.*, I, 2, p. 4, l. 41–46.

56. *Ibid.*, I, 2, p. 7, l. 140–143.

57. Pour l'arrière-plan augustinien de l'exégèse de «ciel du ciel», cf. J. Pépin, «Recherches sur le sens et les origines de l'expression *caelum caeli* dans le livre XII des *Confessions* de S. Augustin», *Archivum latinitatis medii aevi*, 27 (1953), p. 185–274.

58. Bède, *In principium Genesis*, I, 2, éd. JONES, p. 4, l. 62–65, l. 1.

59. *Ibid.*, I, 2, p. 7, l. 140–143.

60. *Liber floridus*, UB Gand, MS 92, folio 23: *Die primo deus novem ordines celestium spirituum, videlictet angelos, archangelos, virtutes, potestates, principatus, dominationes, thronos, cherubin, seraphin, condidit. Diei secundo deus celos VII condidit […]*. Lambert revient sur la question des neuf orders angéliques aux ff. 148v–149, à propos de la fin du monde, par référene à Grégoire.

61. DEROLEZ, *The Making, op. cit.* (note 18), p. 61, n. 26.

62. M. L. COLISH, «Early Scholastic Angeology», *Recherches de théologie ancienne et médiévale*, 62 (1995), p. 80–109; repr. in Ead., *Studies in Scholasticism*, Variorum Collected Studies Series, CS838 (Ashgate, 2006), XIV; D. LUSCOMBE, «The Commentary of Hugh of Saint-Victor on the Celestial Hierarchy», in *Die Dionysius Rezeption im Mittelalter*, éd. T. BOIADJIEV, G. KAPRIEV, A. SPEER, Rencontres de Philosophie Médiévale, 9 (Turnhout, 2000), p. 159–175.

63. *Liber floridus*, MS Gand, Bibl. Univ. 92, folio 226; DEROLEZ, *Codex autographus, op. cit.* (note 16), p. 451; transcr., p. [96].

64. Cf., entre autres, *Hebrew Apocalypse of Enoch*, 17–18, trad. P. ALEXANDER, in *The Old Testament Pseudepigrapha I: Apocalyptic Literature and Testaments*, éd. J. H. CHARLESWORTH (New York, 1983), p. 269–271; pour le septième ciel comme demeure de Dieu, cf. p. 240.

65. Reprod. in HEITZMANN, CARMASSI, *Der Liber floridus in Wolfenbüttel, op. cit.* (note 35).

66. Macrobe, *Commentaire*, I, 17, 2–3: «L'assemblage du tout est fait de neuf orbes, ou globes, dont l'un est l'orbe le plus extérieur, qui entoure tous les autres, divinité suprême qui enserre et contient les autres, et sur laquelle sont fixées les étoiles dont s'accomplissent les révolutions sempiternelles. Au-dessus d'elle sont placées les sept <planètes> qui tournent à l'envers en un mouvement contraire à celui du ciel […]» (éd. et trad. ARMISEN-MARCHETTI, *op. cit.*, note 7, p. 93). Dans le *Commentaire*, la citation de Cicéron se poursuit (I, 17, 4; éd. et trad. ARMISEN-MARCHETTI, *op. cit.*, note 7, p. 93–94); Cicéron, *De re publica*, VI, 21 [xvii], éd. J. G. F. POWELL (Oxford, 2006).

67. Macrobe, *Commentaire*, I, 17, 4; 22, 1 (éd. et trad. ARMISEN-MARCHETTI, *op. cit.*, note 7, p. 94; p. 131). A propos de la terre, Armisen-Marchetti traduit par «astre» les termes «orbe» et «globe»!

68. *Ibid.*, I, 17, 12–13: *Quod autem hunc iste extimum globum qui ita volvitur, summum deum vocavit, non ita accipiendum est ut ipse prima causa et deus ille omnipotentissimus aestimatur, cum globus ipse quod caelum est animae sit fabricat, anima ex mente processerit, mens ex deo qui vere summus est procreata sit. Sed summum quidem dixit ad ceterorum ordinem qui subiecti sunt, unde suos subiecit: "arcens et continens ceteros"* […] («Mais le fait même que ce globe le plus éloigné, animé d'une telle rotation, ait été appelé "dieu suprême" par Cicéron, ne doit pas faire penser qu'il soit lui-même la cause première et la divinité toute-puissante, puisque le globe lui-même qui constitue le ciel est une fabrication de l'Âme, que l'Âme a procédé de l'Intelligence, et que l'Intelligence a été procréée par le Dieu, qui est au sens propre "suprême". Cicéron a dit "suprême" par référence à l'ordre des autres sphères qui lui sont inférieures, raison pour laquelle il a ajouté ensuite "qui enserre et contient les autres" […]» (éd. et trad. ARMISEN-MARCHETTI, *op. cit.*, note 7, p. 96); P. HENRY, *Plotin et l'Occident: Firmicus Maternus, Marius Victorinus, Saint Augustin et Macrobe*, Spicilegium Lovensiense, 15 (Louvain, 1934), p. 182–186; J. FLAMANT, *Macrobe et le néo-platonisme latin à la fin du IVᵉ siècle* (Leiden, 1977), p. 399–402.

69. Pline, *Histoire naturelle*, II, 1, éd., trad. et comm. J. BEAUJEU (Paris, 1950), p. 8.

70. Adélard de Bath, *Questions naturelles*, 76, 3: *De deo enim animali, rationali, immortali, si queritur, hoc modo applanon deum concedendum est. De Deo vero a quo universalis rerum causa incomposito, informi, immutabili, infinito, si investigatur, hoc modo extimam speram deum dici abhominandum est*, éd. C. BURNETT, trad. M. LEJBOWICZ, E. NDIAYE, C. DUSSOURT (Paris, 2016), p. 304/305.

71. *Dialogus Malchi ad Hiesum presbiterum*, in Gand, UB, MS 92, ff. 10v–12v-6 (le folio 6 s'insère entre les ff. 12 et 13); Inc.: *Si nunc otio habundas et tibi non displicet […]*; expl.: *[…] honor et gloria nunc et per omnia seculorum secula. Amen. Finit dialogus* (transcr. DEROLEZ, *Codex autographus, op. cit.* (note 16), p. [20–25]).

72. Aristote, *Physique*, IV, 4, 212a 20–21.

73. *Dialogus Malchi ad Hiesum presbiterum*, folio 12v: *M. Ut interim te pueriliter interrogem, dic michi ubi sit corpus quod nullo continetur loco. I. Cur ubi est dicis de eo quod non est in loco? Frustra enim queris huius rei corpus quod non est in loco; locum autem nullum corpus sine aliquo locali spatio invenitur excepto tocius mundi corpore; suprema enim omnium corporum extremitas nullo corporeo circumdatur loco, alioquin non esset extremitas vocanda* (transcr. DEROLEZ, *Codex autographus, op. cit.* (note 16), p. [24], l. 26–30).

74. *Ibid.*, folio 12: *M. Ubi nunc Christus secundum carnem esse creditur, an in celo ethereo infra firmamentum an supra? I. Numquid non recolis quid super hac re Paulus apostolus et psalmista atque Augustinus testantur, qui Christum super omnes celos ascendisse confirmant? Hoc tandem pro certo scimus, quod, si in celo ethereo Christus per hominem esse eligeret, huismodi locus nullo modo illius meritum, vel potentiam minueret, qua Dominus est omnium non solum secundum Deum, sed etiam secundum hominem* (transcr. DEROLEZ, *Codex autographus, op. cit.* (note 16), p. [23], l. 17–22).

75. *Ibid.*: *M. Ubi iusti post diem iudicii manebunt, in terra an in celo? I. Clemens in sua Historia refert homines iustos in terra degentes sublato firmamenti velo superioris celi secreta et Deum et angelos esse visuros, sed firmior est apostolica auctoritas qua dicitur: Rapiemur in aera obviam Christo, et sic cum ipso erimus. Dominus quoque in Evangelio ait: Ubi fuerit corpus, illuc congregabuntur aquile, id est: Ubi fuerit Christus secundum carnem, ibi erunt iusti. Christus autem sine dubio in celo est. Erunt igitur cum illo ibidem post diem iudicii omnes electi qui a domino aquilarum nomine vocantur. Augustinus itaque in libro De civitate Dei multiplici disputatione iustorum corporea resurgentium ad celos*

elevanda ac rapienda esse confirmat et illic semper mansura (transcr.
DEROLEZ, *Codex autographus, op. cit.* (note 16), p. [23],
l. 22–30).

76. *Ibid.*, folio 12v : *M : Numquid de inferno celum fieri
potest ? I. Etiamsi in quo Deus habitat celum dicitur, unde dicimus :
Pater noster qui est in celis (id est in iustis), eodem modo infernus
dicendus impius qui est templum diaboli […]. M. Ubi creditur
infernus esse, in terra an alibi ? I. Si igitur infernus in medio terre
est, terra autem ipsa in medio celi spatio sita est, manifestum in celo
infernum esse* (transcr. DEROLEZ, *Codex autographus, op. cit.*
(note 16), p. [24], l. 20–23 ; l. 30–36).

77. Pour d'autres ouvrages dans lesquels Honorius aborde
ces questions et aussi pour les prises de position d'Hugues
de Saint-Victor, voir l'article de fond de W. GOETZ :
« Endzeiterwartung und Endzeitvorstellung im Rahmen des
Geschichtsbildes des frühen 12. Jahrhunderts », in *The Use
and Abuse of Eschatology in the Middle Ages*, éd. W. VERBEKE,
D. VERHELST, A. WELKENHUYSEN, Louvain, 1988
(Mediaevalia Lovaniensia, Series I / Studia, 15) p. 306–331 ;
esp. p. 326–328.

78. Honorius Augustodunensis, *Elucidarium*, I, 10 : *D. Ubi
habitat Deus ? M. Quamvis ubique potentialiter, tamen in intel-
lectuali caelo substantialiter* (éd. Y. LEFÈVRE, *L'Elucidarium et
les Lucidaires : contribution, par l'histoire d'un texte, à l'histoire des
croyances religieuses en France au Moyen Âge*, Bibliothèque des
Écoles françaises d'Athènes et de Rome, 180 (Paris, 1954),
p. 362 ; pour *« potentialiter »* versus *« essentialiter »*, cf. p. 106–
107 ; Id., *Cognitio vitae*, c. 23–25 (*PL* 40, cols 1005–1033 ; esp.
cols 1019–1020).

79. Id., *Elucidarium*, I, 11 : *Tres celi dicuntur : unum corporale,
quod a nobis videtur ; aliud spirituale, quod spirituales substan-
tie, scilicet angeli, inhabitare creduntur ; tertium intellectuale, in
quo Trinitas sancta a beatis facie ad faciem contemplatur* (éd.
LEVÈVRE, p. 362).

80. *Ibid.*, p. 106–107 ; D. YINGST, *Towers in the Mud :
Honorius Augustodunensis Through the Lens of Pedagogy*, Thèse
inédite (Chicago, 2017), p. 142–143.

81. Sur les prises de position d'Honorius dans son traité
hexaméral, *De neocosmo*, cf. W. CIZEWSKI, « Interpreting
the Hexaemeron : Honorius Augustodunensis *De neocosmo* »,
Florilegium, 7 (1985), p. 84–108 ; esp. p. 92.

82. Honorius Augustodunensis, *Imago mundi*, I, 146–147 :
c. *Aqueum celum : Super firmamentum sunt aque instar nebule
suspense, que celum in circuitu ambire traduntur, unde et aqueum
celum dicitur* : c. *Spiritale celum : Super quod est spiritale celum,
hominibus incognitum, ubi est habitatio angelorum per IX ordines
dispositorum. In hoc est paradysus paradysorum in quo recipiuntur
anime sanctorum. Hoc est celum quod in principio legitur cum
terra creatum* ; c. « *Celum celi : Huic longe supereminere dicitur
celum celorum, in quo habitat rex angelorum*, éd. F. I. J. FLINT,
« Honorius Augustodunensis, *Imago mundi* », *Archives d'histoire
doctrinale et littéraire du Moyen Âge*, 49 (1982) : p. 7–153 ;
91–92.

83. Par exemple, *Glossa ordinaria, Cantic. Cantic.*, V, 17,
Quo abiit dilectus [Greg.] : *Sciendum quod Deus qui ubique est
in locum est, sed localis non est. Locale dicitur quod circumscribitur
secundum partes loci supra et infra, ante et retro, dextra et sinistra.
Cum vero angeli et humanae animae loco circumscribi non possunt,
longo minus illa incomprehensibilis substantia […]* (*PL* 113,
col. 1157 b). L. VALENTE, « Deus est ubique, ergo alicubi ?
Ubiquité et présence de Dieu dans le monde au XIIe siècle »,
in *Lieu, espace, mouvement : physique, métaphysique et cosmologie
(XIIe–XVIe siècles).* Actes du colloque international, Université
de Fribourg, 12–14 mars 2015, éd. T. SUAREZ-NANI, O.
RIBORDY, A. PETAGINE, Fédération Internationale des
Instituts d'Études Médiévales. Textes et Etudes du Moyen
Âge, 86 (Barcelone-Rome, 2017), p. 17–38.

Les anges et leurs images dans le *Liber floridus* de Wolfenbüttel, entre traditions et innovations iconographiques

Philippe Faure

Les analyses minutieuses d'Albert Derolez ont permis de mettre en lumière la complexité de l'élaboration du manuscrit autographe de Gand, d'en restituer les étapes et le contenu, et d'en montrer la cohérence symbolique et eschatologique. Il s'avère qu'une part importante, dédiée à l'Apocalypse de Jean, a disparu de l'œuvre originale[1]. Par conséquent, étudier les représentations des anges dans le *Liber floridus* conduit nécessairement à se reporter à la copie la plus ancienne du manuscrit de Gand, qui permet d'en reconstituer les cahiers manquants, c'est-à-dire le manuscrit conservé à Wolfenbüttel, daté de la période 1150–1170[2]. Chaque manuscrit mérite d'être étudié en lui-même, non comme témoin plus ou moins proche de l'original, mais en tant qu'objet culturel, tributaire d'un contexte d'élaboration et d'un milieu spécifiques. Comme l'a montré la récente étude d'Hanna Vorholt, si le projet du copiste de Wolfenbüttel était bien de suivre son modèle, il a opéré une série d'interventions qui ont transformé le *Liber floridus*. Il s'agit de corrections, d'ajouts, d'omissions, de modifications de la mise en page ou du rapport entre textes et figures[3]. Cette transformation consciente du savoir rassemblé par Lambert fait du manuscrit de Wolfenbüttel une œuvre à part entière.

Concernant les anges, celui-ci comporte une abondante iconographie, élaborée peut-être à l'abbaye Saint-Bertin de Gand[4], et que l'on suppose proche de celle que devait contenir le manuscrit autographe, achevé en 1120–1121. Si les noms des chœurs célestes, inscrits dans le diagramme du macrocosme, n'ont pas donné lieu à des représentations, la première miniature figurée met en scène Gabriel et Marie. Et surtout, une série d'images illustre le livre de l'Apocalypse de Jean. C'est dans ce contexte que les anges sont particulièrement sollicités et mis en valeur. Aux yeux de l'historien des images, ce corpus iconographique apparaît comme un ensemble tout à fait remarquable, aussi bien en ce qui concerne la première scène que la séquence consacrée à l'Apocalypse. On s'intéressera donc successivement à l'une et à l'autre, en essayant de les situer dans la production d'enluminures des XIe et XIIe siècles. On s'interrogera sur le rapport de ces images aux traditions iconographiques existantes et sur la part d'innovation qu'elles comportent. Se pose également la question de la relation entre ces images et les traditions exégétiques, et du discours théologique qui peut éventuellement en résulter. Cela dit, il convient de souligner d'emblée que l'un des acquis majeurs des études iconographiques des dernières décennies est celui de la complexité du rapport entre texte et image, de la mise en évidence d'une pensée plastique, d'une logique propre aux représentations figurées, et de leur autonomie par rapport aux textes[5]. À cet égard, sur le plan méthodologique, on prêtera attention aux autres miniatures, car les images se pensent entre elles, à l'intérieur même du manuscrit, et le sens peut résulter de leur mise en réseau. C'est en suivant une telle approche que l'on va s'efforcer d'aborder l'iconographie des anges dans le manuscrit du *Liber floridus* de Wolfenbüttel.

L'ange Gabriel et la Vierge Marie : un montage iconographique complexe

La mise en scène de Gabriel et Marie occupe la plus grande partie du folio 9, sous une courte compilation de formules liturgiques dédiées à celle-ci, qui contient des mots lourds de sens (Fig. 1). Le terme *imperatrix*, choisi de préférence à *regina*, renvoie à un usage de la période ottonienne et aux Vierges en majesté développées en miroir aux impératrices ottoniennes. C'est ainsi qu'au XIe siècle, Marie est qualifiée *d'imperatrix augusta* par Brunon ou Boniface de Querfurt (v. 974–1009)[6]. La

Fig. 1. Wolfenbüttel, Herzog August Bibliothek, Cod. Guelf. 1 Gud. lat., folio 9, Lambert de Saint-Omer, *Liber floridus*, vers 1170 : L'ange Gabriel prononçant ses paroles de salutation (Luc 1, 28) devant la Vierge Marie, Trône de la Sagesse (*Sedes Sapientae*)

Vierge couronnée renvoie à des modèles germaniques de la Vierge souveraine, ou Vierge-Église, qui porte la couronne par dessus le *maphorion* ou voile, comme dans l'Évangéliaire de Uota de Niedermünster ou sur la peinture de la coupole de l'ancienne abbatiale de Prüfening[7]. Cette préférence sémantique pour *imperatrix* s'accorde en outre parfaitement avec les options politiques de Lambert, qui n'a pas hésité à modifier le texte d'Adson, *De ortu et tempore Antichristi*, pour faire de l'empereur germanique l'empereur des derniers temps[8].

Si l'affirmation de la Vierge comme type de l'*Ecclesia* remonte à saint Ambroise, cette conception est sollicitée aussi bien par les empereurs que par les tenants de la réforme grégorienne. Une question majeure du temps est en effet de savoir qui doit diriger l'Église, et la figure mariale représente dans ce contexte un enjeu capital. L'image de Marie est ici celle d'une *Sedes Sapientiae*, telle qu'elle s'est développée depuis le xe siècle dans le cadre

d'une Église en quête de ressourcement, d'un mode de gouvernement avec ses valeurs et son mode d'organisation, et de l'image d'un pouvoir souverain. En milieu monastique, la Vierge est un symbole de l'*ordo* qui se généralise par le biais des réformes, de 1050 à 1120. La titulature présente dans la compilation de formules liturgiques met aussi l'accent sur cette dimension : Marie est «fontaine de miséricorde», «mère de la vie», «porteuse de la lumière perpétuelle», autant de titres qui sont mis à l'honneur dans la liturgie et promeuvent le culte de la Vierge comme figure de l'Église fondée et unie par le Christ. Au moment où s'impose la réforme grégorienne et où est élaborée l'iconographie du *Liber floridus*, l'image de la Vierge comme *Sedes Sapientiae*, portant le voile et la couronne, s'impose dans la peinture et la sculpture[9]. Cela s'accorde avec le fait que Lambert, en dépit des conflits opposant le comte de Flandre aux évêques locaux, apparait comme nettement favorable à la réforme grégorienne, dans le cadre de sa vision générale centrée sur Rome et Jérusalem[10].

La majesté de la Vierge est rehaussée par la présence d'un piédestal ou escabeau sous ses pieds. Formée d'un triple étagement d'arcatures en plein cintre, l'architecture du trône qu'elle occupe évoque l'architecture de la Jérusalem céleste et le type des statues romanes auvergnates initié par la Vierge de Clermont au milieu du xe siècle. En effet, le récit du moine Robert de Mozat associe la statue de la Vierge Marie à la cité céleste, dont le reflet terrestre est la crypte de la cathédrale, au sein de laquelle doit trôner la statue commandée par l'évêque de Clermont[11]. Les arcatures en plein cintre et les bandes horizontales sont des motifs traditionnellement employés pour évoquer les murs de la Jérusalem céleste. Les termes *imperatrix* et *assumpta* peuvent être interprétés dans le sens d'un règne et d'une ascension considérés comme l'accomplissement céleste et final du règne inauguré par l'Incarnation du Verbe ici-bas. Dans l'une de ses œuvres, Bède a identifié l'*Ecclesia* et la Vierge, en conjonction avec l'épouse du Cantique des cantiques[12]. Il faut encore signaler qu'à cette époque on représente assez rarement l'Assomption de Marie, en raison des doutes qui pèsent sur cette doctrine, exposés en particulier dans un écrit pseudépigraphique attribué à saint Jérôme, et dont le véritable auteur

est Paschase Radbert[13]. Mais quand on la re-présente, c'est justement sous la forme de la Vierge couronnée, qui monte au ciel dans une mandorle emportée par deux anges et bénie par la main de Dieu[14].

Un détail supplémentaire mérite d'être mentionné. Si l'on envisage le contexte proche de la miniature, on constate qu'un lien visuel unit le trône de la Vierge et celui du roi Salomon au folio précédent : le trône de la Vierge possède trois niveaux et douze arches, tandis que celui du souverain possède deux niveaux et quatre arches. Or, dans cette miniature, Salomon est présenté comme roi pacifique (*rex pacificus*) et figure du Christ, ce qui invite l'observateur à une exégèse typologique. Cette mise en correspondance de Salomon et du Christ est bien connue dans la culture savante, en particulier depuis Raban Maur, et relayée par la liturgie durant le cycle de l'Avent[15]. Sous la forme d'une architecture à plusieurs niveaux, le trône du royaume d'Israël apparaît comme une préfiguration du trône de la sagesse, c'est-à-dire du Christ, identifié à la sagesse éternelle, dont le roi Salomon est l'éminente figure dans l'Ancien Testament.

La représentation de la *Sedes Sapientiae* est donc centrale dans cette miniature ; elle est même singulièrement mise en valeur par la présence de l'ange Gabriel, qui, bien qu'étant debout à sa droite, n'est pas d'une taille supérieure à elle. Le procédé est courant dans l'iconographie depuis la période carolingienne, mais il accentue particulièrement ici l'impression de souveraineté qui se dégage de la Vierge à l'enfant. De surcroît, l'attitude de Gabriel est tout à fait originale, voire inédite dans l'iconographie romane. En effet, tourné vers Marie, il étend en avant ses deux bras, qui accompagnent le mouvement du phylactère qui contient les paroles de la salutation angélique : *Ave Maria gratia plena*. La référence à la séquence de l'Annonciation est évidente, mais s'inspire directement de la formulation liturgique plutôt que du texte même de l'Évangile de Luc, qui se contente de la salutation *Ave gratia plena*, sans mentionner à cet endroit précis le nom de Marie. Ce choix de la version liturgique plutôt que de l'Évangile est bien en phase avec le texte qui précède, lui-même pétri de formules liturgiques. Il reste que nous n'avons pas trouvé d'autre exemple du geste de l'ange Gabriel, les deux bras projetés vers l'avant, dans l'iconographie romane. Ce geste d'accompagnement de la salutation angélique est aussi un geste qui montre le mystère, car l'enfant n'est pas « à venir », comme dans la mise en scène classique de l'Annonciation ; il est déjà là, présent entre les genoux de Marie, sous la forme d'un jeune adulte en réduction, conformément au type de la *Sedes Sapientiae*.

Cette mise en scène relève donc d'un montage iconographique et de la volonté délibérée d'assembler deux éléments disjoints. Il ne s'agit pas de la scène de l'Annonciation telle qu'elle est alors le plus souvent représentée au XIIe siècle[16], mais bien d'une composition originale délivrant un contenu théologique fort, au point de départ du programme d'images figuratives. D'entrée de jeu, se trouvent ainsi étroitement associés le mystère de l'Incarnation, à travers le rappel de l'Annonciation par Gabriel, l'antétype du Christ qu'est le roi Salomon, et la figure couronnée de l'*Ecclesia* dans la cité céleste, sous la forme de la *Sedes Sapientiae*. Avec Salomon, Gabriel et la Vierge à l'enfant, c'est le passé, le présent et le futur de l'histoire du salut qui se trouvent visuellement reliés. Cette scénographie complexe ne se comprend pleinement que dans la perspective de l'exégèse typologique alors en plein essor dans la culture monastique. Comme l'a bien montré Erich Auerbach dans un article classique[17], la démarche typologique part du présent de l'Incarnation, porte un regard rétrospectif vers l'Ancien Testament, pour y déceler des figures qui annoncent le dévoilement et l'accomplissement du message du Christ dans l'Église, jusque dans l'au-delà, dans l'éternité. Une telle démarche autorise des combinaisons d'images, de faits ou de personnages qui induisent l'émergence de significations nouvelles. C'est précisément le cas ici : l'attitude de Gabriel renvoie au mystère de l'Incarnation, la *Sedes Sapientiae* renvoie au trône et à la sagesse de Salomon, antétype du Christ, la Vierge couronnée renvoie à la Vierge-Église, figure du salut et souveraine de la cité céleste à la fin des temps.

Rappelons encore que la méditation des clercs sur le mystère de l'Incarnation a pris toute son ampleur avec Anselme de Cantorbéry, Guillaume de Champeaux, Bernard de Clairvaux. Or on sait qu'Anselme s'est rendu à Saint-Omer et à Saint-Bertin à deux reprises, en 1097 et 1099, et que Lambert a compilé

des *Flores libri Anselmi Cur Deus Homo*; il est donc tout à fait sensible à cette thématique théologique[18]. Dans la période où est élaboré le *Liber floridus*, le portail royal de la Vierge à Chartres, vers 1130, témoigne de cette méditation centrée sur l'Incarnation, avec sa *Sedes Sapientiae*, placée juste au-dessus de la présentation de Jésus au temple, elle-même surmontant la Nativité du Seigneur[19]. Cette séquence figurative inaugurale du manuscrit de Lambert de Saint-Omer semble donner une clef de lecture essentielle de l'ensemble du projet iconographique.

Les anges de l'Apocalypse

C'est dans le cadre de l'illustration du livre de l'Apocalypse que se situe l'ensemble des autres représentations angéliques du *Liber floridus* de Wolfenbüttel[20]. Or l'historien des images manque de points d'appui pour situer ce corpus documentaire dans la production du XIIe siècle et pour découvrir à quelles traditions, iconographiques et exégétiques, il pourrait être rattaché. En effet, les illustrations de l'Apocalypse sont rares entre les manuscrits du haut Moyen Âge et la floraison des manuscrits anglo-français au XIIIe siècle. Peter Klein a réparti en quatre groupes les traditions iconographiques antérieures; le quatrième groupe, qui a donné naissance à la série des *Beatus*, serait issu d'un modèle hispanique, voire nord-africain; les trois autres dériveraient d'un modèle romain du VIe ou du Ve siècle[21]. Le premier groupe est représenté par les Apocalypses de Trèves et de Cambrai, le deuxième par les Apocalypses de saint-Amand, de Valenciennes, et de Bamberg par une autre ramification[22]. Le troisième groupe, dans lequel Peter Klein inscrit le *Liber floridus*, est plus composite et ne comporte pas de témoins issus de la période carolingienne. Les principaux jalons de cet ensemble sont la Bible de Roda et deux manuscrits de l'Apocalypse conservés à Oxford et Berlin[23].

En ce qui concerne l'exégèse de l'Apocalypse, selon Yves Christe, la tradition médiévale dominante est issue de Ticonius (v. 364–395) plutôt que de saint Jérôme. Cela signifie qu'après la période paléochrétienne, où s'était maintenue une lecture eschatologique dans l'attente espérée de la parousie, une conception du texte comme une série de récapitulations de l'histoire du salut s'est progressivement imposée. Avec des nuances diverses, les auteurs tels que Bède, Ambroise Autpert, Haimon d'Auxerre, le pseudo-Alcuin, ont développé l'exégèse dans ce sens[24]. L'ordre de la vision s'inscrit dans l'ordre de la narration, et l'interprétation demeure centrée sur le Christ de l'Incarnation. Jusqu'à la fin du XIe siècle, l'exégèse d'Ambroise Autpert, relayée par Haimon d'Auxerre, est dominante; elle met l'accent sur la spiritualisation du combat terrestre et sur le mépris du monde, sur le durcissement de la lutte entre le diable et l'Église, et conduit à un renforcement de l'union entre les vivants et les morts, autour des corps saints.

À la fin du XIe siècle, Anselme de Laon a remis l'accent sur la périodisation de l'Apocalypse en sept visions définie par Bède et sur la lecture historique des septénaires. Ce principe de succession historique a donné lieu à une interprétation des sept sceaux comme désignant des états successifs de l'Église et à une prise en compte du temps qui sépare le présent du jugement final. Cette extension temporelle a donné prise à une réflexion sur l'écart entre l'idéal spirituel et la réalité du désordre politique, notamment à une critique du système féodo-vassalique, bien installé en France du Nord, et a servi l'entreprise grégorienne de réforme de l'Église[25]. Comme l'a bien remarqué Guy Lobrichon, il est révélateur qu'un commentaire de l'Apocalypse ait été inséré dans l'encyclopédie historique qu'est le *Liber floridus*, alors que la pratique la plus courante était celle de l'isolement des commentaires bibliques[26]. Anselme de Laon et le *Liber floridus* séparent une séquence historique qui va de l'Incarnation à l'Antéchrist et une séquence des derniers temps, la césure entre les deux étant située à la fin du chapitre 14. Les scènes des quatorze premiers chapitres concernent donc l'histoire terrestre. Tous les exégètes ont adopté ce cadre défini par Anselme de Laon et diffusé par la glose ordinaire. Anselme ne cite que deux auteurs, Bède et Haimon, et le *Liber floridus* en représente un écho au début du XIIe siècle, alors que la glose ordinaire n'est pas encore fixée[27]. Celle-ci tente d'unifier l'enseignement sur l'Apocalypse, en introduisant une tension historique et chronologique, mais sans éliminer l'interprétation antérieure.

Sur le plan iconographique, la question des liens entre l'iconographie du *Liber floridus* et

celle des manuscrits produits dans la période antérieure, ou dans la même période et le même espace, n'est pas simple à appréhender, en raison de la faiblesse de la documentation. On a vu que le *Liber floridus* est tributaire de modèles carolingiens-ottoniens à propos de la Vierge, mais que la *Sedes Sapientiae* peut également s'inscrire dans la vision grégorienne, qui promeut la Vierge Marie comme image de souveraineté de l'Église, unie autour des évêques. De même, l'iconographie de l'Apocalypse du *Liber floridus* semble dépendre de plusieurs traditions et entremêler leurs influences. Si l'on suit la classification de Peter Klein, cette iconographie est assez éloignée des traditions carolingiennes représentées par les deux premiers groupes, mais présente des points de convergence avec la Bible catalane de Roda, les manuscrits d'Oxford et de Berlin. Portons à présent le regard sur les images du manuscrit de Wolfenbüttel.

Les sept églises d'Asie (Apocalypse 1, 9–3, 22) sont bien mises en valeur et représentées par leur ange, situé derrière chacune d'elles (Fig. 2). Cette disposition présente des correspondances avec l'Apocalypse de Trèves et surtout avec l'Apocalypse de Berlin, manuscrit qui provient de l'Italie du Nord[28]. Sur ce point, il ne semble pas exister de rapport avec le manuscrit d'Oxford où les anges sont en fait les évêques des communautés d'Asie, suivant en cela l'exégèse de Cassiodore. Les anges qui tiennent dans leur main les vents sous la forme d'une tête humaine semblent également tributaires de modèles romains : on trouve une semblable représentation dans le manuscrit de Berlin, dans celui d'Oxford, et, à la fin du XIe siècle, dans les Bibles catalanes[29] et aux pendentifs du ciborium de l'église abbatiale San Pietro al Monte de Civate, près de Côme. Ces deux occurrences sont particulièrement remarquables, car les têtes symbolisant les vents sont tenues d'une seule main par les anges[30]. Or, c'est également le cas pour deux des anges dans le *Liber floridus* de Wolfenbüttel (Fig. 3). Ce détail a probablement été emprunté à la tradition méridionale, italienne, de l'iconographie de l'Apocalypse. D'autres éléments vont dans le même sens : Laurence Rivière Cavaldini a établi des correspondances entre le manuscrit de Wolfenbüttel et les deux panneaux de bois de Stuttgart, qui présentent quarante-quatre scènes de l'Apocalypse, réalisées à Naples vers

Fig. 2. Wolfenbüttel, Herzog August Bibliothek, Cod. Guelf. 1 Gud. lat., folio 9v, Lambert de Saint-Omer, *Liber floridus*, vers 1170 : La vision inaugurale de saint Jean et les anges des sept Églises d'orient (Apoc. 1–3)

1330–1350. En dépit de leur datation tardive, ces panneaux dévoilent l'existence d'une tradition napolitaine très ancienne d'illustration du texte de Jean[31].

Avant d'en venir aux autres images des anges, il paraît utile de s'arrêter sur les scènes centrales que sont les visions du trône et de l'Agneau (Apocalypse 4–7). La représentation de la divinité sous la forme du Christ en majesté fait appel aux modèles ottoniens et carolingiens, en associant la mandorle et le cercle[32]. Sous l'autel ou estrade où reposent les pieds du Christ, figurent les âmes des martyrs d'Apocalypse 6, 9, sous la forme de trois petits corps nus, transpercés par une lance et deux épées. La scène de l'adoration du Seigneur s'étend sur deux folios[33] ; les vingt-quatre vieillards sont répartis en deux séries de douze personnages, d'abord autour du Christ en majesté, puis de l'Agneau, et saisis dans des attitudes diverses, debout, assis ou esquissant une prosternation. Certains sont nimbés, couronnés, ou offrent une couronne ; ils tiennent

une coupe ou un instrument de musique. Plusieurs traditions se mêlent, car dans la tradition romaine ils sont debout, comme dans les manuscrits de Bamberg, Berlin et Oxford. La position assise des vieillards et leur esquisse de mouvements semblent provenir de modèles méridionaux ; là encore c'est dans Bible de Roda que l'on trouve les vieillards assis et couronnés, puis, au registre inférieur, tête nue, sur le point de s'agenouiller devant l'Agneau[34]. Dans la sculpture romane, le portail de Moissac a donné à la position assise des vieillards, en lien avec la *Maiestas domini* qu'ils entourent, son expression la plus remarquable.

Dans le *Liber floridus*, ils sont tous nommés, suivant une tradition d'origine copte ; outre des noms issus de la liste des vingt-quatre prêtres énumérés dans le premier livre des Paralipomènes (1 Chroniques 24, 7–18), on trouve essentiellement les noms de douze prophètes puis de douze apôtres[35]. Autrement dit, ce double folio réunit l'Ancien et le Nouveau Testament et se prête à une lecture augustinienne de l'histoire du salut, à une évocation du règne de Dieu plutôt qu'à une apparition à la fin des temps. Ces images n'indiquent pas une influence nette d'auteurs comme Primase, Bède ou Haimon d'Auxerre, qui font de la scène de l'adoration une anticipation du jugement. Plutôt qu'un tiraillement entre deux tendances de l'exégèse, ce double folio évoque la permanence du Règne de Dieu selon saint Augustin, une réalité présente et céleste, une image de la gloire de l'Église associée au Christ, préfigurée par l'ancienne alliance et acquise par l'Incarnation[36]. Cette vision d'une histoire universelle, rythmée en séquences mais pensée également comme un retour incessant du temps sur lui-même, dans le plan de la Cité de Dieu, s'accorde avec la place centrale des figures circulaires, si aptes à figurer la double dimension, historique et eschatologique, de l'*Ecclesia*[37].

La séquence suivante peut s'interpréter dans cette perspective christologique. Selon la tradition exégétique issue de Ticonius et poursuivie par Ambroise Autpert, l'ange à l'encensoir d'Apocalypse 8, 3 est interprété comme l'ange du Seigneur du livre d'Isaïe (Isaïe 9, 5), c'est-à-dire comme une figure du Christ de l'Incarnation[38]. Dans le registre inférieur du folio 11v, selon un procédé courant dans l'iconographie romane, l'ange pivote sur

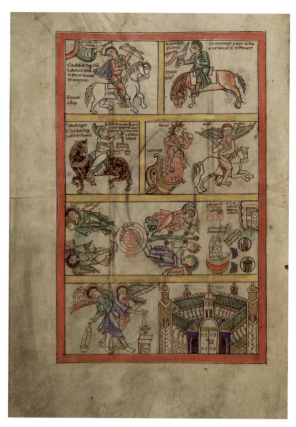

Fig. 3. Wolfenbüttel, Herzog August Bibliothek, Cod. Guelf. 1 Gud. lat., folio 11v, Lambert de Saint-Omer, *Liber floridus*, vers 1170 : Les quatre cavaliers (Apoc. 6, 1–8), les anges retenant les quatre vents (Apoc. 7, 1), et l'ange à l'encensoir d'or (Apoc. 8, 3)

lui-même pour encenser l'autel de la main droite, tout en portant de la myrrhe dans l'autre main. On retrouve ce motif de l'ange à l'encensoir et à la myrrhe dans la sculpture romane du temps. À droite de l'autel, une architecture carrée, surmontée de tours, évoque le temple céleste plutôt que le trône. Les anges aux trompettes d'Apocalypse 8, 6–13 et 9, 1–15, qui annoncent les fléaux se déploient sur les trois folios suivants[39]. Selon l'exégèse de tradition ticonienne, jalonnée par Primase, Césaire d'Arles, puis Ambroise Autpert et Haimon d'Auxerre, ces anges, placés dans la dépendance de l'ange à l'encensoir, figurent la venue présente du Christ dans son Église ou dans ses prédicateurs, anticipation du Royaume à venir[40]. Leur allure générale et leur tenue vestimentaire dénotent une influence byzantinisante, sans doute filtrée par des modèles ottoniens ou italiens. Au registre supérieur du folio 13v apparaît, debout sur la mer et la terre, l'ange puissant descendu du ciel, qui donne à saint Jean le livre à manger

(Apocalypse 10, 1–7). Impressionnant par sa taille et ses ailes déployées à l'horizontale, il fait le double de la hauteur du visionnaire de Patmos. L'inscription qui accompagne l'ange est assez ambigüe ; or la tradition exégétique médiévale, incarnée par Bède, Ambroise Autpert et Haimon d'Auxerre, a fait de lui une figure du Christ ressuscité, qu'elle situe plutôt au début du temps de l'Église[41]. Au registre inférieur, un ange aptère descendant du ciel apporte à Jean le roseau pour mesurer le temple, tandis qu'à sa droite se trouvent les deux témoins, identifiés à Enoch et Elie, conformément à la tradition exégétique (Apocalypse 11, 1–6).

Au folio 14, le registre supérieur illustre les calamités provoquées par « la Bête qui monte de l'Abîme », la mort et l'ascension au ciel des deux témoins (Apocalypse 11, 7–14). C'est avec l'ange à la septième trompette d'Apocalypse 11, 15–19 que l'on note une première allusion explicite au jugement futur : dans le registre inférieur du folio 14, le Christ juge, escorté de trois anges dans une gloire à la bordure ondulée comme une nuée, est assis sur l'arc-en-ciel et les pieds posés sur une estrade ; il tient le livre dans sa main gauche et le pommeau de l'épée nue dans sa main droite (Fig. 4). Si l'on considère l'ensemble du programme iconographique, un rapprochement s'impose ici avec l'image inaugurale du roi Salomon, *rex pacificus*, tenant l'épée par l'extrémité de sa lame nue. Le roi de paix a cédé la place au roi de justice, présidant au jugement des âmes. On peut voir dans cette première allusion au jugement futur un écho visuel de l'ambigüité que les commentateurs comme Ambroise Autpert ont introduite à cet endroit précis, en situant cette vision dans le présent et dans le futur[42].

Dans cette série d'images, on ne peut guère déceler l'influence des tendances exégétiques qui en viennent à privilégier le futur et la fin du temps de l'Église sur le présent. Il faut dire que le manuscrit de Wolfenbüttel s'arrête au chapitre 13 de l'Apocalypse, donc aux quatre premières visions du découpage septénaire de Bède, qui sont interprétées par Ambroise Autpert et Haimon d'Auxerre comme la récapitulation des combats de l'Église, dans une conception du temps présent, temps de l'Église et de la première résurrection, étendu vers le passé et vers l'avenir. Préparée par

Fig. 4. Wolfenbüttel, Herzog August Bibliothek, Cod. Guelf. 1 Gud. lat., folio 14, Lambert de Saint-Omer, *Liber floridus*, vers 1170 : La mort et l'ascension au ciel des deux témoins (Apoc. 11, 1–13), l'ange à la septième trompette et l'avènement du règne de Dieu (Apoc. 11, 15–19).

l'école d'Anselme de Laon, dont aurait fait partie Lambert de Saint-Omer[43], la glose ordinaire est tardivement fixée pour l'Apocalypse. Le *Liber floridus* serait donc plutôt tributaire de la « glose périmée » selon la formule d'Yves Christe[44].

Mais le manuscrit de Wolfenbüttel est incomplet : il manque les cinquième, sixième et septième visions du découpage initié par Bède, qui sont de plus en plus interprétées comme concernant le temps d'avant la parousie et l'accomplissement eschatologique, la résurrection et le jugement, comme en témoignent les commentaires de Richard de Saint-Victor, de Berengaud, et finalement la glose ordinaire, qui présentent une vision plus discursive et historicisante du destin de l'Église. L'idée de jugement tend alors à s'insinuer de plus en plus dans l'interprétation des visions premières des chapitres 4 et 5 du texte de saint Jean. S'il y a bien une évolution des

commentaires contemporains, le caractère fragmentaire du programme iconographique du *Liber floridus* de Wolfenbüttel invite à la prudence et à la nuance à propos de la place accordée à la dimension eschatologique de l'ensemble. Même dans son adaptation très personnelle de la légende de l'Antéchrist, qui met en valeur la conversion finale des Juifs et leur admission dans l'Église, Lambert demeure dans l'attente et se garde de toute spéculation historique, rappelant que nul ne connaît le moment et l'heure du jour du Jugement dernier, et cela d'autant moins que le succès de la première croisade a confirmé l'empereur dans sa mission[45].

L'archange saint Michel et la femme de l'Apocalypse

Une autre séquence iconographique nous permet d'aller plus loin dans l'analyse. Il s'agit de la mise en scène de la confrontation entre la femme, le dragon et l'archange Michel dans Apocalypse 12, 1–5. Sur le premier folio (14v), en dépit de son voile et de son manteau bleu, la femme n'est pas identifiable à la Vierge Marie, et l'enfant qu'elle tient emmailloté dans son bras droit ne porte aucun signe christique (Fig. 5). L'image est associée à l'ouverture de l'arche ou temple dans le ciel, sous la forme d'une rotonde et de quatre tours, conformément au découpage de Ticonius, qui est suivi par la plupart des manuscrits des groupes 2 et 3 définis par Peter Klein. Même si des auteurs comme Ambroise Autpert et Beatus de Liebana considèrent que la femme pouvait être la Vierge, il faut souligner qu'en règle générale la tradition exégétique privilégie une identification de la femme couronnée avec l'Église. Qu'il s'agisse de Bède, d'Haimon d'Auxerre, de Bérengaud, d'Anselme de Laon et de Lambert de Saint-Omer lui-même, tous vont dans ce sens, exprimant ainsi la tendance de la culture monastique à développer une interprétation mystique de la scène. De même, l'engendrement de l'enfant mâle et son enlèvement au ciel représentent aussi bien les mystères de la résurrection et de l'Ascension que les âmes des fidèles, membres de l'Église[46].

En face, sur le folio 15, figure le combat contre le dragon d'Apocalypse 12, 7–9, ultime affrontement avant la victoire finale du Christ (Fig. 6). L'archange Michel est mis en valeur

Fig. 5. Wolfenbüttel, Herzog August Bibliothek, Cod. Guelf. 1 Gud. lat., folio 14v, Lambert de Saint-Omer, *Liber floridus*, vers 1170 : La femme et le dragon à sept têtes (Apoc. 12, 1–5).

Fig. 6. Wolfenbüttel, Herzog August Bibliothek, Cod. Guelf. 1 Gud. lat., folio 15, Lambert de Saint-Omer, *Liber floridus*, vers 1170 : Saint Michel et ses anges combattant le dragon (Apoc. 12, 7).

par sa taille immense, au moins deux fois supérieure à celle des autres anges du manuscrit, excepté Gabriel. Cette grande taille est également repérable dans les manuscrits apparentés à celui de Wolfenbüttel, notamment dans celui d'Oxford, où Michel est en armure de profil dans une mandorle et occupe la moitié du folio, exceptionnellement découpé en trois registres au lieu de quatre[47].

Sur le plan du schéma iconographique, il semble que là encore, le *Liber floridus* porte la marque d'une tradition venue d'Italie, et plus précisément du Piémont. C'est dans l'église abbatiale de San Pietro al Monte, à Civate, près de Côme, qu'a été exécutée vers 1100 la plus grandiose fresque représentant cette fameuse séquence de l'Apocalypse[48]. Il convient de s'y arrêter, car cette peinture est un jalon capital dans l'histoire de la mise en images du récit visionnaire, et son influence sur l'iconographie postérieure est certaine. Telles qu'ils sont traités à San Petro al Monte, la femme et son enfant sont une adaptation du type byzantin de la Nativité ; ainsi, la scène associe la femme apocalyptique à la Vierge, mais surtout à l'Église, car l'inscription qui encadre la fresque mentionne les douleurs de l'enfantement. La réunion en une seule image de la femme d'Apocalypse 12 et de la Vierge n'est pas une nouveauté dans la peinture italienne, comme en témoigne la fresque du baptistère de Novare, datée du XIe siècle.

Au folio 14v du *Liber floridus*, face à la femme, le dragon à tête couronnée possède six têtes couronnées adjacentes, qui émergent de part et d'autre de son cou. Or ce détail est également remarquable sur la fresque de San Pietro al Monte. Il convient d'insister sur cette convergence particulière, sans précédent notable, semble-t-il, dans la tradition iconographique. En effet, dans les manuscrits antérieurs, lorsque les têtes adjacentes du dragon apparaissent, elles ne sont pas disposées symétriquement des deux côtés du cou, mais sont superposées d'un seul côté ou sur la tête[49]. Intéressons-nous maintenant à l'archange. Sa haute stature et son comportement dans le manuscrit de Wolfenbüttel sont très caractéristiques : la jambe droite pliée, la jambe gauche tendue, il tient un petit bouclier dans sa main gauche et relève son bras droit pour manier la lance, le regard tourné vers le dragon. Cette attitude est également

extrêmement proche de celle du saint Michel de la fresque de San Pietro al Monte, même s'il ne tient pas de bouclier et présente des références romano-byzantines, notamment son équipement militaire et sa lance ornée du labarum d'origine constantinienne. Les anges qui participent au combat contre le dragon viennent du haut, ils sont dans les deux cas en surplomb par rapport au dragon (Fig. 7). Bien que la position de celui-ci soit inversée dans les deux représentations, ce qui importe est la relation directe qu'elles instaurent entre les deux protagonistes par le coup de lance, mais aussi par l'échange de regard : il s'agit bien d'un combat entre deux puissances, que les inscriptions issues du texte de l'Apocalypse viennent confirmer sur le folio 15. Cette mise en scène tranche avec un autre type de représentation en usage encore au XIIe siècle, qui consiste à montrer l'archange debout sur le

Fig. 7. Église San Pietro al Monte, Civate, près de Lecco, sur le lac de Côme. Le porche ouest vu de la nef. Peinture à fresque, fin du XIe siècle (détail) : le sauvetage du nouveau-né auprès de Dieu et le combat de saint Michel et de ses anges contre le dragon (Apoc. 12, 5–7) [credits : Otto Demus et Max Hirmer, *La peinture murale romane*, Paris, Flammarion, 1970, planche couleur II.]

dragon, le terrassant par sa puissance bien plus que par sa lance[50]. Inspiré de l'image du Christ marchant sur l'aspic et le basilic (Psaume 90, 13), ce type iconographique, caractérisé par la position statique de saint Michel, a cédé le pas à une mise en scène dynamique, fondée sur la référence au chapitre 12 de l'Apocalypse. Le combat contre le dragon est une image occidentale, dont le succès s'est trouvé amplifié par la réception favorable du livre de l'Apocalypse, dont l'orthodoxie a longtemps été contestée en Orient byzantin.

Le faisceau de similitudes que l'on a relevé semble indiquer que le miniaturiste du *Liber floridus* de Wolfenbüttel a pu avoir connaissance, directement ou non, du schéma de composition de la fresque de San Pietro al Monte, des modèles utilisés, et même de certains détails iconographiques. Il est possible qu'entre les deux œuvres, séparées de quelques décennies, des relais aient pu exister ; on ne peut qu'en rester à des suppositions à cet égard, mais les ressemblances que l'on a relevées ne peuvent être fortuites ; elles traduisent une inspiration et confirment l'influence de modèles italiens sur l'iconographie du *Liber floridus*. Cela dit, concernant l'attitude de l'archange, on ne peut exclure l'influence d'un modèle germanique antérieur, comme peuvent le suggérer l'ivoire carolingien de Leipzig, probablement sculpté dans la région de Trèves ou d'Aix-la-Chapelle, ou une miniature du tropaire de Prüm, de la fin du Xe siècle, où Michel fléchit les jambes, tout en plantant sa lance dans la gueule d'un dragon devant lui sur la droite, la queue ascendante[51]. La position caractéristique de l'archange est également présente dans l'iconographie byzantine, ce dont témoigne une miniature illustrant la légende du miracle de Chonae, datée de 985 environ[52]. De manière indirecte, ce type de représentation a pu influencer l'iconographe du manuscrit de Wolfenbüttel, car on y retrouve des similitudes dans la découpe de la partie inférieure du manteau de l'archange. Que ce soit par des médiations germaniques ou italiennes, le saint Michel du *Liber floridus* est tributaire de traits byzantinisants, qu'un spécialiste comme Hubert Schrade avait déjà relevés à propos de la fresque de San Pietro al Monte, notamment de la troupe des anges autour du Christ, et de la femme traitée comme une scène de Nativité.

La mise en correspondance des deux œuvres est précieuse sur un autre plan, car elle permet de mettre en évidence le poids de l'exégèse typologique sur la mise en images. En effet, la fresque de Civate est réputée avoir subi l'influence du commentaire d'Ambroise Autpert, daté de 758–767, qui identifie la femme d'Apocalypse 12 à l'Église qui enfante chaque jour le Christ avec douleur aux fidèles ; les deux ailes d'aigle qu'elle reçoit pour échapper au dragon sont les figures de l'Ancien et du Nouveau Testament, mais aussi les vies active et contemplative[53]. L'Église est le temple de Dieu et le corps du Christ. À San Pietro al Monte comme dans le *Liber floridus* de Wolfenbüttel, l'enfant n'est pas caractérisé comme Christ, il peut donc figurer les croyants enfantés par l'Église, selon l'exégèse spiritualiste. Mais l'inscription de la fresque de San Pietro al Monte en fait une figure du Christ. On serait tenté de considérer comme fâcheuse l'ambiguïté entre l'interprétation littérale et l'interprétation spirituelle, mais la combinaison des deux interprétations est précisément exposée par Ambroise Autpert et la plupart des auteurs[54] ; qu'on la retrouve dans la fresque ne saurait donc surprendre.

Le commentaire d'Ambroise Autpert a été repris par Haimon d'Auxerre ; or l'Apocalypse d'Oxford, qui contient le commentaire d'Haimon, présente une riche iconographie, conçue en Germanie vers 1100[55]. On y repère des analogies avec certaines scènes du *Liber floridus* de Wolfenbüttel : La femme en majesté, les bras étendus dans une auréole solaire, entourée de quatre têtes, rappelle le type *ecclesia imperatrix*. À côté, sur la droite, figure la *Sedes Sapientiae* présentant son fils. Or Haimon compare la naissance du fils de la femme à la Nativité du Christ, et l'enlèvement de l'enfant à la fuite en Egypte et à l'Ascension du Christ. Il a repris à son compte le parallèle entre Marie et la sagesse, en insistant sur la prédestination de Marie comme mère de Dieu et réceptacle du Christ. Il évoque ensuite l'*Ecclesia* pour aboutir à une équivalence entre *Virgo Maria*, *Mater Ecclesia* et *mulier amicta sole*. L'exégète tisse un lien entre l'Incarnation, l'Église et la femme d'Apocalypse 12, qui montre combien les interprétations s'étagent ou s'additionnent plutôt qu'elles ne se contredisent.

Les ambiguïtés de l'iconographie se comprennent à la lumière de l'exégèse

typologique, qui tend alors à s'exprimer dans l'iconographie romane. À cet égard, bien qu'ils soient légèrement postérieurs au *Liber floridus* de Wolfenbüttel, on peut mentionner les premiers manuscrits typologiques dans l'espace germanique, comme cet exemplaire du *De laudibus sanctae crucis* de Raban Maur et sa crucifixion symbolique, où la croix est entourée du lion et du dragon, de l'aspic et du basilic évoqués dans le Psaume 90. La légende précise à gauche : l'orgueil du diable est vaincu par l'humilité de la croix du Christ[56]. On songe également à certains manuscrits dont la composition en registres, en vignettes, ou certaines scènes semblent proches de l'Apocalypse d'Oxford et même du *Liber floridus* de Wolfenbüttel, par exemple le martyre de Christophe, qui rappelle la représentation des martyrs sous l'autel, ou le combat de saint Michel et la chute des anges dans un recueil provenant de Zwiefalten[57]. Un autre point de comparaison est digne d'intérêt. Au folio 70 de l'Apocalypse de Berlin, la femme est assise en majesté sur un trône, le serpent est couché en bas tout en s'élevant sur la gauche, un ange est debout à droite. Au registre inférieur, Michel porte un vêtement byzantinisant, avec trois anges à droite, tandis que le serpent, enroulé en spirale, est placé du côté gauche.

Suivant l'exégèse typologique en plein développement dans la culture monastique, notamment dans l'espace germanique occidental, Michel est une figure du Christ. De nombreux auteurs, comme Césaire d'Arles, Berengaud, Honorius Augustodunensis, se sont exprimés dans ce sens. L'un des plus anciens témoignages iconographiques de saint Michel terrassant le dragon, l'ivoire carolingien de Leipzig, daté des années 800, s'inscrit précisément dans cette tradition[58]. Selon Alcuin, le combat *in caelo* signifie *in ecclesia*. Berengaud précise que c'est à cause du ciel et pour notre salut que lutte l'archange[59]. Le combat est l'allégorie du mystère du salut et spécialement de la Passion. C'est en instituant l'Église, en rachetant l'humanité, que le Christ a combattu le dragon. Or le commentaire de Berengaud de Ferrières, dont la datation est incertaine, mais située généralement dans le courant du XIᵉ siècle, est proche de celui d'Haimon d'Auxerre. Les anges combattants au côté de l'archange sont les apôtres et les

saints qui participent à la Passion par le martyre, ils sont vainqueurs[60]. Selon Bède, le dragon précipité à terre est écrasé par les pieds des saints comme dans le psaume, « tu marcheras sur l'aspic et le basilic » (Psaume 90, 13). Le combat symbolise aussi la lutte intérieure contre les passions et les tentations. Jean Beleth récapitule la tradition exégétique en distinguant nettement les deux interprétations, historique et symbolique, du combat contre le dragon.

Dans un manuscrit conservé à Bruxelles et apparenté à celui d'Oxford, Michel est non seulement l'ange combattant et terrassant le dragon au folio 35v, mais aussi et d'abord le premier ange qui sonne de la trompe : *Michael turba cecissit* est-il écrit au folio 24. Au folio 43v, un personnage invoque Michel[61]. La présence de Michel dans l'iconographie des manuscrits de cette période dans l'espace germanique est donc particulièrement forte et investie de sens multiples. Cela n'est pas surprenant, si l'on prend en considération la densité symbolique de cette figure, seul archange à fonction eschatologique, et l'étagement des significations qu'engendre la doctrine des sens de l'Écriture, pratiquée depuis la période des Pères de l'Église.

Dans l'iconographie des XIᵉ–XIIᵉ siècles, des images vont jusqu'à mettre en scène l'équivalence entre la Passion du Christ et le combat de saint Michel. Sur l'autel de la comtesse Gertrude († 1077), l'adoration de la croix par Constantin et Hélène a pour pendant, sur l'autre petit côté, un saint Michel en position frontale, terrassant le dragon, inspiré du modèle du Christ marchant sur l'aspic et le basilic[62]. Selon Rupert de Deutz, qui fait le rapprochement entre le combat du chapitre 12 de l'Apocalypse et le thème de la pêche au léviathan, le Christ est l'appât sur l'hameçon de la croix. Ce sujet a fait l'objet de la fresque perdue d'Aquilée, où se trouvaient à la fois l'*Ecclesia* qui pêche le léviathan et Michel qui combat le dragon. Le combat de l'archange figure sur une croix danoise ; à Florence, l'ivoire mosan du Bargello juxtapose les deux scènes du combat de Michel contre le dragon et du Christ sur l'aspic et le basilic[63].

Il convient aussi de rappeler qu'à l'époque romane, saint Michel est régulièrement sollicité comme associé et protecteur de la Vierge et de l'Église, dans les sanctuaires et

dans l'iconographie, en raison de son combat victorieux contre le dragon[64]. Dans le *Liber matutinalis* de Conrad von Scheyern, au début du XIIIe siècle, la femme d'Apocalypse 12 est associée à la Vierge, et l'enfant est identifié au Christ, tandis que plus loin la femme poursuivie par le dragon est identifiée comme figure de l'Église. Les deux interprétations, mariologique et ecclésiologique, sont combinées, comme chez Ambroise Autpert, Haimon d'Auxerre et même Rupert de Deutz, plus porté vers l'exégèse historicisante. Au verso de cette image de la femme et du dragon, au lieu de l'image attendue du combat de Michel figure une crucifixion où la croix s'enfonce dans la gueule du dragon à ses pieds, avec la légende : *Tu contrivisti caput draconis*[65]. Cette image peut paraître surprenante, mais elle ne l'est pas si l'on considère que Michel est une *figura* du Christ et que la crucifixion est sa victoire, malgré la tentative du dragon de s'y opposer. On est donc encore en présence de deux niveaux de lecture.

Au terme de cette étude, une chose encore est frappante : deux figures angéliques se détachent dans le manuscrit de Wolfenbüttel par leur taille, et c'est dans une moindre mesure encore le cas dans le manuscrit de Paris[66], ce sont les archanges Gabriel et Michel. En dehors de l'image du Christ et de la Vierge, ils sont les seuls à être mis en valeur en occupant deux miniatures pleines pages. L'Annonciation et l'accomplissement du salut, la venue du Sauveur et sa victoire sur le mal sont clairement mis en relation par ces deux figures. Comme on l'a vu plus haut, le combat est l'allégorie du mystère du salut et spécialement de la Passion ; c'est en rachetant l'humanité et en fondant l'Église que le Christ a combattu le dragon. On peut se demander si la mise en valeur des deux archanges ne serait pas à mettre en rapport avec une particularité relevée jadis par les Bollandistes dans les martyrologes de la région de Cologne, Trèves, Tournai et Liège, dans lesquels on liait la fête de la Passion, située le 25 mars, qui est aussi fête de l'Annonciation, à la victoire de Michel sur le dragon[67]. Sur le plan symbolique, le positionnement de la fête de l'Annonciation et de la fête de saint Michel, à proximité des équinoxes de printemps et d'automne depuis le Ve siècle au moins, liait déjà fortement les deux figures angéliques.

Conclusion

Le schéma naguère mis en évidence par Erich Auerbach semble bien pouvoir s'appliquer ici. Le Christ est figuré par Salomon ; le roi pacifique du royaume d'Israël préfigure le roi de paix venu parmi les hommes : l'image de Gabriel debout devant la *Sedes Sapientiae* manifeste le mystère de l'Incarnation. Cette polarité s'accomplit dans un troisième terme, à savoir Michel vainquant définitivement le dragon dans l'au-delà, en préambule à la descente de la cité céleste. Il s'agit d'un parcours figuratif, qui va du trône de Salomon à l'eschatologie et à la cité céleste, passe par l'Incarnation, les visions christiques, le combat de Michel-Christ. La thématique de l'Église fondée par le Christ, combattante et triomphante, est fondamental ; la *Sedes Sapientiae*, la figure de la Vierge-Église et la polarité de l'archange Michel et de la Femme céleste sont mis au service de la perspective eschatologique, entendue au sens de la réunion du Christ et de l'Église. L'image du trône, exprimée ensuite sur le plan visuel par une architecture (le temple, peut-être inspiré par l'*anastasis* et les lieux saints) suggère qu'il s'agit de l'Église comme corps du Christ. L'image finale de la cité céleste circulaire, par delà le caractère inachevé de l'iconographie de l'Apocalypse, suggère plutôt une vision d'un temps présent éternel, passé, présent et futur. Ce programme s'harmonise assez bien avec la vision d'une Église en pleine réforme, tournée vers la réalisation du règne du Christ, dont les maîtres des écoles dans les cités de France du Nord établissent les principes, repérables dans les recueils de sentences et les commentaires bibliques, dont celui de Lambert[68].

Quant à la représentation des anges, l'iconographie, plutôt byzantinisante, du manuscrit de Wolfenbüttel est tributaire de modèles italiens. Qu'il s'agisse des anges des Églises, de l'archange Michel, des anges retenant les vents ou des vieillards assis, les indices sont nombreux à aller dans ce sens, même si les éléments font défaut pour établir les canaux directs ou indirects de cette transmission. Les liens avec les images des Apocalypses du haut Moyen Âge sont en tout cas beaucoup plus ténus. Quoi qu'il en soit, c'est bien le mystère de l'Incarnation et son expression historique qu'est l'enfantement de l'Église qui se trouvent au centre du programme iconographique du *Liber floridus* de Wolfenbüttel.

NOTES

1. A. DEROLEZ, *The autograph manuscript of the Liber floridus. A key to the Encyclopedia of Lambert of Saint-Omer*, Turnhout, 1998 ; *The Making and Meaning of the Liber floridus : A Study of the Original Manuscript Ghent, University Library MS 92*, Londres/Turnhout, 2015.

2. Wolfenbüttel, Herzog August Bibliothek, Cod. Guelf. 1 Gud. lat. Voir *Der* Liber floridus *in Wolfenbüttel, eine Prachthandschrift über Himmel und Erde*, éd. C. HEITZMANN, P. CARMASSI, Darmstadt, 2014.

3. Voir H. VORHOLT, *Shaping Knowledge : The transmission of the* Liber floridus, Londres, The Warburg Institute, 2017.

4. Voir H. SWARZENSKI, « Comments of the figura illustrations (fig. 2–35) », in A. DEROLEZ (éd.), *Liber floridus Colloquium. Papers Read at the international Meeting Held in the University Library Ghent on 3–5 september 1967*, Gand, 1973, p. 21–30 (p. 27).

5. Voir J. BASCHET, *L'iconographie médiévale*, Paris, 2008 ; J. BASCHET et P.-O. DITTMAR (dir.), *L'image médiévale*, Turnhout, 2016.

6. P. CORBET, « Les impératrices ottoniennes et le modèle marial », dans D. IOGNA-PRAT, E. PALAZZO, D. RUSSO (dir.), *Marie. Le culte de la Vierge dans la société médiévale*, Paris, 1996, p. 109–135 (p. 131).

7. Évangéliaire d'Uota de Niedermünster, abbesse de 1002 à 1025, Munich, Bayer. Staatsbibl., Clm 13601, folio 2 (1er quart du XIe siècle) ; Evangéliaire de Passau (v. 1170), Munich, Bayer. Staatsbibl. Clm 16002, folio 39 ; *Ecclesia imperatrix* de l'ancienne abbatiale de Prüfening, près de Regensburg. Voir H. SCHRADE, *La peinture romane*, Paris, 1966, p. 140, 157, 169–172.

8. Voir D. VERHELST, « Les textes eschatologiques dans le *Liber floridus* », dans *The Use and abuse of eschatology in the middle ages*, éd. W. VERBEKE, Louvain, 1988, p. 299–305, et l'article de Marco RIZZI dans ce volume.

9. Sur l'ensemble de ce dossier, voir D. RUSSO, « Les représentations mariales dans l'art d'Occident », dans D. IOGNA-PRAT, E. PALAZZO, D. RUSSO (dir.), *op. cit.* (notre note 6), p. 173–291.

10. Voir W. BLOCKMANS, « À la recherche de l'ordre divin. Le *Liber floridus* de Lambert de Saint-Omer en contexte (1121) », *Revue du Nord*, 2018/1 (n° 424), p. 11–31.

11. M. GOULLET et D. IOGNA-PRAT, « La Vierge en Majesté de Clermont-Ferrand », dans D. IOGNA-PRAT, E. PALAZZO, D. RUSSO (dir.), *op. cit.* (notre note 6), p. 383–405.

12. Bède le Vénérable, *De muliere forti*, PL 91, 1039–1051.

13. Voir H. BARRÉ, « La croyance de l'assomption corporelle en Occident de 750 à 1050 », dans *Études mariales. Assomption de Marie*, II, 7, 1949, p. 63–123 ; S. MIMOUNI, « De l'Ascension du Christ à l'Assomption de la Vierge. Les *Transitus Mariae* : Représentations anciennes et médiévales », dans D. IOGNA-PRAT, E. PALAZZO, D. RUSSO (dir.), *op. cit.* (notre note 6), p. 471–509, et, pour l'ensemble de la question, S. MIMOUNI, *Dormition et Assomption de Marie. Histoire des traditions anciennes*, Paris, 1995.

14. Un sacramentaire enluminé au Mont-Saint-Michel vers 1060 illustre parfaitement cette formule iconographique : New York, Pierpont Morgan Library, ms. 641, folio 142v. Voir H. DECAËNS (dir.), *Le Mont-Saint-Michel*, Paris, 2015, p. 105.

15. Raban Maur, *Commentaire du Livre des Chroniques*, III, 9, PL 109, 479. Sur l'usage liturgique, voir R.-J. HESBERT, *Corpus antiphonalium Officii*, Rome, 1963, nr 1156.

16. Sur ce point, je me permets de renvoyer à mon article « L'ange Gabriel et son image au Moyen Âge : un révélateur des évolutions de la spiritualité médiévale », dans J.-M. VERCRUYSSE (dir.), *L'ange Gabriel, interprète et messager*, Collection Graphè, Arras, Artois Presses Université, 2019, p. 43–64.

17. E. AUERBACH, *Figura. La Loi juive et la promesse chrétienne* (1938), Paris, 2003.

18. Voir W. BLOCKMANS, « À la recherche de l'ordre divin. Le *Liber floridus* de Lambert de Saint-Omer en contexte (1121) », *Revue du Nord*, 2018/1 (n° 424), p. 11–31 ; A. DEROLEZ, *The Making, op. cit.* (notre note 1), p. 127, n° 196.

19. Voir A. PRACHE, *Notre-Dame de Chartres. Image de la Jérusalem céleste*, Paris, 2001, p. 34–42 ; P. KURMANN et B. KURMANN-SCHWARZ, *Chartres. La cathédrale*, La Pierre-qui-Vire, 2001, p. 266–268.

20. Pour une vue d'ensemble, voir L. RIVIERE CAVALDINI, *Imaginaires de l'Apocalypse*, Paris, 2007, p. 190–195.

21. P. KLEIN, « Les cycles de l'Apocalypse du Haut Moyen-Âge (IXe–XIIIe s.) », dans Y. CHRISTE (dir.), *L'Apocalypse de Jean. Traditions exégétiques et iconographiques IIIe–XIIIe siècles*, Genève, 1979, p. 135–186.

22. Trèves, Stadtbibliothek, ms Cod. 31 (Nord de la France, premier quart du IXe s.) ; Cambrai, BM, ms 386 (début du Xe s.) ; Valenciennes, BM, ms 99 (premier quart du IXe s.) ; Paris, BNF, ms Nal 1132 (France du Nord-Est, début du Xe s.) ; Bamberg, ms Bibl. 140 (Reichenau, premier quart du XIe siècle).

23. Bible de Roda, Paris, BNF, ms lat. 6 (seconde moitié du XIe siècle) ; Oxford, Bodleian Library, ms Bodley 352 (vers 1100, royaume de Germanie) ; Berlin, Staatsbibliothek, ms theol. lat. folio 561 (Italie du Nord, seconde moitié du XIIe siècle). Sur la mise en scène de l'Apocalypse, voir D. GANZ, « Gefässe der Endzeit. Inszenierungen der apokalyptischen Bücher in der mittelalterlichen Bildkunst », in S. EHRICH, A. WORM (éd.), *Geschichte vom Ende her denken*, Regensburg, 2019, p. 391–401, et H. VORHOLT, *Shaping knowledge, op. cit.*, (notre note 3).

24. Voir Y. CHRISTE, « Traditions littéraires et iconographiques dans l'interprétation des images apocalyptiques », dans Y. CHRISTE (dir.), *op. cit.* (notre note 21) p. 109–134, et l'article de Raffaele SAVIGNI dans ce volume.

25. G. LOBRICHON, « L'ordre des temps et les désordres de la fin. Apocalypse et société, du IXe à la fin du XIe siècle », *La Bible au Moyen Âge*, Paris, 2003, ch. 8, p. 129–144.

26. G. LOBRICHON, « Conserver, réformer, transformer le monde ? Les manipulations de l'Apocalypse au Moyen Âge central », *ibidem*, ch. 7, p. 109–128 (p. 124–126). Le commentaire n'est présent que dans le *Liber floridus* de Paris, vers 1260 (Paris, BNF, ms lat. 8865), qui refléterait un état primitif de l'encyclopédie.

27. Dans l'article cité ci-dessus, Guy Lobrichon estime (p. 125–126) que les différences entre les trois manuscrits du *Liber floridus* (Gand, Universiteitsbibliotheek 92 ; Wolfenbüttel, Herzog August Bibliothek, Cod. Guelf. 1 Gud. lat.; Paris, BNF, ms lat. 8865) témoignent de deux états de l'ouvrage et d'une défiance face à l'exégèse d'Anselme de Laon, puisque le commentaire de l'Apocalypse n'apparait que dans le manuscrit de Paris, près d'un siècle et demi après celui de Gand.

28. Daté du premier quart du XIIe siècle et peut-être conçu à Farfa, ce manuscrit contient le commentaire de

l'Apocalypse par Beatus de Liebana et dérive de la tradition italienne qui a inspiré les autres manuscrits de l'Apocalypse (Valenciennes, Paris, Bamberg) et la Bible de Roda. Malgré sa datation tardive, c'est un témoin important de la tradition romaine, notamment par sa mise en page qui intègre complètement les images au texte de Beatus et ses traits byzantinisants. Voir A. FINGERNAGEL (éd.), *Die illuminierten Lateinischen Handschriften deutscher Provenienz der Staatsbibliothek Preussischer Kulturbesitz Berlin*, Wiesbaden, 1991, Kat. 29, p. 29–35.

29. Oxford, Bodleian Library, ms 352, folio 7 ; Bible de Roda, Paris, BNF, ms lat. 6, folio 106v.

30. Voir Y. CHRISTE, *L'Apocalypse de Jean. Sens et développements de ses visions synthétiques*, Paris, 1996, p. 111.

31. L. RIVIERE CAVALDINI, *op. cit.* (notre note 20), p. 190–195.

32. Voir par exemple la Bible de Charles le Chauve (846), Paris, BNF, ms lat. 1, folio 329v ; le sacramentaire de Metz (vers 870), Paris, BNF, ms lat. 1141, folio 5 ; l'Apocalypse de Bamberg, Bamberg, Staatsbibliothek, Ms. Bibl. 140 ; le Commentaire du livre d'Isaïe (Reichenau, fin du Xe siècle), Bamberg, Staatsbibliothek, Ms. Bibl. 76, folio 10v.

33. Wolfenbüttel, Herzog August Bibliothek, Cod. Guelf. 1 Gud. lat., folio 10v–11.

34. Bible de Roda, Paris, BNF, ms lat. 6, folio 105.

35. Voir F. VAN DER MEER, *L'Apocalypse*, Anvers, 1978, p. 129–131.

36. Voir Y. CHRISTE, *L'Apocalypse, op. cit.* (notre note 30), p. 26–27.

37. Voir l'analyse des figures du manuscrit de Gand par J.-C. SCHMITT, *Penser par figure. Du compas divin aux diagrammes magiques*, Paris, 2019, p. 99–122.

38. Voir Y. CHRISTE, « L'Ange à l'encensoir devant l'autel des martyrs », *Cahiers de Saint-Michel de Cuxa*, 13, Codalet, 1982, p. 187–199. On a noté que dans le *Liber floridus* de Wolfenbüttel, les martyrs sont transpercés d'une épée ou d'une lance, et placés sous la *Maiestas Domini* (folio 10). Ce détail est à rapprocher des peintures de l'église San Quirce de Pedret en Catalogne (vers 1100) dans lesquelles, pour la première fois, l'ange à l'encensoir accompagne la représentation des martyrs sous l'autel, transpercés par une épée (Ap 6, 9–11). Cette association n'est présente que dans le commentaire d'Ambroise Autpert, rédigé vers 760 en Italie. Yves Christe soupçonne une source italienne, et la circulation d'un carnet de modèles, qui aurait ensuite inspiré certaines scènes peintes dans la crypte de la cathédrale d'Anagni, vers 1250.

39. Wolfenbüttel, Herzog August Bibliothek, Cod. Guelf. 1 Gud. lat., folio 12, 12v, 13.

40. Voir Y. CHRISTE, *L'Apocalypse, op. cit.* (notre note 30), p. 29.

41. Sur ce point, Ticonius, suivi par Beatus de Liébana, aurait localisé cette théophanie angélique à la fin du temps de l'Église, juste avant la Parousie. À cette interprétation eschatologique, Césaire d'Arles et Primase ont préféré l'interprétation figurative et répétitive du Christ ressuscité, suivie par les commentateurs du haut Moyen Âge. Voir Y. CHRISTE, *ibidem*, p. 21–22 et 29.

42. Voir R. WEBER (éd.), *Ambrosii Autperti opera. Expositionis in Apocalypsin libri X*, CCCM, t. 27, Turnhout, 1975, p. 437.

43. Voir Y. CHRISTE, *L'apocalypse, op. cit.* (notre note 30), p. 41, qui relaie l'hypothèse soutenue par Guy LOBRICHON dans sa recherche inédite, *L'Apocalypse des théologiens au XIIe siècle*, thèse manuscrite de l'EHESS, Paris, 1979. Sur les sources de Lambert, voir la mise au point d'A. DEROLEZ, « Le manuscrit autographe du *Liber floridus* et les sources à la disposition de l'auteur » dans ce volume.

44. Voir Y. CHRISTE, *L'Apocalypse, op. cit.* (notre note 30), p. 41–43.

45. Voir D. VERHELST, « Les textes eschatologiques dans le *Liber floridus* », *op. cit.* (notre note 8), p. 299–305.

46. Voir G. LOBRICHON, « La femme d'Apocalypse 12 dans l'exégèse du haut Moyen Âge latin (760–1200), dans D. IOGNA-PRAT, E. PALAZZO, D. RUSSO (dir.), *op. cit.* (notre note 6) p. 407–439 (p. 425–428 pour le texte de Lambert).

47. Oxford, Bodleian Library, ms Bodley 352, folio 9v. Conçu en Allemagne, peut-être dans le scriptorium de Saint-Blaise en Forêt Noire, le manuscrit est antérieur au *Liber floridus* de Gand (vers 1100–début XIIe siècle).

48. O. DEMUS et M. HIRMER, *La peinture médiévale romane*, Paris, 1970, p. 56–57, pl. I–IV et pl. 12–15 ; H. SCHRADE, *op. cit.* (notre note 7), p. 104–118 ; Y. CHRISTE, *op. cit.* (notre note 30), p. 108–111 ; P. PIVA, « San Pietro al Monte de Civate : lecture iconographique en contexte », *Cahiers archéologiques*, 49, 2001, p. 69–84 ; M. MÜLLER, Omnia in mensura et numero et pondere disposita : *die Wandmalereien und Stuckarbeiten von San Pietro al Monte di Civate*, Regensburg, 2009.

49. Apocalypse de Trèves, folio 37 ; Apocalypse de Valenciennes, folio 24 et 25 ; Apocalypse de Saint-Amand, folio 24 ; Apocalypse de Bamberg, folio 31 ; Apocalypse d'Oxford, folio 8v.

50. Voir notamment le sacramentaire de Warmund (Ivrea, Bibl. capitulaire, Cod. LXXVI, folio 108, vers 999–1002), un manuscrit du *Traité des Psaumes* de saint Augustin (Avranches, BM, ms 76, folio 1v ; vers 1060), le légendier de Cîteaux (Dijon, BM, ms 641, folio 64 ; premier tiers du XIIe siècle), la fresque de la tribune nord de la cathédrale Notre-Dame du Puy-en-Velay (fin XIe ou début XIIe siècle). Dans ce type de représentation, saint Michel est présenté de face ou de trois-quart, et n'échange aucun regard avec le dragon, foulé aux pieds et transpercé par la lance.

51. Ivoire (vers 800), Leipzig, Museum für Kunsthandwerk, Inv.-Nr. 53.50 ; Paris, BNF, ms lat. 9448, folio 71 (v. 995). Voir A. SCHALLER, *Der Erzengel Michael im frühen Mittelalter*, Berne, 2006, pl. 5 et pl. 57. En Occident, l'ivoire de Leipzig est la plus ancienne occurrence conservée de saint Michel terrassant le dragon de sa lance.

52. Rome, Bibl. Apost. Vat., Cod. gr. 1613. Voir A. SCHALLER, *op. cit.* (notre note 51), p. 35 et pl. 38 ; M. MARTENS, « Symbolisme du culte dans sa conjonction du sacré et du profane », dans *Saint Michel et sa symbolique*, Bruxelles, 1979, p. 119–166 (pl. p. 128–129).

53. Voir P. KLEIN, « Les Apocalypses romanes et la tradition exégétique » dans les *Cahiers de Saint-Michel de Cuxa*, 12, Codalet, 1981, p. 123–140, et Y. CHRISTE, *op. cit.* (notre note 30), p. 108–112.

54. Voir G. LOBRICHON, « La femme d'Apocalypse 12 dans l'exégèse du haut Moyen Âge latin (760–1200), dans D. IOGNA-PRAT, E. PALAZZO, D. RUSSO (dir.), *Marie, op. cit.* (notre note 6), p. 407–439.

55. Oxford, Bodleian Library, ms Bodley 352, folio 8. Voir. O. PÄCHT et J. J. G. ALEXANDER, *Illuminated manuscripts in the Bodleian Library Oxford*, 1, Oxford, 1966, cat. 66, p. 5.

56. Munich, Staatsbibliothek, Clm 14159, folio 15 (Regensburg, vers 1170–1175). Voir *Regensburger Buchmalerei, von Frühkarolingischer Zeit bis zum Ausgang des Mittelalters*, Munich, 1998, Kat. Nr 38.

57. *Vie des apôtres*, Munich, Staatsbibliothek, Clm 13074, folio 66v (Regensburg-Prüfening, vers 1175). Voir *Regensburger Buchmalerei*, Kat. Nr 39 ; recueil de textes (Zwiefalten, vers 1138–1147), Stuttgart, Württembergische Landesbibliothek, Cod. Hist. 2° 415, folio 17. Voir S. VON BORRIES-SCHULTEN et H. SPILLING, *Die Romanischen Handschriften der württembergischen Landesbibliothek Stuttgart*, I, Stuttgart, 1987, cat. 67, p. 97–111.

58. M. de WAHA, dans son article « Le dragon terrassé, thème triomphal depuis Constantin », dans *Saint Michel et sa symbolique*, Bruxelles, 1979, p. 43–117 (p. 62–63 et 69–71) signale que l'ivoire de Leipzig doit être considéré comme une partie d'un ensemble plus vaste, sans doute proche du

thème du Christ marchant sur l'aspic et le basilic, et dérivé d'un modèle constantinopolitain.

59. PL 17, col. 877 : *id est propter caelum pro salute praeliatus est Michael.*

60. Haimon d'Auxerre, PL 117, 1086.

61. Bruxelles, Bibliothèque Royale, ms 3089 (fin du XIIe siècle, pays rhénans). Voir C. GASPAR et F. LYNA, *Les principaux manuscrits à peinture de la Bibliothèque royale de Belgique*, première partie, Paris, 1937, p. 91–92.

62. M. de WAHA, *op. cit.* (notre note 58), p. 75–76.

63. Voir F. AVRIL, « Interprétations symboliques du combat de Saint Michel et du dragon », dans *Millénaire monastique du Mont-Saint-Michel, t. III. Culte de saint Michel et pèlerinages au Mont*, Paris, 1971, p. 39–52.

64. A. BONNERY, « Les sanctuaires associés de Marie et de Michel », *Les anges et les archanges dans l'art et la société à l'époque préromane et romane, Les Cahiers de Saint-Michel de Cuxa*, XXVIII, Codalet, 1997, p. 11–20.

65. Livre d'heures pour les matines, du monastère de Scheyern, vers 1205–1227 ; Munich, Staatsbibliothek, ms Clm 17401, folio 14. Voir E. KLEMM, *Die illuminierten Handschriften des 13. Jahrhunderts deutscher Herkunft in der Bayerischen Staatsbibliothek*, Wiesbaden, 1998, Kat. Nr. 10 et pl. 36.

66. Paris, BNF, ms lat. 8865, folios 33 et 39.

67. Voir F. AVRIL, « Interprétations symboliques du combat de Saint Michel et du dragon », *op. cit.*, (notre note 62) p. 39–52, qui relaie les Bollandistes sur ce point. Sur le calendrier du *Liber floridus*, voir l'article de Laura ALBIERO dans ce volume.

68. G. LOBRICHON, « Les courants spirituels dans la Chrétienté occidentale à l'aube du concile de Plaisance », *op. cit.*, (notre note 25) ch. 9, p. 145–156 (p. 153–154).

Times and their Declination

Time, the *Liber floridus* and the Science of the Stars in the Twelfth Century

Charles Burnett

The encyclopedic collection of scientific and historical information known as the *Liber floridus* was put together by Lambertus, canon of the church of Our Lady in Saint-Omer, at various stages between 1111 and 1121. This progressive development of the encyclopedia can be seen in MS Ghent, University Library, 92, which contains the text and revisions of Lambertus himself. This was just the period in which the process of translating scientific texts from Arabic into Latin was getting going. In the earliest extant revision of the text, that of Wolfenbüttel, Herzog August Bibliothek, Cod. Guelf. 1 Gud. lat. (second half of the twelfth century), a few more pieces of information have been added, and the translation movement was in full swing. In this paper I consider the *Liber floridus* in respect to features that it shares with the texts on astronomy and astrology that had been translated from Arabic up to the time of its composition, and continued to be translated during the twelfth and early thirteenth century. I shall point out common mentalities shared by Lambertus and the translators, and their attitudes towards past, present and future time.

Material from Arabic can be found in the *Liber floridus*. First, there are the Arabic – or what we should more correctly call Hindu-Arabic – numerals that have been copied onto folio 85v, after lists of roman numerals and Greek alphanumerical signs (Fig. 1).[1] These had first appeared in a Latin manuscript in AD 986, and had frequently been used on counters for the abacus at a time when calculating using the abacus was in vogue amongst scholars – i.e. from the late tenth century until the early twelfth century. Adelard of Bath's *Regule Abaci* would have been roughly contemporary with the *Liber floridus*.[2] The particular shapes and fact that their names (a mixture of Arabic and Berber)[3] are included confirm that they belong to the abacus tradition, rather than to

Fig. 1. Ghent, University Library, MS 92, folio 85v, Lambert of Saint-Omer, *Liber floridus*, s. xii: The nine Hindu-Arabic figures.

the new works on calculating with Hindu-Arabic numerals (the algorism), which were just becoming known when the *Liber floridus* was written.[4]

In the Wolfenbüttel manuscript we have, in addition, evidence of the text known as *On the Difference between the Spirit and the Soul*, written in Baghdad in the ninth century by the mathematician and doctor, Qusṭā ibn Lūqā (Constantine, son of Luke), and translated into Latin in the late eleventh century, probably by his namesake, Constantine the African.[5] This very popular work consisted of three short sections: the first on the role of

the corporeal spirits within the human body (which facilitated the five senses, digestion, expulsion, etc.) was based on medical sources; the second, a commentary on the definitions of the soul in Plato and Aristotle, belonging to the realm of natural philosophy, and the third (and shortest) on the difference between the spirit and the soul as defined in the first and second sections. The text in the copies deriving from the Wolfenbüttel manuscript is close to that of a contemporary copy that was once in the Augustinian abbey of Rookloster near Brussels (late twelfth century).[6] These two copies are amongst the earliest copies of the text that are known.

These are rather meagre pickings, one (Hindu-Arabic numerals) deriving from a Latin translation or adaptation of an Arabic work that had already been around for 150 years when the *Liber floridus* was written, the other including a text (*On the Difference*) that had been diffused rapidly since it was translated, and could have been copied from a local manuscript. We might expect the Ghent or Wolfenbüttel manuscripts to include references to Arabic culture within the texts on the first Crusade (AD 1099), which was 'hot news' when Lambertus was compiling the *Liber floridus*, and which are a prominent feature in the *Liber*.[7] However, there are very few such references, and nothing relevant to astronomy and time.

We can, however, take another approach to the *Liber floridus*' relationship to the scientific interest at the time, especially that interest that led to the translation of a huge number of Arabic texts into Latin. One justification of this approach is that most of the early twelfth-century translators of texts from Arabic and Latin came from outside the areas where the translations were made (Spain, Sicily and the Crusader States), and especially from England and the Low Countries. Their early education would have been, precisely, in monasteries and church schools of the kind to which Lambertus belonged. Walcher of Malvern (fl. 1091, d. 1135) never left the abbey of Greater Malvern where he was abbot, Adelard of Bath was educated in Bath Abbey and in Tours in the late eleventh century, Hugo Sanctelliensis was probably from Cintheaux in Normandy, close to Caen, while Hermannus Secundus originated in 'Carinthia' in central Istria. Finally, Rudolph

of Bruges, who authored a work on the astrolabe in 1144, may indeed have been educated in Flanders, not so far from Saint-Omer.[8] Their Latin education would have been based on the same texts as those used by Lambertus for his encyclopedia, and this shaped not only their view of the universe, but also their attitudes and predispositions. To give one out of many possible examples, Hugo Sanctelliensis drew on Isidore's definition of the divisions of magic, when he named a particular form of Arabic divination (divination by lines of dots randomly sketched on sand) 'geomancy'.[9]

One of the very few original passages in the *Liber floridus* is Lambertus' prologue, where he explains the reasons for his compilation, and the method that he uses. The primary purpose is to investigate closely (*perscrutari*) the richness of God's creation, in order to lead human beings to a greater awe of God, especially in a context in which a formerly flowering world has dried up entirely (*penitus exaruit*). And the method is to give the reader titbits or 'tasters' (*rara fercula*) of the best parts of this richness, because, if too much of one dish (*ferculum*) or another is offered, the reader, being unable to choose (*fastidiosus*) between them, does not eat anything. These titbits are referred to as 'flowers' and hence the book, which Lambertus has put together (*coadunare*) from these flowers may be called 'the flowery book' – the *Liber floridus*. The 'tasters' or 'titbits' turn out to consist to a large extent of lists or catalogues of a great range of things, from Roman emperors, bishops, kings, animals, plants and minerals, to historical events from Adam to the present day, the saints' festivals throughout the year and the prediction of future events. As has often been pointed out, what is especially characteristic of the *Liber floridus* is its colourful illustrations, several of which provide information in themselves, without continuous text, including maps —of Jerusalem, Europe and the inhabited regions of the world — and cosmological diagrams. These, too, can be regarded as colourful flowers that justify the title the book eventually achieved: *Liber floridus*.

Lambertus, in his prologue, as we see, uses the example of a feast, laid out by a king, in which various dishes are presented. The contemporary work by Adelard on the abacus, written over the Channel in England, also starts with

the metaphor of a feast, but this time in order to encourage the reader to choose the abacus as a taster that will make the subjects of the quadrivium (the mathematical sciences) more palatable:

> Do you remember, H<enricus>, that occasion when we were dining at the philosophical table? Several dishes were in front of us… Our nearest fellow-diners were enjoying the second part of the dinner, eating a triple course (the *trivium*). But I was trying to slip between your lips a few morsels from a dish which had four compartments. When you were objecting (*fastideres* – from the same root as Lambertus's *fastidiosus*) to all the dishes that I was trying to make you eat because you noticed that the other diners had neglected them, you first sipped this Pythagorean *hors d'oeuvre*.[10]

Lambertus laments the dryness – the lack of fruitfulness – of his surroundings – a metaphor for the lack of 'culture' (itself a word meaning two things: the tilling of fields, and civilisation). The Arabic-Latin translators lament the *penuria Latinitatis* ('the poverty of Latin culture'). It was the *penuria Latinitatis* that led Gerard of Cremona, the greatest of the translators from Arabic into Latin, who lived from 1114 to 1187, to travel to Toledo in the mid-twelfth century to search for Arabic texts that would enrich the Latins.[11]

Lambertus chose flowers from amongst the vast amount of Latin literature that was available to him. Gerard of Cremona is said by his earliest biographers to have been 'like a prudent man who, walking through green meadows, weaves a crown from flowers – not from all of them, but from the most beautiful ones – he (Gerard) read through the writings of the Arabs, from which he did not cease until the end of his life to transmit to Latinity… books on many subjects (*facultates*), whatever he esteemed to be the most choice'.[12] Lambertus chose flowers from Latin texts as well as whole texts; Gerard chose whole texts from a large number of Arabic texts. The flowers have been 'put together' (*flore… coadunato*) by Lambertus, and the same root had already been used by Constantine the African, when he referred to himself as a 'coadunator' of many medical authorities, rather than an 'auctor' (author), in his preface to the medical compendium, the *Pantegni*.[13]

The Arabic-Latin translators could also find, or refer to, flowers within the subjects that they chose to translate: two of Abū Maʿshar's works were called in Latin 'flowers', *Flores de electionibus*, and simply *Flores*, where *flores* translates an Arabic word meaning 'Choice Sayings' – *nukat*, which is probably a translation of John of Seville (fl. 1133–1135).[14]

Lambertus refers to God's 'great and marvellous works' (*magnalia operaque mirabilia*). John of Seville, translating Abū Maʿshar's *Great Introduction to Astrology* in 1133, found that the Arabic book began with similar words: 'Praise be to God, who created the heavens and the earth with those wonders which are in them. He made the stars an adornment and illumination… and He made the earth a place of repose and He apportioned its nourishments in it'.[15] Here we have the culinary metaphor again, but this time made up of verses from the Qurʾān, which praise God's bounty.

In the *Liber floridus* the prologue is followed by a list of contents. There is nothing unusual in this in itself. But the constant concern to correct the list of contents befits a scientific work. Chapter numbers are added and changed every time material is added or its position changed. The translators from Arabic, following their Arabic exemplars, also took great care over lists of contents. An example of this is the *Royal Book on Medicine*, by ʿAli ibn al-ʿAbbās al-Majūsī, which was translated as the *Pantegni* by Constantine the African in the late eleventh century. Fig. 2 shows an example of an early twelfth-century manuscript of the *Pantegni* (Cambridge, Trinity College, R.14.34), with corrections made, similar to the corrections that Lambertus introduced to his own list of contents. Chapter titles, and especially, numbers, are essential for enabling the reader to find his or her way round the text. So important was the division into chapters that some Arabic scientific works translated into Latin were known simply by their number of chapters: e.g. al-Farghānī's *30 Chapters*, translated by John of Seville in 1135 (*Liber triginta differentiarum Alfragani*), and the work on interrogations by ʿUmar ibn al-Farrukhān, translated by Hugo Sanctelliensis, described as *Hic autem CXXXVIII capitulis est distinctus* ('This is divided into 138 chapters').[16]

Once the prologue and the finding principle for the contents have been discussed, we

Fig. 2. The Master and Fellows of Trinity College, MS R.14.34, folio 1, Constantine the African's *Pantegni*, s. xii: The chapter numbers on the opening page.

can look at the contents themselves, especially in relation to questions of time: time past, time present and future time.

The past

Historical texts pervade the *Liber floridus*. World history is arranged according to the five ages that preceded the coming of Christ, the sixth age being inaugurated by Christ's nativity. The five ages are dealt with on folios 33v–36 (Lambertus' reworking of information taken from Orosius, Isidore and Freculphus of Lisieux). The ages are distinguished by changes of rulers or peoples: the first age, Adam and the generations that follow him; the second, Noah, and the repopulation of the earth after the Flood; the third age, the kings of the Assyrians; the fourth, the kings of the Medes; and the fifth, the kings of the Persians (see Fig. 3).

In the early twelfth century a new way of dividing world history was becoming known through the translation of another book by the Arabic astrologer Abū Maʿshar, entitled in Arabic 'The Book of Religions and Dynasties' (*Kitāb al-Milal wa-l-duwal*). In this book we read about the origins of religions (progressively Judaism, Zoroastrianism, the religion of the Greeks and Romans, Islam, and Christianity) related to the positions of the planets in the astrological 'place' of religion (the tenth place), and the conjunctions of the superior planets (Jupiter and Saturn). For the rise of new dynasties, the great conjunctions (occurring every 960 years) when the conjunctions of Saturn and Jupiter complete a revolution of the circle of the zodiac, or the middle conjunction (occurring every 240 years) which was specifically described as the 'conjunction of the shift', when the conjunction of Saturn and Jupiter shift from one group of three signs (triplicity) to the next, were significant. Because of the predominance of conjunctions in this book, the Latin translation, made again most probably by John of Seville, was known as 'the book of the Great Conjunctions'. In it we find another account of the time of Adam's birth and the distance between his birth and the occurrence of (Noah's) Flood. Recalculated in terms of solar years, this gives 5327 BC for the creation of Adam, and 3101 BC for the occurrence of the Flood. As this is an astrological work, a great conjunction of Saturn and Jupiter precedes the Flood and, since the origin of the text is in the Islamic world, the culmination of the time scale is not with Christ's

Fig. 3. Ghent, University Library, MS 92, folio 19v, Lambert of Saint-Omer, *Liber floridus*, s. xii: The Six Ages.

Fig. 4. Paris, Bibliothèque nationale de France, lat. 16208, folio 121, s. xii: (s. xii), *The Toledan Tables*: a table for the movements of Mars.

nativity, but rather with the birth of Muhammad in AD 570.[17] But the idea of dividing the whole of world history into great chunks marked by changes of religion or dynasties is common to the mentality of the compiler of the *Liber floridus* and Abū Maʿshar. One might even say that the perception of great breaks in this history predisposed the reader to find an explanation of these breaks in astrology.

The present

Most relevant for the handling of present time are the *computus* tables in the *Liber floridus*. There were originally sixteen pages devoted to this subject (two are now missing), dedicated to calculating the position of the Sun and the Moon over cycles of 28 years and 19 years, whose main purpose was to enable the calculation of the date of Easter and other moveable Christian festivals. This is traditional material, taken from genuine and spurious works of the Venerable Bede (d. 735). Yet, when these instructions were being written down, a totally new way of calculating the positions of the Sun

and the Moon was being revealed to the Latins – a way which included tables for the other planets also: Saturn, Jupiter, Mars, Venus and Mercury. The first translation of these complete Arabic tables, compiled by al-Khwārizmī, was made by Petrus Alfonsi in 1116, and this was soon followed by translations of the Toledan Tables, compiled in Muslim Toledo in the eleventh century (see Fig. 4). Even the visual comparison between the tables shows that we are dealing with two different methods of computing the positions of the heavenly bodies. The traditional *computus* and the Arabic-derived tables were recognized as being the *computus artificialis* and the *computus naturalis* respectively, and during the twelfth century attempts were made to reconcile the two.[18]

Within each year it was necessary to know which saints were to be celebrated on which days of the year. Lambertus includes a complete

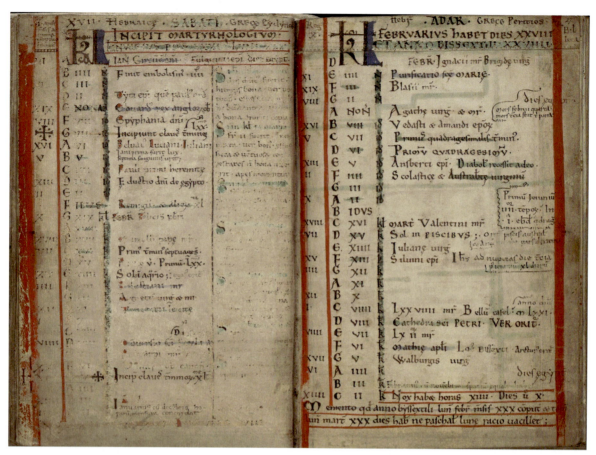

Fig. 5. Ghent, University Library, MS 92, folio 26v–27, Lambert of Saint-Omer, *Liber floridus*, s. xii: Calendar, with notes.

calendar, occupying twelve pages, one page for each month (folio 26v–32r). But, as one can see from Fig. 5, notes have been added to the calendar, which give a large amount of miscellaneous information, including notes of an astronomical, chronological, meteorological, liturgical and historical nature, some quite unusual, such as the dates when birds start and stop singing (respectively 6 April and 6 June).[19] Contemporary events are included, such as the dramatic occurrence on 28 July (V kal. August) of the year 1113 'of pestilential wind <when the statue of> St Omer was carried around by the people, because the rain was great, and calm weather was restored'.[20] And occasionally there is a reference to the rising of a constellation: (in February) *Oritur Piscis australis et Andromeda pars dextera* ('The Southern Fish and the right part of Andromeda rise').[21] The verses of a popular, but enigmatic, poem are inserted into each month: these include *Mars regit in primo, prosternit quartus ab imo* ('Mars reigns in the first <day of the month>, the fourth <day> lays low

from the bottom'), *tertia dissolidat septembris, dena trucidat* ('The third <day> of September breaks open solid things, the tenth slays'), and *septima cum dena rapit ossa Decembris hyena* ('On the seventh and the tenth of December the hyena seizes bones'!). Lambertus calls this calendar a *martyrologium* ('an account of the martyrs'). Again, a rival tradition can be found in the Arab-Latin tradition. This is originally a Mozarabic (Christian Arabic) calendar, which fully correlates the saints' days with the stellar constellations. This calendar survives in various forms.

The earliest of them was copied into MS Lyon, Palais des Arts 45 in 1132, where it is also called a *martyrologium*; the saints mentioned are specific to the Angers region. The text has been copied with works on the astrolabe based on the tenth-century translations from Arabic made in Catalonia (Hermannus Contractus, including the *De utilitatibus astrolabii* and *De mensura astrolabii*, the *liber horologii regis Ptolomei*, and a short passage from the *Liber Alchandrei*), which makes one suspect

that this originally Mozarabic calendar may have originated from the same milieu. A version of the same calendar was translated by Gerard of Cremona under the title *Liber Anoe* (though the term *martyrologium* is preserved in the list of works translated by Gerard of Cremona drawn up by his pupils after his death in 1187).[22] The naming of the saints' days, and addition of the Latin names of month division (*Kalendae, Nonae, Idus*) is common to this Mozarabic tradition and the tradition represented by the *Liber floridus*. But these Mozarabic texts also add the rising and setting through the year of twenty-eight constellations which the Moon divides off from the zodiac in its monthly course ('the mansions of the Moon'; see Fig. 6). The source of Gerard of Cremona's translation adds extensive notes similar in style to those found in the *Liber floridus*: (at the end of April) *et pariunt ova pavones et ciconie et multe aves* ('peacocks,

cranes and many birds lay eggs'); May 25: *in ipso incipiunt secare ordeum in campestribus Cordube* ('on this <day> they begin to cut the barley in the Cordovan countryside'); end of May *et pavones faciunt filios* ('and peacocks bear their young').[23]

The future

Finally, I would like to take up the preoccupation in the *Liber floridus* with the future. The account of the six ages of the world (ending with the Antichrist) on folio 20v, was originally followed in Lambert's autograph by a series of lavish illustrations on the last days, visualising the *Apocalypse* of St John. It is no longer there, but, fortunately, a copy of it has been preserved in the Wolfenbüttel manuscript (folio 9v–15v). Scattered through the *Liber floridus* are other references to the coming of the Antichrist, largely from a work

Fig. 6. Paris, Bibliothèque nationale de France, lat. 9335, folio 153v, late s. xii: Gerard of Cremona's translation of the *Liber Anoe*.

by Adso of Montier-en-Der, and fifteen signs announcing the Last Judgement from Julian of Toledo's *Prognosticum futuri saeculi* ('The prognostication of future time').[24]

On a less dramatic level in the *Liber floridus* is a prognosis for the following year based on the weekday of the first day of January: 'if on the kalends of January, the day is a Sunday, winter will be good, spring windy, and summer dry…'.[25]

On folio 26 of the Ghent manuscript there is a beautifully drawn example of a diagram generally known as 'the Sphere of Life and Death', but often called 'The Sphere of Pythagoras' or 'The Sphere of Apuleius'. Here the title is *Spera Apulei Vite et Mortis* (Fig. 7). The technique involves transferring the letters of the name of the sick person into numbers, and knowing the age of the moon and the number of the weekday on which he or she became sick; adding them all together, and dividing by 30. The resultant number can be found either in the upper half (= life) or the lower half (= death) of the sphere, and each half is further divided

Fig. 7. Ghent, University Library, MS 92, folio 26, Lambert of Saint-Omer, *Liber floridus*, s. xii: The *Spera Apulei Vite et Mortis*.

into three, indicating quick recovery, medium recovery or long term recovery, and the same for death.[26]

Another form of prognosis is entitled the *Sortes apostolorum* ('The Lots of the Apostles') (Fig. 8). This is, in fact, a prognosis involving the throwing of dice, which are inscribed with the numbers I, II, III, V, and C, and results of the throws are listed from the highest combination (C C C) downwards. The pronouncements are sometimes predictions: 'As a ship arrives at its destination, so there will come to you what you want';[27] 'What you are worried about and need will come into your hands'.[28] At other times they take the form of advice or warnings: 'You wish to go from light into darkness, therefore turn away from this plan.'[29] 'Avoid going to sea: expect little and good will come to you'.[30] Frequently the time is given: 'What you want will come in a short time, if you ask God'.[31] 'An unexpected good will come to you suddenly'.[32] The phrase *opportuno tempore* ('at an appropriate time') occurs more than once.

This phrase appears in the statement that is added to the end of the table: 'These are the lots of the Saints which never fail, but indicate the truth at an appropriate time'.[33] This whole text is undercut, however, by a piece of advice which is buried in the middle of it: 'Avoid (prognostic) lots, since they will lie to you'.[34]

Another passage in the *Liber floridus* deals with the prediction of storms and calm weather (folio 96): 'If the sun is speckled in its rising or hiding under a cloud, it presages rain and, if it is pale, announces a stormy day… The fourth moon, if it reddens like gold, indicates winds and, if on the tip of its crescent it blackens with spots, the beginning of the month indicates rain. But if in the middle (of its crescent), the full moon announces cloudless weather'.[35] This comes from Bede's *De temporum ratione* ('On the Reckoning of Time'), from which Lambertus takes a lot of material also elsewhere.

Inquisitiveness about, or even fear of, the future is a common attitude, and if it is possible to predict 'scientifically' what the future will bring, that gives a person power and self-confidence and can allay his or her fear. Hence the strong interest in astrology amongst the Arabic-Latin translators, which

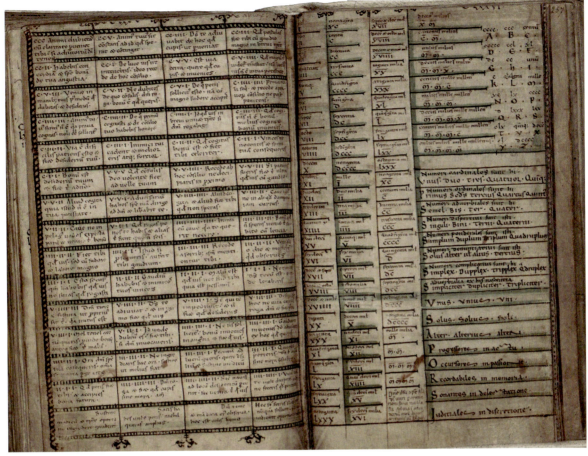

Fig. 8. Ghent, University Library, MS 92, folio 256v–257, Lambert of Saint-Omer, *Liber floridus*, s. xii: *Sortes Apostolorum*.

is already apparent in the corpus of texts translated in Catalonia in the late tenth century. At the time that the *Liber floridus* was being compiled Adelard of Bath was describing 'astronomia' in his book on the seven liberal arts, called *De eodem et diverso (On the Same and the Different)*: astronomy enables one to know the present, the past and the future. He writes:

> If anyone could make her (*the lady personifying astronomy*) his own, he would be confident in declaring not only the present condition of lower things, but also their past or future conditions. For, those higher and divine animate beings are the principle and causes of the lower natures.[36]

Adelard set about translating from Arabic works which were relevant to astronomy, progressing through Euclid's *Elements* and Theodosius' *Spherics*, to al-Khwārizmī's astronomical tables (the same text as that which Petrus Alfonsi had translated, but ten years later: i.e.

in 1126), Ptolemy's (or rather Pseudo-Ptolemy's) *Centiloquium*, and Abū Maʿshar's *Small Introduction to Astrology (Ysagoge Minor)*.

The *Centiloquium* is the principal Latin title under which was known a collection of astrological maxims attributed falsely to Ptolemy. Its name, in Greek and Arabic, is 'the fruit' (*ho karpos, al-thamara*) and the author, who pretends to be Ptolemy, writes that:

> I have now written to you, O Syrus, books about what effects the stars have in this world, and these books are very useful for those who want to know the future in advance. And this is the fruit of all those books and has been proved (by experiment) many times.[37]

It was so popular that at least five translations were made into Latin before the middle of the twelfth century. One may get a taste of its aphorisms, especially in respect to how they deal with future time, from the following examples.[38]

Verbum 5. The astrologer is able to remove many effects of the stars when he knows the nature of the stars' influences, and how he can prepare himself in advance for the influences that are to come.[39]

Verbum 8. The wise soul will cooperate with the stars, just as the agriculturist cooperates with the forces of nature in ploughing and irrigating.[40]

Verbum 9: The forms of this world are subject to the celestial forms.[41]

Verbum 10: In choosing days and hours, you should use the harmful planets just as skilled doctors use poisons.[42]

Verbum 22: Do not put on new clothes when the Moon is in Leo.[43]

As in the 'The Lots of the Apostles', in the *Liber floridus* many of these *verba* take the form of advice rather than predictions of what cannot be avoided.

Centiloquium verbum 5 refers to the necessity of knowing astrological doctrine ('the nature of the stars' influences') before making predictions, and this is precisely what is provided in the *Small Introduction to Astrology* of Abū Maʿshar, which Adelard of Bath must have translated at about the same time as the *Centiloquium*. Picking up on phrases in the Arabic original, he writes that the person who wants to reach the heights of philosophy has to do this through investigating the wonderful effects of the celestial beings on the world around us (which we perceive with our senses). He refers, as does *verbum* 9 of the *Centiloquium*, to earthly forms following celestial forms, and the purpose of all this is the *rerum futurarum prenotio* ('the foreknowledge of future things').[44]

A lot of this doctrine is already set out in a pictorial way in the *Liber floridus*: the form of the cosmos, with the spheres of the seven planets: Moon, Mercury, Venus, the Sun, Mars, Jupiter and Saturn; the surrounding sphere of the zodiac, consisting of 360 degrees, divided amongst the 12 signs: Aries, Taurus, Gemini, Cancer, Leo, Virgo, Libra, Scorpio, Sagittarius, Capricorn, Aquarius and Pisces. There are hints too of the characteristics of the planets: 'joyful Venus, bloody Mercury'.[45] But astrological works add doctrine that would only be used by an astrologer: the assignment of each of the signs of the zodiac to one planet as its 'house', the assignment of individual degrees within the zodiac to the seven planets, as their 'exaltations'; the assignment of the three equal divisions of each sign (the 'decans') to particular planets, etc.

In astrology, the 360 degrees of the zodiac are also divided according to their position in respect to the observer: either rising over the horizon, being in the middle of the sky, setting, or being below his/her feet. This circle is divided into twelve divisions, starting from its rising point, and each of the twelve divisions is assigned to a particular topic: the native's life, his possessions, his brothers and sisters, his parents, his sons, his illnesses, his marriage, his death, journeys, leadership, friends and enemies (with many other topics woven in). It is by considering the number of 'dignities' ('house', 'exaltation', 'decan', etc.) that every planet has in the sign or degree of the zodiac that belongs to or overlaps with that particular place (plus other factors), that predictions are made for the topic represented by that place. The *Small Introduction* tells us what each of the planets indicates: e.g. Jupiter is a benefic (favourable planet), and is life-bringing, indicating children and philosophers and judges; it interprets dreams and is truthful, it loves women and treats them well, and is generous.[46] If Jupiter is the 'lord' of the place of brothers, then the person whose horoscope is being interpreted is likely to find his brothers kind towards him and offering good advice. Of course, many other things should be brought into consideration when making judgements about the future events in the life of an individual, most of which are sketched in Abū Maʿshar *Abbreviation*, but also in many other texts on astrological doctrine (including two translations of the same Abū Maʿshar's *Great Introduction* made in 1133 and 1141). Such texts give the material on which to form an astrological judgement, but judgements themselves are found elsewhere: in examples of horoscopes, such as those drawn up mainly between June and September 1151 by an astrologer who was answering questions as to whether a Norman army would invade England.[47]

Questions (interrogations) are one branch of astrology, which involves casting a horoscope for the time of the question. Interpreting horoscopes cast at the time of the birth

of an individual is another. Predicting the events that affect whole nations or religions is yet another, of which we have already seen an example. But finally, there is the most practical branch of all: choosing the right time to do something (called 'elections'). The desire to know when to marry, to put on new clothes, to approach a ruler, to make a business deal, etc. is a natural desire.

The *Liber floridus* gives advice on what to do in the future only occasionally, e.g. in some of the answers to the *Sortes Apostolorum* (as we have seen above), and in an excerpt on the best time to cut wood which I quote:

> One should cut wood after the summer solstice, that is, from the month of July and August up to the kalends of January, for in these months, with the moisture dried up, the wood is dryer and therefore stronger.[48]

This passage comes from Bede's *De temporum ratione* ('On the Reckoning of Time'), where it follows the advice that trees should be felled between the fifteenth day and the twenty-second day of the Moon. This reflects a large amount of popular literature indicating what to do when the Moon is in each of the 'days' of its monthly cycle, or in each of the signs of the zodiac. Of Arabic origin are the predictions of what to do when each of the lunar mansions (described above) is rising. One example of this is a text attributed to Aristotle's *De luna*, which begins:

> When the Moon enters Sharaṭān make a <talisman> for love, do not put on new clothing, nor go before the powers of this world. If anyone takes a wife, there is also love between them. Buy, do not sow, nor do business. Do not medicate anyone, and do not begin a journey.[49]

But among the new translations from Arabic were much more scientific texts on choosing the days and hours to do something, such as Haly Embrani ('Alī b. Aḥmad al-'Imrānī)'s 'On the Choosing of Hours' (*De electionibus horarum*) translated in 1133–1134 by the Jew Abraham Bar Hiyya (probably with the help of Plato of Tivoli),[50] and 'the Choices of the Indians and Dorotheus' (*Electiones Indorum et Doronii*), which comes at the end of Iohannes Hispalensis' *Epitome Totius Astrologiae* of 1142.[51]

At the beginning of the twelfth century, those Latin scholars who desired to know about the past, the present and the future, could adopt two different approaches. They could either collect everything already available about the progression of the past in Latin chronicles and histories; about the regulation of the present in calendars and *computus* texts; and about the management of the future, through texts based on chance (such as the throwing of dice). Or they could seek out texts that would provide a different perspective on the past, teach one how to reveal hidden things in the present time, and determine more precisely how to predict what will happen in the future. Lambertus belonged to the first category: his aim was to lead his readers to appreciating the great and marvellous works of God. The translators from Arabic into Latin belonged to the second category: their aim was to provide Latin readers with the scientific texts that they needed for dealing with the past, present and future. But, in several ways, the aims and attitudes of both categories were similar: the restoration of knowledge, the structuring of knowledge, the regarding of items of knowledge as something beautiful ('flowers') and the recognition that knowledge raises man from the level of beasts to a position close to God.[52]

NOTES

1. For Hindu-Arabic numerals, see MS Ghent 92, folio 85v (ch. LXIX): *Figure, quas alii caracteres appellant, omnes XXXIII diverse, quantumlibet multiplicentur ad similitudinem horum figurabuntur* (Fig. 1). Nine *integri* plus 24 *minutiae* with their names and values. From Ps-Bede, *De ratione unciarum* (PL 90, coll. 699–700).

2. Edited by B. BONCOMPAGNI, 'Intorno ad uno scritto inedito di Adelardo di Bath intitolato "Regule abaci"', *Bullettino di bibliografia e di storia delle scienze matematiche e fisiche*, 14, 1881, p. 1–134.

3. *Igin, andras, ormis, arbas, quimas, calctis, zenis, temenias* and *celentis*: see M. FOLKERTS, *"Boethius" Geometrie II*, Wiesbaden, 1970 and (for the names) idem, 'Frühe westliche Benennungen der Indisch-arabischen Ziffern und ihr Vorkommen', in *Sic itur ad astra: Festschrift für den Arabisten Paul Kunitzsch zum 70. Geburtstag*, eds M. FOLKERTS and R. LORCH, Wiesbaden, 2000, p. 216–233.

4. A. ALLARD, *Moḥammad ibn Mūsā al-Khwārizmī, Le Calcul indien*, Paris and Namur, 1992.

5. It is mentioned in a contents' list in Wolfenbüttel, Herzog August Bibliothek, Cod. Guelf. 1 Gud. lat., but the relevant pages of the manuscript are now missing. It was, however, preserved in four manuscripts deriving from the Wolfenbüttel manuscript before the loss: see H. VORHOLT, *Shaping Knowledge: The Transmission of the* Liber Floridus, London, 2017 (Warburg Institute Studies and Texts, 6), p. 90–91.

6. The manuscript is now Brussels, Bibliothèque royale de Belgique 2772–2789 (1381), of the twelfth century: see VORHOLT, op. cit. (note 5), p. 151, n. 51.

7. The Arabs are mentioned on MS Ghent 92, folio 1, about the Apple of Paradise (*De pomo paradisi*), as the people who told the Crusaders that the Euphrates river was its source: *Parvo tempore ante expedicionem Christianorum, que sub rege Godefrido* (Godfrey of Bouillon, the first king of Jerusalem) *Hierosolimis facta est, ut ab incolis terre Arabum regi principibusque Francorum relatum est, pomum de Paradiso produxit Eufrates* (A. DEROLEZ, *The Making and Meaning of the* Liber Floridus, London, 2015, p. 45).

8. C. H. HASKINS, *Studies in the History of Mediaeval Science* (Harvard University Press: Cambridge MA, 1927²) and J.-C. SANTOYO, *La traducción medieval en la Península Ibérica (siglos III–XV)*, León, 2009, p. 118–120.

9. HASKINS, op. cit. (note 8), p. 77–79; compare ISIDORE OF SEVILLE, *Etymologiae*, VIII.ix.13.

10. MS Leiden, Bibliotheek der Rijksuniversiteit, Scaliger 1, folio 1: *Cum inter nonnulla fercula philosophice mense apposita nobis … proximi convive de parte secunda tripliciter sumerent, et me de quadrifida lance pauca ori tuo instillante omnia fastidires, quippe que ab aliis seposita et hactenus intemptata tibi videres Pitagoricum antedotum ante prelibasti.*

11. *Toletum perrexit, ubi librorum cuiuslibet facultatis habundantiam in Arabico cernens et Latinorum penurie de ipsis quam noverat miserans …: Vita Gerardi*, in C. BURNETT, 'The Coherence of the Arabic-Latin Translation Program in Toledo in the Twelfth Century', *Science in Context*, 14, 2001, p. 249–288 (275).

12. Ibid., p. 276: *… more prudentis qui virida prata perlustrans, coronam de floribus – non de omnibus sed de pulcrioribus – connectit, scripturam revolvit Arabicam, de qua plurium facultatum libros quoscunque valuit elegantiores Latinitati tamquam dilecte heredi, planius ac intelligibilius quo ei possibile fuit, usque ad finem vite sue transmittere non cessavit.*

13. *Pantegni* in *Omnia opera Ysaac*, Lyons, 1515, vol. II (beginning).

14. The former is found in Latin MS Paris, Bibliothèque nationale de France, lat. 16204, s. XIII¹, 333b–353b and frequently printed in the Renaissance; the latter in Cambridge, University Library, Kk 4.2 (= Clare Coll. 15), s. XIII, folio 170ra-172vb.

15. *The Great Introduction to Astrology by Abū Maʿšar*, 2 vols, ed. K. YAMAMOTO and C. BURNETT, Leiden, 2019, I, p. 43.

16. MS Dublin, Trinity College, 368, folio 56.

17. *Abū Maʿšar on Historical Astrology, The Book of Religions and Dynasties (On the Great Conjunctions)*, ed. and transl. K. YAMAMOTO and C. BURNETT, 2 vols, Leiden, 2000, I, p. 23 (I, I [26]).

18. For these terms see C. P. E. NOTHAFT, *Walcher of Malvern*, De lunationibus *and* De dracone, Turnhout, 2017, p. 18–31.

19. MS Ghent 92, folio 28 and 29: *Incipiunt aves cantare; desinunt aves cantare.*

20. MS Ghent 92, folio 29v: *V Kal. Augusti vento flante pestifero sanctus Audomarus deportatus est a populo quia pluvia magna erat, et facta est serenitas.*

21. MS Ghent 92, folio 27. It is not unusual to have such topical references in Western calendars.

22. *Liber Anohe et est tamquam sacerdotii martyrologium*: BURNETT, op. cit. (note 11).

23. R. DOZY and C. PELLAT, *Le Calendrier de Cordoue*, Leiden, 1961, p. 77, 87 and 91 respectively.

24. See the article of Rizzi in this volume.

25. MS Ghent 92, folio 26v: *Si in kalendis Januarii dies Dominicus fuerit, hiemps bona, ver ventuosus, estas sicca, …*

26. MS Ghent 92, folio 256: *Si scire volueris de egris qua die ebdomadis incurrit febrem, ea die quota luna fuerit scire debes, et adde nomen ipsius secundum litteras infra scriptas et in unum collige et partire per XXX et quicquid remanserit in spera respicies et sic invenies… Collige per numeros quicquid cupis esse probandum. Iunge simul numerum feriae luneque diem.*

27. MS Ghent 92, folio 256v: *IIII IIII II Sicut navis ad locum desideratum pervenit, sic veniet tibi quod vis.*

28. Ibid.: *C V III veniet in manibus tuis postmodum quod dubitas et desideras.*

29. Ibid.: *C C I de luce vis ire in tenebris, ideo recede de hoc consilio.*

30. Ibid.: *V II II Cave ne in pelagus vadas, expecta parum et veniet tibi bonum.*

31. Ibid.: *C IIII I Id quod vis in brevi veniet tempore, si Deum rogabis.*

32. Ibid.: *IIII III II Bonum quod non speras veniet tibi subito cum letitia.*

33. Ibid.: *Hec sunt sortes sanctorum que numquam fallunt, sed verum indicant op[p]ortuno tempore.*

34. Ibid.: *III III III Recede a sortibus, quoniam mentientur tibi.*

35. MS Ghent 92, folio 96: *Sol in ortu suo maculosus vel sub nube latens pluviam presagit et, si palleat, tempestuosum denuntiat diem… Luna quarta si rubeat quasi aurum, ventos ostendit et, si summo in corniculo maculis nigrescit, mensis exordium pluviam ostendit. Si vero in medio, plenilunium serenum nuntiat.*

36. Adelard of Bath, *Conversations with his Nephew*, ed. C. Burnett, Cambridge, 1998, p. 68: *Hanc si quis sibi privatam facere posset, non modo presentem rerum inferiorum statum, verum etiam preteritum vel futurum non differetur. Superiora quippe illa divinaque animalia inferiorum naturarum et principium et cause sunt.*

37. This preface is missing in Adelard's version, but is here translated from Plato of Tivoli's slightly later version: *Iam scripsi tibi, Iesure, libros de hoc quod operantur stelle in hoc seculo et sunt libri multe utilitatis illis qui volunt prescire future. Et hic est fructus illorum librorum omnium et qui probatus est multotiens.* All quotations from the different versions of the *Centiloquium* are taken from the website of *Ptolemaeus Arabus et Latinus*.

38. The English translations take into account the text of different versions.

39. Adelard: *Iam potest astrologus super removendos multos actus stellarum cum doctus fuerit natura efficaci in illo et pretendet actui antequam accidat antecedentem passionem;* Iam premisi version: *Astrologus potest avertere multos effectus planetarum cum fuerit sciens naturam impressionis. Temperabit enim recepturum priusquam accidat.*

40. Adelard: *Anima sapiens actum stellarum adiuvat sicut seminator potens adiuvat naturalia cum aratione et mundatione;* Plato: *Anima sapiens ita adiuvabit opus stellarum quemadmodum seminator fortitudines naturales.*

41. Adelard: *Forme que in mundo composito sunt formis circularibus obedient;* Plato: *Vultus huius seculi sunt subiecti vultibus celestibus.*

42. Adelard: *Subserviant tibi infelicitates in electionibus sicut quod facit medicus peritus cum quantitate sufficienti;* Plato: *Uti oportet infortunis in electionibus sicut periti medici utuntur venenosis.*

43. Adelard: *Vestium novarum improper actus et usus Luna in Leone.*

44. Abū Maʿšar, *The Abbreviation of the Introduction to Astrology*, ed. and trans. C. BURNETT, M. YANO and K. YAMAMOTO, Leiden, 1994, p. 92.

45. MS Ghent 92, folio 226: *iocunda Venus, sanguineus Mercurius.*

46. Abū Maʿšar, op. cit. (note 44), p. 124–125.

47. J. D. NORTH, 'Some Norman Horoscopes', in *Adelard of Bath: An English Scientist and Arabist of the Early Twelfth Century*, London, 1987, p. 147–161.

48. MS Ghent 92, folio 261: *De observatione arborum quo tempore incidantur. Architectores observent docente beato Ambrosio, testante Beda in libro de temporibus capitulo XXVIII, ut post solstitium ęstivale …* (= Bede, *De temporum ratione*, XXVIII). Translation of F. WALLIS, *Bede, The Reckoning of Time*, Liverpool, 1999, p. 81.

49. C. BURNETT, 'Nīranj: a category of magic (almost) forgotten in the Latin West', in C. LEONARDI and F. SANTI (ed.), *Natura, scienze e società medievali: studi in onore di Agostino Paravicini Bagliani* (Micrologus' Library, 28), Firenze, 2008, p. 37–66, here p. 56 and 62.

50. Paris, Bibliothèque nationale de France, lat. 16204, p. 507a–534b.

51. Printed Nuremburg, 1548, sig. S3–T3v.

52. I am very grateful to Hanna Vorholt for providing materials and solving several problems, and to David Juste for making a French translation and, at the same time, correcting some points.

Le *Liber floridus* comme «encyclopédie visuelle»: l'occasion d'une enquête sur les manuscrits du *De ordine ac positione stellarum* et l'iconographie du *Draco inter Arctos**

Isabelle Draelants

Le *Liber floridus* est-il une œuvre encyclopédique? On pourrait d'emblée répondre à cette question par l'affirmative, dans la mesure cet album illustré médiéval a pour vecteurs principaux la nature et le temps. Par ailleurs, n'aurait-on pas déjà tout dit à propos du caractère encyclopédique ou non du *Liber floridus*[1]? Albert Derolez, éminent spécialiste gantois dont les travaux ont exploré tous les aspects de cette œuvre exceptionnelle conservée dans sa propre ville, lui a consacré en 2015 son dernier livre, *Making and Meaning*, qui présente une étude minutieuse des différentes phases du travail de compilation et d'illustration et de leur chronologie. Le colloque organisé à Orléans en mars 2019, à l'initiative du présent volume, offrait néanmoins une occasion de revenir sur les critères typologiques qui permettent de situer le «livre fleuri» de Lambert de Saint-Omer parmi les œuvres encyclopédiques, comme le fait la première partie, introductive, de cette contribution.

Davantage que d'autres auteurs «encyclopédiques» du XIIᵉ siècle, Lambert porte un intérêt spécifique aux mécanismes astronomiques rythmant la vie sur terre jusqu'à la fin des temps, ce qui explique la place considérable qu'il réserve à l'astronomie et au comput. Pour autant, les sources de sa documentation dans ces domaines n'ont pas été identifiées de manière satisfaisante jusqu'ici. La seconde partie de cette étude, plus étendue, s'attache à un motif iconographique utilisé deux fois dans le *Liber floridus*, et qui n'a pas suffisamment attiré l'attention: celui du «*Draco inter Arctos*», la constellation du Dragon ou du Serpent et ses deux ourses inversées. Elle constitue en effet un bon cas de comparaison, tant pour étudier les méthodes de compilation «visuelles» de Lambert de Saint-Omer, que l'emploi éducatif

qu'il fait des diagrammes et son degré d'intervention personnelle. Bien plus, cette illustration issue de la tradition extrêmement complexe des *Aratea* est susceptible de révéler des informations insoupçonnées sur la documentation astronomique et les modèles manuscrits du *Liber floridus*. La recherche typologique que j'ai menée sur cette illustration, soutenue par une enquête sur les variantes textuelles, permet d'indiquer que Lambert de Saint-Omer a connu et utilisé le catalogue d'étoiles illustré du *De ordine ac positione stellarum*, compté parmi les pseudo-Bède, dont je présente ici une liste des manuscrits identifiables à ce jour. Une telle recherche permet également de reconstituer par types les collections de textes astronomiques et computistiques qui accompagnent ce cycle illustré de constellations dans nombre de manuscrits, afin de s'approcher de celle qu'a pu utiliser Lambert de Saint-Omer.

Une encyclopédie visuelle et spirituelle, «locale», marquée par l'eschatologie et inachevée… ou sans fin?

Il est piquant de constater d'entrée de jeu la différence de perspective historiographique qui nous sépare de la «notice historique» rédigée en 1844 par Jules, Baron de Saint-Genois, sur le *Liber floridus* (désormais *LF*): «C'est une de ces encyclopédies indigestes, telles qu'on en rencontre souvent parmi les monuments littéraires du moyen âge, et qui, à une époque où il y avait peu de livres, présentaient, resserrées en un volume, les principales notions scientifiques dont on pouvait avoir besoin». Il ajoute en conclusion p. 34: «En terminant l'analyse de ce volumineux manuscrit, nous avouons qu'il serait certes assez inutile de publier en entier cette vaste et indigeste compilation,

dont des parties entières ont déjà vu le jour. Nous croyons cependant que pour les notions historiques qui concernent le moyen âge, on pourrait livrer avec fruit à l'impression toutes celles que renferme le *Liber floridus*.»[2]. Si son classement du *LF* parmi les encyclopédies ne s'est pas démenti, l'historiographie postérieure a donné tort au Baron de Saint-Genois sur le peu d'intérêt qu'il y aurait à publier *in extenso* les textes rassemblés par Lambert. Ces propos contrastent évidemment avec l'affirmation d'Albert Derolez qui qualifiait l'ensemble comme «the best example of a Romanesque encyclopedic work» pour caractériser un type de compilation didactique utilisée dans les écoles des monastères, couvents, et écoles cathédrales au XIIe siècle[3].

Le *LF* prend une place notable parmi les ouvrages sur la nature de type encyclopédique de la première moitié du XIIe siècle. Les distinctions typologiques qui en font un écrit encyclopédique sont fondées en partie sur une caractérisation «disciplinaire» de ses contenus et de ses sources, c'est-à-dire des branches du savoir qui y sont représentées. Mais le seul fait de rassembler des connaissances disponibles sur l'ensemble du cosmos, sans autre intervention de composition personnelle que l'*ordinatio* et l'*abbreviatio* du texte, suffit-il à faire d'une œuvre une encyclopédie ? D'autres exemples permettent de répondre par l'affirmative, mais en rester là serait ignorer la part d'originalité que constitue l'appareil iconographique incomparable mis en œuvre par le chanoine de Saint-Omer, la *figuratio*. Car le *LF* est aussi et surtout, selon un large consensus, une «encyclopédie visuelle»; l'apport didactique des diagrammes colorés constitue une de ses caractéristiques les plus singulières et les plus marquantes, bien qu'il n'ait pas encore été exploré dans toute sa richesse. L'iconographie omniprésente y prend même le pas sur le texte pour le mettre au service d'une louange spirituelle de la création, fortement marquée par une perspective eschatologique. Porté par cette ambition, Lambert a retouché son œuvre jusqu'à sa mort en 1121.

Le *LF* forme une encyclopédie «spirituelle» car il unit constamment le monde ici-bas à l'au-delà par des correspondances exégétiques. L'œuvre est dominée par une vision du monde centrée sur Rome et sur Jérusalem, plusieurs fois représentées dans les cartes et les

textes. D'après les mots-mêmes du prologue, elle se place dans la ligne des «études sacrées» menées par les Pères de l'Église pour l'édification des esprits. Reflétant l'aspect chamarré de son œuvre visuelle, Lambert ajoute que son «florilège», ou sa «guirlande» ou encore son «pré» de fleurs sont destinés à être butinés par des «abeilles fidèles» qui forment la communauté ecclésiale, une image présente dans la littérature exégétique depuis l'Antiquité tardive :

> *Cum igitur, diversis temporibus, diversis in libris, sanctorum patrum curiosa manus operum ejus magnificentiam stilo fideli exaraverit, suisque posteris ad edificationem anime legenda reliquerit, nos videlicet, quorum temporibus mundus, olim sacris* florens studiis, *penitus exaruit, quoniam illa omnia velud tediosi et inertes relegere non possumus, saltem quedam de multis proposita fercula avidius ore cordis sumamus.* (…) Floridum *intitulavi, quia et variorum librorum ornatibus floret, rerumque mirandarum narratione prepollet*[4].

Lambert tresse dès l'ouverture de son album coloré autant d'images florales qui justifient son titre, passé à la postérité. Le titre de la traduction française de Lambert elle-même est «Livre fleurissant en fleurs». Contrairement aux autres encyclopédies, le *LF* n'a pas connu, en termes de postérité, de remaniements sous forme d'amplification, d'abrègement ou de moralisation[5], ce qui en fait un exemple atypique. Son titre a-t-il néanmoins fertilisé les intitulés des compilations ultérieures construites sur le mode de l'anthologie de citations ? Avant le *De floribus rerum naturalium*, titre de l'encyclopédie naturelle d'Arnold de Saxe rédigée vers 1230–1240[6], on ne trouve pas d'équivalents homonymes pour couvrir des œuvres encyclopédiques. Thomas Falmagne, qui a constitué une base de données de tous les florilèges qu'il a pu rassembler, m'a indiqué que les florilèges ou collections formées avec *florid-* sont peu communes. Dans un environnement assez proche de Lambert de Saint-Omer, le *Floridus aspectus* ou *Floretus aspectus* est le nom d'une série de poèmes attribuée parfois à Petrus Pictor, collègue de Lambert au chapitre-même de Saint-Omer, mais à rendre plus sûrement à Pierre Riga (m. *c.* 1209), chanoine de Reims[7]. On trouve en outre sous le nom d'Henri de Pacy, moine de Lyre en Normandie au XIIIe siècle, une glose

sur l'Écriture intitulée *Campus floridus*, «le champ fleuri»[8]. Par ailleurs, un *Liber floridus* ou *Liber florum* consacré à l'*ars dictaminis* fut compilé par Botus de Vigevano/Veglevano vers 1230 à Venise[9]. Ensuite, au xve siècle seulement, le manuscrit Giessen, Universitätsbibl. 687 (B.G. XVI. 31.4) achève, sur un *Explicit floridum manuale*, un traité des vices et des vertus conservé aux f. 196–274.

Le *LF* a par ailleurs des points communs avec les œuvres cosmologiques à portée universelle de son temps. Avec ceux de ses contemporains qui portent un regard englobant sur le cosmos, il a en commun de s'intéresser aux interactions continues entre microcosme et macrocosme. Guillaume de Conches fait de même dans la *Philosophia mundi* (*c.* 1125)[10] ou sa révision, le *Dragmaticon* (1147–1149)[11], comme Honorius Augustodunensis dans son œuvre catéchétique de jeunesse, l'*Elucidarius*[12], ou dans l'*Imago mundi* (*c.* 1110–1139)[13] plus abouti ; on peut aussi comparer de ce point de vue avec le *Liber divinorum operum simplicis hominis* (1163–1173)[14] œuvre spirituelle d'Hildegarde Bingen, où l'homme est le reflet du cosmos[15]. Même s'il n'est pas traversé par une vision mystique, ni marqué au même point par le combat entre le bien et le mal, le *LF* est comme le *Liber divinorum* une œuvre illustrée de «quadrivium visuel» qui relie constamment terre et ciel.

Pour un tel résultat, le *LF* s'est nourri d'œuvres astronomiques et computistiques relevant du *quadrivium* de la fin de l'Antiquité et du début du Moyen Âge. À cette documentation marquée par les doctrines platoniciennes, il a mêlé des données historico-chronologiques pour la plupart d'origine locale[16], et mis en œuvre ces informations dans une optique eschatologique d'histoire du salut, en maniant souvent l'allégorie. Une telle perspective justifie la part qu'y prend l'Apocalypse[17]. L'œuvre fut conçue pour l'utilité d'un public local, constitué d'abord des chanoines de Notre-Dame de Saint-Omer, mais aussi sans doute de leurs visiteurs de marque, nobles et laïcs, car la collégiale était soutenue par le comte de Flandre, qui nommait les prévôts ; ensuite, l'œuvre s'adressait sans doute plus largement à d'autres communautés monastiques. Pourtant, elle n'a eu selon toute apparence aucune postérité encyclopédique, restant une sorte de collection privée richement illustrée,

à usage local, à l'exception de quelques copies de prestige à l'identique[18]. En ce sens, elle se distingue du genre encyclopédique qui s'auto-alimente constamment[19].

L'œuvre compte plus de cent sources différentes ; parmi elles, les encyclopédistes et compilateurs d'histoire de la nature du début du Moyen Âge, Isidore et Bède le Vénérable, occupent une place essentielle. Lambert a pu les lire à Saint-Omer dans des volumes présents, entre autres, dans les riches bibliothèques locales, soit à la bibliothèque du chapitre de Notre-Dame, soit dans celle de l'abbaye Saint-Bertin. On a pu jusqu'ici identifier parmi ses sources vingt-cinq textes issus du chapitre de Notre-Dame ou de l'abbaye voisine de Saint-Bertin[20]. Presque tous les auteurs et les textes dont des extraits apparaissent dans le *LF* étaient présents dans la bibliothèque de l'abbaye de Saint-Bertin : de nombreux manuscrits subsistants en attestent et le catalogue médiéval, appelé *brevis annotatio librorum Sancti Bertini* dans la copie alphabétique trouvée dans un cartulaire aujourd'hui perdu de l'abbé Simon, du xiie siècle[21], en est un autre témoignage évident. Il est pourtant étrange qu'on n'ait jusqu'ici pas pu identifier ses sources astronomiques parmi les manuscrits provenant de Saint-Omer, pourtant riches en la matière ; la deuxième partie de cet article tente d'éclairer ce paradoxe.

À partir de cette documentation surtout locale, Lambert a rédigé plus de trois cent petits chapitres sur deux grands types de sujets. Le premier touche aux rapports macrocosme-microcosme, constamment porteurs d'un sens eschatologique, ce qui justifie les chapitres sur la cosmologie, la géographie, le comput, le calcul du temps et la chronologie, la météorologie, les animaux, plantes et pierres, auxquels s'ajoutent quelques recettes de pharmacopée monastique. Mais Lambert étend la question du compte du temps universel à la chronologie et à l'histoire, c'est pourquoi le second type de sujet regroupe l'histoire universelle et régionale depuis l'histoire antique, celle des papes, des empereurs, des Juifs (avec un parti-pris de controverse polémique typique du temps)[22], et de celle de la Flandre et de son propre diocèse, essentielle au propos, avec des listes d'abbés et de personnages régionaux. À cet égard, Wim Blockmans a récemment rappelé l'importance du contexte de

victoire de la première croisade et le rôle de la rencontre du héros Bohémond de Tarente par Lambert en 1106, comme stimulus pour la rédaction d'une encyclopédie qui donne toute sa place à l'histoire du monde jusqu'à l'Apocalypse[23]. À ces deux grands ensembles d'histoire de la nature et d'histoire du monde – la nature et le temps – s'ajoutent le récit de quelques merveilles et des poèmes contemporains du chanoine Petrus Pictor, compagnon de Lambert de Saint-Omer.

Traditionnellement, la littérature des merveilles parle de ce qui est étrange mais vrai ; les paradoxographes de l'époque hellénistique recueillaient des faits inattendus (*paradoxa*), les compilateurs de *mirabilia* de la fin de l'Antiquité romaine, à l'instar de Solin, désiraient susciter l'étonnement ou l'admiration. Au début du XIIe siècle, une telle préoccupation s'observe davantage dans l'*Imago mundi* d'Honorius que chez Lambert de Saint-Omer, même si le chanoine ambitionne une œuvre extraordinaire par sa brillance et sa science du temps. Il désire surtout rassembler tout ce qui l'intéresse lui-même et peut intéresser ses proches contemporains. Pourtant, plutôt qu'une somme de « savoir commun », le *LF* est davantage un recueil illustré constitué de tout ce que Lambert a pu trouver comme notions « philosophiques » – on dirait aujourd'hui « scientifiques » –, même spécialisées. Il les a organisées dans son « album de science », pour reprendre l'expression de John Murdoch[24], dans l'objectif de donner au lecteur un sens universel à l'expérience quotidienne des événements du monde cahotique ici-bas.

Le plan de l'œuvre, cohérent au départ, a été plusieurs fois modifié, comme le montrent la table des matières et les repentirs successifs de l'auteur par grattages et palimpsestes. L'analyse codicologique très fine d'Albert Derolez l'a démontré, relevant aussi l'abandon d'un cahier et le déplacement de certaines parties du codex au cours du travail constamment repris du compilateur[25]. Un des motifs de ces modifications est la disponibilité de nouvelles sources, comme le *Commentaire sur le Songe de Scipion* de Macrobe, que Lambert a introduit tardivement dans sa compilation. Le montre la comparaison du manuscrit autographe avec les fragments Cotton de Londres, écrits à Saint-Omer dans les années 1118–1119[26], dépourvus d'illustrations, où Macrobe

n'intervient pas encore. À la contingence de la disponibilité des sources s'ajoute la nécessité de continuer l'histoire de Flandre en vertu de préoccupations locales. Ce ne sont cependant pas là les seules raisons d'évolution du *LF* ; la place matérielle disponible limitée dans le codex en est une autre, évidente : il fallait réécrire au même endroit, et combiner entre elles les illustrations tirées des sources[27]. Enfin, le fait que Lambert de Saint-Omer meure en 1121, en laissant son *work in progress* inachevé, contribue aussi à faire échapper l'œuvre à la rigueur d'un système encyclopédique et à expliquer la relative incohérence de la succession des sujets et la répétition de certaines thématiques géographiques et astronomiques.

Comme d'autres œuvres consacrées au XIIe siècle à la description de l'univers, qui mêlent à la fois histoire de la nature et histoire des hommes, le *LF* est le résultat d'une collecte de textes et non d'investigations d'expérience ou de réflexions originales. L'originalité de ces œuvres de compilation ne réside pas dans l'invention philosophique, littéraire ou stylistique, qui peut y être très modeste, mais dans la créativité mise à profit pour l'organisation, l'arrangement et l'abréviation de la matière, y compris dans la mise en scène visuelle et chromatique, dans le cas de Lambert. Le *LF* se singularise en effet par la place impressionnante qu'y prennent l'illustration et les diagrammes colorés même si, par exemple, l'*Hortus deliciarum* de l'abbesse Herrade de Hohenburg (1130–1195)[28] se place un peu en concurrent comme encyclopédie illustrée. Dans les deux cas on peut se demander si cette exigence picturale n'a pas été un frein pour la diffusion. À moins de recopier en miroir son modèle et d'être bon artiste, ce qui est rare, il est en effet difficile de replacer les images dans une copie.

Marqué par une iconographie florissante, le *LF* fait-il partie des œuvres sur la nature et le cosmos étiquetées comme représentatives d'une « Renaissance du XIIe siècle » ? Comme le mot « encyclopédie », cette expression est anachronique et rétrospective lorsqu'on l'applique au Moyen Âge ; il convient donc chaque fois de ramener l'étude de ces œuvres dans leur contexte intellectuel et institutionnel. Parmi elles, la *Philosophia mundi* où Guillaume de Conches développe sa propre physique ; le *Liber subtilitatum diversarum naturarum creaturarum*, terminé en 1158, où Hildegarde

de Bingen dévoile ce qui est caché à l'intérieur des natures des animaux, plantes et pierres[29]; l'*Apex physicae* très peu diffusé[30]; l'*Elucidarium* ou l'*Imago mundi* où Honorius Augustodunensis met en avant l'exercice de la rationalité. A ces œuvres sur la physique théologisée s'ajoutent les sommes spirituelles de l'ère germanique que l'*Elucidarium* aurait influencées, à savoir l'*Hortus deliciarum* d'Herrade, le *Dialogus de cruce* de Conrad de Hirsau (*c.* 1070-*c.* 1150), le *Liber de auctoritate diuina* du Pseudo-Werner de Saint Blaise (m. 1178)[31]. Le *LF* comme encyclopédie visuelle est aussi l'antécédent immédiat d'œuvres chartraines sur la nature. Mais, s'il partage l'intérêt des Chartrains pour la cosmologie, on ne peut cependant le classer parmi les textes de philosophie néoplatonicienne. Lambert ne manifeste pas de spéculation philosophique personnelle ou de calculs originaux. On est loin par exemple de l'*Heptateuchon*, où Thierry de Chartres insère les premières tables astronomiques provenant du *Preceptum* du VIe siècle, conservé à Chartres sous le nom de Ptolémée[32]. Contrairement aux Chartrains, Lambert ne montre pas non plus de préoccupation de commenter les auteurs classiques et aucune trace n'a subsisté d'un éventuel enseignement de sa part. S'il a connu une œuvre de Fulbert grâce à la visite de Bohémond, il est probable que Lambert n'ait cependant pas eu de contact direct avec les Chartrains.

Le *LF* ne peut définitivement pas être classé parmi les ouvrages de ce qu'on a appelé la «Renaissance du XIIe siècle». Tous ces livres cosmologiques du XIIe siècle décrivant la nature créée au prisme du récit biblique sont eux-mêmes distincts du courant encyclopédique postérieur, contemporain de la naissance de l'Université. À un bon siècle près, les encyclopédies naturelles du XIIIe siècle font la part belle à la science d'origine grecque et arabe et diffèrent à toutes sortes de niveaux: leurs sources, les doctrines qu'elles véhiculent, le milieu de composition et le public destinataire. Les œuvres de Thomas de Cantimpré, Barthélemy l'Anglais ou Vincent de Beauvais collectent des sources sur tout le spectre chronologique et thématique depuis l'Antiquité classique jusqu'aux plus récents philosophes contemporains, en passant par les médecins et philosophes arabes, avec une prédilection pour la nouvelle science naturelle aristotélicienne

et la nature et les propriétés des choses; elles se destinent dans un premier temps aux collèges d'ordres religieux, pour la formation des prédicateurs, et sont écrites dans un objectif de large diffusion de la connaissance. Leurs contenus sont aussi appelés à être encadrés par une moralisation, ce dont la vague encyclopédique suivante, reprenant la même matière, ne se privera pas dans la seconde moitié du XIIIe siècle et surtout au XIVe siècle.

Il ne faudrait pas cependant occulter deux aspects qui sont communs à la littérature de type encyclopédique du XIIe et celle du XIIIe siècle: d'une part l'aspect de tradition, d'autre part le caractère typiquement cumulatif, deux facteurs qui entraînent une continuité et le partage d'un certain nombre de sources. Ainsi, Macrobe, Isidore de Séville, Bède le Vénérable, qui étaient les sources cosmologiques privilégiées des sommes du XIIe siècle, restent-ils des références traditionnelles de presque toutes les encyclopédies du XIIIe siècle, quoiqu'en proportion bien moindre par rapport aux «nouvelles sources» issues de traductions arabo-latines et gréco-latines. En outre, les œuvres du XIIe siècle nourrissent elles-mêmes les compilations universelles du XIIIe: la *Philosophia mundi* de Guillaume de Conches, écrite une génération plus tard que le *LF*, devient à son tour une source principale sur les éclipses du livre XX et dernier, *De ornatu celi*, ajouté chez Thomas de Cantimpré dans la seconde phase de rédaction du *Liber de natura rerum* (qui se serait prolongée jusque *c.* 1256 d'après les récentes recherches de Mattia Cipriani[33]). La *Philosophia mundi* est aussi une source du livre VIII sur la cosmologie de Barthélemy l'Anglais[34] et un réservoir de citations pour le *Speculum naturale* de Vincent de Beauvais. De même, l'*Imago mundi* d'Honorius a été une source de Thomas de Cantimpré et un modèle avoué pour le *Speculum maius* de Vincent de Beauvais (il l'avoue dans son prologue), qui par ailleurs a aussi utilisé le *Liber de natura rerum* de son homologue dominicain de Louvain.

Bien que Lambert partageât des sources cosmologiques et un certain réseau intellectuel avec son contemporain Honorius, il n'a pas réalisé le même type d'œuvre. Lambert comme Honorius a connu Pline (toujours à travers un intermédiaire, que ce soient Solin, Isidore, ou des *compendia* astronomiques), Orose, Macrobe, Isidore, Martianus Capella,

des œuvres de Bède et d'autres qu'on a attribuées à ce dernier. Il a pu lire Raban Maur comme l'a fait Honorius qui semble, d'après V. Flint, bien connaître les computistes des Xe et XIe siècles comme Helpéric dit d'Auxerre ou de Saint-Gall, Gerland de Besançon et Roger d'Hereford, même s'il affirme préférer la tradition[35]. À part Helpéric, dont le *De computo* aurait été terminé en 903 et que Lambert cite notamment au f. 94v, les computistes « innovants » du XIe siècle ne sont pas nommément cités parmi les sources du *LF*, mais il conviendrait de s'assurer qu'il n'a pas connu leurs travaux. Lambert et Honorius ont en tous cas tous deux utilisé des compilations computistiques carolingiennes étudiées et répertoriées par Arno Borst[36] (dont il sera abondamment question dans la seconde partie de cet article). Honorius est aussi le plus précoce témoin d'Anselme de Canterbury, auquel l'*Imago mundi* a même été attribué dans certains manuscrits. Or, l'archevêque britannique était venu visiter Saint-Bertin en novembre 1097 et juillet 1099, à l'occasion d'un synode provincial à l'initiative du comte Robert II[37] ; il n'était donc pas inconnu non plus de Lambert de Saint-Omer, qui insère des passages de son œuvre au cahier V du *LF*. Anselme participe aussi du lien avec les Chartrains, puisqu'Yves de Chartres avait étudié à l'abbaye du Bec en Normandie aux côtés d'Anselme et avait été le maître de Jean de Warneton, archidiacre d'Arras, et de Lambert de Guînes, évêque d'Arras en 1094 (depuis la restauration de l'évêché). En termes de réseau intellectuel, Honorius et Lambert sont donc reliés, sans qu'on puisse mettre en évidence une véritable communauté de documentation ni qu'on puisse supposer que Lambert ait voyagé.

Comme ouvrage cosmologique, le *LF* a des traits typiques des œuvres computistiques et astronomiques des IXe–XIIe siècles illustrées par des diagrammes, qui étaient encore appréciées dans le second quart du XIIe siècle à Chartres et à Saint-Victor ; mais rien n'indique que Lambert ait connu les œuvres philosophiques des Chartrains qui lui sont contemporaines ou légèrement postérieures, et l'absence de spéculation philosophique dans sa propre compilation le met à distance des témoins de la « Renaissance du XIIe siècle ». La place qu'il ménage au *quadrivium* comme science du

nombre et du temps situe son album coloré dans le contexte d'un intérêt renouvelé, au tournant des XIe et XIIe siècles, pour ces disciplines et pour l'œuvre de Macrobe, que Lambert a introduite dès qu'il a pu en disposer.

Comme ce qui suit tend à le montrer, le *LF* est l'héritier des *libri computi* carolingiens illustrés du début du IXe siècle et de collections postérieures qui ont transmis et amplifié ces *compendia* carolingiens jusqu'au XIIe siècle. Il présente un certain nombre de sources et de diagrammes communs à la fois à ces collections et à certaines œuvres néoplatoniciennes du XIIe siècle[38]. Cependant, il ne cherche pas à atteindre dans ces matières, qu'il résume, le degré de technicité des collections astronomico-computistiques des Xe–XIIe siècles.

Le *Draco inter Arctos* et les sources des illustrations astronomiques du *Liber floridus*

Dans quelle mesure peut-on déterminer si le rapport de Lambert avec les sources de science est demeuré seulement livresque et régional ? Pour ce qui concerne les sources des illustrations astronomiques du *LF*, qui restent mal identifiées, Gerard Isaac Lieftinck avait affirmé assez rapidement en 1973, en s'appuyant seulement sur l'histoire politique qui voudrait que l'abbaye bénédictine de Saint-Bertin, soutenue par le comte de Flandre, soit hostile au chapitre de Saint-Omer, que les figures des constellations du *LF* ne dérivaient pas des manuscrits des *Aratea* copiés à Saint-Bertin et ne devaient rien à des manuscrits qui étaient conservés à l'abbaye[39]. Des textes rares et des images qui étaient disponibles à Saint-Bertin ont en effet été parfois négligés par Lambert au profit d'autres modèles. Pourtant, comme l'a montré Albert Derolez[40], Lambert aurait souvent « descendu la colline » pour quitter son chapitre et consulter les livres à l'abbaye des moines de Saint-Bertin, malgré les oppositions entre les deux institutions voisines.

L'étude d'un motif astronomique précis, celui du *Draco inter Arctos*, permet d'apporter une réponse supplémentaire à la question des sources du *LF* et constitue par ailleurs un excellent exemple pour étudier la méthode de transposition illustrative de Lambert par rapport à un modèle. Elle a nécessité une enquête approfondie dans l'iconographie des

manuscrits de la tradition aratéenne pour repérer la famille de manuscrits à laquelle se rattache le *L. floridus*.

Le *Draco* céleste apparaît dans des contextes iconographiques liés à la tradition des *Aratea*[41], où il est dessiné comme *Draco inter Arctos*, entouré ou non du cercle zodiacal, c'est-à-dire sous la forme d'un serpent dont les boucles entourent les Ourses. Dans certains cas il forme trois et non deux boucles, ce qui correspond à l'aspect réel de la constellation, les deux boucles étant un parti-pris artistique qui a prospéré. Le dragon à deux boucles, doté des deux Ourses symétriques, renvoie aussi au motif astrologique antique où l'animal tourne autour de l'axe du monde ou le fait tourner, ou au mythe d'origine orientale du ou des deux dragons cosmiques (*attalû, tali, atalya* selon les cas) dont la tête et la queue correspondent à ce qui est devenu les nœuds lunaires[42].

Contenus des cahiers astronomiques XII et XIII du manuscrit autographe de Gand

Parmi les 190 chapitres du *LF* numérotés par Lambert lui-même (161 chapitres décomptés dans la table des matières) ou les trois cent sujets ou items abordés au total, la représentation du Serpent/Dragon et des deux Ourses intervient deux fois dans le manuscrit autographe n°92 de l'Université de Gand [*G*], copié par Lambert à la Collégiale Notre-Dame à Saint-Omer: d'une part au f. 89r, au chapitre numéroté LXXVIIII et intitulé *De ordine ac positione signorum* [*W* f. 62r], au début d'un cycle de constellations illustré[43] (Fig. 1), d'autre part au f. 94r (*W* f. 64v), au centre d'un schéma des constellations du ciel septentrional surmonté du titre *De astrologia secundum Bedam*[44] (Fig. 2) et après le schéma sur les phases de la lune et l'année mondiale selon Macrobe qui se trouve au f. 93v [*W* f. 60v]. Autrement dit, ces deux représentations ouvrent et ferment en quelque sorte le cahier XII du manuscrit autographe, formant un ensemble astronomique et computistique encore mal étudié[45]. On les retrouve aussi dans le manuscrit de Wolfenbüttel, Herzog Augustbibl., 1 Gud. lat. 2° [*W*], qui en est la copie la plus ancienne et la plus fidèle, menée probablement dans une abbaye de Flandre

Fig. 1. Ghent, Universiteitsbibliotheek, MS 92, f. 89r, Lambert de Saint-Omer, *Liber floridus*, entre 1112 et 1121: Début du *De ordine et positione stellarum in signis* dans la copie du *Liber floridus*, avec le *Draco inter Arctos*

ou du Hainaut par l'entremise de Jean II de Marchiennes (1158–1182), ancien moine de Saint-Bertin[46].

Pour la suite de notre étude, il est nécessaire de décrire le contexte de composition de cette partie de l'œuvre, reconstituée par A. Derolez. Le cahier XI, fortement remanié par Lambert lui-même, semble présenter une certaine incohérence de ce fait[47]. Des poèmes de Petrus Pictor, qui fut compagnon de Lambert, y ont été copiés (f. 83v–84r, cahier XI.d) dans une phase postérieure à celle des premiers chapitres du cahier, quant à eux antérieurs à la première table des matières. Venaient ensuite deux chapitres, LXXII et LXXIII, qui manquent dans le manuscrit autographe, mais il en subsiste des copies: le c. LXXII, *Quot modis annus dicitur secundum Bedam presbyterum* (*W* f. 56va) ou *De diversitate annorum*, portait sur les années égyptienne, naturelle, hébraïque, bissextile, grecque, etc., et le c. LXXIII, *De diversitate numeri*, portait une table des nombres romains en cinq colonnes qui subsiste dans *W* au f. 56vb. Deux autres chapitres sur la

Fig. 2. Ghent, Universiteitsbibliotheek, MS 92, f. 89r, Lambert de Saint-Omer, *Liber floridus*, entre 1112 et 1121 : Planisphère et constellations du ciel septentrional avec le *Draco inter Arctos*

chronologie, LXXIIII et LXXV, étaient copiés sur les f. 86v–87r (cahier XI.d), mais ont été complètement effacés ensuite par Lambert pour être remplacés par une longue série d'extraits bibliques, des Proverbes, de l'Ecclésiaste et de l'Ecclésiastique dans des chapitres numérotés LXXIIII, *Flores proverbiorum Salomonis* et LXXV, *De Ecclesiaste et Ecclesiastico*. On ne connaît pas la raison de ce palimpseste, mais Lambert a trouvé les extraits chronologiques précédemment copiés dignes d'être remplacés par des passages qui témoignent de son intérêt pour Salomon. Sont copiés au f. 87v de *G* les c. LXXVI, *De diffinitione dierum* (*W* f. 57vb), sur les définitions des divisions du temps comme *athomus, momentum, minutum* et les éclipses, tirées d'Isidore, *Etym.*, V, 29–36 et III, 55 et 58–59 et le très bref c. LXXVII, *De natura solis* (*W* f. 58ra), à propos des quatre éléments, emprunté à Bède, *De natura rerum*, c. 19, puis c. 8 et c. 4.

Vient ensuite le cahier XII (f. 88–94) où se trouve deux fois le motif du « *Draco cum arctos* ». D'une composition codicologique tout

à fait inhabituelle, il est consacré à l'astronomie illustrée. Il est le résultat d'un assemblage, mais le cœur de ce cahier remonte, comme le cahier XIII.a, aussi très illustré, à la deuxième des treize phases de réalisation identifiées par Albert Derolez, entre la première phase réalisée entre 1111 et 1115, et la troisième, datée entre 1111 et 1118[48]. La deuxième phase de rédaction, concernée ici, commence avec la pleine page-frontispice avec le char du Soleil (*G* f. 88v, *W* f. 61v), qui est un premier brouillon d'une image du cycle apocalyptique déplacé de sa location initiale (bifeuillet 88–91, venant du cahier IIIbis perdu)[49], que Lambert a ensuite adaptée à un contexte astronomique en effaçant ou en recouvrant certaines matières.

Le cahier XII, hétérogène, est arbitrairement divisé en deux chapitres qui n'ont rien de comparable aux autres, le c. LXXVIII (qui avait probablement à l'origine le numéro LXXX), f. 88r-v, intitulé dans la table *De quattuor elementorum* et illustré par le Christ dans une mandorle, entouré de médaillons sur les quatre éléments (*G* f. 88v – *W* f. 58v)[50], et le c. LXXVIIII, doté du titre *De ordine et positione signorum* au f. 89r mais du titre *LXXVIIII Beda de astrologia* dans la table, alors que le chapitre accompagné de ce dernier titre se trouve au f. 94r. Le *De ordine et positione signorum* recouvre aux f. 89r–91v [*W* f. 62r–63v] un cycle de constellations illustré pour lequel le modèle de Lambert n'avait pas été identifié mais où j'ai reconnu le *De ordine ac positione stellarum in signis* souvent attribué à Bède[51] ; il est étudié ci-dessous (p. 93 et suiv.) et j'en donne en annexe une liste de manuscrits, commentée. Le cycle est dépourvu de son bref prologue et commence avec la notice sur la grande Ourse : *Helice Arcturus Maior habet stellas in capite VII*. Il s'ouvre sur la représentation du *Draco inter Arctos*, c'est-à-dire un serpent (*serpens*) bleu, bicornu, au dos crénelé, marqué de dix gros « pois » blancs ; le reptile forme un *S*, dont les boucles contiennent chacune une Ourse grise sortante (*Ursa maior* en haut, *Ursa minor* en bas). Ensuite, dans la moitié basse du f. 91v, se trouve un texte sur la course du soleil à travers le Zodiaque et la durée des circuits du Soleil et de la Lune[52] [*W* f. 64r].

A. Derolez a montré d'une manière convaincante que le bifeuillet 92/93 [*W* f. 59–60], avec la carte circulaire du monde

très colorée sur une double page, devait être la partie initiale du douzième cahier, à laquelle le reste a dû être ajouté à une date très précoce[53]. Un axe rouge et oblique traverse la carte du monde ; il s'y trouve un dessin du cours annuel de chaque planète[54]. Les textes d'accompagnement sont tirés d'Augustin, de Macrobe, et d'autres auteurs tardo-antiques[55]. Au dos de la carte, f. 92r [W f. 59r], se trouvent des dessins du Soleil, de la Terre, de la Lune, ainsi qu'un cadran solaire[56], accompagnés d'extraits du *Commentaire sur le Songe de Scipion* de Macrobe, à propos du diamètre du soleil et de l'univers[57].

Quand au bifeuillet 88/91, dépeignant l'*Apocalypse* mais resté inachevé, il devait constituer des feuilles rejetées d'un cycle initial consacré à ce sujet dans le cahier III^bis maintenant perdu[58]. Au f. 88r figurent des extraits de la Révélation, la représentation du Seigneur, de l'Agneau et du Livre, et de l'Autel, mais sans les Innocents sous l'autel et d'autres figures qui sont mentionnés dans la table des matières. A la place, les six médaillons contiennent des textes sur les quatre éléments, l'abysse, et les qualifications de l'année[59], assortis des c. 1 et 2 du *De natura rerum* de Bède, sur la Création. Ainsi, Lambert a composé une page qualifiée d'« énigmatique » par A. Derolez, car mi-cosmographique, mi-apocalyptique ; cette combinaison est typique de la compilation de Lambert, à la fois scientifique et spirituelle, mais le changement de sujet dénote à mon avis l'accès à une nouvelle source cosmologique. Au milieu du f. 88v, devaient figurer logiquement le Christ et les douze premiers Anciens dans les rectangles autour de lui, alors que la préparation de ces dessins a fait place dans le rectangle central à une tout autre image, celle du char de Phoebus ou Helios, le Soleil, entouré des étoiles de six autres planètes, tandis que les douze compartiments autour contiennent désormais, dans le sens horlogique, les noms des mois et des signes zodiacaux correspondants, l'évaluation de la longueur du jour et de la nuit pour chaque mois, et l'étymologie du nom des mois, probablement d'après Isidore[60] [W f. 61v ; P f. 54v[61]].

Suit au f. 93v une *rota* avec les phases de la Lune et les cycles planétaires[62], dont le titre est placé dessous : *Exemplar lunam lumen habere a sole*, « un exemple montrant que la Lune reçoit sa lumière du soleil », tandis que le titre en

haut de la page renvoie au texte de Macrobe sur l'*annus mundanus* de 15 000 ans, inscrit dans l'image [W f. 61r][63].

Vient enfin dans le même cahier XII la seconde illustration (Fig. 2) contenant le *Draco cum Arctos*, sur le recto du singleton du f. 94 : le *Draco* est placé au milieu d'une sorte de planisphère portant les constellations du ciel septentrional et des révolutions planétaires [W f. 61r en haut] suivi dans le registre inférieur du texte *Duo sunt extremi uertices mundi...* Cet incipit est le début de l'*Excerptum de astrologia* qui continue en haut du f. 95r, où il porte à juste titre celui de *De astrologia excerptum*, avec le numéro de chapitre LXXX. Cependant, le feuillet 94r avait été intitulé par Lambert *De astrologia secundum Bedam* [W f. 61r, P f. 56v] et a donné son nom à tout le chapitre dans la table des matières (où il est numéroté *LXXVIII, Beda de astrologia*). Dans le dessin du planisphère du f. 94r, le nombre d'étoiles composant chaque constellation avait été chaque fois noté, mais le plus souvent effacé ensuite ; j'ai pu remarquer qu'il correspond aux nombres d'étoiles notés en chiffres romains dans la suite du texte de l'*Excerptum de astrologia* copiée comme on l'a vu dans le cahier XIII au f. 95r [W f. 64r] et au début du f. 95v [W f. 64r], sous le titre *De astrologia excerptum*[64]. Ce fait indique que le planisphère et l'*Excerptum* sont liés ici comme ils devaient l'être dans la source. Le planisphère présente les constellations boréales au centre, entourées du zodiaque, puis à la périphérie des constellations australes.

La dernière partie du cahier XII est faite d'une image du système planétaire ptoléméen des orbes planétaires intitulé *Circuli VII cursusque VII planetarum* au f. 94v (W f. 61r en bas), similaire à un des diagrammes des manuscrits illustrés du *De natura rerum* d'Isidore, avec au centre la carte T-O de la Terre ; y apparaissent les noms des planètes, leurs durées de révolution et leurs distances respectives[65]. Du point de vue de la mise en page des *rotae*, l'image circulaire présente des similarités avec les feuillets 24v–25v du cahier IV, offrant à voir successivement la carte du monde en T entouré des douze vents (24v), le parcours du soleil sur les zones climatiques terrestres entourées de l'océan (25r), la roue des levers et couchers du Soleil aux solstices et aux équinoxes (25v), et les phases de la Lune

combinées avec les saisons et éléments[66]. Au f. 94v, les textes de part et d'autre de la *rota*, et sous elle (texte à grandes lignes surlignées en rouge comme celui du début de l'*Excerptum*), portent sur la nature propre à chaque planète ; ils sont empruntés au *De natura rerum* de Bède et au commentaire sur le *Songe de Scipion* de Macrobe[67]. Divers indices, qui seront détaillés plus bas, tendent à montrer que Lambert s'est servi pour ce cahier XII d'une compilation astronomico-computistique déjà constituée. Cependant, le chanoine de Saint-Omer en a réorganisé d'une manière toute personnelle la matière à la fois textuelle et iconographique.

Le cahier XIII, f. 95–102, contient 36 petits chapitres, dont certains sont réécrits sur des grattages et ne figurent donc pas dans la table des matières. Le cahier a été inséré entre les cahiers IX et XIV comme le XII, il date de la même phase de travail et est matériellement beaucoup plus cohérent que le XII (avec aux f. 96–102 les restes d'un quaternion (XIII.a), alors que le f. 95 a été ajouté pour remplacer le pendant perdu du f. 102). Il poursuit la matière astronomique du cahier XII et passe à la météorologie. Les textes du f. 95 sont des additions par rapport à un état antérieur (XIII.b), comme en témoignent les titres copiés sur un grattage dans la table des matières (*LXXX. Item de astrologia*). Le c. LXXX est suivi sur la part inférieure du f. 95v [*W* f. 64va] du chapitre LXXXI, *De XII signis*, sur le lever et le coucher des principales constellations au cours de l'année, copié, à l'exception de ce titre, antérieur, par la main E sur un passage gratté et également tiré de la tradition d'Aratus[68]. Cette substitution a été numérotée comme XIII.d par A. Derolez. Il s'agit du dernier emprunt à la tradition des *Aratea*, la collection de sources propre au cahier XII et au premier feuillet additionnel du cahier XIII. Il se peut que *De XII signis* soit le titre qui couvrait le passage d'Ausonius (par Priscianus grammaticus), inc. *Ad boree partes arcti vertuntur et anguis*, qu'on retrouve dans certains manuscrits contenant l'Aratus révisé ou le *De ordine et positione stellarum* que je rapproche ci-dessous (p. 209 et suiv.) du modèle probable de Lambert.

Dans la suite immédiate, il manque un feuillet entre les feuillets actuels 95 et 96, le premier d'un quaternion (pendant du f. 102). Ce feuillet illustré a été coupé, probablement en raison de la valeur de son illustration. Il

contenait trois chapitres d'après la table et le manuscrit de Wolfenbüttel : le c. LXXXII, *Item de astrologia* sur le recto [*W* f. 64r][69], et sur le verso, le c. LXXXIII de la table, à savoir le *De tonitruo* sur le tonnerre et l'éclair, tiré également du *De natura rerum* de Bède, précédé d'une petite note sur le Soleil et l'année[70] [*W* f. 65ra], ainsi que le c. LXXXIIII, *De naturis elementorum*, qui reprend les chapitres de Bède sur l'arc-en-ciel, des nuages, de la pluie, de la grêle, de la neige et des tremblements de terre [*W* f. 65r, et *G* pour les deux premières lignes du f. 96r, *P* f. 59r][71]. Le premier des trois chapitres a une illustration astronomique différente du reste des *rotae* du manuscrit autographe, mais qui est néanmoins le pendant du planisphère du f. 94r dans le ms. *G* [*W* f. 64v] dans la mesure où les constellations y sont représentées par des réseaux d'étoiles dans les sphères des rotations des planètes. Au centre des cercles, le manuscrit autographe [*G* f. 94r] avait représenté le *Serpens* et noté entre ses boucles « ursa maior » et « ursa minor » à leurs places respectives, mais le copiste de *W* y a substitué la terre en T-O. Il a dessiné le Christ bénissant dans une mandorle, au-dessus des cercles des planètes, des constellations et du Zodiaque. Dans *G*, avant de passer à une matière biblique complètement différente, la météorologie se termine sur le f. 96r avec deux autres très brefs extraits regroupés dans le c. LXXXV *De tempestate et serenitate*, l'un sur les intempéries en fonction de l'aspect du Soleil et de la Lune, toujours tiré du c. 36 du *De natura rerum* de Bède, et l'autre sur les déluges, *De diluviis*, copié des *Etymologies* d'Isidore (XIII, 22, 2-4) [*G* f. 96r ; *W* f. 65b].

La suite du cahier XIII, à partir du c. LXXXVII jusque CXVI, présente moins de cohérence apparente : Satan, Saul, Salomon, le Christ et son temps, sont des sujets qui renvoient à une matière traitée auparavant[72]. Suivent diverses notes.

Les fragments très intéressants pour l'histoire du *LF*, mais très endommagés, du manuscrit Cotton de Londres, écrit dans les années 1118–1119 à Saint-Omer, furent redécouverts par David Dumville en 1980 ; ils constituent une sorte de terminus *post quem* pour la matière astronomique que nous venons d'examiner. En effet, ils témoignent d'un moment dans la réalisation de l'œuvre, à savoir les trois ou quatre phases primitives (datant des années

1112–1115), durant lesquelles Lambert n'avait pas encore montré d'intérêt astronomique ni fait usage de l'œuvre de Macrobe, dont des extraits sont copiés après le cycle de constellations *De ordine et positione signorum* des f. 89r–91v. Ces fragments constitueraient donc un *LF* primitif doté d'un nombre restreint de sources, sans Julien de Tolède, Macrobe, Martianus Capella, Raban Maur, sans la matière aratéenne, et dépourvu de matières relatives « à la théologie, à l'eschatologie, à la morale, au droit canon, à la poésie et à la littérature, rien sur Alexandre le Grand, l'histoire des Normands, l'histoire de l'Angleterre, rien sur le symbolisme animal, végétal, cosmique, historique si typiques pour l'œuvre de Lambert »[73]. Les fragments Cotton, qui ne sont pas autographes, ont d'après A. Derolez des rapports étroits avec l'abbaye de Saint-Bertin, alors que le manuscrit autographe de Gand fut réalisé pendant la période de 1112–1115 à 1121 et montre paléographiquement l'écriture d'un homme d'un certain âge, déjà démodée au début du XIIe siècle et sans aucune caractéristique de la gothique primitive[74]. En effet, le père de Lambert étant mort en 1077, Lambert devait déjà être assez âgé au moment de la réalisation du *LF.*

Le *De ordine ac positione stellarum* et son contexte dans les compilations computistiques et astronomiques

La source du cahier astronomique du *LF* a pour contexte la tradition des *Aratea* illustrés. L'examen attentif des extraits astronomiques rassemblés par Lambert permet de découvrir qu'il a puisé dans des textes de la tradition aratéenne qui circulent dans un certain nombre de *compendia* astronomiques à partir du IXe siècle.

Les premières encyclopédies computistiques furent produites autour de la cour carolingienne, à la faveur de la curiosité suscitée par la suite exceptionnelle d'éclipses visibles de 806 à 812[75]. Elles ont pour sources principales Pline l'Ancien, Macrobe, Isidore de Séville et Bède le Vénérable, des autorités dont use aussi le *LF.* Un des deux compendia principaux fut probablement rédigé à Salzburg après la consultation de savants qui eut lieu à la cour de Charlemagne en 809 ; il mentionne cette date sous la forme de l'année 4761 *ab initio mundi*. Il compte trois livres et est édité par Arno Borst sous le nom de *Liber calculationis* ou « Salzburger Enzyklopädie ». L'autre, rassemblé à Aix-la-Chapelle, donne la date de 812, il est supposé avoir été constitué entre 810 et 812 en sept livres et est édité par A. Borst sous le nom de « Aachener Enzyklopädie » ou *Libri computi*[76] ; on l'appelle aussi « Seven Book Computus ». Il est considéré généralement par l'historiographie comme le premier des deux. Celui en trois livres en constituerait un résumé ; dans un certain nombre de manuscrits est ajouté un quatrième livre recopiant le *De natura rerum* de Bède, qui constitue parfois le livre VII dans les *Libri computi*. Cependant, W. Stevens a contesté cet ordre d'exécution et considère le comput en trois livres comme le premier, composé à Aix-la-Chapelle ou à l'abbaye de Saint-Amand (à 100 km de Saint-Omer)[77]. Les manuscrits de référence du comput en trois livres ou *Liber calculationis* sont les codices Wien, Ö.N.B. 387, f. 1r–165v et München, Bayerische Staatsbibl., Clm 210, réalisé de manière contemporaine dans les environs de Salzburg en 818. Bien qu'on n'en conserve pas l'archétype, le manuscrit emblématique des *Libri computi* en sept livres est le Madrid, Bibl. Nac. 3307 copié à Metz ou à Murbach pour l'évêque Drogon vers 830[78], dont le ms. Città del Vaticano, Biblioteca apostolica vaticana, Vat. lat. 645, qui porte une marque de Saint-Quentin du Xe siècle, est un jumeau[79]. D'après A. Borst[80], le livre II des *libri computi* rassemble des formules pratiques pour déterminer la chronologie de l'année en cours, dont beaucoup sont basées sur le calendrier du Mont-Cassin. Or, Adalhard, abbé de Corbie (751–827), formé au Mont-Cassin avant 780 et connaissant Alcuin (*c.* 730–804), aurait connu ce calendrier dans sa première version avant 780. Il serait donc le coordinateur présumé du compendium en sept livres.

Au XIe siècle, un intérêt astronomique renouvelé, en particulier sous l'impulsion d'Abbon de Fleury, donne à nouveau lieu à des manuels astronomiques et computistiques[81] qui s'alimentent aux sources traditionnelles et aux œuvres de computistes novateurs comme Helpéric (dont il a été question plus haut) ou le lotharingien Gerland, qui écrit son comput vers 1081–1093[82]. Parmi ces manuels, le manuscrit Madrid, Biblioteca Nacional, 9506, probablement réalisé *c.* 1026 à Saint-André

d'Avignon, dont la collection de textes et d'images extrêmement riche vient d'être décrite en détail par Faith Wallis[83]. Ce courant scientifique s'illustre sur la côte nord-ouest du continent européen et passe en Angleterre où il connaît des développements techniques propres ; par exemple, le manuscrit Oxford, Corpus Christi College, 283, du XIIe siècle, contient aux f. 66v–81v le *Preceptum* de Ps.-Ptolémée, c'est-à-dire des tables astronomiques rudimentaires dont les autres copies sont chartraines, ainsi que les tables astronomiques de Walcher de Malvern[84]. On peut citer aussi le manuscrit d'origine française Oxford, Bodleian Libr., Digby 23, très richement illustré[85]. L'intérêt de Lambert pour les matières relatives au calcul du temps et de l'espace s'inscrit dans ce courant scientifique et utilise les mêmes sources, tout en donnant l'impression que malgré son goût prononcé pour les diagrammes, il n'a pas tiré autant de profit de la science computistique récente que les autres compilateurs de la fin du XIe et du début du XIIe siècle.

La complexe tradition des Phénomènes d'Aratos

Pour permettre de comprendre les grandes lignes des relations entre les versions des *Aratea* et pouvoir situer les illustrations du cycle de constellations du *LF* par rapport aux compilations computistiques dont il vient d'être question, je propose un schéma[86] (Fig. 3) auquel j'ai joint des représentations-types du *Draco inter Arctos* trouvées dans les manuscrits, car elles serviront ensuite de critère de classification entre les manuscrits du *De ordine et positione stellarum* rassemblés en annexe.

Les commentaires aux *Phaenomena* d'Aratos et toute la tradition aratéenne ont offert aux savants carolingiens comme à Lambert de Saint-Omer un complément au savoir astronomique de la fin de l'Antiquité ou du début du Moyen Âge. Cette tradition est extraordinairement complexe et ses enchevêtrements sont loin d'être encore débrouillés, mais le fait que son histoire est liée aux contrées qu'a fréquentées le chanoine de Saint-Omer est essentiel pour notre propos. Les *Phaenomena* d'Aratos sont un poème didactique décrivant pour la cour macédonienne les constellations et des phénomènes astronomiques ; ils datent de *c.* 315–240 ACN. Germanicus, fils adoptif de Tibère (G. Julius Caesar, 15 ACN-19 PCN), en a livré une traduction poétique en latin au début de notre ère (inc. *Ab Iove principium magno deduxit Aratus carminis*). Il existe aussi une version latine en vers de Cicéron, et une autre d'Avienus. En outre, les textes mythologiques du livre II du *De astronomia* d'Hyginus sur les constellations (inc. *Sed quoniam quae nobis de terrae positione*) ont accompagné la tradition des *Aratea*. Par ailleurs, une traduction du grec en latin d'Aratos, en prose, est probablement née à Corbie sous l'abbé Grimo de Corbie (723?-748), qui était aussi archevêque de Rouen à partir de 744 ; ces textes grecs seraient arrivés de Rome en Gaule à cette époque[87]. L'«Aratus latin» commence par une biographie d'Aratos et quelques informations astronomiques, et des sections du poème sont complétées par des scholies sur les mythes et les nombres et les descriptions des étoiles. L'Aratus latin a connu une révision au début du IXe siècle, où les noms latins sont substitués aux noms grecs et les descriptions des constellations sont simplifiées dans un style formulaire ; où, aussi, un cycle d'illustrations des constellations a été ajouté. On appelle cette révision l'«Aratus latin révisé» ou la *recensio interpolata*[88]. À cette révision sont venues s'ajouter ensuite des scholies au texte de la traduction faite par Germanicus au début de notre ère.

Corbie, Reims, Fleury, Auxerre sont les lieux d'origine des plus anciens manuscrits des *Aratea*, qui proviennent en général de la moitié Nord de la France. Le scriptorium de Saint-Bertin a joué lui-même un rôle important dans la diffusion, avec non moins de trois copies des *Aratea* dans la traduction latine de Germanicus. La question est, comme le dit à ce propos Albert Derolez : «One really wonders how and where Lambert had access to another copy of these rare illustrations»[89], se demandant comment il se faisait que l'auteur du *LF* n'avait selon toute apparence pas utilisé le ms. de Boulogne-sur-Mer, 188 (fait probablement sous l'abbé Odbert de Saint-Bertin vers 1000), sur lequel fut copié celui de Bern, Burgerbibl., cod. 88[90], pour être donné à la cathédrale de Strasbourg dès 1004. Quant au plus ancien exemplaire, illustré, de la traduction par Germanicus du poème d'Aratos, le Leiden, Universiteitsbibl., Voss. Lat. Qu. 79, lui-même père du ms. de Boulogne-sur-Mer, il fut composé entre 816 et 825 selon les datations, en Lotharingie (Aachen ou Metz) et

Fig. 3. Schéma des versions des *Aratea* et illustrations du *Draco inter Arctos*

probablement commandé par Louis le Pieux, puis conservé à Saint-Bertin, mais on ne sait pas à partir de quelle date[91].

Parmi les scholies qui se sont agrégées à l'Aratus latin révisé comptent les *Scholia Basileensia ad Germanicum* (inc. *Queritur quare ab Ioue coepit et non a musis*), faites sur la famille O du texte poétique de Germanicus, révisé peut-être autour de l'an 300[92]. Ces scholies qui intègrent à la fois des mythes et des catalogues d'étoiles pour chaque constellation se présentent pour la première fois dans un ms. originaire de Fulda dans le premier tiers du IXe siècle : Basel, Universitätsbibl., AN IV 18, où le *Draco inter Arctos* du f. 14r, *barbatus* et chevelu, est horizontal à deux boucles, tête en bas, avec les Ourses dressées sur les pattes arrière et les étoiles marquées par des croix à l'encre pâle rosée[93] (Fig. 4) ; le manuscrit présente aussi au f. 1v (détaché) un planisphère dont le centre est orné d'un tel *Draco* à deux (presque trois) boucles avec les Ourses entrantes, dos à dos.

Les *Scholia Sangermaniensia* sont un commentaire marginal à l'Aratus latin destiné à compléter les Catastérismes. E. Maass l'avait déjà affirmé en 1898 en consultant le ms. Dresden,

Dc 183, mais il appelait ce texte la *Recensio interpolata* anonyme[94]. Ces scholies, éditées par A. Breysig[95], sont appelées ainsi d'après le ms. Paris, B.n.F. lat. 12957, f. 57–74, copié à Corbie entre 810 et 840, et passé à Saint-Germain-des-Prés au XVIIe siècle, qui est la version de référence de l'*Aratus latin* révisé, réaménagé (β)[96]. Les deux copies antérieures faites à Corbie n'ont pas subsisté. Les *Scholia Sangermanensia* ont utilisé des versions plus précoces de textes aratéens et d'autres sources (Fulgence, Isidore, peut-être Bède) pour réviser l'Aratus latin.

Les *Scholia Strozziana* (ms. Firenze, Bibliotheca Medicea Laurenziana, Strozzi 46)[97], elles, ont peut-être vu le jour à l'abbaye de Saint-Gall[98] et sont surtout présentes dans des manuscrits italiens *recentiores*. A. Dell'Era[99] considère que leurs sources sont triples : l'Aratus latin révisé/interpolé, les *Scholia Basileensia ad Germanicum* et un des deux catalogues de constellations qui ont circulé sous le nom de Bède, *De signis celi*.

Quant au *De ordine ac positione stellarum in signis*, frère du *De signis celi*, dont il va être question d'une manière plus détaillée ci-dessous, il peut être considéré comme un résumé carolingien des descriptions des constellations, qui a émergé

Fig. 4. Basel, Universitätsbibl., AN IV 18, f. 14r, début des *Scholia Basileensia* à Germanicus, Fulda, 1er tiers du IXe siècle : *Draco inter Arctos*

autour du texte de Germanicus et des scholies qui l'accompagnaient. Il est basé sur les *Scholia Basileensia*. D'après H. Le Bourdellès[100], le *De ordine* aurait pour modèle le *De signis celi*, mais la chose reste à prouver par une étude généalogique des textes des manuscrits de l'un et de l'autre cycle de constellations ; on peut constater en tous cas des interférences entre les deux cycles. Le Bourdellès voit l'origine du *De ordine* dans la confection des *Libri computi* en sept livres à Aix-la-Chapelle, où il aurait été conçu pour compléter la description du planisphère faite dans l'*Excerptum de astrologia* qui ouvre le livre V. S'il n'est pas prouvé que le *De ordine* a bien vu le jour à ce moment-là, il me semble incontestable que les compilations carolingiennes ont été son principal canal de diffusion.

Dans tous les textes aratéens, la manière standard de présenter les constellations, dont le Zodiaque, est de commencer avec l'hémisphère céleste au nord de l'écliptique et de continuer avec les constellations qui se trouvent au sud de l'écliptique. C'est

pourquoi les versions latines du poème d'Aratos incluaient souvent une carte sous forme de planisphère ou de représentation des deux hémisphères d'été et d'hiver, pour montrer la relation des constellations entre elles dans l'espace[101] ; on ne sait pas si c'était déjà le cas dans les *Phainomena* d'Aratos à l'époque classique, mais peut-être déjà dans les modèles latins des IVe–Ve siècles vus par les savants carolingiens.

Une telle carte du ciel est fréquente, sous forme de planisphère, dans les manuscrits des *Aratea* de Germanicus[102]. Dans les manuscrits de l'Aratus révisé[103], on la trouve sous forme de représentation des deux hémisphères suivie des *Scholia Sangermanensia* ; les hémisphères sont coupés suivant le colure des équinoxes, avec le pôle nord dans la partie supérieure, et non comme aujourd'hui d'après l'équateur ; ils sont divisés par les lignes parallèles figurant l'équateur, les tropiques et les cercles polaires, et traversés de haut en bas par le colure des solstices ; la moitié des signes du Zodiaque figure ainsi dans chaque hémisphère dans une bande

oblique[104]. Un troisième type de carte du ciel est représentée comme un globe fixé à l'intérieur d'un temple à colonnes dans des manuscrits de l'Aratus révisé[105]. En conséquence, cette illustration sous différentes formes de carte du ciel précède dans certaines des compilations astronomiques médiévales un exposé des constellations et quelques extraits de la *Naturalis historia* de Pline concernant les planètes et les signes, de même que dans le *Liber floridus*, un planisphère précède aussi le cycle de constellations illustré.

Les séquences des compendia carolingiens

On retrouve une séquence de diagrammes célestes et de textes similaire, mais plus longue que dans le *LF*, dans les *compendia* astronomiques et computistiques suscités à la cour carolingienne. Il faut donc se poser la question si l'un d'entre eux a pu être le type de manuel que Lambert a consultés. B. Eastwood[106], qui a pris pour modèle le manuscrit emblématique Madrid, Bibl. Nac. 3307, énumère la séquence typique des manuscrits qui présentent ce que A. Borst a publié comme le livre V des *libri computi*. J'ai suivi ci-dessous cette séquence en ajoutant en regard la correspondance avec des passages des cahiers astronomiques du *LF* et en donnant les éléments historiographiques et les manuscrits précoces qui documentent chacun de ces petits textes ou diagrammes :

[Planisphère] [diagramme **LF** G f. 94r]
1. *Excerptum de astrologia Arati*[107] [= **LF** G f. 94r, en bas et 95v]. L'*Excerptum* vient d'une variante textuelle des *Scholia Sangermanensia*. Il fut cependant appelé aussi *Anecdoton* d'Hygin car il adapte, selon certains, le *Poeticon astronomicon* d'un auteur grec du IIe siècle homonyme de l'Hygin latin, un poème qui adaptait lui-même les *Phénomènes* d'Aratos. Pour d'autres, il s'agit d'une partie de l'œuvre perdue de l'Hygin latin. L'opuscule fait un survol des constellations et de leur place, en décrivant et illustrant quarante-trois constellations avec un bref texte donnant le nombre d'étoiles pour chacune. Il a été édité pour la première fois parmi les oeuvres de Bède[108]. On en conserve au moins 46 manuscrits, d'après ce que j'ai pu recenser[109], un nombre supérieur à celui des témoins du *De ordine et p. st.* le suit dans les manuscrits. L'*Excerptum*

décrit les constellations célestes en suivant le modèle des *Phénomènes* d'Aratos, mais il n'y a pas de relation directe entre l'Aratus latin et cette description. Il y aurait en revanche une relation directe entre une carte du ciel et l'*Excerptum*. C'est pourquoi H. Le Bourdellès considère que l'*Excerptum* a été extrait de la révision de l'*Aratus* faite à Corbie au milieu du VIIIe siècle et qu'il a été fourni pour son intégration dans la compilation de 809 par un parent de Charlemagne, l'abbé de Corbie Adalhard[110], qui faisait aussi partie de la cour d'Aix-la-Chapelle. C'est d'Aix que provient en effet le plus ancien témoin de l'Aratus révisé, le ms. Köln, Dombibliothek 83/II, commencé en 798 et fini en 805, qui devait aussi contenir les deux hémisphères[111]. D'autres hypothèses ont été avancées pour voir l'origine de l'*Excerptum* en France[112]. Kauffmann l'appelle *Excerptum Parisinum* à cause des manuscrits parisiens qu'il a utilisés pour son édition[113] ; il n'a pas vu les liens avec le *De ordine*. Ces liens furent entrevus par Manitius, puis examinés par Dell'Era, qui édite l'*Excerptum* avec le *De ordine*[114].

2. *De ordine ac positione stellarum in signis*[115] [= **LF** G f. 89r–91v, haut] : 43 constellations accompagnées d'un bref texte donnant le nombre d'étoiles pour chacune. (ms. Madrid 3307, f. 54r–62v). Le texte qui accompagne les dessins serait tiré des *Scholia Basileensia*, le commentaire aratéen en forme de scholies présent dans la famille O. Le catalogue des constellations du *De ordine* fut découvert pour la première fois par W. Hasper, dans sa publication de la version réduite du IIIe livre de l'*Astronomicon* d'Hygin[116] ; il a pris le *De ordine* pour une rédaction abrégée de ce livre. K. Rück, *Auszüge aus der Naturgeschichte des C. Plinius Secundus in einem astronomisch-komputischtischen Sammelwerke des achten Jahrhunderts*, München, 1888, voit dans le texte dérivé des scholies de Germanicus un traité astronomique-computistique composé dans un milieu anglo-saxon au VIIIe siècle et réélaboré au début du IXe siècle[117]. E. Maas, *Commentariorum in Aratum reliquiae*, Berlin, 1898, p. 312, en reste à la position de Hasper et considère le *De ordine* comme une « *alia caeli descriptio cum stellarum indicibus Hygini libro III*

similibus coniuncta». La première édition du texte – bonne – est celle de G. Kauffmann, en appendice à *De Hygini memoria scholiis in Ciceronis Aratum Harleianis seruata*, Breslau [Wrocław], 1888. Il considère le *De ordine* comme un nouveau témoin des *Scholia Basileensia* à Germanicus, de valeur supérieure à *A* et *P* qu'avait utilisés BREYSIG pour les *Scholia*[118]. Quant à W. KÖHLER, *Die karolingischen Miniaturen*, III, Berlin, 1960, p. 100, il voit les dessins de constellations comme un produit de l'école impériale d'Aix-la-Chapelle. Plus récemment, Le Bourdellès voit l'origine du *De ordine* dans la confection des *Libri computi* en sept livres à Aix-la-Chapelle, où il aurait été conçu pour compléter la description du planisphère faite dans l'*Excerptum de astrologia*. S'il n'est pas prouvé que le *De ordine* a bien vu le jour à ce moment-là, il me semble incontestable que les compilations carolingiennes ont été son principal canal de diffusion et qu'il n'est pas attesté auparavant.

3. *De positione et cursu septem planetarum*, qui présente l'ordre et les durées de révolution des planètes, d'une manière plus détaillée pour les planètes sous le Soleil. Le texte est extrait de Pline, *NH* II, 12, 32, 34–36, 38–44. (Texte et diagramme: ms. Madrid 3307, f. 63r-v). [correspond plus ou moins, avec le *De intervallis earum* (4), à la matière et au diagramme du *LF*, G 94v: *Circuli septem cursusque septem planetarum*]

4. *De intervallis earum*, qui donne les distances interplanétaires absolues et relatives, avec un diagramme circulaire, d'après Pline, *NH* II, 83, 84 (ms. Madrid 3307, f. 63v–64r). [cf. *LF*, G 94v]

5. *De absidibus earum*, des extraits tirés de Pline *NH* II, 59–61, 69, 70, 63, 64 qui fournissent les levers, couchers, stations et rétrogradations des cinq planètes autres que la Lune et le Soleil, avec explication et place des apsides, c'est-à-dire des apogées et périgées (ms. Madrid 3307, f. 64v–65).

6. *De cursu earum per zodiacum circulum*, qui donne les latitudes zodiacales des sept planètes, levers et couchers et invisibilités des cinq planètes, excepté la Lune et le Soleil, et les phases de la Lune. Tiré de Pline, *NH* II, 62, 66–69, 71, 75–78, 80, 78, 79, 76, 77 (ms. Madrid 3307, f. 65v–67r).

7. *De interlunio*: un extrait d'Isidore, *Etymologies*, III. Traite de l'intervalle de temps entre la dernière et la première apparition visible de la Lune quand elle passe à travers la conjonction avec le Soleil (ms. Madrid 3307, f. 67r).

8. *De eclyppsi lunae*: autre extrait des *Étymologies*, III, 59, III, 1, 1. Relation temporelle du Soleil et de la Lune pendant l'éclipse de lune, avec une phrase ajoutée sur l'indépendance des mouvements solaire et sidéraux (ms. Madrid 3307, f. 67r).

9. *De eclyppsi solis*: *Etym.* III, 58. Définition d'une éclipse de Soleil (ms. Madrid 3307, f. 67r).

10. *De solis eclypsi quando sit*: 8 éclipses solaires avec des dates de 760 à 812 (D'une main différente du reste du livre V dans le ms. Madrid 3307, f. 68v).

D'après Le Bourdellès[119], le matériau du livre V des *Libri computi*, sur la mesure, venait très probablement de Corbie, comme l'*Excerptum* et le *De ordine*; il s'y serait donc trouvé un Aratus révisé, source de l'*Excerptum*, et un Germanicus et ses scholies, source du *De ordine*. Suivent en effet dans les *Libri computi* trois chapitres d'un contenu plus rare, tiré des *agrimensores*[120]:

11. *Dimensio caelestium spatiorum secundum quosdam*: distances interplanétaires correspondant aux intervalles du ton, en distances absolues. Révision du passage de Pline, *NH* II, 83 sur les intervalles (ms. Madrid 3307, f. 68v–69r).

12. *De praesagiis tempestatum*: tiré de Pline, *NH*, XVIII, 340–365. Il s'agit de pronostics météorologiques par les nuages, le Soleil, la Lune, les étoiles et d'autres éléments météorologiques comme l'arc-en-ciel; évocation de feux terrestres, passages sur les eaux, les comportements animaux, les modifications de la végétation, etc. (ms. Madrid 3307, f. 69r–71v). [Dans le *LF*, des passages du même genre sont tirés de Bède, DNR, 28–30, 36 et 49, aux c. LXXXIII à LXXXV dans *W*, 65r et partiellement dans G 96r]

Ensuite, le livre VI des *Libri computi* porte sur les poids et les mesures, avec un chapitre 6 contenant trois extraits d'astronomie géométrique relatifs aux dimensions du ciel et de la terre, tirés du Commentaire au *Songe de*

Scipion de Macrobe et aux *Noces de Philologie et Mercure* de Martianus Capella[121], autant de sujets traités dans le *LF* avec d'autres sources, par exemple pour les poids et mesures dans le cahier VII, chapitres XLI et XLII, f. 55v, où Lambert dit que sa source est Isidore quand il s'agit des *Instructiones ad Salonium* de l'évêque du Vᵉ siècle Eucher de Lyon[122]. Enfin, le livre VII des *Libri computi* est constitué de 51 chapitres du *De natura rerum* de Bède, aussi amplement cité par Lambert de Saint-Omer.

Dans le livre II du comput en trois livres, le *Liber calculationis*, on trouve une séquence comparable, mais réduite, par rapport à celle qui vient d'être décrite[123]. Le livre II reprend, d'après A. Borst et W. Eastwood, les livres V et VI du comput en sept livres et les abrège en modifiant en particulier le livre V (le livre III du *Liber calculationis* correspondant au livre VII des *Libri computi* (*i. e.* le *De natura rerum* de Bède)) :

1. *Excerptum de astrologia*
2. *De ordine ac positione stellarum in signis* (très illustré aussi)
3. *De positione et cursu septem planetarum*
4. *De intervallis earum*
5. *De absidibus earum* (puis omission des 4 chapitres du comput en 7 livres, *i. e.* V, c. 7–10 : *De interlunio, De eclypsi lunae, De eclypsi solis, De solis eclypsi quando sit*)
6. *De caelestibus spatiis secundum quosdam*
7. *De temporum mutatione* (extrait nouveau de Pline)
8. *De praesagiis tempestatum*

Si l'on compare les deux séquences, comme je l'ai fait, avec le contenu des cahiers astronomiques du *LF*, la concordance des thématiques est frappante ; cependant, seuls les trois premiers items sont strictement identiques : le planisphère, l'*Excerptum*, le *De ordine ac positione stellarum*. Cette confrontation macroscopique constitue un premier indice pour supposer que Lambert n'aurait pas tiré la matière de ses cahiers astronomiques d'un manuscrit contenant une des deux encyclopédies computistiques carolingiennes en trois ou sept livres. Cependant, les séquences qui ont été reconstituées par Eastwood ne sont pas immuables ni toujours complètes dans les manuscrits des *compendia* carolingiens recensés par A. Borst. En outre, la mention par Lambert de Bède, Macrobe et Helpéric, en bas du f. 94v, à la suite immédiate d'extraits de Cicéron et Macrobe, pourrait être

une indication qu'il aurait utilisé plutôt une compilation computistique du XIᵉ siècle reprenant ces auteurs ; mais on sait qu'il a lu directement le *De computo* du bénédictin Helpéric, rédigé en 903, car il a laissé une note dans le ms. qu'il a utilisé[124] pour réaliser les extraits qu'il en fait aux f. 25r-v du cahier IV de l'autographe. Un examen microscopique s'impose dès lors pour rassembler d'autres indices de la documentation à laquelle Lambert a pu avoir accès pour ces trois items sur les constellations (planisphère, *Excerptum, De ordine*) dont l'historiographie tend à situer l'apparition à Corbie (à 140 km de Saint-Omer) à la fin du VIIIᵉ siècle : H. Le Bourdellès a écrit que l'*Excerptum* comme le *De ordine* y auraient été composés puis transportés au synode carolingien de 809[125].

Le De signis celi et le Liber Nemroth

Pour aller plus loin, il importe de bien distinguer les deux cycles de constellations illustrés attribués à Bède et souvent confondus l'un avec l'autre ou assimilés, le *De ordine ac positione stellarum*, que j'ai identifié comme la source de Lambert, et le *De signis celi*. Raban Maur s'est inspiré de ce dernier dans son *De computo*, le *De signis celi* est donc antérieur à 820. *De signis celi* est le nom donné par l'éditeur des *Aratea*, E. Maass, à un catalogue des étoiles des constellations assorti d'un chapitre sur les cinq planètes, qu'Antonio Dell'Era a ensuite appelé θ dans son édition[126]. En suite de l'attribution médiévale, le texte du *De signis celi* a gardé la paternité de Bède pour son premier éditeur au XVIᵉ siècle, J. Herwagen, et pour J.-P. Migne[127]. En 1867, Alfred Breysig avait publié une partie du *De signis celi* sous le titre *Scholia Bernensia ad Germanicum*, d'après le manuscrit Bern, Burgerbibl. 88, copié sur un modèle de Saint-Bertin (sans faire le lien avec ce qui a été édité par Herwagen parmi les oeuvres de Bède)[128]. Ce manuscrit contient le texte en vers des *Aratea* de Germanicus très illustré, avec sous forme de scholies dans les marges, toutes les notices sur le placement des étoiles dans les constellations, qui forment le *De signis celi*. Celles-ci proviennent directement de l'Aratus latin dont la traduction avait été menée au VIIIᵉ siècle à Corbie[129]. Il existait à Fleury deux copies du *De signis celi* dès le Xᵉ siècle[130].

Ce *De signis celi* a été intégré par Michel Scot au début de son *Liber introductorius* astrologique

Fig. 5a. Città del Vaticano, Pal. lat. 1417, f. 9r, Italie, XIᵉ siècle : *Draco inter Arctos* dans le *Liber Nemroth* (fig. 19 du *Liber Nemroth*, se rapportant au chap. 30)

Fig. 5b. Paris, B.n.F. lat. 14754, f. 209r, Chartres, 2ᵉ tiers du XIIᵉ siècle : *Draco inter Arctos* dans le *Liber Nemroth* (fig. 19 du *Liber Nemroth*, se rapportant au chap. 30)

au début du XIIIᵉ siècle, ce qui a donné lieu à une des traditions du motif du *Draco inter Arctos*[131]. Le *De signis celi* est également copié à la suite du *Liber Nemroth* dans deux de ses copies subsistantes[132]. Ce dialogue cosmologique et computistique entre le maître Nemroth et son disciple Ioanthon, composé en latin au haut Moyen Âge[133], a été bien reçu dans le milieu naturaliste chartrain, comme en atteste la copie faite à Chartres au milieu du XIIᵉ siècle[134]. L'attention qu'on lui a portée coïncide avec le renouvellement de l'intérêt chartrain pour ces matières qui se manifeste par la rédaction du *Dragmaticon*, lui aussi dialogué, de Guillaume de Conches, et de l'*Heptateuchon* de Thierry. Le *Liber Nemroth* est l'œuvre où j'ai trouvé le plus de représentations du *Draco inter Arctos* ; elle compte en effet plus de cinquante diagrammes ou tableaux et partage avec les collections quadriviales et l'encyclopédie visuelle du *LF* nombre de thématiques sur le cosmos, ses dimensions et ses rythmes, les planètes, les éclipses, le comput, la météorologie, les éléments, autant de thèmes qu'on trouvait déjà traités par Bède le Vénérable au début du VIIIᵉ siècle dans le *De natura rerum* ou le *De temporum ratione*. Cependant, tandis que le *LF* et les collections computistiques occidentales sont composés de sources cosmologiques traditionnelles, héritières des encyclopédies d'Isidore et de Bède, le *Liber Nemroth* est extrêmement singulier dans ses doctrines scientifiques, étrangères à l'astronomie ptoléméenne, et

dans ses références sapientielles, qui reflètent une cosmologie d'inspiration sémitique, aux accents syriaques ou iraniens. On doit supposer, lors de sa copie ou de sa rédaction en latin, une contamination de l'imagerie de ses diagrammes par l'illustration astronomique latine traditionnelle, plutôt que l'inverse. Ce qui réunit les copies survivantes du *Liber Nemroth*, le *LF* et les *compendia* conservés à Oxford mentionnés plus haut (Digby 23 et Digby 83), c'est en revanche le choix de mêmes thèmes scientifiques et un arrangement pédagogique visuel typique de ce qu'on peut trouver dans le Sud de l'Angleterre et dans le Nord-Ouest de la France (la Normandie d'alors) à la fin du XIᵉ siècle et dans la première moitié du XIIᵉ siècle.

Quoi qu'il en soit, aucune des diverses représentations du *Draco inter arctos* dans le *Liber Nemroth* n'est tout à fait semblable en termes d'orientation au *Draco inter Arctos* du *LF*. Elles présentent le *draco* en « S » horizontal avec les ourses entrantes, tête-bêche (Fig. 5 a et b)[135]. Son iconographie est typologiquement proche de celle du f. 64r du ms. Dijon, Bibliothèque municipale, 448[136] (originaire d'un monastère bénédictin, probablement du

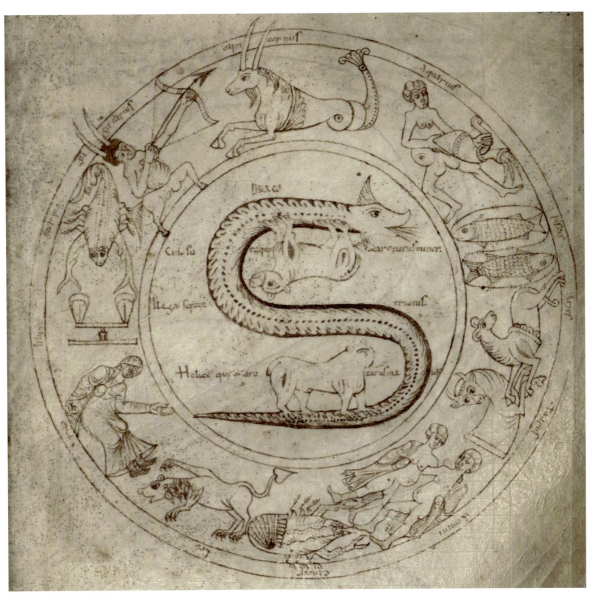

Fig. 6. Dijon, Bibliothèque municipale, 448, f. 64r, probablement diocèse de Toul, *c.* 1054 : *Draco inter Arctos* dans un *circulus Zodiaci*, avant le *De signis celi*

diocèse de Toul, *c.* 1054 d'après A. Borst[137]), au début d'un *De signis celi* (f. 64r–67r) relevant de ce qu'on a appelé la « Classe I » d'origine tardo-antique et dont les manuscrits sont pour la plupart français. Une deuxième copie, différente, du *De signis celi* suit aux f. 67r–71r. Au f. 64r, le *Draco* en S avec les *Ursae* inversées est entouré des cercles planétaires et du cercle du Zodiaque en sens horlogique, c'est-à-dire vu de la Terre[138] (Fig. 6) ; mais au f. 64v, un second *Draco inter arctos* à trois boucles Ourses entrantes, tête-bêche, relève de la Classe II d'origine carolingienne (Fig. 7). Le manuscrit contient divers textes que A. Borst retrouve dans les *Libri computi* d'Aachen (version β corr.). Aux f. 71v–72r se trouve l'*Excerptum*

(*Excerptio De astrologia Arati*), suivi du calendrier de Lorsch, d'extraits des c. 28–29 du *De temporibus* de Bède, le *De computo* d'Helpéric, le *De temporum ratione* de Bède, sa *Chronica maiora* et le *De natura rerum*. Bien que la plupart de ces textes furent aussi utilisés par Lambert de Saint-Omer, les extraits diffèrent et le cycle de constellations n'est pas celui du *LF*[139]. Cet exemple dijonais s'ajoute au bilan historiographique ci-dessus pour montrer que les deux cycles de constellations illustrés ont un environnement semblable et souvent un même contexte français, ce qui ne facilite pas le discernement. Dresser une liste exhaustive des témoins comme je le fais en annexe pour le *De ordine* est dès lors indispensable.

Fig. 7. Dijon, Bibliothèque municipale, 448, f. 64v, probablement diocèse de Toul, *c.* 1054 : *Draco inter actos*, avant le *De signis celi*

L'Opusculum de ratione spere

Il me reste cependant à mentionner la compilation astronomique de l'*Opusculum de ratione spere* en quatre livres, qui s'inscrit dans la tradition des réécritures des *Aratea* et emprunte à l'iconographie des mêmes cycles de constellations. Le manuscrit London, British Libr., Harley 647, venu de France, a servi en Angleterre de modèle à plusieurs déclinaisons, dont le volume London, British Libr., Cotton Tiberius B.V./1 (Canterbury, 991–1016). Ce dernier a un archétype commun avec l'*Opusculum de ratione spere* qu'on trouve dans les manuscrits Oxford, Bodleian Libr., Bodley 614 (Angleterre, *c.* 1120–1140) et Oxford, Bodleian Libr., Digby 83, copié vers 1150 près de Winchester[140]. Tous trois contiennent les *Aratea* de Cicéron accompagnés de scholies. Le ms. Digby 83 contient en guise de livre IV la *Recensio interpolata* d'Hyginus mêlée à des extraits du *De natura rerum* d'Isidore de Séville, des *Scholia Sangermanensia* et de la

Philosophia mundi de Guillaume de Conches, avec le même type d'illustrations que les deux cycles attribués à Bède, le *De signis celi* et le *De ordine et positione stellarum*. Au f. 44r, on trouve un *Draco inter Arctos* à quatre boucles, la tête barbue, à deux cornes, orientée à gauche, avec les Ourses sortantes, dos à dos ; les étoiles sont marquées par des points dorés. Le ms. Bodley 614 contient aux f. 17r–34r le même livre IV de l'*Opusculum de ratione spere* avec les dessins de constellations. Au f. 34v du Bodley 614 et au f. 42v du Digby 83, on trouve le *De involutio spere*, inc. *Duo igitur sunt extremi vertices mundi quos polos appellauimus*[141], c'est-à-dire un texte qui a un incipit similaire à l'*Excerptum de astrologia Arati*. L'*Involutio spere* se trouvait dès le IXe siècle dans un manuscrit de Corbie (Paris, B.n.F. lat. 12957) qui offre le texte fondamental des *Scholia Sangermaniensia* et dans le manuscrit de Dresden, Landesbibl. Dc 183, f. 13, son jumeau (voir ci-dessous) ; dans les deux manuscrits, il accompagne le globe céleste reposant dans un temple à six colonnes et une copie de l'*Aratus* révisé[142].

Les manuscrits du *De ordine ac positione stellarum in signis* et le *Draco inter Arctos* (voir liste en annexe)

Dans le manuscrit autographe du *LF*, l'*Astrologia secundum Bedam*, commençant en bas du f. 94r sous le planisphère par *Duo extremi uertices*, et continuée f. 95, peut être identifiée comme on l'a vu avec le texte aratéen *Excerptum de astrologia*, assez souvent attribué à Bède, comme le fait Lambert de Saint-Omer. Au f. 95r, les noms de constellations dans le texte sont accompagnés de chiffres romains suscrits (*Serpens*[XV], *Corona*[VIII], *Boetes*[XIII], etc.) qui correspondent aux nombres d'étoiles que Lambert avait inscrits aussi primitivement dans le planisphère du f. 94r, là où il a ensuite gratté le dessin des constellations[143]. À moins de trouver dans un autre manuscrit un planisphère qui contienne ces chiffres, on peut attribuer ce transfert innovant au chanoine de Saint-Omer, qui a évité aussi de représenter les personnalisations ou animaux, se contentant des noms de constellations. Lambert a aussi fait courir des textes le long des cercles célestes, ce qui est le cas dans le célèbre planisphère de l'*Aratus* révisé du manuscrit Boulogne-sur-mer, B.M. 188, f. 30v, fait à Saint-Bertin

(comme dans son modèle de Leiden), mais pas dans la bonne vingtaine d'autres planisphères que j'ai pu examiner. Néanmoins, les textes-courants en question sont différents et le planisphère du *LF* n'est pas entouré du *zodiacus circulus* comme celui du f. 30 du manuscrit de Saint-Bertin actuellement à Boulogne. Ce dernier présente aussi au f. 20r une autre sphère céleste au centre de laquelle se trouve, comme dans celle du *LF*, le *Draco inter arctos*, mais ce planisphère-là n'a ni noms de constellations, ni chiffres... ceci permet de supposer que si Lambert a vu ce beau manuscrit dans l'abbaye voisine, il s'en sera inspiré avec beaucoup de liberté.

La comparaison avec les autres copies du *De ordine ac positione stellarum* met en évidence le fait que Lambert a sans conteste opéré ici une transposition graphique et bousculé la mise en page traditionnelle du cycle de constellations, en regroupant plusieurs notices de textes sur un même plan horizontal dans de petits encadrés, comme des auxiliaires à l'image et non l'inverse. Il a de ce fait parfois bouleversé

légèrement l'ordre des notices. L'économie de parchemin peut avoir joué dans cette réorganisation visuelle, qui n'est cependant pas une exception dans le *LF*, mais plutôt un parti-pris personnel de présentation.

Pour retrouver un manuscrit proche de celui qui fut le modèle de Lambert à Saint-Omer, et débrouiller les conditions d'émergence des deux opuscules, j'ai dressé en annexe une liste aussi complète que possible des copies du *De ordine ac p. st.*, accompagnées ou non de l'*Excerptum*. Cette liste ne saurait être exhaustive, car de nouvelles recherches peuvent toujours mettre au jour des témoins inconnus du *De ordine ac positione stellarum*, mais une fois dressée, elle permet de confronter les caractéristiques des vingt-huit manuscrits qui conservent le *De ordine et p. st.* à ce que nous savons du cahier astronomique du *LF*. Le tableau synoptique ci-dessous rend la comparaison plus aisée et met en évidence certains regroupements que j'ai pu repérer sur la base des caractéristiques typologiques mises en évidence et décrites.

Tableau comparatif des caractéristiques du *De ordine* dans les manuscrits

Mss	Date	Origine	*Aratea Aratus* révisé ou *Germanicus* ou *Scholia Basileensia*	Bède DNR, DTR ou autres	*Libri computi ou **L. calculationis	Hémisphère	Planisphère	Excerptum	De ordine, avec avec ou sans prologue	Variante priori ou primo	Illustré	Etoiles marquées	Draco inter arctos horizontal ou vertical	Ourses entrantes ou sortantes	Serpens seul après les Ourses	Ourses griffues	Liens avec d'autres mss
Vaticano, Reg. lat. 309	c. 859–860	Saint-Denis	/	Pacificus, *Spera celi* et Horologium Abbon de Fleury DNR DTR	*			X	X avec p.	*primo*	X	X araignées	Vertic. en S à 2 boucles, **tête en bas**	Sortantes, debout	/	/	**Paris lat. 12117**
Paris, B.n.F. lat. 12117	1060–1063	Saint-Germain	/	Pacificus, *Spera celi* et Horologium	*	/	/	X	X avec p.	*primo*	X	X araignées	Vertic. en S à 2 boucles, **tête en bas**	Sortantes, debout	/		Texte et image : **Vaticano, Regin. 309** Image : Augsburg, U.B., II.1.2° 110
Augsburg, U.B., II.1.2° 110	c. 1500	Augsburg?	/	/	/	/	/		X avec p.	*primo*	X	/	?	?	?	?	Paris, lat. 12117
Berlin, Phillipps 1869	2e quart 9e s.	Prüm puis Trèves 11e s.	/	DTR	?	/	/	X fin mutilée	X résumé, début, *sans* prol.	**priori**	/	/	/	/	–	–	*Liber floridus*
Madrid, B.N. 3307	c. 820	Murbach (Bischoff, Borst) / Metz (Ramirez) / Prüm puis Liège en 921 (Boschen)	/	(DNR)	*	1 hémisphère inachevé	/	X	X avec p.	**priori**	X	/	/		X *Serpens* vertic. 4 boucles **incliné**, barbu avec crête rouge orienté dr.	/	Monza, F. 9/176 **Vat. lat. 645**
Monza, Bibl. Capit. F. 9/176	c. 864	Lobbes? Rhénanie inf.	/	Priscianus De 12 signis	*	X	Sphère colorée	X	X avec p.	**priori**	X	/	/		X *serpens* vertic. 4 boucles, **incliné** orienté dr.	/	Madrid 3307 Vaticano, Vat. lat. 645 Iconogr. : Berlin, Phillipps 1832 Wien 12660
Vaticano, Vat. lat. 645	peut-être c. 845	Saint-Quentin en Vermandois (N. Fr.)	/	Priscianus de 12 signis	*	/ (perdu ?)	/	perdu	X (lacune en début)	**priori**	X	/	/	/	X *Serpens* vertic. 4 boucles barbu avec crête orienté dr.	X	**Madrid 3307** Monza, Bibl. Capit. F. 9/176 Berlin, Phillipps 1832

Mss	Date	Origine	Aratea Aratus révisé ou Germanicus ou Scholia Basileensia	Bède DNR, DTR ou autres	*Libri computi ou **L. calculationis	Hémisphères	Planisphère	Excerptum	De ordine, avec ou sans prologue	Variante priori ou primo	Illustré	Etoiles marquées	Draco inter arctos horizontal ou vertical	Ourses entrantes ou sortantes	Serpens seul après les Ourses	Ourses griffues	Liens avec d'autres mss
Berlin, Phillipps 1832	873?	Laon, donné à Metz c. 980	Germanicus + Sch. Basil.	DNR DTR	★★	/	X (Phillips 1830)	X	X avec p.	priori	X	/	/	/	X Serpens vertic. 4 boucles orienté dr.	/	Iconogr.: Madrid 3307 Monza F 9/176 Vat. Lat. 645
Freiburg, Bibl. des erzbischöfl. Ordinariats, 35 b	c. 850	Prüm ou Lotharingie (Reims?)	/	/	★ et ★★ et L. annalis	/	/	/	De signis celi	–	X	/	Vertic. 3 boucles, tête à l'envers à dr.; 3 points sur le corps, gueule en bec ouvert recourbé	U. maior renversée entrante, U. minor debout sortante	/	/	Iconogr. Montecassino, Archivio 3 (De signis celi) Vat. Lat. 645 Madrid 3307
Paris, lat. 12957	c. 810-840	Corbie	Aratus révisé + Sch. Sangerm.	Boèce De trinitate, glosé	/	X	Sphère temple	/	/	/	X Aratus révisé	/	Dans l'Aratus révisé : SERPENS INTER AMBAS ARCTUROS Vertic. 3 boucles, tête vue d'en haut	Entrantes, tête-bêche, dos-à-dos,	/	X Aratus révisé : U. maior et U. minor successives, orientées à g.	Dresden, Dc. 183 D^I St.-Gallen 250
Dresden, Sächsische Landesb., Dc. 183	Après 850	N-O France	D^I Aratus révisé + Sch. Sangerm.	D^I Priscianus de 12 signis Hygin	/	X D^I	Sphère temple Zodiacus circulus (vota)	X D^I X D^II	X D^II avec p.	D^II priori	X D^I Aratus rév. D^II numérotation des notices	/	D^I Aratus révisé : SERPENS INTER AMBAS ARCTUROS Vertic. 3 boucles, tête vue d'en haut	Entrantes, tête-bêche, dos-à-dos, U. maior vers la dr., U. minor vers la g.	D^II /	X Aratus révisé : U. maior et U. minor successives, orientées à g.	D^I St-Gallen 250 D^I Paris, lat. 12957 Paris, n.a.l. 1614 D^II Einsiedeln 178 München 4423
St.-Gallen, Stiftsbibl. 250	4/4 9e s.	St.-Gallen	Aratus révisé + Sch. Sangerm.	Hygin	/	x	Sphère temple, Zodiacus circulus	X à la fin devant Hygin	/	/	X Aratus révisé	X	Aratus révisé, 3 boucles, tête de profil, cornes fines, langue fourchue à 3 points, 4e boucle ondulée, dos cranté	Entrantes, tête-bêche, dos-à-dos, U. maior vers la dr., U. minor vers la g.	/	X Aratus révisé : U. maior et U. minor successives, orientées à g.	Paris, lat. 12957 Dresden Dc. 183

Mss	Date	Origine	Aratea Aratus révisé ou Germanicus ou Scholia Basileensia	Bède DNR, DTR ou autres	*Libri computi ou **L. calculationis	Hémisphères	Planisphère	Excerptum	De ordine, avec ou sans prologue	Variante priori ou primo	Illustré	Etoiles marquées	Draco inter arctos horizontal ou vertical	Ourses entrantes ou sortantes	Serpens seul après les Ourses	Ourses griffues	Liens avec d'autres mss
Paris, B.n.F., nouv. acq. lat. 1614	Après 825	Saint-Martin de Tours	Aratus révisé	Arithmétique Boèce	/	X	X (découpé)	X	X avec p	priore	X	X croix	Aratus révisé : SERPENS INTER AMBAS ARCTUROS très incliné à 5 boucles, 2 cornes, bec ouvert recourbé	Sortantes, tête-bêche	X De ordine : Serpent barbu avec col, très incliné, personnalisé, longue queue ondulée, langue à branches multiples	X Aratus révisé : U. maior et U. minor successives, orientées à g. X De ordine : U. maior orientée à dr., U. minor orientée à g.	Dresden Dd 183 Paris, lat. 12957
Austin, Univ. Texas, HRC 29	2e quart 11e s.	Tegernsee (et liens avec Fleury)	/	DNR Calcidius Priscianus de 12 signis	/	/	X	X	X avec p	priori	X	/	/	--	X Serpens vertic. à crête, barbu, 4 boucles, langue à 3 branches	X U. maior orientée à dr., U. minor orientée à g.	St-Gallen, 250 Wien 12600 St. Petersburg, lat. Q.v.IX, 2
Saint-Petersburg, lat. Q.v.IX, 2	c. 1100	Suisse ou N. Italie	--	--	--	--	--	/	X avec p	priori	X	/	/	--	X Serpens vertic. chevelu barbu, 3 boucles, à longue queue ondulée	X U. maior orientée à dr., U. minor orientée à g.	Austin HRC 29 St-Gallen 250
Einsiedeln, Stiftsb. 178	3e quart 9e s.	Einsiedeln	De astronomia Arati anonymi Sangallensis	DNR DTR Priscianus de 12 signis	/	/	/	X	X avec p	priori	/	--	--	--	--		(St-Gallen 250) München 4423 Dresden, Dc 183 Wien 12600
München, BSB, Clm 4423	a. 1481	Abbaye de Mondsee	De astronomia Arati anonymi Sangallensis	Priscianus De 12 signis	/	/	/	X	X avec p	priori	/	--	--	--	--	--	Texte : Einsiedeln 178 Wien 12600
Wien, Ö.N.B., 12600	c. 1130 ou dernier ¼ 12e s.	Prüfening près de Regensburg	De astronomia Arati anonymi Sangallensis	Priscianus De 12 signis	*	/	/	X	X en 3 colonnes avec p	priori	X	X	/	/	X Serpens incliné 4 boucles, barbu et avec une crête	X	Texte : München 4423 Einsiedeln 178

Mss	Date	Origine	Aratea Aratus révisé ou Germanicus ou Scholia Basileensia	Bède DNR, DTR ou autres	*Libri computi ou **L. calculationis	Hémisphères	Planisphère	Excerptum	De ordine, avec ou sans prologue	Variante priori ou primo	Illustré	Etoiles marquées	Draco inter arctos horizontal ou vertical	Ourses entrantes ou sortantes	Serpens seul après les Ourses	Ourses griffues	Liens avec d'autres mss
Paris, B.n.F. lat. 8663	c. 1000	Fleury? ou Suisse (écriture)	/	Hygin Macrobe Sphère d'Apulée Textes musicaux	/	/	/	/	X avec p.	priori	X	?	Horiz. Tête vers le bas, à 3 boucles, tête barbue avec col.	Entrantes, tête-bêche	/	X dressées sur leurs pattes arrières	Los Angeles, Ludwig XII.5 (serpent à col) Drao horiz. ourses dressées comme Basel, UB. An. IV 18.f. 14 (Sch. Basileensia) Texte: München 210 Wien 387
Los Angeles, Getty Museum, Ludwig XII.5	Déb. 13e s.	Sud Angleterre	/	Abbon de Fleury Sphère d'Apulée	/	/	/	X abrégé	X avec p. abrégé; jusque Lepus	priori	X	X oranges 3 traits croisés	Horiz. à 2 boucles, orienté à dr., avec col, étoiles oranges	Entrantes, tête-bêche	X	Seulement la dernière patte de l'U. maior	Iconogr. Groupe «V» Paris lat. 8663 Drao horiz. comme Basel, UB. An. IV 18. f. 14 (Sch. Basileensia)
Reykjavik, Stofnun Árna Magnússonar, GKS 1812 4to	14e s.	Angleterre ou Islande	/		/	/	/	X en islandais	X sans prol.	--	x	X	/		/	/	Los Angeles, Ludwig XII.5
München, Clm 210	c. 818	Salzburg	/	/	**	/	X Draco inter Arctos à 3 boucles Ourses entrantes	X	X avec p.	priori	X	X oranges 5/6 branches fines	/		X serpens vertic. 4 boucles, incliné, bec ouvert	/	Wien 387
Wien, Ö.N.B., 387	818	Sankt Peter, Salzburg	/	DNR	**	/	/	X	X avec p. sans IX–XVIII	priori	X	X	/		Serpens vertic. 4 boucles, incliné, à bec ouvert	/	München 210
Paris, B.n.F., n.a.l. 176	c. 1300	France	/	Theorica planetarum	/	/	/	X sur 2 colonnes	X avec p.	priori	(x) prévues, pas réalisées	--	--	--	--	--	
Basel, U.B., F III 15h	c. 1400	France	/	Isidore, Etym.	/			X	X sans prol., termine avec capricornus	priori	/	--	--	--	--	--	

Mss	Date	Origine	Aratea Aratus révisé ou Germanicus ou Scholia Basileensia	Bède DNR, DTR ou autres	*Libri computi ou **L. calculationis	Hémisphères	Planisphère	Excerptum	De ordine, avec ou sans prologue	Variante priori ou primo	Illustré	Etoiles marquées	Draco inter arctos horizontal ou vertical	Ourses entrantes ou sortantes	Serpens seul après les Ourses	Ourses griffues	Liens avec d'autres mss
Augsburg, St.Bibl. 8° Cod. 143	15e s.	Augsburg?	?	?	?	?	?	?	X avec p.	?	X	?	?	?	?	?	?
Firenze, B.N. Centr., Magl.VIII 53	c. 1465	Florence	?	?	Macrobe De mensura terre et solis et autres c. du livre V des Libri computi	/	/	X	X avec p. Résumé, termine sur piscis magnus	/	/		/	/	/	/	
Montpellier, Ecole méd., H 334	2e moitié 9e s.	Loire?	/	Hygin	*	/	/	X	X, avec p. 6 lignes	–	/	–	–	–	–	–	
Berlin, Phillipps 1845	Avant 1472	A appartenu à l'abb. des Dunes	Compendium historiarum Trogi Pompei.	/	/	/	/	X	X, avec p. et début 1e notice	priori	/	–	–	–	–	–	
Metz, B.M. 271	?	?	?	?	?	?	X	?	X	?	/	?	?	?	?	?	

Comparaison textuelle et iconographique des copies du *De ordine* avec celle du *Liber floridus*

L'examen du texte du *De ordine et positione stellarum* devrait permettre d'ajouter des arguments discriminants pour se rapprocher de manuscrits apparentés au modèle du *LF*. La comparaison avec les éditions du *De ordine* par A. Dell'Era, « Una "caeli descriptio" » en 1974 et par A. Borst, *Schriften zur Komputistik*, en 2006 fait apparaître des différences considérables avec les manuscrits collationnés dans ces éditions[144] : la version du *LF* présente de nombreuses omissions ou abréviations, tout en intégrant de temps à autre ce qui semble être des gloses explicatives (*hoc est…*), ce qui l'éloigne assez nettement des autres manuscrits. Pour donner un exemple de variante, dans la deuxième notice, *Cynosura*, le *LF* a *Sub his Polus apparet, circum quod sydus totus orbis uerti putatur*, là où les autres ont les mots dans l'ordre suivant : *Sub his apparet sidus, quod uocatur Polus, circum quod putatur totus orbis uerti*. Néanmoins, il est parfois possible de le rapprocher des manuscrits Dresden, Dc 183, Augsburg U.B., II. 1. 2° 110, Paris, B.n.F., n.a.l. 1614 et Wien, Ö.N.B. 12600. Le *LF* a des omissions propres, qui peuvent être dues à sa volonté d'abréviation, comme l'omission du passage *id est aquilonalis* dans la notice *Pisces*, après *borius*. On peut remarquer aussi qu'il omet des passages édités en caractères italiques dans Dell'Era (éd. 1974, p. 11) qui soulignait ainsi qu'ils étaient des ajouts du *De ordine* par rapport aux *Scholia Basileensia* qui constituent sa source. Est-ce à dire que le *LF* est plus proche d'une version primitive du *De ordine* ? Ainsi, dans la notice *Hercules*, le *LF* omet *qui est in geniculo dicitur*, comme le font les manuscrits Berlin, Phillipps 1869, originaire de Prüm au IXe siècle, et Augsburg II. 1. 2° 110. Parmi les omissions, Lambert omet le plus souvent l'adjectif « *claram* » ou les autres précisions de luminosité (*obscuras*) pour qualifier l'étoile dont il est question, ce qui est souvent le cas aussi, quoique moins fréquemment, dans le ms. Phillipps 1869. Avec celui-ci, le *LF* partage d'autres omissions[145], comme dans la notice *Equus*, l'omission *de quem et de uocant* dans « *Equus, quem Pegasum uocant* ». Une autre caractéristique commune de leurs textes est de ne pas présenter le prologue du *De ordine*. Malheureusement,

le ms. Phillipps 1869 n'est pas illustré, ce qui limite gravement les comparaisons.

Par ailleurs, le *LF* conserve aussi des portions de texte qui ont disparu dans le *Liber calculationis* (comput en trois livres). Par exemple, les manuscrits München, Clm 210[146], Wien, Ö.N.B. 387 et Paris, lat. 8663 omettent dans la notice *Perseus* le bout de phrase *circa caput Gorgonis claras III*, que le *LF* conserve, alors qu'il omet comme eux la phrase suivante, *Caput autem et harpe singulis stellis notata sunt*.

Dix copies du *De ordine* sur vingt-huit ne sont pas illustrées ; certaines pourraient témoigner d'un état précoce du texte où il n'avait pas encore emprunté ses illustrations à un autre cycle aratéen (comme Einsiedeln 178 et München 4423), d'autres trahissent la décision de leurs copistes d'en éliminer les dessins (pour les *recentiores*) ou l'absence de temps pour les réaliser (comme Paris, n.a.l. 176). A part le Phillipps 1869, les plus anciennes copies du *De ordine* sont cependant illustrées ; une partie d'entres elles est constituée des « encyclopédies computistiques » carolingiennes, comme

Fig. 8. Madrid, Biblioteca Nacional, 3307, f. 54v, Metz ou Murbach, *c.* 830 : *Libri computi* ou *Aachener Enzyklopädie* en sept livres : *Ursa maior, Ursa minor, Serpens*, séparés

dans Madrid, Bibl. Nac. 3307 conservant les *Libri computi*, et München, Clm 210 daté de 818 et conservant le *Liber calculationis*.

L'examen des images des premières constellations du cycle mène au constat qu'il s'y trouve deux types de représentation du *Serpent* et des Ourses, selon les cas : soit le *Draco inter Arctos* – c'est-à-dire la figure combinée des trois constellations –, soit le *Serpent* et les deux Ourses séparés les uns des autres, précédant ou suivant respectivement les notices qui les concernent. Ce deuxième cas se rencontre dans ce qui est considéré comme la meilleure copie des *Libri computi* en sept livres, copiée à Metz ou à Murbach pour l'évêque Drogon vers 830, le ms. Madrid, Bibl. nac. 3307, f. 54v–55r (Fig. 8) ; c'est aussi le cas dans les exemplaires de Berlin, Phillipps 1832 et de Città del Vaticano, Vat. lat. 645[147]. Il en va de même dans le *Liber calculationis* en trois livres, c'est-à-dire dans les copies quasiment contemporaines l'une de l'autre des manuscrits München, Clm 210 et Wien, Ö.N.B. 387. L'abbé Arn de Salzburg était un abbé double qui dirigeait deux abbayes, à Saint-Amand près de Tournai et à Salzbourg. Le ms. Wien 387 peut donc a priori avoir été copié à Salzburg comme à Saint-Amand dans le nord de la France. Dans le second cas, il serait plus susceptible d'être proche d'un manuscrit utilisé par Lambert. Cependant, outre le fait que l'iconographie diffère, d'une manière générale, le texte du *De ordine* dans le *LF* ne se rapproche pas particulièrement de celui des manuscrits Madrid 3307 et Wien 387.

Treize manuscrits marqués d'un ou deux astérisques dans la liste en annexe contiennent une de ces deux encyclopédies computistiques carolingiennes comprenant les chapitres du livre V des *Libri computi*, précédés d'un planisphère[148]. Le début de cette séquence, observé dans le *LF*, à savoir le *Planisphère*, l'*Excerptus* (V 1) et le *De ordine* (V 2), pourrait indiquer que Lambert a pu se servir d'un manuscrit contenant ces compendia. Cependant, comme on vient de le voir, contrairement au *LF*, les manuscrits typiques de ces encyclopédies computistiques ne présentent pas le *Draco inter arctos*, mais les notices successives de l'*Helice*, de la *cinosura* et du *Serpens* avec leurs dessins respectifs (c'est-à-dire avec le *serpens* seul).

Il y a pourtant une paire de manuscrits des *Libri computi* qui diffère des autres et qui sont sans conteste directement apparentés l'un à l'autre iconographiquement : le Vaticano, Reg. lat. 309 (*Draco inter Arctos* au f. 91v) et le Paris, lat. 12117 (*Draco inter Arctos* f. 131r). Le premier est un des plus « purs » exemples des *Libri computi* d'Aix[149], copié à Saint-Denis vers 859–860, et le second fut copié à Saint-Germain en 1060–1063 (Fig. 14 et 11). Ces deux manuscrits présentent en début du *De ordine* un dessin du *Draco inter arctos*, qui plus est en forme de S à deux boucles, avec les ourses debout et sortantes, comme dans le *LF*, à la différence près que le serpent s'y présente tête en bas et que les étoiles sont figurées sur son corps par des croix. On observe aussi au f. 92r du ms. Reg. lat. 309 que la couronne est dessinée comme dans le *LF*, c'est-à-dire qu'elle est ornée de huit étoiles semblables à des soleils. Ces deux manuscrits ont cependant tous les deux la particularité de porter, dans la première notice *Helice*, la variante *primo*, au lieu de la forme beaucoup plus courante *priori* qu'ont – comme le *LF* – tous les autres à l'exception du ms. Augsburg, U.B. II. 1. 2° 110. Ce dernier pourrait de ce fait être le parent de Reg. lat. 309 et Paris, lat. 12117. Ces deux manuscrits présentent à la fois l'*Excerptum*, le *De ordine*, et le poème *De spera celi* de Pacificus de Vérone qu'on trouve parfois dans des manuscrits contenant l'autre cycle de constellations attribué à Bède, le *De signis celi* ; en revanche, ils n'ont pas la carte du ciel qui précède ces textes dans des manuscrits contenant l'Aratus révisé.

Les manuscrits qui témoignent d'une circulation du *De ordine ac positione stellarum* en dehors des deux collections des *Libri computi* et du *Liber calculationis* révèlent d'autres similarités avec le *LF*. Ainsi, le manuscrit conservé à Austin au Texas, HRC 29, présente la même séquence planisphère – *Excerptum* – *De ordine*. Il fut glosé par l'abbé Ellinger à Niederaltaich près de Tegernsee dans le deuxième quart du XIe siècle. Après une copie glosée du *De natura rerum* de Bède et la traduction de Calcidius du *Timée* de Platon, il contient sur un même feuillet le texte de l'*Excerptum* commençant par *Duo extremi uertices mundi quos appelant* (*appellamus* dans *LF*) *polos*, à côté du planisphère (inachevé), où le Serpent est la seule constellation représentée au centre des cercles planétaires, du Zodiaque et de l'écliptique (Fig. 9). Suit le *De ordine ac p. st.* illustré. Le *De ordine*

Fig. 9. Austin, University of Texas, Harry Ransom Humanities Research Center HRC 29, f. 25v,
2ᵉ quart du XIᵉ siècle, glosé par l'abbé Ellinger au monastère de Niederaltaich près de Tegernsee :
Planisphère inachevé avec *Draco* à côté de l'*Excerptum*

ne commence pas par la représentation du
Draco inter Arctos, mais, comme dans les ency-
clopédies computistiques, il présente successi-
vement les notices *helice, cinosura, Serpens* avec
les dessins correspondants de la Grande et de
la Petite Ourse, puis du Serpent.

La plupart des manuscrits les plus anciens du
De ordine se répartissent grosso modo en deux
zones géographiques, du Nord au Sud de la
Lotharingie : le nord de la Lotharingie (France
du Nord-Picardie ou Belgique francophone
actuelles) région qui comprend Saint-Omer,
et la région alémanique au Nord de l'Italie,
une aire couvrant l'Alsace, la Suisse, l'Autriche
et la Bavière actuelles ; on soulignera que
le ms. Phillipps 1869 se situe quant à lui à
Prüm, entre Trèves et Aix-la-Chapelle. L'his-
toriographie, en particulier depuis les travaux
de Le Bourdellès, s'entend à situer l'origine
des deux cycles de constellations du pseudo-
Bède à Corbie au Nord-ouest de la France.
Cette localisation est à mettre en rapport
avec l'importance que prennent, pour notre
propos, deux manuscrits très proches l'un de
l'autre contenant l'Aratus révisé et les *Scholia*

Sangermanensia sans le *De ordine* : le Paris, lat.
12957, fait à Corbie *c.* 810–840 et conservé
ensuite à Saint-Germain, et le Sankt-Gallen
250, copié dans l'abbaye suisse dans le der-
nier quart du IXᵉ siècle[150]. Ils présentent tout
à fait la même iconographie que le manus-
crit Dresden Dc 183, qui pour sa part ajoute
à l'Aratus révisé le *De ordine*. Tous les trois ont
à la fois le dessin des deux hémisphères, le
planisphère, la sphère portée par les sept co-
lonnes d'un temple, et dans l'Aratus révisé les
caractéristiques identiques du dessin du *Draco
inter arctos*, en plus de l'inscription en capitales
« *Serpens inter ambas arcturos* ». L'hypothèse d'un
glissement iconographique de l'Aratus révisé
vers le *De ordine* de tout l'apparat iconogra-
phique me paraît donc la plus plausible. De
la même manière, l'inscription « *Serpens inter
ambas arcturos* » semble attirer l'attention sur le
fait que le cycle de constellations ne devait pas
originellement porter cette figure combinée
du Serpent et des Ourses mais qu'elle a été
introduite par une initiative volontaire.

Ce manuscrit de Dresden, malheureuse-
ment très endommagé et mutilé aujourd'hui,

semble témoigner de la genèse du *De ordine*, avant qu'il n'emprunte ses illustrations aux *Scholia Sangermanensia*. Ce qu'on a appelé les *Scholia Sangermanensia*, c'est-à-dire le texte de l'Aratus révisé, mais sous forme de scholies, se trouve précisément dans le ms. Paris, lat. 12957. Pour la partie astronomique, la composition des textes comme l'iconographie de ce manuscrit (du f. 57r au f. 74v), sont extrêmement proches du manuscrit de Dresden. En particulier, le *Draco inter Arctos*, f. 64v, avec la tête vue d'en haut, dotée de 2 yeux, est tout à fait semblable à celui de l'Aratus révisé dans le ms. de Dresden, f. 15r. Maass considère le manuscrit de Dresden comme *« fere gemellus »*[151] du Sankt-Gallen, Stiftsbibl. 250, à la différence près que ce dernier n'a pas copié les vers de Priscianus Grammaticus ni la première version de l'*Excerptum* qui les suit dans le manuscrit de Dresden. À partir de la neuvième entité, p. 447 et suivantes, le manuscrit de Saint-Gall est semblable pour la copie de l'Aratus et des textes associés (*Incipit astrologia. Arati ea quae videntur. Ostensionem quoque de quibus uidentur oportet fieri*). Entre autres, à la p. 462, on trouve le dessin des deux hémisphères ; à la p. 472, est tracé le dessin de la sphère céleste supportée par des colonnes dans un temple, puis p. 473, la copie de l'Aratus latin dans la *recensio interpolata*, Inc. *Vertices extremos*. P. 474 se présente le dessin de l'*Arctus minor*, et p. 475, celui de la grande Ourse (*Helix*). P. 476, le *Draco inter Arctos* à trois boucles (Fig. 10), cette fois avec la tête *de profil*, comme c'est plus usuel (et comme dans le *LF*), dotée de deux fines cornes en arrière, et la langue fourchue à trois pointes ; les étoiles, en forme de petits ronds comme dans le *LF*, sont placées à l'encre orange sur le corps, qui se termine par une nouvelle et quatrième boucle ondulante, à nouveau comme dans le *LF*. Le dos du serpent est cranté comme dans le *LF*, mais il est aussi marqué d'une ligne de petits points. P. 525 se trouve l'*Excerptum* (*Excerptio de astrologia*), avant *Hyginus M. Fabio* (f. 540 *sq.*).

Une autre copie de l'Aratus révisé illustré est liée aux manuscrits qui viennent d'être examinés : le ms. Paris, B.n.F., n.a.l. 1614, peut-être copié à Tours après 825 et provenant de l'ouest de la France. L'illustrateur, très maladroit, a représenté le serpent de manière un peu oblique, avec quatre boucles, avec les *Ursae* sortantes et la tête de profil dotée de deux

Fig. 10. Sankt-Gallen, Stiftsbibliothek, Cod. Sangallensis 250, p. 476, Saint-Gall, 4e quart IXe s.: *Scholia Sangermanensia*, avec *Draco inter Arctos* à trois boucles, à fines cornes et langue fourchue et longue queue ondulée

cornes, sans langue, comme dans le *LF*. Les étoiles ne figurent plus sur le serpent dans ce dessin rapidement tracé, et l'échine du serpent n'est pas crantée, montrant que le copiste s'est éloigné de son modèle. Le ms. contient l'*Excerptum de astrologia* au f. 93v, après les mots *« Explicit liber astrologorum »*, comme dans les manuscrits Sankt-Gallen 250, Paris, lat. 12957 et Dresden, Dc 183. Ce qui était le planiphère a été découpé (gros trou rond) au f. 94v. Le *De ordine ac positione stellarum* illustré est au f. 95r et *sq.*, avec les Ourses et le serpent séparés et successifs. Les étoiles sont représentées par des petites croix sur chacun des dessins des constellations. Bien que les dessins en soient très maladroits, le manuscrit se rapproche iconographiquement du modèle du *LF*.

Les Ourses « sortant » des boucles du serpent, qui distinguent le Paris, n.a.l. 1614 des manuscrits qui lui sont apparentés, est une caractéristique iconographique des *Aratea* de Germanicus, type « Z », dont l'abbaye de Saint-Bertin à Saint-Omer a possédé non moins de trois exemplaires illustrés ; parmi eux, le plus célèbre, le ms. Leiden, Universiteitsbibl., Voss. Lat. Qu. 79, f. 3v (*ex-libris* de Saint-Bertin au XIVe s.), fait probablement à Aachen (sinon ailleurs en Lotharingie) en 816, c'est-à-dire dans la foulée des *Libri computi* et du *Liber calculationis*. Ce manuscrit a fait l'objet à Saint-Bertin de deux copies, l'une *c.* 1000 sous l'abbé Otbert dans le ms. Boulogne-sur-Mer, B.M. 188, qui est resté longtemps à Saint-Bertin[152], l'autre dans le ms. Bern, Bürgerbibl. 88 qui

Fig. 11. Boulogne-sur-Mer, B.M. 188, f. 20v, Saint-Bertin, x^e siècle : *Aratea* avec *Draco inter Arctos* barbu avec crête

a été offert à la cathédrale de Salzbourg par l'évêque Werner de Strasbourg (1001–1028) ; il est connu pour reprendre des modèles carolingiens mais a semble-t-il été copié sur celui de Boulogne. Cependant, dans ces manuscrits des *Aratea*, le «S» du serpent, et les Ourses, sont retournés en miroir, l'Ourse du haut étant orientée à gauche, et l'Ourse du bas *renversée* et orientée à droite, dressées toutes deux sur leurs pattes arrière (Fig. 11, Boulogne-sur-Mer, f. 20v), alors que dans le *LF*, le serpent forme un S à l'endroit et les Ourses sont toutes les deux *debout*, celle du haut orientée à droite, celle du bas à gauche. On peut néanmoins supposer une influence de cette représentation sur le travail d'illustrateur de Lambert de Saint-Omer, donnant lieu à une certaine hybridation de ses dessins. Cette hybridation explique aussi qu'on ne puisse trouver aucune copie du *De ordine* qui présentât tout à fait la même iconographie que le *LF* pour le *Draco inter Arctos*.

Dans les manuscrits Paris, B.n.F. lat. 8663, originaire de Fleury ou Tours *c.* 1000 (mais provenant de Fleury), et Los Angeles, Getty Museum, Ludwig XII.5, probablement originaire du sud de l'Angleterre (Worcester ?) au début du xiii^e siècle, le *Draco inter Arctos* apparaît non dressé mais horizontal, et placé à la suite des dessins respectifs des deux *Ursae* ; il est à trois boucles dans le ms. de Paris 8663, f. 20r

(*Draco barbatus*, avec échine à points) (Fig. 12), comme dans les copies du *De signis celi*, et horizontal à deux boucles dans le ms. de Los Angeles, f. 149v (*Draco* à dents, avec un col). Dans les deux cas, les Ourses sont entrantes, alors qu'elles sont *sortantes* dans le *LF*.

L'enquête ne saurait être tout à fait complète sans une comparaison serrée avec l'iconographie du *De signis celi* ; il n'est pas possible de la mener dans le cadre de la présente étude. Or, en plus des similitudes originelles, il existe des interférences iconographiques entre les deux cycles et dans leur environnement. En voici quelques exemples. Le *De duodecim signis* (inc. *Ad Boree partes*) accompagne les manuscrits de l'Aratus révisé qui forment un groupe autour du Sankt-Gallen, Stiftsbibl. 250 (Dresden, Sächsische Landesbibl. Dc 183 ; Einsiedeln, Stiftb. 178 ; München, BSB, Clm 4423 ; Wien, Ö.NB., 12600, etc.) qui a donné lieu aux copies du *De ordine ac positione stellarum in signis*, mais on trouve aussi ce petit texte sur les douze signes dans des manuscrits du *De signis celi*. Le manuscrit Freiburg, Bibliothek des erzbischöflichen Ordinariats, 35 b, contient le *De signis celi* avec les illustrations du *De ordine*. Le ms. Paris, B.n.F. lat. 13013, originaire de Saint-Germain[153], qui conserve le *De signis celi*, présente au f. 20r, après le texte du pseudo-Priscien (Ausonius) *Ad Boree partes*, un *Zodiacus circulus* comparable à la *rota* qui se trouve

Fig. 12. Paris, B.n.F., latin 8663, f. 20r, Val de Loire, voisinage de Fleury, *c.* 1000 : *De ordine et positione stellarum*, avec *Draco inter Arctos* horizontal, après les notices *Helice* et *Cinosura*, illustrées des Ourses dressées sur les pattes arrière

dans le ms. Dresden Dc 183, qui contient le *De ordine*, ou à celui du ms. Sankt-Gallen 250 (très ressemblant au ms. de Dresden, mais contenant l'*Aratus* révisé). Dans le ms. Paris 13013, le centre de la *rota* du Zodiaque n'est pas ornée du Soleil et de la Lune personnalisés, mais du *Draco inter Arctos* en S, avec les Ourses sortantes, tête-bêche, dos-à-dos. Cette image centrale rappelle le premier motif du *De ordine* dans les deux manuscrits voisins des *libri computi*, Vaticano, Reg. lat. 309 et Paris 12117 (ourses sortantes, debout), copiés respectivement à Saint-Denis et à Saint-Germain ; elle rappelle aussi le motif tel qu'il est dessiné dans le *LF* (ourses sortantes, debout).

Conclusion

Lors de la confection, toujours reprise, de son album coloré, Lambert a probablement introduit Macrobe en même temps que la matière aratéenne, à savoir le planisphère,

l'*Excerptum* et le *De ordine ac positione stellarum in signis*, qui font partie du cahier XII astronomique ; les mêmes sources se trouvaient dès le ixe siècle dans les compilations astronomiques et computistiques carolingiennes. Celles-ci comportaient souvent un dernier livre constitué du *De natura rerum* de Bède ; or, dans le *LF*, toute la partie naturaliste tirée de Bède – notamment la roue des vents, les notes sur le tonnerre et les tremblements de terre –, comme celle extraite du *De computo* d'Hilpéric copiée sur les f. 24–27, ont fait partie d'une campagne de collecte antérieure. En outre, Lambert a adapté l'objet au support matériel : il a rangé horizontalement trois par trois les notices du *De ordine*, il a modifié le planisphère qui se trouvait avant l'*Excerptum* et y a effacé, comme l'a montré A. Derolez, les configurations des constellations dont il n'a tracé que le nom et le nombre d'étoiles[154]. Il a peut-être aussi fait sauter le paragraphe de prologue, à moins que son modèle en ait déjà manqué, à l'instar du ms. Berlin, Phillipps 1869 originaire de Prüm, dont j'ai montré qu'il est, en l'état actuel des choses, le texte du *De ordine* le plus proche de celui du *LF*, tout en gardant des variantes significatives.

Au sein de ce cahier astronomique, le *LF* présente sans aucun doute un témoin important du cycle de constellations illustré du *De ordine ac positione stellarum*, dont j'ai dénombré vingt-huit manuscrits en-dehors des dix copies de la version du *LF*. Quel était son modèle ? Les *Libri computi* du ms. Vaticano, Reg. lat. 309, originaire de Saint-Denis, et de son cousin français Paris, B.n.F. lat. 12117, fait à Saint-Germain – même s'ils ont la variante *primo* et non *priori* comme la plupart des manuscrits et le *LF* dans la copie du *De ordine* –, présentent l'iconographie du *Draco inter Ursas* la plus proche de celle du *LF* : une forme en S avec Ourses debout, «sortantes». Cependant, dans cette figure, il manquait des éléments caractéristiques : la quatrième boucle du serpent, le dos cranté et la gueule ouverte qu'on retrouve ensemble dans des manuscrits français de l'*Aratus* latin révisé qui contiennent en outre le planisphère, l'*Excerptum*, et le texte du *De ordine* doté de la «bonne» variante *priori*, comme dans le ms. Paris, B.n.F. n.a.l. 1614 originaire de Tours après 825.

En toute hypothèse, le modèle du *De ordine* de Lambert devait se trouver dans le Nord

de la France et, si la théorie de Le Bourdellès d'une émergence à Corbie à l'époque de la confection des encyclopédies computistiques carolingiennes est exacte, il dépendait d'un modèle carolingien produit à Corbie, comprenant au moins les trois premiers chapitres de ce qui est devenu le « livre V » des *Libri computi* : le planisphère, l'*Excerptum*, et le *De ordine*. Dans les manuscrits présentant une telle configuration, le ms. Paris, n.a.l. 1614 est d'une part apparenté au ms. de Corbie de l'*Aratus* révisé avec les *Scholia Sangermanensia*, Paris, B.n.F. lat. 12957, qui est jumeau iconographique du Dresden, Landesbibl. Dc 183 (qui conserve deux fois le *De ordine*), et d'autre part il est étroitement lié au ms. Sankt-Gallen, Stiftsbibl. 250. Ce dernier présente un *Draco inter Arctos* dont la forme rappelle celui du *LF*.

Le modèle de Lambert se situait donc entre un manuscrit de l'Aratus révisé illustré (comme celui du manuscrit Sankt-Gallen, Stiftsbibl. 250), auquel a été ajouté le texte des *Scholia Basileensia* pour former le *De ordine*, et un manuscrit du Nord de la France proche du Reg. lat. 309 ou du lat. 12117, avec un *De ordine* illustré indépendant. Cela signifie que son état de texte était vraisemblablement proche de la genèse du texte du *De ordine* au début du IX^e siècle, avant, ou à l'époque où, il a été intégré aux *Libri computi*.

À la recherche d'indices supplémentaires pouvant mener au modèle du *De ordine* dans le *LF*, j'ai observé l'iconographie du *Draco inter Arctos*, et montré que celle du *Liber* ne correspondait pas à celle du *De signis celi*, avec les illustrations de la classe I, tirées d'un modèle tardo-antique, comme dans le ms. Dijon, B.M. 448 (probablement diocèse de Toul, *c.* 1054), où le f. 64v présente un *Draco inter Arctos* à trois boucles. Les manuscrits de la classe II carolingienne, très proches iconographiquement de ceux qui contiennent le *Liber Nemroth* dont des copies circulent avec le *De signis celi*, ne peuvent pas davantage être rapprochés des dessins du *LF*[155]. En revanche, les *Aratea* de Germanicus constituent un contexte où se trouve un *Draco inter Arctos* qui ressemble davantage à celui de Saint-Omer. C'est le cas dans les plus beaux manuscrits de la famille *Z*, issus de l'abbaye toute proche de Saint-Bertin : le manuscrit Boulogne, B.M. 188 (qui présente un Serpent à trois boucles et des Ourses *sortantes* au f. 20r), à partir duquel a été copié

le ms. Bern, Burgerbibl., cod. 88, f. 1v–7v. Pourtant, s'il a pu voir l'un de ces manuscrits à Saint-Bertin, rien n'indique que Lambert ait emprunté quoi que ce soit d'autre à ces merveilleuses illustrations-là. D'ailleurs, le *De ordine ac positione stellarum* relève de la famille *O* du commentaire à Germanicus, bien que l'archétype de cette famille ait vu ses illustrations modifiées ou substituées pour certaines par contamination avec une autre tradition.

En termes de réseau intellectuel, Anselme de Canterbury, Yves de Chartres, Honorius Augustodunensis, étaient proches, ou furent même en contact avec Saint-Omer, sans qu'un véritable partage de documentation avec le chanoine Lambert puisse être mis en évidence dans l'œuvre très personnelle de celui-ci. De même pour les sources astronomiques, on pourrait supposer un lien avec l'enseignement vivant d'Odon de Tournai, que Lambert aurait pu fréquenter, mais les indices éventuels qu'il aurait laissés ne sont pas évidents. La question reste à explorer, car les sources du *LF* sont loin encore d'avoir livré tous leurs secrets. Il est certain en tous cas qu'il faut compter avec une grande part de « transposition créative » chez Lambert de Saint-Omer.

Du point de vue encyclopédique, Léopold Delisle avait parlé du *LF* comme d'une « compilation tout à fait désordonnée », « assez bizarre »[156] ; quant à Yves Lefèvre, qui avait longuement étudié l'*Elucidarium* d'Honorius, il avait affirmé que c'était « la vitrine d'un collectionneur », car Lambert y a recueilli tout ce qu'il avait pu accumuler, dans une séquence de 190 petits traités qui n'a jamais beaucoup servi. Ces constats expliquent le destin d'un « livre fleuri » ou d'un florilège conçu longuement par un chanoine d'un certain âge et à l'ancrage local fort ; mais ils sont trop sévères car ils font peu de cas du rôle de l'image : l'œuvre a bien été conçue comme une encyclopédie illustrée. Lambert est intervenu sur les dessins comme dans la découpe des textes pour construire cette compilation visuelle où dès le départ, il a privilégié le dialogue texte-image pour donner une vision frappante de la nature et de l'histoire. Mi-cosmographique, mi-apocalyptique, son « album of science » présente une combinaison typique à la fois scientifique et spirituelle qui mêle la nature et le temps dans un objet coloré extraordinaire.

Annexe : Liste commentée des manuscrits du *De ordine et positione stellarum in signis*

Le nom de la ville est souligné pour les manuscrits dont le *De ordine* est illustré. Dans la liste qui suit, la plus complète à ce jour[157], les manuscrits marqués d'un ou de deux astérisques sont des copies des *compendia* d'Aix★ (en VII livres, *Libri computi*) ou de Salzburg★★ (en III livres, *Liber calculationis*) ; les chapitres concernés de ces *compendia* sont indiqués entre crochets droits d'après l'étude de A. Borst sur les *Libri Computi* ou « Aachener Enzyklopädie » (*op. cit.*, ma note 36). J'ai pris soin de noter la présence ou non du planisphère et de l'*Excerptum*[158], et quand c'était possible les apparentements entre certains manuscrits, en observant en particulier la configuration de l'illustration des Ourses et du Dragon ou Serpent, qui sont les premières constellations illustrées du *De ordine*, de manière à offrir des points de comparaison avec ces motifs dans le *De ordine* du *LF*. Lorsque j'ai pu voir le texte du manuscrit ou en consulter les variantes dans une édition, je mentionne certains parallèles textuels avec le *LF*. Les sigles utilisés par les éditeurs successifs du *De ordine* sont indiqués.

À la liste de manuscrits ci-dessous, il faut ajouter les dix témoins complets du *LF*, qui contiennent tous le même type d'adaptation illustrée du *De ordine* commençant avec la notice *Helice* (grande Ourse), sans le bref prologue, avec le titre *De ordine et positione signorum*. Elles proviennent de Flandre ou de Hainaut pour la plupart ; deux datent du XIIᵉ siècle, deux du XIIIᵉ, une du XIVᵉ siècle et le reste du XVᵉ siècle, montrant une continuité dans l'intérêt pour l'œuvre. Celles du XVᵉ siècle semblent réalisées pour des bibliophiles des Pays-Bas méridionaux, et l'une peut-être pour l'Université de Louvain[159]. Dans l'ordre chronologique : Gent, Universiteitsbibl., 92 (autographe) ; Wolfenbüttel, Herzog August-bibl., 1 Gud. lat. 2° ; Leiden, Universiteit-sbibl., Voss. Lat. F. 31, f. 1–120 ; Paris, B.n.F., lat. 8865, *c.* 1260 ; Genova, Bibliotheca palazzo Durazzo-Giustiniani, A IX 9 (113) ; Paris, B.n.F., lat. 9675, commandité par un bourgeois de Bruges, Godevaert de Wilde, mort en 1429 puis acquis par Philippe le Bon ; Chantilly, Musée Condé, 724 (*olim* 1569), *c.* 1448 ; Douai, Bibl. municipale, 796, après 1447 ; Den Haag, Koninglijke Bibl., 72 A 23, *c.* 1460 pour Pierre de Goux, seigneur de Wedergrate (traduit sur l'ordre de Philippe de Clèves : Den Haag, Koninglijke Bibl., 128 C 4, a. 1512, Hainaut).

1. AUGSBURG, Staatsbibliothek, 8° Cod. 143, composé de 4 entités reliées ensemble à Augsburg, qui ont séjourné au couvent de Carmélites Sainte Anne avant la sécularisation en 1534 et le passage dans la bibliothèque de la ville. XVᵉ siècle pour la quatrième entité, où se trouve le *De ordine ac p. st.*, illustré de 39 figures, f. 282r–292r. Titre dans la liste de contenus en page de garde : *Figure et positio siderum in celo*. Prologue : *Est quidem hic ordo et posicio siderum que fixa celo plurimum coarcervatione stellarum in signum aliquot formata…* Texte : *Helice Arcturus maior habet stellas in capite VIII…-… Anticanis habet stellas III subtus geminos quare una splendidior est ceteris ideo anticanis vocatur quod contra sit cani*.

2. AUGSBURG, Universitätsbibl., II. 1. 2° 110, ajout *c.* 1500, f. 180v–183v, *De ordine ac positione stellarum in signis*, illustré. A été jusque 1980 conservé comme ms. Harburg über Donauwörth, Schloss, Fürstlich Öttingen-Wallersteinische Bibl. II, 1, 2°, 110 [comme tel dans l'éd. DELL'ERA, sigle *H* ; pas présent dans l'éd. BORST]. Sans l'*Excerptum*. Dans la copie du *De ordine*, l'ordre des chapitres est modifié : 2, 4, 3, 6, 7, 5, 8, 9, 11, 10, 19, 22, 24, 21, 23, 13, 20, 16, 15, 14, 17, 25, 18, 26, 28, 30, 29, 31, 27, 36, 37, 35, 34, 37, 39, 33, 40, 41, 42, 43 et les illustrations sont groupées toutes ensemble, sans le dessin des étoiles ; ajout d'une notice *Canis minor*. Lié au ms. Paris, B.n.F. lat. 12117 et au Città del Vaticano, Regin. lat. 309 par des lieux variants ou des omissions, mais il se distingue très nettement du reste de la tradition et a été largement contaminé[160].

3. AUSTIN, Univ. Texas, Harry Ransom Humanities Research center HRC 29 (*olim* Phillipps 816, *olim* Chardin)[161], 2ᵉ quart du XIᵉ siècle, glosé par l'abbé Ellinger (*c.* 975–1056) au monastère de Niederaltaich (près de Tegernsee) où Ellinger fut en exil à la fin de sa vie, voir p. ex. « *Ellinger scripsit istam glosam (Fllknghr scrlpsmt nstbm glqsem)* » f. 32r. Ellinger a été abbé de Tegernsee entre 1017–1026 et à nouveau entre 1031–1041. Le manuscrit est de

plusieurs mains de la même région. F. 1r Table du *De natura rerum*; f. 2r, Recettes médicales; f. 2r–12r, *Excerptum Bede de naturali historia Plinii*, très glosé; f. 12v–25r, Calcidius, *Comm. in Timaeum* (sans la fin); f. 25v–26r: *Excerptum de Astrologia Arati*, accompagné du planisphère inachevé, avec le seul *serpens* au centre; f. 26v–31r, *De ordine ac p. st.* illustré, sans marquage des étoiles dans les figures. Les Ourses et le *Serpens* se succèdent à proximité de leurs notices respectives. Inc. *Est quidem hic ordo et positio siderum.* F. 31v, Priscianus Grammaticus (Ausonius), *De duodecim signis*, inc. *Ad boree partes arcti vertuntur et anguis. Post has artofilax pariterque corona genuque...* F. 32r–99r, Sextus Pompeius Festus, *De verborum significatu.* Titre précédé par la lettre dédicatoire de Paul Diacre à Charlemagne: *Divine largitatis munere sapientia...*; f. 99v–100v, Ps.-Jérôme, Lettre 23 à Dardanus sur les instruments de musique. Deux notes sur l'interprétation spirituelle de diverses choses, et les grades des officiers romains ajoutés en bas du f. 100v. F. 101r–102v, ce qui m'apparaît comme la plus ancienne copie d'un texte sur le début de l'Avent attribué à Bernon de Reichenau (*c.* 983–1048), né en Lorraine, moine bénédictin à Prüm puis par moments à Fleury avant 999, puis abbé de Reichenau à partir de 1008, maître de Hermann de Reichenau: *Ratio generalis de initio adventus domini secundum auctoritatem Hilarii episcopi*[162]. Inc.: *Sciendum sane est, et omnibus orthodoxis fidelibus memoriter retinendum.* Dans cette lettre, l'auteur se présente comme moine de Fleury ayant assisté à un concile à Orléans qui opposait les moines de Fleury aux chanoines d'Orléans sur la question du début de l'Avent. La note en majuscules du scribe Ellinger vient après cette lettre, écrite d'une écriture différente mais contemporaine du reste du manuscrit.

Le contenu astronomique et iconographique de ce manuscrit est très proche de celui de Sankt-Gallen, 250 (Aratus révisé sans *De ordine*) et se rapproche de Wien, Ö.N.B. 12600.

4. BASEL, Universitätsbibl., F III 15h, *c.* 1400 ou deuxième moitié du XIV^e siècle[163], d'origine française, 257 ff. F. 254r: *Excerptum*, inc. *Duo sunt vertices mundi quos appellant polos*; f. 254v–255v, *De numero stellarum* (c'est-à-dire le *De ordine ac p. st.*), sans le petit prologue et sans illustrations. Inc. *Arcturus maior habet stellas in capite septem. In singulis humeris .i.* (...). Termine sur le Capricorne et non sur l'*Anticanis*.

5. ★★BERLIN, Staatsbibl. Preussischer Kulturbesitz, Phillipps 1832 (cat. ROSE 130) [*B* dans l'éd. DELL'ERA[164], *B¹* dans l'éd. MANITIUS, *Bh* dans l'éd. BORST]. Le premier cahier du manuscrit dans son état médiéval est le ms. Berlin, Phillipps 1830 (cat. ROSE 129), qui contient le planisphère aux actuels f. 11v–12r, mais il se peut qu'il ait été déplacé. Au centre du planisphère, le *Draco inter arctos* horizontal à deux boucles et une troisième petite juste avant la tête, avec les Ourses entrantes, dos à dos[165]. Les cahiers suivants forment l'actuel ms. Phillipps 1832. Le ms. médiéval fut utilisé, d'après Contreni, par Martin Scot *sive* de Laon (819–875) qui serait un des annotateurs. Une glose (f. 46r) porte la date de 873 dans la transcription des *De natura rerum* et *De temporum ratione* de Bède (f. 1–55). Selon B. Bischoff, le codex originel est originaire de Reims ou de Laon, et dans le troisième tiers du IX^e siècle il fut probablement donné par Thierry I, évêque de Metz (965–984) à l'abbaye bénédictine de Saint-Vincent, d'après des annotations annalistiques dans le premier cahier (ms. Phillipps 1830)[166].

Cahiers II–VIII, f. 1–55, contiennent principalement le *De natura rerum* de Bède, glosé; cahiers VIIII–XI, f. 56–80, *Chronica minora et maiora* de Bède, en deux colonnes, avec la « Ostfränkische Ahnentafel von 807 »[167] aux f. 78v–80. Cahiers XII–XIII, f. 81–92: f. 81r: *Excerptum de astrologia Arati*, inc. *Duo sunt extremi vertices mundi*; f. 81v–85v: *De ordine ac positione stellarum*, inc. prol. *Est quidem hic ordo expositio siderum...* f. 82r, Inc. textus: *Helice arcturus maior habet stella in capite septem...* Gloses et dessins de Servius sur Virgile en marge. Le *De ordine* est illustré de figures bien maîtrisées à l'encre violine, suivant chaque notice, et *sans* le tracé des étoiles; K. Linpicott y voit des caractéristiques du «group I» où se retrouvent les manuscrits des *Libri computi* de Madrid 3307, Monza F. 9/176 et Vat. lat. 645; il est notable que tous sont «lotharingiens».

Fig. 13. Berlin, Staatsbibl. Preussischer Kulturbesitz, Phillipps 1832 (cat. 130), f. 82r, Reims ou Laon, *c.* 873 : *De ordine ac positione stellarum*, début avec Ourses séparées [photo personnelle]

Le *Draco* à quatre boucles, orienté vers la droite, et les *Ursae*, sont représentés séparément et de profil, en-dessous de leurs notices respectives au f. 82r (Fig. 13), l'*ursa maior* est orientée vers la droite, l'*ursa minor* vers la gauche ; toutes deux ont l'échine saillante. F. 86r–92v : *Aratea* de Germanicus, accompagnés des *Scholia Basileensia*, qui ont donné lieu au texte du *De ordine ac p. st.* Les figures du *piscis* et de l'*antecanis* du *De ordine* se trouvent reproduites une nouvelle fois, mais avec la même encre que le texte cette fois, au f. 86r, avant le début des *scholia basileensia*, ce qui montre la labilité du placement des images. [Borst, γ corr. ? : f. 14v, 54v–55r, 78v–80r, 81r–85v : V 13a ; I 8, 5 ; V 1–2].

6. Berlin, Staatsbibl. Preussischer Kulturbesitz, Phillipps 1845, 68 ff., xv^e siècle, acheté par le célèbre abbé bibliophile de l'abbaye cistercienne des Dunes, Jean Crabbé, en 1472. Contient le *Compendium historiarum Trogi Pompei*. F. 67v–68v, *Excerptum*, Inc. *Duo sunt extremi vertices mundi. quas appellant polos...*, suivi sans transition f. 68v du prologue et du début de la première notice du *De ordine et p. st.*, jusqu'à *Helice*

arcturus maior... in cauda tres. fiunt XXII, sans illustrations.

7. Berlin, Staatsbibl. Preussischer Kulturbesitz, Phillipps 1869 (cat. Rose 131) [**Z** dans l'éd. Dell'Era, *B^2* dans l'éd. Manitius, *Bi* dans Borst], originaire de Prüm d'après B. Bischoff[168], 2^e quart du IX^e siècle ; provient de Saint-Maximin de Trèves où il se trouve dès le XI^e siècle[169]. Après un calendrier, f. 13v–14r-v, *Excerptum* ; f. 14r, début du *De ordine ac positione st.* sans le prologue[170] ; f. 11v : *De ordine ac positione st.*, suite, notices XX à XXVII, 4. Sans illustrations. Grand nombre d'omissions et de simplifications qui l'éloignent du texte du *LF.* Les f. 15–139 contiennent le *De temporum ratione* de Bède [Borst : f. 7v, 8v, 11v–12v ; 13v–14v : V 6a, 10 ; I 2 B ; V 2 C–D ; II 14 ; I 2 A ; V 1–2 A]

8. ★Città del Vaticano, Biblioteca apostolica vaticana, Reg. lat. 309[171] [**R** dans l'éd. Dell'Era ; *Vp* dans éd. Borst], partie de *c.* 859–860 (nombreuses mains), originaire du monastère de Saint-Denis au nord de Paris (f. 1r, en haut : *Liber sancti Dionisii*), f. 90r–99r. Il contient les *Libri computi* en sept livres, ainsi qu'une des quatre principales copies des œuvres computistiques d'Abbon de Fleury et des extraits du *commentaire au songe de Scipion* de Macrobe, cités par Byrhtferth dans ses *Glossae in Bedam*[172]. F. 90r–91r : *Excerptum de astrologia*. Inc. *Duo sunt extremi vertices mundi quos appellant polos septentrionis et austri ... effusionem urnae acquarii que ad ipsum decurrit accipiens.* F. 91r–99v : *De ordine ac p. st.*, avec toutes les figures en grand, à l'encre brune, rehaussées de vert : f. 91r-v : Inc. prol. : *De ordine ac positione stellarum in signis. Est quidem hic ordo et positio ... Sed quia iuxta aratum numerus stellarum unicuique signo adscriptus est, eo quod ab ipso est ordine digesta descriptio proferatur;* f. 91v : Inc. textus : *Helice arcturis maior habet stellas in capite septem, in singulis umeris singulas, in armo .i. in pectore .i., in pede primo claras duas, in summa cauda claram unam... (...).* F. 91r, le *Draco inter Arctos* à deux boucles, en S, a la tête en bas et les Ourses debout, sortantes (Fig. 14). Les étoiles sont dessinées comme de petites araignées dans et autour des figures. F. 105, *De probatione auri et argenti*, inc. *Omne aurum purum cuiuslibet ponderis omni argento similiter puro eiusdem*

Fig. 14. Città del Vaticano, Biblioteca apostolica vaticana, Reg. lat. 309, f. 91v, Saint-Denis, *c.* 859–860 : *Draco inter Arctos* à deux boucles, tête en bas, au début du *De ordine et positione stellarum* (cf. Ms. Paris, B.n.F. 12117)

tamen ponderis densius est. [BORST, version α f. 2v–3r, 4v–13r, 17r–29v, 59r–119r, 121r, 128r : I 1 ; V 15a–16a ; Capitula ; I 3, 2 A, 4–9, 9a-d, 10–11 ; II 1–12, 12a-d, 13–15, 15a-d, 16–22 ; IIII 28a ; III 1–14 ; IIII 1–27, 31a–33a ; V 6b, 1–12 ; VI 1–7 ; VII 1–4 ; I 2 B ; IIII 29a].

9. ★CITTÀ DEL VATICANO, B.A.V., Vat. lat. 645, exemplaire de l'abbé Hugues de Saint-Quentin dans le nord de la France, 830–860, peut-être *c.* 845. Vaste lacune dans les *libri computi* après le f. 55v : tout le livre IV est perdu et le début du V, dont l'*Excerptum*. F. 3r : Priscianus grammaticus (Ausonius), *De 12 signis*. F. 56r–65v : *De ordine ac positione stellarum*, illustré, sans le dessin des étoiles. Inc. : *Helice Arcturus maior habet stellas*… Expl. : *Anticanus habet stellas. III.* Présente les deux Ourses griffues et le serpent successivement, séparés, en dessous de leurs notices respectives (*Ursa maior* orientée à droite, *Ursa minor* à gauche au f. 56r, *Serpens* barbu et à crête, à 4 boucles, figuré verticalement, f. 56v). Le *LF* a de nombreuses variantes par rapport à son texte.

[BORST, sigle *Vy* : f. 1r–2v, 5r–34v, 36v–65v, 66v, 67v–92v : Capitula ; I 3–4, 7–10 ; II 1–12, 12a, 14–21 ; III 1–2, 5–14 ; IIII 1 ; V 2–12 ; VI 1–5, 7 ; VII 1].

10. ★DRESDEN, Sächsische Landesbibl., Dc 183, originaire du Nord-Ouest de la France, après 850[173]. Le manuscrit, fortement endommagé par le feu suite au bombardement de 1945, ne contient actuellement plus que les f. 1–18 et 95–101. Il contenait deux fois l'*Excerptum* et une fois le *De ordine ac positione stellarum in signis*. [ms *D* éd. KAUFFMANN 1888 et DELL'ERA D^I et D^{II}, utilisés par l'éd. MANITIUS 1888 ; pas utilisé pour l'éd. BORST]. [BORST : f. 32r-v, 98r–101r : (V 1), 1–2].

D^I a la séquence suivante : f. 7 : Dessin et description des deux hémisphères (*Descriptio duorum semisperiorum*) et liste d'étoiles ; f. 8v : dessin des deux hémisphères ; f. 11r : *Involutio spherae*, avec au f. 13r la sphère céleste représentée à la manière tardo-antique à l'intérieur d'un temple à colonnes et dotée des signes du zodiaque dans le bandeau de l'écliptique ; f. 13v–31r : Aratus latin avec les *Scholia Sangermanensia*, illustré, sans le marquage des étoiles (éd. MAAS 1898, p. 180–277 comme *recensio interpolata*, Inc. *Vertices extremos circa quos sphaera caeli volvitur…*), c'est-à-dire l'*Aratus* révisé [f. 13v–26r[174]], avec au f. 15r le *Draco inter Arctos* à trois boucles, appelé *Serpens inter ambas Arcturos* aux Ourses entrantes, tête-bêche, qui suit les deux Ourses présentées chacune au début de leurs notices respectives (Fig. 15). F. 28v : *Zodiacus circulus*, avec Soleil et Lune personnifiés au centre. F. 31r : Priscianus Grammaticus (Ausonius), *De duodecim signis* (Inc. *Ad boree partes arcti…*) ; f. 32r-v : *Excerptum* ; f. 33r–86r : « Hyginus ad. M. Fabium » : Hyginus, *De astronomia* (d'après Maas, car actuellement il ne subsiste pas les feuillets suivant le f. numéroté 27). Cette partie du manuscrit est apparentée iconographiquement et textuellement au ms. Sankt-Gallen, Stiftsbibl., Sangall. 250 (qui ne contient pas le *De ordine*), à partir de la p. 447 du Sangall. : p. 472 : dessin de la sphère céleste soutenue par des colonnes dans un temple ; p. 473 : Aratus latin révisé, illustré ; p. 525 : *Excerptum* (*Excerptio de astrologia*) ; p. 540 *sq.* : Hyginus, *Astronomica*.

Fig. 15. Dresden, Sächsische Landesbibl., Dc 183 (*D^I*), f. 15r, Nord-Ouest de la France, après 850 : *Scholia Sangermanensia*, début : *Draco inter Arctos* à trois boucles, avec inscription *Serpens inter ambas Arcturos*

La copie de l'*Aratus* révisé des f. 14r–31r de *D^I* est incontestablement apparentée, iconographiquement et textuellement, au ms. Paris, lat. 12957 du début du IX^e s., qui contient aux f. 60v–61r la même *Descriptio duorum semispheriorum* et l'illustration de ces hémisphères, au f. 63v la sphère céleste dans le temple, et au f. 64r *et sq.*, la version de référence de l'Aratus révisé avec les *Scholia Sangermanensia*, illustrée, commençant par le *Draco inter Ursae*.

D^II : F. 94r : *Incipiunt versi Ciceronis de signis* ; f. 98r–101r : *De ordine ac p. st.*, cette fois sans les images ; f. 98r–99r : *Excerptum (Excerptio de astrologia)* [E. Maass avait vu le manuscrit et l'appelle *D^II* dans son édition de l'*Excerptum*[175]] ; f. 99r–101r : *De ordine ac p. st.*, sans illustration, comme les mss. Einsiedeln, Stiftsbibl. 178 et München, Clm 4423, mais avec une numérotation de chacune des notices en chiffres romains, de I à XLVI.

11. Einsiedeln, Stiftsbibl. 178, originaire d'Einsiedeln, 3^e quart du x^e siècle[176] [*E* éd. Dell'Era ; pas utilisé par éd. Borst], 216 pp. F. 1–203 : *De natura rerum* et *De temporum ratione* de Bède. P. 204r :

Excerptum, Inc. *Duo sunt extremi vertices mundi* ; f. 204v–213r : *De ordine ac p. st.* sans titre, et non illustré (comme München, Clm 4423 et Dresden, Dc 183 ; ils ont entre eux dix erreurs communes ; Einsiedeln 178 partage 40 variantes avec München, Clm 4423). P. 211r, les 12 vers astronomiques de Priscianus Grammaticus, inc. *Ad Boree Arcturi…* Contient aussi une partie du *De astronomia Arati anonymi Sangallensis* édité par Maass (inc. *Herodius dicit Elicem Licaonis fuisse filiam*) qui est aussi dans le Sankt-Gallen 250[177]. Ces deux derniers textes se suivent aussi dans les manuscrits apparentés Wien, Ö.N.B. 12600 et München, Clm 4423. [Borst : p. 204–211 : V 1–2.1].

12. Firenze, Bibl. Nazionale Centrale, Magl. VIII 53, Florence, *c.* 1465, possesseur Agnolo Manetti. Après le *De mensura et magnitudine terre et circuli per quem solis iter est*, c'est-à-dire la mesure de la grandeur de la terre, du soleil et de la lune d'après Macrobe (f. 26r–27v), et la *Probatio argenti et auri*, puis le *De mensura cere et metalli in operibus fusilibus* (f. 28r–v), vient aux f. 29r–29v : *Excerptum de astrologia*. Inc.: *Duo sunt extremi uertices mundi quos appellant polos*

septentrionis et austri, quorum alter a nobis semper uidetur… Expl. *Iuxta pedes autem Andromede a latere Cassiepie Perseus*; f. 30r–v, *De ordine ac positione stellarum in signis*, non illustré et abrégé; inc. prol.: *Est quidem hic ordo et positio siderum que fixa caelo…*; inc. textus: *Helice habet stellas xxii. et uocatus arcturus maior. Cinosura arcturus minor…* Aux f. 84v–88r se trouvent les autres chapitres du livre V: *De positione et cursu VII planetarum, De intervallis eorum, de habsidibus* [sic], *De interlunio, De eclypsi solis, de eclyspi lune*, avec les schémas. [Borst: f. 25v–30v, 84v–88r: VI 1, 4–7, 2–3; V, 1–7, 9, 8, 11]

13. [★Freiburg, Bibliothek des erzbischöflichen Ordinariats, 35 b (BD 1442), Lotharingie (Reims?) ou peut-être Prüm, *c.* 850, 32 ff. Contient des extraits des compendia du *Libellus annalis* de 793 (c. 66–68, 69 a–c), des *Libri computi* (III 28a; V 3–6, 12 avec diagrammes) et du *Liber calculationis* (c. 107). F. 1r–11r: *De signis celi: Incipit de astronomium excarpsum. Helix arcturus maior habet autem in capite stellas obscuras .vii*, mais avec des illustrations empruntées au *De ordine ac p. st*[178]. L'*Ursa minor* de la deuxième notice a le haut du corps et la tête de face. Après la troisième notice, le *Draco inter Arctos* vertical à trois boucles, marqué de points, la tête à droite, renversée de bas en haut, avec une gueule en forme de bec de canard; les *Ursae* sont dos-à-dos, mais l'Ourse supérieure est pattes en l'air, entrante, l'Ourse inférieure est debout, sortante [Borst: γ corr., f. lr, 11v–13v, 14v–15v, 16v–31r: IIII 28a; V 3–7, 9, 8, 12; VII 1] Le manuscrit est relié avec deux imprimés, *De natura rerum*, Basel, H. Petri, 1529 et Beatus Rhenanus, *In C. Plinium*, Basel, J. Frober, 1526].

14. Los Angeles, J. Paul Getty Museum, Ludwig XII.5 (*olim* Phillipps 12145, cote actuelle Acc. 83.MO 134), sud de l'Angleterre (Worcester?), première partie jusqu'au f. 152 du premier quart du XIIᵉ s., le reste du début du XIIIᵉ siècle[179]. F. 55v–79r, textes de comput, dont celui d'Abbon de Fleury. F. 112v–125v, Extraits de Macrobe, *Commentarium in Somnium Scipionis*. F. 126v–149v: Hygin, *Astronomica*, I–IV, non illustré. F. 149v, *Excerptum*; suit jusqu'au f. 151v une version abrégée du *De ordine ac p. st.* Inc. prol. *Est quidem*

hic ordo et positio siderum. Inc. textus: *Helice arcturus maior habet stellas in capite VII*. Termine sur la notice XXIII, *Lepus*. Illustré après chaque notice par de grandes figures tracées avec la même encre que le texte, dans lesquelles les étoiles sont marquées à l'encre orange par trois traits croisés. Les deux Ourses sont présentées successivement de profil, *Ursa maior* orientée à gauche, *ursa minor* à droite. La troisième notice, *Serpens*, présente le *Draco inter Ursas* horizontal à deux boucles, orienté vers la droite, avec les Ourses entrantes, dos à dos; le dos du *Draco* n'a pas d'autre décoration que les étoiles oranges[180]. Le manuscrit contient au f. 47v une sphère d'Apulée, comme dans le *LF* et le ms. Paris, lat. 8663, peut-être originaire de Fleury.

15. ★Madrid, Bibl. nacional, 3307, Murbach ou Metz, *c.* 820, copie de prestige réalisée pour l'archevêque Drogon de Metz (823–855), représentative des *Libri computi* d'Aachen en VII livres, dont il manque le livre VI entier et des parties du Vᵉ et du VIIᵉ. F. 53r, *Exceptum de astrologia*; f. 54v–62v, *De ordine ac positione stellarum in signis* illustré, dans le livre V 2[181]. Les étoiles ne sont pas dessinées dans les illustrations des constellations, multicolores. Présente les images des *Ursae* et du *Serpens* successivement, séparés et dotés chacun de leur notice; *Serpens* vertical incliné, à quatre boucles, barbu et avec crête, sans les Ourses f. 54v. F. 67v, dessin d'un hemisphère inachevé [Borst: α - A (Leithandschrift); f. 5r–80v: I 3–4, 10–11; II 1–12, 12a, 13–22; III 1–14; IIII 1–27, 28a, 31a–33a; V 1–12; VII 1–4].

16. Metz, Bibl. municipale, 271, feuillet final[182]; le *Catalogue général des manuscrits* dit «Mappemonde figurée; énumération succinte de constellations».

17. ★Montpellier, Bibl. de l'Ecole de médecine, H 334, deuxième moitié du IXᵉ siècle, Loire? d'après B. Bischoff[183], peut-être Fleury ou Auxerre. [éd. Maass, 1898, p. 312; *T* dans l'éd. Dell'Era; *Mr* éd. Borst] Contient des textes d'Hygin (f. 1–38), suivis f. 38r–53r d'une partie des *Libri computi*. F. 43r: *Excerptum*; f. 44r: *De ordine et p. stellarum*, inc. *Est quidem hic ordo et positio siderum*, seulement les six premières lignes du prologue. Le texte n'est

donc pas illustré. Il est suivi f. 44v du *De positione et cursu septem planetarum*. [Borst : f. 38r–53r : III 2–4, 8–10, 14 ; IIII 31a–33a ; V 1–9, 11–12 ; VI 1–7].

18. ★Monza, Bibl. Capitolare della Basilica di San Giovanni Battista, F. 9/176, peut-être Lobbes[184] (ou Rhénanie inférieure, Westdeutschland), *c.* 864, 94 ff. [*Mt* dans l'éd. Borst]. Exemplaire représentatif des *Libri computi*. Présente f. 58r, Sphère céleste colorée, hémisphère d'hiver comme dans Madrid 3307 (ainsi que dans le ms. Bernkastel-Cues, Kusanusstift, 212, f. 24r-b)[185]. F. 60r–61r : *Excerptum de astrologia*. Inc. *Duo sunt extremi vertices mundi* ; f. 61r–69v : *De ordine ac p. st. in signis*, inc. *Est quidem hic ordo et positio siderum … anticanis habet stellas III*. Le manuscrit est très proche du Madrid 3307, y compris pour les illustrations et présente des similitudes iconographiques avec Berlin, Phillipps 1832. Présente au f. 61v les deux Ourses et le serpent successivement, séparés, avec chacun leur notice ; le *serpens*, à quatre boucles, est vertical, tête en l'air, légèrement incliné. F. 61v, dans un espace laissé libre, Priscianus Grammaticus (Ausonius), *De duodecim signis*, inc. *Ad boree partes*. [Borst : A, f. 7r–9r, 10r–92v : Capitula ; I 1–3 ; IIII 1 ; I 4–11 ; II 1–22 ; III 113 ; IIII 2–27, 28a, 31a–32a ; V 1–12 ; VII-7 ; VII 2–4, 1. S'y trouvent aussi des chapitres propres au *Liber calculationis* et au « comput de Vérone » ou *Libellus annalis* de 793].

19. ★★München, BSB, Clm 210, Salzburg, *c.* 818, conservé dès le xᵉ siècle à St. Emmeram à Regensburg, puis parmi les manuscrits de Hartmann Schedel à partir de 1488[186] [ms. *A* dans l'éd. Dell'Era, qui donne les f. 113v–122v ; *Mu* dans éd. Borst ; connu de K. Rück, 1888[187]]. F. 113v : Planisphère coloré sur fond vert, avec le *Draco inter Arctos* vertical à 3 boucles au centre, avec les Ourses entrantes, dos à dos ; f. 114r–115r : *Excerptum de astrologia*, Inc. *Duo sunt extremi vertices mundi*, suivi aux f. 115r–121r du *De ordine ac p. st.*, avec de fines illustrations colorées où les étoiles sont des ronds orangés à six branches fines, figurées non pas sur, mais autour des figures. Inc. : *Est quidem hic ordo et positio siderum quae fixa caelo plurium coarceruatione stellarum in signum*. Des. : *Anticanis habet stellas III*. Il s'agit de

Fig. 16. Paris, B.n.F. lat. 12117, f. 131r, Saint-Germain, entre 1060 et 1063, enluminé par Ingelard : *De ordine et positione stellarum*, début avec *Draco inter Arctos*

la plus ancienne copie du *De ordine ac p. st.* Les dessins des constellations précèdent chacune des notices, comme dans Wien, Ö.N.B. 387. Ces deux manuscrits presque contemporains contiennent le *Liber calculationis*. [Borst : f. 4r–8r, 16r–67v, 73r–77r, 79r–v, 82r–v, 113v–123r, 124r–145r : I 5 ; II 1, 5 ; I 2, 4 ; IIII 1, 12 ; I 10,8 ; II 16–17, 4, 15, 713, 18–20 ; III 6–7, 9, 8 ; IIII 8, 20 ; V 1–5, 11–12 ; VII 2–4, 1][188].

20. München, BSB, Clm 4423, abbaye de Mondsee, *a.* 1481 [*M* éd. Dell'Era ; pas utilisé pour éd. Borst], f. 165r–168v : *Excerptum*, suivi du *De ordine ac p. st.*, sans les illustrations. Proche du ms. Einsiedeln, Stiftsbibl. 178 avec lequel il compte quarante lieux concordants (Dell'Era, p. 26) et du ms. Wien, Ö.N.B. 12600 (illustré). Il présente le *De duodecim signis* de Priscianus Grammaticus et une partie du *De astronomia Arati anonymi Sangallensis* édité par Maass [Borst : f. 165r–168v : V 1–2].

21. Paris, Bibl. Nationale de France, lat. 8663, Val de Loire (voisinage de Fleury ?), *c.* 1000, 58 ff. [ms. *L* dans l'éd. Dell'Era, qui parle d'écriture "tedesco-svizzero",

Fig. 17. Paris, B.n.F., nouv. acq. lat. 1614, f. 85r, Saint-Martin de Tours, après 825 : *De ordine et positione stellarum*, début : *Draco inter arctos*, avec inscription *Serpens inter ambas Arcturos*

P dans l'éd. de G. KAUFFMANN 1888 ; pas vu par BORST ; connu de HASPER 1861][189]. Présente les *Astronomica* d'Hygin. N'a pas l'*Excerptum*. F. 19v–23v, *De ordine ac positione stellarum in signis*. Inc. *Est quidem hic ordo ac positio siderum que fixit celo*. Des. *Anticanis habet summam stellarum .iii.* Les illustrations sont de la même encre brune que l'écriture, de grande taille par rapport à la place occupée par les notices. Au f. 20r, le *Draco inter Arctos* est horizontal à trois boucles, tête barbue dotée d'un col, tournée vers le bas ; il a les Ourses entrantes, dos à dos ; il suit la notice *Serpens*, en-dessous de celles consacrées à chacune des Ourses, qui ont les griffes sortantes et sont dressées sur leurs pattes arrière (notices *Helice* et *Cinosura*). *Cinosura* est figurée comme sautant, l'échine très arquée. Le ms. a des points communs textuels avec les mss. München, Clm 210 et Wien, Ö.N.B. 387, mais Dell'Era note p. 17 qu'il diverge de tous les manuscrits qu'il a collationnés en 31 cas (amplifications). F. 24r : *De positione et cursu septem planetarum*, f. 24v : *De absidibus earum*, f. 25r–34r : *Macrobii Ambrosii Theodosii V.C. et in L. commenta ex Cicerone In Somnium Scipionis*. Contient, comme le *LF* (*W* f. 19r) et le manuscrit Los Angeles, Ludwig XII.5, une sphère d'Apulée au f. 57r, et des textes musicaux. [BORST, f. 19v–24v : V 2–3, 5.]

22. ★PARIS, B.n.F., lat. 12117, abbaye de Saint-Germain, copié entre 1060 et 1063, enluminé par Ingelard [*S* éd. DELL'ERA et

éd. KAUFFMANN 1888 ; *Pn* éd. BORST][190]. F. 129v–130r : *Excerptum de astrologia*. Inc. *Duo sunt extremi vertices mundi quos appellant polos…-…in virginem memoratam semper inveniri planetam*. F. 130v : Poème de Pacificus de Vérone, *Spera caeli quater senis horis horis dum reuoluitur…-…radius, ad ima mersus hiemalis dicitur*[191]. F. 131r–137v : *De ordine ac positione stellarum in signis*, illustré. Inc. Prol. *Est quidem hic ordo et positio siderum que fixa caelo plurium coaceruatione stellarum in signum aliquod formata…* Inc. textus : *Helice arcturus maior. habet stellas in capite vii.* Expl. *Anticanis habet stellas III.* Commence f. 131r par le *Draco inter Arctos* à deux boucles en S, tête en bas, avec les Ourses «sortantes», debout ; le S du *Draco* passe ainsi à travers les deux premières notices et son corps est marqué d'étoiles traçant des croix (Fig. 16). Les étoiles sont sophistiquées et de différents types, à l'intérieur et dans les figures. Lié au ms. Augsburg, U.B., II. 1. 2° 110 et au Città del Vaticano, Reg. lat. 309 par six lieux variants ou omissions et plus encore au Reg. lat. 309 par une iconographie quasiment semblable et par une série de variantes (éd. DELL'ERA, p. 18–19), dont *primo* au lieu de *priori* dans la première notice. [BORST, sigle β corr., f. 105r–108r, 111r–126v, 129v–139r, 180r–183r : 15,4 ; V 6b, 1, 16a ; IIII 29a ; V 2 ; II 9 ; V 3–6, 11–12 ; VI 2–7].

23. PARIS, B.n.F., nouv. acq. lat. 176, *c.* 1300, France, centre régional au sud de Paris, d'après l'écriture[192], pour le

cahier f. 65–72. [*N* éd. DELL'ERA ; *Pp* éd. BORST][193]. Contient surtout la *Theorica planetarum* attribuée à Gérard de Crémone. Nouveau cahier commençant au f. 64r ; f. 64r, *Excerptum* en deux colonnes. *Incipit liber arati de ymaginibus celi et ordine earum constellatione.* Inc. *Duo sunt extremi vertices mundi.* F. 66ra : *De ordine ac posicione stellarum in sisnis* [sic]. Inc. prol. *Est quidem hic ordo et posicio…* ; f. 66ra : inc. textus : *Helice arcturus maior habet stellas in capite vii.* F. 72ra : expl. : *Anticanus habet stellas .iii.* Le texte est abrégé mais compte aussi des amplifications. Les emplacements sont laissés vides pour les illustrations, jamais réalisées.

24. PARIS, B.n.F., nouv. acq. lat. 1614, Saint-Martin de Tours (région de Fleury ou Auxerre d'après Dell'Era), après 825 [*P* éd. DELL'ERA ; pas vu pour l'éd. BORST][194]. Le ms. originel se composait comme suit : ms. nouv. acq. lat. 1612 (cahiers A, B, C) + ms. Tours, B.M. 334 (cahiers D-K) + ms. nouv. acq. lat. 1613 (cahiers G-H ; L, M, N incomplet) + ms. nouv. acq. lat. 1614 (cahiers O-V, [X-Y], I–III). F. 1–77, arithmétique de Boèce, suivie aux f. 77 et *sq.* de textes aratéens. F. 81r : *Discriptio duorum semispherium* ; f. 81v, Dessin des deux hémisphères ; f. 82r, Aratus révisé : *Arati genus* ; f. 82v, *De caeli positione* ; *De stellis fixis et stantibus* ; f. 83v, *Involutio spherae*, incomplet car un feuillet est arraché. F. 84r, Aratus révisé, inc. *Vertices circa quos sfera caeli uoluitur* ; illustré de manière malhabile de la même encre que l'écriture ; les illustrations commencent successivement par l'*Ursa maior*, l'*Ursa minor* et au f. 85r un *Serpens inter ambas Arcturos*, à cinq boucles, aux Ourses sortantes et griffues (Fig. 17). F. 93v : *Explicit liber astrologorum.* Suit l'*Excerptum*, Inc. *Duo extremi vertices mundi…* F. 94v : le planisphère, qui avait déjà été découpé avant 1916 (date de l'article de Cumont), juste avant, f. 95r–99v, *De ordine ac p. st.*, illustré dans la même encre que l'écriture, avec les étoiles placées dans et autour des figures sous forme de petites croix ; les dessins des Ourses et du Serpent sont séparés, sous leurs notices respectives ; le serpent est barbu, crachant et doté d'un col a une longue queue ondulée. La première notice a la variante *in pede priore* [sic] *clara* (là où les autres manuscrits ont *priori*, à part deux exceptions qui ont *primo*). C'est avec la notice *navis* que se termine le ms. Le f. 97 a été arraché. [BORST, f. 93v–99v : V 1–2.] Le manuscrit est mutilé en divers endroits. Son contenu l'apparente au ms. Dresden Dc 183.

25. REYKJAVIK, Stofnun Árna Magnússonar, GKS 1812 4[to], provient du monastère augustinien de l'île de Viðey, fondé en 1226 et fermé en 1539 ; il était conservé à Copenhague jusqu'en 1984[195]. Il compte 36 ff. qui subsistent de quatre volumes. La première partie (I 4[to]) est du XIVe siècle et contient des textes calendaires, avec des dessins de quinze constellations, dont neuf signes du Zodiaque dans des médaillons (trois par page) aux f. 3–7v, accompagnés d'un texte sur leur nombre d'étoiles, et f. 4v une division de la philosophie (*divisio scientiarum*), une roue des mois f. 6v et une roue des orbites planétaires tirée de Macrobe f. 7r, puis f. 10v les orbites de Vénus et Mercure, f. 11r ceux de Mars, Jupiter et Saturne avec des épicycles, f. 11v les phases de la Lune, f. 12v, un diagramme des éclipses. C'est dans cette partie du XIVe siècle (les f. 1r–4v et 7r–13r sont du même scribe) que se trouve une copie illustrée incomplète du *De ordine*, à savoir des extraits choisis pour ces neuf signes du Zodiaque (*Cancer, Leo, Virgo, Libra, Scorpio, Sagittarius, Capricornus, Aquarius, Pisces*). La couleur en a disparu presque entièrement. Inc.: *Cancer habet stellas in pectore claras ii. quas appellant asinus inter quas nubicula que candidi colens apparens…* On peut remarquer que les notices de la *Libra* et du *Scorpio* ont été séparées, ce qui n'est pas le cas habituellement dans le *De ordine*, qui n'a pas de notice distincte pour la Balance prise dans les pinces du Scorpion[196]. La suite des constellations se trouve f. 7v, avec les *Centaurus, Lepus, Orion, Cetus, Canis maior, Canis minor*. Le cycle illustré semble apparenté iconographiquement au ms. du Getty Museum, Ludwig XII.5, originaire du sud de l'Angleterre. Il est lié aux compilations computistiques anglaises des manuscrits London, British Libr., Tiberius B.V., qui est le modèle de Oxford, Bodl. Libr., Bodley 614, avec le même archétype que Digby 83. Suit aux f. 8v–9v une version islandaise de l'*Excerptum de astrologia*

Arati. Les autres parties du manuscrit actuel sont les suivantes : II 4^to, f. 13v–23v, date du XIV^e siècle, avec le traité islandais *Algorismus* (13v–16v) avec des chiffres arabes, et le traité astronomique *Rím II* qui aurait été écrit à Viðey dans le dernier quart du XIII^e siècle ; III 4^to, faite de quatre feuillets (f. 5r–6v et 35r–36v), date du deuxième quart du XIII^e s. et contient entre autres une *mappa mundi*, des dessins cosmologiques, un calendrier et un texte de comput ; IV 4^to, f. 24r–34v, date de 1190–1200, avec un glossaire islandais-latin et les traités de comput en vieil islandais *Rím I* et *Oddatala*.

26. S<small>AINT</small>-P<small>ETERSBOURG</small>, Rossiyskaya national'naya bibl., lat. Q.v.IX, 2, *c.* 1100, de provenance inconnue ; Nord de l'Italie ou Suisse d'après l'écriture. Contient un seul cahier fait du *De ordine ac p. stellarum*, f. 1r–7r : *Ordo et posicio stellarum*. Inc. prol. : *Est quidem hic ordo et posicio siderum que fixa celo plurimum coaceruacione stellarum in signum aliquot formata.* Inc. textus : *Helice arcturus maior habet stellas in capite .iii.* Expl. : *Anticanis habet stellas III subtus geminos contraria quarum una splendiorem ceteris et ideo anticanis uocatur quot cuncta sit cani.* Illustré à l'encre brune surlignée en rouge. Les dessins des deux Ourses griffues et du *Serpens* chevelu, à trois boucles et longue queue se succèdent, sans *Draco inter Arctos*. La copie se termine sur la représentation d'un personnage qui pourrait être le scribe, sous la forme d'un moine jeune, tonsuré, aux chausses trouées aux talons, assis comme accablé sur un socle carré (avec pose-pieds), tenant un livre dans les mains. Ce qui précédait ou suivait ce cahier isolé reste indéterminé malgré mes recherches. J'ai pu montrer que l'exemplaire qui se rapproche le plus de ce manuscrit du point de vue iconographique est celui d'Austin HRC 29, du même type que le Sankt-Gallen 250 (on notera par exemple le nez rond très caractéristique de l'*Ursa minor-cinosura*)[197].

27. ★★W<small>IEN</small>, Österreichische Nationalbibl., 387, Orig. Sankt Peter, Salzburg, *c.* 818 [*W* éd. D<small>ELL</small>'E<small>RA</small> qui pense (p. 7) qu'il est datable de *c.* 820 ; *Wi* dans éd. B<small>ORST</small> ; connu de R<small>ÜCK</small>, *Auszüge*, 1888, qui le date de 830][198]. F. 116v–120v : *De ordine ac positione stellarum in signis*, illustré. Inc. : *Est quidem hic ordo et positio siderum quae fixa caelo plurium coaceruatione stellarum…* Expl. : *Anticanis habet stellas. III.* Omet IX–XVIII. F. 180v : *De positione et cursu septem planetarum.* 121v : *De intervallis earum* puis *De absidibus earum.* F. 124r, *De caelestis spatiis secundum quosdam.* F. 124v : *De temporum mutatione.* F. 125r. *De presagiis tempestatum.* F. 127v. *De mensuris ac ponderibus.* (etc.). Jumeau du ms. München, Clm 210 ; les dessins des constellations précèdent de même chacune des notices ; les étoiles entourent les dessins [B<small>ORST</small> : *Liber calculationis*, version α, sigle *Wi*].

28. ★W<small>IEN</small>, Österreichische Nationalbibl., 12600, 2^e partie : Prüfening près de Regensburg, *c.* 1130 ou dernier quart du XII^e siècle, sous la direction de Wolfger[199] [*V* éd. D<small>ELL</small>'E<small>RA</small> ; *Wn* éd. B<small>ORST</small>]. F. 23r–26r : <*De ordine ac positione stellarum in signis*>. Inc. : *Est quidem hic ordo et positio syderum. Helice arcturus maior habet stellas.* Expl. : *Anticanis habet in toto corpore stellas. III.* Illustré et très coloré, avec les étoiles formant des ronds orangés, sur les figures. Le texte est à trois colonnes. F. 23r-v : *Serpens* à quatre boucles barbu et doté d'une crête rouge, dont la notice vient après celle des deux Ourses, griffues. [B<small>ORST</small> : version β corr. F. 14v–17v, 22r–28v, 29v, 30v–31r, 38r, 136r–137r : III 2–9, 14 ; IIII 10 ; V 12 ; III 1 ; V 2–6 ; II 21 ; VI 7 ; I 2 ; V 1]. Comme München 4423 et Einsiedeln 178 (qui eux ne sont pas illustrés), a les 12 vers astronomiques de Priscanus Grammaticus et, suivant immédiatement, une partie du *De astronomia Arati anonymi Sangallensis* édité par Maass.

NOTES

* Les normes du RILMA préconisent d'utiliser « folio » pour indiquer la pagination du manuscrit et de ne pas mentionner le « r » de « recto » dans les indications de feuillets précis. J'ai cependant utilisé la mention de « feuillet » ou « f. », recommandée en codicologie, car « folio » indique un format. De même, pour éviter les confusions qu'entraînerait l'absence de mention précise du recto (ex : f. 95 pour f. 95r) dans les très nombreuses indications codicologiques de cet article, j'ai toujours précisé s'il s'agissait du recto ou du verso, ainsi que la colonne quand il y avait lieu (ex. : f. 94ra).

1. Pour une bibliographie à jour jusque 2009 sur le *Liber floridus*, cf. http://www.liberfloridus.be/literatuur_fr.html. Le site *Liber floridus.be* offre en outre une présentation synthétique de l'œuvre (rubrique « Inhoud ») et la liste des manuscrits conservés (rubrique « Copieen »). Texte et étude principale : A. DEROLEZ, *The Autograph Manuscript of the Liber Floridus. A Key to the Encyclopedia of Lambert of Saint-Omer*, Turnhout, 1998 (*Corpus Christianorum*, Autographa Medii Aevi, 4) ; par ailleurs, le dernier ouvrage que lui a consacré A. DEROLEZ, *The Making and Meaning of the* Liber Floridus. *A study of the original manuscript, Ghent, University Library MS 92*, London-Turnhout, 2015, donne toutes les clés pour comprendre au mieux l'œuvre, son organisation et ses contenus en fonction de sa présentation codicologique. Le dernier article en date, d'ordre assez général, est celui de W. BLOCKMANS, « À la recherche de l'ordre divin. Le *Liber floridus* de Lambert de Saint-Omer en contexte (1121) », *Revue du Nord*, 100, n°424, 2018, p. 11–31. Les deux études les plus récentes, la première avec fac-similé, la seconde centrée sur la transmission du *Liber floridus* : Ch. HEITZMANN – P. CARMASSI, *Der* Liber floridus *in Wolfenbüttel. Eine Prachthandschrift über Himmel und Erde*, Darmstadt, 2014 ; Hanna VORHOLT, *Shaping Knowledge : The Transmission of the Liber Floridus*, London, 2017 (Warburg Institute Studies and Texts, 6).

Fritz SAXL avait déjà situé le *Liber floridus* en comparaison avec l'encyclopédisme médiéval dans une leçon faite en 1939 au Warburg Institute : *Illustrated Medieval Encyclopaedias*, in *Lectures*, London, 1957, t. 1, p. 228–254 ; sur le même sujet, quelques années plus tard, Y. LEFÈVRE, « *Le* Liber Floridus *et la littérature encyclopédique au Moyen Âge* », dans « *Liber Floridus* » *Colloquium : Papers read at the International Meeting held in the Univeristy Library Ghent on 3–5 September 1967*, éd. A. DEROLEZ, Gent, 1973, p. 1–9. Les contributions les plus récentes sur le point de vue encyclopédique sont celles de Michel DE GANDILLAC et d'Anna SOMFAI, « The *Liber Floridus* in the Encyclopaedic Tradition. Philosophical and Scientific Diagrams in Context », dans *Liber Floridus 1121 : The World in a Book*, éd. K. DE COENE, M. DE REU, P. DE MAYER, Tielt, 2011, p. 75–88, sur les encyclopédies illustrées et le *Liber floridus* de Saint-Omer.

2. Jules BARON DE SAINT-GENOIS, *Notice sur le Liber floridus Lamberti Canonici, Manuscrit du XII⁰ siècle*, extrait du *Messager des Sciences historiques de Belgique*, Gand, 1844, p. 1 et p. 34.

3. DEROLEZ, *The Autograph Manuscript*, p. 182.

4. Sur le prologue et sa traduction, voir DEROLEZ, *Making and Meaning*, p. 47–49, et la contribution de Ch. BURNETT dans le présent volume.

5. Sur la comparaison des copies du *LF*, Cf. VORHOLT, *op. cit.* (ma note 1).

6. Cf. I. DRAELANTS, *Un encyclopédiste méconnu du XIII⁰ siècle : Arnold de Saxe. Oeuvres, sources, réception*,

Louvain-la-Neuve, 2000 ; l'édition de 1904–1905 de E. STANGE donne l'intitulé erroné de *De finibus* d'après la graphie du manuscrit d'Erfurt.

7. Edité dans la *Patrologia latina*, t. 171, col. 1381–1391 parmi les œuvres d'Hildebert de Lavardin. Voir A. BOUTEMY, « Recherches sur *Floridus Aspectus* de Pierre la Rigge », *Le Moyen Âge*, 54, 1948, p. 89–112 ; ID., « Recherches sur le *Floridus Aspectus*, II » et « Recherches sur le *Floridus Aspectus*, III », *Latomus*, 8, 1949, p. 159–168 et 283–301 ; C. WOLLIN, « Der "Floridus Aspectus" D des Petrus Riga », *Mittellateinisches Jahrbuch*, 44, 2009, p. 407–447.

8. H. OMONT, *Catalogue des manuscrits des bibliothèques publiques de France. Départements. II. Evreux*, 1887, p. 29, manuscrit 8, avait trouvé cette attribution dans un manuscrit provenant de Lyre, du XIV⁰ s., maintenant conservé à Evreux en Normandie, et on trouve la même œuvre dans la liste dressée au XIII⁰ s. du catalogue de la bibliothèque du prieuré de Carisbrooke en Angleterre, dont la maison-mère était à Evreux. Cf. l'Item 113, 2, dans le « Catalogus Manuscriptorum Bibliothecae Lyranae Dioecesis Ebroïcensis » : « *Liber qui dicitur* Campus Floridus *auctus ab Henrico de Paceyo Monacho Lyrae* » ; et l'item 123, 1 : « *Item liber devotus qui sic incipit :* Adam ubi es ? *Ex quo Henricus de Paceyo suum composuit Campum floridum, in-4°* ». Le catalogue de Lyre est édité par Jérémy DELMULLE d'après la *Bibliotheca bibliothecarum manuscriptorum nova* [1738], dans *Inventaires mauristes*, J. Delmulle, dir., Caen, Presses universitaires de Caen (Thecae), 2018, en ligne : https://www.unicaen.fr/services/puc/sources/maur/doc/BBMN_Lyre_Notre-Dame_1738_01.xml [consulté le 17/12/2019].

9. H. M. SCHALLER, s.v. dans *Lexikon des Mittelalters*, t. 2, 1983, p. 490.

10. *Wilhelm von Conches, Philosophia*, herausgegeben, übersetzt und kommentiert von G. MAURACH, unter Mitarbeit von H. TELLE, Pretoria, (Studia, 16), 1980. (1⁰ éd. 1974, Studia, 15).

11. Éd. I. RONCA, L. BADIA, J. PUJOL, Guillelmus de Conchis, *Dragmaticon*, Turnhout, 1997 (*Corpus Christianorum, Continuatio Mediaevalis*, 152).

12. Éd. Y. LEFÈVRE, *L'Elucidarium et les Lucidaires. Contribution, par l'histoire d'un texte, à l'histoire des croyances religieuses en France au Moyen Age*. Paris, 1954 (*Bibliothèque des Écoles françaises d'Athènes et de Rome*, 180). Gleb Schmit vient de soutenir (février 2021) une thèse de doctorat en cours à l'Université de Lorraine (Nancy) sur la tradition manuscrite et la postérité de l'*Elucidarium*, qui compte plus de soixante copies.

13. Ed. V. FLINT, « Honorius Augustodunensis : *Imago mundi* », *Archives d'histoire doctrinale et littéraire du Moyen Âge*, 82, 1949, p. 7–153. Natalia Petrovskaïa (Univ. d'Utrecht) a dressé une liste des manuscrits sur https://imagomundi.hum.uu.nl/.

14. Ed. *PL*, t. 197, c. 741–1038. Trad. B. GORCEIX, *Hildegarde de Bingen, Le livre des œuvres divines*, Paris, Albin Michel, 1982.

15. Le ms. Lucca, Biblioteca statale, 1942, en contient une copie très richement illustrée.

16. Ainsi, dans la carte du monde du f. 241r, la *Flandria* est située, ainsi que les *Morini*, nom des habitants du diocèse de Thérouanne qui constituent une exception dans une carte du monde.

17. Cf. P. C. MAYO, « The Crusaders under the Palm. Allegorical Plants and Cosmic Kingship in the *Liber Floridus* », *Dumbarton Oaks Papers*, 27, 1973, p. 31–67 ;

D. VERHELST, « Les textes eschatologiques dans le *Liber floridus* », dans *The Use and Abuse of Eschatology in the Middle Ages*, éd. W. VERBEKE, D. VERHELST, A. WELKENHUYSEN, Leuven, 1988, p. 299–305 ; D. LECOQ, « La mappemonde du *Liber Floridus* ou la vision du monde de Lambert de Saint-Omer », *Imago Mundi. The Journal of the International Society for the History of Cartography*, 39, 1987, p. 9–49 (sur la représentation cartographique de l'histoire universelle, du Paradis à la Jérusalem céleste). Sur ces sujets, voir aussi dans le présent volume les contributions de Raffaele Savigni, Philippe Faure et Hannah Vorholt.

18. On trouvera en annexe, avec la liste des manuscrits du *De ordine et positione stellarum*, la liste de ceux du *LF*.

19. Je me permets de renvoyer, sur les critères typologiques qui caractérisent l'encyclopédie médiévale, à I. DRAELANTS, « Le "siècle de l'encyclopédisme" : conditions et critères de définition d'un genre », dans *Encyclopédire : Formes de l'ambition encyclopédique dans l'Antiquité et au Moyen Âge*, textes réunis par A. Zucker, Turnhout, 2013 (Collection d'Études médiévales de Nice, 14), p. 81–106, et EAD., « Modèles épistémologiques de l'enquête encyclopédique sur la nature des choses "ob posteritatis utilitatem" », dans *Apprendre, produire, se conduire. Le Modèle au Moyen Âge. Actes du XLV^e congrès de la SHMESP à Nancy et Metz, mai 2014*, Paris, 2015 (Histoire ancienne et médiévale), p. 235–260.

20. DEROLEZ, *Making and Meaning*, p. 198–199. A. Derolez n'a pas ajouté de nouvelle identification lors de son intervention au colloque de mars 2019, publiée dans le présent volume.

21. Edité par G. BECKER, *Catalogi bibliothecarum antiqui*, I, *Catalogi saeculo XIII vetustiores*, Bonn, 1885, p. 181–184, n°77, après l'édition de Dom Anselme BERTHOD, « Notice du cartulaire de Simon, manuscrit de la bibliothèque de Saint-Bertin », *Nouveaux mémoires de l'Académie des sciences et belles-lettres de Bruxelles, Histoire*, 1, 1788, p. 227–231. Berthod considérait ce catalogue comme du xii^e s., mais il se peut qu'il soit antérieur. Pour les manuscrits conservés originaires de Saint-Bertin, voir les travaux menés sous la houlette de D. Stutzmann à l'IRHT : https://saint-bertin.irht.cnrs.fr/site/php/liste_notices.php?catalogue = st-omer (travail en cours).

22. Odon de Tournai (dit aussi Odon de Cambrai), moine bénédictin et théologien que Lambert a peut-être connu, est un de ces auteurs qui a écrit une disputation antijudaique. Il est né en 1060 à Orléans ; il meurt à proximité de Saint-Omer, à l'abbaye d'Anchin, en 1113. Après avoir enseigné à Toul, il devient écolâtre au chapitre cathédral de Tournai, où il enseigne les arts libéraux, dont l'astronomie. On sait qu'il observait avec ses élèves les constellations et les planètes. Il refonde en 1092 l'abbaye de Saint-Martin autour d'une communauté de chanoines qui adopteront ensuite la règle de Saint Benoît ; il y promeut la copie de manuscrits.

23. BLOCKMANS, *Ordre divin*, p. 12–13 et p. 17, et DEROLEZ, *Making and Meaning*, p. 186–187. A la suite de cette visite, de 1106 à 1108, Lambert aurait travaillé à l'*Histoire de la conquête de Jérusalem par les Francs*, en partant de la version de Fulbert de Chartres apportée par Bohémond.

24. John E. MURDOCH, *Album of Science : Antiquity and the Middle Ages*, New york, 1984, est un ouvrage d'histoire des sciences qui reprend un grand nombre d'illustrations de manuscrits scientifiques médiévaux.

25. Voir les analyses codicologiques dans DEROLEZ, *The Autograph Manuscript* et DEROLEZ, *Making and Meaning*.

26. Cf. A. DEROLEZ, « Le "Liber Floridus" et l'énigme du manuscrit Cotton Fragments vol. 1 », *Mittellateinisches Jahrbuch*, 17, 1982, p. 120–129.

27. À mon sens, le diagramme circulaire du f. 25v du ms. de Gand, U.B. 92 est typique de la manière dont Lambert a réuni dans un seul graphique au moins trois diagrammes isidoriens tirés du *De natura rerum* (dans une version longue proche de celle du ms. Zofingen, Stiftsbibl., Pa 32, f. 60v), pour représenter dans une même *rota* les trente phases de la lune, les vents principaux, les équinoxes et les solstices, les saisons, les éléments et qualités.

28. *Hortus deliciarum*. Planches par Cl. TISSERANT-MAURER, introduction et explication des planches par A. CHRISTEN, Obernai, 1990 [Reconstitution de planches d'après l'ouvrage de Herrade de Landsberg détruit en 1870]. *Hortus deliciarum. Garden of delights. Herrad of Landsberg*, commentary and notes by A. STRAUB and G. KELLER, ed. and translated by A. D. CARATZAS, New Rochelle, N.Y., 1977.

29. L'œuvre a connu de nombreux remaniements après la mort d'Hildegarde. Éd. H. REINER – Th. GLONING, *Hildegard von Bingen Physica : Liber subtilitatum diversarum naturarum creaturarum*, Berlin, 2 vol., 2010.

30. On n'en conserve que deux manuscrits complets (Vatican, Trèves) et un fragment récemment découvert à Leipzig (information que je dois à Monsieur Mackert, directeur de l'Universitätsbibl.), et à la Bibliothèque royale de Bruxelles un reliquat brûlé de l'exemplaire qui se trouvait dans l'abbaye cistercienne de Villers-la-Ville en Brabant. M.-O. GARRIGUES, « L'*Apex physicae*, une encyclopédie du xii^e siècle », *Mélanges de l'Ecole française de Rome*, 87, 1975, p. 303–337 ; transcription et étude : H. EMKE – Gr. MAURACH, « *Apex phisice anonymi* ». *Abhandlungen der Braunschweigischen Wissenschaftlichen Gesellschaft* », 45, 1994, p. 171–263 et 49, 1999, p. 7–80. Th. FALMAGNE, « Un nouveau témoin de l'*Apex phisice anonymi* (ou *De philosophia et eius secretis*) : le manuscrit Bruxelles, B.R. II 3308 provenant de l'abbaye cistercienne de Villers-en-Brabant », *Sudhoffs Archiv*, 87, 1, 2003, p. 69–79.

31. Conservé dans les mss Milano, Bibl. Ambrosiana, D 40 sup. et Y 43 sup. et Troyes, Bibl. municipale, 1317, f. 1–43. Inc. : *Augustinus de ciuitate Dei in libro XVII*. Analyse dans E. BRAMBILLA, « Alle origini dell'enciclopedismo medioevale : il "Liber de auctoritate divina" e il "Liber deflorationum" di Werner di Sankt Blasien », *Aevum*, 57/2, 1983, p. 245–281. Dans la nouvelle édition, cette collection encyclopédique est attribuée à Garnier : éd. G. MAZZANTI, *Guarnerius Iurisperitissimus, Liber divinarum sententiarum*, praef. A. PADOA SCHIOPPA, Spoleto (Perugia), 1999, (Testi, studi, strumenti 14).

32. Éd. D. PINGREE, *Preceptum Canonis Ptolomei*, Louvain-la-Neuve, Academia-Bruylant, 1997 (Corpus des astronomes byzantins, 8) ; voir aussi ID., « Avranches 235 dans la tradition manuscrite du *Preceptum Canonis Ptolomei* », dans *Science antique, science médiévale (autour d'Avranches 235) : Actes du colloque international (Mont-Saint-Michel, 4–7 septembre 1998)*, éd. L. CALLEBAT – O. DESBORDES, Hildesheim, 2000, p. 163–169 ; C. BURNETT, « L'astronomie à Chartres au temps de l'évêque Fulbert », dans *Le temps de Fulbert : enseigner le Moyen Age à partir d'un monument, la cathédrale de Chartres*, éd. par l'Association des Amis du Centre Médiéval Européen de Chartres, Chartres, Société archéologique d'Eure-et-Loir, 1996, p. 91–103, ici p. 96–97. P. KUNITZSCH présente un autre ms. du *Preceptum Canonis Ptolemei* (ms. Hannover, Niedersächsische Landesbibl., IV 394, f. 54r, xii^e s.) dans « Eine bilingue Arabisch-lateinische Lostafel », *Revue d'histoire des textes*, 6, 1976, p. 268–304.

33. Selon la nouvelle chronologie établie par M. CIPRIANI, *La place de Thomas de Cantimpré dans l'encyclopédisme médiéval : les sources du* Liber de natura rerum *- Tommaso di Cantimpré nell'enciclopedismo medievale : le fonti del* Liber de natura rerum. Partie I : *Texte* ; Partie II : *Commentaire* (thèse de doctorat en cotutelle EPHE, Paris - Scuola normale superiore, Pisa), 2014, t. 2, p. 124 *sq.* et ID., « "In dorso colorem habet inter viridem et ceruleum"… *Liber rerum* e osservazione zoologica diretta nell'enciclopedia di Tommaso di Cantimpré », *Reinardus*, 29, 2018, p. 16–98.

34. Cf. I. DRAELANTS – E. FRUNZEANU, « Le savoir astronomique et ses sources dans le *De mundo et corporibus celestibus* de Barthélemy l'Anglais », dans *Rursus. Poiétique,*

réception et réécriture des textes antiques, 11, 2017, http://journals.openedition.org/rursus/1352.

35. *Hic nihil autem in eo pono, nisi quod majorum commendat traditio*. Cf. V. FLINT, «Honorius Augustodunensis: *Imago mundi*», p. 16.

36. *Libri Computi* = Die Aachener Enzyklopädie von 809, éd. A. BORST, *Schriften zur Komputistik im Frankenreich von 721 bis 818*, Hannover 2006, (MGH. Quellen zur Geistesgeschichte des Mittelalters, 21), t. 3, p. 1054–1334.

37. D. BARTHÉLEMY, «Paix de Dieu et communes dans le royaume capétien de l'an mil à Louis VI», *Comptes rendus de l'Académie des Inscriptions et Belles Lettres*, 2014, p. 207–241.

38. Par exemple, le *Dragmaticon* et les *Gloses sur le Timée* de Guillaume de Conches contiennent le même diagramme *Lambda* sur les intervalles musicaux qui se trouve aussi au f. 88 du manuscrit autographe du *LF*. Cf. A. SOMFAI, «The *Liber Floridus* … Philosophical and Scientific Diagrams in Context», (à propos de deux diagrammes dont le contenu conceptuel dérive du *Commentaire* de Calcidius sur le *Timée* de Platon). Elle dit p. 88: «Lambert of Saint-Omer made use of diagrammatic material that was in the making, which appeared in visual encyclopaedias and which was linked with William of Conches or his pupils, whether his involvement with that circle was direct or second hand». A. Somfai compare notamment avec l'«encyclopédie visuelle» du ms. Oxford, Bodleian Libr., Digby 23, qui contient la traduction du *Timée* par Calcidius, glosée, dans laquelle se trouvent aux f. 25r-v et 26r trois diagrammes *lambda* des proportions du ton. La copie est suivie aux f. 51v–54v de divers diagrammes des proportions harmoniques, et de *rotae* sur les planètes, les signes et les éclipses, les climats de la terre, la localisation des eaux et des océans, les phases de la lune, les quatre éléments, et même les localisations des démons aériens, puis des degrés de légèreté des éléments et des saisons, qui se trouvent aussi dans le *LF*. Sur ce type de diagrammes dans les œuvres «chartraines», voir A. HICKS, *Composing the World. Harmony in the Medieval Platonic Cosmos*, Oxford University Press, 2017. Des diagrammes musicaux comparables furent copiés dans un cahier du début du XIIIᵉ s. à la fin du ms. Venezia, Bibl. Marciana, lat. VIII.22 qui contient le *Liber Nemroth* et le *De signis celi*: cf. I. DRAELANTS, *Cinq diagrammes musicaux inédits dans le manuscrit Venezia, Bibl. Marciana, lat. VIII. 22 (2760)*, dans «Textes et savoirs magiques médiévaux entre Orient et Occident», s. dir. J.-P. Boudet – I. Draelants, dossier des *Cahiers de recherches médiévales et humanistes / Journal of Medieval and Humanistic Studies*, 33, 2017–2011, p. 27–41.

39. G. I. LIEFTINCK, «Lambert de Saint-Omer et son *Liber Floridus*», dans *Miscellanea in memoria di Giorgio Cencetti*, Turin, 1973, p. 81–87, ici p. 83–84: «Il n'y a aucun doute: Saint-Bertin était fermé à double tour pour un chanoine de Saint-Omer. Les rapports de voisinage paraissent avoir été des plus mauvais».

40. DEROLEZ, *Making and Meaning*, p. 41.

41. Sur l'histoire du poème d'Aratos et les versions latines successives, le site «Aratea Online» donne des indications précises et synthétiques à la fois: http://www.digital-archiv.at/aratea-online/ (notice par Ivana DOBCHEVA).

42. Pour une bonne synthèse récente sur la question, A. PIRTEA, «Is There an Eclipse Dragon in Manichaeism? Some Problems Concerning the Origin and Function of ātālyā in Manichaean Sources", in *Zur lichten Heimat. Studien zu Manichäismus, Iranistik und Zentralasienkunde im Gedenken an Werner Sundermann. Herausgegeben von einem Team „Turfanforschung"*, Wiesbaden, 2017 (Iranica, 25), p. 535–553.

43. F. 89r: *De ordine et positione signorum. Helice arcturus maior habet stellas in capite .vii., in singulis humeris singulas, in armo .i., in pectore I, in pede priori claras II claras .ii. In summa caude .i. In uentre claram .i. In crure posteriori; duas. In extremo dede .ii. In cauda iii. fiunt xxii.* Illustration 45.2, n°121, dans *Making and Meaning*. On trouvera en ligne un fac-similé

complet du ms. autographe de Gand (aussi sur Google Books): https://lib.ugent.be/en/catalog/rug01:000763774.

44. Illustration 50.2, n°126, dans DEROLEZ, *Making and Meaning*.

45. Jusqu'ici, l'historiographie s'est le plus souvent bornée à répéter les conclusions d'A. Derolez à propos de cette partie astronomique du *Liber Floridus*. Par ex., les contenus astronomiques du *Liber floridus* ont été récemment étudiés par deux membres de l'Institut de physique de l'Université Karl-Franzens de Graz: S. DRAXLER – M. E. LIPPITSCH, «Astronomy in the medieval *Liber floridus*», *Mediterranean Archaeology and Archaeometry*, 16/4, 2016, p. 421–428. L'étude très superficielle des sources n'apporte rien de neuf à ce qui a déjà été écrit, mais la traduction moderne des contenus astronomiques leur donne du sens. Quant au livre récent de Marion DOLAN, *Astronomical Knowledge Transmission Through illustrated Aratea Manuscripts*, Springer, 2017, p. 131–137, il reprend les conclusions d'A. DEROLEZ, *The Autograph Manuscript*, p. 31 et p. 100, notamment concernant le fait que le modèle de Lambert pour cette partie ne peut être constitué des manuscrits des *Aratea* originaires de Saint-Bertin (voir ci-dessous). D'une manière générale, l'ouvrage n'est pas dépourvu d'erreurs dans les textes latins et l'identification des œuvres.

46. Le ms. de Wolfenbüttel a l'avantage de contenir des parties disparues du ms. autographe, comme les illustrations de l'Apocalypse. Voir le facsimilé et le commentaire de HEITZMANN – CARMASSI, *op. cit.* (ma note 1). En revanche, il a perdu lui-même près de 90 feuillets à la fin. Voir l'étude monographique récente sur la transmission du *Liber floridus* par VORHOLT, *op. cit.* (ma note 1).

47. *Making and Meaning*, p. 99–101 pour la description. A. Derolez indique p. 99–100: «The contents of the quire under discussion were not particulary coherent from the beginning, but the strange and inconsistent substitutionnal texts Lambert has subsequently included, after erasure of the original texts, are difficult to understand and have caused real disorder in this part of the codex».

48. Première phase: sous le prévôt Arnould (1075/6–1112/4), aussi archidiacre de l'évêché de Thérouanne; troisième phase: cahiers IIIa, IIIb, IIIbis A, IV a, V a, V b, VI a, VI b. Troisième phase sous Otger, aussi clerc de la chancellerie des comtes Robert II et Baudouin VII de Flandre, en pleine réforme grégorienne. Cf. DEROLEZ, *Making and Meaning*, p. 175–178 pour les diverses phases, auxquelles une chronologie plus fine encore est apportée que dans DEROLEZ, *Lambertus qui librum fecit. Een codicologische studie van de Liber Floridus-autograaf*, Bruxelles, 1978, p. 372–379. Sur le contexte politique en lien avec les phases de rédaction, voir BLOCKMANS, *Ordre divin*, notamment p. 20–21.

49. Sur cette modification codicologique, cf. *Making and Meaning*, p. 102. Le cahier apocalyptique du *Liber floridus* est étudié en profondeur dans le présent volume par H. VORHOLT, qui en fait l'examen codicologique en comparaison avec les autres copies du *LF*, en montrant que ces dernières ont procédé à des ajouts sans modifier le texte antérieur mais en lui adjoignant de nouvelles traductions, notamment relatives aux Anjou. F. FAURE a quant a lui mis en lien l'iconographie de l'Apocalypse avec certaines fresques italiennes.

50. Illustration 119 dans *Making and Meaning*.

51. *Making and Meaning*, figures 45.2–48.1 Dans DOLAN, *op. cit.* (ma note 45), p. 124 *sq.*, le chapitre d'une vingtaine de lignes intitulé «De Signis Coeli of Pseudo-Bede», consacré à ce catalogue des constellations, contient erreurs et approximations; il répète à la suite de DEROLEZ, *The Autograph Manuscript* (ma note 1), qu'il s'agit d'une version variante du «De signis celi» du Pseudo-Bède et oriente sans plus vers les manuscrits illustrés d'Hygin pour y trouver la source des illustrations astronomiques.

52. *De cursu solis et lune per signa XII. Sol Arietem ingreditur in medio Martio et finitur medio Aprili…*

53. *Making and Meaning*, p. 102 et DEROLEZ, *Lambertus qui librum fecit* (ma note 48), p. 170–172.

54. A ce propos, voir l'article de B. OBRIST dans le présent volume.

55. Comme l'a montré A. DEROLEZ, *Making and Meaning*, p. 103.

56. *Making and Meaning*, figure 48.2.

57. *Solis diametros CXL milium stadiorum extenditur, unde duplex quam terre diametros invenitur…– Umbra terre, quam sol post occasum in inferiore hemisperii currens sursum cogit emitti …* (Macrobius, *Commentum in Somnium Scipionis*, I, 18, 10–11 ; 1, 19, 8–13 ; I, 20, 18 ; I, 20, 22–24 ; I, 20, 26–32).

58. *Making and Meaning*, p. 63.

59. *Ignis serenus summum locum tenet ethereus, naturalem sui sedem querens super aera… - Annus X modis dicitur …* (*Making and Meaning*, ill. 113) *– Abissus est profunditas aquarum inpenetrabilis testante propheta David …* (*Making and Meaning*, ill. 63).

60. *Aquarius in Ianuario, cuius nox horas XVI, dies vero VIII. Ianuarius a Iano idolo nomen accepit, vel ab eo quod sit anni ianua, hoc est principium…* (cf. Isidore, *Etym.* V, 33, 3–11). Cf. *Making and Meaning*, p. 102, et illustration 45.1 pour le char du Soleil.

61. *P* = ms. Paris, Bibliothèque nationale de France, lat. 8865.

62. *Making and Meaning*, figure 50.1 (cf. p. 103).

63. *De anno mundano Macrobius a Romulo post multa secula annis finitis XVm. Mundani anni finis est cum stelle omnes omniaque sidera a certo loco ad eundem locum ita remeaverint, u tne una quidem celi stella in alio loco sit quam in quo fuit* (Macrobius, *Comm. in Somnium Scipionis*, II, 11, 10–11 ; II, 11, 15 ; II, 11, 12 ; II, 11, 15–16).

64. *Serpens* ^XV *cauda sua cingit Helicen, hoc est Ursam Maiorem* ^XII*, et cetero circuitu Cynosuram, hoc et Ursam Minorem* ^VII*…* (où les numéros *supra lineam* représentent le nombre d'étoiles composant chaque constellation). Cf. *Making and Meaning*, p. 104–105 ; n. 126, A. Derolez dit «The texts above the picture [planisphère] are various astronomical excerpts, whereas those at the bottom come from an Aratus commentary», et en note 347, il donne à la suite le titre du f. 94r et l'incipit d'un extrait de Bède, ainsi que ce qui est l'incipit de l'*Excerptum*, comme s'il s'agissait de l'explicit du même texte, sans remarquer la différence entre les deux textes, pourtant séparés par le planisphère : *De astrologia secundum Bedam. Stelle a sole illuminantur et sunt immobiles et cum celo fixe perpetuo motu feruntur…* [Bède] *– Duo sunt extremi vertices mundi, quos appelamus polos Septentrionis et Austri* [*Excerptum*] ; p. 105, n. 351, il donne l'incipit du f. 95r sans remarquer qu'il s'agit de la suite du texte du f. 94r, c'est-à-dire de l'*Excerptum*.

65. *Making and Meaning*, figure 51.1.

66. *Making and Meaning*, figures 20.1 à 21.1, commentées p. 66–67. Voir aussi ma note 27 ci-dessus.

67. *Novem ordinibus* [sic] *vel globis conexa sunt omnia, quorum unus est celestis extimus, qui reliquos omnes complectitur…* (Cicero, *Somnium Scipionis*, in Macrobius, *Commentum in Somnium Scipionis*, IV, 1–2 et V, 2 – *Inter celum terramque hec VII sidera pendent. Saturnus candidus natura gelidus…* (Beda, *De natura rerum*, 12–13).

68. *Signa XII. In Ianuario Aquario oriente oritur Equ<u>s Pegasus. In Februario Piscibus ortis oritur Andromedi pars dextera et Piscis Austrinus…* Je n'ai pas pu identifier précisément ce passage, qui n'est pas tiré, contrairement à ce qu'indique DEROLEZ, *Making and Meaning*, p. 105, note 352 («[Aratus], *Isagoga*, p. 117–123») de ce qui est édité par MAASS, *Commentariorum in Aratum reliquiae*, Berlin, 1898, p. 99 *sq.*, comme «Anonymus II Arati Epitomam Isagogis et scholiis auctam continens».

69. Texte de *W*, f. 64v : *De astrologia. Sol apellatus est eo quod solus appareat, obscuratis fulgore suo cunctis celorum sideribus… – Celum superioris circuli Deum virtutesque continet angelicas… – Luna terra maior est et lumen suum in modum speculi a sole irradiata recipit… – Celum a supremo tercium celestes continet potestates…*

70. *Making and Meaning*, n° 131 p. 106. *Ab ignea solis natura illustrantur elementa, ideoque iuxta cursus eius variantur dies et tempora… – De tonitruo et fulminibus Beda. Tonitrua dicuntur ex fragore nubium generari, cum spiritus ventorum earum sinu concepisse ibidem versando pererrantes et virtutis sue mobilitate in quamlibet partem violenter erumpentes concrepant murmure ad instar exilientium de stabulis quadrigarum* (Beda, *DNR*, c. 28–30). Cf. DEROLEZ, *Lambertus qui librum fecit*, (ma note 48), p. 178.

71. *De arcu. Arcus in nubibus quadricolor ex sole adverso nubibusque formatur… - De nubibus. Nubes coacto guttatim aere conglobantur… - De ymbribus. Ymbres ex nubium concrete guttulis* (etc.: Beda, *De natura rerum*, c. 31–35) *– De terre motu. Terre motum vento fieri dicunt, eius visceribus instar spongie cavernosis incluso, qui hanc horribili fremore percurrens et evadere nitens vario murmure concutit et se tremendo vel dehiscendo cogit effundere* (Beda, *DNR*, c. 49). Cf. DEROLEZ, *Lambertus qui librum fecit*, (ma note 48), p. 178–179.

72. Items 154–160 dans *Making and Meaning*, p. 108–109.

73. DEROLEZ, *Le "Liber Floridus" et l'énigme*, (ma note 26), p. 128.

74. DEROLEZ, *Le "Liber Floridus" et l'énigme*, p. 127. Cette situation amène A. DEROLEZ, *Making and Meaning*, p. 184, à se demander comment comprendre la position isolée et «the terribly difficult material circumstances under which our author had to do most of his compilation»? On peut considérer que la familiarité initiale entre le chanoine de Notre-Dame Lambert et l'abbaye bénédictine de Saint-Bertin a peu à peu cédé le pas à des relations plus houleuses, mais cette hypothèse est apparemment contredite par le fait que c'est seulement à une étape tardive que Lambert a utilisé certains auteurs présents dans la bibliothèque de Saint-Bertin, comme Martianus Capella et Raban Maur, et aussi le fait que les fragments Cotton n'étaient pas finis avant 1118–1119. Le constat que des chapitres ajoutés par Lambert à son œuvre à un stade tardif semble être absents de ces fragments pourrait indiquer un changement des relations entre les deux parties durant cette période.

75. J'ai répertorié les annales et chroniques du nord de la France et de la Belgique qui ont des notices originales sur ces éclipses dans I. DRAELANTS, *Eclipses, comètes, autres phénomènes célestes et tremblements de terre au Moyen Âge. Enquête sur six siècles d'historiographie médiévale dans les limites de la Belgique actuelle (600–1200)*, Louvain-la-Neuve, 1995 (*Travaux de la Faculté de Philosophie et Lettres de l'Université catholique de Louvain*, XXXVIII, *Section d'Histoire*, IX).

76. BORST, *Schriften zur Komputistik*, (ma note 36), avec la liste des manuscrits p. 1071–1086.

77. Wesley STEVENS conteste et inverse cette chronologie des «three-books» et du «seven-books» compendia de comput dans le chapitre 8 (VIII. *Compilationes Astronomicae et Computisticae*) de son livre *Rhetoric and Reckoning in the Ninth Century, The "Vademecum" of Walahfrid Strabo*, Brepols, 2018 (Studia Traditionis Theologiae, 24), il appelle les *Libri computi* en sept livres du nom de «*Compilatio DCCCXII*» et la considère comme un compendium écrit en second lieu, tandis que celui en trois livres (appelé *Liber calculationis* par A. Borst), qu'il nomme *Compilatio DCCCVIIII*, aurait été rédigé en premier lieu. M. DOLAN, *Astronomical Knowledge Transmission Through illustrated Aratea Manuscripts*, p. 244, présente les choses dans le même ordre d'après McCLUSKEY 1993 et écrit que le comput en sept livres fut composé à Salzburg vers 818. Vernon K. KING, *An Investigation of some Astronomical Excerpts from Pliny's Natural History found in Manuscripts of the Earlier Middle Ages*, Thesis, Oxford, 1969, p. 77–79, présentait aussi la chronologie dans cet ordre, 810 pour le comput en 3 livres, après 812 pour le comput en 7 livres.

78. E. RAMÍREZ-WEAVER, *A Saving Science. Capturing the Heavens in Carolingian Manuscripts*, University Park,

(Penn.), 2017 (qui ne tient pas compte de la partie compu-
tistique mais la mentionne comme importante). Fac-similé :
M. SANCHEZ MARIANA, *Codice de Metz. Tratado de
computo y astronomia*, Madrid, 1993. Sur les diagrammes,
B. KÜHNEL, *The End of Time in the Order of Things, Science
and Eschatology in Early Medieval Art*, Regensburg, 2003.

79. D'après W. NEUSS, «Eine karolingische kopie antiker
Sternzeichbilder im Codex 3307 der Biblioteca Nacional zu
Madrid», *Zeitschrift des deutschen Vereins für Kunstwissenschaft*,
8, 1940, p. 113–140. Pour B. Bischoff, le ms. Vat. lat. 645 date
du milieu ou du troisième quart du IXᵉ s. et est du nord-
ouest de la France.

80. BORST, *Schriften zur Komputistik*, (ma note 36),
p. 1060.

81. Cf. B. OBRIST, «Les tables et figures abboniennes
dans l'histoire de l'iconographie des recueils de comput»,
dans *Abbon de Fleury : Philosophie, sciences et comput de l'an mil*,
éd. B. Obrist, *Oriens-Occidens : Sciences, mathématiques et philo-
sophie de l'Antiquité à l'Âge classique* (numéro spécial), 4, 2004.

82. Édition A. LOHR, *Der Computus Gerlandi. Edition,
Übersetzung und Erläuterungen*, Stuttgart, 2013.

83. F. WALLIS, «Mss/9605 : An Eleventh-Century
"Science Album"» in *HispaNord. De l'Europe du Nord à
l'Espagne : les manuscrits enluminés français et flamands de la
Biblioteca Nacional de España*, s. dir. Anne-Marie LEGARÉ et
Samuel GRAS, Lille, 2021, sous presse. J'ai pu lire les deux
premiers jets de ce travail.

84. Sur les tables de ce ms. voir notamment
O. NEUGEBAUER, *The Astronomical Tables of Al-Khwârizmî.
Translation with Commentaries of the Latin Version edited by
H. Suter supplemented by Corpus Christi College MS 283*,
Kobenhavn, 1962, (Historisk-filosofiske Skrifter, Bd 4,
no. 2), p. 218. Sur le *Preceptum*, voir ma note 32.

85. Fait en France et daté de 1123, pour le *Timée* dans la
traduction de Calcidius que contient la première partie, et
provenant de l'abbaye d'Osney près d'Oxford pour la deu-
xième partie. Contient p. ex. aux f. 51v–54v les diagrammes
des divisions du ton, des climats, des phases de la lune, des
éléments, qualités et contraires, de la légèreté des éléments,
des saisons.

86. F. GUIDETTI, *Texts and illustrations in Venice,
Biblioteca Nazionale Marciana, ms. Lat. VIII 22 (2760)*,
dans F. PONTANI, Certissima Signa. *A Venice Conference
[16–17 Giugno 2016] on Greek and Latin Astronomical Texts*
(Antichistica 13, Filologia e litteratura 2), p. 97–125, donne
un schéma de la tradition aratéenne en fig. 2, p. 102).

87. H. LE BOURDELLÈS, *L'Aratus Latinus. Etude sur
la culture et la langue latines dans le Nord de la France au VIIIᵉ
siècle*, Université de Lille III, Travaux de recherche, Diffusion
P.U.L., 1985, p. 259–263.

88. C'est cet Aratus révisé qui se mélange pour la pre-
mière fois avec la famille *O* de Germanicus dans le ms. Basel,
U.B. AN IV 18 (Fulda), dont il est question plus bas.

89. *Making and Meaning*, p. 103 (n°121).

90. Cf. D. BLUME, M. HAFFNER, W. METZGER,
*Sternbilder des Mittelalters : Der gemalter Himmel zwischen
Wissenschaft und Phantasie*, I. 800–1200, 1, *Text und Katalog
der Handschriften*, Berlin, 2012, p. 214–218.

91. Fac-similé avec comm. de B. BISCHOFF, B. S.
EASTWOOD, T. A. P. KLEIN, F. MÜTHERICH,
P. F. J. OBBEMA, Lüzern, 1987–1989 ; voir aussi B. S.
EASTWOOD, «Origins and Contents of the Leiden
Planetary Configuration (MS Voss. Q.79) : An Artistic
Astronomical Schema of the Early Middle Ages», *Viator*, 14,
1983, p. 1–40. Les liens entre les trois manuscrits (Leiden,
Bern, Boulogne) viennent d'être rappelés dans J. LIVESEY,
*Science in the Monastery : Texts, Manuscripts and Learning at
Saint-Bertin*, Turnhout, 2020, (Bibliologia, 55).

92. Ed. A. BREYSIG, «Scholia Basileensia», dans
Germanicus Caesar Aratea cum scholiis, Berlin, 1867, p. 55–104 ;
MAASS, *Commentariorum in Aratum reliquiae* (ma note 68),
p. 177 ; l'éd. de référence est de A. DELL'ERA, «Gli

"Scholia Basileensia" a Germanico», *Atti della accademia na-
zionale dei Lincei, Memorie : Classe delle Scienze morali, storiche
et filologiche*, VIII, 23, 1979, p. 301–379. M. HAFFNER, *Ein
antiker Sternbilderzyklus und seine Tradierung in Handschriften
vom frühen Mittelalter bis zum Humanismus. Untersuchungen
zu den Illustrationen der "Aratea" des Germanicus*, Hildesheim,
1997 (Studien zur Kunstgeschichte, 114), a supposé une
traduction latine de Germanicus effectuée *c.* 300 et repré-
sentée par les *Scholia Basileensia*. Les manuscrits relèvent de la
branche v (*classis Francica*).

93. Décrit dans HAFFNER, *op. cit.* (ma note 92), Anhang
I, p. 121–124.

94. LE BOURDELLÈS, *op. cit.* (ma note 87), p. 72–87,
et E. MAASS, «*Arati Latini recensio interpolata*» (= *Scholia
Sangermanensia ad Germanicum*), dans *Commentariorum in
Aratum Reliquiae* (ma note 68), p. XXI–XXII, p. 180 sv. (éd.
des *Scholia*), et p. 309–312.

95. A. BREYSIG, «Scholia Sangermanensia», dans
Germanicus Caesar Aratea cum scholiis, Berlin, 1867, p. 105 *sq.*

96. A. DELL'ERA, «Una "caeli descriptio" d'età caro-
lingia», *Quaderni della facoltà di magistero dell'Università di
Palermo. Serie di filologia latina*, 2, 1974, p. 11 et note 15,
affirme comme l'avait pensé M. MANITIUS, «Ein Excerpt
der *Scholia Basileensia* zu *Germanici Aratea*», *Rheinisches
Museum*, 54, 1899, p. 295–304, ici p. 295, qu'il y a contact
entre l'Aratus latin révisé et les *Scholia Sangermaniensia* pour
VIII 2, XII, 6 et XXI, 1.

97. A. BREYSIG, «Scholia Strozziana et Sangermanensia»,
dans *Germanicus Caesar Aratea cum scholiis*, Berlin, 1867,
p. 105 *sq.*

98. LE BOURDELLÈS, *op. cit.* (ma note 87), p. 257 ;
la source de la branche μ (*classis italica* avec les *scholia
Strozziana*) serait un ms. carolingien de Sicile décrit au XIVᵉ
siècle par Poggio. Sur les classes des familles de Germanicus,
cf. E. LOTT, «The textual tradition of the Aratea of
Germanicus Caesar : missing links in the «μ» branch», *Revue
d'histoire des textes*, 11, 1981, p. 147–158.

99. A. DELL'ERA, «Una rielaborazione dell'Arato
latino», *Studi medievali*, Ser. 3, 20, 1979, p. 269–281, ici
p. 271–272.

100. LE BOURDELLÈS, *op. cit.* (ma note 87),
p. 99–107, sp. 102. Repris par l'étude assez superficielle
d'A. SANTONI, «*De signis coeli* and *De ordine ac positione
stellarum in signis. Two Star Catalogues from the Carolingian
Age*», dans PONTANI, *op. cit.* (ma note 86), p. 127–144, ici
p. 127.

101. Sur ces planisphères, voir E. DEKKER, *Illustrating the
Phaenomena. Celestial Cartography in Antiquity and the Middle
Ages*, Oxford, 2012, dont le c. 3 étudie et regroupe les cartes
du ciel qui accompagnent l'Aratus révisé. Elle les partage
en trois groupes : 1. hémisphères d'été et d'hiver, donnant
le ciel estival et hivernal ; 2. planisphères avec l'ensemble du
ciel, soit vu d'en-haut, c'est-à-dire avec le Zodiaque en sens
horlogique et la Voie lactée, soit vu de l'intérieur, en sens
antihorlogique ; 3. Hémisphères montrant le ciel au nord
et au sud de l'équateur, dont il n'est pas sûr qu'elles soient
héritées des *Phaenomena*.

102. Les manuscrits des *Aratea* de Germanicus illustrés
connus, antérieurs au XVᵉ siècle, sont les suivants : Leiden,
Bibl. der Rijksuniversiteit, Voss. Lat. Q. 79, originaire d'Aix-
la-Chapelle, *c.* 816, auxquels s'apparentent Boulogne-sur-
Mer, B. M. 188, *c.* 1000, avec un planisphère au f. 20r et
Bern, Burgerbibl., 88, f. 1v–7v, fin du Xᵉ-début du XIᵉ s, fait
à Saint-Bertin, planisphère f. 11v ; Basel, Universitätsbibl.,
AN IV 18, originaire d'Allemagne de l'Ouest (peut-
être Fulda), 820–830, planisphère sur un feuillet détaché ;
Aberystwyth, National Libr., 735C, originaire de Limoges
ou de Fleury, *c.* 1000, avec le dessin des hémisphères d'hiver
et d'été aux f. 3r–4r et un planisphère f. 20v (apparenté à
Basel AN IV 18) ; Madrid, Bibl. Nac., 19, originaire du sud
de l'Italie (peut-être Montecassino), 2ᵉ tiers du XIIᵉ s., utilisé
par Michel Scot ; contenait un planisphère aujourd'hui

disparu. Les quelques autres manuscrits sont italiens et du xv^e s.

103. DEKKER, *op. cit.* (ma note 101), p. 192. On trouve les deux hémisphères avec le texte de l'Aratus révisé par ex. dans les mss suivants : Aberystwyth, National Libr. of Wales, 735 C, f. 3r–4r et f. 5v ; Köln, Diözesan- und Dombibl., 83 II, *c.* 805, où les hémisphères manquent aujourd'hui ; Sankt-Gallen, 250, *a.* 889, p. 462 ; Sankt-Gallen 902, p. 76 ; Dresden, Dc 183 ; Paris, lat. 12957 (au f. 63v, la sphère céleste dans un temple), f. 60v–61r ; Paris, lat. 614 (découpé) ; Città del Vaticano, Vat. Lat. 1324, f. 23v (au f. 27, globe céleste dans un temple). S'y ajoutent Bernkastel-Kues, St. Nikolaus Hospital, Stiftsbibliothek, 212, proche de Darmstadt, Universitäts u. Landesbibl. 1020, f. 61v (probablement originaire de Saint-Jacques de Liège avant 1050, contenant le comput d'Helpéric et des extraits des compendia carolingiens de Vérone (*Annalis libellus* de 793), Aix (*Libri computi*), Salzbourg (*Liber calculationis*)), manuscrits dont je ne sais pas s'ils contiennent aussi l'Aratus révisé.

104. Un seul exemple de ce type est conservé dans un manuscrit grec, Città del Vaticano, BAV, Vat. gr. 1291, f. 2v et 4v, qui présente, comme dans les manuscrits d'Aratos, les deux hémisphères célestes en noir, avec les constellations tracées à la peinture blanche. La datation de ce manuscrit, qui ne conserve pas les *Phénomènes* d'Aratos mais les *Tables faciles* de Ptolémée, est controversée, mais l'époque la plus fréquemment retenue est le règne de Léon V (813–820), cf. A. TIHON, « L'astronomie à Byzance à l'époque iconoclaste (viii^e–ix^e siècles) », in P. L. BUTZER – D. LOHRMANN, éd., *Science in Eastern and Western Civilization in Carolingian Times*, Basel, 1993, p. 196–200, ici p. 195–199 (sur le diagramme du f. 9 relatif à la station du soleil dans les signes, dont une des dates possibles est 830/1 ou quatre ans plus tôt ou plus tard) ; pour une mise au point, T. JANZ, « The Scribes and Dates of the Vat. gr. 1291 », in *Miscellanea Bibliothecae Apostolicae Vaticanae*, 10 (2003), p. 159–180. Comme une telle représentation des hémisphères semble unique dans les manuscrits grecs conservés, la coïncidence de date avec l'apparition des mêmes diagrammes dans les manuscrits aratéens latins doit être soulignée et permet d'avancer l'hypothèse d'un contact scientifique entre savants byzantins et carolingiens.

105. Voir ci-dessous la description du ms. de Dresden, Dc 183. Christen LINPICOTT a reproduit certaines de ces illustrations de cartes du ciel dans des PDF du Saxl Project, mis en ligne.

106. B. EASTWOOD, *Ordering the Heavens. Roman Astronomy and Cosmology in the Carolingian Renaissance*, Leiden, Brill, 2007 (Medieval and Early Modern Philosophy and Science, 8), p. 100–101.

107. Éditions : *Patrologia latina*, 90, col. 368B–369C (d'après l'édition de J. HERWAGEN, Bedae, *Opera*, Basel, 1563, t. 1, qui l'avait déjà inclus dans les gloses du *De temporum ratione* de Bède) ; J. KIEHL, « *Hygini Anecdoton* », *Mnemosyne*, 2, 1853, p. 82 *sq.* (d'après le ms. Leiden, Universiteitsbibl., Voss. Lat. Q. 92) ; MAASS, *Commentariorum in Aratum reliquiae*, Berlin, 1898, p. xlv–xlvi, p. 309–312 (d'après les mss. Berlin, Preussische Staatsbibl., Phillipps 1832 (cat. Rose 130), Dresden, Sächsische Landesbibliothek, Dc 183 ; Montpellier, Ecole de Médecine, H 334 ; Paris, B.n.F. lat. 7400A) et A. DELL'ERA, « Una "caeli descriptio" d'età carolingia », (ma note 96), p. 43–46 ; cette dernière édition est complète et tient compte des précédentes. Le texte a été associé à l'œuvre d'Hygin sous le nom de *Yginus philosophus, De imaginibus caeli*, comme dans le ms. du xiv^e s. Paris, B.n.F., 7400A, [ms. *m* dans l'éd. DELL'ERA], ce qui a poussé L. W. HASPER, *Hyginus, Philosophus. De imaginibus coeli (d. i. das dritte Buch des Poëticon Astronomicon des C. Jul. Hyginus)*, Leipzig, 1861, à l'éditer d'après ce manuscrit avec le même titre, considérant ce texte comme le livre III. L'*Excerptum* est aussi attribué à Hygin dans le ms. Sankt Gallen, Stiftsbibl. 250, du dernier quart du ix^e s. HASPER a aussi collationné

le ms. Montpellier, Bibl. de l'École de médecine, H 334, qui contient l'*Excerptum* intégré dans le livre V des *Libri computi*.

108. Editio princeps : *Bedae Opera* II, Köln, 1612, p. 73 *sq.*, reproduite dans la *Patrologia Latina*, 90, 1862, p. 368 *sq.*

109. Voir principalement les listes de BORST, *Schriften zur Komputistik*, (ma note 36), p. 1071–1086 (*Excerptum* = « V 1 ») et de DELL'ERA, « Una "caeli descriptio" » (ma note 96), note 19, auxquels doivent s'ajouter quelques témoins.

110. H. LE BOURDELLÈS, *op. cit.* (ma note 87), p. 85–89, où il dit que l'*Excerptum* fut écrit à la suite d'une carte du ciel tirée de l'Aratus latin et que l'auteur était un moine connaisseur de Pline et de Virgile. Dans l'*Excerptum* il y a une description de la Voie lactée qui ne se trouve dans aucune autre rédaction des traditions aratéennes ; Hygin, qui en décrit le cours, ne l'utilise pas pour situer une constellation par rapport à une autre comme le fait au contraire l'*Excerptum*. Par exemple, l'*Excerptum* affirme que deux constellations apparaissent à l'intersection entre la Voie Lactée et le zodiaque : Gémeaux et Sagittaire, et l'usage de *commissura* pour désigner cette intersection remonte à Pline. Voir aussi le chap. 4, « Lieu de rédaction de l'*Aratus latinus* », p. 251–252. Voir aussi BORST, *Schriften zur Komputistik*, (ma note 36), p. 1243–1250. C. BURSIAN, *Litterarisches Centralblatt*, 1861, p. 854, G. KAUFFMANN, *Breslauer philolog. Abhandl.*, III, 4, 1888, p. 74–76 et E. HEYDENREICH, *Die Hyginhandschrift der Freiberger Gymnasialbibliothek*, 1878, p. 4–5, pensaient que l'auteur de l'*Excerptum* était Alcuin. D'après K. SPRINGSFELD, *Alkuins Einfluss auf die Komputistik zur Zeit Karls des Grossen*, Aachen, 2000, (Sudhoffs Archiv, 48), p. 111, ce n'est probablement pas le cas ; elle considère comme MAASS, *Commentariorum in Aratum reliquiae*, (ma note 68), p. XLV–XVLI que ce pouvait être la traduction d'une œuvre grecque (en outre, Maass l'attribuait à la fin de l'époque romaine).

111. L'argument principal de LE BOURDELLÈS, *op. cit.* (ma note 87), p. 253, est la nécessité d'une bibliothèque qui comprenait à la fois Pline, Hygin, Pseudo-Censorinus et Fulgence le Mythographe (ainsi que le 3^e Mythographe du Vatican), ce qui d'après lui ne pouvait être possible qu'à Corbie. On trouve une *Naturalis historia* de Pline copiée à Corbie au début du ix^e s., mais sans qu'on puisse savoir si elle s'y trouvait depuis la fin du viii^e s. Il serait également possible d'avancer la candidature de bibliothèques de Bavière ou de Suisse…

112. Par ex., le spécialiste de Bède, C. W. JONES, *Bedae Pseudepigrapha : Scientific Writings falsely attributed to Bede*, Ithaca (N.Y.), 1939, p. 35–38, a supposé une origine à Auxerre, auquel cas, comme le note Vernon H. KING, *op. cit.*, (ma note 77), p. 59, l'*Excerptum* aurait pu arriver à Auxerre à l'intérieur d'un manuscrit des *Libri computi*.

113. *P* (= *L* chez Dell'Era : ms. Paris, B.n.F. lat. 8663), et *S* (B.n.F. lat. 12117). Il utilise aussi Dresden, Sächsische Landesbibliothek Dc 183, f. 98r–101r (*D*), qu'il date des ix^e–x^e s. et *K*, London, B.L. Cotton Tiber. B.V, du xi^e s. (que Dell'Era appelle *C*), et encore *D*, Dresden Dc 183, f. 13v–26r, intégré dans le catalogue d'étoiles de l'Aratus latin interpolé (cf. appendice de Dell'Era). Kauffmann donne en cursive toutes les différences avec les *Scholia Basileensia*.

114. Voir ci-dessous la bibliographie pour le *De ordine*.

115. Éd. DELL'ERA, « "Una caeli descriptio" » (ma note 96), p. 49–70, qui tient compte des éditions précédentes et établit le texte (d'après les mss *P*, Paris, B.n.F. lat. 1614 ; *R*, Città del Vaticano, B.A.V., Regin. lat. 309 ; *S*, Paris, B.n.F. lat. 12117 ; *H*, Schloss Harburg über Donauwörth, Fürstliche Öttingen-Wallersteinische Bibl. II, 1, 2°, 110 [= Augsburg, U.B., II. 1. 2° 110] ; *E*, Einsiedeln Stiftsbibl. 178 ; *M*, München, BSB Clm 4423 ; *Z*, Berlin, Staatsbibl., Phillips 1869 ; *D*, Dresden, Sächsische Landesbibl. Dc 183). BORST, *Schriften zur Komputistik*, (ma note 36), p. 1054 *sq.*, en particulier p. 1251–1260, édite le *De ordine* au sein des *Libri computi* et a vu un

beaucoup plus grand nombre de manuscrits. MAASS, *Commentariorum in Aratum reliquiae*, (ma note 68), a édité seulement le début du *De ordine*, à la suite de l'*Excerptum de astrologia*, p. 312, en bas de page, d'après le ms D^{II} [Dresden, Dc 183], f. 99a. Maass cite aussi les mss *M* [Montpellier, H 334] ; München, BSB, Clm 210 ; et *Ph* [Berlin, Phillipps 1832, f. 81a] ; il écrit que ce qui suit dans *P* [Paris, 7400A, xive s.], Hyginus, *De imaginibus celi*, inc. *Duo sunt uertices celi*, éd. HASPER, *op. cit.* (ma note 107)] est imprimé par HASPER p. 15 *sq.* (« *est alia caeli descriptio cum stellarum indicibus Hygini libro III similibus coniuncta* ») ; il ajoute que dans D^I [Dresden Dc 183, f. 32a, *i. e.* la partie où se trouve une autre copie de l'*Excerptum*] vient ensuite le livre d'Hygin. Ces manuscrits du *De ordine* figurent dans la liste commentée en annexe.

116. Hasper se base sur les mss. Paris, B.n.F. lat. 7400A, xive s.; Montpellier, Ecole de médecine, H 334, 2e moitié ixe s., et Paris, B.n.F. lat. 8663, fin xe s. (*L*), qui contient le *De ordine*. HASPER, *op. cit.* (ma note 107) écrit p. 10 : « dieselben Sternbilder, die doch schon in dem dritten Buche des *Astronomicon* behandelt sind, noch einmal begleitet von zum Theil sehr hässlichen Bildern, jedoch in anderer Ordnung, als dort und so, dass einzig und allein die Zahl der Sterne und ihre Vertheilung innerhalb des Sternbildes angegeben wird, währen dort im *Astronomicon* ausserdem die Stellung jedes Sternbildes im Verhältniss zu den andern beschrieben und die mit demselben zugleich auf- und untergehenden anderen Sternbilder angegeben werden » (cité par DELL'ERA, *op. cit.* (ma note 96), p. 6).

117. Aux côtés de la chronique abrégée de l'âge du monde, de l'*Excerptum de astrologia*, et d'extraits de la *Naturalis historia* de Pline. Rück se base sur les mss. München, BSB, Clm 210 (*A*) et Wien, Ö.N.B. 387 (*W*), et Paris, B.n.F. lat. 8663 (*L*), ainsi que Paris, B.n.F. lat. 12117 (*S*).

118. Une deuxième édition, moins bonne, est réalisée en 1899 par M. MANITIUS, *op. cit.* (ma note 96), p. 293 *sv.* Manitius ignore tout ce qui précède, mais connaît l'édition de Hasper.

119. LE BOURDELLÈS, *op. cit.* (ma note 87), p. 106–107.

120. B. BISCHOFF, *Hadoard und die Klassiker-handschriften aus Corbie*, 1961, repr. dans *Mittelalerliche Studien*, 1, 1966, p. 59–60, a montré que le scriptorium de Corbie avait copié au milieu du ixe s. trois manuscrits des *Agrimensores* : Napoli, Bibl. Naz., V A 13, Paris, B.n.F. lat. 13955 (extraits seulement) et Wolfenbüttel, Hertzog-August Bibl., Gudianus lat. 105. Peut-être qu'il y avait un modèle à Corbie antérieur à ces trois copies.

121. Contenu du livre VI d'après les titres de l'éd. de Borst des *Libri computi* (« Aachener Enzyklopädie ») : I. *De ratione unciarum* ; II. *De probatione auri et argenti* ; III. *De mensura caerae et metalli in operibus fusilibus* ; IIII. *Ambrosii Macrobii Theodosii de mensura et magnitudine terrae et circuli, per quem solis iter est* ; V. *Item eiusdem de mensura et magnitudine solis* ; VI. *Felicis Capellae de mensura lunae* ; VII. *Eiusdem argumentum quo magnitudo terrae depraehensa est*. Cf. BORST, *op. cit.* (ma note 36), p. 1062–1063.

122. *Making and Meaning*, p. 82 et note 261.

123. Cf. EASTWOOD, *op. cit.* (ma note 106), p. 127–128, pour le détail.

124. Il s'agit du Paris, B.n.F. nouv. acq. lat. 1249, numérisé sur *Gallica* : https://gallica.bnf.fr/ark:/12148/btv1b52502003c. Cf. *Making and Meaning*, p. 66 et note 201. Le *De computo* est édité dans la *Patrologia Latina*, 137, col. 21–48.

125. LE BOURDELLÈS, *op. cit.* (ma note 87), c. 4, « Lieu de rédaction de l'*Aratus latinus* », p. 252.

126. MAASS, *Commentorum in Aratum reliquiae*, (ma note 68), p. 582–592, fait une édition sur la base du ms. Montecassino, Archivio della Badia, 3, *a.* 874–892 (*C*). A. DELL'ERA, « Una rielaborazione », (ma note 99), donne une édition de θ basée sur tous les manuscrits connus et montre qu'il s'agit d'un remaniement de l'*Aratus latin*.

127. J. HERWAGEN, Bedae, *Opera*, Basel, 1563, t. 1, p. 445–455 ; *Patrologia latina*, 90, col. 945–948D8.

128. A. BREYSIG, *Germanici Caesaris Aratea cum scholiis*, Berlin, 1867, édition p. 233–238 (avec un certain désordre des notices).

129. SANTONI, *op. cit.* (ma note 100), p. 131.

130. Les mêmes scholies apparaissent dans la copie des *Aratea* fragmentaires de Cicéron, originaire de Fleury *c.* 994 dans le ms. London, British Libr., Harley 2506 (cf. BLUME, HAFFNER, METZGER, 2012, 1, p. 327–332). Il existait dès le deuxième quart du xe s. à Fleury une autre copie faite probablement déjà à Fleury en 847 (datation B. Bischoff, § 4367) du *De signis celi* comme texte indépendant, dont les illustrations se fondaient sur un manuscrit tardo-antique : ms. Paris, B.n.F. lat. 5543, f. 158r–171r (f. 160–162, 158–159, 163–171). Il est probable qu'elle ait été le modèle du ms. Harley, mais je n'ai pu le vérifier.

131. Michel Scot reprend dans son *Liber quattuor distinctionum* un catalogue d'étoiles qui s'inspire du manuscrit Madrid, Bibl. nacional, 19, étudié par S. ACKERMANN, *Sternstunden am Kaiserhof : Michael Scotus und sein Buch von den Bildern und Zeichen des Himmels*, Frankfurt am Main, 2009, et EAD., « *Habent sua fata libelli – Michael Scot and the Transmission of Knowledge between the Courts of Europe* », dans *Kulturtransfer und Hofgesellschaft im Mittelalter. Wissenskultur am sizilianischen und kastilischen Hof im 13. Jahrhundert*, éd. G. GREBNER, J. FRIED, Berlin, 2008 (Wissenskultur und Gesellschaftlicher Wandel, 15), p. 273–284. Voir aussi W. METZGER, *Im Anfang war das Bild. Die Sternbilder in der Astrologie des Michael Scotus*, dans *Transfert des savoirs au Moyen Âge – Wissenstransfer im Mittelalter, Actes de l'Atelier franco-allemand, Heidelberg, 15–18 janvier 2008*, éd. St. DÖRR, R. WILHELM, Heidelberg, 2009, p. 149–161.

132. Je connais à ce jour quatre copies complètes subsistantes du *Liber Nemroth*. Sur la forme du *De signis celi* qui suit le *Liber Nemroth* dans le ms. Venezia, Bibl. Marc. VIII. 22, voir GUIDETTI, *op. cit.* (ma note 86).

133. Toutes sortes d'indices montrent que le texte latin est antérieur au début du ixe siècle, peut-être plus ancien. Pour une mise au point : I. DRAELANTS, « Le *Liber Nemroth de astronomia* : État de la question et nouveaux indices », *Revue d'histoire des textes*, nouvelle série, 13, 2018, p. 245–329 ; EAD., « La mesure du monde dans le ms. Montecassino, Archivio dell'Abbazia 318. Étude, édition et traduction des chapitres cosmologiques », dans *Sciences du quadrivium au Mont-Cassin : regards croisés sur le manuscrit Archivio dell'Abbazia 318*, s. dir. L. Albiero – Is. Draelants, Paris-Turnhout (coll. *Bibliologia*, 51), 2018 ; EAD., « "*Depingo ut ostendam, depictum ita est expositio*" : Diagrams as an Indispensable Complement to the Cosmological Teaching of the *Liber Nemroth de astronomia* », dans *Inscribing Knowledge in the Medieval Book : The Power of Paratexts*. Ed. by R. Brown-Grant, P. Carmassi, G. Drossbach, A. D. Hedeman, V. Turner, and I. Ventura, Kalamazoo, MI/Berlin : Medieval Institute Publications/De Gruyter, 2019, p. 57–92.

134. Le ms. Paris, B.n.F. 14754 contient une belle copie du *De signis* aux f. 229v–232v, après le *Liber Nemroth*. Il a été copié à Chartres pour la première partie, contenant le commentaire de Rémy d'Auxerre au *De nuptiis* de Martianus Capella, un commentaire utilisé par Hugues de Saint-Victor avant 1141 ; le manuscrit a été recopié une ou deux décennies plus tard d'une main anglaise pour former le codex devenu Venezia, Bibl. Marciana, VIII, 22 (2760). Dans ce ms., le *De signis celi* est au f. 31v–36r, inc. *Helix arctus maior habet autem in capite stellas obscuras viii.*.

135. Sur l'iconographie des manuscrits de la classe I et de la classe II par rapport au *Liber Nemroth*, cf. DRAELANTS, « Le *Liber Nemroth de astronomia* : État de la question », p. 273–276.

136. Reproduction sur le site de la médiathèque de Dijon : http://patrimoine.bm-dijon.fr/

pleade/img-viewer/MS00448/viewer.html?ns =
FR212316101_MS00448_000_01_PS.jpg.

137. Jacopo Bisagni, que je remercie vivement pour ces informations, m'indique en outre que les contenus du ms. Dijon 448 présentent de nombreux points de contact avec le monde insulaire, ainsi que, peut-être, avec la Bretagne. Par exemple, la mention du *quadrans artificalis* au f. 26r, les nombreuses abréviations insulaires « traduites » par des abréviations continentales dans la copie du *DNR* d'Isidore (f. 37v–47v) ; la rare note annalistique *Sanctus Columbanus Burgundiam intrat* pour l'année 595 (f. 55v), etc. Comme l'a remarqué aussi J. Bisagni, la présence de plusieurs mentions d'*annus praesens* pour des dates différentes (*a*. 853 et 867, *a*. 968, *a*. 1044) trahit une stratification complexe de matériaux carolingiens et post-carolingiens.

138. Dans la figure 6 du *Liber Nemroth*, le sens est en revanche antihorlogique, comme dans les modèles grecs.

139. M. VIEILLARD-TROIEKOUROUFF, « Les illustrations astrologiques des chroniques de Saint-Denis et de Saint-Germain-des Prés (ixᵉ–xiᵉ siècle) », *Bulletin de la Société nationale des Antiquaires de France*, 1963, p. 200–204, a montré que *De ordine* était souvent associé aux annales de l'abbaye pour laquelle il est copié, mais c'est aussi le cas du *De signis celi*. Elle fait le rapprochement entre les illustrations du *De ordine et positione stellarum* dans le Vat. Reg. lat. 309, contenant les *Annales de Saint-Denis*, et dans le ms. Paris, lat. 12117 contenant les *Annales de Saint-Germain-des-Prés*.

140. Sur le contenu computistique du ms., cf. J. M. MILLÀS VALLICROSA, *Assaig d'història de les idees físiques i matemàtiques a la Catalunya medieval*, Barcelona, Estudis Universitaris Catalans, p. 259 et n. 2, 260 et 263 ; p. 264–267. Millàs Vallicrosa voit dans les quatre livres un texte cosmologique-astronomique-géographique rassemblant des matériaux divers, dont beaucoup classiques, mais externe au courant scientifique des traductions de traités sur l'astrolabe. Il présente d'après lui un caractère d'archaïsme de filiation classique et des apports orientaux de naturalisme astrologique, avec des accents hispaniques ; il ne partage pas l'opinion de L. THORNDIKE, *A History of Magic*, II, New York, 1923, p. 707, qui voudrait que ce traité soit une œuvre de Gerbert.

141. Aussi dans le ms. Cambridge, Trinity College, R 15 32, écrit à Winchester dans le deuxième quart du xiᵉ s.

142. Sur la tradition iconographique qui relie ces manuscrits, voir A. W. BYVANCK, « De platen in de Aratea van Hugo de Groot », *Mededelingen der koninklijke Nederlansche Akademie van Wetenschappen. Afd. Letterkunde*, n.r., 12, n°2, 1949, p. 221–223 ; B. OBRIST, « La représentation carolingienne du zodiaque. A propos du manuscrit de Bâle, Universitätsbibliothek, F III 15a », *Cahiers de civilisation médiévale*, 44ᵉ année, n°173, 2001, p. 3–33, ici p. 24.

143. On trouve un planisphère avec le nom des constellations dans les manuscrits suivants : London, British Libr., Harley 647, f. 21v, d'origine lotharingienne, *c*. 830, contenant la traduction par Germanicus des *Phénomènes* d'Aratos et des scholies à la traduction de Cicéron ; Aberystwyth, National Libr. of Wales, 735 C, f. 41r, sans les dessins d'animaux ou de personnages (Limoges ou Fleury, copié par Adhémar de Chabannes *c*. 1000) ; Berlin, Phillipps 1830, f. 11v–12r, le seul qui contienne le *De ordine et p. st.*

144. La transcription diplomatique complète du *De ordine et positione stellarum* dans la version du *Liber floridus* est lisible aux p. [63]-[67], f. 89r–91v de *Liber floridus : Lamberti S. Audomari canonici Liber floridus. Codex autographus Bibliothecae Gandavensis, auspiciis eiusdem Universitatis in commemorationem diei natalis editus*, Ghent, 1968. Je l'ai comparée aux éditions du *De ordine* de DELL'ERA 1974 (ma note 96) et de BORST 2006 (ma note 36), p. 1251–1260 (*libri computi*, V 2).

145. Sur les omissions propres à ce ms., cf. DELL'ERA, *op. cit.*, (ma note 96), p. 24–25.

146. Pour W. STEVENS (*Rhetoric and Reckoning in the Ninth Century*, c. 8. *Compilationes Astronomicae et

Computisticae), ce comput en 3 livres a été réalisé au nord-ouest de l'Autriche, peut-être à Mondsee, entre 812 et *c*. 820. Il note qu'au f. 7, on trouve l'*annus mundi IIII milia DCC LXII* (4772), qui peut correspondre avec *c*. 819, 820, ou 821.

147. L'archétype des *Libri computi* d'Aachen de 809 devait contenir en guise de livre VI (manquant dans le ms. Madrid 3307) des discussions sur les mesures cosmiques, dont la Terre, le Soleil, et la Lune (A. BORST, « Alkuin und die Enzyklopädie von 809 », dans *Science in Western and Eastern Civilization in Carolingian Times*, éd. P. L. Butzer, D. Lohrmann, Basel – Boston - Berlin, 1993, p. 53–78, ici p. 72–73). Le livre VII devait contenir une copie complète du *De natura rerum* de Bède. Dans la copie de Drogon, il ne subsiste plus qu'un fragment du texte de Bède, et d'autres textes additionnels sur les poids et mesures dérivés en partie d'Isidore. Ces éléments correspondent à des contenus que Lambert a pu avoir sous les yeux pour les mesures cosmiques et pour les indications sur les poids et les mesures.

148. Voir ci-dessus, le point 2.2.2. ci-dessus à propos de la séquence de textes dans le livre II du *Liber calculationis* et le livre V des *Libri computi*.

149. Cf. Fl. MÜTHERICH, *Die Buchmalerei am Hofe Karls des Grossen*, in *Karl der Grosse. Lebenswerk und Nachleben*, III, W. BRAUNFELS – P. E. SCHRAMM, éd., *Karolingische Kunst*, Düsseldorf, 1965, p. 9–53, ici p. 50–51, sur les images du *De ordine et positione stellarum* dans le comput en 7 livres des manuscrits Madrid 3307 et Vat. Reg. 309.

150. Description et numérisation sur e-codices : https:// www.e-codices.unifr.ch/fr/description/csg/0250/.

151. MAASS, *op. cit.* (ma note 68), p. XXII.

152. Voir, sur la BVMM (*Bibliothèque virtuelle des manuscrits médiévaux*) de l'IRHT en ligne, le planisphère contenant au centre un *Draco inter actos* avec Ourses entrantes au f. 20r, et le *Draco inter arctos* des *Aratea* du f. 20v https://bvmm. irht.cnrs.fr/iiif/115/canvas/canvas-94675/view) : *Ursa Major, Ursa Minor*, et *Draco* à trois boucles, avec les Ourses en miroir et tête-bêche. Cette première figure du cycle de constellations, le *Draco inter arctos*, est reproduite dans RAMÍREZ-WEAVER, *op. cit.* (ma note 78), p. 85, fig. 42. Voir aussi ma note 91 ci-dessus.

153. Le ms. B.n.F. lat. 13013 est un volume composite constitué de trois unités codicologiques : I, f. 1–23 ; II, f. 24–29bis ; III, f. 30–161.

154. L'exemple n'est pas unique. Ainsi, A. SOMFAI, « The *Liber Floridus*... Philosophical and Scientific Diagrams in Context », a montré que pour le diagramme Lambda, Lambert est intervenu et a modifié le schéma en agrégeant divers diagrammes.

155. P. ex. le ms. Padova, Bibl. Antoniana, I 27 (le serpent horizontal à 4 boucles y est figuré sans les Ourses), au contenu apparent directement aux mss Paris, B.n.F., lat. 14754 et Venezia, Bibl. Marciana, VIII.22, qui contiennent à la fois le *De signis celi* et le *Liber Nemroth*, mais aussi aux f. 67r–71v du Dijon, B.M. 448, qui contient deux versions du *De signis celi* ; aussi Oxford, Bodl. Libr., Laud 644, f. 8r–10v et Durham, Cathedral Libr., Hunter 100, f. 61v–64v (*a*. 1100–1135).

156. Léopold DELISLE commençait de la manière suivante sa « Notice sur les manuscrits du "Liber Floridus" de Lambert de Saint-Omer », dans *Notices et extraits des manuscrits de la Bibliothèque nationale et autres bibliothèques*, 38, 1906, p. 577–791, ici p. 577 : « Le *Liber Floridus* est une compilation tout à fait désordonnée dans laquelle un chanoine de Saint-Omer, nommé Lambert, a fait entrer des morceaux de genres très divers, que le hasard de ses lectures lui faisait remarquer et dont il trouvait à propos de conserver le texte, ou des extraits parfois très courts, en y ajoutant ou faisant ajouter des illustrations aussi nombreuses que variées » ; p. 179 : « compilation assez bizarre et mal ordonnée ». Dans ce long article, L. Delisle compare les neuf manuscrits du *Liber floridus* qui lui sont connus.

157. Une liste de 16 manuscrits est collectée sur http:// certissimasigna.sns.it/ (rubrique *Testi*) de la Scuola Normale

Superiore de Pise par Fabio Guidetti. Le ms. München, BSB, clm 13021, des xii^e–xiii^e s., est à éliminer de la liste, où il y a une erreur dans la cote (indiquée comme Clm 10321, comme dans Saxl III, 1953). Certaines illustrations de ces manuscrits sont reproduites au Warburg Institute (*Aratea*, Pseudo-Beda, *De signis celi*) : http://warburg.sas. ac.uk/vpc/VPC_search/subcats.php?cat_1 = 9&cat_2 = 71&cat_3 = 32&cat_4 = 39&cat_5 = 975&cat_6 = 452, et sur le site du projet Saxl : http://www.kristenlippincott. com/the-saxl-project/manuscripts/, qui donne aussi accès à des descriptions des manuscrits dans un état inachevé, dressées par Christen Linpicott autour de 2002 (fichiers PDF). HAFFNER, *op. cit.* (ma note 92), compte 11 manuscrits du *De ordine* p. 174–176 et décrit l'iconographie du cycle de constellations de Germanicus p. 134–165. La liste la plus complète est celle de BORST, *op. cit.* (ma note 36), p. 1071–1086, avec l'inconvénient que «V 2» corresponde indistinctement au *De signis celi* ou au *De ordine et p. st.*, les deux catalogues de constellations ne sont donc pas distingués l'un de l'autre. Dans le répertoire que j'ai dressé en annexe, les copies du *De signis celi* sont exclues.

158. Le ms. Bruxelles, Bibliothèque royale Albert I^{er}, 2194–2195, provenant de Saint-Omer avant 1200, conserve l'*Excerptum* au f. 49r-v, sans le *De ordine* (BORST, *op. cit.* (ma note 36), p. 1071 et DELL'ERA, «Una "Caeli Descriptio"» (ma note 96), note 19). L'*Excerptum* y est suivi de petites oeuvres computistiques d'Abbon de Fleury. D'après A. Boutemy, il proviendrait de Winchester et serait lié aux mss antérieurs Cambridge, Trinity College, 945, f. 200–212, originaire de Winchester au X^e s., et London, British Library, Royal 13.A.XI, contenant les cinq mêmes opuscules (cf. A. Boutemy, in M.-Th. Vernet-Boucrel, L. Herrmann, A. Boutemy, *Notes sur des manuscrits classiques de la bibliothèque royale (Supplément au catalogue de P. Thomas)*, in *Latomus*, 3, fasc. 2, 1939, p. 126–137, ici p. 128–137.

159. Les copies ont été étudiées récemment par VORHOLT, *op. cit.* (ma note 1).

160. DELL'ERA, «Una "Caeli Descriptio"» (ma note 96), p. 18, 20.

161. Reproduction : https://norman.hrc.utexas.edu/MnEMgal/29/HRC_29.pdf.

162. Éd. *PL*, t. 142, col. 1085–1088. Les autres exemplaires connus de ce texte sont : München, B.S.B., Clm 14477, originaire d'Hersfeld et provenant de St. Emmeran de Regensburg, du xi^e–xii^e s.; Wien, Ö.N.B., lat. 701, du xi^e s., originaire de Saint-Alban à Mainz, découvert par B. Pez ; ms. Paris, B.n.F. lat. 2265, copié à l'abbaye cistercienne de Bonport au xiii^e s.

163. K. ESCHER, *Die Miniaturen in den Basler Bibliotheken, Museen und Archiven*, Basel, 1917, n°84.

164. DELL'ERA, «Una "Caeli Descriptio"» (ma note 96), p. 22, note que le ms. a deux leçons justes qu'il est le seul à conserver, dans l'*Excerptum* et la notice 24, 1 du *De ordine* (*Lyra*).

165. Le dessin, actuellement trop pâli, est donné d'après le tracé de G. THIELE, *Antike Himmelsbilder*, Berlin, 1898, p. 163, par Kristen Linpicott dans sa description de 2012 en ligne https://www.thesaxlproject.com/assets/Uploads/MSS-descriptions-de-ordine-ac-positione-Berlin-130–115-Nov-2012.pdf. Elle a travaillé pour cette description avec Elly Dekker, et une version à jour de leur description est publiée par cette dernière dans *Illustrating the Phaenomena : Celestial Cartography* (ma note 101).

166. Il y a confusion dans la description de K. Linppicott, qui situe «Saint-Bertin» à Metz, alors que les annotations sont du couvent Saint-Vincent de Metz. La source de son information sur les annotations est L. BOSCHEN, *Die Annales Prumienses, Ihre Nähere und ihre weitere Verwandtschaft*, Düsseldorf, 1972 (p. 25, n. 82) qui a vu que le Phillipps 1830 était originellement la première partie du Phillipps 1832; il notait aussi à tort que les annotations dans la première partie du Phillipps 1830 se référant à Metz n'ont été

ajoutées qu'aux xi^e–xii^e s. (alors que la première remonte à 968) ; il ajoutait que les deux textes des f. 81r-v (*Excerptum* et *De ordine et p. st.*) étaient copiés par des mains différentes avec un espacement différent.

167. Éd. BORST, *Schriften zur Komputistik*, (ma note 36), p. 951–1008.

168. B. BISCHOFF, *Die Abtei Lorsch im Spiegel ihrer Handschriften*, Lorsch, 1989, p. 88 et 102–103. Le texte du calendrier a un modèle de Lorsch.

169. Numérisé sur la *Bibliotheca Laureshamensis* : https://bibliotheca-laureshamensis-digital.de/view/sbb-pk_msphillipps1869.

170. Comme Basel, U.B., F III 15h, qui n'est pas non plus illustré ; leurs textes respectifs diffèrent.

171. Numérisé sur la *Biblioteca digitale* du Vatican : digi.vatlib.it/view/MSS_Reg. lat.309.

172. M. LAPIDGE, *Byrhtferth of Ramsey : The Lives of St Oswald and St Ecgwine*, Oxford, 2008, (Oxford Medieval Texts), p. 209, note 10.

173. Description sans reproduction sur le site *Aratea digital* d'Ivana DOBCHEVA : https://aratea-digital.acdh. oeaw.ac.at/pages/show.html?document = desc__dresden_slub_dc_183.xml&directory = descriptions ; il existe une reproduction de 1950, maintenant numérisée, à l'IRHT DS 15138–15147 et quelques photos avant le bombardement de 1945 au Warburg Institute, mais ces dernières ne couvrent pas les parties vues par MAASS, contenant l'*Excerptum* (f. 32r et f. 98r–99r) et le *De ordine* (f. 99r–101r).

174. Cf. DELL'ERA, «Una "Caeli Descriptio"» (ma note 96), appendice : «I cataloghi di stelle nelle "recensio interpolata" dell'Arato latino e la ricostruzione del codice λ», p. 77 *sq.*

175. MAASS, *Commentariorum in Aratum reliquiae*, (ma note 68), en note de la p. 312.

176. H. HOFFMANN, *Schreibschulen des 10. und des 11. Jahrhunderts im Südwesten des Deutschen Reichs*, Hannover, 2004 (M.G.H., Schriften, 53), p. 96.

177. Ce texte pourrait avoir une origine dans le nord de la France, car il semble que le ms. le plus ancien soit Valenciennes, Bibl. municipale, 343, du ix^e s., qui était déjà présent à Saint-Amand au xii^e s.; le texte s'y trouve au milieu d'œuvres de Bède (LE BOURDELLÈS, *op. cit.* (ma note 87), p. 84).

178. BLUME, HAFFNER, METZGER, *OP. CIT.* (ma note 90), disent p. 251–255 (comme K. Linpicott dans la fiche descriptive en ligne) que la tradition iconographique est comparable à celle des mss. Montecassino, Archivio dell'Abbazia, 3 (qui ne contient pas le *De ordine* mais le *De signis*), du Vat. lat. 645 et surtout de Madrid 3307, et que le style des dessins rappelle celui de Reims, avec référence au Psautier d'Utrecht. Sur le manuscrit du Mont-Cassin, voir G. OROFINO, «Il ciclo illustrative del "Libellus de signis coeli" dello pseudo Beda, cod. Cass. 3 : interessi scientifici e cultura figurative a Montecassino durante l'abbaziato di Bertario», dans *Montecassino. Dalla prima alla seconda distruzione*, Montecassino, 1987 (*Miscellanea Cassinese*, 55), p. 571–595.

179. Voir en ligne quelques illustrations sur le site du Paul Getty Museum : http://www.getty.edu/art/collection/objects/1410/unknown-maker-miscellany-of-texts-on-the-quadrivium-english-early-12th-century-additions-early-13th-16th-century/?artview = dor254042.

180. D'après K. Linpicott (description en ligne), l'iconographie du *De ordine* relève du groupe «V» comme le Paris, B.n.F., lat. 8663.

181. Sur ce manuscrit, entièrement numérisé : http://bdh-rd.bne.es/viewer.vm?id = 0000122617&page = 1, voir l'étude complète d'E. RAMÍREZ-WEAVER, *op. cit.* (ma note 78), en particulier p. 8, fig. 3 pour le *Draco inter Arctos*.

182. Je n'ai pas pu vérifier l'existence dans ce ms. du *De ordine*; l'information provient du projet *Ptolemaeus Arabus* : https://ptolemaeus.badw.de/jordanus/ms/3149.

183. Le manuscrit est numérisé sur le site de la Bibliothèque interuniversitaire de médecine.

184. Il est parfois attribué à la bibliothèque de Lobbes, du fait de la présence de ce qui a été édité dans les M.G.H. comme les *Annales Laubacenses*, mais les annales de ce manuscrit n'auraient, d'après François Dolbeau et d'autres érudits, rien à voir avec cette provenance ; certains la rapprochent de Vérone.

185. Cf. E. DEKKER, *op. cit.* (ma note 101), p. 182–191.

186. Reproduction sur le site de la BSB : https://daten. digitale-sammlungen.de/~db/0004/bsb00047183/images/.

187. K. RÜCK, *Auszüge aus der Naturgeschichte des C. Plinius Secundus*, München, 1888, p. 5–10 entre autres.

188. Cf. BORST, «Alkuin und die Enzyklopädie von 809», (ma note 147), p. 73–74. Éd. critique : BORST, *Die Salzburger Enzyklopädie von 818 (Lib. calc.)*, in BORST, *Schriften zur Komputistik* (ma note 36), t. 3, p. 1367–1451.

189. Reproduction disponible sur Gallica : https://gallica. bnf.fr/ark:/12148/btv1b8432469w.

190. Cf. Y. DESLANDRES, «Les manuscrits décorés au XIᵉ siècle à Saint-Germain-des-Prés par Ingelard», *Scriptorium*, t. 9/1, 1955, p. 3–16, ici p. 9 *sq.* Reproduit dans *Gallica* : https://gallica.bnf.fr/ark:/12148/btv1b9076834n.

191. Comme dans le ms. Burgo de Osma, Bibl. Capitolare 7, où le *Spera celi* se trouve après l'*Excerptum*. Il arrive aussi que le *Spera celi* se trouve dans des manuscrits contenant le *De signis celi*.

192. Je dois l'expertise paléographique à Thomas Falmagne, que je remercie vivement.

193. Reproduction disponible à partir d'un microfilm en noir et blanc sur *Gallica* https://gallica.bnf.fr/ark:/12148/btv1b100342892.

194. Le ms. a fait l'objet d'une description par Franz CUMONT, «Astrologica», *Revue archéologique*, 5ᵉ série, 3, 2016, p. 1–22, ici p. 11–16. Ms. numérisé d'après un microfilm en noir et blanc sur *Gallica* : https://gallica.bnf.fr/ark:/12148/btv1b100325759.r = 1614?rk = 42918;4.

195. Cf. Chr. ETHERIDGE, «A Possible Source for a Medieval Icelandic Astronomical Manuscript on the Basis of Pictorial Evidence», *The Retrospective Methods Network Newsletter*, 7, 2013 (*Limited Sources, Boundless Possibilities. Textual Scholarship and the Callenges of Oral and Written Texts*, p. 69–78 ; voir aussi G. HARDARSON, «A *Divisio Philosophiae* in the Medieval Icelandic Manuscript GKS 1812 4°», *Cahiers de l'Institut du Moyen-Âge grec et latin*, 84, 2015, p. 1–21.

196. Dans le *Liber floridus*, la partie de la notice du *Scorpio* relative à la Balance est absente.

197. Ed. et reproduction des illustrations (et du texte, assez fautif) par A. STAERK, *Catalogue des Manuscrits de la Bibliothèque impériale de Saint-Petersbourg*, 1910, t. 1, p. 240 et t. 2, planches LXXXII–VII et une illustration dans *The State Hermitage Museum. Catalogue. The Art of V–XVI Century European Manuscripts*, St. Petersburg, 2005, p. 88–89. J'ai pu montrer lors d'une communication le 21 septembre 2019 à Saint-Petersbourg que le ms. Q.v.IX, 2 se rapprochait fortement de celui d'Austin copié à Tegernsee (mais lié à Fleury), et qu'aucun indice ne montrait une provenance de Corbie ; cela, même si la majorité du fonds ancien de Saint-Petersbourg vient de la bibliothèque de Peter Dubrowski, qui s'était emparé des manuscrits de Saint-Germain, abbaye qui avait elle-même recueilli les manuscrits de Corbie au XVIIIᵉ siècle. (*Le "De ordine et positione stellarum" du manuscrit Saint-Petersbourg, Bibl. nationale, lat. Q.v.IX, 2, histoire et transmission*. Communication au colloque *Manuscrits et chartes d'Europe occidentale de la fin de l'Antiquité au début des temps modernes dans les collections et les dépôts de Saint-Pétersbourg : Recherche, catalogage et édition numérique*, Org. Vladimir Mahzuga, 19–22 septembre 2019).

198. Numérisé : http://digital.onb.ac.at/RepViewer/viewer.faces?doc = DTL_3049329&order = 1&view = SINGLE.

199. Reproductions : http://digital.onb.ac.at/RepViewer/viewer.faces?doc = DTL_2949728&order = 1&view = SINGLE.

Le temps sacré dans le *Liber floridus*

Laura Albiero

Le remarquable ouvrage de Lambert de Saint-Omer est, encore aujourd'hui, une des compositions les plus exceptionnelles et mystérieuses du Moyen Âge. Le caractère à la fois hétérogène et organique de cette entreprise pose des questions de première importance quant aux principes qui régissent l'ordre de cet écrit, son organisation interne, les sources utilisées, les finalités et sa destination. Les manuscrits qui en transmettent les textes ont stimulé l'intérêt des chercheurs et la réflexion à plusieurs niveaux, en raison de leur complexité codicologique, paléographique et décorative. En particulier, le manuscrit qui a été identifié comme l'autographe de Lambert lui-même a été l'objet depuis plus d'un siècle[1] de plusieurs investigations portant sur son écriture, sa structure matérielle et l'organisation de son contenu[2]. Si la fourchette de datation du manuscrit autographe et son milieu de production ont pu être établis avec certitude[3], reste à évaluer l'éventuelle adaptation que les autres témoins ont subi afin de les conformer à des usages différents.

Parmi les études qui ont été consacrées à cette ouvrage, les aspects liturgiques souffrent d'une certaine désaffection et n'ont jamais été examinés de près : et pourtant, c'est bien sur des détails liturgiques que les chercheurs se fondent pour mieux localiser les témoins. Les éléments liturgiques du *Liber floridus* se présentent à trois endroits du manuscrit autographe : le calendrier, la liste des leçons des offices, et les hymnes en l'honneur de Saint-Omer[4]. D'abord, quant au calendrier, il convient d'en voir le contenu et les particularités et d'essayer de comprendre les raisons pour lesquelles Lambert l'a inséré dans sa compilation et quel est son rôle à l'intérieur de l'ouvrage ; deuxièmement, il faudra évaluer la liste des lectures pour en déceler la place et éventuellement le lien avec les autres sections.

Comme Francis Wormald l'avait déjà signalé[5], le calendrier du *Liber floridus* est appelé martyrologe. La différence entre ces deux types d'écrits étant évidente[6], il convient de s'interroger sur ce choix apparemment incohérent. À bien regarder, le « martyrologe » a reçu à tort cette dénomination, s'agissant d'un calendrier à part entière ; toutefois, des rares et succinctes mentions des circonstances ou des épisodes relatifs à la vie du saint en question exhortent à réfléchir sur le lien entre les deux types et leur superposition éventuelle[7], et surtout sur les sources utilisées par Lambert dans la rédaction de cette partie : s'il est possible qu'il ait eu sous les yeux un vrai martyrologe et en même temps un calendrier, cela n'explique en aucune manière pourquoi il aurait eu besoin de fusionner les deux en un seul document, le seul calendrier étant suffisant – à notre sens – à fournir les renseignements nécessaires pour compléter le dossier de comput[8].

Parmi les mentions « martyrologiques » insérées dans le calendrier, sept occurrences seulement évoquent des évènements ponctuels : l'évêque Titus, ordonné par Paul ; Longin, qui a percé le flan du Christ ; le pape Victor qui a succédé à Pierre ; Euprobus, ordonné par saint Clément ; Jean l'évangéliste, plongé dans l'huile bouillante devant la Porte latine ; la translation de Thomas de l'Inde à Édesse ; et Salomé qui se rendit au sépulcre du Christ[9].

À côté de ces indications, on trouve sporadiquement la mention du lieu du martyre pour une série de dix-sept saints de l'antiquité tardive et du haut Moyen Âge[10] : parmi ceux-ci, nous sommes surpris de retrouver des groupes de martyrs qui ne figurent pas dans le martyrologe romain, tels que les 42, les 44, les 18, les 162 et les 500 martyrs. Nous observons la présence de saint Macaire à Gand, d'Isidore dans l'île de Chios : à Rome, de Basile et les Sept frères ; à Auxerre, d'Hélène et Germain ; à Paris, de saint Germain ; en Thébaïde, de saint

Arsène. L'analyse du calendrier a mis en évidence des éléments tout à fait courants et à la fois des aspects absolument remarquables : parmi les éléments, pour ainsi dire, ordinaires du calendrier, nous observons une série de notes de comput, qui se retrouvent habituellement intégrées aux calendriers. L'une de leurs fonctions étant de faciliter le calcul de la date des Pâques, il va de soi que ces indications abondent aux mois de janvier, février, mars et avril, dans lesquels tombent les dates de la Septuagésime, du début du Carême et de la Semaine sainte. On remarque également la présence de tables pascales qui portent la date de 1121. Pour compléter les notes de comput, un feuillet supplémentaire, portant un tableau de correspondance, a été ajouté entre les mois de mars et avril.

Le lien entre la notion du temps et l'usage effectif du calendrier est évident, de telle sorte qu'on ne peut pas s'étonner d'y retrouver également des épisodes bibliques et évangéliques. En effet, le calendrier est parsemé de notes qui renvoient à des évènements de l'Ancien et du Nouveau Testament, comme la Création du monde et d'Adam, et surtout de la vie du Christ, tels que la sortie d'Égypte, la tentation du diable, les noces de Cana et l'Annonciation[11]. Ces notes ne sont pas uniques à ce calendrier, mais il faut observer qu'elles sont ici particulièrement abondantes. Certaines d'entre elles ont été ajoutées par une autre main, peu après la rédaction du texte primitif : c'est le cas, par exemple, de la note qui suit l'Annonciation, qui indique, à la même date, le sacrifice d'Isaac, la traversée de la Mer Rouge et la victoire de saint Michel sur le Dragon.

Comme il arrive souvent dans les calendriers médiévaux, les indications des signes du zodiaque sont inscrites à leur date de changement, ainsi que l'indication du nombre de jours solaires et lunaires de chaque mois et le nombre d'heures du jour et de la nuit. Cette dernière mention est accompagnée, dans les premiers six mois, d'une autre indication qui établit une correspondance entre les mois quant au nombre d'heures. La série des notes est tirée du *De concordia mensium* de Bède[12] et n'a pas eu une large diffusion dans les calendriers liturgiques ; de plus, elle ne correspond pas au calcul du nombre d'heures, car les mois de décembre et de janvier n'ont pas le même nombre d'heures du jour et de la nuit mais diffèrent entre eux de deux heures.

Enfin, les éléments ordinaires comprennent également une série de fêtes et de saints du calendrier romain qui sont très diffusés et qui n'aident pas à détecter les particularités de ce calendrier. On y retrouve les saints que Victor Leroquais[13] appelle « universels » et dont le culte est diffusé à toute l'église latine. S'agissant d'éléments généraux, leur présence est importante pour indiquer que le calendrier suit la structure et le contenu d'un calendrier liturgique, même si les indications de comput sont massivement présents. Mais afin de comprendre en profondeur ce document, il faut considérer également les aspects les plus exceptionnels, les détails inattendus, les indications rares et même uniques, qui sont assez abondantes dans le calendrier du *Liber floridus*.

Parmi ces derniers, le manuscrit autographe de Lambert présente, au mois de janvier, une série de pronostics sur le temps de l'année en fonction du jour de la semaine où tombe le premier janvier. Il suffit de regarder le premier texte pour se rendre compte du caractère tout à fait superstitieux de cette littérature : « si le premier janvier tombe un dimanche, l'hiver sera bon, le printemps venteux, l'été sec, avec abondance de miel, les vendanges bonnes, il y aura beaucoup de froment »[14]. Les deux premiers pronostics sont tout à fait lisibles ; l'écriture apparaît très effacée à partir du troisième, bien qu'il ne s'agisse pas de grattage mais plutôt d'un effacement dû à la composition de l'encre.

Francis Wormald avait déjà attiré l'attention sur une série d'indications de grand d'intérêt historique : d'une part, la mention de noms de lieux qui renvoient à des toponymes identifiables avec des centres proches de Saint-Omer dont Lambert pouvait avoir connaissance. Wormald suppose que ces lieux, inscrits à des dates précises, pourraient indiquer la dédicace de l'église locale, ce qui ne résulte pas clairement du calendrier et nous semble peu vraisemblable : les toponymes sont en fait inscrits dans les marges du calendrier, sans aucune indication de dédicace[15]. Si leur rôle dans le calendrier demande encore à être éclairci, il convient de retenir leur présence en considérant le contexte dans lequel Lambert travaillait et les possibles liens avec des établissement voisins.

D'autre part, la mention de faits historiques qui remontent aux années de compilation du *Liber floridus* est bien présente : ainsi, on retrouve au 21 février la mémoire de la bataille de Cassel de 1071 pour le comté de Flandre ; au 5 avril, la mention de la première croisade en 1097, après le Concile de Clermont ; au 7 juin, la conquête de Jérusalem par les Chrétiens en 1099 ; au 19 octobre, le Concile de Reims de 1119[16]. Ce sont des évènements proches de Lambert que lui-même avait intérêt à consigner pour leur actualité et l'impact qu'ils avaient sur la société de l'époque. Mais ce ne sont pas les seules indications de date dans le calendrier. Les mentions datées relèvent de deux autres types d'indication : la première, et la plus curieuse, concerne la mémoire de phénomènes atmosphériques jugés exceptionnels. Ainsi, un vent pestifère se lève le 29 juin 1113 ; le 30 juillet de la même année, pour faire face au vent qui soufflait encore et à la grande pluie qui ravageait les campagnes, le peuple porta Saint-Omer en procession, obtenant ainsi le beau temps ; le 21 décembre 1118, c'est encore le grand vent qui est enregistré dans le calendrier[17].

Les dernières mentions datées concernent les notes obituaires qu'il faudra ici distinguer : d'un côté, des personnages de haut rang, dont la mort pouvait affecter la vie sociale et politique de l'époque ; de l'autre, des nobles a rayonnement régional, dont l'intérêt est limité à l'aire géographique du Nord-Est de la France ; et enfin, la mention de décès de personnages tout à fait inconnus, qui étaient vraisemblablement liés à Lambert et à son entourage le plus étroit. Parmi les premiers on remarque la présence de Baudoin, roi de Jérusalem, mort en 1118, et celle d'Édouard, roi d'Angleterre (ou Édouard le Confesseur, décédé en 1066) : étant donné que la canonisation de ce dernier remonte à 1161 et est postérieure à la compilation de Lambert, il est cité parmi les notes obituaires et non parmi les saints. Dans la deuxième catégorie on observe la présence de comtes et de comtesse telles que la comtesse de Boulogne Ida, morte selon les annales en 1113 ; la même année, Gertrude de Saxe, comtesse de Furnes ; Adèle de Flandres, reine de Danemark et duchesse d'Apulie, morte en 1115 ; Robert comte de Chelis, mort en 1111 ; Bohemond, duc d'Antioche, qui arriva à Saint-Omer en 1106 ; et

Baudoin VII, comte de Flandres, blessé dans la guerre contre Henri Ier d'Angleterre et mort en 1119, dont les restes ont été ensevelis à l'abbaye de Saint-Bertin. Ces entrées trouvent un correspondant dans les Annales du *Liber floridus*. Enfin, les obits des personnages les plus proches de Lambert : Ornulf, chanoine et père de Lambert ; Arnould, prêtre de Saint-Omer ; les trois derniers noms – Eustachius, Robertus, Elisabeth – n'ont pas été identifiés.

Notes obituaires : catégories

Personnages de haut rang
5 janvier Eduardus rex anglorum obiit
2 avril Balduinus rex Ierusalem obiit

Personnages à rayonnement régional
28 mars Athela duccissa Apulie obiit dominica
30 mars Feria IIII Pasche Boamundus dux Antiochie ad Sanctum Audomarum
13 avril Ida comitissa Bolonie obiit
17 juin Anno domini MCXVIIII comes Balduinus obiit et apud sanctum Bertinum sepultus
4 août Getrudis comitissa Furnensis obiit anno MCXIII
5 octobre Rotbertus Chelis moritur Atrebas sepelitur anno domini MCXI

Personnages à rayonnement local
27 janvier Ornulfus canonicus : Ornulfus canonicus pater Lamberti qui librum scripsit
9 juin Arnulfus prepositus obiit anno MCXVI die sabbato
4 octobre Eustachius obiit anno MCXX
31 octobre Robertus anno MCXI natus
9 décembre Elizabeth obiit

Avant d'aborder le sanctoral en détail, il convient de prêter attention aux vers egyptiacques reportés dans le calendrier. Il s'agit des vers, généralement inscrits en tête de chaque mois, qui indiquent les jours égyptiaques, à savoir des jours considérés funestes, pendant lesquels certaines activités – notamment des activités agricoles – étaient déconseillées. À travers des images poétiques diverses, ils indiquent les jours néfastes en les associant à la mort, à la difficulté, à l'effort, aux blessures, à l'obscurité. Chaque mois contient deux jours néfastes, l'un au début et l'autre vers la fin du mois ; ces jours sont généralement marqués dans le calendrier par une lettre

D, en rouge, et par un verset qui en indique les dates. Plusieurs séries de vers différents sont attestés dans les calendriers médiévaux : John Hennig, qui avait consacré un article à ce sujet[18], a identifié sept séries de vers calendriers, correspondant chacune, plus ou moins, à une tradition déterminée. Or, il se trouve que les vers du calendrier de Lambert ne correspondent à aucune des traditions signalées jusqu'à présent. Chaque vers est par ailleurs caractérisé par une assonance interne qui le divise en deux parties inégales.

Versus de mensibus in Ghent 92

1. Iani prima furit lux septima sanguinis urit
2. Mors februi quarta mors tercia stat tibi parta
3. Mars necat in primo prosternit quartus ab imo
4. Dena sub aprili gravis est undenaque fili
5. Est mai pigra lux tertia septima nigra
6. Iunii dena ligat quindenaque membra fatigat
7. Iulii tredecima lux denaque sternit ad ima
8. Augusti prima parat antra secundaque lima
9. Tercia dissolidat septembris dena trucidat
10. Nota sit octobris lux tercia denaque probris
11. Quinta nocet membris et tercia plaga novembris
12. Septima cum dena rapit ossa decembris hyena

Il convient d'observer que ces vers semblent avoir été ajoutés au calendrier, probablement par la même main, après l'achèvement du texte principal. En fait, ils ne sont pas inscrits au début de chaque mois mais à l'intérieur du calendrier, dans un espace resté libre. Malgré plusieurs essais d'identification, notamment avec des calendriers anglais, leur source demeure inconnue.

Pour ce qui est du sanctoral proprement dit, le calendrier de Lambert se distingue par une série de caractéristiques hagiographiques qui marquent ce texte comme une production tout à fait locale. Il a déjà été observé[19] que le calendrier présente une série de saints anglais, comme il arrive souvent dans les sources du Nord-Est de la France : Cuthbert évêque de Lindisfarne (30 mars) ; Dunstan évêque de Cantorbéry, exilé à Saint-Bertin (19 mai) ; Augustin, évangélisateur de l'Angleterre (26 mai). On observe également la présence d'une série de saints à caractère régional, à savoir des personnages dont le culte n'est ni universel ni propre à Saint-Omer : il s'agit de saints du Nord de la France, vénérés dans l'ancien diocèse de Thérouanne dont Saint-Omer faisait partie, ou bien dans des régions voisines, comme le Brabant, le diocèse d'Amiens et celui de Rouen. Plusieurs évêques de Thérouanne sont mentionnés, aussi bien que des moines, des abbés et des abbesses des monastères installés dans la région. Enfin, on remarque la présence de fêtes typiques de Saint-Omer : pour saint Omer, trois fêtes sont inscrites dans le calendrier, à savoir le *dies natalis*, la translation et l'*inventio* du corps ; pour saint Bertin, la fête principale et la translation ; la fête de saint Winnoc, moine anglais disciple de saint Bertin.

Sanctoral du *Liber floridus*

1. Saints anglais
 Cuthbert évêque de Lindisfarne (20.3)
 Dunstan évêque de Cantorbéry (19.5)
 Augustin évêque de Cantorbéry (26.5)
2. Saint régionaux
 Aldegonde de Mauberge (30.1)
 Austreberte, abbesse de Pavilly (10.2)
 Aubert, abbé de Fontenelle (9.2)
 Silvin de Thérouanne (17.2)
 Walburge, abbesse de Hildenheim (25.2)
 Gertrude abbesse de Nivelles (17 mars)
 Erchembode de Thérouanne (12.4)
 Richel de Celles (26.4)
 Machaire de Gand (8.5)
 Bain de Thérouanne (20.6)
 Wilmar, fondateur de Hautmont (20.7)
 Translation de saint Amand (26.10)
 Quintin et Follien (31.10)
 Livin, moine anglais, dont les reliques sont à Gand (12.11)
 Fuscien, Victoric et Gentien (11.12)
 Folquin de Thérouanne (14.12)
3. Saints locaux
 Translation de saint Omer (8.6)
 Translation de saint Bertin (16.7)
 Bertin (5.9)
 Omer (9.9)
 Invention de saint Omer (21.10)
 Winnoc, disciple de saint Bertin (6.11)

L'usage liturgique de ce calendrier est aisément identifiable comme étant celui de Saint-Omer ; et pourtant, Francis Wormald estimait qu'il ne pouvait pas être utilisé pour la liturgie,

et que Lambert l'avait copié d'après un calendrier de Saint-Omer, en le laissant incomplet et en y ajoutant des notes de comput, des références aux annales et des précisions tirées du martyrologe. Il faut observer que ce problème concerne la plupart des calendriers liturgiques, qui ne contiennent pas forcément toutes les informations nécessaires pour repérer les fêtes d'un établissement particulier. Cependant, l'observation de Wormald est digne d'attention dans la mesure où, si un calendrier à l'usage de Saint-Omer pouvait bien fonctionner localement, il faut se demander comment celui-ci était adapté une fois que le *Liber floridus* était copié pour être utilisé ailleurs.

Nous avons pris le soin d'examiner d'autres copies du *Liber floridus*, en particulier les copies les plus anciennes : il s'agit des manuscrits Wolfenbüttel, Herzog August Bibliothek, Cod. Guelf. 1 Gud. lat. (XIIᵉ siècle), et Leyden, Universiteitsbibliotheek, Voss. Lat. f. 31 (XIIIᵉ siècle)[20]. Dans les manuscrits considérés, l'adaptation liturgique attendue n'a pas été mise en place : tous les calendriers présentent exactement le même sanctoral à l'usage de Saint-Omer, à quelques exceptions près.

Les différences entre le calendrier de Ghent 92 et ceux de Wolfenbüttel et Leyden ne relèvent pas de l'adaptation à un autre usage, mais plutôt de l'alignement sur un sanctoral déjà très localisé. Par exemple, le 1ᵉʳ mai, sainte Walburge, absente de Ghent 92, est copiée de première main dans les deux autres manuscrits (Fig. 1) : il s'agit d'une sainte anglaise qui a fait œuvre d'évangélisation dans les pays germaniques et qui est vénérée à Heidenheim, dont on célèbre en ce jour la translation des reliques. Son nom se trouve dans le calendrier de Lambert uniquement au 25 février, *dies natalis* de la sainte. Encore, le 1ᵉʳ octobre saint Germain est inséré parmi saint Remi et saint Bavon, selon un usage courant dans les calendriers du Nord de la France ; au 31 octobre, saint Feuillen de Fosses, missionnaire en Belgique, fait son apparition à côté de saint Quentin ; les saints Césaire et Eustache sont présents respectivement les 1ᵉʳ et 2 novembre ; saint Aubert, évêque de Cambrai, est inscrit au 13 décembre.

Il est certes imprudent de tirer des conclusions à partir de détails si peu significatifs : il vaut toutefois la peine d'examiner les calendriers dans leur ensemble, et de tenir compte

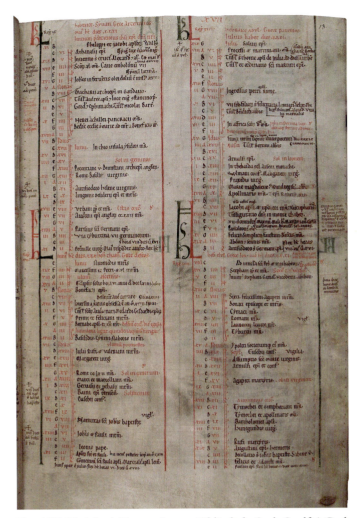

Fig. 1. Wolfenbüttel, Herzog August Bibliothek, Cod. Guelf. 1 Gud. lat., folio 18, Lambert de Saint-Omer, *Liber floridus*, XIIᵉ siècle, troisième quart : calendrier (mois mai-août).

d'autres détails qui sont susceptibles de donner des informations importantes sur la fonction des éléments liturgiques. L'observation ponctuelle des autres éléments du calendrier suggère que certaines informations, qui pourraient nous sembler superflues, ont été conservées dans les copies successives, alors que certains détails ont été supprimés. Les événements historiques, par exemple, tels que les épisodes liés aux croisades, sont encore présents dans les sources plus tardives, bien qu'ils ne fussent plus d'actualité. De même, les événements atmosphériques se retrouvent dans les manuscrits de Wolfenbüttel et Leyden, alors qu'on pourrait se demander quelle était l'utilité de ce type d'information. Quant aux vers des mois, ils sont eux aussi copiés dans tous les témoins successifs, et gardent leur place à l'intérieur du texte, sans avoir été reportés en début de chaque mois : il semble que les copistes

Différences dans le Sanctoral

	Ghent 92	Wolfenbüttel	Leyden
1 mai	Philippi et Iacobi	Philippi et Iacobi + Walburge (tr.)	Philippi et Iacobi + Walburge (tr.)
1 octobre	Remigii Bavonis *et al.*	Remigii Germani Bavonis *et al.*	Remigii Germani Bavonis *et al.*
31 octobre	Quintini	Quintini et Folliani	Quintini et Folliani
1 novembre	Omnium sanctorum	Omnium sanctorum + Cesarii	Omnium sanctorum + Cesarii
2 novembre	Omnium fidelium defunctorum	Omnium fidelium defunctorum + Eustacii	Omnium fidelium defunctorum + Eustacii
10 novembre		Martini pape	Martini pape
13 décembre	Lucie	Lucie + Auberti	Lucie + Auberti

Correspondance d'éléments dans les calendriers (hors sanctoral)

	Ghent 92	Wolfenbüttel	Leyden
Evènements historiques	x	X	x
Evènements atmosphériques	x	X	x
Versets des mois	x	X	x
Noms de lieux	x		
Notes obituaires			
5.1 Eduardus rex anglorum	x	X	x
27.1 Ornulfus canonicus	x		
28.3 Athela duccissa Apulie	x		
30.3 Boamundus dux Antiochie	x		
2.4 Balduinus rex Ierusalem	x	X	x
13.4 Ida comitissa Bolonie	x		
9.6 Arnulfus prepositus	x		
17.6 Comes Balduinus	x		
4.8 Getrudis comitissa Furnensis	x		
4.10 Eustachius	x		
5.10 Rotbertus Chelis	x		
31.10 Robertus	x		
9.12 Elizabeth	x		

Leçons liturgiques

Fête	Livre biblique
Vigile de Noël	Isaïe
1er dim. après Noël – Septuag.	Épîtres de Paul
Épiphanie	Isaïe
Septuag. – 15e jour avant Pâques	Pentateuque
15e jour avant Pâques – Jeudi saint	Jérémie
Jeudi saint – Vendredi saint – Samedi saint	Lamentations Épîtres de Paul Augustin (ps. 53)
Octave de Pâques – Ascension	Actes des Apôtres, Épîtres canoniques, Apocalypse
Octave de Pentecôte – 1er août	Rois, Paralipomènes
Août	Proverbes
Septembre	Job, Tobie, Esther, Esdras
Octobre	Maccabées
Novembre	Ezéchiel, Daniel, Prophètes mineurs
Décembre	Isaïe

successifs aient été soucieux de respecter non seulement les informations contenues dans le manuscrit original, mais aussi sa présentation.

Les noms de lieux, en revanche, ne sont pas reportés dans les sources successives, du fait, peut-être, qu'ils étaient sans rapport avec l'usage local ou le contenu même du manuscrit. Les notes obituaires méritent une remarque particulière. En fait, seule une petite partie d'entre elles a été reportée dans les manuscrits successifs, et notamment les notes obituaires des personnages les plus importants et les plus connus : Édouard, roi d'Angleterre, et Baudoin, roi de Jérusalem. Tous les autres ont été supprimés, et non seulement les figures proches à Lambert, mais aussi les comtes et les ducs dont l'intérêt tient à leur caractère régional. Cet aspect ouvre de nouvelles interrogations quant à l'usage du calendrier et sa valeur liturgique : si les notes obituaires ont été supprimées en tant que marques d'un régionalisme trop localisé, on pourrait se demander pourquoi le sanctoral n'a pas été adapté à l'usage du lieu.

Avant de répondre à cette question, il convient de regarder la liste des leçons qui apparaît dans l'autographe de Lambert (folio 98v–99). Comme Albert Derolez l'avait déjà observé[21], la séquence des lectures correspond à celle donnée par Burchard de Worms dans son *Decretum*, en accord avec la tradition plus ancienne. Il s'agit en effet des lectures bibliques du premier et deuxième nocturne de l'office, qui correspondent aux livres bibliques qu'il faut « poser » dans des temps déterminés de l'année liturgique. Ainsi, on aura Isaïe à la vigile de Noël, les épîtres de Paul dans le temps de Noël, selon un schéma qui attribue à un livre biblique une signification pertinente par rapport à la période liturgique de référence.

Pour les lectures non bibliques et notamment pour les fêtes du sanctoral, il y a une vague mention des leçons et des homélies qu'il faut choisir selon ce qui convient à l'occurrence liturgique. Les seules lectures non bibliques mentionnées concernent le *triduum sacrum*, qui comporte, pour chaque jour, trois leçons des Lamentations, trois des Épîtres de Paul et trois du traité d'Augustin sur le psaume 53. Les lectures bibliques du temps d'été sont organisées par mois solaires, selon un programme qui change de livre biblique ou d'ensemble cohérent de livres pour les mois d'août à novembre. On observe par ailleurs que, pour la même période, les leçons du troisième nocturne – des homélies sur une péricope évangélique – continuent à suivre la série des dimanches après la Pentecôte et que les deux cycles ne se superposent pas forcément de la même manière d'une année à l'autre.

Il est significatif de noter que cette partie a été reportée dans une seule autre copie du *Liber floridus*, la latin 8865 de la Bibliothèque nationale de France. En effet, des indications si générales ne pouvaient pas être d'une grande utilité, alors qu'une église disposait généralement d'un lectionnaire de l'office et d'un ordinaire. On notera que les indications de cette liste sont valables uniquement dans un contexte non monastique : dans ce dernier, les leçons d'Isaïe pour le premier nocturne de la vigile de Noël et de l'Épiphanie seraient au nombre de quatre et non de trois, comme mentionné ici. On peut bien comprendre que cette liste ait été jugée superflue et qu'elle n'ait pas été copiée dans la plupart des sources ; il est toutefois légitime de se poser la question quant aux raisons qui ont conduit Lambert à l'insérer dans sa compilation.

A bien regarder, on s'aperçoit qu'il y a une idée de fond qui émerge dans toutes les différentes parties et les aspects concernant le *Liber floridus* : c'est la notion du temps, de sa mesure et de son organisation. Le contenu du *Liber floridus* est conçu sur ce concept : d'un côté, le comput répond à la question des principes constitutifs de la notion de temps et de son calcul[22] ; de l'autre, les annales projettent la dimension temporelle dans la linéarité du temps.

La liturgie joue un rôle fondamental dans la perception du temps : non seulement parce qu'elle matérialise la notion du temps dans la circularité de l'année liturgique et dans la récurrence des temps liturgiques, mais aussi, et surtout, parce que le temps médiéval est fondamentalement un temps liturgique, dont le rythme et l'organisation sont gérés par la transformation du temps astronomique et historique en un temps sacré. L'année liturgique, structurée en périodes, semaines, jours et heures, constitue l'ensemble des références de base de l'homme médiéval, tant clerc que laïc. Ce n'est pas un hasard si les référents temporels, à l'intérieur des actes et des chartes, renvoient souvent à des jours liturgiques, de

la même manière qu'on mentionne une date quelconque.

Le cycle des lectures bibliques a justement cet ancrage : comme l'organisation du temps liturgique est réglé par les fêtes de l'année solaire et le calcul de la date des Pâques, la perception du changement du temps repose sur les textes qui se succèdent d'une semaine à l'autre, et qui diversifient ainsi les différents temps en les caractérisant. Ainsi, le livre d'Isaïe marque le temps de l'Avent pour son caractère prophétique qui le rend propice à une lecture adaptée à l'attente de la venue du Christ. Les livres bibliques constituent alors un marquage assez fort de la dimension temporelle dans la vie médiévale et c'est à ce titre que Lambert les a inclus dans son ouvrage.

L'importance de l'aspect temporel en tant que reflet d'une pratique qui forge le déroulement de l'année pourrait impliquer une forte localisation des témoins : et pourtant, si l'ancrage au temps vécu est à la base de la rédaction du calendrier, pourquoi le sanctoral n'a pas été adapté dans les témoins copiés ailleurs qu'à Saint-Omer ? Parce que le *Liber floridus* est un instrument qui fonctionne dans un système auto-référentiel. Le calendrier renvoie constamment aux éléments de comput, au catalogue des rois, aux événement signalés dans les annales, aux faits qui ont marqué les années de sa rédaction. Toute adaptation aurait dénaturé ce système en le rendant inutilisable : pour lire le *Liber floridus* avec un calendrier adapté à un usage différent, il aurait fallu le réécrire entièrement.

Il faudrait enfin s'interroger sur la valeur liturgique de ces documents, et également sur le concept de liturgie. Si on l'admet que la liturgie est une pratique et que ces textes et ses livres ne sont qu'un support servant au bon déroulement des cérémonies et des rituels, le calendrier et la liste des leçons ne sont pas des documents liturgiques. La référence à la liturgie est ici inévitable, parce que la liturgie articule l'organisation du temps et parce qu'on peut faire référence à la temporalité seulement à travers les éléments qui structurent le temps, qui sont des éléments liturgiques : dans la compilation de Lambert, le calendrier, ainsi que les leçons bibliques de l'office, n'ont pas été choisis pour leur valeur fonctionnelle dans un contexte liturgique, mais pour leur capacité à rendre perceptible l'organisation du temps et de ses changements.

NOTES

1. Léopold Delisle a pour la première fois identifié la main du manuscrit Ghent, University Library, MS 92 comme celle de Lambert ; l'attribution a été confirmée par Albert Derolez. Cf. L. DELISLE, « Notice sur les manuscrits du "Liber floridus" de Lambert, chanoine de Saint-Omer », *Notices et extraits des manuscrits de la Bibliothèque nationale et autres bibliothèques*, 38, 1906, p. 577–791.

2. Cf. A. DEROLEZ, *The Making and Meaning of the* Liber floridus. *A Study of the Original Manuscript Ghent, University Library MS 92*, London, 2015, qui fait aussi le point sur la bibliographie précédente.

3. Le manuscrit a vraisemblablement été copié dans les premières années du XIIᵉ siècle, les dernières annotations ayant été ajoutées peu avant la mort de Lambert (1121), à Saint-Omer, certainement à Notre-Dame, où il était chanoine.

4. Respectivement, les numéros 38, 148 et 298 du classement Delisle, *op. cit.* (notre note 1). Les hymnes, s'inscrivant dans le contexte fortement localisé de l'autograph, ne seront pas traitées dans cette contribution.

5. Gand 92, folio 26v. Cf. F. WORMALD, « The Calendar of the Liber Floridus », dans *Liber Floridus Colloquium*. Papers read at the International Meeting held in the University Library Ghent on 3–5 September 1967, éd. A. DEROLEZ, Ghent, 1973, p. 13–17.

6. Le calendrier liturgique présente une ligne pour chaque jour et la mention des fêtes à date fixe, notamment des occurrences du Sanctoral ; le martyrologe contient, pour chaque jour concerné par une fête, une mention brève – éventuellement un peu plus développée dans les martyrologes historiques – des circonstances du martyre, du lieu de la mort et des éléments chronologiques.

7. Leur rapprochement devient évident en considération de l'usage liturgique du martyrologe, à l'office du chapitre : dans ce contexte, plusieurs typologies sont réunies dans un seul livre et le martyrologe trouve sa place à côté d'un calendrier-obituaire, d'un homéliaire, d'une Règle et d'un lectionnaire.

8. Il convient de remarquer que l'intitulation "martyro-loge" a été conservées dans les copies non autographes du Liber floridus (Leyden, Bibliotheek der Rijksuniversiteit, Voss. Lat. Fol. 31, folio 127v ; Wolfenbüttel, Herzog August Bibliothek, Cod. Guelf. 1 Gud. lat. ; Gènes, Bibliothèque Durazzo Giustiniani, A IX 9, folio 16v ; Chantilly, Musée Condé, 724, folio 18v ; La Haye, Koninklijke Bibliotheek, 72 A 23, folio 16v et 128 C 4, folio 33).

9. Cf. au 4 janvier, *Tyti episcopi quem Paulus ordinavit* ; au 15 mars, *Longini martyris qui latus Christi perforavit* ; le 20 avril, *Victoris pape post Petrum V* ; au 30 avril, *Euprobii episcopi quem sanctus ordinavit Clemens* ; au 6 mai, *Iohannes in ferventis olei dolium missus est ante portam latinam* ; au 3 juillet, *Translatio*

sancti Thome apostoli de India ad Edissam urbem ; au 22 octobre, *Salome que ad sepulchrum domini venit.*

10. Le 8 janvier, *Belvacum Luciani Iuliani* ; le 10 mars, *In Persida XLII martyrum* ; le 14 mars, *Rome XLIII martyrum* ; le 9 avril *In Syrmio VII virgines* ; le 16 avril *Cesarauguste XVIII martyrum* ; le 9 mai, *Translatio Andree apostoli et Luce evangeliste Constantie* ; le 16 mai, *In Chio insula Ysidori martyris* ; le 20 mai, *Rome Basille virginis* ; le 22 mai, *Autisiodoro Helene virginis* ; le 23 mai, *Lingonis Desiderii episcopi et martyris* ; le 28 mai, *Parisius sancti Germani episcopi* ; le 29 mai, *Via Tyburtina VII Germanorum* ; le 17 juin, *Rome CCLXII martyrum* ; le 13 juillet, *In Affrica sanctorum D martyrum* ; le 19 juillet, *In Thebaida sancti Arseni monachi* ; le 31 juillet, *Autisiodoro sancti Germani episcopi* ; le 15 octobre, *Colonie Maurorum CCCLX martyrum.*

11. Le 11 janvier, *Eductio domini de Egypto* ; le 9 février, *Diabolus recessit a deo* ; le 17 février, *Iesus ad nupcias die tercia post ieiunium XL dierum* ; le 25 mars, *Mundus factus Adam plasmatus Christus adnuntiatus et passus*, auquel s'ajoute l'addition *Immolatio Isaac et transitus filiorum Israel per mare rubrum et victoria Michaelis archangeli contra draconem* ; le 28 avril, *Egressio Noe de Archa.*

12. Beda Venerabilis, *De temporum ratione liber*, éd. Ch. W. JONES, Turnhout, 1977 (CCSL 123B).

13. V. LEROQUAIS, *Les Bréviaires manuscrits des bibliothèque publiques de France*, vol. 1, Paris, 1934, p. LXVI.

14. Ghent 92, folio 26v : *Si Kalendae Ianuarii dies dominicus fuerit, hiemps bona, ver ventuosus, estas sicca, mellis habundantia, vindemia bona, frumenti copia.*

15. Cf. par exemple *Blendiacus* le 26 septembre, *Broker* le 22 août, *Rike* le 12 avril.

16. Le 21 février, *Bellum Casel. Anno domini MLXXI* ; le 5 avril, *Item Iᵘᵐ Christianorum Ierusalem post Clarimontis concilium anno 1097* ; le 7 juin, *Ierusalem a Christianis obsessa est anno MXCVIIII* ; le 19 octobre, mention ajoutée, *Concilium Remis Calixti pape anno domini MCXIX.*

17. Au 29 juin, *Hic ventus pestiferus incepit anno MCXIII* ; au 30 juillet, *Anno MCXIII, V Kal. Augusti ventis flante pestifero Audomarus deportatus a populo quia pluvia magna erat, et facta est serenitas* ; au 21 décembre, *Ventus magnus anno domini MCXVIII.*

18. J. HENNIG, « Versus de Mensibus », *Traditio*, 11, 1955, p. 65–90.

19. Cf. WORMALD, *op. cit.* (notre note 5).

20. Le manuscrit Paris, Bibliothèque nationale de France, lat. 8865, datant également du XIIIᵉ siècle, ne contient pas de calendrier.

21. A. DEROLEZ, *The autograph manuscript of the Liber Floridus : a key to the encyclopedia of Lambert of Saint-Omer*, Turnhout, 1998, p. 106.

22. A. DEROLEZ, *Die komputistischen Tafeln des Liber floridus*, Trier, 2003.

Time in Medieval Philosophy. Concepts and Considerations on a Complex Phenomenon

Hans Otto Seitschek

Introduction

Time is a central and important subject of medieval thinking, throughout different schools and traditions. It is linked with the concept of the eternal. First, ancient sources of medieval concepts of time will be explained, in particular Augustine in late antiquity, and then the main topics of medieval concepts of time will be discussed, especially concerning the context of God and time. Finally, the consequences of medieval thoughts on time on modern philosophical positions are introduced.

The importance of time in medieval thinking is not least proofed by the encyclopedic work of the *Liber floridus* in the early twelfth century. The autograph has been preserved at the University Library in Ghent.[1] Time plays quite an important role in the compiled work (*ex multis excipere optimum*)[2] of Canon Lambert of Saint-Omer (Saint Audomar) in northern France respectively Flanders, because '[t]he World as a whole in its static and dynamic aspects is the subject of Lambert's work'.[3] A main interest of Lambert is the eschatological question of the end of time, and as a result the end of world and humankind: visions of the End Time and the Antichrist are present in the *Liber floridus* in the *Apocalypsis depicta*. The historic background of Lambert's work includes the Conquest of England (1066), the success of the First Crusade (1099) and the arising Investiture Struggle. In 1097, Lambert met Anselm of Canterbury in person, when Anselm visited Saint-Omer on his journey to Rome. Lambert's work is a typical Romanesque encyclopedia and an important step in paving the way to scholastic encyclopedias and to scholastic methods in general. Not too long after Lambert, Master Gratian finished his *Decretum* around 1140.

Ancient sources of the concept of time: Plato, Aristotle and Plotinus

With his idea or form of the good, Plato (*c.* 428–348 BCE) has characterized the universal good in *The State* VI, 509 b, as 'beyond being and essence (*epékeina tês ousías*)', hence beyond world and time. Platonic ideas in general have the same essential qualities: they are eternal, immaterial, indivisible, beyond space and time. In the platonic dialogue, *Timaeus*[4] the *dêmiourgós* (constructor) is mentioned, the God who built the world out of basic, raw material. This God has only a creational function, he is not really a transcendent God. But the material out of which he creates the world is eternal. Therefore, this God is neither the Christian God, nor a Creator, who creates out of nothing. He has only the function to give order and reason to the qualities of the cosmos. In *Timaeus* 39 e 'the formation of time (*chrónou génesis*)' is mentioned, in order to distinguish between time and eternity. 'Time was created along with the heaven (*chrónos d' oûn met' ouranoû gégonen*)'.[5] This was the moment (*kairós*) of creation.

Aristotle (384–322 BCE), scholar of Plato, explains 'For time is just this – number of motion in respect of "before" and "after"'.[6] Hence time 'numbers' the movements of things. Therefore, time is something relational to Aristotle, because one can differentiate earlier and later moments, connected by an instant moment in the middle.

In Aristotle's thinking, the concept of eternity is closely connected with the (first) Unmoved Mover.[7] This first principle, which gives motion to everything in the cosmos, does not move itself. The first principle is loved by everything,[8] so all things in the cosmos move towards it as an aim (*télos*) in circles. By this non-moving quality, the Unmoved Mover is beyond time, because moving can only

be measured within time. The first principle remains always the same, it is the unchangeable 'thinking of thinking (nóêsis noêseôs)'.[9] Though it is not God in a theistic, personal sense, the first principle is called 'God' (theós) by Aristotle.[10]

Plotinus (c. AD 204/5–270) as the most influential thinker of Neoplatonism deals with the general notions and presuppositions which will have formed in us a concept of time and of eternity, as he points out in his *Ennead* III, 7 (*On eternity and time*). He starts his considerations with: 'We call eternity and time different from each other, in fact the first belonging to perennial essence, time however belonging to generation and to the manifest universe (*Tòn aiôna kaì tòn chrónon héteron légontes hekáteron eînai kaì tòn mèn perì tên aídion eînai phýsin, tòn dè chrónon perì tò gignómenon kaì tóde tò pân*)'.[11] A very important and central element in Plotinus' thoughts is the linking of eternity with the unchanging and transcendent intelligible world, and time with the physical, changing world of becoming. Plotinus identifies timelessness with intellectual life. The Intellect (*noûs*) is eternal and beyond time, it has duration and lacks succession. Eternity is 'life of the intellect (*noûs*)',[12] but time is 'life of the soul (*psychê*)'.[13]

'Time' in late antiquity: St Augustine and Boethius

Saint Augustine's (*doctor gratiae*, AD 354–430) thoughts on time are embedded in his interpretation of the *Genesis* in book X and especially book XI of his *Confessiones* (397/398). Time (*tempus*) is linked with the divine creation (*creatio*) according to Augustine. Before creation, it makes no sense to speak of 'time'. There was not any time (*nulla tempora*[14]) before God created the universe. One could say that time was within God before the creation. So there is meaning in speaking of 'time' when there are processes of rising and vanishing. Time gives natural processes a basis and also a framework within which they can progress. Concerning the *Liber floridus*, the concepts of time of Augustine and later Boethius are especially important, because they emerged before the *Liber floridus* was compiled between the years 1112 and 1121. Both of them, Augustine and Boethius, have influenced in an indirect

way the thinking of time in *Liber floridus*. Boethius especially is not a primary source concerning the subject of time in the *Liber floridus*. Lambert of Saint-Omer considers theories of 'time' generally in an implicit way, while he reflects on calendars and on the relation between macro- and microcosm (*Mundus maior et Mundus minor*). Lambert stays with the classic scheme of the six ages of the world (*sex etates mundi*), which corresponds to the ages of a man: the first age is from the creation (Adam) until Noah and corresponds to the age of an infant. The second is until Abraham, corresponding to boyhood. The third is until King David, corresponding to adolescence. The fourth is until the Babylonian exile of the Jews, corresponding to the age of an adult. The fifth is until Jesus Christ, corresponding to senescence. The sixth and last is until the final judgement and corresponds to frailness. In analogy to an allegoric person or a statue like in the book *Daniel* in the Old Testament, the six ages of the world are represented by a head of gold, a breast of silver, an abdomen of bronze, thighs of cupper, lower legs of iron and feet of clay.[15] This scheme also has a correspondence to the six days of Creation: on the first day, the angels were called into being, on the second the heaven, on the third water and earth, on the fourth sun, moon and stars, on the fifth the animals of the sea, and on the sixth day of creation the animals of the earth, and Adam, the first human being, were created.[16] The scheme of the six world ages goes back to Augustine's main reflections in his *De civitate Dei*.[17] Augustine also characterizes a world age, the eternal sabbath, eternal rest.[18] This scheme was later part of the works of two other main reference authors of Lambert beside Augustine: Saint Isidore of Seville with his *Etymologiae* (c. 623) and the Venerable Bede, also a saint, with his work *De natura rerum* (703). Walafrid Strabo, student of Saint Rabanus Maurus, took up the scheme of the six world ages as well in his personal *Breviarium*.[19] 'The six periods are used by Lambert as a theological and biblical structuration of the past', as Albert Derolez underlines.[20] Isidore is, together with Bede and Saint Rabanus Maurus (*De universo*, 847), a late antique predecessor of the encyclopedic technique. The other main reference authors of Lambert are Saint Ambrose, Saint Gregory the Great and Saint

Jerome.[21] Furthermore, Orosius, Martianus Capella, Blessed Alcuin of York, Freculphus of Lisieux and Elperic of Auxerre are among the sources of Lambert concerning 'time'.[22]

Augustine is very honest when he says that he knows quite well what time is, as long as he is not asked. But when he is asked what time is, he does not know anything to answer to this question: 'What, then, is time? If no one ask of me, I know; if I wish to explain to him who asks, I know not (*Quid est ergo tempus? Si nemo ex me quaerat, scio; si quaerenti explicare velim, nescio*)'.[23] Therefore, one can say that time is at first easy to understand, but very difficult to explain. This sounds a bit paradoxical,[24] but Augustine wants to reach a deeper philosophical understanding of time. So, he goes on with his investigation by dividing time into three levels, past, present and future: 'but perchance it might be fitly said, there "are" three times; a present of things past, a present of things present, and a present of things future (*fortasse proprie diceretur: tempora 'sunt' tria, praesens de praeteritis, praesens de praesentibus, praesens de futuris*)'.[25] So, Augustine aims to give time an own ontological status, because he stresses that there 'are' three times. The *Liber floridus* knows the division of time: in the *Liber floridus* time is divided threefold, too, but into years, months and days.

Time is located in the mind (*animus*): past, present and future, the three kinds of time, are all represented in the mind as dimensions of it.[26] 'Therefore do I not measure themselves [heard syllables], which now are not, but something in my memory, which remains fixed. (*Non ergo ipsas, quae iam 'non' sunt, sed aliquid in memoria mea metior quod infixum manet*)'.[27] This also sounds somewhat paradoxical, because past, present and future are basically in the mind at the same time.[28] Though man only lives in the present, the past and future can be represented by man in his mind. Past is represented in memory. That is the main content of Augustine's theory of *memoria* (memory). In a further step, Augustine says that time is measured by the soul as an extension of the mind: 'In you, O my mind, I measure my times (*In te, anime meus, tempora mea metior*)'.[29] Time is a representation in the person's mind and not a corporal motion.[30] Therefore, it is evident that Augustine's concept of time is highly subjective. In this case, Augustine's position is different from the more objective point of view of the platonic and neo-platonic tradition. With Augustine, the concept of subjective time arises.

Augustine links the timelessness of God with his eternal being. This is the cause of all moments of time and the immutability of God:

For whence could innumerable ages pass by which You did not make, since You are the Author and Creator of all ages? Or what times should those be which were not made by You? Or how should they pass by if they had not been? Since, therefore, You are the Creator of all times, if any time was before You made heaven and earth, why is it said that You refrained from working? For that very time You made, nor could times pass by before You made times. But if before heaven and earth there was no time, why is it asked: What were You doing then? For there was no 'then' when time was not.

Nam unde poterant innumerabilia saecula praeterire, quae ipse non feceras, cum sis omnium saeculorum auctor et conditor? Aut quae tempora fuissent, quae abs te condita non essent? Aut quomodo praeterirent, si numquam fuissent? Cum ergo sis operator omnium temporum, si fuit aliquod tempus, antequam faceres caelum et terram, cur dicitur, quod ab opere cessabas? Id ipsum enim tempus tu feceras, nec praeterire potuerunt tempora, antequam faceres tempora. Si autem ante caelum et terram nullum erat tempus, cur quaeritur, quid tunc faciebas? Non enim erat 'tunc', ubi non erat tempus.[31]

Furthermore, God is the only being that can (pre-)exist without time: 'It is not in time that you precede times. Otherwise you would not precede all times. In the sublimity of an eternity which is always in the present, you are before all things past and transcend all things future, because they are still to come (*Nec tu tempore tempora praecedis: alioquin non omnia tempora praecederes. Sed praecedis omnia praeterita celsitudine semper praesentis aeternitatis, et superas omnia futura, quia illa futura sunt, et cum venerint, praeterita erunt*)'.[32]

The human being, on the other hand, bursts into moments of time. The only hope is in God, the eternal one: 'But I have been divided amid times, the order of which I know not; and my thoughts, even the inmost bowels of my soul, are mangled with tumultuous varieties, until I

flow together unto You, purged and molten in the fire of Your love (*at ego in tempora dissilui, quorum ordinem nescio, et tumultuosis varietatibus dilaniantur cogitationes meae, intima viscera animae meae, donec in te confluam purgatus et liquidus igne amoris tui)*'.[33]

Augustine points out that Christian eschatology, doctrine of the last things, teaches us that man cannot fulfill time on his or her own. God will fulfill time, when He returns in Christ at the end of our time. So, the perfection of everything can only be achieved by God and it is not what happens in time, but rather the perfection of time out of time. Therefore, Augustine wrote that in time and in the world, we only can use (*uti*) things, but God is the only one who can be enjoyed (*frui*).[34] In the last books of *City of God*,[35] Augustine shows us that Christian eschatology differs from political eschatology, which tries to create an earthly paradise solely on the basis of political considerations, often linked with political ideologies and violence.

The love of God and the love of man for God is what maintains their relationship to God through time. If man is within the love of God, one can do whatever is wanted, it cannot be against the Almighty: 'Love, and do what thou wilt (*Dilige, et quod vis fac)*'.[36]

God, the Sacred Trinity, is independent of time. God is over, behind or next to time, because He is the eternal, pure being (*esse*) and has never been created. God is and always was, is and will always be,[37] He is timeless and unchanged. The universe, created by God, is in time. But the created universe is contingent, it is not a necessary being like God. God, existing out of time, is the only necessary being as a basic ground of contingent being in the universe and in our world.

With his early considerations on time in the fourth/fifth century, Saint Augustine is the starting point of medieval theories of time. He influenced later thinkers deeply, especially during scholasticism, e.g. St Thomas Aquinas (1224/25–1274). But Augustine influenced the thoughts about 'time' also beyond Christianity: modern thinkers like Edmund Husserl (1859–1938), with his phenomenology of time, Henri Bergson (1859–1941), in whose thinking the durative aspect of time (*durée*, duration) is central, and Martin Heidegger (1889–1976), with his main work *Sein und Zeit* (1927), refer directly or indirectly to the considerations of Augustine on time.

Boethius (*c.* AD 477–524) concentrated on the question of whether God's foreknowledge determines humans in time, because no future contingent event can come to existence without the knowledge of God, the omniscient and almighty. In the fifth book of his *On the Consolation of Philosophy*, especially in the sixth prose, Boethius mentioned that God has no *fore*knowledge, because he is an eternal being and has got no distinction between before and after. God is outside of time, so he is eternal, he has got an eternal duration, and is not perpetual, which means an uncountable amount of moments. For Boethius 'Eternity […] is the complete, simultaneous and perfect possession of everlasting life (*Aeternitas igitur est interminabilis vitae tota simul et perfecta posessio)*'.[38] So God is not mixed with time at all. He is eternal presence and he witnesses all events as they occur simultaneously like from the peak of a high mountain: '*quasi ab excelso rerum cacumine cuncta prospiciat* (like from the exalted peak of things he oversees everything)'. Thomas Aquinas took up this picture in his *Summa Theologiae*.[39] Therefore, God has knowledge of contingent events as a timeless being, and by that the divine omniscience does not destroy or even determine the human free will, which exists only within time. Human free will, as the free will of a finite being, is not like God's free will, as a free will of an eternal mental being. Hence, the human being can make truly free decisions, for which the individual may be praised or blamed within time. In the late Middle Ages, similar positions were held by Richard of Lavenham in his *De Eventu Futurorum*, by Peter Aureol and by William of Ockham, who countered Aureole's argument in the *Tractatus de praedestinatione et de prescientia dei respectu futurorum contingentium* (1322–1324). In this work, Ockham indicated that God knows all future contingencies, while human beings can choose between alternative possibilities.

Core concepts of medieval thinking of time: St Thomas Aquinas, John Duns Scotus and William of Ockham

Time (*tempus*) for St Thomas Aquinas (*doctor angelicus*, 1224/25–1274) as for St Augustine,

is a phenomenon, which has to do with the divine creation (*creatio*). God creates, as He is the first cause (*prima causa*). All the beings in the created world are creatures in time. Outside the world and the cosmos, time has no meaning, no use. Together with creation, time appears. All of the natural developments happen in time. Without time, man could not recognize developments. Human processes, even social and moral processes, also need time as a framework. As St Thomas pointed out in his early commentary to the sentences of St Peter Lombardus in his *Scriptum super IV libros Sententiarum*, time is likewise necessary for processes in the mind,[40] because it serves as a measurement for what we have in mind.[41] During the lifetimes of Thomas, Duns Scotus and William of Ockham, the *Liber floridus* already existed, but they are nevertheless important attestations of the thinking of time in medieval philosophy and theology.

Lambert of Saint-Omer does not primarily deal with theories of time. He has a more compotistical approach to 'time' by connecting considerations on time, e.g. lists of kings, emperors or popes, ecclesiastical calendars or a *Martyrologium*, with calendars of local saints, especially of the Collegiate Church *Our Lady* in Saint-Omer.[42] In that way he also connects aspects of universal history, such as the expedition of Alexander the Great in ancient times, and aspects of history of salvation, which link time (world) and eternity (God), with the local history of the annals of Saint-Omer, the diocese of Thérouanne and of the expanding Flanders, gaining more and more influence in politics, up to Lambert's own times. Moreover, climatic aspects of the region and aspects of astronomy play a role in these considerations on calendars and time. It was an important aim of Lambert 'to situate Flanders in world history and especially in the first crusade'.[43]

Also in his main work, the *Summa Theologiae*, St Thomas investigated time as an important phenomenon. Here, Aquinas differentiates between time (*tempus*), which was for him well known as one of the ten Aristotelian categories, and real eternity (*aeternitas*) as well aseternal time (*aevum*). *Aevum*, 'eternal time', is a kind of 'infinite time' for St Thomas, as an infinite sum of time, which is not a real eternity. It stands in the middle between time and eternity: 'And by this way can be measured

eternal time, which is the middle between eternity and time (*Et ideo huiusmodi mensurantur aevo, quod est medium inter aeternitatem et tempus*)'.[44] Then time can be a continuum or be separated into parts of time. Time can be imagined or real time. This distinction is different to Augustine, who teaches us that all three kinds of time, past, present and future, are only representations in mind and dimensions of it. But similar to Augustine, Aquinas says that there are three kinds of time: the first time is the beginning, the second time is the following time and the last time is the end of time: 'time has a beginning and an end (*tempus autem habet principium et finem*)'[45] and 'between two instants, there is a middle time (*inter quaelibet duo instantia sit tempus medium*)'.[46] Yet, again in contrast to Augustine, Aquinas admits that time is a kind of motion as posited by Aristotle. Time can be measured as the number of changes (e.g. dark – bright, night – day) or of motions: 'movement, whose measurement is time (*motus, cuius mensura est tempus*)'[47] and 'because time is the number of motions (*quia tempus est numerus motus*)'.[48] Time serves also to represent a metaphysical, not only a physical development or motion: as angels come to their nature at once, so do men come to their nature after a while,[49] because he or she has to discover the nature of man as a creature of God.

Finally, for moral actions, time is an important indicator. Man needs sufficient time in order to act morally (*Tempus autem est una de circumstantiis quae requiruntur ad actus virtutum.*[50]) Therefore nobody can be forced to immoral action by reducing his or her time to act or to react properly.

Within time, there are temporal things, which are contingent, not necessary. These temporal things, all material things, come to existence and vanish after a certain amount of time. They cannot exist eternally. However, in his mainly philosophical work *De aeternitate mundi* (*c.* 1271), St Thomas shows that the universe itself is eternal, because the substance, the 'basic material (*materia prima*)', is not created and eternal. This does not mean that our world is in its concrete appearance eternal, but the world and the universe are eternal in their 'basic material (*materia prima*)'. By this argument, St Thomas wanted to increase the philosophical value of the pagan philosopher

Aristotle to Christian theology. According to Aquinas, species are not eternal; they will, like other temporal beings or material things, appear and vanish in time. Without *materia prima*, there would have been a serious vacuum, which is, according to St Thomas, impossible.[51] In opposition to Aristotle and St Thomas, the ninth-century Rabbinite Saadia Gaon ben Joseph pointed out that the past cannot be eternal: he argues that 'nothing which is subject to time can be eternal, hence not even prime matter (*materia prima*).' But what about God? He exists prior to everything. But God is timeless, so his existence is not to be compared with existence in time in the way that is true for the whole creation. God is un-created. Similarly, William of Auvergne, who was Bishop of Paris in the thirteenth century, said that the idea of empty time prior to creation depends on a confusion between time and eternity. Eternity cannot be understood as a time which needs traversing. God as eternal being does not need anything, not even an uncountable amount of time before creation.

Another problem is that man cannot end time. According to Christian eschatology, it is only God who is able to fulfill time when Christ returns and separates the good from the evil. So, God is the creator and the dominator of time. 'To Him belongs time and the ages' (*Eius sunt tempora et aeternitas*), as it is written in the Office of the liturgy of the *Easter Vigil* of the Church. God is outside of time and He is the timeless, eternal being (*esse*). God is creator of everything and has never been created. He is and always was, is and will always be, without any changes.[52] God, the Sacred Trinity, is the origin of time and the basic ground of being. Similar to Augustine, it is not sensible for St Thomas to speak of time before creation.

St Thomas Aquinas influenced Christian doctrine in a very profound way. His considerations on the properties of time and other main subjects were philosophically and theologically investigated in many books and treatises, e.g. by the Arab philosopher Avicenna (Ibn Sina). But for him there was no clear distinction between time and eternity. With his thoughts, St Thomas stands in the tradition of the *philosophia perennis*, Everlasting or Permanent Philosophy, which has its starting point in the philosophy of Plato and Aristotle. John Duns Scotus (*doctor subtilis*, *c.* 1266–1308) Friar Minor in the fourteenth century and commonly known for his concept of the 'univocity of being', held the position of 'potential time'. According to him, time can also exist without motion: it could measure the 'universal rest'. By that, Duns Scotus has very much influenced one of the most important thinkers of late medieval philosophy, the English Friar William of Ockham (*c.* 1287–1347). Ockham writes in his *Brevis summa in libros Physicorum* (1322–1323): 'Time is the measure of movements whose magnitude is not known to us; in fact, it is by time that we recognize the length of a movement [...]. Time is also the measure of temporal things [...]. Finally, in the same way that time measures movements and temporal things, it also measures rest [...]. Those are the principal reasons for which one posits time and for which the knowledge of time is necessary for us.' Hence time measures both movement and rest.

Coming back to St Thomas and his tradition, in the early twentieth century, *Neo-Thomism* emerged. Neo-Thomistic philosophers and theologians kept alive Aquinas' thoughts in a multitude of ways: the French thinker Jacques Maritain (1882–1973), the Jesuit Erich Przywara (1889–1972) and the German philosophers Max Müller (1906–1994), Robert Spaemann (1927–2018) and Josef Pieper (1904–1997) represent, among others, Thomistic thinking in present times.

At the end of the Middle Ages, the most important elements of a philosophical theory of time are still present:

1. Time can be differentiated in past, presence and future.
2. Time can be measured.
3. Eternity can be characterized in three ways:
 a. eternal past <--------x final point
 b. starting point x---------> eternal future
 c. eternity (no starting point, no final point)
 <---------->

Consequences of medieval thoughts on time on modern philosophical positions

Early rationalistic positions: Giordano Bruno, Baruch de Spinoza and Gottfried Wilhelm von Leibniz

All three thinkers have a rationalistic approach to the question of God and time.

Giordano Bruno (1548–1600), Dominican friar, philosopher and cosmologist, was the first thinker in this group. Some of his thoughts are taken over by the two others, Spinoza and Leibniz. Bruno and Spinoza are in general pantheists and monists. Leibniz is a monotheistic thinker and not a monist, but he has the rationalistic method in common with Bruno and Spinoza. Bruno presumes that world and God are at first different, but in the end, they are together, because reality has its origin in eternal imagination.[53] The cosmos is infinite for Bruno, in the same way that there is an infinite number of beings in the cosmos. The universe is infinite, because God as the creator of the cosmos is almighty and infinite. A finite cosmos would be a too sharp contrast to the honor of an almighty and infinite God. So both God and the cosmos are infinite, but within time, as he pointed out in *De l'infinito, universo e mondi* (1584). In the opinion of Bruno, there could exist several parallel worlds, each of them eternal. He also believed that it is possible to have right measurements of time in our own world. Before Bruno, most of the thinkers followed Aristotle, who was convinced that only in the sphere of the fixed stars there could be a correct measurement of time. Time can be measured by motion. Therefore, Bruno developed a pendulum system, with which time could be measured by the motion of the pendulum in a correct way. Bruno was against the Ptolemaic, geocentric model of the universe, and because of his heretic opinions he was condemned to death in Rome in 1600.

The philosopher Baruch (or Benedict) de Spinoza (1632–1677), influenced by Bruno and Descartes (1596–1650), was convinced that the substance of nature and God are all the same, as the sentence 'God or Nature (*Deus sive natura*)' underlines. So he is an exponent of monism and pantheism. God is natural and living, and cannot be separated from matter. He is within every being. Some presumed that Spinoza was an atheist, because all materialistic things are finite in contrast to God, who is immaterial and eternal. But the Spinozistic concept of nature is not merely materialistic but much more complex. For Spinoza, nature has divine qualities even though it is material. God is the necessary, eternal and infinite substance of nature and the universe.[54]

So there is only *one* substance in the universe (monism), because God and nature are of the same substance. For this reason, God exists necessarily and, furthermore, He was forced to create the universe, because of this monistic union of God and nature. The main structures of the universe are causality and necessity. Beyond space and time there is only the true knowledge about the real being of beings in the universe. The world exists as an infinite sequence of natural processes throughout time. God exists as the eternal substance – eternal, but within time.

Gottfried Wilhelm von Leibniz (1646–1716), scientist, mathematician and philosopher, argues that there is a pre-established harmony, which is based on the monads as first non-material elements, as his *Monadologie* (1714) teaches us. Incidentally, it was Leibniz, who purchased a transcription of *Liber floridus* for the Duke Anton Ulrich of Braunschweig-Lüneburg in 1710, when he was appointed as librarian: this is the Wolfenbüttel manuscript.[55] The first monad is God, who has created the world as the best possible world. So, the evil in the world is reduced to a minimum, because God has compared our universe to every other possible universe, and He has decided for this world to be the best possible world. The metaphysical, physical and moral evil that exists, has its origin in the imperfect and finite cosmos, as Leibniz pointed out in his *Essais de Théodicée sur la Bonté de Dieu, la Liberté de l'Homme et l'Origine du Mal* (1710). God is the eternal reason and necessary being of the finite world. Space and time are not absolute, but relative. God and the universe are not of the same substance. So, Leibniz is, in contrast to Bruno and Spinoza, neither a monist nor a pantheist. Leibniz earned great status posthumously, for example in Bertrand Russell's (1872–1970) publications.

Recent positions: Pierre Teilhard de Chardin and Alfred North Whitehead

The French Jesuit priest, palaeontologist and philosopher Pierre Teilhard de Chardin (1881–1951) managed to reconcile the Christian – namely Catholic – position with the results of his research. God is the Alpha and the Omega Point of the universe, so He is outside of time and its framework. But in the universe

there are evolutionistic processes, which end up in the Omega Point as the last point of the Noosphere, which is God, at the end of time, but they are not teleologically directed to that Omega Point. From this point of view, God is somehow a spectator of the evolution of the universe, but also its aim. Teilhard de Chardin, who was present at the discovery of Peking Man in 1923–1927, has presented these arguments in his controversial seminal book *The Phenomenon of Man* (1959, first published in French 1955), which the Roman Holy Office banned during the lifetime of Teilhard de Chardin. Pope John XXIII later rehabilitated him, and his work became an influential contribution to the Church's position on evolution.

The mathematician and later philosopher Alfred North Whitehead (1861–1947) made his process philosophy the starting point for process theology, defending theism: the world and the whole universe is in fluent change, as he assessed in his *Process and Reality* (1929), a revised version of his Gifford Lectures, delivered in 1927/28. Therefore, God as the creator of the universe is also in a fluent process and is not able to predict each process in the universe precisely. God can also be understood within the framework of time, which make changes, growths and flows possible. This argument of Whitehead defends theism, but God is not almighty, so Whitehead's position is different from the Judaic and the Christian positions. Nevertheless, theologians as Charles Hartshorne, John B. Cobb Jr. and David Ray Griffin followed Whitehead and further developed process theology.

Both positions, that of Teilhard de Chardin as well as that of Whitehead, make clear that in the twentieth/twenty-first century, the distance between God as timeless being and the universe as creation within time, but maybe endless, became increasingly smaller. Summing up, one can say that the concept of time in medieval thinking is an important concept embedded in the European history of ideas leading up to the present day, in science and also in philosophy.

Further reading and references

Beierwaltes, W. (1967, 5th ed. 2010). *Plotin. Über Ewigkeit und Zeit* (Enneade III, 7), übers., eingel. und kommentiert von W. Beierwaltes. Frankfurt/M.: Klostermann.

Brague, R. (1982, 2nd ed. 1995, 3rd ed. 2003). *Du temps chez Platon et Aristote. Quatre études*. Paris: Presses universitaires de France.

Carmassi, P./Heitzmann, Chr. (eds) (2014). *Der Liber Floridus in Wolfenbüttel. Eine Prachthandschrift über Himmel und Erde. Faksimile mit Kommentar*. Darmstadt: Wissenschaftliche Buchgesellschaft.

Derolez, A. (1969). *Report on the Proceedings of the Liber Floridus Colloque. Ghent, University Library, 5–6 Sept. 1967*, Ghent: Centr. Bibl. van de Rijksuniv. te Ghent.

——— (ed.) (1973). *Liber Floridus Colloquium. Papers read at the international Meeting held in the University Library Ghent on 3–5 September 1967*, Ghent: Story-Scientia.

——— (1998). *The autograph Manuscript of the Liber Floridus. A Key to the Encyclopedia of Lambert of Saint-Omer*, Turnhout: Brepols.

——— (2003). *Die komputistischen Tafeln des Liber Floridus*, Trier: Paulinus.

——— (2015). *The making and meaning of the "Liber Floridus". A Study of the original Manuscript, Ghent, University Library MS 92*, London: Harvey Miller Publishers.

Gatti, H. (ed.) (2002). *Giordano Bruno. Philosopher of the Renaissance*, Aldershot et al.: Ashgate.

Jeck, U. R./Mojsisch, B./Rehn, R./Sprandel, R. (1998). *Zeit*, in: Lexikon des Mittelalters [LMA], ed. by R.-H. Bautier et al., vol. IX: Werla bis Zypresse, Anhang, München: Artemis, Sp. 509–514.

Kenny, A. J. P. (1993). *Aquinas on Mind*, London, New York: Routledge.

——— (2002). *Aquinas on Being*, Oxford: Clarendon Press / New York: Oxford University Press.

Lamberti S. Audomari canonici Liber Floridus. Codex autographus Bibliothecae Universitatis Gandavensis, ed. by A. Derolez (1968), Ghent: Story-Scientia.

Mercier, A. (1996). *God, World and Time*, New York, Frankfurt/M. et al.: Lang.

Padgett, A. G. (1992). *God, Eternity and the Nature of Time*. New York: St Martin's Press.

Poe, H. L. & Mattson, J. S. (eds) (2005). *What God knows. Time, Eternity, and divine Knowledge*, Waco/Tex.: Baylor University Press.

Porro, P. (2004). *Zeit. III. Mittelalter*, in: Historisches Wörterbuch der Philosophie [HWPh], ed. by J. Ritter et al., vol. 12: W-Z, Basel: Schwabe, Sp. 1210–1220.

Simon, J. (2001). *Zeit, Zeitlichkeit. II. Philosophisch*, in: Lexikon für Theologie und Kirche [LThK³], ed. by W. Kasper et al., vol. 10: Thomaschristen bis Žytomyr, Freiburg/Br., Basel, Wien: Herder, Sp. 1405–1409.

Smith, A. A. II (2007). *Time and the Medieval World* (https://philosophynow.org/issues/62/Time_and_the_Medieval_World, 01.07.2021).

Teske, R. J. (1996). *The Paradoxes of Time in Saint Augustine. Under the auspices of the Wisconsin-Alpha Chapter of Phi Sigma Tau*, Milwaukee/Wis.: Marquette.

DeWeese, G. J. (2004). *God and the Nature of Time*, Aldershot et al.: Ashgate.

Westermann, H. (2004). *Zeit, B. Platon bis Boethius*, in: Historisches Wörterbuch der Philosophie [HWPh], ed. by J. Ritter et al., vol. 12: W-Z, Basel: Schwabe, Sp. 1197–1207.

Wissink, J. B. M. (ed.) (1990). *The Eternity of the World in the Thought of Thomas Aquinas and his Contemporaries*, Leiden, New York et al.: Brill.

NOTES

1. Ghent University Library, *Ms. 92*.
2. LAMBERT, *Liber Floridus*, prol.
3. A. DEROLEZ, *The autograph Manuscript of the Liber Floridus. A Key to the Encyclopedia of Lambert of Saint-Omer*, Turnhout, 1998, p. 182.
4. *Timaeus* 29 a.
5. *Timaeus* 38 b.
6. *Physics* IV 11, 220 a 24.
7. *Physics* VIII 1, 251 a 8–252 b 6 and *Metaphysics* XII 6, 1071 b 4–11.
8. *Metaphysics* XII 7, 1072 b 4/5.
9. *Metaphysics* XII 9, 1074 b 34/35.
10. *Metaphysics* XII 7, 1072 b 25 and 30–32.
11. *Ennead* III, 7, 1.
12. *Ennead* III, 7, 2–6.
13. *Ennead* III, 7, 11–13.
14. *Confessiones* XI. xiv (17), transl. by J. G. PILKINGTON, *From Nicene and Post-Nicene Fathers*, First Series, Vol. 1, ed. Ph. SCHAFF, Buffalo/NY, 1887.
15. See *Daniel* 2. 31–33.
16. See P. CARMASSI/CHR. HEITZMANN (edd.), *Der Liber floridus in Wolfenbüttel. Eine Prachthandschrift über Himmel und Erde. Faksimile mit Kommentar*, Darmstadt, 2013, p. 28–31 and 35–37 (Introduction).
17. *De civitate Dei* XI–XVIII.
18. *De civitate Dei* XXII. 30.
19. *Codex Sangallensis* 878.
20. A. DEROLEZ, *Report on the Proceedings of the Liber Floridus Colloquy* (Mededeling, Nr. 12), Ghent, 1969, p. 225.
21. See CARMASSI/HEITZMANN, op. cit. (fn. 16), p. 21sq. (Introduction).
22. See DEROLEZ, *Report*, op. cit. (fn. 20), p. 225sq. and DEROLEZ, *The autograph*, op. cit. (fn. 3), p. 29–34 and 182sq.
23. *Confessiones* XI. xiv (17).
24. See R. J. TESKE, *Paradoxes of Time in Saint Augustine*, Milwaukee/Wis., 1996.
25. *Confessiones* XI. xx (26).
26. *Confessiones* XI. xx (26).
27. *Confessiones* XI. xxvii (35).
28. See R. J. TESKE, *Paradoxes of Time in Saint Augustine*, Milwaukee/Wis., 1996.
29. *Confessiones* XI. xxvii (36), see also *Conf.* XI. xxi–xxii (27–28) and xxviii (37).
30. *Confessiones* XI. xxiv (31).
31. *Confessiones* XI. xiii (15).
32. *Confessiones* XI. xiii (16).
33. *Confessiones* XI. xxix (39).
34. *De doctrina Christiana* I. iv (4).
35. Esp. *De civitate Dei* XXII.
36. *In epistulam Ioannis ad Parthos*, tr. VII, 8.
37. *Exodus* 3. 14.
38. *De consolatione philosophiae*, V, 6. prose, transl. by V. E. WATTS, 1969.
39. *Summa theologiae*, Ia, qu. 14, a. 13, ad 3.
40. *Scriptum super quattuor libros sententiarum Petri Lombardi*, lib. 1, d. 3, q. 4, a. 1, arg. 2.
41. See A. KENNY, *Aquinas on Mind*, London, New York, 1993, p. 54 f.
42. See DEROLEZ, Report, op. cit. (fn. 20), p. 226sq. A. DEROLEZ, *Die komputistischen Tafeln des Liber Floridus*, Trier, 2003, and CARMASSI/ HEITZMANN, op. cit. (fn. 16), p. 34sq. and 46sq. (Introduction).
43. A. DEROLEZ, *Report*, op. cit. (fn. 20), p. 233sq., p. 234 (quotation); DEROLEZ, *The autograph*, op. cit. (fn. 3), p. 182sq. and CARMASSI/HEITZMANN, op. cit. (fn. 16), p. 55–57 (Introduction).
44. *Summa theologiae*, Ia q. 10 a. 5 co.
45. *Summa theologiae*, Ia q. 10 a. 5 co.
46. *Summa theologiae*, IIIa q. 75 a. 7 ad 1.
47. *Summa theologiae*, Ia q. 10 a. 6 co.
48. *Summa theologiae*, Ia q. 46 a. 1 arg. 6.
49. See *Summa theologiae*, Ia-IIae q. 5 a. 1 ad 1.
50. *Summa theologiae*, IIa-IIae q. 62 a. 8 arg. 3.
51. See J. WISSINK (ed.), *The Eternity of the World in the Thought of Thomas Aquinas and his Contemporaries*, Leiden, New York, 1990, p. vii f.
52. See A. KENNY, *Aquinas on Being*, Oxford, New York, 2002, p. 70.
53. See H. GATTI (ed.), *Giordano Bruno. Philosopher of the Renaissance*, Aldershot et al., 2002.
54. *Ethica Ordine Geometrico Demonstrata*, 1677, pars Ia.
55. Herzog August Bibliothek, Cod. Guelf. 1 Gud. lat.

About the Authors

Albiero Laura

Laura Albiero est chercheur associé à l'Institut de recherche et d'histoire des textes et est spécialiste de liturgie médiévale. Elle a publié le *Repertorium Antiphonarum Processionalium*, une étude sur les sources notées du diocèse de Côme (Lugano, 2016) et le volume collectif Sciences du Quadrivium au Mont-Cassin (Turnhout, 2018, avec Isabelle Draelants), ainsi que des nombreux articles sur les manuscrits liturgiques. Déjà impliquée dans plusieurs projets ('Clairvaux' à l'IRHT, Polonky France Angleterre 700–1200 à la Bibliothèque nationale de France), elle est *visiting fellow* à Oxford en 2016 et *senior fellow* pour le projet Fragmentarium (Université de Fribourg) en 2019–2020. En 2020 elle est lauréate du concours Émergence(s) de la Ville de Paris.

Burnett Charles

Charles Burnett (PhD Cambridge, FBA LGSM) is Professor of the History of Arabic/Islamic Influences in Europe at the Warburg Institute, University of London. His work centres on the transmission of Arabic science and philosophy to Western Europe, which he has documented by editing and translating several texts that were translated from Arabic into Latin and by describing the historical and cultural context of the translations. Among his latest publications are editions and translations of *The Great Introduction to Astrology by Abū Maʿshar* (Leiden, 2019, with Keiji Yamamoto) and *Thābit ibn Qurra, On Talismans* (Florence, 2021, with Gideon Bohak).

Carmassi Patrizia

Patrizia Carmassi, Dr. phil., studied in Pisa and Münster Classical Philology, Medieval History and Palaeography. Her PhD dealt with the liturgical Lectionary of the Ambrosian Church in the Middle Ages. Currently she is a senior researcher at the Herzog August Bibliothek in Wolfenbüttel. She has also worked at the University of Göttingen and at LE STUDIUM, Orléans. Her research focuses on Medieval Church history, Liturgy, Latin philology, codicology, the history of libraries and the concepts of time in medieval culture. Recent publications include: *Katalog der mittelalterlichen und frühneuzeitlichen Handschriften aus Halberstadt. Verzeichnis der Bestände der Kulturstiftung Sachsen-Anhalt, Domschatz zu Halberstadt, und des Historischen Archivs der Stadt Halberstadt*, Wiesbaden, 2018; ed. (together with G. Toussaint), *Codex und Material*, Wiesbaden, 2018 (Wolfenbütteler Mittelalter-Studien, 34); ed. (together with C. Heitzmann), *Marginalien im Bild und Text: Essays zu mittelalterlichen Handschriften*, Wiesbaden, 2019 (Wolfenbütteler Forschungen, 156); 'Concezioni e percezioni del tempo nel monastero benedettino di Weißenburg nell'Alto Medioevo', in *Il tempo delle comunità monastiche nell'altomedioevo*, ed. L. Pani Ermini, Spoleto, 2020 (De re monastica, VI), p. 163–186; 'Manoscritti italiani nel progetto di nuova catalogazione dei codici latini medievali della SUB-Göttingen. Precisazioni e scoperte', in *Rivista di Storia della miniatura* 24 (2020), p. 83–94.

Derolez Albert

Albert Derolez (1934) is Curator emeritus of Manuscripts and Early Printed books at Ghent University Library. He taught for many years palaeography and codicology at the Free Universities of Brussels and at several American universities. President of the Comité International de Paléographie Latine 1995–2005. Editor-in-Chief of the series *Corpus Catalogorum Belgii. The Medieval Booklists of the Southern Low Countries* (1994–2021). Editor of the *Liber Floridus* of Lambert of Saint-Omer (1968), the *Liber divinorum operum* of Hildegard of Bingen (1996), and other medieval texts. Author of books and articles on medieval libraries, codicology and palaeography, including *Codicologie des manuscrits en*

écriture humanistique sur parchemin (1984) and *The Palaeography of Gothic Manuscript Books* (2003).

Draelants Isabelle

Médiéviste, Isabelle Draelants (doctorat Univ. de Louvain-la-Neuve, Habilitation Paris-IV Sorbonne) est directrice de recherche au CNRS et travaille à l'Institut de recherche et d'histoire des textes, où elle est responsable de la section latine et de l'*Atelier Vincent de Beauvais* spécialisé dans l'étude des encyclopédies médiévales et a créé le corpus en ligne SourcEncyMe.fr destiné à identifier les sources des encyclopédies médiévales. Elle a dirigé de 2009 à 2013 le *Centre de médiévistique Jean-Schneider* à Nancy. Elle est co-responsable avec N. Weill-Parot de l'axe « Doctrines et techniques scientifiques » du LabEx Hastec. Ses premiers travaux portaient sur la chronologie des événements célestes, des famines et des séismes dans les textes annalistiques ; ensuite, ils ont été orientés vers les sources de la philosophie naturelle médiévale et l'histoire des textes sur la nature, en particulier au 13ᵉ siècle (minéralogie, botanique, zoologie, cosmologie). Elle dirige, avec Arnaud Zucker, la revue *RursuSpicae. Transmission, réception et réécriture de textes, de l'Antiquité au Moyen Âge.* Elle participe à l'International Research Network (IRN) Zoomathia sur la zoologie antique et médiévale. Ses derniers travaux portent sur la cosmologie du haut Moyen Âge (elle prépare l'édition commentée et la traduction du *Liber Nemroth de astronomia.*

Faure Philippe

Philippe Faure est maître de conférences en histoire du Moyen Âge à l'Université d'Orléans. Docteur de l'EHESS, spécialiste de la spiritualité et de l'iconographie chrétienne, ses recherches ont porté principalement sur la dévotion aux anges et sur leurs représentations pendant la période mediévale. Il a publié une trentaine d'articles relatifs à cette thématique, ainsi que deux ouvrages, *Les anges* (Paris, 2004) et, avec le philosophe Yves Cattin (†), *Les anges et leur image au Moyen Âge* (La Pierre-qui-Vire, 1999). Il a coordonné le dossier *La protection spirituelle au Moyen Âge,* dans les *Cahiers de Recherches Médiévales 8* (Paris, 2001), et codirigé deux ouvrages collectifs, *De Socrate à Tintin. Anges gardiens et démons familiers* (Presses Universitaires de Rennes, 2011) et *Le roi*

Salomon au Moyen Âge. Savoirs et représentations (Turnhout, sous presse). En tant qu'historien des religions et de la spiritualité, il a également dirigé un recueil d'études d'histoire contemporaine, *René Guénon. L'appel de la sagesse primordiale* (Paris, 2016).

Heitzmann Christian

Christian Heitzmann is senior curator of Manuscripts and Special Collections at the Herzog August Bibliothek Wolfenbüttel. He is head of the library's centre of manuscript studies, supervising projects for cataloguing and digitizing medieval manuscripts according to the guidelines of the German Research Foundation (DFG). He studied History, Classical Philology and Medieval Latin and holds a PhD in Medieval Latin of the University of Freiburg im Breisgau. His research is dedicated to codicology, the history of libraries and the transmission of texts in the Middle Ages. Selected publications: *Marginalien in Text und Bild. Essays zu mittelalterlichen Handschriften,* ed. Patrizia Carmassi and Christian Heitzmann, Wiesbaden 2019 (Wolfenbütteler Forschungen 156); *500 Jahre Schichtbuch. Aspekte und Perspektiven der Hermann-Bote-Forschung,* ed. Henning Steinführer, Thomas Scharff and Christian Heitzmann, Braunschweig 2017 (Braunschweiger Werkstücke 116 = Reihe A 57); *Der Liber floridus in Wolfenbüttel. Eine Prachthandschrift über Himmel und Erde,* Darmstadt 2014 (together with Patrizia Carmassi); *Corvina Augusta. Die Handschriften des Königs Matthias Corvinus in der Herzog August Bibliothek Wolfenbüttel,* ed. Edina Zsupán and Christian Heitzmann, Budapest 2014 (Supplementum Corvinianum 3).

Obrist Barbara

Barbara Obrist holds a PhD degree in Art History from the University of Geneva and is currently *Directeur de recherche émérite* at the Centre national de la recherche scientifique and the University Paris Diderot. She is a scholar of medieval history of science and philosophy and of scientific images, specializing in history of alchemy and cosmology. Among her books are *Constantine of Pisa: The Book of the Secrets of Alchemy. Critical Edition, Commentary, and Translation* (Leiden, 1990); *La cosmologie médiévale. Textes et images I. Les fondements antiques,* Micrologus' Library, 11

(Florence, 2004). Recently published studies include: 'La cosmologie du Haut Moyen Age, le statut de la connaissance philosophique et la question d'un univers christianisé', in *La conoscenza scientifica nell'Alto Medioevo*, LX-VII Settimana di studi, 25 aprile–1 maggio 2019 (Spoleto, 2020), 53–112 ; 'The Idea of a Spherical Universe and its Visualization in the Earlier Middle Ages', in *The Visualization of Knowledge in Medieval and Early Modern Europe*, Conference, Jerusalem, Israel Institute for Advanced Studies, June 6–9, 2016, eds M. Kupfer, A. Cohen, J. H. Chaies, A. Worm (Turnhout, 2020), 229–258. Her current work focuses on volume II of *La cosmologie médiévale*, dealing, above all, with twelfth-century cosmology.

Rathmann-Lutz Anja

Anja Rathmann-Lutz est historienne et historienne de l'art. Après avoir étudié l'histoire, l'histoire de l'art et le management des musées, elle a obtenu son doctorat à l'Université de Hambourg (publié Berlin, Akademie 2010) et est actuellement chargée de recherche principale au département d'histoire de l'Université de Bâle (Suisse). Son habilitation a été achevée en 2020 sous le titre « Stories of Change – Changing Stories. Conceptualiser et narrativiser le changement au Moyen Âge central » et est actuellement en cours de révision pour publication. Les recherches de A. Rathmann-Lutz portent sur l'histoire culturelle du Moyen Âge et de la Renaissance, en particulier sur la perception du changement du Moyen Âge central, sur l'utilisation politique des images et les questions de visibilité, sur la médialité, ainsi que sur l'histoire des corps, des villes du Moyen Age et sur questions sur la temporalité et les relations espace-temps. Elle s'intéresse aux *tools*, aux défis et aux possibilités de la *public history* et des *digital humanities*.

Rizzi Marco

Marco Rizzi (1962) is Professor of Early Christian Literature and Dean of the Department of Religious Studies at the Catholic University in Milan. Among his recent books are: *L'Anticristo*, 3 vols, Fondazione Valla – Mondadori, Roma – Milano 2005–2019 (with Gian Luca Potestà); *Hadrian and the Christians*, De Gruyter, Berlin – New York 2010; *Anticristo. L'inizio della fine del mondo*, il Mulino, Bologna 2015;

La secolarizzazione debole, il Mulino, Bologna 2016. He is also Secretary of the AIEP-IAPS (Association Internationale d'Études Patristiques – International Association of Patristic Studies), editor of 'Annali di Scienze Religiose' (Brepols – Turnhout), member of the Scientific Committee of the series 'Adamantiana' (Aschendorff – Münster), 'Studia Patristica Mediolanensia' (Vita e Pensiero – Milano), 'Nuovi Testi Patristici' (Città Nuova – Roma) and of the Editorial Boards of the Reviews 'Interdisciplinary Journal for Religion and Transformation in Contemporary Society' (Ferdinand Schöningh Paderborn), 'Встник ПСТГУ. Серия I: Богословие. Философия. Религиоведение' (St. Tikhon's University Review. Series I: Theology. Philosophy. Religious Studies, Moscow), 'Adamantius' (Morcelliana – Brescia), 'Rivista di storia del Cristianesimo' (Morcelliana – Brescia), 'Politica e Religione' (Morcelliana – Brescia).

Savigni Raffaele

Raffaele Savigni (1953) est professeur d'histoire du Moyen Âge à l'Université de Bologne. Il a étudié l'ecclésiologie, l'historiographie et l'exégèse carolingienne, les institutions ecclésiastiques et l'hagiographie médiévale, l'histoire de Lucques et le culte de la Sainte Face. Principales publications: *Giona di Orléans: una ecclesiologia carolingia*, Bologna 1989; *Episcopato e società cittadina a Lucca da Anselmo II († 1086) a Roberto († 1225)*, Lucca, 1996; *Il commentario di Aimone all'Apocalisse*, dans R.E. Guglielmetti (dir.), *L'Apocalisse nel Medioevo*, Actes du Colloque de Gargnano sul Garda (18–20 maggio 2009), Firenze, 2011, pp. 207–266; *I trattati "adversus Graecos" di Enea di Parigi e Ratramno di Corbie*, in *Per respirare a due polmoni. Chiese e culture cristiane tra Oriente e Occidente. Studi in onore di Enrico Morini*, Bologna, 2019, p. 449–475; *Représentation du passé et de la mémoire dans l'historiographie médiévale de Lucques*, dans P. Bourgain, J. Y. Tilliette (dir.), *Le Sens du temps. Le Sense of Time*, Actes du VIIe congrès international de latin médiéval (Lyon, 10–14 septembre 2014), Genève, 2017, p. 649–666; *L'humanisme à Lucques (vers 1450–1550): un mouvement à a croisée des chemins*, in « Diasporas », 35 (2020), p. 39–62; *Presenze istituzionali e centri di elaborazione della cultura scritta a Lucca tra XII e XIV secolo: un sondaggio*, in « Codex studies », 4 (2020), p. 245–286.

Seitschek Hans Otto

Hans Otto Seitschek studied philosophy, psychology, catholic theology and canon law at Ludwig-Maximilians-Universität Munich. After his MA (2000), Seitschek earned a PhD in philosophy in 2005. His doctoral thesis *Politischer Messianismus*, 2005, deals with a central concept of the Jewish historian Jacob L. Talmon. In his Habilitation (postdoctoral degree), Seitschek outlines a systematic approach to the philosophy of religion (*Religionsphilosophie als Perspektive*, 2017). Hans Otto Seitschek became an adjunct professor of philosophy at LMU Munich in 2018. He teaches at LMU and he also taught at the universities of Freiburg and Augsburg. Among other articles and books, he edited the volume *Sein und Geschichte. Grundfragen der Philosophie Max Müllers*, 2009, and the history of his faculty: *Philosophie an der Ludwig-Maximilians-Universität*, 2010.

Vorholt Hanna

Hanna Vorholt is Senior Lecturer in the Department of History of Art and the Centre for Medieval Studies at the University of York. She holds a PhD degree in Kunst- und Bildgeschichte from the Humboldt University of Berlin and specialises in the study of illuminated manuscripts. Her monograph *Shaping Knowledge. The Transmission of the Liber Floridus* appeared in 2017 as vol. 6 of the *Warburg Institute Studies and Texts*; she also co-edited the volumes *Imagining Jerusalem in the Medieval West* (Oxford, 2012), *Visual Constructs of Jerusalem* (Turnhout, 2012), and *Between Jerusalem and Europe* (Leiden, 2015). Recent publications include 'The Ruled Line and the Drawn Line in Medieval Maps', in *France et Angleterre: Manuscrits Médiévaux entre 700 et 1200*, eds C. Denoël and F. Siri (Turnhout, 2020), p. 75–106; and 'The Local, Regional, and Universal in Knowledge Compilations: Observations on the *Codex Aldenburgensis*', in *Between Encyclopaedia and Chorography: Defining the Agency of Early Modern "Cultural Encyclopaedias" from a Transcultural Perspective*, ed. A. Boroffka (Berlin and Boston, forthcoming). She collaborated in the ERC-funded project *Projections of Jerusalem in Europe* (2010–2015) and the AHRC-funded project *The Production and Reading of Music Sources* (2010–2014).

Index of Manuscripts